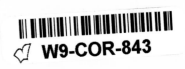

Leonardo da Vinci

Leonardo da Vinci on the human body

The Anatomical, Physiological, and Embryological Drawings of Leonardo da Vinci.

With Translations, Emendations and a Biographical Introduction

by **Charles D. O'Malley** and **J. B. de C. M. Saunders**

GREENWICH HOUSE
Distributed by Crown Publishers, Inc.
New York

*This 1982 edition is published by Greenwich House, a
Division of Arlington House, Inc., distributed by
Crown Publishers, Inc.*

Manufactured in the United States of America

Library of Congress Cataloging in Publication Data
Leonardo, da Vinci, 1452–1519.
 Leonardo da Vinci on the human body.
 *Reprint. Originally published: New York:
H. Schuman, 1952.*
 *1. Anatomy, Human—Early works to 1800.
I. O'Malley, Charles Donald. II. Saunders, J. B.
de C. M. (John Bertrand de Cusance Morant),
1903- III. Title. QM21.L53 1982
611 82-12063*
ISBN 0-517-381052

h g f e d c b a

CONTENTS

introduction

illustrations

FOREWORD

One must be prepared before opening this book of the Leonardo da Vinci drawings to look between and behind each line or sketch. These drawings are no accident of fate, no meanderings of an artist. They represent in every instance of line, space, shading and shadow, or background mirror writing, the product of a powerful figure of history. Whether they are his idle speculations or daydreams, or the most succinct, defined, fully realized renditions, they command full respect, scrutiny, and study. None can be passed over lightly or skimmed. This perspective of the drawings is reinforced by the fact that every newly discovered fragment, whether tattered or torn or faded, mutilated or ravaged by time, is headline news around the world.

The birth of the universe is studied by all disciplines and, like the riddle of the Sphinx, the location of the tomb in the Great Pyramid of Egypt, or the smile of the Mona Lisa, has yet to give up its secret. As a man of endless curiosity, Leonardo da Vinci was not concerned with being artist, engineer, inventor, or anatomist, except as it provided a sequence of relatively undemanding employers. He reserved for himself a range of internal and external freedom as exemplified by the drawings in this volume.

Here, he sought within the human model the structure and locus of shape, form, and dynamic configuration of the secrets of man and universe. His major inquiry into the human body was to expose the source of its strength and ingenuity on the physical side, as well as the evidence of the impact of life's vicissitudes. This acknowledged that in developing from foetus to child to youth, adult, and into old age, that anatomy and life change.

In addition, he sought the residence of heart and soul, and no less successfully, in the material sense. As the body dissolved into bits and shreds while the dissection progressed, it left within him an increasingly enriched sense of what man was all about, in death, while his prodigious intellect filled in between the lines and spaces and shadings the vivid depiction of how much life had taken with it in its departure. It was this continual enrichment and depiction of spirit, power, and strength carried to infinite lengths that made Leonardo da Vinci a colossus in the history of mankind. As long as man, the only living creature capable of preserving in visual and oral form an accumulation of knowledge and passing it on from one generation to the next, continues in this sequencing, the vision of Leonardo will not dim.

To approach this book intelligently one has to see that each drawing shows front view, left side, right side, rear view and unmistakably conveys that there is more inside. That is the power of this work that makes it so distinguished. Likewise, the reverse writing is meant to separate the intellectual aspect from the visual imagery of what is optically seen. Leonardo da Vinci did not fail to recognize the gap to be spanned between what one sees and putting it into words. Reading the translation of the words reveals the elements that parallel what is evident in the drawings. It is necessary to look first at the drawings without making reference to the reverse writing and then go back and read the translations of the reverse writings on their own in order for one to really appreciate the colossal achievement of this duality; that so much of the artistry, creativity, and spirituality that is in the drawings is in the writing.

GEORGE BREITBART, M.D.
New York City
1982

THE AUTHORS WISH TO EXPRESS THEIR PROFOUND GRATITUDE FOR THE MOST GRACIOUS PERMISSION OF HER MAJESTY, QUEEN ELIZABETH II FOR THE USE OF THE REPRODUCTION OF THE LEONARDO DA VINCI DRAWINGS AT WINDSOR CASTLE. WE WISH ALSO TO EXPRESS OUR GRATITUDE TO SIR OLIVER FRANKS, BRITISH AMBASSADOR TO THE UNITED STATES AND MR. J. MITCHESON, H. B. M., BRITISH CONSUL GENERAL AT SAN FRANCISCO FOR THE KINDNESS THEY HAVE SHOWN IN THIS MATTER.

acknowledgments

In the assembling and editing of this work we found
the extraordinary Elmer Belt Library of Vinciana of
Los Angeles most helpful and cooperative. Profound
thanks are also due to The Burndy Library of Nor-
walk, Conn., which provided the source works from
which these anatomical drawings were reproduced.

CHARLES D. O'MALLEY

J. B. de C. M. SAUNDERS

introduction

anatomical illustration before Leonardo

If it may be said that the fourteenth century ushered in a new period of civilization, for convenience called the Renaissance, then it may be remarked that anatomy in that new age was long to remain mediaeval, at least insofar as it was reflected in medical illustration. Prior to this new era the teaching of anatomy had been based largely upon the dissection of animals, but in the thirteenth century even this limited procedure of direct observation was largely superseded by the Arabic influence which led to efforts to teach anatomy wholly from textbooks. Although the Arabic influence was to be cast off eventually, yet anatomy was still to suffer from strictures arisen from a misunderstanding of the position of the church. In 1300 Pope Boniface VIII had issued a bull, *De sepulturis*, which proclaimed excommunication for any who should follow the practice of boiling the bones of persons, in particular crusaders, in order to make their storage and transport easier for burial at home. This bull was frequently and incorrectly interpreted, even by anatomists, as a prohibition against dissection. Partly perhaps as an outgrowth of this situation and partly as the result of too literal religious views there was also considerable popular opposition to dissection of the human body for fear of the consequences upon resurrection.

Despite such obstacles there was a limited knowledge of anatomy, partly traditional, partly the outgrowth of surgical experience and very likely from time to time the reflection of surreptitious dissection. The first open mention of dissection was of one performed in Italy in 1286. However, it was nothing more than a post-mortem examination of a victim of a pestilence then raging and was for the purpose of attempting to find the cause of death. There is a more formal account of an examination performed in 1302 in Bologna to ascertain the cause of a death which had occurred under suspicious circumstances. The account does not suggest the procedure as unusual and presumably post-mortem examinations as legal devices had previously been performed. Yet such examinations would yield little anatomical information since normally the procedure required little more than the opening of the thorax and an examination of the contents.

With the appearance in 1316 of the *Anothomia* of Mundinus (c.1270-1326) we enter upon what might be called the non-mediaeval rather than the modern period of anatomy. Moreover, it should be emphasized that in this period anatomy was considered to include both a knowledge of the structure and of the function of the human body. Mundinus' book is the first devoted entirely to this subject, and although the Arabic tradition is still strong, yet it is obvious that Mundinus incorporated the results of dissection and, indeed, performed the dissections himself. From the time of Mundinus the medical school at Bologna was to become the centre of such anatomical knowledge as there was. There dissection was officially recognized by university statute in 1405, to be followed in 1429 by a similar recognition at Padua. However, permission did not necessarily imply opportunity, and cadavers were only very infrequently at the disposal of the schools. Furthermore, the successors of Mundinus for the next century and a half did little more than echo and confirm what he had already propounded, and this is not to be wondered at in view of what passed for dissection.

This limited interest in anatomy is supported by text and illustration, although the situation is more precisely defined in the former since it was not until the sixteenth century, and even then far from unanimously, that physicians came to look upon correct anatomical drawings as having any pedagogical value. Indeed, many physicians up to this time decried the employment of anything which might tend to distract the reader from the text. Under such conditions, it is not astonishing to find that illustration displayed no development. Such as there was remained traditional, often having no immediate relationship to the text and frequently merely a kind of symbolic decoration. Thus to judge the anatomical knowledge at any given time from such illustrative material would be wholly misleading.

The major tradition insofar as anatomical illustration is concerned was one which is said to go as far back as the time of Aristotle who in his *De generatione animalium*, I:7, speaks of the teaching of anatomy through "paradigms, schemata and diagrams". Thereafter the Alexandrian anatomists such as Herophilus and Erasistratus are said to have continued the employment of such sorts of illustrative materials in their teaching.

While it is impossible to say precisely what these illustrative materials were, nevertheless there is fairly general support for the belief that what Karl Sudhoff called the "Five Picture Series" represents a portion of them. These five views, representative of the bones, muscles, nerves, veins and arteries, and displayed in crude human figures, invariably in a semi-squatting position, have been found not only in Europe and Asia, but also in the western hemisphere. The similarity of pose—with full anterior view of body and face, the latter completely rigid—suggests a long-standing tradition which Sudhoff considers as indicating characteristics of early Egyptian and Greek sculpture and therefore supporting a Hellenic and Alexandrian origin.

Through successive centuries the tradition appears to have remained constant with the exception that occasionally a sixth figure was added, either a view of the pregnant woman or depiction of the generative organs, either male or female. However, the anatomical content of the series passed on to successive centuries without change despite the fact that anatomical texts indicate gradually increasing knowledge. It is not astonishing therefore that as anatomical knowledge increased, notably at the end of the fifteenth century, this series of five or six crude figures is less and less associated with the physician and becomes a device to assist the unlearned barber-surgeon in his activities, especially that of bloodletting. Nevertheless the pedagogical aspect of the tradition associated with the figures continued in regular medical circles. Thus the *Tabulae anatomicae* of Vesalius (1538) are the result of this influence although the new pose of the figures, the superior draughtsmanship and far more nearly correct anatomy represent a novelty.

If therefore the traditional anatomical drawings became less and less a true representation of the state of anatomical knowledge with the passing centuries, there is another sort of anatomical drawing which does more truly represent the situation. This is the miniature which is to be found on manuscripts from about the fourteenth century, depicting dissection scenes. While it is true that the extent of knowledge is not indicated in these miniatures, yet the dissection scenes are revealing. Human dissection, it is apparent, was once again being practiced, and in the course of time such dissections would inevitably lead to an increase of anatomical knowledge. It is true that the dissection was still an occasional affair and indicated as such by its ceremonious nature. It is also true that the actual dissection was delegated to assistants, and the physician-teacher lectured from a book with little profit to himself or to his students. Yet inevitably and gradually, knowledge would be acquired. From our advantage of hindsight it may be said that the appearance of the dissection miniature meant the eventual banishment of the traditional anatomical series from academic medical circles.

While it can be said with considerable correctness that from the fourteenth century on the physician looked with more and more scorn upon anatomical illustration—possibly in some degree because of its useless character so long as it remained traditional—about this time the professional artist was becoming interested in the study of anatomy as an auxiliary to a more naturalistic portrayal of the human body. In recent years (1916, 1919) a study of this was made by E. C. Streeter, and while certain of his conclusions are tenable, unfortunately too great enthusiasm for his thesis and certain incorrect interpretations have distorted the picture. These errors were then compounded and strengthened by the affirmation and support of F. H. Garrison (1919, 1926). However, a thorough study of the anatomico-artistic career of Leonardo da Vinci suggests certain revisions in what might be called the Streeter-Garrison thesis.

According to Streeter, Florentine painters were accustomed to purchase their pigments in the apothecary shops, and as a result tended to become acquainted with physicians who were also patrons of such establishments. The result of such contact produced a certain fellow-feeling which led the artists to apply for admission into the guild of physicians and apothecaries (1303). This condition was to remain for "more than two and a half centuries" and consequently led to a considerable exchange of interest and information. Thus Masaccio was to join the guild as an apothecary (1421) but decided to continue his membership as a painter (1423). In addition to such changes of interest there developed a number of close friendships between physicians and painters such as that of Giotto with Dino del Garbo and Luca della Robbia with Benivieni. The presumption here is that along with the artist's desire for greater naturalism in painting he was further fostered in this direction through his association with physicians. Here it might be interposed that such association, like a double-edged sword ought to cut both ways, yet we have no evidence that the physician was influenced to an appreciation of the role which art might play in medicine.

However this may be, it appears that from the time of Giotto onwards the movement was toward greater anatomical realism, and it was Giotto's assistant, Stefano, who was called "the ape of nature" because of the skill he acquired in the depiction of the superficial veins in the human body. Indeed, the story is that barber-surgeons studied his pictures before opening a vein. This story, needless to say, has a certain apocryphal ring to it, since in view of the prevalence of bloodletting the barber-surgeons would have had through experience even more knowledge of the position of the superficial veins than Stefano, while the appearance of the veins on the surface of the body would make it unnecessary, if study were required, to resort to paintings. Finally, it is rather difficult to imagine the barber-surgeons of that era, in view of their general character, taking such pains over anything so common as a matter of venesection.

Through the close contact of artist with painter it is related that in their pursuit of naturalism the artists perceived the advantage to them of anatomical study through dissection, which had been authorized at the Florentine university in 1387, and began to attend and then to assist their guild colleagues, the physicians, at such dissections. Thereafter these artists began to dissect for themselves, the first who undertook such scientific study of anatomy being apparently Donatello (1386-1466), who has left us a bronze tablet "The anatomy of the miser's heart" in commemoration of his interest. The weakness in this otherwise fascinating thesis is the fact that dissection as it was performed provided very little anatomical knowledge, certainly no more than was already available in Mundinus, while such studies, particularly that displayed by Donatello, would be of little or no value to the artist who naturally would be interested in the more superficial structures and certainly for his purpose not in the contents of the thorax.

Further consideration of the artist as anatomist rests upon the anatomical correctness with which he has painted the human body and the various accounts given by Vasari, an authority who, be it noted, is frequently unreliable. Of Antonio Pollaiuolo (1432-1498) Vasari has written: "He understood the nude in a more modern way than the masters before him; he removed the skin from many corpses to see the anatomy underneath". A recent judgment of Pollaiuolo's "Battle of the Ten Nudes", in which perhaps his anatomical knowledge is best portrayed, declares him the great anatomical student among artists before Leonardo. Without criticism of the latter judgment, it should be noted that Vasari's statement suggests both truth and error. It is quite within reason that the artist "removed the skin . . . to see the anatomy underneath", that is, his interest was myological, while the dissection as performed in the medical school would have no particular value for him. To call an artist whose interest is only in such structures as would be reflected in the surface features of the body a student of anatomy is to distort the meaning of the term, especially in the Renaissance sense of anatomy and physiology. Finally, Vasari's reference to the "many corpses" which Pollaiuolo flayed suggests a legendary growth, in view of the great difficulties that confronted the medical schools in obtaining cadavers, and the

relatively few specimens that Leonardo obtained a century later.

In the case of del Verrocchio (1435-1488) it is said that as a student under Pollaiuolo and Donatello he displayed a like scientific interest. Moreover, as the teacher of Leonardo it has been assumed that he initiated his great student into anatomical studies; hence he himself must be a student of anatomy. While del Verrocchio did not paint many nudes, yet, as it has been stated, in his drawings there is no question of his anatomical studies, as for example, his representations of the surface muscles in bodies from which the skin has been removed. Again Vasari has been cited, regarding del Verrocchio's restoration of the limbs of an ancient torso of the flayed Marsyas:

> [Lorenzo de'Medici] gave it to Andrea to restore and finish, and that artist made the legs, sides and arms that were lacking. . . . This antique torso of a flayed Marsyas was made with such skill and judgment that some slender white veins in the red stone came out, through skilful carving, in the proper places, appearing like small sinews, such as are seen in natural figures when flayed, and this rendered the work most life-like.

Here once again it must be noted that del Verrocchio has displayed not much more knowledge than might have been gained from a flayed cadaver and from close observation of a very lean, but living subject. And in view of the fact that Leonardo recommends precisely this latter sort of study for knowledge of superficial structures, it is entirely possible that much of the anatomy of artists of the time was gained in this fashion.

No doubt the artists attended the public dissections at the medical schools, as indeed did also a great many of the townsfolk both lay and ecclesiastical. It is in regard to such dissections that Vesalius has remarked in his *China Root Letter* (1546): "As for those painters and sculptors who flocked around me at my dissections, I never allowed myself to get worked up about them to the point of feeling that I was less favored than these men, for all their superior airs". But to use this remark as indicating a high degree of anatomical knowledge among artists is to misunderstand the case. It is true that Vesalius has been the victim even in the twentieth century of certain hasty and ignorant conclusions as to his true position in the history of anatomy, but to men of his own day who were competent to judge, such as Cardan, Columbus and Fallopius, there was no question as to his primacy. If it is true that "a little knowledge maketh a fool", then such would be Vesalius' opinion of at least some of the artist spectators, well-acquainted with certain of the superficial structures, and probably therefore authoritative in their attitude about such things, wholly ignorant of everything else and finally and most important, completely unsystematic in whatever anatomical knowledge they possessed. Even Leonardo, who eventually passed from the superficial structures to a study of the deeper parts, never overcame this defect.

What then is the precise position of the artist in relationship to the development of anatomical knowledge. A tempered judgment suggests first that he was interested in anatomy only insofar as it would assist him in a more naturalistic portrayal of the human body. For this purpose he studied living subjects, preferably lean ones in whom muscle contours, tendons and certain superficial blood vessels could be identified. Then possibly certain artists went a step further by flaying cadavers, when obtainable, for this even better mode of studying the surface muscles. Yet cadavers for such purpose were seldom obtainable, and more frequently such study was piecemeal. Thus Luca Signorelli (1442-1524) is said to have visited burial grounds in search of parts of bodies. The purpose of all such studies was not anatomy *per se*, and the result was that the artist never achieved a systematic knowledge of the subject and made no contribution to the advance of anatomy. The one exception to much of this was Leonardo, who, always primarily the artist, yet came to recognize anatomy as more than merely a subject auxiliary to art. It was this attitude which led him to pursue it beyond the point of need for his major interest as an artist. Nevertheless Leonardo was never an anatomist since he, too, unsystematically followed only those aspects which interested him. However, he represents the closest approach of art to anatomy.

Meanwhile it has become fashionable to suggest that artists were the true anatomists and had better knowledge of the subject from approximately the period of Giotto to Leonardo. This belief arises from a study of their paintings and certain statements made by Vasari together with a liberal dash of enthusiasm. It also bases itself upon the traditional medical illustration such as the "Five Picture Series" mentioned above. Rather conveniently it overlooks the fact that the traditional illustrations were retained by medical writers purely as traditional and that frequently there was no relationship with the text, and, moreover, that among very many of the medical writers any illustration was frowned upon. Among artists the important thing was detail; among anatomists it was system. The artist from observation could draw superficial muscles correctly; the anatomist might be well acquainted with them and far more capable of relating them to the rest of the human structure, but he was incapable of good draughtsmanship. The drawing can be observed readily, the textual description is in difficult Latin. Leonardo at times unwittingly emphasizes the distinction when he fails in his efforts to draw from memory some structure which he can draw superbly from direct observation. If we follow the anatomist from the superficial to the deeper structures it is possible to point out many errors, but here it is impossible to make any comparison with the artists since with the exception of Leonardo who, be it remembered, thought of anatomy as a separate discipline, none of them pursued the study this far. Indeed, Leonardo represents the greatest heights reached by the artist-anatomist. Thereafter and gradually the anatomist asserts superiority in this combination of disciplines. Gradually the pedagogical value of correct illustration was recognized although only after a struggle with such conservative forces as Jacobus Sylvius who even as late as the mid-sixteenth century frowned upon the contamination of text by illustration. He was, however, fighting a losing battle. With the publication of Vesalius' *Tabulae anatomicae* in 1538 and the *Fabrica*

in 1543, the employment of anatomically correct and naturalistic illustrations produced under the direction of the anatomist and carefully related to the text became an important adjunct to the further advance of anatomical studies. Thus the final integration was achieved of these two arts which had first become acquainted in the apothecary's shop in fourteenth century Florence.

life of Leonardo da Vinci

The little Tuscan hill-town of Vinci, lying between Florence and Empoli, saw the birth of Leonardo, her most famous son, on 15 April 1452. The child was the son of a young notary, Ser Piero and a young girl named Caterina of the nearby village of Anchiano, and so of illegitimate birth. Nonetheless he appears to have been heartily accepted into his father's family, and on Sunday, the day after his birth, young Leonardo was baptized in the church of Santa Croce in the presence of the family and some ten witnesses.

Ser Piero, already a successful businessman, married a woman of his own station in the year of Leonardo's birth, and thereafter in the course of his life contracted three other marriages which eventually produced a number of offspring, although the first of these was not to appear until Leonardo was twenty-four years old. Leonardo grew up in what appears to have been a normal family circle in which his stepmother treated him as her own son. We know little of his early youth except for the fact that from infancy he seems to have lived outdoors, and he himself was later to write of the incident in which a kite swooped down upon his cradle, brushing its tail against his mouth. Vasari records the great physical strength of Leonardo, while other contemporaries note his fine physique and generally handsome appearance. Meanwhile Leonardo's mother, shortly after the birth of her son, married a man of rather lower social position, one Accattabriga di Piero del Vacco. Some forty years later in Milan Leonardo employed a housekeeper named Caterina who died, presumably in his service, and whose funeral expenses he paid. A story, not completely improbable, makes this woman his mother.

Ser Piero, the father, of shrewd, hardheaded and logical disposition, appears to have passed on some of these traits to his son, although the intuitive and poetic qualities of the later great artist were an inheritance from elsewhere, possibly from his mother. At any rate, father and son were apparently attached to one another, although it may have been by respect rather than by love. Certainly the introspective, artistic nature of the son may at times have been repulsed by the calculating, commercial characteristics of the father, not to mention the father's much stronger attraction to women, his numerous marriages and eventual progeny with all their resultant problems. Leonardo's view is expressed in his reply to his brother Francesco's announcement of the birth of a son: "You are pleased at having created an enemy intent on his liberty, which he will not have before your death". Sigmund Freud, who wrote a brief study of Leonardo in which he attempts to prove a latent homosexuality, appears to have overlooked this remark of which he might have made much.

Leonardo remained in Vinci until somewhere between his thirteenth and seventeenth year. His education there was of the simplest sort. He learned some elementary arithmetic and is reported to have displayed an early bent toward mathematics and engineering. He was never educated in the classical languages although around the age of forty he acquired some facility in Latin through his own efforts. While still in Vinci Leonardo had become intensely interested in drawing, and unlike the usual town-bred artist he had the opportunity to observe nature closely. Indeed, the whole foundation of his lifelong interest in the various phenomena of nature seems to have been laid at this time. The fact that he had few youthful companions appears to have been no cause for complaint, and later he was to write: "If you are alone you belong entirely to yourself", a phrase which might almost be termed the Leonardine creed of independence.

A document of the year 1469 informs us that Ser Piero was by then official notary to the Signoria of Florence. He had already acquired a large private clientele and was sufficiently well-to-do so that he possessed an apartment in the Palazzo del Podestà, rented a house in the Via delle Prestanze (now the Via de'Gondi) and maintained a villa in his native place. It is thus difficult to say precisely when Leonardo may be said to have taken residence in Florence since no doubt frequent visits were paid to Vinci. At some time not definitely ascertainable between 1464-70 the father displayed some of his son's drawings to the famous sculptor and artist del Verrocchio with the result that young Leonardo was accepted as a pupil by that Florentine master, and in 1472 he was enrolled in the Compagnia di San Luca, the guild of Florentine artists.

Presumably del Verrocchio thought highly of his gifted pupil since he retained him as a collaborator for five years after Leonardo's admittance to the painter's guild, and in 1476 he is mentioned as living with del Verrocchio. Probably no better choice of teacher could have been made than this artist whose interests were wide enough to comprise all forms of the arts, music, mathematics and engineering, subjects in which Leonardo would in time surpass his teacher, but also subjects in which he must first gain an elementary discipline. However, it must be noted that the many interests of del Verrocchio possibly influenced his student to a similar multitude of interests without the necessary mental discipline to follow most of them through to ultimate completion. Del Verrocchio's eventual recognition of the superior ability of his student appears to have led not to jealousy and enmity but rather to collaboration and a further fostering of the great gifts of the student. Leonardo was apparently also aware of this situation as his later remark may indicate: "He is a poor disciple who does not excel his master".

It was during this period (1476) that Leonardo, together with several other young men of Florence, was indicted on a charge of sodomy. Two appearances in court did not lead to acquittal but rather to an inconclusive dismissal of the case on the ground that it was not proved, and there appears to be some basis for the truth of the original indictment according to some authorities.

It may have been in del Verrocchio's studio, or under the guidance of his master, that Leonardo received his introduction to anatomical studies, and possibly, although in view of his earliest individual efforts at anatomical illustration not likely, that he may have assisted at dissections. However, such anatomical studies were primarily for the purpose of better depiction of the human body and presumably went no fur-

ther than a study of the superficial structures. Thus his acquaintance with anatomy at this time would be that of the artist, and it must be remembered that his contemporary fame was gained primarily as an artist. Leonardo was to differ from his contemporaries not because he was the *uomo universale* but because of the distances to which he pursued his many interests and thereby the contributions which he was sometimes able to make. While it is doubtful that Leonardo ever thought of himself as an anatomist, and certainly he never acquired a discipline in that study, yet it is noteworthy that he pushed his investigations far beyond the point of artistic usefulness; and it is possibly correct that Leonardo thought of these studies as a separate discipline rather than auxiliary to art.

The question naturally arises as to where artists obtained bodies and where they carried out their dissections of them. In the case of Leonardo, either with his master or alone, it must be noted that the medical school had been moved from Florence to Pisa shortly after Leonardo took up residence in the former city. Thus attendance at demonstrations by the medical faculty was out of the question except for a short period of time. It is true that a contemporary but anonymous biographer remarks that he "made many anatomies, which he performed in the Hospital of Santa Maria Nuova in Florence". This remark, however, refers to a later residence in Florence. Certainly we possess no anatomical drawings from this early period, while the earliest we do possess, c.1487, do not indicate any considerable experience of dissection. However, Leonardo's remark (182) "those hanged of whom I have seen an anatomy" might well refer to the anatomizing of Bandino Baroncelli, hanged after the failure of the Pazzi revolt in 1477. In short, Leonardo's participation in dissections at this time seems to have been that of a spectator at most.

In later years Leonardo was to write: "The Medici created and destroyed me". While the latter part of this statement may refer to the difficulties that Leonardo experienced later in Rome during the pontificate of Leo X, the prior portion very likely refers to whatever encouragement and assistance may have been given to him by Lorenzo de'Medici in Florence. The contemporary biographer known only as the Anonimo Gaddiano wrote that Leonardo attracted the attention of Lorenzo who arranged for him to work in the garden of the Medici in the Piazza di San Marco, and it may have been through the influence of Lorenzo that he was chosen to paint the altarpiece of the chapel of the Signoria in 1478. In the same year Leonardo also met for the first time his future patron Lodovico Sforza, who had come to Florence to offer his sympathies as a result of the assassination of Lorenzo's brother Giuliano. In December 1479 Leonardo made a drawing of the body of one of the assassins, Bandino Baroncelli, hanging from a window of the Palazzo della Signoria.

first Milanese period

It appears possible that Lorenzo also played some part in Leonardo's transference to Milan. A contemporary account informs us that Lorenzo dispatched Leonardo to Milan with a silver lute as a gift for Lodovico Sforza. However, there also exists a long letter written by Leonardo to that Milanese tyrant in which he recounts his abilities as a military engineer, mathematician, architect and sculptor as recommendation for employment. Possibly there is some truth in both accounts. Leonardo may have felt that Florence was too full of established artists, and there he might remain the disciple without the opportunity to develop his own independent views. Hence he may have been attracted to Milan artistically hungry and as yet unsatisfied, while Lorenzo de'Medici, ever ready to assist young and capable artists, and widely known as a connoisseur, could give very effective aid by his recommendations. At any rate, Leonardo transferred his activities to Milan, although the date of this removal has been variously placed from the end of 1481 to 1483.

To understand either the attraction or the invitation of Milan for Leonardo it is necessary to give brief consideration to the political situation in that Lombard duchy. With the assassination of the Duke Galeazzo Maria, the succession fell to his son Gian Galeazzo, a child of seven, and therefore under the nominal regency of his mother Bona of Savoy, Commines' *dame de petit sens*. Actually the control rested with a former ducal secretary, Cecco Simonetta. The division of Italy into numerous small states, and at the time disturbed by papal and Neapolitan ambitions, led to the upsetting of the political balance which since 1454 had maintained a relative condition of peace through political equilibrium. It was under these conditions that Lodovico Sforza, fourth son of the former Duke Francesco and uncle of Gian Galeazzo, succeeded in overthrowing the regency and establishing himself as the power in Milan, first in the guise of protector of the young duke, but from 1481 openly as the actual if not legal ruler. This position, thanks to the physical and mental weakness of Gian Galeazzo, he continued to retain though the duke survived until 1494.

From this situation arose several results which go to explain Leonardo's sojourn in Milan, at least in part. The political alignments resulting in some degree from Lodovico's *coup d'état* saw agreement reached between Naples, Milan and Florence to which the lesser state of Ferrara adhered. Aggressively opposed to this were Venice and the Papacy, with the result that war broke out in 1482 over the control of Ferrara as well as certain lesser territories, and although the Papacy withdrew in the following year, peace with Venice did not occur until 1484. Thereafter feudal risings in Naples, fostered by the Papacy, led to uneasiness over possible French intervention on the basis of the old Angevin claim to that territory. The solution of this problem in 1486 merely ushered in a period of coolness between Milan and Florence over the eventual possession of the important fortress of Sarzana on the Ligurian coast which Florence finally obtained in the following year, while the control established over Genoa by Milan in 1490 removed the buffer between the latter state and Florence and did nothing to ease the tension. Finally, brooding over all was the constant and ever growing danger of French

intervention to assert the claim to Naples and a lesser claim to Milan, which was brought into stronger relief as a result of Lodovico's forceful but illegal control of the duchy.

Under these conditions it is obvious that anyone who could proffer military assistance would be welcome to the Milanese government, and it is therefore likely that Leonardo as a military engineer would be welcome. In the second place, the fact that Lodovico had usurped the dukedom was nothing novel. Rather it was the common-place representation of the Italian tyrant, a manifestation of Machiavelli's later *Prince*. However, the successful tyrant must be endowed with the quality of *virtù*, demonstrated among other ways by concern for the general welfare of his state and a certain brilliance at his court or immediate milieu. These qualities Lodovico possessed not only by design but by personal inclination as well, and the resultant ducal patronage was able to give ample scope to the many talents of Leonardo. It is possibly a fact of some significance that in his letter to Lodovico, in which Leonardo recounts his available talents, he places first and in greatest detail his abilities as a military and then a civil engineer, and it is only in the closing paragraphs that he refers to himself as an artist. Even here the emphasis is upon his capability to execute the equestrian statue which it was known that Lodovico desired to commemorate the name of his illustrious forebear and ancestral tyrant, Francesco Sforza.

In this letter to the Sforza, Leonardo had described himself, among other things, as an architect, and in due course he was called upon for the exercise of this talent in conjunction with the erection of the cathedral in Pavia, about 1490. Despite the fact that Leonardo had been dispatched to Pavia to give advice on the construction of the building, he became, characteristically it may be said, so absorbed in the laws of geometry and mechanics which governed the construction that his visit produced no tangible results, and eventually the work progressed only under the supervision of a lesser but more practical architect. Similarly, about the same time he was consulted on the construction of the dome or tiburio for the Milan cathedral with like intangible results. Still further time and effort appears to have been consumed in decoration of the interior of the Castello di Porta Giovia. Originally a citadel destroyed in the revolution of 1447, it had been rebuilt by the Sforzi as a ducal residence, and was elaborately furbished by Lodovico Sforza after his marriage to Beatrice d'Este in 1491. Between about 1492-98, Leonardo appears to have been employed both on the problem of fortification and of interior decoration. Moreover, as a military engineer a certain amount of time had to be spent in visiting border fortifications. In 1496 when Lodovico with a large retinue travelled through the Valtellina to Mals in order to pay a visit to the Emperor Maximilian and the empress, Lodovico's niece, it is probable that Leonardo was one of the party, while certain of his drawings of Alpine scenes are identifiable as representing points in the area. Still further time-consuming ducal employment required Leonardo's services as costume and scene designer for various ducal revels and celebrations.

Presumably, however, the most exhausting efforts were those directed toward the completion of the equestrian statue of Francesco Sforza. The idea of such a statue appears to have originated with Galeazzo Maria, but hitherto all attempts to execute the work had failed. Now Lodovico was determined that something extraordinary should be produced, but despite the confidence of his assertion in his letter to the ruler of Milan it seemed doubtful that even Leonardo would be able to cope with the task which he had set for himself. The earliest sketches for the proposed bronze horse are attributed to the period c.1486-90, and represent a prancing horse, a design which was technically beyond Leonardo's ability to execute, and apparently led him for a time to abandon the task. Thereafter from 1490-93, there are a number of further sketches, and in the autumn of this last year a full-scale model was completed and placed under a triumphal arch in the Piazza of the Castello on the occasion of the marriage of Bianca Maria Sforza to the Emperor Maximilian. However, the model was never to be cast in the permanence of bronze. The appearance of the French in Italy strained Milanese resources to the utmost. "I will not speak of the horse", wrote Leonardo to the duke, "for I know the times". Furthermore, such bronze as had been collected for the casting was sent by Lodovico to his brother-in-law Ercole d'Este who had need of it for the manufacture of cannon. As late as 1501 the model was in existence, although it must have suffered considerably from the elements, and after that time it is reputed to have been destroyed by soldiers of the French army of Louis XII.

So much for Leonardo's time-consuming labors on behalf of the state. In addition, private enterprises in the field of art ate further into his time and energies, most notably the painting of the "Last Supper" in the refectory of Santa Maria delle Grazie, begun in the latter part of 1496.

When one comes to consider Leonardo's activities in anatomy during this first Milanese period, it is clear that he could not have had any very considerable amount of time to devote consistently to them, while a considerable number of such anatomical studies as he made must have been devoted to the dissection of the horse in preparation for the ill-fated statue. Moreover, while the bulk of the drawings on the anatomy of the horse are, as one might expect, of the surface anatomy, and drawn by Leonardo in the guise of the artist, there are nevertheless some detailed ones illustrating the muscles of the horse's thigh compared to the corresponding muscles of man, suggesting that he was carrying on his studies of the anatomy of the horse and of man simultaneously. Yet the amount of work which he accomplished in human anatomy, if we may at all judge by the surviving drawings, was relatively small. This, perhaps, is what ought to be expected. It must be remembered that Leonardo had arrived in Milan as a product of Florentine culture, a culture much influenced by the doctrines of Plato. As a result the Florentine was concerned for beauty as much as for truth, and in the case of the latter goal he was more prone to seek the absolute truths of mathematical and physical law than the more relative posi-

tion of the biological sciences. It is perhaps no accident that the anatomical works of this period such as those of Benedetti and Ketham appeared in the north. It may be said that Milan, far more congenial to the thought of Aristotle, was to be of great influence upon the new attitude which Leonardo developed toward anatomy. Only gradually did he cease to be the artist concerned with anatomy solely as an auxiliary to the naturalistic portrayal in art and become a seeker of biological truth for itself. Illustration of this is to be found in a comparison of his earlier and later plates, as for example, the Platonic interpretation of the vena cava (116) as opposed to the later Aristotelian view expressed in 119.

There is, moreover, the question of the conditions under which Leonardo carried on his anatomical studies in Milan and how much dissection material was available to him. To neither of these matters can a precise answer be given. Possibly, as it has been suggested, he was afforded opportunities in the Ospedale Maggiore, the erection of which had begun in 1456, as well as the Collegio dei Nobili Fisici, the chief medical school of the city, although we have no evidence of this, and the evidence to the contrary, as represented in his anatomical drawings, is strong.

The earliest anatomical drawings by Leonardo are attributed to c.1487 (33-35, 72, 151-3). On the basis of these drawings certain facts become manifest. It is apparent that his knowledge of anatomy was merely such as he had acquired by reading traditional writers such as Avicenna and Mundinus, by some animal dissection and by surface inspection of the living human. Such seems the only answer to errors which are rectified later when we know that he had human materials under observation, and to obvious and erroneous efforts to synthesize traditional information and animal structures with those of the human.

The heterogeneous nature of the earliest plates suggests that at the beginning of his anatomical studies Leonardo had no system of procedure in mind. However, he did have some thoughts, if not answers, on the matter by 1489 as is witnessed by the statement "the book entitled On the Human Figure" (5) of which, however, the phraseology suggests more the attitude of the artist than of the anatomist, while a note (154) suggests that Leonardo is still thinking of anatomy as ancillary to draughtsmanship, and the final admonition on 161 suggests once again not so much anatomical study as the correct artistic portrayal of the anatomical specimen. Yet there is some greater consistency after 1489 since we have five plates of that year (3-7) dealing with different aspects of the skull as well as some suggestion of systematization in his descriptive notes. Plate 71 again suggests method in the delineation of the muscles of the leg observed from different aspects, in this case for the sake of surgeons as well as for artists. The notes also suggest subjects to be pursued later, presumably as topics for the projected book. It should, however, be recognized that they represent matters about which Leonardo was inquisitive rather than informed, and plates 125-6 indicate a similar uninformed interest in certain aspects of physiology and muscular action. Perhaps the most important thing introduced during this period is the technique of cross-sectional representation (142-3, 159-60). Insofar as anatomy demonstrated through illustration is concerned, Leonardo had already conceived his plan of representing the subject from four aspects as though the viewer were able to walk completely around it and observe it from every aspect (182). This admirable method was to be used by him throughout his career in anatomy.

While it seems very unlikely that Leonardo had participated in any dissections in Florence, it likewise appears improbable that up to this time he had had any such opportunities in Milan. Thus far the only human material available to him appears to have been a head, probably that of a decapitated criminal (34). Two drawings of 1489 (125-6) suggest observation of the living subject, and of the drawings attributed to the following year, 154 suggests a schematic or diagrammatic projection of a reading of Galen, as does 155, while 64-5 appear to be the result of observation of the living subject. The drawings that may be attributed to the next several years, 144, 161, suggest a combination of reading in the traditional writers and dissection of the horse or cow with the results applied to man. In other works of this first Milan period (71, 116, 142-3, 159-60, 164) the conclusion which must be drawn in no way differs, that the drawings are based upon reading, some animal dissection and observation of the living subject. This is particularly apparent in 142. There are, however, two exceptional instances worthy of note. The accuracy of the drawing of the thigh and leg in 159 makes it seem likely that Leonardo did in some fashion acquire this particular human specimen, while the use of cross-section in 143 is interesting because of the novelty of the technique.

On the basis of the existent drawings it may be said that as yet Leonardo is a tyro in the study of anatomy. He is still under the influence of his reading of Galen, Avicenna and Mundinus. There is, moreover, no indication of a systematic approach to the subject. This does not mean that Leonardo's interest was confined solely to these subjects of which he has left record since in plate 5, dated 1489, is the phrase "the book On the human figure", while 125-6 suggest a number of contemplated anatomical subjects. Yet it must also be remembered that since Leonardo was as yet barely initiated into the art of anatomy, he was certainly in no position to develop a system or method of presentation, and one must not be misled by the questions he asks—indicative at the same time of ignorance and interest—into believing that they represent a genuine plan of procedure. The truth of the matter appears to be that, if for no other reason, he was prevented from expansion of his inquiries and his knowledge by lack of dissection material. So far as we know he had access to a single human head and possibly a thigh and leg. There is no evidence or even suggestion that he had access to the Ospedale Maggiore or the Collegio dei Nobili Fisici in Milan. On the basis of the now existent drawings it appears unlikely that Leonardo had access to a cadaver during his first Milanese period. In view of his penchant for the bizarre we should certainly expect, if possible, a drawing of the human skeleton.

Together with the lack of dissection material as a

hindrance to anatomical investigation it must be recalled that Leonardo was very active in other directions and the various architectural, engineering and mathematical problems related to state activities must have consumed enormous amounts of his time. Such were the interests of the assemblage of savants gathered by Lodovico Sforza, and no doubt these general interests and problems constantly deflected Leonardo from such other interests as he may have had. Of this group of aulic savants the most significant for Leonardo was Luca Pacioli, the mathematician. Pacioli had been invited in 1496 to lecture in Milan, and during his four years' residence lived on close terms with Leonardo. In 1497 Pacioli completed his treatise *De divina proportione*, although not published until 1509, for which the illustrations were drawn by Leonardo. While most of the illustrations dealt with proportion in geometric solids, one figure represents the proportions of the human body, a suggestion that Leonardo may already have become interested in the canon of the proportions of the body.

Toward the close of 1499 Leonardo's first residence in Milan was to come to an end as a result of the political situation. In 1492 Lodovico Sforza, none too sure of his hold upon the ducal throne and at odds with the ruling house of Naples which comprised the rival claimant to Milan, as well as with Florence, had aligned himself with Charles VIII of France. As a result of the agreement Charles was invited to invade Italy through its Milanese bastion, assert the old Angevin claim upon Naples and thereby remove the major threat to Lodovico's throne. Only after the French had entered and traversed the length of the peninsula did the duke realize his blunder and thereafter joined with Venice, the Papacy, Spain and the Empire in the Holy League (31 March 1495) to drive out the invader. However, the evil had been precipitated and Italy opened up to the northerners. But since Italian leagues were as unstable as they were numerous it is not astonishing to find France next entering into an understanding with its recent foes and Louis XII again leading the French into Milan in October 1499, this time to assert an old claim upon the ducal throne, gain the betrayal and imprisonment of Lodovico (1500), who was to die a captive in France.

Lodovico's fall was the greatest misfortune which could have overwhelmed Leonardo. Under the duke his stipend had been ample and down to 1497 fairly regular, while the relations between the two men had on the whole been harmonious. After 1497, when difficulties beset the Sforzi, Leonardo's salary was left unpaid and while relations were occasionally strained, yet one of Lodovico's last acts before his flight from Milan was to present Leonardo with a vineyard outside the Porta Vercellina. Now the latter was reduced to the necessity, just as he was entering upon old age, of seeking another patron—who was to be tardy in appearance—or beginning his career again, a career which had been more fruitful hitherto in masterpieces and the admiration they had won than in tangible rewards, and expose himself to the danger which had hung over his whole life, that of the dispersal and scattering of his great gifts. Thus it was that as a

consequence of the disorders in Milan and the loss of his patron that Leonardo in company with Luca Pacioli left that city in December 1499.

By way of Mantua Leonardo paid a visit to Venice which lasted at least until March 1500, and where he may possibly have been a spectator at the anatomy course then being conducted by Alessandro Benedetti, then at the height of his fame. However, this remains merely surmise since it may be that systematic anatomy had no charms for Leonardo. While he may at this time have been familiar with Benedetti's treatise on anatomy, nevertheless he mentions it only in a note-book which carries the date of September 1508.

Florentine period

From Venice Leonardo paid a brief visit to Friuli to give the Venetians advice on their fortifications against the Turkish threat and thereafter he returned to Florence. That he had managed to amass some money during his years in Milan is indicated by the fact that he placed 600 florins on deposit in Florence, from which at various times up to 1506 he withdrew 450. Anatomical studies were now neglected, whence it is possible to assume that he had had nothing to do with Benedetti and his circle in Venice. Certainly there seems to have been no enthusiasm or impetus for further anatomical research carried away with him from Venice. Rather he was to return to his artistic pursuits, and in the month of April 1501 he was working upon his "Saint Anne" with considerable eagerness, but as he did with so many of his pictures he soon thereafter put it aside half finished. All through this period, scientific enquiry alternated with artistic labor, though the latter is not, perhaps, pursued with the same intensity as the former. In 1501 Fra Pietro da Nuvolaria wrote to the Marchesa Isabella that Leonardo grows very impatient of his painting and is devoting himself exclusively to geometry, no doubt under the influence of his friend Luca Pacioli. And in the following September he was travelling about in the character of military engineer to Cesare Borgia.

As part of the cost of liquidation of the Holy League, preparatory to his invasion of Milan, Louis XII had granted the Duchy of Valentinois, or Valentino, to Cesare Borgia, son of Pope Alexander VI, with a promise to assist Cesare in carving out a substantial state in central Italy. So it was that at the end of 1499 Alexander on the pretence that the signori of the Romagna and the Marches had not paid their tribute to the papal government, divested them of their fiefs and so prepared the way for his son's conquest of those territories. Cesare first seized Imola and Forlì. Thereafter with funds which his father had obtained through the creation of twelve cardinals, Cesare was able to hire fresh troops with which he seized Pesaro, Rimini and Faenza and so completed the conquest of the Romagna. Continuing his conquests by taking Siena and Piombino, by the summer of 1502 he was in possession of the Duchy of Urbino and Camerino, and was threatening Bologna. In conjunction with these conquests Cesare obtained the services of Leonardo to whom he sent a patent (18

August 1502) in which he is described as architect and engineer-in-chief, and intended to assist his inspections of the towns and fortresses which had been so boldly seized from their former owners. In his new capacity Leonardo prepared numerous topographical maps of cities and areas of central Italy, some of which he has left us in his note-books, and appears to have gained the appreciation and esteem of the Borgia conqueror.

Apparently Leonardo was eventually shocked into realization of the sort of man it was to whom he had given his services when Vitellozzo Vitelli, a captain of Cesare's army and a friend of Leonardo, was strangled by order of the tyrant. At the beginning of March 1503 Leonardo returned to Florence, caused his name to be re-inscribed in the roll of the guild of Florentine painters, and thereafter proceeded to the Florentine camp before Pisa to advise on the siege of that city (23 July 1503). During this period political changes occurred. On 10 September 1502, Piero Soderini had been elected Gonfaloniere for the Florentine republic for life. In the following year Alexander VI died and thereafter occurred the downfall of his son, the erstwhile conqueror Cesare. The result was the deliverance of Florence from redoubtable enemies, and a period of calm ensued except for the long protracted siege of Pisa which had been in course since 1496 and did not finally end until the capitulation of that city in 1509. Precisely what part Leonardo played or how valuable his advice was is impossible to say.

With his return to Florence Leonardo again took up his anatomical studies, and it appears that for the first time he was to have access to a reasonably large amount of dissection material, obtained, so it appears, at the Hospital of Santa Maria Nuova. It was there that he met the centenarian and thereafter obtained his body, or at least parts of it, for dissection (128). Thereafter, as the dates of his drawings indicate, he had further dissection specimens available to him, although whether he ever during this Florentine period became the possessor of an entire cadaver we are not certain. It may therefore be said that at the beginning of this period he was still the veriest amateur in the anatomical discipline, and that in view of this his remarkable observations emphasize his genius. However, it is curious that even with the dissection of the body of the centenarian and despite the excellence of many of the observations which he made, yet, and possibly because hitherto such dissection material had not been available to Leonardo, his independence is still restrained by the dead hand of tradition. Thus despite his remarkable observations upon arteriosclerosis, indicative of close observation of the arterial system, Galenical authority or perhaps Leonardo's use of animal materials and his attempt to fit them to man compels him to note a five-lobed liver (129).

We are unaware whether or not he worked more or less consistently at anatomy during these Florentine years, although it appears unlikely in view of his other undertakings and his characteristic inability to remain absorbed for a long period in a single study. Moreover, he still exhibited an odd mixture of knowledge beyond his time and traditional ignorance. Thus in

the group of drawings attributed to c.1504-06 in plate 131 he represents an imaginary vein on the thesis that each artery has a corresponding vein. Plates 129, 135, 139 indicate that he was still seeking to apply animal anatomy to the human. But these may be compared with 128, with its remarkable description of arteriosclerosis. Another characteristic of the period and one which indicates that Leonardo was yet primarily the artist rather than the anatomist is his inability to draw an anatomical structure from memory as in plate 21. What is immediately before him he can reproduce with precision, but despite his assertions from time to time, he has at least thus far developed no real discipline or method in, and certainly no sure grasp of, anatomy.

How many more human specimens Leonardo was able to dissect we do not know, although in one instance he speaks of the body of a child of two years which he dissected (128). Elsewhere (188) he refers to the splenic vessels and the liver in the young, although without any drawings. Whether this is a reference to the child or to some other human subject is not known; and a similarly equivocal statement, this time respecting the colon, and again without illustration is to be found on 183. Nevertheless, it appears most likely that these two bodies were the extent of his available human material between the opening of this second period and 1506. Certainly drawings of this time still reflect the use of animal subjects (119, 171), and as late as the period dated 1504-09, there are still composite drawings of human and animal materials, while on 127 the remark to "represent the arm of Francesco the miniaturist, which shows many veins" indicates that he was still making observations upon living subjects. Thus while his further remarks on the same page, drawing a comparison between the veins of old and young may well include observation upon the body of the centenarian, they do not necessarily suggest the dissection of any younger subject except possibly the previously mentioned child. They are, in short, remarks such as could have been made about young living subjects.

It is perhaps noteworthy that in plate 118, dated c.1504-06, the drawings are based on findings in animals, but a statement "Of the human species" may suggest dissatisfaction and a determination to seek out human materials if possible. Indeed, it may be that the dissection of the centenarian was the result. Nevertheless, human bodies were difficult to come by, and plate 146, dated c.1504-09, although it contains the remark that Leonardo had dissected more than ten human bodies, yet another remark on the same page, "Try to get a skull", suggests a paucity of material and the likelihood that the "ten human bodies" were probably far from complete ones. Leonardo's final remarks on the same plate illustrate one difficulty to a correct estimate of his activities. At times he has a tendency to speak in rather grandiose fashion and to confuse his future hopes with his past achievements. Thus mention of the "hundred and 20 books composed" appears to be his ultimate goal, and in like fashion his dissection of numerous bodies for the sake of studying particular structures has a false ring to it. Finally, his suggestion of quartered and flayed

corpses in his living quarters can most probably be more correctly reduced to bits and portions of human material more consonant with the heterogeneous nature of his anatomical drawings. It appears unlikely that Leonardo, in view of his bizarre humor, and if given the opportunity, would have refrained from articulating a skeleton; moreover, a skeleton would naturally have been desirable in view of his scheme for cord and wire representations of muscles. However, the only drawing of this nature is one of a partial skeleton and that of a much later time.

While in later years human material was presumably available on occasion, yet there was not constant supply, and not even then does Leonardo appear to have realized the futility of attempting to fit animal or traditional forms to the human structure. Thus in the period 1504-09, three drawings (37, 136, 166) represent respectively a drawing based on the traditional anatomical literature, a human dissection and a composite of human and animal dissection.

Yet while Leonardo purely as an anatomist can be strongly criticized, we must have the greatest admiration for the techniques which he introduced during this Florentine period and which reflect his interests in engineering and mechanics. His plan for the representation of the body and its parts from four aspects, which originated in the first Milanese period, is continued (171, 212), as well as his cross-sectional technique. Furthermore, he now displays a greater interest in problems of muscle leverage (55) and consequently has resort to the employment of diagrams and mathematical formulae. Somewhat related is his use of cord diagrams (58) and wire diagrams (73) to represent muscles, although we are unaware whether or not Leonardo ever constructed such a figure.

Of singular significance is his method of injecting wax into the ventricles of the brain in order to learn their shape (147), a procedure which Leonardo appears to have been the first to employ, although from the results apparent in his drawings he seems deserving of praise more for the ingenuity of his method than for the achievement of successful results from it.

It is also during this Florentine period that Leonardo begins to waver in his allegiance to Aristotle. Thus in two pages of his note-book, both dealing with the dissection of the centenarian (1504-06), he supports the Aristotelian position that the heart rather than the liver is the blood-making organ and the source of the vessels (119) and then discards this view for the opposite Galenical position (149). Gradually thereafter he becomes more and more a Galenist, and it will not be until the very end of his career, c.1513, that he will begin to take a position of independence from all previous authority and base his conclusions solely upon observation.

Since it was for the first time in this Florentine period that Leonardo had access to a human cadaver, therefore it was also for the first time that he was in a position to understand the problems and difficulties of anatomical presentation. Thus we find him (135) suggesting a method of relating the major structures of the body as a whole by means of anterior, lateral and posterior projections. While in the general demonstration, it was his intention first to illustrate the superficial features before going on to the figures of anatomical dissection. His plan is unsystematic and impractical in arrangement so far as purely anatomical studies are concerned, but it is significant that it would undoubtedly have been of some merit for the artist. It is still as the artist that we find Leonardo constantly concerned with the maintenance of outlines, as, for example, in the case of individual parts for which he would have outline drawings within which the various structures would be placed in proper proportional size and location (127), while in the case of the removal of a superficial muscle, a dotted line would continue to retain the original superficial outline. Indeed, since in this period the artist still retains supremacy over the anatomist, it is not amazing to find that his memoranda are much concerned with the proper distribution of the muscular structure of the body as in plate 181.

Leonardo was somewhat more successful in his treatment of the head and its contents. This may or may not have been because of the readier availability of material. However, it must be noted that although his method of describing the cranial nerves is a distinct advancement for his time (148), nevertheless in this instance he was probably employing animal material.

An indication of the incomplete state of his anatomical knowledge is apparent from the fact that he appears already to have concluded that at least some of his plates were now complete and ready for ultimate reproduction in the projected book. Here once again is an indication of the artist satisfied with the pictorial representation while the anatomist should have been quite unsatisfied with the text. Such completed plates appear to be those that have captions written at the head (128, 150). The majority, however, as yet lack such caption titles, and their incomplete state is possibly further indicated by the fact that they bear memoranda written by Leonardo as reminders for the development of the individual plate or, indeed, reminders of any ideas whatsoever that may have occurred to him. Thus on plate 21 he notes a plan for the presentation of the muscles of respiration at the foot of a page devoted to this subject. Plate 15 contains memoranda for details of muscles such as measurement, reason for use, how they work and what moves them, and 157 contains a long list of demonstrations to be made in the future, that is, what Leonardo considers desirable, although not necessarily indicative of what he was capable of achieving. It is necessary in his case to avoid confusing lack of realism with vision. Perhaps, most striking of all such memoranda is that at the lower end of the nerve on plate 167 where he writes "more underneath", thus clearly suggesting that this is only a rough draught to be extended later.

This second period of Leonardo's anatomical studies is a transitional one. He is, it is true, still much influenced by tradition and from time to time follows it exclusively. In addition, he undertakes a good deal of animal anatomy which he seeks to project upon the human structure. Finally, he has also begun the dissection of human material, although not as yet in any considerable amount, and the clear lines of distinction between animal and human anatomy are not

thus far very distinct to him. Together with this transition he has gradually given up the authority of Aristotle for that of Galen. Thus although he remains bound to authority, nevertheless he is moving closer to the camp of the physicians, and we may therefore expect a growing respect for anatomy as an independent discipline, that is, a lessening of the view that it is ancillary to art. On occasion the genius of the man bursts the bonds of tradition as when for example he observes and describes the arteriosclerotic condition of the centenarian. In general, however, if we close our eyes to the Leonardine draughtsmanship and concern ourselves only with the text, the result is disappointing. It is akin to the usual anatomical text of that day, indeed, in some respects such as lack of system and spotty knowledge of medical texts, such as Galen, it suffers by comparison.

It was also during this period that he was commissioned to enrich the Great Council Chamber of the Palazzo Vecchio with an interpretation of the battle of Anghiari, fought between the Florentines and Milanese in the year 1440. However, as with so many of his tasks, Leonardo was not to complete this commission, and in 1505 he spent a short period of time in Fiesole where he undertook the study of bird flight, an interest which he had previously initiated in Milan. It appears that it was also at this time that he constructed his flying machine, for which, of course, the study of the flight of birds was preparatory. Before the end of the year Leonardo had returned to Florence and completed his portrait of "Mona Lisa", originally commissioned in 1502, and thereafter in the following year, possibly May, he returned to Milan, summoned thither by Charles d'Amboise, the vice-regent of Louis XII for that duchy.

The last several years of Leonardo's stay in Florence had been difficult. The importunities of the city government for the completion of the Anghiari commission were irksome enough, but still more intolerable was a lawsuit with his family in which he became involved from the time of his father's death in 1504. On the grounds of his illegitimacy, Leonardo's brothers refused him a share in the paternal legacy, and the whole unfortunate matter dragged on until a final division was achieved in 1506. Thereafter, although Leonardo had already gone to Milan an attempt was made by the same litigants to deprive him of another legacy left him by his uncle Francesco in 1507. This suit dragged on until 1511 when Leonardo was finally forced to gain the intercession of Charles d'Amboise, the Cardinal Ippolito d'Este, one of his former protectors in Milan, and even Louis XII.

second Milanese period

It seems likely that not only the possibility of patronage in Milan but such unpleasant family squabbles as well played their part in Leonardo's determination to leave Florence, and on 30 May 1506 he obtained permission from the Florentine government to absent himself on condition that he return at the end of three months; default of this condition was to be punished by a money fine. Actually Leonardo was to return to Florence from time to time but only on personal business in conjunction with the family lawsuits. Thus he returned during the autumn of 1507, the spring of 1509, as well as in 1511, 1513, and finally in 1514. Meanwhile he had so ingratiated himself with the regency in Milan, and even with Louis XII when he was present there, that official requests for Leonardo's continued services in Milan eventually extended his leave of absence indefinitely; not, however, without extreme irritation from the Florentine government which could not, however, afford to incur the displeasure of its powerful northern neighbor.

While it is difficult to ascertain precisely what Leonardo's occupations were on behalf of the state and precisely what he accomplished, he appears to have played some part in the development of the canal system under construction in the Lombard plain. Of more immediate interest, however, is his considerable activity in anatomy, which for the first time now represents a study to a greater extent based upon his findings in human materials. In general it can be said that all the plates of Fogli A are based upon such materials. The marked superiority of the anatomy of the drawings is readily apparent and as readily explained. The subjects dealt with in this series are almost wholly osteology and myology. They are clear-cut subjects, and given the human models, Leonardo could observe and draw them correctly. There are some exceptions such as the poorly drawn tibia on plate 13, which is most likely the result of an effort by Leonardo to draw from memory. This and other similar examples once again emphasize the danger of allowing the excellence of the draughtsman to hide the deficiencies of the anatomist.

The plates of Fogli A suggest that Leonardo now had much more dissection material, but there is still the puzzle of why he did not draw a skeleton, the nearest thing to it being on plate 1, merely the upper portion. A closer inspection of Fogli A indicates that there is by no means a complete representation of osteology and myology, suggesting that perhaps while dissection specimens were more numerous, nevertheless complete cadavers were still very scarce. It may have been some such situation that led Leonardo from time to time to give up some of his grandiose ideas for his book on anatomy which would have required virtually unlimited supplies of material. Thus the final note on plate 49 suggests a move toward economy in the representation of the aspects of a specimen.

At the close of this period, c.1513 Leonardo began an intensive study of the heart and its action, and the great majority of his drawings and notes on the cardiovascular system relate to this final period. However, these later observations are drawn almost exclusively from the dissection of the heart of the ox.

It was during this second sojourn in Milan that Leonardo became acquainted with the professional anatomist Marcantonio della Torre, and the friendship which developed may have had some influence in the production of Leonardo's more mature period of anatomizing, although there is very little factual evidence to support this theory.

Marcantonio della Torre was born in Verona in 1478-81, the son of Girolamo della Torre, for a time professor of medicine at Padua. Continuing his

father's profession, young Marcantonio at the age of twenty was appointed public instructor in medicine and later professor of the theory of medicine at Padua. Thereafter with the spread of his fame he was attracted to Pavia as director of the department of anatomy during the control of Milan by Lodovico Sforza. It was either at Pavia or possibly during a visit to Milan that Marcantonio met Leonardo sometime in 1510 or 1511. However, any friendship which may have developed was short-lived since Marcantonio died of the plague in 1511.

The young physician was apparently a man of considerable attainments. His precocity in medicine is indicated by the academic posts he had acquired while in his twenties, and as well he was an ardent student of the classics. His early death led to numerous humanistic obituaries including one by Girolamo Fracastoro, the celebrated author of the *De contagione* (1546). Of his medical work little is known. One of his contemporaries asserts that he illustrated his anatomy course by public dissections and published writings, while a pupil states that he was the author of a work on anatomy. Presumably such accounts are apocryphal or, at least, none of his lectures or published works appears to have survived. It should also be noted that Marcantonio as a classicist and particularly as a Hellenist, was a supporter of the revived Galen as read in the recovered Greek texts, and it is said that he sought to substitute Galen for the *Anathomia* of Mundinus which was then the prescribed text in the Italian schools.

The story of the planned collaboration of Leonardo and Marcantonio della Torre rests primarily upon the account of Vasari, although it should be noted that Vasari never saw either of the persons involved in the matter and thus had his information at second hand. Moreover, Vasari's account relying upon gossip and second-hand information is frequently found to be in error. On the basis of Vasari's story, nineteenth century writers generally assumed that della Torre was to write the anatomy while Leonardo would as an artist supply the illustrations, but a fuller knowledge of Leonardo's work and such information as has been gathered concerning the life of della Torre tend to alter this view. There is first of all the great discrepancy in age—indeed, it seems likely that Leonardo had already gained some interest in anatomy prior to the birth of Marcantonio. In the second place, Leonardo was neither Arabist nor Galenist but having partaken of both was by this time beginning to advance beyond any such authorities. It is true that his knowledge of anatomy had its foundations in these sources and that he continued to employ the Arabist terminology, and one would therefore assume that in the event of any influence by the younger man we might notice a change in this terminology. Moreover, we might assume that the influence of the professional anatomist would lead to the appearance of some sort of system in the anatomical studies as reflected in the drawings; indeed, some sort of collaboration would have been a very desirable thing so far as the direction of Leonardo's studies was concerned. We might also expect that if the two men had joined forces we should find mention of the anatomist on some of the anatomical

drawings, but only once is the name Marcantonio employed by Leonardo and that not in connection with anatomical studies, so that we are not certain that it is a reference to the same person (210). Finally, the two men would have had less than two years in which to become acquainted, arrange for their collaboration and get it under way. Was such a project ever agreed upon? Disparity in age, temperament and training all seem to oppose such an idea. Furthermore, it must be recalled that the whole story depends largely upon the statement of Vasari, a writer who has frequently been found in error and who in this case took his information at second hand.

If Marcantonio ever saw Leonardo's note-books he could not but have been impressed by them and presumably would have urged the older man to get on with their publication. Indeed, he might even have suggested the need for some sort of system which might have influenced Leonardo but just as easily might have angered him since in his note-books he frequently mentions the plan or plans which he had for the organization of his anatomical studies. He was writing about the anatomical text which he hoped to publish long before he became acquainted with Marcantonio. In the final analysis it appears that if Marcantonio had any influence at all it is more likely that it would have been that of a goad—eventually unsuccessful—rather than that of a collaborator.

It was during this second Milanese period that Leonardo made one of his friendships which was to have important implications for the future. Early in the year 1507 he was living at the villa of Gerolamo Melzi at Vaprio, a short distance outside of Milan. The son of his host, Francesco, then some fourteen years old, displayed a certain artistic ability which first aroused interest in him on the part of the great artist, and gradually there developed a relationship almost that of father and son. It was as a result of this close friendship that when Leonardo was compelled to leave Milan, his young disciple Francesco Melzi chose to accompany him, first to Rome and thereafter to France, remaining faithfully in his service until the death of Leonardo. It was in return for such service that in his last testament Leonardo bequeathed to young Melzi all his books, which meant primarily that the young man became the possessor of the note-books and the source from which we shall trace their ultimate distribution.

Meanwhile Italian politics in their wayward and changing fashion were once again preparing events which would force Leonardo once more to become an outcast and refugee. The pope, now the militant Julius II, allied the Papacy with the Emperor Maximilian, Ferdinand of Aragon and Louis XII of France to form the League of Cambrai, of which the object was the recovery of certain papal territories seized by Venice. With the successful attainment of this goal, the pope thereupon turned on the French and sought to drive them from Italy with the ready assistance of Maximilian and Ferdinand and even that of the erstwhile enemy Venice. For a time Charles d'Amboise, as governor of Milan, with the aid of the French general Gaston de Foix successfully resisted the movement, but the sudden death of Amboise in

1511 and thereafter the fall of Gaston de Foix before the walls of Ravenna in 1512 completely discouraged the French, and Milan, with the consent of the allies, once more passed into the possession of a Sforza, Massimiliano, son of Lodovico.

Thus Leonardo had not only lost his patron, but as one who had transferred his allegiance from Sforza to Valois, he could not readily recover his position with the former family, and although the Sforza tenure was to be brief, terminating in 1515, Leonardo had by that time departed the city. Meanwhile, in March 1513, Giovanni de'Medici, son of the famous Lorenzo, had ascended the papal throne as Leo X. The new pope, recognized as heir to the Medici tradition of aesthetic discrimination and patronage, was soon surrounded by painters, sculptors and architects. Not the least hopeful was Leonardo, now sixty-one, who had left Milan in September in company with the faithful Francesco Melzi as well as several other disciples. In Rome he was successful in gaining the patronage of Giuliano de'Medici, brother of the new pope, and was quartered in the Belvedere.

the final period

In Rome Leonardo continued his anatomical studies, apparently at the Ospedale di Santo Spirito, and as well carried on studies in distillation and phys-ics, or more particularly optics. Unfortunately such studies appear to have brought him into conflict with a German mirror-maker known merely as Giovanni degli Specchi who seems to have been envious not only of Leonardo's influence with their common patron but as well of the considerably larger stipend that he received. As a result of the slanderous rumors which he spread, including suggestion of sacrilege in connection with Leonardo's anatomical studies, the latter found himself in papal disfavor and barred from Santo Spirito. Hence Leonardo terminated his anatomical studies. However, he appears to have remained in Rome at least until 1515. In July of that year his patron Giuliano de'Medici was taken ill and returned to Florence, and Leonardo quite possibly followed him there only to be deprived once again of a patron with the death of Giuliano in March 1516.

Fate, however, had reserved its kindest treatment for Leonardo's final years. The French king Francis I, who possessed the greatest admiration for the artist, invited him to France to live on the royal bounty, and a pension and the castle of Cloux near Amboise provided ample comforts until Leonardo's death in 1519, while royal friendship and visits to Cloux must have persuaded Leonardo, if such was necessary, of the greatness of his achievements.

Leonardo's anatomical achievements

To bring Leonardo da Vinci into proper historical perspective it is essential that his biological contributions be viewed as a whole. It is not enough to examine his illustrations alone, but if we are to understand this extraordinary figure as a unified personality and historical phenomenon, it is necessary to study the many notes and observations which accompany the drawings. We may excuse the incompleteness and disorganization of his writings on the grounds of their haphazard informality, and we can make allowances for the uncertainty which surrounds their chronological sequence, but we cannot ignore them and the imperfections which they reveal without gravely distorting the true historical picture. Without the notes it would be impossible to perceive beneath the genius of his art the groping of his mind as it sought emancipation from a debased mediaeval Aristotelianism, through a corrupted Galenism to the achievement of a position of relative scientific independence. We would fail to see him as part of the contemporary growth, and we would lack an appreciation of the difficulties which he had to surmount. It has been this failure to consider the notes and illustrations as one which has been responsible for the many specious and unjustifiable claims that have been made on his behalf such as the all too frequent assertion that Leonardo had knowledge of the circulation of the blood.

Moreover, it needs to be emphasized how slender were Leonardo's resources in human dissection material, and it should be pointed out that the word anatomy does not necessarily mean a human dissection. He uses the term in its literal sense as a dissection and applies it when he is definitely referring to the dissection of an animal or a portion of an animal. Despite various assertions which have been made regarding the numerous dissections—presumably human—which Leonardo performed, the only evidence of human dissection which can be drawn from the note-books seems as follows: (1) a human head and neck dissected during the first Milanese period; (2) dissection of the centenarian and Leonardo's statement of having dissected a child of two years, during the Florentine period; (3) dissection of a human foetus c.7 months; (4) the dissection of the series in Fogli A which seems to have been that of an elderly man (cf. 45), and perhaps the body of a younger individual, cf. facial features (36, 56); (5) perhaps a leg. Undoubtedly Leonardo was a spectator at other dissections.

osteology

Leonardo's representation of the skeletal system is one of the outstanding features of his work, but all the evidence seems to suggest that at no time did he ever possess an intact skeleton. Around the year 1489 he acquired, possibly from an execution, a human head, and from the dissections of this were made the series of magnificent illustrations of the skull found on plates 3-7. However, the accompanying notes display his Aristotelian position and the fact that he was more interested in the material-istic psychological implications than in the osteological system as such.

In his examination of the action of the bones as levers and especially in the mechanism of pronation and supination of the forearm, Leonardo turned his great knowledge and deep interest in mechanics to excellent account.

Fairly late in his career, c.1509-10, he acquired a copy of Galen's *De usu partium*, a work which must have appeared to him as a revelation, and thenceforth Leonardo became essentially a Galenist. It is from this period on that most of his studies on the skeletal and the myological systems date. His great powers and imagination in illustration are best seen in the series on the foot, but here again the misarticulation of the tibia and fibula with the tarsal bones of the opposite side indicate the incompleteness of his skeletal material.

Leonardo's greatest difficulty was with terminology which was then in a very confused state, most of the terms being of Arabic origin. As late as 1510 we find him reminding himself of the origin of the word *acciaiolo* (11). Indeed, he seems to have depended upon the physicians for his terms for on plate 214 he reminds himself to enquire about "the vein which was searched for in the lungs on Sunday". Despite the many imperfections, Leonardo's standard of osteological illustration is immeasurably superior to that of his predecessors and is, together with a large part of the myological section, one of the few systems in which his illustrations are based on human dissection.

myology

For accuracy of representation Leonardo's figures on the muscular system are among his best drawings. However, his interest is primarily that of an artist concerned with the influence of the superficial muscle masses on surface modeling as indicated by the large number of illustrations which treat of this aspect, and seldom does he penetrate very far below the surface. This initial interest is later extended to the action of muscles and physiological problems.

It is noteworthy that almost all the dissections are dated between 1505-10, and that the great majority of the material is human. We suspect that most of the drawings are based fundamentally upon the dissection of the centenarian.

Leonardo's early dependence upon spare living subjects led him to the conception that muscles such as the deltoid, pectoralis major, etc., are compound or multiple muscles, and this explains his division of these muscles in dissection into multiple fasciculi. Logically he extends these ideas to the production of cord diagrams.

While it is true that the presentation of muscles, as in the case of the series on the upper extremity, viewed from every aspect, is indicative of his very considerable imaginative skill, yet in the representation of the abdominal muscles Leonardo is still relying upon tradition.

As mentioned above, almost all the studies of

muscles are from the period 1505-10, and it was during this period that he had come into possession of Galen's *De usu partium*. We suspect that Leonardo derived much profit from this work, especially as regards his consideration of muscle action and the action of antagonistic muscles, and it may have been the cause of his very considerable preoccupation with the problems of respiration and the action of the intercostal muscles.

It is extremely difficult to attempt any comparison between the treatment of muscles by Leonardo and contemporary physicians since myology was at the time one of the most poorly understood aspects of anatomy. Among the difficulties plaguing any study of the muscle structure was the lack of any proper myological nomenclature. Few of the muscles were specifically named, and the result was constant confusion of identity which bothered Leonardo no less than the medical fraternity.

comparative anatomy

Leonardo has been called the first comparative anatomist since Aristotle, but this statement cannot be accepted without many reservations. Like Galen, Leonardo dissected many forms and like Galen, he made the fundamental error of supposing that the structure of man was essentially the same as that of most animals, differing only in relative proportions. Consequently in a large number of his drawings it will be found that he has transposed observations made on animals to the human body, distorting the proportions to fit the outlines of the human figure, or combining observations made on both. Nonetheless, he was aware that in many cases certain animal structures differed from the human. It was his interest in proportional differences which enabled him to draw correctly such comparisons between the bones of the lower limb of man and the horse as found on plate 58. His comparative anatomy was thus an extension of his interest as an artist in body proportions. It is therefore quite impossible to separate altogether Leonardo's observations in comparative anatomy from his major interest in the anatomy of the human body without creating a false impression. It is only when he makes a faithful and accurate drawing of some animal part such as his dissections of the bear's foot or the wing of a bird that it is possible to segregate his studies on animals. Unlike Aristotle, Leonardo's interests are directed towards the structure of the body in relationship to its workings, and here the structure of animals had much to offer.

cardiovascular system

At the outset it should be stated that Leonardo had no knowledge of the circulation of the blood and that his views on the function of the heart were in a continual state of flux. Prior to 1500 he appears to have derived his opinions entirely from Mundinus or other contemporary sources and to have had little or no experience of the cardiovascular system based on dissection (cf. 116). Consequently illustrations from this period reflect a debased Galenism in which the emphasis lies on the liver as the source and origin of the vascular tree. Later he was to adopt a mediaeval-Aristotelian position in which primacy is placed in the heart, and thereafter reverted once more to a modification of the Galenical theory on the flux and reflux of the blood. However, it is extremely difficult to provide a connected account of Leonardo's final concepts on the movement of the blood since not only do his ideas vary over a very short space of time but he makes no complete statement. His earlier observations are quite sporadic and desultory, but c.1513 he began to study the heart and its action more intensively, and the great majority of his drawings and notes on the cardiovascular system date from this period. However, these later observations are made almost exclusively upon dissections of the heart of the ox.

As has been mentioned, Leonardo's views on the motion of the blood were largely governed by the Galenical theory of its flux and reflux. Piecing together Leonardo's theory as well as possible, his views may be briefly stated as follows: Right ventricular diastole is initiated by the active contraction of the papillary muscles which open the tricuspid valve and the active dilation of the ventricle itself which creates a vacuum. Blood is simultaneously forced into the ventricle by active contraction of the right auricular appendage and the passive elastic recoil of its previously dilated walls. Owing to the action of these forces the right ventricle is filled with great impetus, creating frictional currents and eddies among the interstices of the irregular muscular walls of both chambers which heat and thin the blood. Excessive expansion of the ventricle is prevented by the moderator band. In the meantime, the left ventricle has contracted so that right ventricular diastole occurs with left ventricular systole.

Right ventricular diastole is followed by its systole which forces the blood in three directions. That portion of the column of blood lying in the tricuspid orifice and between its valves is returned to the right auricle which is passively dilated. A second portion is driven through the pulmonary orifice into the lungs for their nutrition. A third portion is forced through the pores of the interventricular septum into the left ventricle. The passage of the blood through the septum is facilitated by the simultaneously active dilation of the left ventricle which has established a vacuum creating a *vis a fronte* and by the loss of viscosity of the blood due to its frictional heating. The septum thus acts as a filter removing impurities which are left behind in the right ventricle, and the subtilized blood becomes the vital spirit of the left heart. Thus, as Leonardo puts it, "the right ventricle has a double loss", to the lungs and to the left ventricle. This loss "is paid back by the liver, the treasurer", but the amount of the loss is very small, being calculated, by means unknown, as seven ounces per hour.

Diastole of the left ventricle occurs simultaneously with right ventricular systole at which time not only does the left ventricle receive the minute quantity of blood which passes through the septum but also

that forced into it by the contraction of the left auricle. On the other hand, blood escapes in two directions on left ventricular systole, a part returning to its auricle and the pulmonary veins by way of the mitral valve and a part being expelled into the aorta. Owing to the flux and reflux of the blood and the greater thickness and power of the left ventricular wall, the blood is heated more on the left than on the right. This heat subtilizes and vaporizes some of the blood and converts it into gas which is carried with the blood on systole to the lungs to escape into the bronchi. At the same time the blood is cooled and refreshed prior to its return to the left heart. The blood which escapes to the aorta is lost to the tissues and is apparently made good by that which sweats through the septum so that the greater quantity of blood participating in the ebb and flow movement on the left side is that which passes through the mitral valve to the pulmonary veins.

The cycle of events between two beats of the pulse is thus right ventricular systole, left ventricular diastole, left ventricular systole or as Leonardo puts it, "Between one and the next beat of the pulse, the heart closes twice and opens once". Likewise systole and diastole of the auricles alternate on the right and left sides.

It is thus apparent from the above outline that Leonardo's opinions on the movement of the blood are no more than a speculative extension of the Galenical ebb and flow theory. The most important modifications are the attempt to supply a mechanistic explanation of the ancient mystery of the source of innate or vital heat and the application of dynamic principles in an attempt to understand the mechanism of closure of the valves. Neither of these problems could be solved without the discovery of oxygen centuries later and without a knowledge of the circulation.

As to the distribution of the vessels, Leonardo's descriptions are very incomplete, confused and uncertain. Again we find a curious mixture of findings based on observations made from dissections of animals and the appearances found on inspection of the superficial veins in the living human subject. His supply of human cadavers was too small to accomplish his purpose and the only human dissection carried out with any degree of thoroughness to uncover the human vascular arrangement was that made on the body of the centenarian at Florence, c.1504-06.

nervous system

Leonardo's treatment of the central nervous system, based upon traditional materialistic psychological notions of mediaeval times, is vague and confused. In his earlier figures he attempts to illustrate these primitive ideas as he drew them from Avicenna or Albertus Magnus by means of schematic sketches. Leonardo's outstanding contributions were the introduction of an injection technique to obtain casts of the cerebral ventricles and his physiological experiments on the nervous system of the frog from which he concluded that the spinal cord was the

center of life. The vast majority of his observations were made on animals, almost all his work on the distribution of the peripheral nerves of the extremities being based on dissection of the monkey with the findings distorted to fit the contours of man.

Later he comes more and more under the influence of Galen and begins to make excellent independent observations on the arrangement of the nervous system. The point of departure can be traced to the dissection of the centenarian, and all his best drawings are derived from this specimen, cf. 148-50, 156-8, 167-8.

respiratory system

Leonardo's observations on the respiratory system, the majority of which are very late, c.1510-13, are based exclusively on animal material. His opinions on the physiology of respiration are almost entirely Galenical with few or very slight modifications. As a musician he was especially interested in the larynx, which he considered the essential organ of the voice and of phonation. He was, of course, far astray since he failed to recognize the vocal cords. The trachea was compared to an organ pipe, and by its length and diameter the pitch of the voice was correspondingly altered.

In respect to the mechanism of respiration, Leonardo was initially confused by his acceptance of the Galenical statement that the pleural cavities contain air; later, however, he became dubious of this statement. While he granted that the function of the lungs was to cool and refresh the blood, this was not by any direct communication with the pulmonary vessels. On the special action of the diaphragm and abdominal muscles in the forcing on of the food through the alimentary tract, see below.

alimentary system

Leonardo's considerations on the alimentary system are very incomplete. Pre-Leonardine illustrations can only be regarded as pure conventionalism, and this conventionalism is also to be seen in Leonardo's early drawings where the alimentary tract is shown diagrammatically and with no pretence to accuracy. The great change came with the dissection of the centenarian in Florence, 1504-06. Almost all the best drawings of the digestive organs, insofar as accuracy and realism are concerned, seem to have been derived from this dissection, cf. 183, 185-6, 188-9.

Leonardo's main interest is in the physiology of digestion, and this physiology is primarily Galen's, but whether he derived his notions of Galen indirectly from Mundinus and Avicenna or directly from the De usu partium, which he was beginning to read about this time, is difficult to say. He devotes considerable attention to the mechanism by which the alimentary contents are passed on from one segment to another, and here his observations and theory are original. However, the wave-like contractions of the intestines which we call peristalsis were quite unknown to him, and, indeed, he specifically denies that the stomach contracts to expel its contents

(177). Instead he theorizes that it is the rhythmical contractions of the diaphragm and abdominal wall in respiration which force the food onward, while the flexures prevent reverse movements of the contents. It is noteworthy that he does not accept the Galenical idea that the longitudinal and circular fibres of the intestines are responsible for the retention and expulsion of the contents.

genito-urinary system

There is not much that can be said on the urinary apparatus beyond that which is contained in the notes to the illustrations. Almost all Leonardo's studies on the kidneys were carried out on animals. He says very little regarding the physiology of the kidney, and his views are very primitive—as, indeed, were the theories of his contemporaries. He was most interested in the mode of entrance of the ureter into the bladder and in the mechanism which prevents reflux of urine from the bladder into the ureters.

The reproductive organs of the male and female are treated with a curious mixture of fact and fancy.

Most of the figures have some objective basis which is, however, overlaid by traditional theories on function. Again, as is common in Leonardo's drawings, the earlier figures reflect primitive mediaeval theories of generation which later on are replaced by drawings and text in which Galenical ideas are predominant.

embryology

To avoid repetition of what is expressed in the notes to the plates, we shall here merely note the chief points of Leonardo's belief.

He started out as an Aristotelian, probably having derived his ideas from Albertus Magnus. Eventually he became a follower of Galen. This is all discussed on plate 201.

There is positive evidence that he dissected a human foetus of c.7 months.

The remainder of his observations are drawn from animals, and since he knew nothing of the foetal coverings of the human, he added those of the ox, cf. plates 210-11.

plans for the anatomical treatise

Vasari's detailed but misleading statement has led to a widely held assumption that Leonardo had written a treatise on human anatomy in collaboration with Marcantonio della Torre and that long since this treatise was lost. This belief has been fortified by quotations from Leonardo's writings in which he speaks of a "Treatise on Anatomy" as though the work had been completed. However, it is now abundantly clear that Vasari's statement is a highly colored and inaccurate reference to one or other of the existing note-books and that Leonardo's mention of a treatise on anatomy reflects his intention, never fulfilled, and not unlike similar remarks regarding other contemplated works such as that "On Waters". Nonetheless, Leonardo had established a plan for such a treatise as early as his first Milanese period, and c.1489 he began to jot down a rough outline of its contemplated contents to which he later (c.1500) added a terminal paragraph.

On the order of the book

This work should begin with the conception of man and describe the nature of the womb, and how the child lives in it, and up to what stage it dwells there, and the manner of its quickening and feeding, and its growth, and what interval exists between one stage of growth and another, and what drives it forth from the body of the mother, and for what reason it sometimes comes forth from the belly of its mother before the proper time.

Then describe which are the members which grew more than the others after the child is born, and give the measurements of a child of one year.

Next describe a grown male and female, and their measurements, and the nature of their complexions, color and physiognomy. Afterwards describe how he is composed of vessels, nerves, muscles and bones. This you will do at the end of the book.

Then represent in 4 accounts 4 universal conditions of man, that is, joy with various modes of laughter and represent the cause of laughter; sorrow, in various ways with its cause; strife, with various acts of slaughter, flight, fear, ferocity, daring, murder, and all things which pertain to such cases.

Then represent labor with pulling, pushing, carrying, restraining, supporting and the like.

ATTITUDES

Then describe attitudes and movement.

EFFECTS

Then perspective through the office of sight; and on hearing. You will speak of music and treat of the other senses.

SENSES

Then describe the nature of the 5 senses.

We shall demonstrate the mechanical structure of man by figures of which the first 3 will be on the ramification of the bones, that is, one from in front

which shows the latitudinal position and shape of the bones; the 2nd will be seen from the side and will show the depth of the whole and its parts and their position; the 3rd figure will be a demonstration of the bones from behind. Then we shall make 3 other figures in similar views with the bones sawn across in which one will see their thickness and cavities. We shall make 3 other figures of the intact bones and of the nerves which arise from the medulla and in which members they ramify; and 3 others of the bones and vessels and where they ramify; then 3 with the muscles; and 3 with the skin and the proportions of the figures; and 3 of the female to show the womb and the menstrual veins which go to the breasts. [Clark 19037v/FB 20v: c.1489; last paragraph c.1500].

To the above could be added innumerable other notes of approximately the same period modifying or, more usually, extending Leonardo's grand plan to encompass every phase of the normal and abnormal anatomy and physiology of the human and animal body. But a single example, typical of his restless and inquiring mind, must suffice.

Represent whence catarrh [i.e., the phlegm supposedly from the pituitary gland] *is derived. Tears Sneezing. Yawning. Trembling. The falling sickness* [epilepsy]. *Madness. Sleep. Hunger. Sensuality. Anger, where it acts in the body. Fear, likewise. Fever. Sickness. Where poison injures. Describe the nature of all the members. Why lightning kills man and does not wound him, and if man blew his nose, he would not die, because it injures the lungs. Write what the soul is. Of Nature which, if necessary, makes the vital and active instruments of suitable and necessary shape and position. How necessity is the companion of Nature. Illustrate whence comes the sperm. Whence the urine. Whence the milk. How the nourishment proceeds to distribute itself through the veins. Whence comes intoxication. Whence the vomit. Whence the gravel and the stone. Whence "pain in the side"* [pleurisy or dolor lateralis as it was called]. *Whence dreams. Whence frenzy resulting from sickness. Whence it happens that by compressing the arteries a man falls asleep. Whence it happens that when pierced in the neck, the man falls dead. Whence come the tears. Whence the turning of the eyes, so that one draws the other after it on sobbing* [Clark 19038r/FB 21r:c.1498].

Nonetheless, keeping in mind that art theory had gone scientific, a careful reading of the description of the contemplated work makes it apparent that at this period Leonardo's conception was that of an artist to which had been grafted the universal outlook of that period. Thus in attempting to classify his drawings it is at times difficult to determine whether a particular drawing was intended to be a scientific or a purely artistic production. It is equally clear that despite the formulation of his thought, no particular plan had as yet jelled, and hence his plans remained in a somewhat nebulous state. Gradually the formlessness of his notes and drawings began to dawn upon him. By c.1509 their mass was so great as to cause some concern, and in reference to those on physics he wrote in the beginning of that collection known as the Arundel Mss. (B.M.1r):

Begun at Florence in the house of Piero di Braccio Martelli, on the 22nd day of March 1508. This makes a collection without order, taken from many sheets which I have here copied hoping to arrange them later, each in its place according to the matters of which they treat. I believe that before I make an end to this I shall have to repeat the same things many times, for which, O reader, do not blame me, for the subjects are many and the memory cannot retain them, and say, "This I do not need to write because I have written it before". If I wished to avoid falling into this error, it would be necessary in every instance when I desired to copy, that I should read over all that had gone before so as not to repeat myself, and especially so since the intervals of time between one writing and the next are long.

About this time, Leonardo may have made some attempt to arrange his anatomical notes, for a memorandum written c.1507-09 (Clark 19070v/Q I 13v) reads: *Have your books on anatomy bound,* which, if carried out, would of necessity have required some sort of ordering of the many loose sheets.

Leonardo had high hopes of completing the work while at Milan during the *winter of 1510* (Clark 19016r/FA 17r), but these hopes were never to be fulfilled. However, he began to compose at a later period, c.1513 a series of more connected and finished passages (Clark 19061-67/Q I 2-8), obviously intended for incorporation in the projected book. Among these is an introductory chapter outlining in more definite fashion his latest plan of arrangement. Because of its importance this passage is given in full.

ORDER OF THE BOOK

This my depiction of the human body will be shown to you just as though you had a real man before you. The reason is that if you wish to know thoroughly the parts of an anatomized man, you must either turn him or your eye so as to examine him from different aspects, from below from above and from the sides, turning the subject around and investigating the origin of each member, and in this way, satisfying yourself as to your knowledge of the actual anatomy. However, you must realize that such knowledge will not leave you satisfied on account of the very great confusion which results from the combination of membranes intermingled with veins, arteries, nerves, cords, muscles, bones, and the blood, which of itself stains every part the same color. The vessels which discharge this blood are not perceptible owing to their minuteness. The continuity of the membranes is inevitably destroyed in searching for those parts enclosed within them and as their transparency is marred by staining with blood, this prevents recognition of the parts covered by them, owing to the similarity of their sanguineous color. You can have no knowledge of one without confusing and destroying the other. Therefore it is necessary to make further anatomies, three of which you will need to acquire a complete knowledge of the veins and arteries, destroying everything else with the utmost care; three others to acquire a knowledge of the membranes; three for the cords, muscles and ligaments; three for the bones and cartilages; and three for the anatomy of the bones which must be sawn through to demonstrate which are hollow and which are not, which are medullary, which are spongy, which are thick from without inwards, which are thin. And some are extremely thin in one part and thick in another, and in other parts hollow or full of bone or of marrow or are spongy. Thus it may be that all these conditions will sometimes be found in one and the same bone and there may be a bone which has none of them. You must also make three of the female body in which there is a great mystery owing to the womb and its foetus

Therefore through my plan every part and every whole will be made known to you by means of a demonstration of each part from three different aspects; for when you have seen any member from the front with what nerves, cords or vessels which arise from the opposite side, the same member will be shown to you turned to the side or from behind, just as if you had the same member in your hand and went on turning it gradually until you had a complete understanding of what you wish to know. And so, similarly there will be put before you in three or four demonstrations of each member from different aspects, in such a way that you will be left with a true and full understanding of all you wish to know of the human figure.

Consequently, here will be shown to you in fifteen entire figures the cosmography of the Microcosmos in the same order as was adopted before me by Ptolemy in his Cosmography. Likewise, I shall then divide each member as he divided the whole into provinces, and then I shall describe the use of parts from every aspect, placing before your eyes a knowledge of the entire form, and habit (valitudine) of man, insofar as it has local motion by means of its parts. And might it so please our Creator that I be able to demonstrate the nature of man and his customs in the way that I describe his figure.

I would remind you that an anatomizing of the nerves by means of bodies macerated in running water or in lime-water, will not give you the position of their branchings nor into what muscles they ramify, because, although the source of their origin may be discerned without, as well with water, their ramifications tend to unite under the influence of running water, just as flax or hemp combed for spinning becomes tangled all in a bundle, so that it is impossible to find out again into which muscles, with what, or with how many ramifications, the nerves are distributed into the aforesaid muscles.

In the margin of the same page Leonardo describes, as an example, the manner in which he hopes to demonstrate certain portions of the body, such as the hand.

ON THE HAND FROM WITHIN

When you begin the hand from within, first place all the bones a little separated from one another so that the true shape of each bone on the internal aspect of the hand may be readily recognized, and

further, the real number and position of each. Prepare some sawn through the middle of their thickness, that is, longitudinally, so that you can show which are hollow and which are full. Having done this, place these bones together properly articulated and draw the entire hand, fully open, from within. Then set down the figures of the first bony joints. The next demonstration will be that of the muscles which tie together the rasetta [carpus] and the pettine [metacarpus and phalanges]. The fifth will demonstrate the cords which move the first joints of the fingers; the sixth, the cords which move the second joints of the fingers; the seventh, those which move the third joints of the fingers; the eighth demonstration, the nerves which provide sensibility. The ninth will demonstrate the veins and arteries. The tenth will show the intact hand, complete with its skin, and its measurements, which measurements should also be made of the bones. And whatever you do for this side of the hand, you will also do for the other three aspects, that is, from the internal side, from the dorsal side, from the external side and the side mentioned above. [Clark 19061r/Q I 2r:c. 1509-13]

From time to time Leonardo proposed numerous other plans from the traditional scholastic arrangement from the head to the feet, to a consideration of the body from the surface to the deeper structures, almost always extending his plan until it would have reached such encyclopaedic proportions, and illustrated with such prodigality that he could not hope for its completion or expect its publication.

history of the anatomical manuscripts

On 10 October 1517, Leonardo, then living at Cloux, was visited by Cardinal Louis d'Aragon and his secretary Antonio de Beatis. The artist, partially paralyzed and almost at the end of his life, displayed his drawings and note-books to his visitors, and Beatis, recording this visit in his journal, remarks:

[Leonardo] has compiled a special treatise of anatomy with pictorial demonstrations of the limbs as well as of the muscles, nerves, veins, joints, intestines and whatever can be imagined in the bodies of men as well as women, such as never have been made before by any person. All this is what we have seen with our own eyes. And he said that he had dissected more than thirty bodies of men and women of all ages.

Such is the only account of the intact collection of Leonardo's anatomical drawings during the lifetime of the artist.

In 1519 Leonardo died, and by his will all his drawings and note-books were inherited by his faithful disciple Francesco Melzi and remained in his possession until his death in 1570. Melzi brought them to his villa in Vaprio near Milan where they were inspected from time to time by visitors. There is record of a visit paid to Melzi somewhere between 1537 and 1545 by the person known today only as Anonimo Gaddiano who has left a description of the collection. Presumably the mathematician and physician Girolamo Cardano, a native of Milan, also saw the collection. His remarks are of considerable interest because of their relationship of Leonardo to Vesalius. In his *De subtilitate*, after remarking that a painter is at once philosopher, architect and dissector, he continues, "for proof there is that remarkable imitation of the whole human body which [I saw] many years ago, by Leonardo of Vinci and of Florence, which was almost complete; but the task required a great master and investigator of nature such as Vesalius". Apparently Cardano the physician immediately recognized the non-systematic nature of the work. Leonardo's treatise on anatomy is also mentioned by Biondo in his *Eulogy of painting* (1549).

Still later (1566), Vasari paid a visit to Melzi, and in his record of it propounded the troublesome thesis of the proposed collaboration of Leonardo and Marcantonio della Torre:

In this attempt Marcantonio was wonderfully aided by the genius and labor of Leonardo, who filled a book of drawings in red crayon, outlined with the pen, all copies made with the utmost care dissected by his own hand. In this book he set forth the entire structure, arrangement, and disposition of the bones, to which he afterwards added all the nerves, in their due order, and next supplied the muscles, of which the first are affixed to the bones, the second give the power of cohesion or holding firmly, and the third impart that of motion. Of each separate part he wrote an explanation in rude characters, written backwards and with the left hand, so that whoever is not practised in reading cannot understand them, since they are only to be read with a mirror. Of these anatomical drawings of the human form, a great part is now in the possession of Messer Francesco da Melzi, a Milanese gentleman, who sets great store by these drawings, and treasures them as relics. . . .

Vasari's statement is incorrect in respect to the order in which Leonardo made his drawings, but nevertheless it does suggest that they may at the time of his visit have been arranged in some such order. He would have had neither the anatomical knowledge nor the time to discover discrepancies in the chronology of the drawings and the varying states of Leonardo's knowledge of the subject. A theory is therefore possible that at some time, possibly after his removal to France, Leonardo had actually arranged the drawings into some sort of system. In view of a similar effort to reorganize some of his note-books during his Florentine period, an effort thwarted by a constantly roving interest, it is possible that in his latter years, less widely occupied, Leonardo did actually achieve some sort of arrangement. Moreover, any such arrangement of the anatomical drawings would naturally have strengthened Vasari's belief in the truth of the story of the collaboration of Leonardo and Marcantonio.

The final visit to the collection prior to the death of Francesco Melzi was that of the Milanese painter Lomazzo who mentions his visit some twenty years later in his *Idea del Tiempo della Pittura*:

Leonardo is worth remembering as he taught the anatomy of the human body . . . which I have seen at Francesco Melzi's, drawn divinely by Leonardo's hand . . . but of all these works none was printed, existing only in his manuscripts which in great part have come into the hands of Pompeo Leoni, . . . and some also came into the hands of Signor Guido Mazenta, distinguished scholar who treasures them lovingly.

Lomazzo's account therefore not only continues the recognition of Leonardo's anatomical studies, but also it is the first notice of the dispersal of the drawings.

In 1570 Francesco Melzi died and his property passed to a relative, the jurist Orazio Melzi, who appears to have had neither interest in nor realization of the significance of his inheritance. Our knowledge of this episode is derived from Ambrosio Mazenta, and recounted by him toward the end of his life, 1631-35. According to Mazenta, when he was studying law in Pisa in 1588, another student, Lelio Gavardi d'Asola, a nephew of Aldus Manutius the younger, showed him some thirteen note-books of Leonardo which he had filched during an earlier period when he had been employed as a tutor in the household of Orazio Melzi. It had been his intention to sell them to Francesco de'Medici, Grand Duke of Tuscany who, however, had died before Gavardi had been able to show them to him. Mazenta eventually persuaded Gavardi to allow him to return the note-books, but as it happened Orazio Melzi who already had a houseful of books and relics of Leonardo was not eager to receive any more. As a result the Mazenta brothers, Ambrosio and Guido, retained the drawings. Thereafter as the Mazenta collection was seen by artists and its source was learned, Melzi found himself under constant request for more of Leonardo's drawings. The person who appears to have been the most eager to acquire them was Pompeo Leoni (c.1533-1608), a sculptor and pupil of Michelangelo, and now in the service of the King of Spain. When he promised that Melzi would gain honors and privilege in Milan, then under Spanish control, if the drawings were presented to the King of Spain, Melzi suddenly recognized a value in his inheritance—hardly aesthetic it may be said—and besought the return of the note-books from the Mazenta brothers who returned seven of them which Melzi in turn handed over to Pompeo Leoni. Eventually the six note-books retained by the Mazentas were dispersed, three of them after the death of Guido Mazenta, coming into the hands of Leoni. It is also possible that he had meanwhile acquired even more drawings from Orazio Melzi. At any rate, Leoni took apart the original note-books and mounted the sheets in paper frames so that both sides were visible. Thereafter he assembled them disregarding any previous order and bound them in two large volumes.

One of these volumes Leoni took to Spain in 1591 where he sold it to Don Juan d'Espina. This volume may have contained the anatomical drawings which eventually found their way to England, although the route is not always clear. We do, however, know that Thomas Howard, Earl of Arundel, purchased the volume while travelling in Spain (1636). The Codex Arundel, representing a portion of the purchase, upon the urging of John Evelyn, was presented by its owner to the Royal Society in 1681 and thence was transferred to the British Museum in 1831. However, a large collection of drawings, including the anatomical ones, in some way or other, and exactly when is unknown, found their way into the Royal Library at Windsor. All that can be said about them is that they were in the Royal Collection as early as 1690 when Queen Mary showed them at Kensington Palace to Constantijn Huygens. Thereafter they appear to have been unnoticed until mention is made of them shortly after 1735 in an inventory of the prints and drawings "in the Buroe of His Majesty's Great Closet at Kensington". Again the collection seems to have been lost until 1778 when "Mr. Dalton, Royal Librarian, fortunately discovered it on the bottom of [a chest]". At this time the collection was said to number 779 drawings. However, when the drawings were properly mounted and cared for in the nineteenth century only 600 could be found. Sixty-four pages had at some time been removed, but why and whither they went is today unknown.

The drawings, in particular the anatomical ones, are next mentioned by William Hunter, the celebrated physiologist, who speaks of them with enthusiasm and announces his intention of publishing them, a task from which he was prevented by his death in 1783, and the first selection of the drawings, including some of the anatomical studies was brought out by John Chamberlaine in his *Imitations of Original Designs by Leonardo da Vinci* (1796).

Once again these drawings were neglected until studies of them were initiated by Gaetanao Milanesi (1872) and by Gustavo Uzielli (1872). In 1878 an exhibit was arranged at the Grosvenor Gallery, at the instigation of the Prince Consort, of a large number of the drawings, not however including the anatomical ones, and in 1883 appeared the first thoroughgoing study, including the anatomical drawings, by J. P. Richter.

The first effort to make the anatomical drawings generally available through publication in facsimile was that of Theodore Sabachnikoff who published a selection of the drawings in 1898 under the title of *Dell' Anatomia, Fogli A*. The volume contains an introduction by Mathias Duval, then professor of anatomy at the Ecole Nationale des Beaux Arts, and a transcription of Leonardo's text together with a translation into French. In 1901 a second volume was published known as *Fogli B*. Regrettably the introduction by Duval displays more admiration for Leonardo's drawings than scholarship and a considerable lack of knowledge of the history of anatomy. Similarly the transcriptions are not wholly lacking in error, while the translations into French contain numerous mistakes arisen through misunderstanding and ignorance of the subject.

Meanwhile Sabachnikoff had continued the photographing of the remainder of the Windsor Collection and had deposited the negatives with Eduard Rou-

veyre, publisher of the *Fogli A*. Apparently with the intention of supplying a waiting market Rouveyre, without waiting for the transcription of Leonardo's text to be completed, published an edition of the photographs. While this unethical if not piratical action is said to have hastened the death of Sabachnikoff, it also meant that the work would eventually have to be done over again.

Between 1911 and 1916, the need for a proper edition of the remainder of the anatomical drawings, that is, those pirated by Rouveyre, was finally met by the appearance of the *Quaderni d'Anatomia* published in Oslo through the editorial efforts of C. L. Vangensten, A. Fonahn and H. Hopstock and contains an Italian transcription and translations into English and German. The facsimiles were carefully and beautifully made, but the volumes lack proper annotations, and the translations suffer frequently and woefully from error.

It is a curious fact that hitherto no editor has attempted to arrange Leonardo's note-books so as to indicate systematically what the extent of his anatomical studies was. This is now done, and the plates have been arranged according to systems. Within the systems, so far as possible, a chronological sequence has been observed to indicate Leonardo's growth and development as an anatomist. The text has been newly translated, and it is hoped that at least a few of the errors in previous translations have been removed. The sources from which the plates have been taken are indicated as follows:

FA *I manoscritti di Leonardo da Vinci della Reale Biblioteca di Windsor. Dell' anatomi fogli A. Pubblicati da Teodoro Sabachnikoff* . . . Parigi . . . 1898.

FB [Ditto] *fogli B* . . . Torino . . . 1901.

Q *Quaderni d'anatomia . . . Pubblicati da ove C. L. Vangensten, A. Fonahn, H. Hopstock* . . . Christiania . . . 1911-16. 6 vols.

Clark, Kenneth. *A catalogue of the drawings of Leonardo da Vinci in the collection of His Majesty the King at Windsor Castle*. Cambridge, England, 1935. Clark's work indicates the number of each plate in the Windsor Collection, occasionally correcting errors such as the indications of recto and verso in Q. Clark has also attempted to date the plates, and while he has achieved considerable success in his efforts, nevertheless the anatomical content occasionally suggests an earlier or later date than he has ascribed.

illustrations

OSTEOLOGICAL SYSTEM

the skeleton

Apart from the four drawings in the Uffizi Gallery in Florence, attributed by Holl and Sudhoff (1914) to Leonardo, and those of the Codex Huygens, which may have followed some Leonardine tradition, these illustrations constitute the nearest approach to the representation of the complete skeleton. They differ greatly from the osteological figures of the Huygens manuscript in their correct representation of the spinal curves, the tilt of the sacrum and innominate bones, and an appreciation of these features in relation to the statics of the erect posture. Despite the remarkable accuracy of observation and delineation, there is evidence of some persistence of traditional authority, although the figures as a whole far surpass the crudities of Leonardo's immediate predecessors.

Written across the top of the page appears the note, *What are the parts of man where the flesh, no matter what the obesity, never increases, and what are the places where this flesh increases more than anywhere else,* indicative of Leonardo's interest in the distribution of the subcutaneous fat modifying the surface contours of the body. It will be recalled that it was Leonardo's encyclopaedic intention to represent the body in all aspects from infancy through the prime of life to old age. This note may, therefore, relate to the larger plan. Such knowledge would be of particular value to the artist and was developed by Albrecht Dürer in his illustrations of various somatotypes.

fig 1. Posterior view of thorax and pectoral girdle.

Make a demonstration of these ribs in which the thorax is shown from within, and also another which has the thorax raised and which permits the dorsal spine to be seen from the internal aspect.

Cause these 2 scapulae (spatole) to be seen from above, from below, from the front, from behind and forward.

Head 1, Jaws 2, Teeth 32.

Although far in advance of anything which had preceded it, this sketch of the posterior aspect of the thorax exhibits certain inaccuracies. The arrangement of the ribs is only approximate, but they show their obliquity which is necessary for an appreciation of the mechanics of respiration. The scapulae are relatively too long since their vertebral borders extend from the second to the tenth rib instead of to the seventh. This may have been due to the fact that Leonardo did not possess a complete skeleton or to the failure, when articulating the specimen, to provide intervertebral discs of adequate thickness or, if these were left *in situ* as was the custom, to their drying out and shrinking. Leonardo employs several terms for the scapula: *spatula, spathula, spatola,* and occasionally *padella.* This last term is also used for the patella but may be a misspelling. The word *spatula,* and its variants, was in common use up to the time of Vesàlius (1514-1564) and was derived from the Greek σπάθη, i.e., any broad blade, and used by Hippocrates for the scapula.

Leonardo's final note on the above illustrations undoubtedly is the beginning of an enumeration of the bones of the body. This was a subject of great concern to mediaeval anatomists, and various figures were given as the total number. Each authority was inclined to defend his mathematics with considerable force.

fig 2. Lateral aspect of thorax.

You will make the first demonstration of the ribs with 3 representations without the scapula, and then 3 others with the scapula.

First design the front of the scapula without the pole m, of the arm [head of humerus], and then you will make the arm.

From the first rib a, and the 4th below b, is equivalent to the [length of] the scapula (padella) of the shoulder c d, and is equal to the palm of the hand and to the foot from its center to the end of the said foot, and the whole is similar to the length of the face.

Before you place the bone of the arm m, design the front of the shoulder which receives it, that is, the cavity of the scapula (spatula), and do it as well for each articulation.

fig 3. Anterior view of thorax and pectoral girdle.

Spondyles [vertebrae] 5.

The clavicle (forcula) moves only at its [acromial] extremity t, and there it makes a great movement between up and down.

You will design the ribs with their spaces open, there where the scapula terminates on these ribs.

The scapula receives the bone of the arm on 2 sides, and on the third side it is received by the clavicle from the chest.

Design first the shoulder without the bone a [summus humerus], and then put it in.

Remark how the muscles attach together the ribs.

Demonstrate the bone of the humerus, how its head fits into the mouth of the scapula, and the utility of the lips of this scapula o t [acromoid and corocoid processes], and of the part a [summus humerus], where the muscles of the neck are attached.

You will make a 2nd illustration of the bones in which is demonstrated the attachment of the muscles on these bones.

Despite its relative accuracy this figure exhibits several features indicative of the overlay of traditional authority. It will be observed that not only is the sternum too long, but it is divided into seven segments consisting of the manubrium, five segments for the body and the xiphoid process. This was Galen's number based on his findings in apes. It was required that there be as many parts of the sternum as attached costal cartilages. However, Leonardo shows eight true ribs instead of the usual seven, and includes the xiphoid with the sternebrae so that his surrender to authority is only partial.

In the shoulder, at the tip of the acromion, a separate ossicle noted by the letter a, is illustrated. This is the so-called summus humerus, a third ossicle believed to exist between the acromion and the clavicle. The notion was derived from Galen, but Rufus of Ephesus (c.98-117) states that Eudemos (c.250 B.C.) referred to the acromion as a separate ossicle. In any case almost all mediaeval anatomists discuss this ossicle. Some have attempted to excuse Leonardo's traditionalism on the ground that he saw an ununited epiphysis in his specimen. This may have been so since many of his drawings of the scapula do not show this

(continued on page 489)

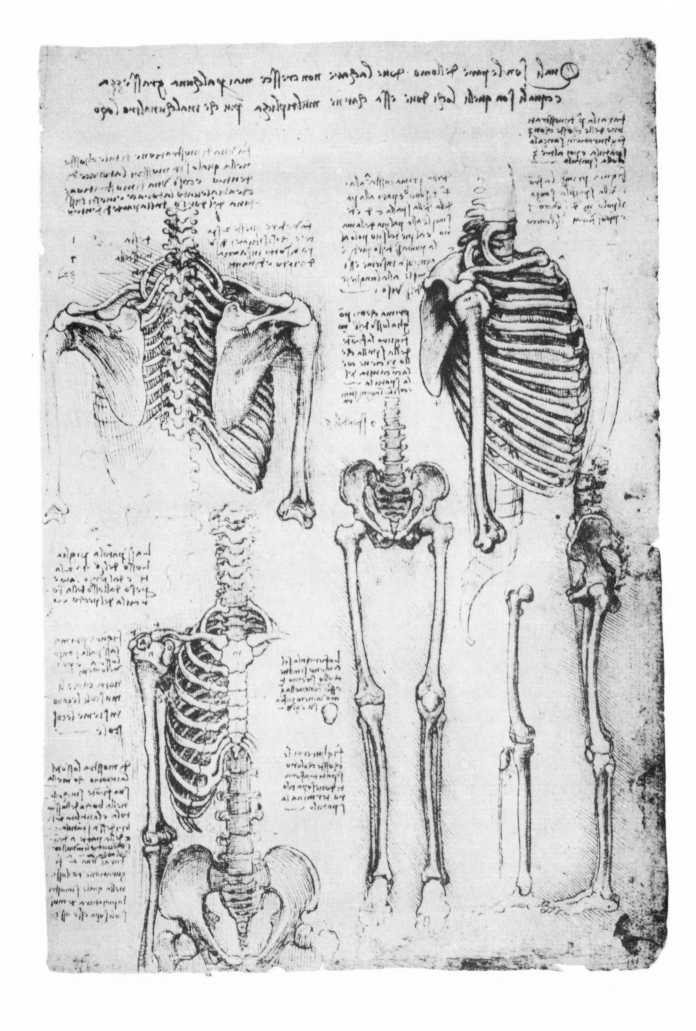

Represent the spine, first with the bones and then with the nerves of the medulla (nucha), is Leonardo's marginal note indicating his intention to present the vertebral column together with the relationships of the spinal nerves.

In figs. 1-2, 5, illustrating the intact vertebral column from lateral, anterior and posterior aspects, Leonardo's notation is as follows:

a b, are the seven spondyles [vertebrae] of the neck through which the nerves go from the medulla and are spread to the arms giving them sensibility.

b c, are the twelve vertebrae where are attached the twenty-four ribs of the chest.

c d, are the five vertebrae through which pass the nerves which give sensation to the legs.

d e, is the rump divided into seven parts which are also called vertebrae.

fig 1. Lateral view of vertebral column.

This is the bone of the spine viewed from the side, that is to say, in profile.

a b, is the bone of the neck viewed in profile, and it is divided into seven vertebrae.

b c, are the 12 vertebrae in which the origins of the ribs are fixed.

The greatest breadth of the vertebrae of the spine in profile is similar to the greatest breadth of the aforesaid vertebrae seen from the front.

Make all the varieties of the bones of the spine so that you represent it as separated in 2 likenesses and united in two, and you will thus make of it 2 borders which vary; you will make them separated [from one another] and then united, and you will obtain in this way a true demonstration.

a b, vertebrae 7 [cervical]
b c, vertebrae 12 [thoracic]
c d, vertebrae 5 [lumbar]
d e, vertebrae 5 [sacral]
e f, vertebrae 2 [coccygeal]

That makes a total of 31 vertebrae, from the beginning of the medulla to its end.

fig 2. Anterior view of vertebral column.

This is the bone of the spine viewed from the internal aspect.

At n [thoracic 5] is the smallest of all the vertebrae of the ribs, and at b and at S [lumbar 4] are the largest.

The vertebra r [lumbar 5] and the vertebra S [lumbar 4] are equally large; o [cervical 3] is the smallest vertebra of the neck.

fig 5. Posterior view of vertebral column.

Say for what reason nature has varied the 5 superior vertebrae of the neck at their extremities.

Represent the medulla, together with the brain, as it passes by the 3 superior vertebrae of the neck which you have separated.

The fifth of the bifurcated [cervical] vertebrae has greater breadth than any other vertebra of the neck, and its wings are smaller than those of all the others.

There was great confusion among mediaeval anatomists as to the number of vertebrae. Galen had described the vertebral column as consisting of thirty segments; of these twenty-four were presacral, but since Galen depended upon the barbary ape he enumerated three sacral and three coccygeal. Both Avicenna and Mundinus give Galen's number. In the illustrations and notes Leonardo shows a bold departure from tradition in his recognition of thirty-one segments. Apart from the twenty-four presacral vertebrae he shows for the first time that the human sacrum is made up of five vertebrae, but he ascribes only two segments, instead of the usual four, to the coccyx. It appears that the coccyx in his figure consists in reality of four vertebrae reduced by fusion to two. However, variation in this region is exceedingly common. Even the great anatomist Andreas Vesalius illustrated a six-piece sacrum and was willing to assume that the coccyx might be regarded as not fully ossified in order to harmonize his findings with the opinion of Galen. Taken to task by Gabriel Fallopius (1523-1562) for selecting a six-piece instead of a five-piece sacrum as the modal type, Vesalius weakly defended himself on the ground that the specimen he had illustrated in his works was the most perfect he had ever seen.

The lateral view of the articulated column correctly represents the spinal curvatures and reflects Leonardo's appreciation of their importance in body mechanics. This appreciation is especially evident in /99, where the pelvic bones are included. However, despite Leonardo's great powers of observation and accuracy of draughtsmanship, it will be observed that he has included in this view, in the interval between thoracic 2 and 3, an additional spinous process without the corresponding body.

A word should be said on the terms here employed. The term "spondyle" (*spondylis*) was derived from the Greek σπόνδυλος and appears in the Latin version of Avicenna. With the recovery of the works of Celsus by Guarino Veronese in 1426, the term "vertebra" gradually superseded "spondyle" and became standard through the efforts of the medical humanists in the middle of the sixteenth century. The surgeons, however, continued to use "spondyle" which long remained the vernacular word for vertebra. Since the terms spondyle, vertebra and trochanter etymologically all imply a turning movement, Leonardo sometimes employs the word spondyle to indicate the lesser trochanter.

As was customary among mediaeval anatomists, Leonardo uses the word *nucha* to mean either the nape of the neck or the spinal cord. The word owes its double meaning to the fact that it is the latinized version of the early translators of two different Arabic words. Constantinus Africanus (d.1087) at Monte Cassino had introduced *nucha* from the Arabic *nucha* for the spinal cord, and the term continued in use until the sixteenth century when *medulla dorsalis*, and eventually *medulla spinalis*, were substituted. However, the Arabic *nugrah* for neck, and especially the nape of the neck, was also rendered *nucha* and in this sense still persists in modern terminology as the ligamentum nuchae and the nuchal lines of the occipital bone.

figs 3-4. Posterior view of cervical vettebrae.

The first bone at the top is joined to the second by two joints, and the second is joined to the 3rd by 3,

(continued on page 489)

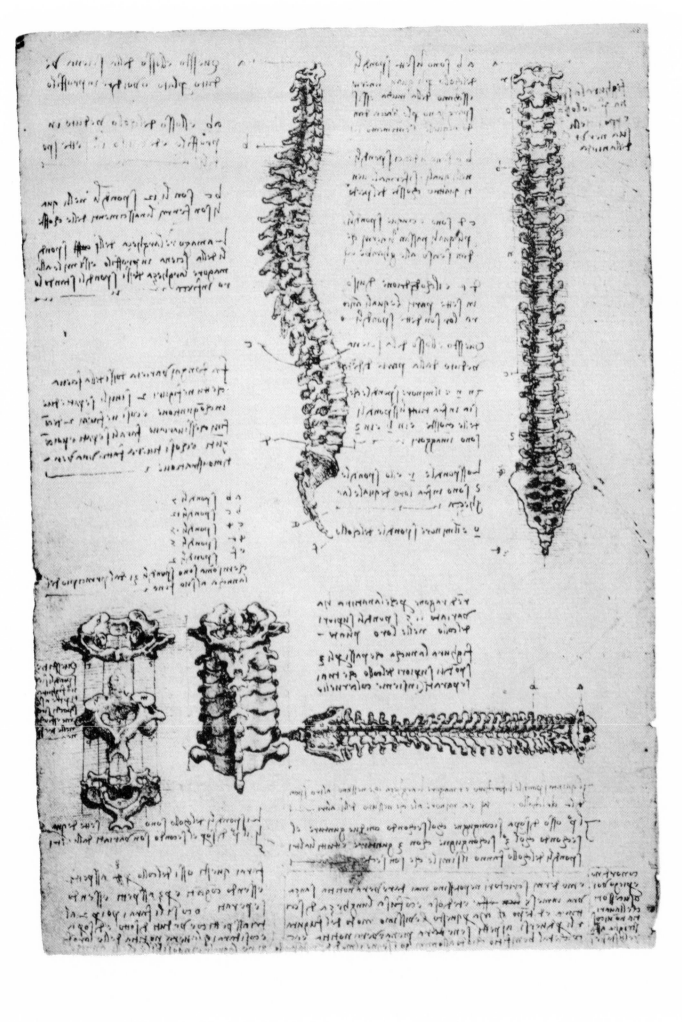

the skull: anterior view

fig 1. **Anterior view of skull with frontal and maxillary sinuses exposed.**

The cavity of the orbit and the cavity of the bone which supports the cheek, and that of the nose and of the mouth, are of equal depth and terminate in a perpendicular line below the sensus communis; and each of these cavities is as long as the third part of a man's face, that is, from the chin to the hair.

This magnificent drawing of the skull has been universally admired. It demonstrates admirably Leonardo's care in anatomical dissection and imagination in presentation. The skull has been divided down the middle. The frontal and maxillary air sinuses, the nasal cavity and placement of the roots of the teeth in the jaws have been exposed on the right half of the specimen. On the left half the superior and inferior orbital fissures, the supraorbital, supratrochlear, infraorbital and mental foramina, as well as other features, are displayed with an accuracy unparalleled for the times. For the meaning of the *sensus communis*, usually corresponding to the third ventricle of the brain, cf. 6, 7.

fig 2. **The teeth of the upper jaw.**

The 6 upper maxillaries [molars] have each 3 roots of which 2 roots are on the outer side of the jaw and one on the inner; and the 2 hindmost erupt in 2 to 4 years or thereabouts.

Then come the 4 maxillaries [premolars] of 2 roots each, one on the inner and the other on the outer side; then follow the 2 maestre [canines, lit., master teeth] with only a single root, and in the front are the 4 teeth [incisors] which cut and have only one root.

The lower jaw, like the upper, also has 16 teeth, but its maxillaries have only 2 roots; the other teeth are like those above. In animals, tooth number 2 seizes the prey, number 4 cuts and number 6 grinds.

At this time great arguments occurred between the peripatetic philosophers and the physicians over the number of the teeth, since Aristotle had stated that females had fewer teeth than males and that longevity in various animals was proportional to the number of teeth. As Vesalius sarcastically remarked, "Since no one is prohibited from counting the teeth, it is obvious that it is as easy for anyone to test this assertion as it is for one to say that it is false". The information here provided by Leonardo is derived almost word for word from Galen through Avicenna. The origin of the word *maestre* for canine tooth is unknown. On 181, Leonardo presents us with a highly original discussion on the occlusion of the teeth and the mechanical principles which determine their power in mastication, as well as the relationship between their form and function.

the skull: lateral view

fig 1. **Lateral view of skull.**

I wish to elevate that part of the bone, the support of the cheek, which is found between the 4 lines a b c d, and to demonstrate through the exposed opening the size and depth of the two cavities which are hidden behind it. The eye, the instrument of vision, is hidden in the cavity above, and in that below is the humor which nourishes the roots of the teeth.

fig 2. **Lateral view of the skull with maxillary sinus exposed.**

The cavity of the cheek-bone has a resemblance in depth and size to the cavity which receives the eye within it, and in capacity it is very similar to it and receives in its interior some veins through the opening m, which descend from the brain, passing through the sieve (cholatorio) [ethmoid] which discharges into the nose the superfluities of the humors of the head. No other obvious openings are found in the above cavity which surrounds the eye. The opening b [optic foramen] is where the visual power passes to the sensorium and the opening n [nasolacrimal] is where the tears well up from the heart to the eye, passing through the canal of the nose.

The first of these two figures is the only illustration left by Leonardo of the intact skull. Like his figure of the vertebral curves, the careful orientation of the specimen by means of a block placed beneath the occiput will be noted. However, nowhere does Leonardo dis-cuss or enumerate the constituent bones of the skull, although undoubtedly he understood its construction far better than any of his predecessors. In fact, among mediaeval physicians there was no more confused subject since in the absence of direct observation their notions were derived from debased versions of Galen who in turn had depended upon the bones of animals.

The maxillary air sinuses here shown are usually associated with the name of Nathaniel Highmore, the English physician, who published a full description of them in 1651. Leonardo's drawings must be regarded as the first representation of the antrum, and Vesalius and the Paduan school of anatomists were well aware of its existence long prior to Highmore.

In Leonardo's notes mention is made of the ancient humoral doctrine that the phlegm or pituita was condensed by the brain to pass to the pituitary gland and thence through the cribriform plate of the ethmoid to the nasal passages. Leonardo employs the term *cholatorio*, sieve, which in Latin form was long the standard term for the cribriform plate of the ethmoid which was regarded as a separate ossicle until Gabriel Fallopius showed it to be but a part of the ethmoid.

The nasolacrimal duct was known to Galen who correctly traced the passage of the tears from the lacrimal glands to the nasal cavity. The notion here expressed by Leonardo that the tears well up from the heart is undoubtedly Aristotelian with its doctrine of the primacy of the heart as the seat of the emotions.

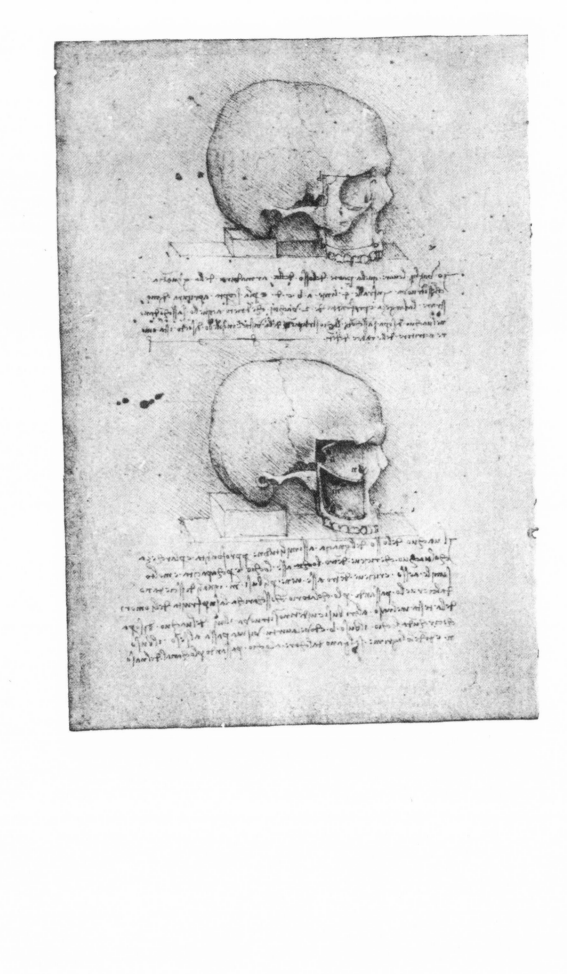

the skull: lateral view

This is one of the few dated anatomical drawings. It is evidently the first leaf of his sketch-book and permits the dating of his early studies on anatomy conducted at Milan.

fig 1. **The skull and vessels of the forehead: antero-lateral aspect.**

The maxillary vein m, is shown passing into the infratemporal fossa and continuing as infraorbital and zygomatic branches. The infraorbital passes through the foramen or anastamoses with the anterior facial. The external nasal, supraorbital and superficial temporal veins are arranged in the same patter as found on 125. Leonardo writes:

The [maxillary] *vein m, ascends upwards and enters beneath the bone of the cheek and through the foramen of the socket of the eye* [infraorbital]. *It passes between the under surface of the eyeball and the bone supporting it. At the middle of the said course the said vein pierces the bone and descends downwards for half a finger's breadth. Having perforated the surface of the bone beneath the margin of the above-mentioned socket at n, it begins to ascend and having bordered for a little distance the margin of the eye, it passes the lacrimator* [lacrimal caruncle and duct]. *At length within the eyelids, after ascending for an interval of 2 fingers, it commences the branchings which spread over the skull.*

The lacrimal glands were unknown to Leonardo and his contemporaries. The tears were supposed to well up through the lacrimator or lacrimal duct from the heart which was the seat of the emotions.

fig 2. **The skull and veins of the forehead: lateral aspect.**

The maxillary vein is shown as in fig. 1. The superficial temporal is now clearly revealed.

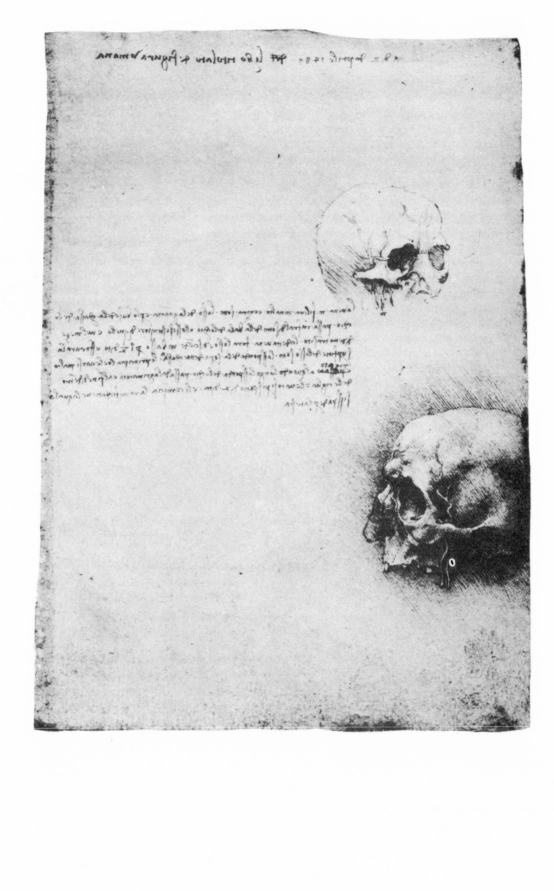

the skull: interior view

fig I. **Lateral view of skull to show meningeal vessels.**

The confluence of all the senses [Ventricle III] *has perpendicularly below it at a distance of 2 fingers the uvula, where one tastes the food, and lies straight above the wind-pipe and above the opening of the heart by the space of a foot. A half-head above it is the junction of the cranial bones* [bregma], *and a third of a head anterior to it in a horizontal line is the lacrimator* [nasolacrimal duct] *of the eye. ⅔ of a head posterior to it is the nape* [of the neck], *and at an equal distance and height to the side are the 2 pulses of the temples. The veins which are represented in the cranium in their ramifications make an imprint of a half of their width in the cranial bone, and the other half is hidden in the membranes which cover the brain. Where the bone is poorly provided with veins within, it is refreshed from without by the vein a m* [middle meningeal vessels] *which issues forth from the cranium, passes into the eye and then into the* [. . .]

As in the previous illustrations, the horizontal and vertical lines intersect above the pituitary fossa at the position of the third ventricle which being the seat of the *sensus communis* was at the point of confluence of all the senses. Thus the optic, acoustic and other sensory nerves are drawn converging upon this point. The relation of the uvula, believed to be the organ of taste, the heart and the nasolacrimal duct which carried emotions from the heart to be expressed as tears, are considered since their sensations would bear upon the *sensus communis*.

Of great interest are the representations of the distribution of the anterior and middle meningeal vessels, not only as the first accurate illustrations of these structures, but also because of their fancied role of providing the brain and eye with animal spirits. The meningeal arteries were long regarded as veins. Even Vesalius fell into this error. Other vessels which may be identified are the angular and frontal veins and the emissary vein passing through the mastoid foramen. The frontal vein was regarded as of special importance since according to Avicenna, following traditional Hippocratic practice, this vessel must be selected for bloodletting in the revulsive treatment of pains in the head and disorders of the mind.

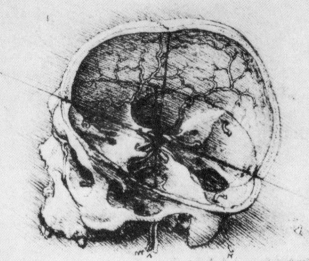

the skull: interior view and saggital suture

fig 1. **Lateral view of skull with the left half of the calvaria removed to expose the interior.**

For the significance of the horizontal and vertical lines intersecting at a point just above the pituitary fossa, which was believed to correspond to the "confluence of the senses" or *sensus communis*, cf. below.

fig 2. **Sagittal section of skull.**

Where the line a m, intersects the line c b, will be the confluence of all the senses; and where the line r n, intersects the line h f, will be the pole of the cranium, at a third of the base of the head, and thus c b, will be a half.

Remember when you delineate this halved head from within, to make another which shows it from without, turned in the same direction as this, so that you may better understand the whole.

The anatomical features presented in these two views of the skull require no comment. The real significance of the illustrations is related to mediaeval notions on the relationship of different parts of the brain to mental processes. It will be observed that the point of intersection of the lines mentioned occurs a little above the pituitary or hypophyseal fossa and would correspond approximately to the position of the third ventricle of the brain. It will be observed also that in the second figure the optic nerve is shown emerging from its foramen and terminates at the point of intersection which Leonardo says is the confluence of all the senses. In the materialistic psychology of the middle ages the intellectual faculties were supposed to be contained within the ventricles of the brain. One of these, variously placed, was the so-called *sensus communis* which received all sensations and especially the "emanations" of vision, and thus is called by Leonardo "the confluence of all the senses". The ventricle was connected with all the others which housed such functions as fantasy, imagination, judgment, cognition, memory, etc. Leonardo's views as to the position and relations of the *sensus communis* changed from time to time. A fuller discussion of this subject will be found in connection with 142-3, 145, 147.

The second feature to be observed is Leonardo's reference to the pole or axis of the cranium. It will be noted that the point of intersection of the second pair of lines mentioned corresponds approximately with the dens of the second cervical vertebra, although the section of the spinal column is purely diagrammatic. There are indications elsewhere that it had been his intention to study the turning movement of the head. The line c b passes through the nasion to extend horizontally backwards, and thus divides the skull, with mandible attached, into approximately equal halves. This would be useful information for his work on bodily proportions.

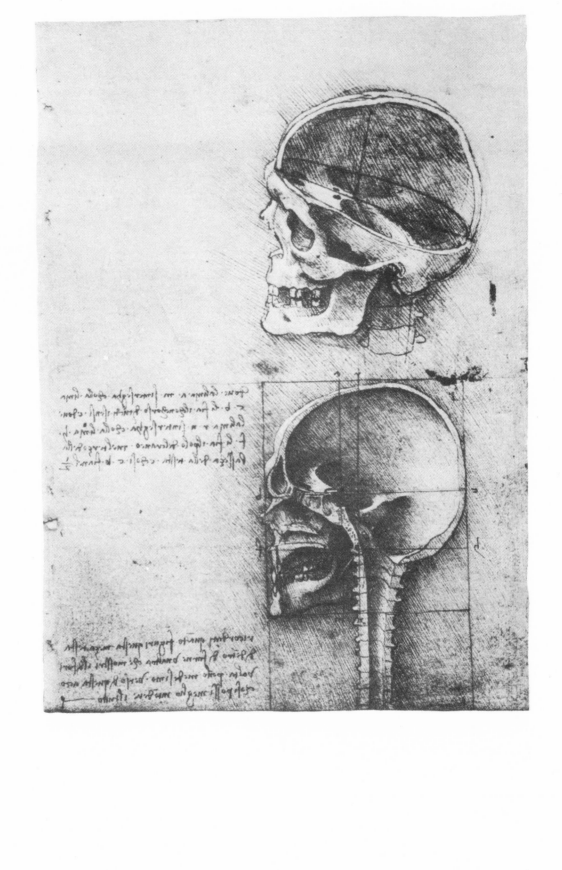

8

the upper extremity

fig I. **Bones of the upper extremity.**

The sinew (nerbo) d [tendon of biceps] is attached midway between the shoulder joint and the tips of the fingers.

The bone of the shoulder c e [for c d, scapula] is one-third of the length of the bone b c [humerus].

The greatest length of the scapula (padella) of the shoulder is from n [acromion] to m [inferior angle], and it is equal to the length of the hand from f to a. The hand, f a, measures six-sevenths of the bone a b [radius].

The bones a b [radius and ulna] are five-sevenths of the length of the bone b c [humerus], the arm remaining extended with the palm of the hand turned toward the sky.

Leonardo was intensely interested in the skeleton of the limbs. As an artist he was concerned with the relative proportions of the several parts of the limbs and usually employs as a unit of measurement the length of the hand or foot. On occasion, as in the text above, he expresses the length of one part in terms of the length of some other part. He fully appreciated the fact that the proportions given were only approximate and subject to individual variation. Of the measurements given, the last is approximately the equivalent of the radio-humeral index. The ratio is stated to be five-sevenths or 71.4 per cent, making the limb brachykerkic, with an index less than 75, as commonly found in Europeans.

However, the primary purpose of the illustrations on this plate is to show the mechanism of pronation and supination. Thus the two chief muscles concerned with these movements, biceps brachii and pronator teres, are included, although no mention of the action of the muscles is made.

fig 2. **Bones of the upper extremity separated.**

a, is the muscle on the inner side of the arm [biceps brachii], which is attached to the scapula of the shoulder.

You will first have these bones sawn longitudinally and then transversely, so that one may see where the bones are thick or thin; then display them intact and separated as here above, but from 4 aspects so that one can understand their true shape; then clothe them step by step with their nerves (nervi), veins and muscles.

The true knowledge of the shape of any body will be obtained by seeing it from different aspects. Consequently, to give a notion of the true shape of any member of man, the first beast among animals, I shall observe the said rule by making 4 representations for the 4 sides of each member, and I shall make 5 for the bones, sawing them in half and showing the cavity of each of them, of which one is the medullary, the other spongy, empty or solid.

The "exploded" view was a method favored by Leonardo to present not only the detailed morphology of the bones but also the relationships of the various parts to one another. Sometimes, as in the illustrations of the ankle joint, he includes leaders to indicate the opposing surfaces. On many occasions mention is made of his intention of including transverse and longitudinal sections of the bones to demonstrate their relative thicknesses and internal structure, but no such drawings have survived.

fig 3. **Anterior view of the bones of the upper extremity to illustrate supination.**

First make this demonstration with the bone called the furchola [clavicle] and then beside it, repeat without the clavicle, that is, like this.

a, the sinew or cord, is joined with b, the muscle [biceps brachii].

The primary purpose of this figure is to illustrate the relationships of the bones of the forearm in supination and the action of the biceps brachii muscle in bringing about this motion. It will be observed that the biceps tendon has been divided, leaving the muscle belly displaced to the medial side and the tendon attached to the radius. As in the preceding drawing, the origins of the short and long heads of biceps are clearly shown, and the muscular portions indicated as though separate. Appearances suggest that Leonardo was exploring, although erroneously, the possibilities that the long head acted as a supinator and the short head as a pronator, cf. fig. 4, where the long head only is shown. The position of the pronator quadratus muscle seems to have been indicated approximately at the distal ends of the radius and ulna. Pectoralis minor, divided into two, is seen passing to its attachment on the coracoid process. For the term *furchola*, cf. 1.

fig 4. **Bones of the upper extremity to illustrate pronation.**

When the man is standing on his feet with the arm extended, the arm, which has two bones [radius and ulna] placed between the hand and the elbow, will be a little shorter when the palm of the hand is turned towards the earth than when it is turned to the sky. And this is because the two bones mentioned, when the palm of the hand is turned towards the earth, intersect in such manner that that which arises from the right side of the elbow goes to the left side of the palm of the hand, and that which arises from the left side of the elbow terminates on the right side of the palm of the aforesaid hand.

The bone a b [radius] makes exactly a half turn when the palm of the hand which was turned towards the sky is turned towards the earth.

fig 5. **Diagram to illustrate relative shortening of the radius on pronation.**

This line becomes shorter as it is placed in a position of greater obliquity.

The figure and diagram illustrate pronation. Leonardo attempts to prove that owing to the oblique position apparently assumed by the bones in pronation, the forearm is somewhat shorter in pronation than in supination. His diagram attempts to show why this would occur, but he failed to recognize that the ulna remains relatively fixed and other factors make the shortening negligible. However, the illustrations emphasize his acute interest in body mechanics.

Roth (1907) has criticized this drawing on the ground that the coracoid process is represented as a distinct bone. Apart from the possibility that Leo-

(continued on page 489)

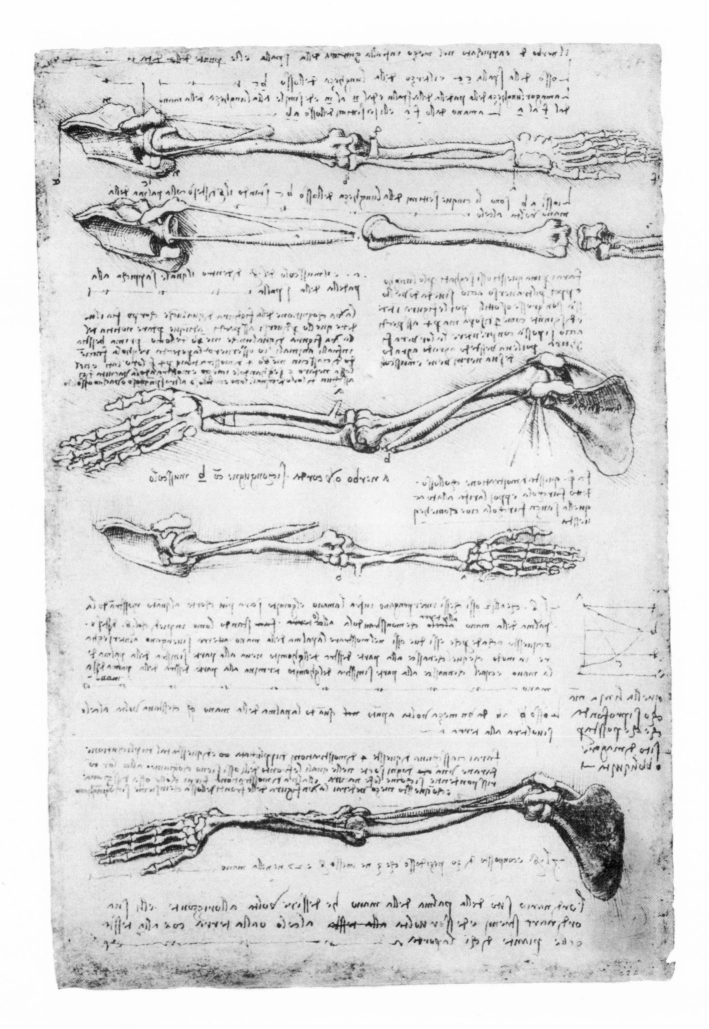

9

the upper extremity

Here one demonstrates how much the hand can be turned without moving the bone of the shoulder, and, likewise, one explains the [apparent] increase which occurs in the arm, from the shoulder to the elbow, in complete flexion of the [fore-]arm.

The above statement placed at the head of the plate requires interpretation. The earlier part of the statement refers to pronation and supination. Leonardo recognized that flexion of the forearm restricts rotation to a half circle while in extension the radius passes through three-quarters of a revolution (cf. 107), hence mention of "the bone of the shoulder". The second portion of his statement concerns the descent of the olecranon of the ulna in flexion and is illustrated in fig. 5.

fig 1. **The surface features of the shoulder from above.**

fig 2. **The bones of the lower extremity.**

See what the spondyles n m [lesser trochanters] serve.
This bone of the tail [coccyx] is folded back when woman gives birth.
For the use of the term "spondyle" as trochanter, cf. 2.

fig 3. **Lateral view of the bones of the upper extremity with forearm extended and pronated.**

Represent each member articulated and disarticulated.
The drawing of the lower end of the ulna is not good. Leonardo seems to have transposed the distal end of the radius to the ulna—an error, perhaps more apparent than real, due to faulty draughtsmanship.

fig 4. **Elbow seen from the outer side.**

fig 5. **Outer aspect of the elbow.**

See what is served by the 2 projections [exostoses] on the inside of the 2 bones of the [fore-]arm.
When the arm is bent, it is shortened [for lengthened] 3 fingers and a half in the interval between the shoulder and its elbow.

The arm does not approach the shoulder at its greatest proximity n m, by less than 4 fingers, and this is caused by the thickness of the flesh which is interposed at the jointure.

The exostosis arising from the interosseous crests of the radius and ulna are evident in both figs. 4 and 5, and may have arisen from trauma, although partial ossifications of the interosseous membrane are not uncommon.

In the second statement Leonardo refers to the descent of the olecranon from a to b, as indicated, during flexion producing an apparent lengthening of the arm. However, he has erroneously written "shortened" which contradicts his statement at the head of the page.

fig 6. **The elbow from within.**

fig 7. **The elbow from within [for anteriorly].**

fig 8. **The elbow from the inner [anterior] aspect.**

fig 9. **The elbow from behind.**

fig 10. **The elbow from behind.**

See what the gibbosity of the arm [deltoid tubercle] at f, serves. And thus for all the other gibbosities in all the bones.

I have examined it and find that the gibbosity f, serves to attach the [deltoid] muscle which elevates the arm; and I note that it will be necessary for me to investigate all the particular uses of each gibbosity of all the bones.

Figs. 6-10 once again illustrate Leonardo's interest in the mechanism of pronation and supination, cf. 8. He now shows pronation in association with both flexion and extension of the elbow. He was aware (107) of the restriction of rotation occurring in flexion and observes that the radius passes through a half circle in flexion but through a three-quarter circle in extension.

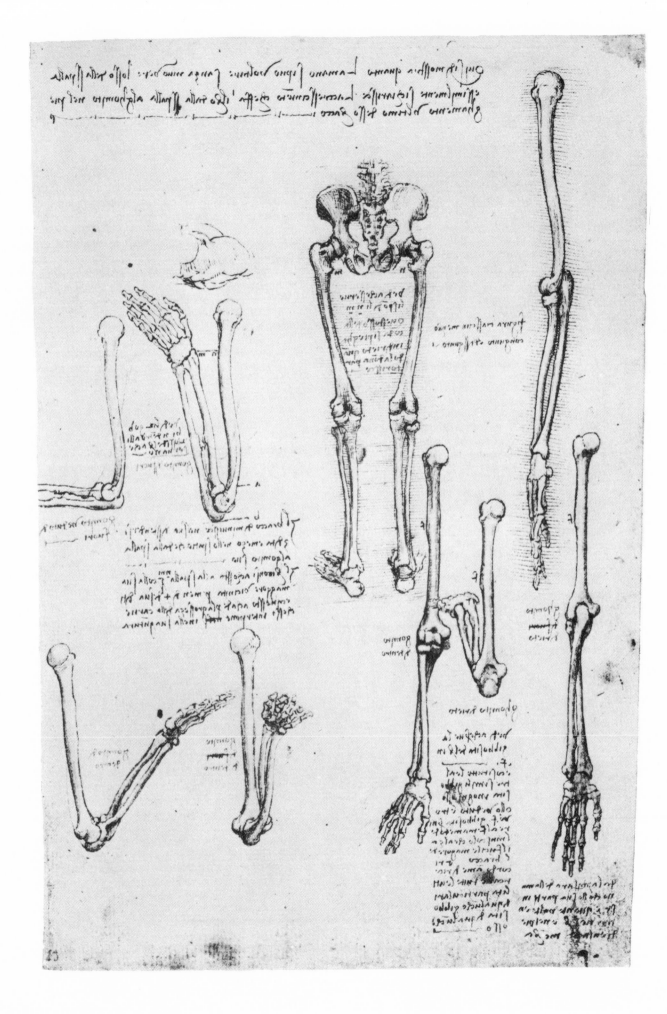

The 1st demonstration of the hand will be made of the bones alone. The 2nd, of the ligaments and the various chains of sinews (nervi) which bind them together. The 3rd will be of the muscles which arise from these bones. The 4th will be of the first cords [flexor digitorum profundus] which lie upon these muscles and assist in giving movement to the tips of the fingers. The 5th will demonstrate the 2nd series of cords [flexor digitorum sublimis] which move all the fingers and which terminate on the penultimate bony segments of the fingers. The 6th will demonstrate the nerves (nervi) which give sensation to the fingers of the hand. The 7th will show the veins and arteries which give nourishment and [vital] spirit to the fingers. The 8th and last will be the hand clothed with skin, and this will be illustrated for an old man, a young man and a child, and for each will be given the measurement of the length, thickness and breadth of each of its parts.

fig 1. **The hand viewed internally [for dorsally].**

First represent these hands with their bones detached from one another and a little separated, so that the number and shape of their bones may be clearly understood, internally as well as externally; and represent the ligaments of the bones.

27 bones, that is to say: 8 in the wrist (rasetta), a b c d, e f g h; 4 in the palm K L m n; 15 in the five fingers, i p q r S, o v x y z, 4 7 9 8 6.

And I give 3 bones to the thumb as to the other fingers, because there are 3 movable bony segments like the 3 of each of the other fingers of the hand.

fig 2. **The hand viewed externally [for ventrally].**

It is necessary to represent as many bones of these hands as may be separated and distinguished from one another, and with the dimensions and shapes of each bone considered fully from four aspects; and you will note the part of the bone united to those surrounding it, and also the part of the bone not united with those surrounding it, and which of them must be moved for the service of whatever action of the hand.

The first bone of the thumb [metacarpal I] and the first bone of the index finger [metacarpal II] are placed upon the basilar bone [multangulum majus] in immediate support, just as the bone i [metacarpal I] receives the same support from the bone K [metacarpal II] that K, receives from the bone f [multangulum minor].

Leonardo's figures of the anterior and posterior aspects of the bones of the wrist and hand are the first to show these structures with any degree of accuracy. The carpus is designated by the term *rasetta* which was derived, usually as *rasceta*, by the translators of Avicenna from the Arabic word *rusgh*. The term was that most commonly used by mediaeval anatomists and surgeons and persisted to the seventeenth century. The word was also employed for the tarsus. Names for the individual carpal bones were a much later introduction so that Leonardo is unusual in naming the multangulum majus as the *os basilare*. The source of this term is unknown.

It will be observed that Leonardo recognizes only four bones in the metacarpus. Here he follows tradition since the first metacarpal was regarded as the first

phalanx of the thumb. Galen was the chief support of this view, and since his time a very considerable literature has developed around the question of which bone has been suppressed. Modern evidence suggests that the reduction occurred by fusion of the second with the third phalanx to form the existing terminal phalanx.

figs 3-4. **The finger seen from the side where it can be touched by the adjoining finger.**

a, is the cord [extensor digitorum] which straightens the flexed finger.

e, is the cord [flexor digitorum] which bends the extended finger.

b, is the vein which nourishes the finger.

d, is the vessel [artery] which gives vital spirit to this finger.

c, is the nerve which gives sensation, etc. This having been cut, the finger no longer has sensation, even when placed in fire; and for this reason careful nature took pains to place it between one finger and the next, so that it would not be cut.

Leonardo frequently uses the word *vena* to mean either artery or vein. In the then current humoral doctrine the artery carried the vital spirit and the vein, the natural or nutritive spirit.

fig 5. **Lateral view of the bones of the wrist and hand.**

fig 6. **Medial view of the bones of the wrist and hand.**

fig 7. **Ventral aspect of the forearm and hand.**

The hand with the fist closed has 4 principal motions of which the first is toward the internal [ventral] side of the arm, and the second, toward the hairy side [dorsal] of the said arm; of the other two movements, one is toward the head [abduction] and the other, toward the feet [adduction], or, in truth, one is between the internal [ventral] and external [dorsal] part toward the focile major [ulna] of the arm, the other, between the internal and external part toward the focile minor [radius] of the said arm. After these movements, design the compound movements, which I name compound because they partake of two of the said movements, and these are infinite for they are produced in the whole of space, a continuous quantity, interposed between the said four principal movements. Finally, there is the rotatory movement of the hand [pronation and supination] for which none of the afore-mentioned muscles is employed but only the muscles which move the fociles [radius and ulna] causing the said hand to turn. Finally come the muscles and the cords, movers of the fingers.

The above passage has every indication of being a paraphrase from the second book of Galen's *De usu partium* to which has been added Leonardo's own conceptions of a continuous infinity of successive phases of motion lying between the extremes of the principal simple movements of the extremity. This is a subject which he discusses at length in his *Trattato della pittura* where a statement similar to that above may be found (§402). He developed a "cinematographic" theory of body motion which he intended to incorporate

(continued on page 489)

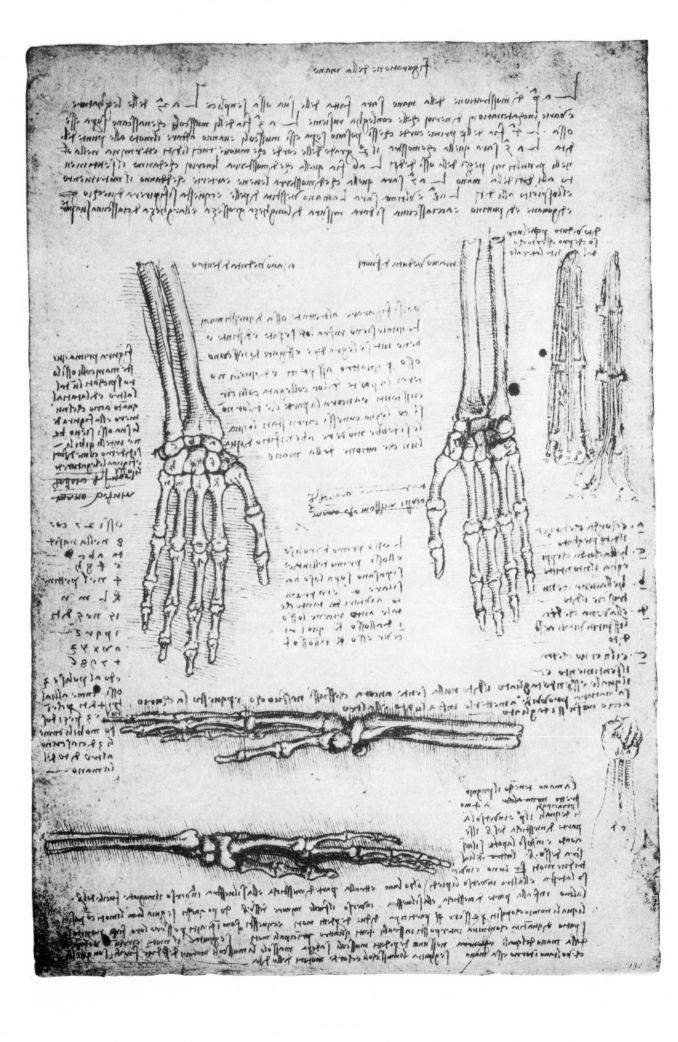

the lower extremity

In the margin to the right of center at the top of the plate appears an outline sketch of a hemicylindrical structure beside which is the word *Accaiolo* (properly *acciaiolo*). This structure represents a fire-stick, two of which could be rubbed together to produce fire. The radius, ulna, tibia and fibula were compared by the Arabs to such fire-sticks, and their term *al-zand* was consequently translated as *focile* from the Latin *focus*, a hearth. Thus the radius and tibia were known as the *focile majus* or *focile superius*, and the ulna and fibula as the *focile minus* or *focile inferius*. Leonardo's sketch indicates the origin of the word which he sometimes employs in the form *fucile* as in fig. 6 of this plate.

fig 1. **Front of knee.**

Below and to the left of this small illustration of the knee joint may be seen presumably the outline of the patella.

fig 2. **Bones of the left lower extremity: anterior aspect.**

fig 3. **Bones of the right lower extremity: anterior aspect.**

fig 4. **Bones of the right lower extremity: posterior aspect.**

For the significance of the lettering, cf. Leonardo's note in connection with fig. 8 of this plate.

fig 5. **Bones of the right lower extremity: lateral aspect.**

fig 6. **Bones of the right lower extremity: medial aspect.**
Rotula. Patella.
First make the fucile [fibula] separately.
Note here that the cord [tendo Achilles] which pulls the heel c, draws to the extent that it elevates a man on the base of his foot. a, the weight of the man being at the center b; and because the lever b c, is half of the counter-lever b a, so 400 pounds of force at c, make a force of 200 pounds at a, with a man standing on one foot.

In this series of drawings the femur, tibia, fibula and patella are displayed from various viewpoints with remarkable accuracy in comparison with any earlier figures. In fig. 6, Leonardo once again shows his interest in mechanical principles as applied to the body by comparing the foot to a lever of the second order. *Rotula* was the vulgar term for patella. It is to be found in all the romance languages and received a Latinized form. The word "patella", of better classical origin was, in Leonardo's day, being reintroduced from the works of Celsus.

fig 7. **Superficial muscles on the lateral aspect of the leg and thigh.**

fig 8. **A figure representing the bones of the lower extremity from the posterior aspect, in flexion at the knee joint as when kneeling on the ground.**

Describe what the gibbosity n [lesser trochanter] serves.
The cord a b [representing the tendon of biceps femoris] and the cord N M [representing semimembranosus] have been provided for the movement occurring on rotation made by the leg below the knee and where it is in contact with the bone of the thigh; that is, when the cord a b, is pulled, it moves with it the side of the leg b, and the opposite cord N M, is elongated, and the side of the bone M, is moved in a direction opposite to the movement of b; and so, when the cord N M, is pulled, it does that which the cord a b, does, which would not occur if the leg were straight as is shown above [fig. 4] in the two cords r S, g h, which when pulled, give no movement to the leg but only attempt to pull, draw together and press the bone of the leg against the bone of the thigh.

Galen in his *De motu musculorum* was the first to discuss the coordination of reciprocally antagonistic muscles and the function of muscles in the maintenance of posture. The first Latin translation of this work is owed to the great medical humanist Nicolaus Leonicenus (1428-1524) of Ferrara. He began his translation c.1509, but it was not published until 1522 when his famous English pupil Thomas Linacre (1460-1524) saw it through the press of Richard Pynson. It is said that only one manuscript of the work was available at that time so that it is doubtful if Leonardo obtained his ideas, as expressed above, from this source. Piero Pollaiuolo (1443-c.1496) is said to have investigated the mechanical action of muscles through anatomical dissection so that there may have been some verbal tradition from which Leonardo could draw and amplify.

fig 9. **A figure representing the bones of the lower limb from the medial aspect in flexion as when kneeling on the ground.**

When a man kneels the interval between the lower end of the patella and the upper part of the bone of the thigh increases by the full thickness of the patella.
The patella of the knee a, has [acting upon it] forces of which the first is the [rectus femoris] muscle of the thigh above it; the second and 3rd [vastus medialis and lateralis] are the right and left lateral muscles of the aforesaid; the 4th is the inferior sinew [lig. patellae] joined to the said patella, and it arises from the tuberosity of the tibia (fuso del gamba); the patella has less sensation than any other bone of man.

The above note sufficiently explains the significance of the drawing.

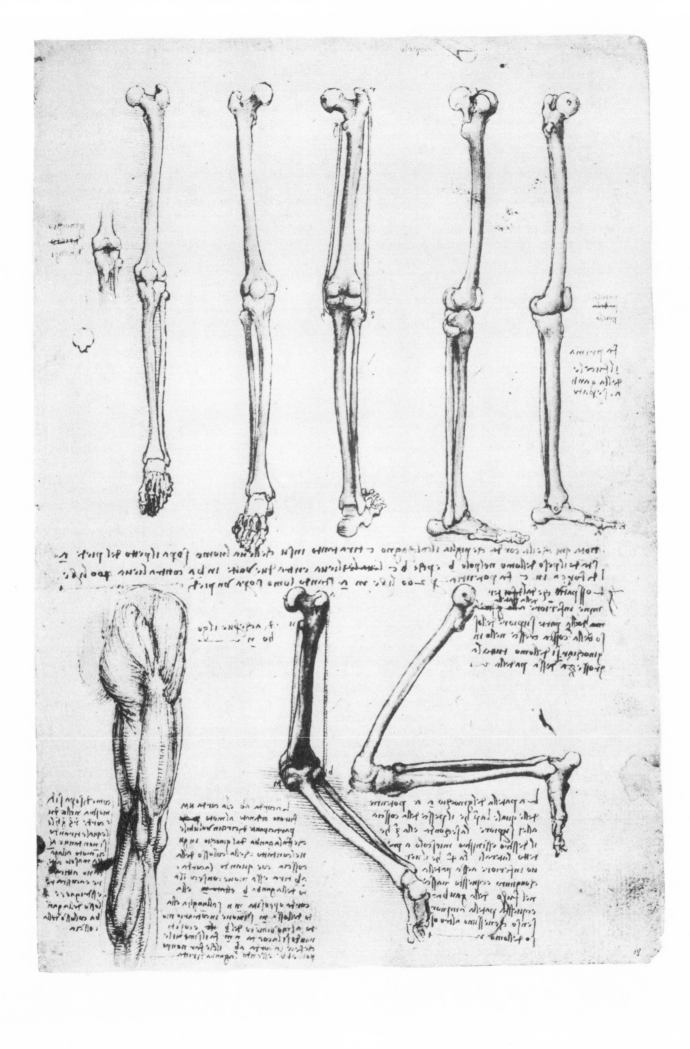

12 the lower extremity

This magnificent series of drawings of the bones of the foot is completed on 13 and 36, where the remainder appear. In the last plate Leonardo states that the bones of the foot are twenty-seven in number, a departure from tradition since Avicenna, following Galen, states that there are twenty-six. Leonardo obtains twenty-seven by including the two sesamoids lying beneath the metatarso-phalangeal joint of the great toe. Furthermore, he reckons only two phalanges for the fifth toe instead of the typical three. However, reduction by refusion of the middle and terminal phalanges is so frequent that he may well have had such a condition before him. However, he may have been attempting to homologize the thumb with the little toe. This is suggested by the fact that the only bone of the tarsus which he names is the cuboid which he calls the *os basilare*, the same term employed for the multangulum majus of the carpus supporting the thumb, cf. 10.

fig 1. Medial aspect of foot and ankle.

Draw still another foot from the same aspect to demonstrate how the ligaments and the sinews of the bones [capsules] bind these bones together.

fig 2. Deep dissection of the shoulder joint.

At first sight the inclusion of a drawing of the shoulder region with the bones of the foot seems to be out of place. The significance of the figure becomes apparent when taken in conjunction with the note accompanying fig. 6 of the series. Its purpose is to show the acromion as a separate ossicle, the summus humerus, lying between the scapula and the clavicle. For the summus humerus, cf. 1, and below. No note identifying the lettered structures is given. However, it is apparent that a, on the left is the infraspinatus muscle turned back; b, on the left, the teres minor which was not recognized as a separate muscle until very much later; a, on the right, the head of the humerus; and b, on the right, the greater tubercle or shaft of the humerus. Other structures nicely shown are the long head of triceps, the supraspinatus, the capsule of the shoulder-joint, the posterior belly of omohyoid, sternomastoid, the upper trunk of the brachial plexus, subclavian artery and other indefinite structures in the posterior triangle of the neck.

fig 3. The bones of the leg and foot: anterior aspect.

fig 4. Dorsal aspect of the bones of the foot.

You will make these bones of the foot all equally separated from one another so that one can clearly understand their number and shape. And you will make this demonstration from four aspects, in order to understand better the true shape of the said bones from all aspects.

fig 5. Dorso-medial aspect of bones of foot and ankle.

Make the bones of the foot separated somewhat from one another so that one may readily distinguish one from the other, and this will be the means of giving knowledge of the number of the bones of the foot and of their shape.

fig 6. Plantar aspect of the bones of the foot and, inset figures, the sesamoid bones.

The glandular bones [sesamoid] are always placed near the termination of the cords when they [the tendons] are attached to the bones. One finds eight of them in the composition of the bones of man; two [acromial bones] in the sinews called the omeri del collo [?trapezius] where these are attached to the upper heads [tubercles] of the bone called the aiutorio [humerus]; and two others [the patellae] in the terminations of the muscles [quadriceps] arising from the alchatin [pelvis] and ending at the knee; 4 in the feet, that is, two for each great toe in the underneath part.

The sesamoid bones were well known to both classical and mediaeval authors. Avicenna frequently mentions them and notes their relationship to the joints. Leonardo calls them *ossi glandulosi* or *ossi petrosi* and appreciates that they are situated at the termination of tendons. In early times there arose among Jew, Christian and Mohammedan a legend of an indestructible bone in the body which was supposed to form a nucleus from which resurrection would occur (Psalms XXXIV:20). This mythical bone was variously supposed to be the petrous temporal, the sacrum or the coccyx. Some held it to be the medial sesamoid of the great toe which received the pseudo-Arabic name of *albadaran*. Vesalius refers to this with the remark, "However, any dispute on the dogma which holds that man is propagated from such an ossicle we leave to the theologians, who claim for themselves alone the right to free dispute and opinion on the resurrection and the immortality of the soul", *Fabrica*, I:xxviii, 126.

There are some curious statements in Leonardo's note. He refers to a separate acromion, the summus humerus of tradition, which he illustrated in fig. 2, and which may be an unfused epiphysis of that process. He says it occurs in the *omeri del collo*, which is possibly the trapezius muscle, but he says this is attached to the humeral tubercles, by which he may have meant the processes about the shoulder since he uses the word *aiutorio* which can mean the shoulder as well as the humerus. The word *aiutorio*, an Italianized form of *adjutorium*, is a literal translation of Avicenna's *al-'adid* and was the customary term for the upper arm, the shoulder region or for the humerus itself. He correctly classifies the patellae with the sesamoids, but he says these lie in the muscle arising from the *alchatin*. The word *alchatin* is also of Arabic origin, but in Avicenna is the lumbar vertebrae, and in Mundinus, the hollow of the sacrum. Leonardo uses sometimes the word to denote the pelvis and at others, the sacrum. Actually the term means the loins and is the equivalent of lumbar. The note suggests that Leonardo regarded the rectus femoris as the main origin of the quadriceps although he shows the vasti muscles arising from the femur. For further remarks on the sesamoids by Leonardo, cf. 13, fig. 4.

fig 7. Lateral aspect of the foot and ankle.

The aspects of the foot are 6, that is, inferior, superior, medial, lateral, posterior and anterior; and added

(continued on page 490)

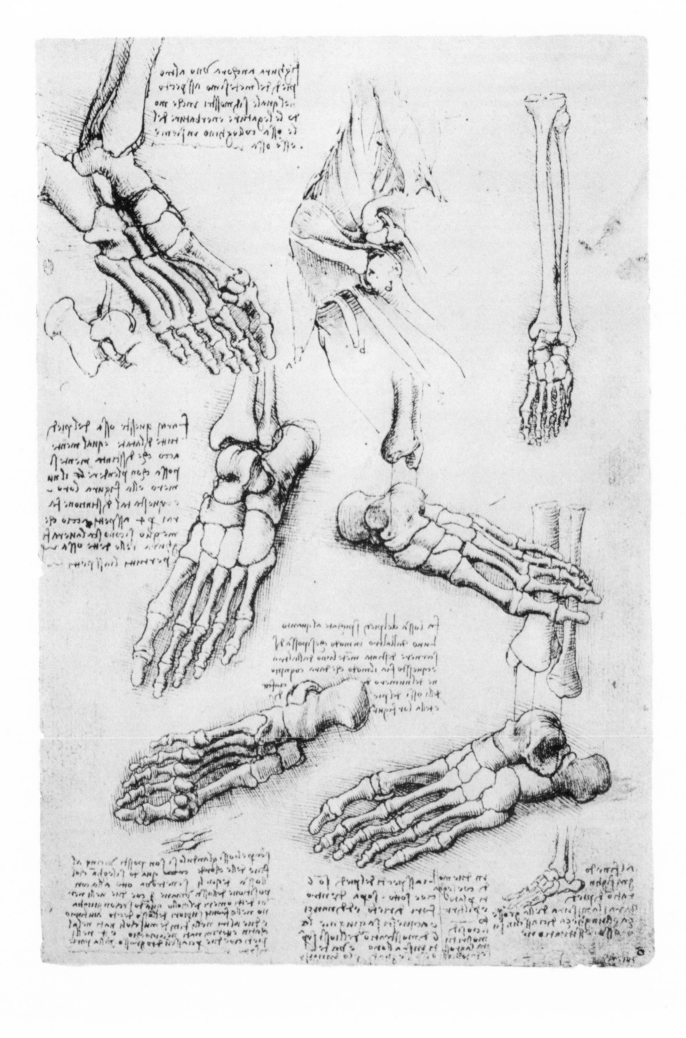

the lower extremity

The figures of this page are primarily a continuation of the series of illustrations of the bones of the foot shown in the previous plate. The series is completed on 36, which has been arranged with the series on myology although it might as well have been placed here. It is evident that the three plates mentioned were drawn at about the same time except for the figures of the shoulder region which are apparently additions made on some other occasion when the blank areas on the page were utilized.

fig 1. **Bones of the foot and ankle from behind.**

Construct the two feet with the same surface (colli) turned in the same direction and do not be disturbed if one remains on the right and the other on the left, for by making them so, they will be more easily understood.

The lower ends of the fibula and tibia are poorly represented in this figure and appear to have been added as an afterthought. The articular surface of the talus and the peroneal tubercle on the calcaneum are well shown. Leonardo's intentions are not very clearly expressed in his note. Apparently he intended to provide bilateral representations of the feet from the same aspect, and he was not concerned if the feet were transposed in so doing.

fig 2. **Surface anatomy of the shoulder region.**

This figure, as may be gathered from the correspondence in pose, appears to belong to the series shown on 36, apparently added to the drawings of the bones of the foot at a later date.

fig 3. **Bones of the foot and ankle from the plantar aspect.**

First you will make all these bones separated from one another, placed in such a way that each part of each bone faces or may be turned towards that part of the bone from which it has been separated and to which it should be united when you restore all the bones of this foot to the original state. And this demonstration is made for a better understanding of the true shape of each individual bone; and you will do the same for each demonstration of each member to whatever aspect it may be turned.

As in fig. 1, the distal ends of the tibia and fibula are poorly and inaccurately drawn. It will be observed that the medial malleolus is absent. So poor is the representation of the tibia in comparison to other drawings of the same bone, and in contrast to the accuracy of delineation of the tarsus in the same drawing, that we may conclude it was sketched in from memory at a later date. This is borne out by the irregularities and overlap in the shading. Cf. the accuracy in the figure below. The sustentaculum tali and groove on the cuboid for the tendon of peroneus longus are well expressed. It will also be noted that as in all drawings of this series only two phalanges are shown for the fifth toe, indicating that they were probably made from a single specimen.

fig 4. **Illustrations of the function of the sesamoid bones at the metatarso-phalangeal joint of the great toe.**

Nature has placed the glandular bone [sesamoid] under the joint of the great toe of the foot because if the sinew to which this glandular bone is united were to be deprived of this glandule, it would be severely damaged by friction under such a weight as that of man when walking and raising himself up on the joints of his feet at each step.

When the potential line of movement passes through the middle of the junctions of movable bodies, they will not be moved but will stabilize themselves in their original straightness as is demonstrated in a n, the mover, which passes through the center of two movable bodies, n m, and m o, and makes them stable [second small figure]. But if the potential line of the mover [b] is outside the central axis of the two rectilinear movable bodies [c d, d e], then if the end of the first or second movable body has a hemispherical shape, the junction of the two rectilinear movable bodies will undoubtedly be angulated at their point of contact [third small figure]. And if the line of the mover [a b c] is outside the junction of two rectilinear movable bodies, then the more distant it becomes from the axis of these movable bodies [through the interposition of a sesamoid bone], the more it will bend their straightness into an angle [c b d], just as a cord does with its arc [fourth and fifth of small figures].

For a further discussion of the function of the sesamoid bones, cf. 12. The mechanical principles of the effects of such bones are clearly set forth.

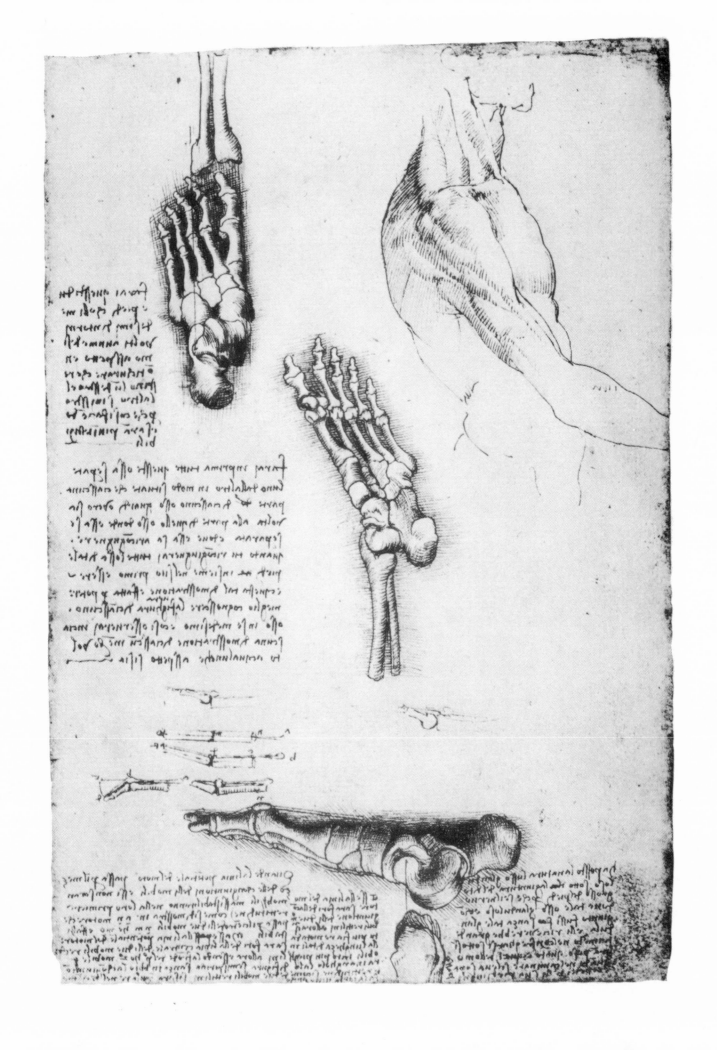

MYOLOGICAL SYSTEM

myology of trunk

fig 1. **Surface features of the muscles of the back.**

Although the figure is possibly of greater interest to the artist than to the biologist, it is included here to provide an illustration of Leonardo's knowledge of the superficial muscles of the back. It will be observed that the contour of the lower portion of the trapezius muscle is clearly shown. Yet in all the dissection figures Leonardo omits this part of the muscle. On the other hand, the drawing shows exaggerations undoubtedly derived not from the living model but by interpretation of his findings in dissected subjects. It was his intention to include in his anatomy figures illustrating the dynamic action of the body, fully described in his note accompanying 10.

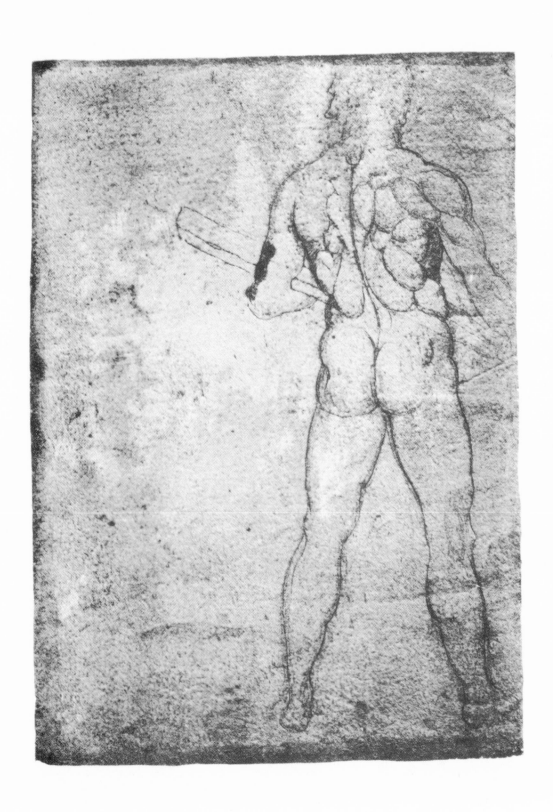

myology of trunk

fig 1. Surface modeling of the muscles of the back and extensor aspect of the upper extremity.

fig 2. Surface modeling of the muscles of the back and upper arm.

Leonardo's figures illustrating the surface modeling produced by the underlying muscles were doubtless intended for the instruction of artists. One would judge that they were not drawn entirely from the living model since they reflect features derived from his method of dissection. Thus we observe the deltoid muscle divided into several distinct elements indicating the artificial divisions which he made with the knife, cf. 47. These exaggerations are frequent in studies of this type. However, Leonardo was aware of the differences in surface contours produced by accumulations of fat and intended to illustrate these differences as indicated in the note below.

The most prominent parts of thin individuals are most prominent in the muscular and likewise in the fat. But the difference which exists in the shape of the muscles of the fat as contrasted with the muscular will be described below.

The remaining notes are memoranda outlining future procedures.

You will make the rule and the measurement of each muscle and give the reason of all their uses, in what manner they work and what moves them, etc.

First make the spine of the back; then clothe it step by step with each of these muscles, one upon the other, and put in the nerves, arteries and veins to each individual muscle; and in addition to this, note to how many vertebrae they are attached, and which intestines are opposite to them and which bones and other organic instruments, etc.

The phrase "organic instruments" is Galenical and had special meaning to mediaeval anatomists, corresponding approximately to present concepts of functional systems. Thus the eye was regarded not only as an organ but when taken together with all structures pertaining to it, constituted the instrument of sight.

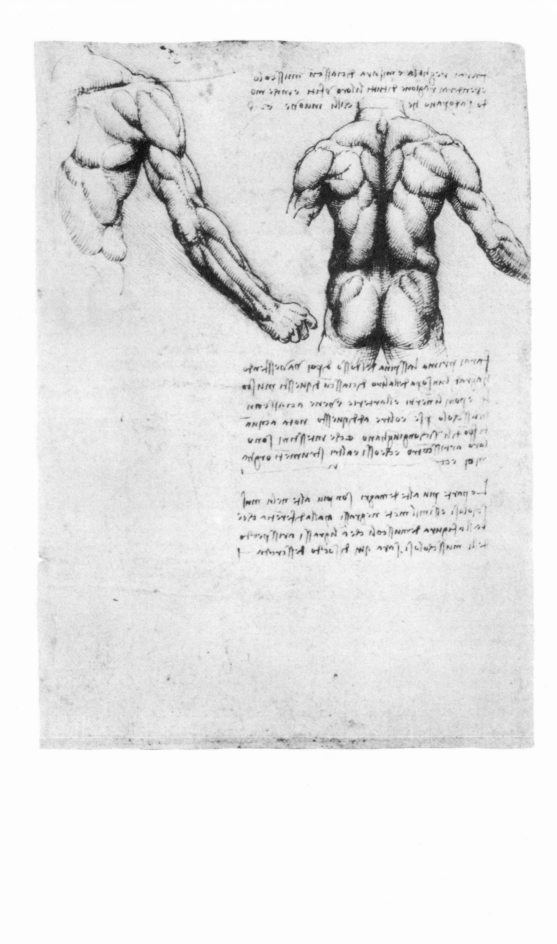

myology of trunk

The figures on this plate should be followed from right to left since, as was Leonardo's custom, they are numbered in this direction and represent successive steps in the same dissection from the more superficial to the deeper structures. Many of the notes, although placed in close relation, do not refer to the figures, but contain general observations. They have, therefore, been rearranged slightly for the convenience of the reader.

At the top of the page and in the margins appear the following general notes.

Commence your anatomy with a man in his prime: then show him old and less muscular; then proceed step by step to strip him down to the bones.

And then do it in the child with a demonstration of the womb.

Describe and sketch the internal muscles of the neck included between the spine and the oesophagus (meri).

Leonardo was greatly interested in the anatomy of the aged and made several illustrations of his findings, cf. 129, 183. Likewise he illustrated the foetus in utero on several occasions. No drawings, if ever made, have survived of the prevertebral muscles. The term *meri* was of Arabic origin and long customary until replaced by *stomachus* and finally by *oesophagus*.

Each muscle moves the member to which it is attached in the line of the fibres of which that muscle is composed.

In all the parts where man has to work with greater effort, nature has made the muscles and cords of greater thickness and width.

fig 1. **The first demonstration of the superficial vertebro-scapular muscles.**

When you have made the muscles which serve the movement of the scapula, elevate the scapula and draw the 3 muscles n m o [serratus posterior superior] which serve only for the use of respiration.

It is curious that Leonardo nearly always represents the trapezius muscle incorrectly. The lower half of the muscle is either omitted or, as in this figure, shown inserting into the vertebral border of the scapula. Since this is the first of five figures designed to show the successive layers of muscles, it is difficult to understand how he could have failed to observe the true insertion of the lower portion of the trapezius when the muscle was reflected. This same error is repeated in the cord diagram below, fig. 7. Numerous errors of this sort suggest that the drawings were not always made directly from the dissection but were, perhaps, outlined at the time and completed from memory. The serratus posterior superior muscle designated n m o, is shown in fig. 3.

fig 2. **The second demonstration of the deep layer of vertebro-scapular muscles.**

First make the sinews which are under the scapula, attached to the ribs, and then place the scapula over them, and represent all the cords.

The posterior belly of the omohyoid, the levator scapulae noted by the letters a b, supraspinatus, infraspinatus and teres minor are well shown. The letter c, marks the base of the scapular spine and the middle of three muscle slips which probably represent rhomboideus minor and major, although the upper most of these is somewhat too high. Covering the inferior angle of the scapula is a muscle which may be a portion of latissimus dorsi or the teres major, but no certain identification can be made.

fig 3. **The third demonstration of the deep muscles of the back.**

The 3 muscles n m o [serratus posterior superior] of the 3rd demonstration elevate and spread the 3 ribs for the benefit of respiration, and especially when man stands stooped, and the 3 ribs draw with them the 4 others below.

The three muscles n m o, placed parallel to the ribs serve to support the ribs with the weight of the shoulder and also the neck when it is bent to the right and to the left.

n m o, are three muscles which pull the cords attached to the vertebrae (spondili) of the neck; and as the vertebrae cannot come towards the muscle, the muscle, together with the rib to which it is attached is elevated towards its vertebra, and this is the cause of the rotation of the chest when one is seated.

Describe how the recurrent nerves (nervi reversivi) serve the 3 muscles n m o.

The 3rd demonstration: the muscles which terminate in the vertebrae are in continuity with those of the 4th demonstration [fig. 4], and this serves the lateral motions of the head, and they are attached to the vertebrae to enable the head to be turned from side to side.

The muscles m n o, are presumably the serratus posterior superior, the digitations of which have been separated. Leonardo regards the muscles as important in respiration but here as elsewhere (17) gives no reason for supposing that they help to stabilize the vertebrae to which they are attached. At times he seems to have confused them with the scalene muscles, hence it is not difficult to understand why he, thought they were supplied by the recurrent nerves, by which is meant the vagi. Other structures clearly indicated are the posterior belly of the omohyoid and the upper trunk of the brachial plexus.

The final note pertaining to the illustration concerns the series of antagonistic muscles acting on the vertebral spines, as will be discussed in the remaining figures.

fig 4. **The fourth demonstration of the deep muscles of the back.**

Each cord attached to the vertebrae has another cord as an opponent which supports that vertebra.

Once again reference is made to the action of antagonistic muscles which are shown attached to the vertebral spines in figs. 3-5. The theme is developed below.

It is quite impossible to identify with any certainty the deep muscles of the back here illustrated. Even Vesalius refers to them as a "chaotic mass". Following the order of Leonardo's dissection it might be hazarded that, from above downwards, semispinalis

(continued on page 490)

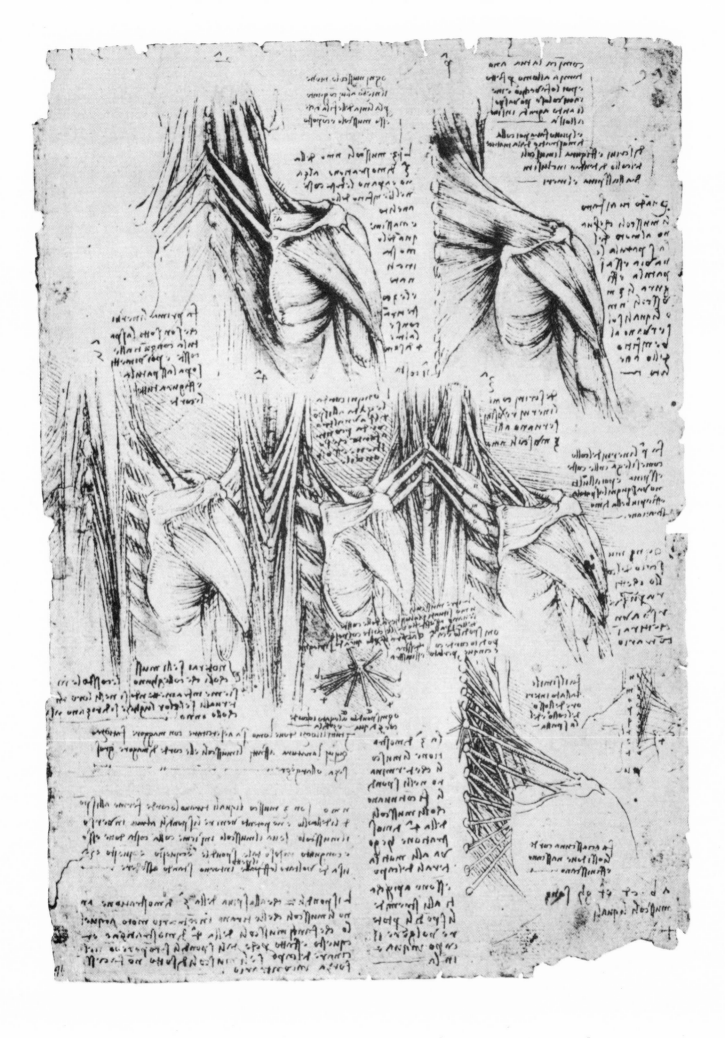

The notes and figures on this page largely supplement and extend the observations made on the function and action of the muscles of the back, found on 16. Leonardo was greatly concerned as to whether these dorsal muscles extending from the cervical vertebrae to the rib were related functionally to the mechanism of respiration or to the stabilization of the cervical spine and thus, indirectly, to the support of the head. He returns to the idea, as illustrated, in 18, that these muscles support the head and neck like "the mast of a ship with its stays", and he provides in figs. 2-3, diagrams showing why he adopts this view. The order of the notes has been rearranged somewhat to maintain the continuity of Leonardo's thought.

OF THE DEMONSTRATION ON HOW THE CERVICAL SPINE IS STABILIZED.

In this demonstration of the neck as many figures of the muscles and cords will be made as are employed in the actions of the neck. And first, as here noted, is how the ribs with their forces maintain the cervical spine upright, and how, by means of the cords which ascend towards the spine, these cords serve a twofold office, that is, they support the spine by means of the ribs and support the ribs by means of the spine. And this duplication of powers, situated at the opposite extremities of such a cord, acts through this cord no differently than a cord acts through the ends of a bow. But such a convergence of muscles on the spine holds it erect just as the ropes of a ship support its mast and the same ropes, tied to the mast, also support in part the framework of the ships to which they are attached.

fig 1. **Diagram of the dorsal muscles of the spine to demonstrate their dual action in support of the spine and in respiration.**

The muscles illustrated are difficult to identify with any certainty since the figure is largely diagrammatic, but by comparing this figure with those of 16, it is probable that the three upper pairs represent serratus posterior superior and the lower group, spinalis thoracis, cf. 16, figs. 3, 5.

All these muscles are to elevate the ribs, and the elevation of the ribs is dilation of the chest, and the dilation of the chest is the expansion of the lung, and the expansion of the lung is the inspiration of the air which enters through the mouth into the increased capacity of the lung.

In addition, these same muscles hold the cervical spine erect when the power of the inferior muscles which arise from the sacrum (alcatin), dominates. When the latter muscles, which terminate on these ribs, come into action, they are qualified to resist and to support the roots of the muscles which hold the neck upright.

Leonardo clearly expresses the opinion that the sacro-spinalis and ilio-costalis muscles act as synergists or fixation muscles in passing from the pelvis to the ribs. By stabilizing the ribs the upper dorsal muscles are provided with a firm foundation from which to act in supporting the neck. The term *alcatin* or

alchatim, of Arabic origin, was variously used to mean the loins or lumbar vertebrae, the sacrum or the pelvis. In Avicenna the term refers to the loins or lumbar structures, but in Mundinus to the sacrum or its hollow.

figs 2-3. **Diagrams comparing the cervical spine and vertebro-costal muscles to the mast and stays of a ship.**

In fig. 2, the last two cervical vertebrae and first thoracic, together with the first ribs extending anteriorly to the sternum, are shown from the posterior aspect: a b, and a c, are a pair of muscles passing from the angle of the rib to the spine of the sixth cervical vertebra, a. a d, is an imaginary line passing on either side from a, to the point of greatest curvature of the rib. The first thoracic vertebra is lettered r.

Fig. 3, is the mast of a ship supported by stays a m, a n, lying almost parallel to the mast, and stays a b, a c, set at an angle of approximately 55 degrees to the base.

ON THE MUSCLES ESTABLISHED FROM THE RIBS AS DRAWN ABOVE.

I have long wondered, and not without reason, whether the muscles [serratus posterior superior] *which are established under the scapula above the 3rd, 4th and 5th ribs on the right, and also on the left side, are made for the purpose of holding erect the cervical spine to which they are attached by their cords, or whether these muscles on shortening are drawn together with the ribs towards the nape of the neck by means of the aforementioned sinews attached to the said portion of the spine. Reason moves me to believe that these muscles are the stays of the spine so that it is not bent in having to support the heavy head of man when it is lowered or elevated, for the help of which the muscles of the shoulders or of the clavicles do not serve, seeing that man will relax these muscles arising from the shoulders and clavicles when he raises the shoulders towards the ears and removes the force from his muscles. By this relaxation and shortening the motion of the neck is not lacking and the resistance of the spine for supporting the head is not impeded. I am further convinced in this opinion by the very strong contours possessed by the ribs in the region where these muscles are situated, which is well adapted to resist any weight or force which would pull the cord a b* [in fig. 2] *in the opposite direction. This cord in pulling against* [the portion of] *the rib b r, stabilizes it more strongly at the point r* [first thoracic vertebra], *and if this cord had to elevate the rib for the service and augmentation of respiration, nature would not have placed the cord at the obliquity a b, but at the greater obliquity a c* [for a d; the line extending to the point of maximum curvature of the rib]. *Read the propositions placed below* [the figures] *in the margin which are concerned with this matter, etc.*

The "proposition" and its corollary placed in the margin beneath figs. 2-3, read from right to left as follows:

The cords with greater ease prevent the fall of the

(continued on page 490)

myology of trunk

The series of diagrams on this page are concerned with the supposed action of the muscles in stabilizing the vertebral column to permit the various movements of the head. This is expressed in Leonardo's note at the head of the page.

You will first make the cervical spine, without the skull, with its cords like the mast of a ship with its stays; then make the skull with its cords which give it its motion upon its axis.

The ideas here illustrated are more fully developed in 16, to which this plate is complementary although of earlier origin. The second note at the top, right-hand corner of the page reads: *Each vertebra of the neck has ten muscles attached to it.* The identical statement is found in 16, where the five pairs of muscles are illustrated. On the bottom, left-hand corner occurs the following: *O speculator on this machine of ours, let it not distress you that you give knowledge of it through another's death, but rejoice that our Creator has placed the intellect on such a superb instrument.*

fig 1. **Diagram of a vertebra and attached tendon.**

This small diagram crudely represents a vertebra with four tendons attached to its spine. It is intended to illustrate the notion that each vertebra is stabilized by the interaction of contra-lateral muscles. This view is further expressed in fig. 4.

fig 2. **Small, rough sketch of skull and upper spinal column from behind.**

fig 3. **Small, rough sketch of skull and upper spinal column: antero-lateral aspect.**

fig 4. **Cord diagram of tendons attached to a vertebral spine.**

n, is a vertebra of the neck to which is attached the origin of 3 muscles, that is, of 3 pairs of muscles which are in opposition to one another so that the bone whence they arise may not be broken asunder.

Leonardo shows four, not three, pairs of muscles attached to the vertebra. Elsewhere, as in his note at the top of the page, he states that there are five pairs or ten in all. He believes that a series of antagonistic muscles is necessary to prevent displacement of the vertebra in the various movements of the head and neck. The tendon with the bulbous extremity representing the muscle belly is undoubtedly his favorite muscle, the serratus posterior superior, as may be gathered by comparison with the illustration of 16.

fig 5. **Cord diagram of the muscles of the head and neck.**

a b [approximately semispinalis capitis] *are muscles holding the skull upright, and so do those c b* [sternomastoid] *which arise from the clavicle* [and are] *joined to the mastoid (pettine) by means of longitudinal muscles.*

In the 2nd demonstration delineate which and how many nerves there are giving sensation and motion to the muscles of the neck.

Written on the left scapula: *Width . . . at the shoulders.* In this rough figure the muscles are represented by cords or "linen threads" and, therefore, only approximate. However, on comparison with 16, the upper portion of trapezius, semispinalis capitis and sternomastoid muscles are intended. The idea of a mast supported by shrouds upon which the head moves is suggested. The figure is very crude. It will be observed that the scapula possesses no spine or acromion, the ribs are attached to the eleventh vertebra, and the sternum is represented by seven segments. Although the figure is obviously diagrammatic and drawn to show the supposed action of muscles rather than bones, nonetheless some of the errors are of a traditional nature and indicate how powerful was this tradition in the absence of the osteological specimens themselves. When drawing from memory, as in this figure, Leonardo frequently makes errors of this kind reflecting, in comparison with other figures, the difference between what he saw and what he read.

The term *pettine* is used elsewhere with the meaning "pubis" or "pelvis", but here obviously the mastoid process is intended. Vangensten, Fonahn and Hopstock (1911), MacCurdy (1939), and other editors render this passage incorrectly. Of course *pettine* may be a *lapsus calami* for *poppa*, the nipple.

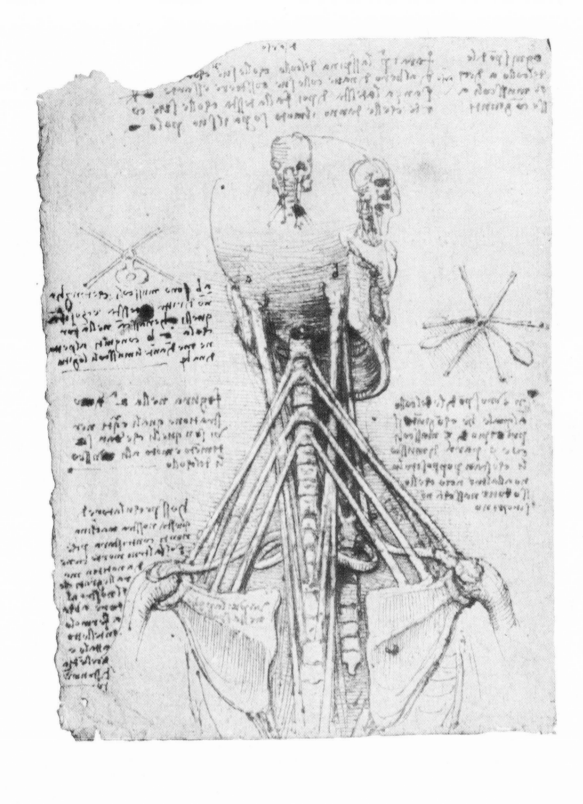

The widely spaced writing of the notes accompanying the figures is also found in 21, 22, and 23, which suggests that the illustrations belong to one and the same series which is confirmed by the fact that all deal with the superficial muscles of the trunk. The style is that of a late period, c.1506.

fig 1. Superficial muscles of the trunk: lateral aspect.

The latissimus dorsi muscle is indicated by the word *superior*, i.e., above or superficial to the serratus anterior, the digitations of which are lettered n, m, o, p, q. On the upper portion of the external oblique muscle is the letter a, and the lower portion of the same muscle is indicated by the letter b, concealed in shadow. The accompanying note apparently describes the attachments of the external oblique and especially the distribution of its fleshy portion, but the attachments are incorrectly given owing to a failure to define the posterior border of the muscle. The note reads:

The muscle a b [external oblique] *has a fleshy termination under the arm, in its upper and lateral part or inferiorly, in the flank, behind, in* [the region of] *the bone of the spine, and in front, longitudinally with the middle of the body* [as seen from the lateral aspect, cf. figure]. *Behind, it terminates in the vertebrae of the spine.*

The serratus anterior muscle and its interdigitation with the external oblique of the abdomen is described as follows:

The muscles n m o p q [serratus anterior] *are placed upon the ribs, and with their angles they are blended into a short, thick cartilage* [costal cartilage] *and are united with the ribs. Where they are placed other muscles immediately arise, that is to say, a m n* [upper portion of external oblique] *and that which is shown appears when the skin has been removed.*

fig 2. Sketch to show the intercostal muscles after reflection of a portion of the external oblique.

Careful study of the figure and Leonardo's note suggest that the external intercostal muscles of the lower four spaces have been revealed by removal of the costal origin of the external oblique.

a b c [external intercostals] *is covered by the mus-*

cle a [external oblique] *above in the 2nd demonstration.*

figs 3-4. Outlines probably of the rectus abdominis seen in profile as originally drawn and as corrected.

The note reads: *a b c, is the concavity of the old muscle.*
 c d f, is the new.

These outlines should be compared with that of the rectus abdominis as seen in fig. 1. It will be observed that the figure has been corrected to follow the second of these two diagrams. Two additional notes of a general nature are included. The first refers to the aponeuroses and tendons of the muscles on the lateral aspect of the trunk and to the longitudinal muscles of the anterior aspect.

All the muscles which arise from the body are converted into membranes (panicholi), which membranes are in continuity with the opposite muscle passing over the lower venter [abdomen], *as are the transverse and oblique muscles. But the longitudinal or straight muscles* [rectus abdominis] *are fleshy from the height of the xiphoid process (pomo granato) to the pubis (pettine). The muscle of the breasts* [pectoralis major] *which arises from the entire middle of the thorax and terminates in the bone of the shoulder, when it has passed some distance under the breasts, is transformed into membrane and* [this membrane] *clothes all the body.*

It was a commonplace for the mediaeval anatomists to divide the trunk into an upper venter, the thorax, and a lower venter, the abdomen. Such a division, introduced by Mundinus, had practical importance. In an age when preservatives were unknown, the "order of an anatomy" was to attack the lower venter and its most corruptible organs first, followed by the upper venter and then the brain in a three day session. For the curious origin of the term *pomo granato*, meaning xiphoid process, cf. 23.

The second general note deals with a favorite subject of Leonardo, namely the arrangement and disposition of the subcutaneous fat.

Note how the flesh increases upon the bones as one grows fat and how it diminishes as one becomes lean, and what shape it assumes, and what [. . .]

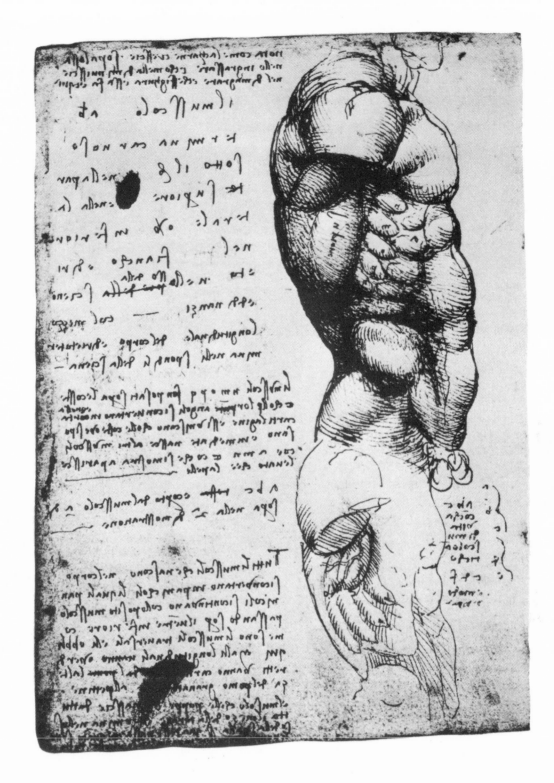

20 myology of trunk

The figures on this page should be followed from right to left and are so numbered.

fig 1. **Superficial muscles of the shoulder, trunk and leg: lateral aspect.**

Although depicting the superficial muscles of the greater part of the body, the accompanying notes chiefly concern the anatomy of the thigh. It will be observed that the trapezius muscle has been removed in the upper extremity. In the abdomen the external oblique muscle is shown interdigitating with the serratus anterior and is labeled by the letter m, placed in the lower right quadrant to indicate the bulge which Leonardo says is produced by the caecum on the right and the colon on the left. In the thigh several structures are indicated by letters as follows: n, the greater trochanter called *ascia*, a term possibly from the mediaeval *scia* meaning the acetabulum and sometimes, the hip; r, the upper end of sartorius; a, tensor fasciae latae; b and c, gluteus medius shown as two muscles; d (like the numeral 4), gluteus maximus; e (like the letter D), vastus lateralis; h, a portion of the ilio-tibial tract. It is difficult to explain the inaccuracies of representation of the muscles of the gluteal region. The notes on the illustration read as follows:

The point n [greater trochanter] is always found in the well-proportioned to lie opposite the fork of the thighs.

The bulging of the flank at m [iliac region] is of skin and thin flesh but is made to project by the colon on the left and by the caecum (monoculo) on the right.

The term caecum (Greek Τυφλο'ν) means blind gut, a term which the Arabs found inappropriate and, since it had an opening, renamed the one-eyed gut (*al-a'war*) which the translators rendered with the word *monoculum*.

There are as many layers (panniculi) which, one upon the other, invest the bony joints as there are muscles which join together at the end of each bone.

This statement is repeated in the note accompanying fig. 2, of 61 where the meaning is more clearly expressed.

There are four muscles which descend from the haunch (anca) m, and which end at the trochanter (ascia) n; they are the muscles a [tensor fasciae latae], b [anterior portion, gluteus medius], c [posterior portion gluteus medius], d [gluteus maximus]; the muscle e [vastus lateralis] arises at the trochanter n, and is attached to the entire length of the bone of the thigh.

Suddenly as though overcome by the complexity of the body and the wonder of its construction, Leonardo interjects in the middle of his discussion the remark: *He who finds it too much, let him shorten it; he who finds it too little, add to it; he for whom it is sufficient, let him praise the first builder of such a machine.*

Leonardo then continues with his anatomical notes: *h [region anterior to ilio-tibial tract] is attached to the skin to a greater degree than e [vastus lateralis and ilio-tibial tract] or any other part.*

There should be five views of this figure; that is, anterior, posterior, lateral, and one which contains a lateral view and the back [i.e., postero-lateral] and one

which contains a lateral and the chest [i.e., antero-lateral].

When the two muscles a [tensor fasciae latae] and r [sartorius] pull, the leg is carried forwards and the 2 muscles b c [gluteus medius] are relaxed and d [gluteus maximus] is elongated; and describe this rule on the action of all the muscles and you will be able to reconstruct, without seeing the living, almost all the actions without error.

To the left of the upper portion of fig. 1, appear a series of small sketches surrounded by text, which were intended as a series on the structure of individual muscles. The series is introduced by the following statement: *Describe each muscle by itself, its shape, the regions where it terminates, and its substance; and see that this is not lacking and carry it out like those I have displayed below [figs. 3-8].*

figs 2-3. **Sketches of the tensor fasciae latae muscle: anterior and posterior aspects.**

a b [in fig. 2] is a thin, broad cord, and in its upper part it ends with the bone of the flank [innominate].

b c, is a fleshy muscle, and it is round outwardly and obtusely angular internally in this way [fig. 3], and its filaments run together at the termination and origin of this muscle.

c d, is a rounded cord; it arises from the lower end of the muscle and terminates in the fascia which binds the knee.

figs 4-6. **Three small sketches illustrating a muscle receiving its nerve and vascular supply, the nerve plexus of a muscle dissected out, and the vascular tree of a muscle.**

With reference to fig. 4, Leonardo identifies the various parts both functionally and anatomically following Galenical tradition.

o, the sensibility; nerve.
m, the force; cord.
S, the nutriment; vein.
t, the spirit; artery.
c, the movement; muscle.

Other structures lettered but not mentioned are h, a branch of the nerve, and k, branches of the vessels. Above these figures he writes: *The nerve always enters the muscle at its thickest part and directs its ramifications towards the cord which arises from this muscle.* The note expresses the then current belief, derived from the Greeks, that the nerve eventually became the tendon so that both were called *nervi*. This idea survives in the modern term aponeurosis.

Below the figures is the reminder: *Sketch first the shape of the muscle with its cords, then show in this muscle [as in fig. 4] the position of the arteries, cords [i.e., nerves] and veins, and finally speak of its necessary government.*

And first make [as in figs. 5-6] the tree of these nerves, veins and arteries.

figs 7-8. **Two sketches of the tensor fasciae latae muscle: posterior aspect.**

It was intended that these figures supplement or replace fig. 3. In the first, the "obtusely angular" shape

(continued on page 491)

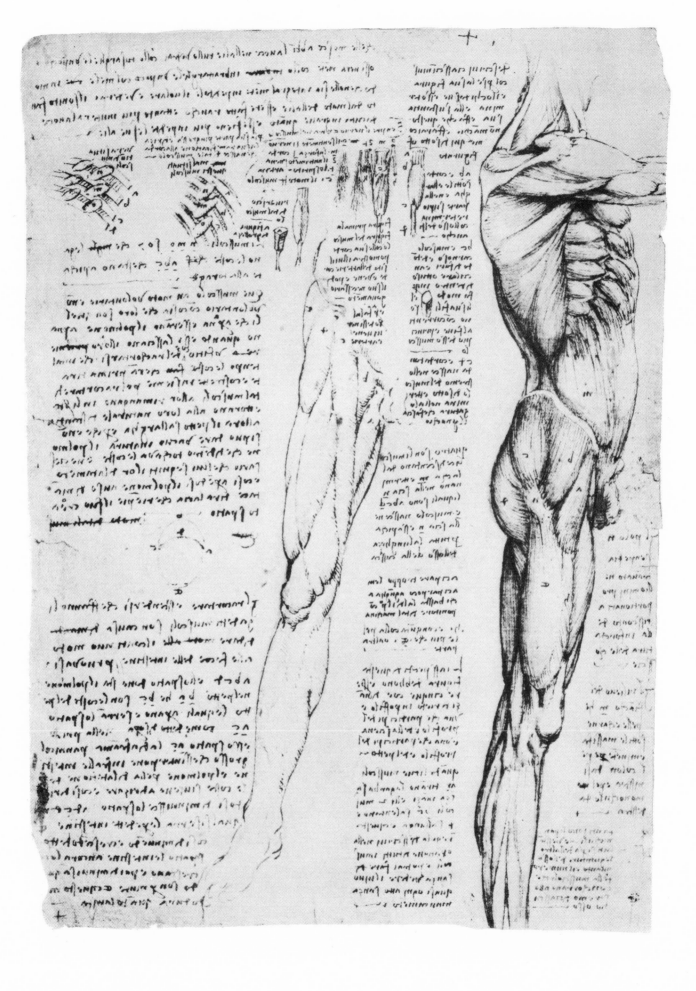

The widely spread writing appears on 19, 22, 23, indicating that these several drawings were executed about the same time, c.1506. It is also evident from the arrangement of the page that the notes in smaller hand were added later. Since these later notes do not refer directly to the figures but are concerned with the general subject of respiration, they have been placed at the end.

fig 1. **The pectoralis minor and external intercostal muscles.**

The pectoralis minor is indicated by the letter b, and its insertion, by n. The purpose of the illustration is to show the function of this muscle as an accessory muscle of respiration. *b* [pectoralis minor] *terminates above at the beginning of the humerus and is the support of the ribs and of the thorax of the chest.*

fig 2. **Superficial muscles of the anterior abdominal wall and thorax.**

The pectoralis major muscle is identified by the letters a c d. Pectoralis minor, indicated by b, and the dotted lines, is carried too low. In fig. 1, the origin of this muscle is correctly shown. What appears to be the external oblique is, as may be gathered from the note, either the deep fascia or possibly the tendon of the oblique. So erroneous are the details as to suggest once again that the drawing was made from memory and not from a dissection. For the curious use of the term *pome granato* below, to mean xiphoid process, cf. 23.

The muscle a [pectoralis major] *supports the breast and descends fleshy as far as the 7th rib, at the side of the xiphoid process (pome granato). Then having been converted into membrane, it proceeds to cover the entire lower venter* [abdomen] *and terminates by uniting with the pubic bone (pettine). This muscle of the breast is composed of several muscles* [fasciculi] *all of which arise over the entire thorax and run together and terminate in the part* [of the muscles, incompletely erased] *of the humerus.*

a d c [pectoralis major] *terminates in the bone of the shoulder and arises in the middle of the thorax. Below, it does not extend to cover b* [pectoralis minor], *marked above* [in fig. 2], *except by its cartilage* [tendon] *with which it covers the entire lower venter and terminates in the flank and in the pubic bone.*

Leonardo did not fully appreciate the action of extrinsic muscles of the thorax as accessory muscles of respiration. His difficulties are evident in the accompanying note. *On the maximum elevation and depression of the shoulders which interfere with the motion of the ribs.*

Because the maximum elevation and depression of the shoulders by means of the muscles of the neck, which are stabilized in the vertebrae of the spine, when the shoulders are raised, impedes the movement of the ribs in their descent, and when the shoulders are depressed, impedes the movement of elevation of the ribs. Nature for this reason has provided the muscles of the diaphragm which depress this diaphragm at its concave middle. The elevation [of the diaphragm] *arises from the air compressed and contained in the intestines—air which arises from the dessication of the faeces which give off vapors. When the elevated shoulders pull up the ribs by means of the muscle b* [pectoralis minor in fig. 1], *then the diaphragm by simply moving through the medium of its muscles performs the office of opening the lung. The compressed intestines with the condensed air which is generated in them, thrust the diaphragm upwards; which diaphragm compresses the lung and expresses the air.*

Leonardo's plan for the representation of the muscles of respiration is contained in his memorandum: *The demonstration of the rib cage requires first merely the ribs, bare, with spaces open; then the* [intercostal] *muscles which are joined to their borders and by which they are connected together; then the muscles* [serratus anterior, etc.] *which are imbricated upon them, serving the movements of expansion and contraction of these ribs; in addition, the other muscles interwoven upon the aforesaid muscles at different angles; serving for various movements.*

myology of trunk

These figures are part of a series which includes 19, 21, 23.

fig 1. **Muscles of the abdominal wall: external oblique muscle.**

The external oblique muscle is indicated by the word *superior*, i.e., the superficial muscle. Leonardo occasionally refers to the muscle as the oblique, a term which had long been in use. Below the figure, the origin of the external oblique is given by the words, *Arises in the spine*, an error which is repeated elsewhere. The muscle is described in the note as follows:

The first muscle [external oblique] *of the lower venter* [abdomen] *arises in its superior part from the 6th rib of the chest and terminates towards the arm, in the manner of a saw, in the muscles* [serratus anterior] *which arise upon the ribs. Having been converted into cartilage* [i.e., tendon], *it terminates below in the bone of the flank* [ilium] *as far as the pubis (pettine).*

For the significance of the term lower venter, cf. 19.

fig 2. **Muscles of the abdominal wall: internal oblique muscle.**

The internal oblique is indicated by the letters n m. However, it should be recognized that Leonardo did not always distinguish the internal oblique from the transversus abdominis but evidently took them to be one; an error not difficult to understand since the fasciculi of the lower portion of the internal oblique are transverse and parallel to those of the underlying muscle. He usually calls the double muscle, the transverse lying on the peritoneum, as mentioned in the caption placed below the figure. *It terminates upon the sifac* [peritoneum]. The term sifac, of Arabic origin, meant "membrane" and although commonly signified the peritoneum as in Mundinus, it was occasionally applied to other membranes such as the dura mater, the pericardium and periosteum.

The accompanying note to the above figure reads: *The muscle n m* [external oblique] *is the inferior* [i.e., deep] *transverse which arises in the vertebrae, behind the umbilicus, passes through the soft parts of the flank and terminates in the penultimate false rib. It is converted into cartilage* [i.e., tendon] *upon the longitudinal muscles* [rectus abdominis]. *It goes fleshy as far as the mons veneris (pettigone).*

These figures are part of the series 19, 21, 22.

At the top of the page is a general note on the fascial sheaths of muscles and on the formation of aponeuroses and tendons. The note appears to have been added later. *All the muscles of the body are ensheathed by a very thin cartilage* [i.e., membrane], *and then they become converted into thicker cartilage* [i.e., tendon], *and in that their substance terminates.*

fig 1. The muscles of the abdominal wall: transversus and rectus abdominis muscles.

The transverse abdominal muscles are indicated by the letters a b, and described in the note. *a b* [transversi abdominales] *are the final latitudinal muscles; the membranes* [aponeuroses] *into which they are converted pass at right angles under the longitudinal muscles a m* [recti abdominales].

The function of the transverse muscles is described thus: *The transverse muscles squeeze the intestines, but not the longitudinal, because if it were so, man when he stands bent and relaxes these muscles, would not have the power to perform the office of squeezing* [the intestines]. *However, the transverse* [muscles] *never relax when man flexes himself but rather they are stretched.*

The recti abdominalis muscles are well shown and their tenuous inscriptions accurately placed.

The muscles n r S h [rectus abdominalis] *are 4, and they have 5 cords and were not made of a single piece like the others so that each would be shorter; for where there is vitality with thickness there is strength, and where there is so great a range of movement there it is necessary to divide the mover into several parts. Its greater extension exceeds the lesser extension by the third part of one of his arms and by as much more as he makes a greater hollow in the arch of his spine, as is seen to occur in those contortionists who bend themselves so far backwards that they join their hands with their feet. This excess* [of movement] *arises from the greater proximity of their feet to their hands.*

These muscles are made in two rows, that is, right and left, from the necessity of bending to the right and left.

fig 2. The muscles of the abdominal wall: posterior sheath of the rectus and aponeurosis of the transversus and internal oblique muscles.

a b [posterior sheath of rectus abdominis] *is entirely cartilage* [i.e., tendon] *which confines the sifac* [peritoneum] *and arises from the fleshy muscles c d* [transversi abdominales]. *These muscles enter under the ribs and are the latitudinal muscles. They arise from the bone of the spine and it is these alone which squeeze the superfluities out of the body.*

Upon the membrane a b, descend the longitudinal muscles n m [recti abdominales] *mentioned above* [fig. 1], *which arise from the last* [true] *ribs at the side of the xiphoid process* (pome granato) *and end below in the pubis.*

The transverse muscles c d, are those which on contraction, constrict and elevate the intestines, and push the diaphragm upwards and drive the air from the lung; afterwards, on relaxation of these muscles, the bowels descend, draw down the diaphragm and the lung opens.

For origin of *sifac*, cf. 22. The term *pome granato* for xiphoid process has been shown by P. de Koning (1903) to have resulted from an error of the translator of Avicenna. The Arabic word for xiphoid was *khanjara* which means sword-like and thus the exact equivalent of the Greek xiphoeides. However, the first letter, *kh*, can only be distinguished from *h* by a diacritic dot so that the translator, Gerard of Cremona, apparently read *hanjara* which means larynx. This was rendered in the Latin Avicenna as *cartilago epiglottalis*, the term applied not to the epiglottis but to the larynx. The common synonym at this time for epiglottis was *pomum granatum*, thus transferred to the xiphoid.

fig 1. **The transversus abdominis muscle.**

The transverse muscles a b c d, are those which cause the compression of the intestines; and the proof of this is that when the intestines are compressed by this cause, the angles of the soft flesh n m, are [?made evident].

fig 2. **Diagram of the action of the external oblique (or possibly recti) and sacrospinales muscles in flexion and extension.**

Of the four longitudinal muscles, the upper and lower attachments are of equal height and depth, but the posterior ones [sacrospinales] are stronger because it requires greater exertion to straighten the body from the side where it bends more [flexion] than where it bends less [extension]; and because it bends little backwards, the anterior muscles experience little exertion in straightening it, which does not happen when it bends forwards.

This and the final figure of the series showing the crossing of the oblique, or possibly recti, muscles are undoubtedly derived from traditional sources. Almost identical figures are to be found in Pietro d'Abano's *Conciliator differentiarum philosophorum et praecipue medicorum*, Venice, 1496, obtained from a later interpretation of the statements of Mundinus. The crossing of these muscles is also shown where they evidently represent the recti abdominales confused with the obliques. We may, therefore, conclude that these figures are an early example of Leonardo's work. Clark dates the drawing c.1505 which is probably a trifle too late since other drawings of around this period show the oblique and recti muscles correctly.

fig 3. **The sacrospinales muscles.**

fig 4. **The external oblique, or possibly recti abdominales muscles.**

Like fig. 2, further diagrams of the presumed action of these muscles in flexion and extension of the body.

It follows that the proper motion of each of the two longitudinal muscles [recti or oblique] placed anteriorly in the body of man is to make the body move in an oblique motion; that is, when the anterior longitudinal muscle [a, in fig. 4] having arisen at b, on the right side and ending at c, on the left side, does its work, then the right shoulder inclines towards the left thigh and thus makes an oblique motion like the obliquity of its mover b c. Then the posterior longitudinal muscle [sacrospinalis in fig. 3] having arisen from ninth vertebra of the back [T.IX] on the right side and terminating in the right flank, comes to be stretched, and the left [muscle] shortens itself, because the obliquity is made straight. Hence the two anterior and posterior muscles serve the oblique inclination of man and its counteraction. When one shortens, the other lengthens, etc.

It follows that when the said muscles employ their force equally then the movement of man is equal flexion. This movement will be equidistant from the right and from the left, and the shoulders will be equidistant from the ground. This is proved in the 4th [book] which says that the motions (and the motions of its mover) will be equal which are performed in equal time.

At the head of the page Leonardo has penned a dictum reading: *Every muscle uses its force in the line of its length.*

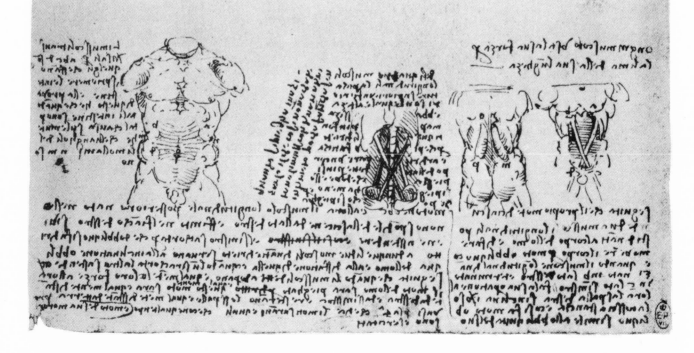

The figures and notes on this page deal for the most part with the mechanics of respiration and appear to be preliminary studies leading to the ideas expressed on 27, 32, on the relative parts played by the intercostal muscles and the diaphragm.

fig 1. **The costal cartilages of the lower ribs.**

The costal cartilages of the eighth to the tenth ribs are shown united for their common attachment at a. The cartilages of the eleventh and twelfth ribs are indicated as free by the letter n. The accompanying note appears to have been deleted by the oblique line running through it.

The connection (introito) which the lower end of the ribs, converted into cartilage, make one below the other, like a piece of rope, occurs only to make them resistant and solid, and gliding and slippery [for] the friction of the skin upon the curved ends of the ribs in the increase and decrease which the ribs make under the skin.

figs 2-6. **Outline of articulated ribs, of thorax (incomplete) and a series of geometrical figures.**

The precise significance of these rough figures is unknown but may be associated with the related note in which Leonardo perceives that the elevation of a rib will tend to raise those below and that the lower ribs have successively more motion than the upper. This note has, likewise, been deleted by an oblique line.

The lower ribs have more motion upwards than the upper, because when each amount of the muscles interposed between the ribs performs its office of contraction and shortening, the lowest rib is moved to a greater extent by these muscles than the uppermost. The reason for this is that if the first rib moves one degree towards the second through the shortening of one degree made between these muscles, the 2nd will move 2 degrees and the 3rd, 3, and so forth to the lowest rib as many degrees as there are muscular spaces which are interposed between the lowest and the uppermost ribs. And this motion is understood even if the uppermost rib remains immobile.

fig 7. **Diagram of the thorax to demonstrate lateral expansion of the ribs.**

The lateral curvature of the rib cage is indicated by the letters a b c, either side and from above downwards. The anterior extremities of the ribs correspond to a line extending from d (like the number 4) to c. The accompanying note explains the increase in lateral diameter which occurs on elevation by the term "curved obliquity", obviously having reference to the "basket-handle" motion of the ribs. The note has also been deleted by a double line, suggesting that like the others it had been transcribed elsewhere.

There are four things which have to be considered in the motion of the ribs. Of these, one is the elevation of the ribs through the curved obliquity a b c—note this definition of curved obliquity. The second is the expansion of the ribs which are removed from the sternum (toracie) owing to the bending of the cartilages which in the form of a supplement to the ribs are interposed between the ribs and the sternum; third, the experiments performed with a bladder which is full of air and that [air] which ordinarily is received by the lung. Fourth, which ribs possess more movement, the lower or the upper.

The use of the term thorax (toracie) for sternum should be observed. This is the classical meaning of thorax, i.e., breastplate, hence sternum, but by the process of synecdoche, the part came to be applied to the whole, especially among medical authors.

figs 8-9. **The internal and external intercostal muscles sketched probably from the ox.**

The figure on the left also shows the distribution of some of the intercostal nerves. The note is a continuation of that on the right. See below.

figs 10-11. **The internal and external intercostal muscles of man.**

The oblique lines n m, and o p, demonstrate the obliquity of the muscle fibres and show that the two obliques lie at right angles to one another. These illustrations appear to be earlier versions of the more finished figures of 26. The floating ribs are lettered S. The notes are concerned with the strength of inspiration.

The chest is very powerful in its expansion and contraction by the inspiration of air into it, and it is such that if the chest is placed on the floor with a man standing on the back, this inhalation when air is drawn into the chest, will raise the man by the force of the inspired air.

A further note proposes an experiment to determine the relative role of the diaphragm in respiration. *And if the chest is prevented from expanding in any direction by a bandage which is not expandable, then observe whether the diaphragm will move up and down and is the cause of respiration or not.*

figs 12-13. **Geometrical figures of unknown significance.**

Only two of the remaining heterogeneous notes have any biological significance. *Take out a bull's liver to make an anatomy.* The second note is of great interest, but we do not know if Leonardo ever constructed the glass model of a heart mentioned here as well as in 110, 113, and *The shape of a glass to see in the glass what the blood does in the heart when it shuts the openings of the heart.*

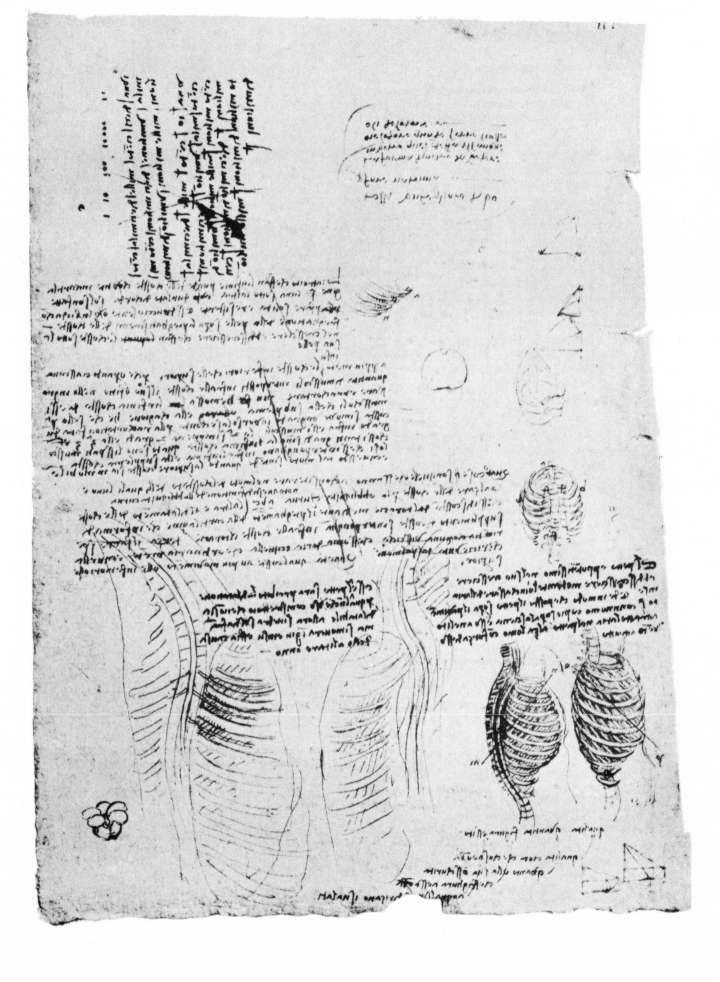

On the office of the mesopleuri [intercostal muscles].

In these three illustrations Leonardo demonstrates the actions of the intercostal and accessory muscles of respiration as assigned by tradition. The use of the term *mesopleuri* for the intercostal muscles indicates a Galenical source. The obliquity of the fibres of the external intercostals is shown as being at right angles to those of the internal intercostals and thus that the action of the muscles is contrary; the external serving to elevate and the internal to depress the ribs. He appreciated the fact that elevation of the ribs increases the antero-posterior diameter of the thorax (27), but was uncertain of the effect on the lateral diameter, 25. As elsewhere, he stresses unduly the importance of the serratus posterior superior muscles for respiration.

fig 1. The muscles of respiration: serratus anterior.

The digitations of the serratus anterior muscle, attached too low, are indicated by the letters c d e f g and the body of the muscle by a b.

To the five muscles c d e f [g] [serratus anterior] *which were created for the dilatation of the chest, we give the name, the dilators.*

fig 2. The muscles of respiration: the external intercostals and serratus posterior superior.

The 3 muscles [o p q in fig. 2] *which pull the ribs upwards, we shall call the pullers* [serratus posterior superior].

fig 3. The muscles of respiration: the internal intercostals.

The intercostals (mesopleuri) are the minute muscles interposed between the ribs, devoted to the dilatation and contraction of these ribs. These two entirely opposed movements are ordained for the collection and expiration of the air in the lung which is enclosed in the rib cage (costato). The dilatation of these ribs arises from the external muscles of the ribs which are placed at the obliquity m n [fig. 2] *and with the aid of the three muscles o p q* [serratus posterior superior], *by drawing the ribs upwards with great force, they increase their capacity in the manner which one sees done in the ventricles of the heart. But the ribs, having to return downwards, would be unable to descend by themselves were man to remain recumbent, if it were not for the internal muscles which have an obliquity opposite to that of the external muscles; an obliquity which extends along the line f n* [in fig. 3].

ON THE POWER OF THE INTERCOSTALS.

The office of the external intercostals is to raise and expand the ribs. They possess extraordinary power from their position, for they are stabilized with their furthest extremities above at the same spine where the unfixed [i.e., moveable] *ribs arise and their obliquity descends towards the umbilicus.*

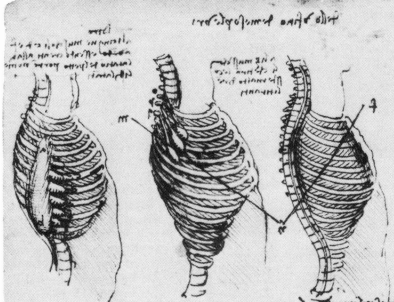

76

The illustrations and notes of this plate are concerned with the problems of leverage on the ribs by the muscles of respiration, especially the insignificant serratus posterior inferior which Leonardo thought to be very important. His opinions on this subject were very uncertain and changed from time to time. The plates 17, 21, 26, 28 should be examined to trace these varying opinions.

fig 1. **The muscles of respiration: serratus posterior superior.**

The upper portion of the thoracic cage is viewed from behind to show the imagined attachments of the serratus posterior superior to the cervical column and upper three ribs. On the right the origin of the muscle is indicated by N, M, D, and the insertion by a, n, m. The upper three ribs are labelled f, g, h. On the left, the muscle slips have been freed from their costal attachment and elevated.

The sinews (nervi) of these muscles [serratus posterior superior] *are branches of the reversive nerves* [vagi, or their recurrent branches].

This curious error is repeated on 17. According to Galen, nerves were believed to enter the muscle and constitute a part of its tendon.

The three sinews feel nothing but the weight of the thorax with its ribs, because the weight of the shoulders and arms is supported by the sinews of the neck on the posterior aspect of the spine.

fig 2. **Diagram of the leverage of serratus posterior superior to illustrate the note below on the mechanism of respiration and the relationship of rib elevation to diaphragmatic action in increasing the thoracic capacity.**

On the muscles which assist in yawning, sighing and dilatation of the lung in all its extreme dilatations.

The extreme dilatation of the lung when one yawns or sighs does not arise from the diaphragm because its power is insufficient to elevate and dilate the ribs united to the thorax. But there are the muscles [serratus posterior superior] *attached to the upper vertebrae of the back by means of very strong cords which are connected between these muscles and the vertebrae of the back. The said muscles are six in number and possess a shape between pisciform and oval. They are stabilized and attached to the furthest six upper ribs. The said six muscles are divided 3 on one side and 3 on the other, that is, 3 on the right and 3 on the left. These muscles on shortening are drawn towards the upper attachment of their cords and carry the ribs, where they are united upwards. They draw*

the thorax with them much more strongly than by their own motion as these muscles are nearer to the attachment of the ribs with the vertebrae than is the thorax according to the second [demonstration, fig. 2] *of the levers placed here in the margin. That is, on the arm b c, the nearer the cord a n, which moves it, is tied to b, than to c, so much the greater will be the motion of c, than of a. Thus as the interval a b, is nearer to b, by one-fourth than c, c, will move four times more than a. Consequently, this dilatation of the lung acquires height by the elevation of the cover which the upper part of these ribs forms for them. And besides this, the diaphragm, which is carried upwards with its anterior sides, comes to separate itself from the stomach and the other intestines, and through this the diaphragm with its middle portion can descend to a lower level and increase the altitudinal interval which exists from the diaphragm to the furthest* [i.e., upper] *ribs.*

The term pisciform used above is discussed in 45, 61.

fig 3. **Diagram illustrating the increase in the antero-posterior diameter produced by elevation of the ribs as described in the accompanying note. The reader should remember that the lettering is reversed, but this should give no difficulty in following the diagram.**

The tendon [of serratus posterior superior] *through the motion of which* [the thorax] *is elevated and enlarged, and thus it is proved. Should the cord r s, move the rib g e, to the height g b, it has elevated itself with* [its arrival at] *b, the entire height n b, and has displaced itself from the* [vertical] *line f d, to the* [vertical] *line a c. Consequently b n, is the height which it* [the rib] *has reached and m b, is the dilatation to which it has enlarged itself. The motion of these 3 cords* [or serratus posterior superior] *can be uniform and it can be unequal. It is uniform when one muscle pulls as much as the other, and unequal when one muscle pulls less than the others. If the motion occurs uniformly, the intervals between the ribs remain equal during their elevation, and if the pulling occurs unequally, the intervals between the ribs will be unequal, etc.*

Leonardo did not finish and was about to go on with an analysis of the actions of the serratus anterior muscles and the diaphragm on the lower portion of the rib cage as indicated by the title which is all that is given.

On the muscles which turn the ribs downwards and restore them to their original position. The reader should therefore turn to 25, 26, and 28, for his views on the action of the respiratory muscles in increasing the lateral diameter of the thorax.

fig I. **The muscles of respiration: serratus anterior and serratus posterior superior.**

The serratus posterior superior muscle is shown as three slips which are believed to elevate·the ribs acting synergistically with the serratus anterior which is called the dilator of the chest. From the accompanying note it is possible that Leonardo meant that the elevator increased the antero-posterior diameter of the thorax and the dilator, the lateral diameter, but his position is very unclear. Certainly he regarded the action of the serratus anterior as being necessary to give fixation to the lower ribs on contraction of the diaphragm. However, his opinions on the action of these muscles changed from time to time, apparently owing to his failure to dissect out the attachments of the muscles. Thus it is obvious here, as in many other drawings, that he knew only the costal digitations of attachment of the serratus anterior muscle which he shows arising by slips from the vertebral column and failed to follow beneath the latissimus dorsi to the vertebral border of the scapula. In 17, 21, 26, and 27, other conflicting views on the action of the respiratory muscles are expressed.

WHAT USE THE MUSCLES OF THE RIBS FULFILL.

The muscles of the ribs attend to the dilatation and

to their elevation. The six lower muscles [serratus anterior] are dedicated to the dilatation. On pulling, they move the flexible cartilages placed at the ends of the ribs. The three upper muscles [serratus posterior superior] are constituted for elevation and these, on pulling, elevate the 3 ribs to which they are attached, drawing with them the other lower ribs whereby they are opened, dilated and acquire capacity. Here it is shown that the dilatation of the lower ribs does not suffice to open the lungs if they are not elevated towards its hump, that is, of the lung. This elevation is effected by the upper muscles. The elevation of all the ribs by these muscles is not sufficient if the ribs are not widened and dilated by the lower muscles. Thus we have discovered what opens and elevates the ribs in respiration and counteracts the power of the pull and contraction which the lateral muscles of the diaphragm exert when the said diaphragm flattens out its hump and increases the space downwards where the lungs enlarge on filling with air, compressing and gradually forcing the food contained in the stomach, making it descend downwards, bit by bit, into the lower intestines successively, etc.

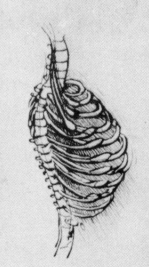

fig 1. **Diagram of diaphragm and abdominal contents.**

Leonardo here contradicts a previous conclusion as to the function of the diaphragm.

Demonstration, how the diaphragm does not assist in the expulsion of the superfluities of the intestines.

Respiration not being prevented at the time when the superfluities of the nourishment are expelled from the intestines.

Leonardo's thinking on this subject is clarified in an unillustrated note (Q IV 5r):

No one can move others if he does not move himself.

If the diaphragm grasped and shut up the intestines between itself and the longitudinal muscles and compressed them, it would follow that the diaphragm would follow the motion of the intestines with its descent. This cannot occur if the diaphragm does not leave a vacuum between itself and the lung. On this you will examine an experiment [as to] what occurs when the lung is restrained by the expulsion of air which is expelled by it [the diaphragm].

myology of trunk

The figures on this plate are largely concerned with the anatomy of the diaphragm from dissection of the ox. The drawings and writing are of a late style, c.1513, and the written notes are almost all upside down.

fig 1. Diagram showing the diaphragm separating the pleural and peritoneal cavities. The anterior wall of the abdomen and thorax is represented as having been turned down en masse.

fig 2. The coverings of the diaphragm.

The legends are written in the usual reversed handwriting but are also upside down, indicating that the figure is to be viewed the other way round. To one side of the figure appear the words, *Coverings of the diaphragm.* The central, vertically placed structure is a segment of the *diaphragm*, so labelled, tapering from its muscular to its tendinous portion. The structure extending to the right, when the figure is viewed in the conventional manner, represents the pleural reflection upon the upper surface of the diaphragm and is labelled with the words, *Clothes all the ribs within.* On the left are two layers seen passing to the lower surface of the diaphragm. The more superficial is indicated by the word *sifac*, that is, the usual mediaeval term for the peritoneum derived from Arabic sources. The deeper layer is called the *vestment of diaphragm* and doubtless represents the phrenic fascia.

fig 3. The deep muscles of the back in the ox.

The longissimus dorsi muscle of the ox is shown on either side labelled a b c (letters upside down). The note reads: *a b c, is a compound muscle.* At the upper end of longissimus, the spinalis dorsi muscle is clearly distinguishable as it is to be found in the ox.

fig 4. The posterior aspect of the anterior thoracic wall.

This illustration also seems to be based on the dissection of the thorax in the ox. The vertical structure outlined on the left is the sternum receiving the attachment of the costal cartilages and ribs. The wavy outline appears to be the attachment of the digitations of the transversus thoracis muscle, indicated by n (letter upside down). We suspect that Leonardo regarded this muscle as an upward extension of the diaphragm. Excision of the transversus thoracis reveals the internal thoracic vessels (internal mammary of

human anatomy), labelled a. Laterally at b, is, judging from Leonardo's description, the pericardiacophrenic artery.

a [internal thoracic artery] *is a vessel (vena) conducted between the muscles of the diaphragm* [transversus thoracis] *and the middle of this diaphragm. n* [transversus thoracis] *is a muscle. b* [pericardiacophrenic] *is a vessel conducted outside the muscles of this diaphragm.*

fig 5. A series of objects (?floats) apparently used in experiments on the flow of water. Leonardo's legend reads: Objects carried by the course of the water between the surface and its depth.

fig 6. Posterior wall of interior of thorax to show costal attachment of diaphragm.

Above the figure is the word ox. Below is a note on the diaphragm.

The diaphragm is a thick and sinewy (nervosa) pannicle which is surrounded by muscles, its extensors. And such a diaphragm, together with the muscles, is covered by a dense membrane composed of very thin ones [cf. fig. 2, above]. *Without, it is clothed by a hard membrane* [pleura], *the covering of the diaphragm and ribs.*

figs 8-10. Details of the costal slips of attachment of the diaphragm.

The accompanying note is similar to that found on 175. Leonardo believed that the diaphragm could not act except by "compound motion", which is to say that expansion and elevation of the ribs giving attachment to the diaphragm is a necessary accompaniment.

HOW THE TENSION OF THE DIAPHRAGM IS EFFECTED BY COMPOUND MOTION.

The tension of the diaphragm is effected by compound motion inasmuch as at the time when the surrounding muscles stretch it, the ribs to which such muscles are united expand themselves.

figs 11-12. Rough sketches of the thorax and diaphragm apparently designed to illustrate the chest in inspiration and expiration.

The remaining notes concern the flow of water and are not pertinent to the illustrations.

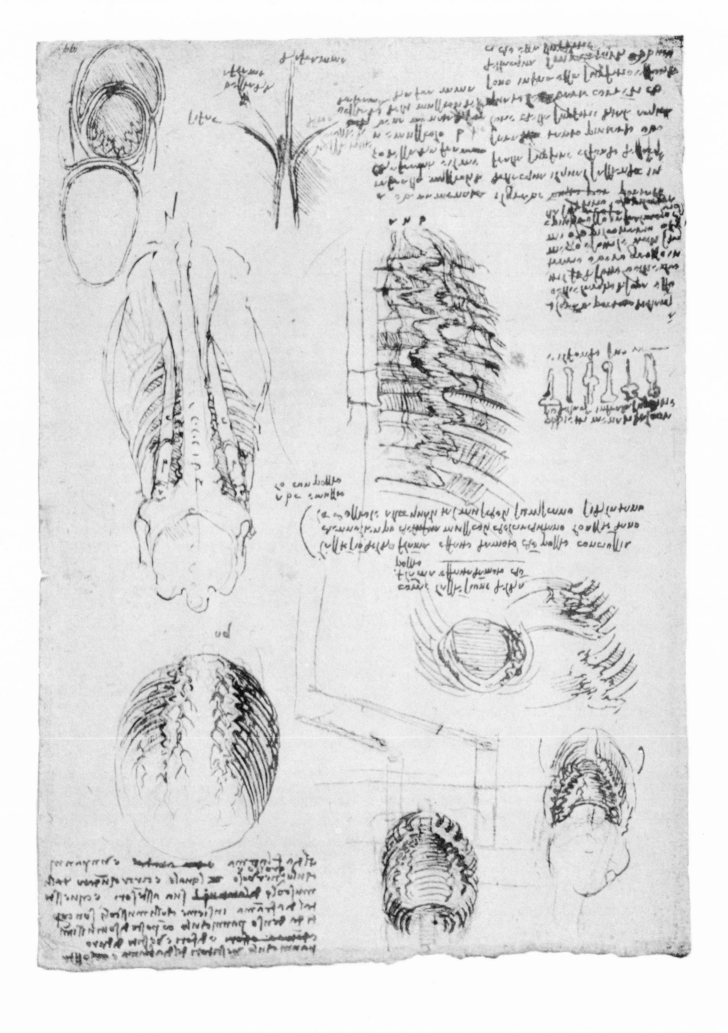

The plate is devoted to the anatomy of the diaphragm and is very similar in both subject and style to 30, and therefore a late production, c.1513. The sepia notes have been carefully inked over, letter by letter. Clark suggests that Leonardo feared that the faint ink would fade with time, which is perhaps evidence of his intention that the notes be read by posterity.

fig 1. **Diagram of diaphragmatic coverings.**

The figure is closely related to fig. 2 of 30. Of the four layers shown, the first or uppermost is the pleura reflected from the diaphragm to the rib cage and here labelled *internal membrane*. The second is the *diaphragm* itself and so called. The third is called the *middle membrane* and represents the phrenic fascia. The fourth and lowermost, designated the *external membrane outside the lung cage*, is the peritoneum.

The notes above the figure are unrelated and describe the appearances of smoke as seen in landscapes.

fig 2. **Diagram of the diaphragm, pleural and peritoneal cavities.**

The figure is similar to fig. 1 of 30. The parts are labelled *Receptacle of the spiritual members*, i.e., the pleural cavity; *Diaphragm*; *Receptacle of the material members*, i.e., the abdominal cavity.

fig 3. **Diagram of the diaphragm, heart and lungs.**

The figure is undoubtedly derived from some form other than man as is clear from the large and distinctive cardiac lobe of the lung. Leonardo says of the figure:

THIS IS THE LUNG IN ITS CHEST.

It is asked where the lung is more cooled or more heated, and the same is searched for in the heart.

It is to be investigated whether the wall of the heart [ventricular septum] interposed between its two ventricles is thinner or thicker in the elongation or shortening of the heart, or, you may say, in the dilation or contraction of the heart. It is judged that on dilation it increases in capacity and that the right ventricle draws blood from the liver, and the left ventricle at this time draws blood from the left [for right] etc.

The pulse beats as often as the heart expands and contracts.

The above note on the heart seems to have been overlooked in discussions of the question of Leonardo's knowledge of the circulation of the blood. It is tantalizingly brief, and much or little may be read into it. Since he mentions the septal wall, one suspects that this statement is no more than a reflection of the Galenical theory of the transmission of blood from right to left through that structure.

To the right of the figure is the observation that *The lung increases and decreases continually in every direction, but more downwards, because it is more useful for the expulsion of food from the stomach.*

Below the figure are a lengthy series of notes and questions on diaphragmatic function.

The diaphragm does not assist in the expulsion from the intestines, and this is evident through the lungs which having emptied themselves of air, the intestines continue the aforesaid expulsion.

What has to be investigated in the position of the lungs.

What shape the lobes have when placed between the diaphragm and the rest of the chest.

In what part is the lung more remote from the wall of the chest on decreasing, and to what does it approach more on increasing.

On the shape of the lungs.

Whether the shape of the lung is exactly similar to its space in the chest or not.

Whether the motion of the lung arises from the diaphragm or not.

How the lateral muscles of the diaphragm are the cause of the motion of the lung, of the stomach and of other intestines.

How the sinews of the neck elevate the entire anterior part of the chest by voluntary motion. This elevation animals sometimes use to relieve the fatigue of the strained diaphragm, and then the lung increases more upwards than downwards.

The elevation of the shoulders does not always compel the lung to draw air into itself.

Nor does the diaphragm always augment the expulsive power of the intestines, because, although the lung is empty of air, this expulsion is not lacking in ordinary function.

How the abdominal wall (mirac) with its longitudinal muscles does not assist in the expulsion from the intestines, but the peritoneum (sifac) with its transverse muscles is decreed for the aforesaid office.

fig 4. **The diaphragm to show its costal origin.**

The illustration purports to show the costal digitations or origin of the diaphragm but is obviously very inaccurate if intended to represent the findings in man. There are too many ribs, and the muscular slips of origin are too numerous. The position and prominence of the musculo-phrenic arteries suggest some animal form. The similarity of the figures to those of 30, where the musculature of the ox is shown, raises the question of this animal, but the number of ribs and digitations excludes this form if the figure is a reasonably faithful representation. Likewise, the dog and sheep can be excluded as well as the pig. This leaves the possibility of the horse with its eighteen or nineteen pairs of ribs and more extensive diaphragmatic attachment. Furthermore, apart from other details, Leonardo was greatly interested in the anatomy of the horse. The relatively small size of the kidneys, the left being labelled *kidneys*, also suggests an animal form. However, the shape of the thoracic cavity is unlike that of animals so that the figure may be purely diagrammatic.

Leonardo apparently intended to illustrate the attachments of the diaphragm step by step as indicated by the statement related to the figure which reads: *First make the ribs and in the second demonstration the ribs and the diaphragm.*

fig 5. **The costal origin of the diaphragm.**

The figure shows the costal attachments of the diaphragm and also the phrenic vessels. The illustration is doubtless derived from fig. 4. The legend reads:

(continued on page 491)

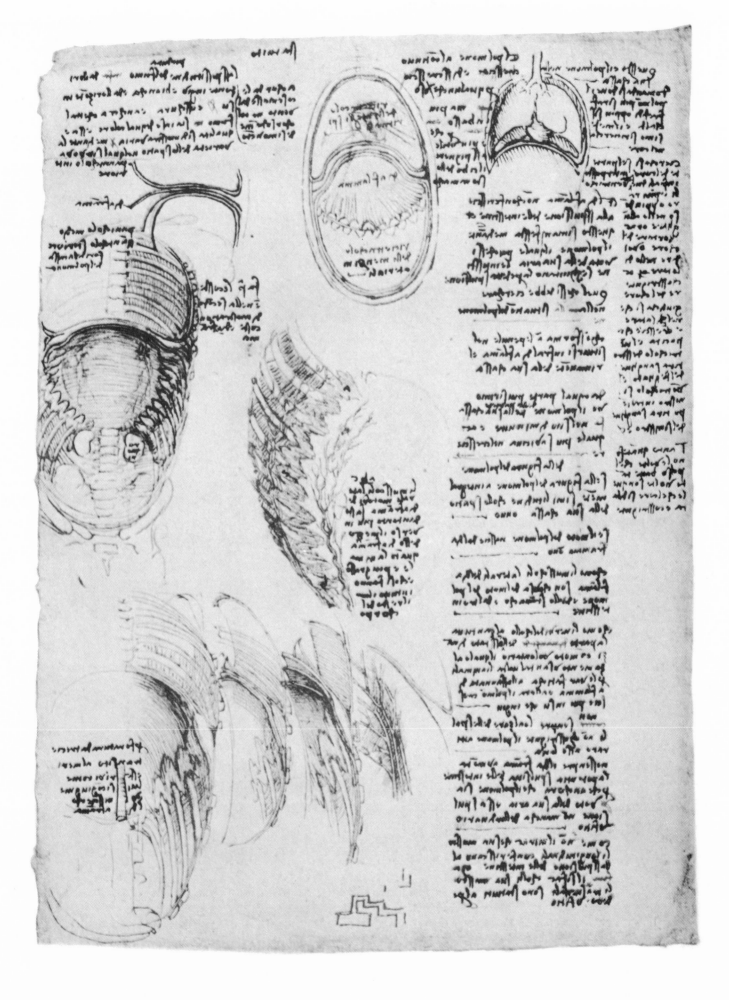

The figures and notes of this page are intended to show what Leonardo calls the paradoxical action of the diaphragm. His argument is based upon the reasoning that since the muscular portion of the diaphragm is peripheral and the tendon central, the diaphragmatic musculature can have little action unless the peripheral origin is translated by expansion of the lower ribs to which it is attached. This requires the synergistic action of the serratus anterior muscle which, as he was in error on its attachments, he believes expands the lower and not the upper ribs. The paradox in Leonardo's mind is that the diaphragm acts not by moving its central tendon but by it itself being moved or translated by the laterally expanding rib cage. Therefore he maintains that the lower ribs have only a single point of articulation with the spine which leaves the anterior ends free as so-called floating ribs to permit the lateral expansion of the ribs.

fig 1. **Diagram to illustrate the "paradoxical" action of the diaphragm.**

The letter f, indicates the rib cage; a b c, the diaphragm relaxed with the central tendon highly curved at b, and the peripheral musculature at a, and c; á b ć, the tensed diaphragm, the curvature of the central tendon flattened by the expansion of the ribs to á ć. The note above the drawing reads: *It is impossible for the cord drawn by the motor to move this motor.* The meaning of this note which refers to the diaphragm is explained above.

fig 2. **Diagram of lower ribs to show action of serratus anterior muscles.**

Leonardo maintains that the serratus anterior arises from the vertebrae and is inserted into the lower floating ribs. Thus he conceives them to be responsible for the outward movement of the ribs.

THE PARADOX OF THE SAID OFFICE OF THE DIAPHRAGM.

The diaphragm without doubt is moved by its own muscles through the medium of which it stretches out [i.e., flattens] its curvature. After this curvature is stretched out, it is more tense and powerful than when it was curved and slack. This being so, it is necessary that the muscles which stretch it should advance towards the middle of the tensed diaphragm and not that they should remove from the middle. As experience clearly shows that these muscles are removed from the middle, it is necessary that the said muscles be moved by other muscles more remote from the middle of the diaphragm. Therefore we shall say that the [serratus anterior] muscles attached to the dorsal spine on the outside are those which dilate the ribs, because when one draws the air into oneself, we observe that all the ribs dilate and increase outwards. This would not occur were it not in an opposite direction, if the muscles of the diaphragm were not assisted by the muscles on the outside which are clearly the dilators of the ribs. These ribs are not fixed [i.e., floating], and their origin from the spine is almost at a [single] point for the benefit of breathing.

33

myology of head and neck

These studies are believed, on the bases of style and paper, to be examples of Leonardo's earliest anatomies. Clark dates the drawings c.1487, hence earlier than the dateable 1489 drawings of 5.

fig 1. **Superficial muscles of the neck and shoulder: lateral aspect.**

fig 2. **Superficial muscles of the neck: lateral aspect.**

We doubt that the figures were drawn from an actual dissection, but they give every indication of being derived from studies on a living but spare subject. The sternomastoid, trapezius, deltoid and pectoralis major muscles are well modelled, but the deeper structures are very indefinitely suggested.

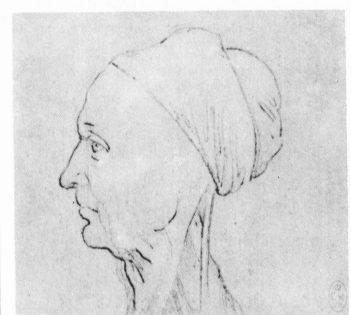

myology of head and neck

Leonardo's knowledge of anatomy at this early period is largely derived from a synthesis of traditional information, animal sources of material and the surface inspection of the living body, with occasional reference to a human specimen as will be illustrated in the main figure of this page.

fig 1. **Dissection of the head and face; mandibular muscles.**

The sketch outlines the masseter and temporal muscles of the mandible. In the face the zygomaticus and possibly the caninus muscles are suggested.

fig 2. **Synthetic dissection of the neck.**

This curious figure is based partly upon human and partly upon animal appearances. The skull is possibly that sketched in fig. 1 and may have been obtained from a decapitation. The larynx is obviously from an animal, probably the ox. The course of the external jugular vein and the sternomastoid muscle would be familiar from surface inspection of the living. On the clavicle appear the letters M N o p q R S t, which are not in Leonardo's hand but added much later as a guide to the identification of the various structures. However, the anatomy is too confused to make identification of any but the salient features certain. One suspects that Leonardo is putting together a figure to illustrate the results of his reading of some traditional manual such as that of Mundinus.

fig 3. **Outline of a head.**

fig 4. **The anatomy of the neck and external jugular vein.**

The external jugular vein has been inked in over a silver-point sketch which is now badly rubbed but represents the structures seen in fig. 2.

fig 5. **Unfinished sketch of undetermined subject, deleted.**

fig 6. **Profile of a man.**

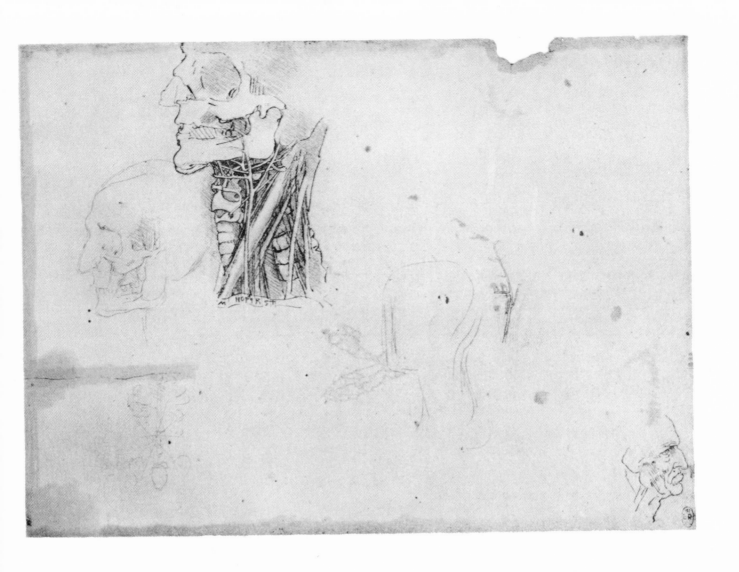

myology of head and neck

The series of anatomical sketches are closely allied to the more finished drawing on 34 and appear to be stages in its development.

fig 1. **The external jugular vein and its tributaries.**

fig 2. **Slight sketch of the larynx.**

The faint outlines show the larynx and oesophagus. The shape of the thyroid cartilage indicates an animal source, but this is better shown in fig. 3 below.

fig 3. **The hyoid bone and larynx.**

The drawing is based on animal anatomy, probably the ox. The hyoid bone exhibits keratohyoids, epihyoids and stylohyoids, and the thyrohyoids curve backwards as in animals. The thyroid cartilage is also of animal type. The attached cords are difficult if not impossible to identify since they may represent either muscles or nerves.

fig 4. **Sketch of the larynx.**

Again the thyroid and cricoid cartilages are of animal form.

fig 5. **Sketch of the external jugular vein.**

fig 6. **The neck and external jugular vein.**

fig 7. **Structures in the region of the mastoid process.**

From an examination of the several figures of the series a guess might be hazarded that these structures represent the hypoglosseal, glossopharyngeal and vagus nerves, but identification is very uncertain because of Leonardo's custom of indicating muscles in similar fashion.

fig 8. **Architectural drawing of columns.**

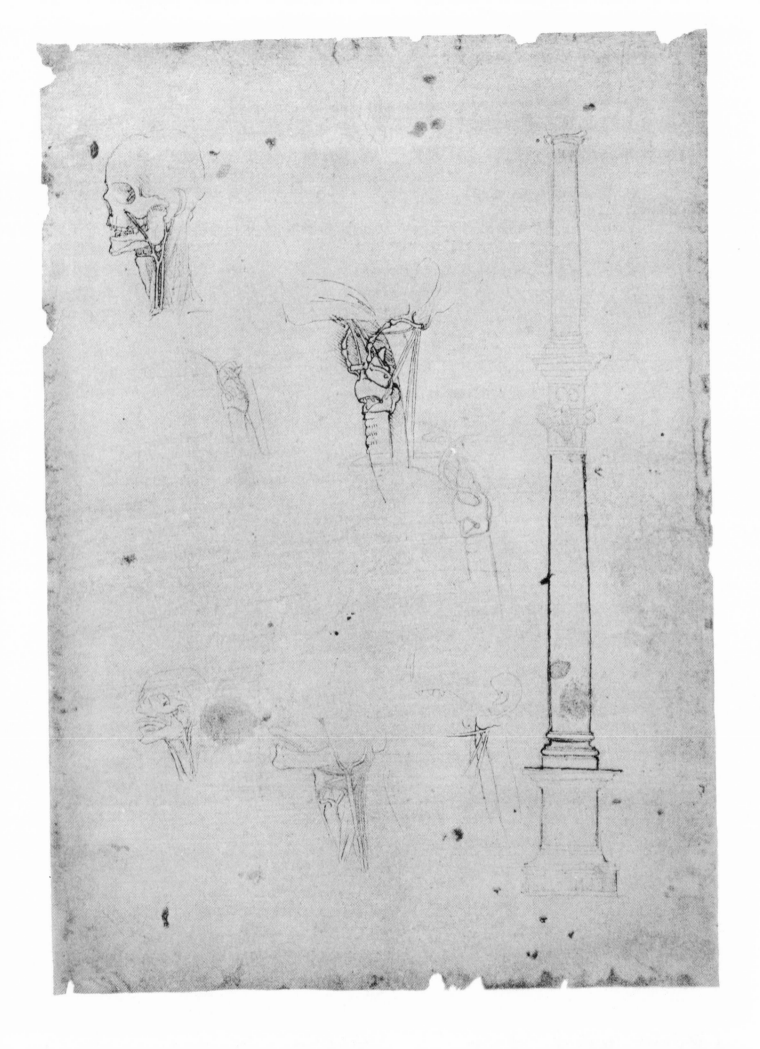

The drawings of the bones of the foot are a continuation of the series to be found on 12, 13, with which they provide representations of almost every aspect of this member. The series of drawings on the musculature of the neck are by far the most detailed and important on this subject.

fig 1. The first metatarsal and phalanges to illustrate an abductor and adductor tendon.

On this figure Leonardo writes: *a b* [an abductor and adductor tendon] *are the 2 lateral movers of the toes.*

fig 2. The bones of the foot: dorsal aspect.

The counterpart of this drawing is to be found in 12 and 13. The tarsal bones are accurately represented, and the articular surface of the talus beautifully shown. However, it will be observed that the tibia and fibula have been reversed so that the bones of the left leg are shown to articulate with the right foot. Errors of this kind suggest, apart from carelessness, that Leonardo possessed an incomplete skeleton. The "exploded" view is a useful device to show articular relationships.

fig 3. Superficial muscles of the shoulders and neck: postero-lateral aspect.

The position of the sternomastoid is poorly represented. Note the prominence given to the upper portion of the trapezius which muscle Leonardo nearly always shows incompletely, omitting its lower half.

fig 4. Rough diagram of the skeleton.

This very rough sketch of the human skeleton is no more than a pictorial reminder to utilize more extensively the "exploded" view to show articular relationships as in fig. 2. This is indicated by the note: *Break or disunite from one another each bony articulation.*

fig 5. The bones of the foot: plantar aspect.

The entire series representing the bones of the foot are remarkable for their accuracy: All show the not uncommon reduction of the little toe to two phalanges, perhaps evidence that the specimens were derived from a single subject. The only tarsal bone specifically named is the cuboid which is called the *os basilare*, cf. 12. The posterior process, tuberosity and anterior lip of the groove for the peronaeus longus tendon are indicated by the letters a, b, c, respectively.

Write what purpose is served by each of the prominences [a, b, c, of fig. 5] *on the inferior part of the basilar* [cuboid] *bone and also by each of its perforations, and into how many parts it is divided.*

Note what the tuberosities (globi) a b c, serve, and also all the other bony shapes.

The sesamoid bones of the first metatarso-phalangeal joint were of great interest to Leonardo (cf. 12), as well as their number. Avicenna, following Galen, stated that there were twenty-six. Leonardo discards tradition by enumerating twenty-seven, a number which he obtains by including the two sesamoids and counting two phalanges for the fifth toe, as his specimen showed, instead of Avicenna's three.

The pieces of bone of which the foot of man is composed are 27, counting those 2 [sesamoids] *which are found under the great toe of the foot.*

fig 6. The superficial muscles of the anterior and posterior triangles of the neck.

The salient features of the superficial muscles are well shown. In the floor of the triangles the omo-hyoid, levator scapulae and scalene muscles are identifiable.

fig 7. The muscles of the anterior and posterior triangles of the neck.

The figure, similar to the above, illustrates some of the smaller muscles in greater detail. The posterior belly of the digastric and, presumably, stylohyoid are now revealed, although the characteristic perforation of the latter muscle by the digastric is not evident here but is suggested in the following figure. The sternohyoid, but not the sternothyroid, is also shown.

fig 8. The deeper muscles of the neck: lateral aspect.

The dissection is carried a stage further exposing the deeper structures by reflection of the sternomastoid muscle. The digastric is seen passing between two "cords" which possibly represent the stylohyoid. In the muscular triangle, both the sternohyoid and sternothyroid muscles are revealed. The carotid sheath is apparent, but it is difficult to say with any certainty what structures are intended in the posterior triangle. The scalenes, levator scapulae and, perhaps, splenius capitis are identifiable, but there are other structures represented which seem to be errors of interpretation.

fig 9. The anterior belly of the digastric muscle.

The diagram outlines the mandible from below to show the anterior bellies of the two digastric muscles which are labelled a, and b.

a b, are the muscles [digastric] *under the chin.*

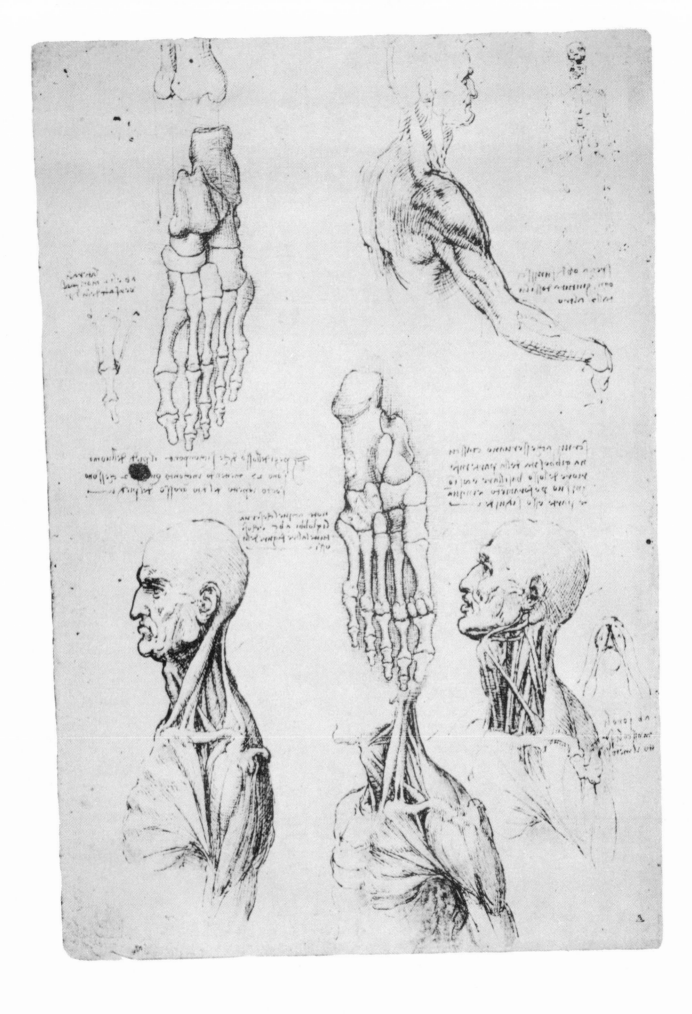

The notes refer largely to the tongue and faucial region so that this page has been grouped with the section devoted to the anatomy of that structure rather than with the cardiovascular system.

fig 1.　**The great vessels of the thorax and superficial veins of the arm.**

This curious and confused diagram seems to date from a much earlier period than the drawings of the tongue and larynx since the vascular pattern closely resembles that of 32 which has been ascribed to c.1504 but is probably of even earlier origin. Unquestionably a composite figure, the vessels of the upper extremity derived from a surface inspection of man, the deeper vessels have been derived from some lower animal as shown by the common brachiocephalic trunk springing from the aorta.

The caval system is shown receiving the pulmonary veins. This region, in fact, represents the right atrium since the heart was regarded as a two-chambered organ, the right ventricle of which was connected directly to the cava. Hence the opening shown on the right is the right atrioventricular orifice. The inferior vena cava is observed receiving the hepatic vein cut short. From this point two vessels pass to the right which are labelled with the words *To the spleen.* This error is also illustrated on 89. The splenic vessels were of great importance in the Galenical philosophy since they carried the black bile from the spleen. Consequently the error is one of tradition. Above, the superior vena cava (anterior vena cava) is distributed in a manner suggestive of the ox or pig.

The aorta, as mentioned above, provides a common brachiocephalic trunk distributed as in the horse or ox. It will be noted that the arterial system provides the cephalic vein of the arm.

The superficial veins of the upper extremity are shown with reasonable accuracy except in their connections at the root of the neck. The confusion here shown is of the sort not uncommonly found in anatomical drawings of the period, which were based on authoritarian statements rather than on dissection. Therefore it is not unlikely that this diagram is a copy from some pre-existing figure.

figs 2-3.　**The tongue, larynx and palate.**

The *tongue* is so labelled, and the circle carries the word tonsil. The inset figure is a rough diagram of the palate and alveolar and possibly displays the palatine vessels emerging from the greater palatine foramina on either side.

The 2 tonsils are formed on opposite sides of the base of the tongue, acting as two cushions interposed between the bone of the jaw and the base of the tongue so that a space may be created between the bone of the jaw and the base of the tongue in order that on one side it may receive the lateral prominence of the convexity arising in the tongue when it is bent, and so that with its convex part it can clean away food from the internal angle of the jaw at the lateral margins of the base of the tongue.

fig 4.　**The intrinsic muscles at the root of the tongue.**

fig 5.　**The larynx showing the vocal cords.**

fig 6.　**The dorsum of the tongue of a feline to show papillae.**

Below fig. 4 it is stated that there are 28 *muscles in the root of the tongue,* but elsewhere (39) the number is given as twenty-four which fuse into six, making up the mass of the tongue. The illustration purports to show the intrinsic muscles at the lingual root, doubtless created by artificial separation of fasciculi as done elsewhere as, e.g., in the pectoralis major muscle.

This is the reverse [fig. 4] of the tongue. Its surface is rough in many animals and especially in the leonine species, such as the lion, panther, leopard, lynx, cat and the like. In these the surface of the tongue is very rough, like somewhat flexible, minute nails [fig. 6]. These nails (when they lick their skin) penetrate as far as the roots of the hair (and act as a comb to remove the minute animals which feed upon them). I once saw a lamb being licked by a lion in our city of Florence, where there are always twenty-five to thirty of them and where they are bred. This lion in a few licks removed the entire covering from the skin of the lamb and so having denuded it, he ate it. The tongues of the bovine species are also rough.

fig 7.　**The superficial veins of the upper extremity.**

The median vein is labelled *vena communis.* The distribution of the cephalic and basilic veins is accurately represented as in fig. 1 above.

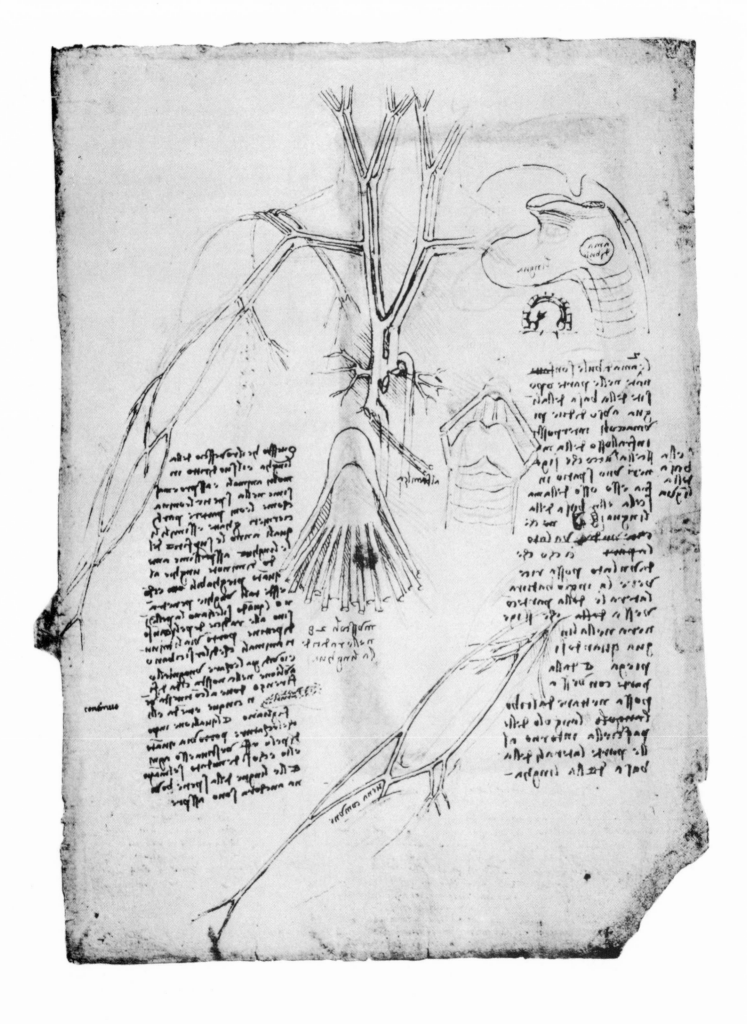

Leonardo's notes are sufficiently explanatory to obviate comment.

ON THE MUSCLES WHICH MOVE THE LIPS OF THE MOUTH.

The muscles which move the lips of the mouth are more numerous in man than in any other animal. This arrangement is necessary to him because of the many operations in which he constantly employs the lips as in the 4 letters of the alphabet b f m p, in whistling, laughing, weeping and the like, and then in the strange contortions which are used by buffoons when they make faces.

fig 1. **Diagram of the mouth with the angles lettered a b.**

What muscle is it that constricts the mouth in such a way that its lateral extremities are brought nearer together?

The muscles which constrict the mouth diminishing its length are in the lips themselves, or rather the lips are the actual muscles which they themselves close. It is true that a muscle [triangularis or quadratus labii inferioris] displaces the lip downward away from the other muscles united to it, of which one pair are those [risorius] which stretch it out and prepare it for laughter. The muscle [orbicularis oris] shortening the lips is the same muscle forming the lower lip itself which is constricted by drawing the extremities towards its center, and the same thing occurs simultaneously in the upper lip. Other muscles are those which bring the lips to a point, others which spread them, and there are others which curl them back, others which straighten them out, others which twist them transversely and others which return them to their first position. Thus one will always find as many muscles as there are positions of the lips and as many more which serve to undo these positions. I here intend to describe and to represent these muscles in full, proving these motions by means of my mathematical principles, etc.

ON THE MOTIONS OF THE MUSCLES OF THE MOUTH WITH ITS LATERAL MUSCLES.

There are many occasions when the muscles comprising the lips of the mouth move the lateral muscles joined to them, and an equal number of occasions in which these lateral muscles move the lips of the mouth to replace it where it cannot return of itself because the office of a muscle is to pull and not to push, except in the case of the genital members and the tongue. But the shortening of the mouth will not of itself regain its lost length unless these lateral muscles return it there. And if these lateral muscles extend the mouth in length for the production of laughter, it is necessary that these lateral muscles be pulled back by the shortening of the mouth in the destruction of laughter.

myology of head and neck

The notes and figures of this page treat of the anatomy and function of the lips, palate and tongue in the mechanism of speech, and seem to be related to the lengthy unillustrated notes of FB28v on the anatomy of the tongue, and to 38 on the action of the lips.

figs 1-3. Three sketches of the lips formulating the vowels a o u, as indicated by these letters.

fig 4. Median sagittal section of the buccal and nasal cavities.

The figure, somewhat faded, shows the tongue c, the buccal cavity a, the soft palate n, the larynx and epiglottis m. The buccal cavity and inferior meatus of the nose are shaded.

THE VOWELS.

The pannicle [palate] interposed between the passage which the air follows partly through the nose and partly through the mouth, is the only one which man employs to pronounce the letter a; that is, the pannicle a n [palate in fig. 4]. Though the tongue and the lips do what they may, this will never prevent the air which streams out of the trachea [larynx] from pronouncing the letter a, in this cavity a n [buccal cavity]. Moreover, the letter u, is formed at the same place with the aid of the lips which are constricted and somewhat protruded. The more the lips are protruded the better the letter u, is pronounced by them. It is true that the epiglottis m [in fig. 4], is elevated a little towards the palate. And if it were not so, the u, would be converted into o, . . .

Trachea here means larynx and not trachea. The translators from the Arabic customarily employed trachea in the above sense. Leonardo sometimes uses trachea when referring to the entire bronchial tree. Likewise epiglottis usually means larynx through synecdoche.

Whether, when a o u, are pronounced distinctly and rapidly it is necessary in their continuous pronunciation without lapse of time that the opening of the lips should contract continuously: that is, in saying a, they will be widely parted, more contricted in saying o, and still more constricted in pronouncing u [as illustrated in figs. 1-3].

It is proved how all the vowels are pronounced with the back part of the movable palate which covers the epiglottis; and furthermore, such pronunciation comes from the position of the lips by means of which a passage is formed for the expired air carrying with it the created sound of the voice. This sound, even when the lips are closed, passes out through the nostrils of the nose, but it will never demonstrate through the latter passage any of these letters, etc. By means of such experiment, one can conclude with certainty that the trachea [larynx] does not create the sound of any of the vowels, but its use extends only to the creation of the aforesaid voice and especially in a o u.

fig 5. The tongue.

The root of the tongue is indicated by the letters a e, the canine vessels by b, the lateral margins of the tongue by c and g, and the dorsum of the tongue by d.

Beside the figure Leonardo places the reminder: *Make the motions of the tongue of the woodpecker.* Elsewhere (37) Leonardo states that there are twenty-eight muscles in the root of the tongue, but here he gives the number as twenty-four. These twenty-four seem to be the extrinsic muscles since he says they go on to form the six intrinsic muscles of the tongue. Vesalius and his contemporaries also had great difficulty in determining the exact number which is to be understood in the case of the intrinsic group.

The tongue is found to have 24 muscles which correspond to the six muscles making up the mass of the tongue which moves in the mouth. The present task is to discover in what way these twenty-four muscles are divided or apportioned in the service of the tongue in its necessary motions which are many and varied. In addition to this, it is to be observed in what manner the nerves descend to it from the base of the brain and how they come to be distributed and ramify through the tongue. Furthermore, it is to be noted how and in what manner the 24 said muscles are converted into the six making up the complex in the tongue. In addition, indicate whence these muscles take origin, that is, at the vertebrae of the neck in the contact of the gullet [superior constrictor], some at the inner side of the jaw [genioglossus] and some at the front and sides of the trachea [larynx-hyoglossus]. Likewise, how the veins nourish them and how the arteries provide them with [vital] spirit (and how the nerves give them sensation [. . .].

The above memorandum seems to have been constructed from a reading of the statements on the tongue given by Mundinus and Avicenna, in an attempt to provide answers to the indefinite remarks made in those works. Leonardo continues:

Furthermore, you will describe and indicate in what manner the office of variation, of modulation and of articulation of the voice in singing is the simple office of the rings of the trachea moved by the recurrent nerves, and in this case no part of the tongue is employed.

And this remains proved by what I have proved before, that the pipes of an organ are not made deeper or higher in pitch by mutation of the fistula (that is, the place where the voice is produced) in making it wider or narrower, but only by the mutation of the pipe to wide or narrow, or to long or short, as is seen in the extension or retraction of the trombone and also in pipes of fixed width and length where the sound is varied by introducing air with greater or less force. (Such variation [of pitch] does not occur in objects struck with a greater or lesser blow as is perceived in bells struck with very small or very large clappers). And the same thing occurs in cannon similar in width but varying in length. But here the shorter makes a louder and deeper noise than the longer. I shall not extend these remarks further because it is fully treated in the book on musical instruments. Therefore, I shall resume the postponed order on the office of the tongue.

The tongue is employed in the pronunciation and articulation of the syllables, the component parts of all words. Further, the tongue acts in the necessary

(continued on page 492)

myology of shoulder region

figs 1-4. **The surface anatomy of the muscles of the shoulder region: anterolateral, lateral and postero-lateral aspects.**

The series is continued on 41, where the same subject is portrayed and the intent similar to that of 44. The style is loose and summary, like that employed by Leonardo in his caricatures but is, nonetheless, effec-tive in showing the surface modeling of the muscles. The tendon of insertion of the deltoid muscle is un-duly prominent and no doubt a projection from the findings at dissection. Again, the fasciculation of the major muscles is emphasized as is common in Leo-nardo's figures of this period, cf. 44, 56. The portrait is undoubtedly that of the subject shown on 45.

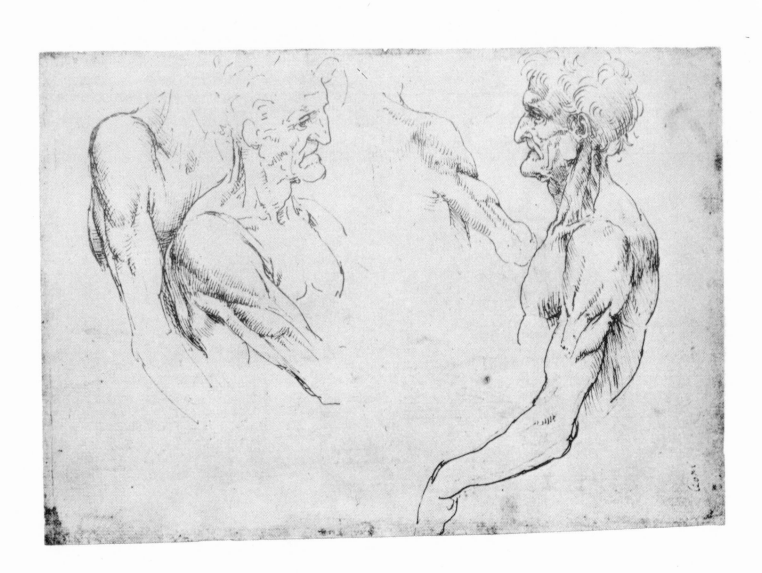

myology of shoulder region

figs 1-2. **Surface anatomy of the muscles of the shoulder: lateral aspect.**

These figures are a continuation of the series found on 40. The same elderly subject is employed. The arm is shown in flexion to bring out in striking fashion the surface modeling of the triceps muscle. The subject is undoubtedly that dissected on 45.

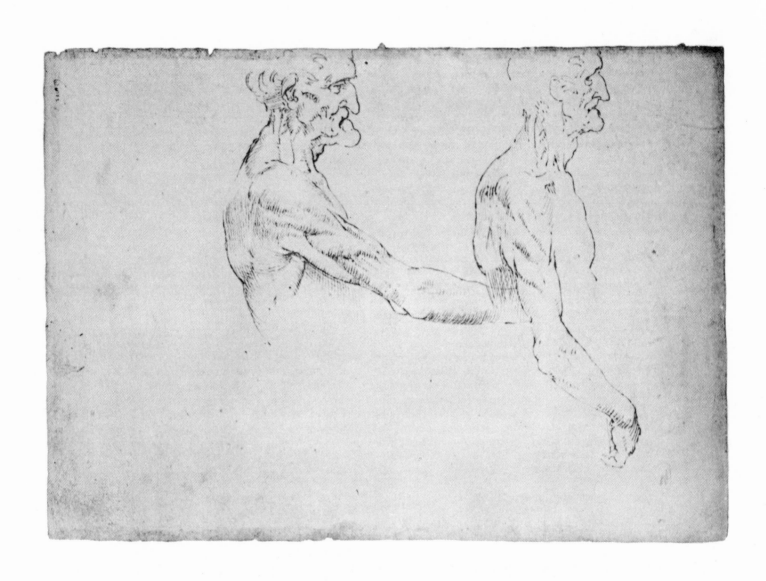

figs 1-6. **Illustration of the surface modeling of the muscles of the shoulder and upper arm.**

In conformity with Leonardo's plan, the surface anatomy of the arm and shoulder region has been sketched from several aspects as the body is turned through two right angles. The subject was evidently younger and more robust than that of 40. These sketches seem to constitute in part the preliminaries to the superficial dissections of the muscles of 53. The outlines of fig. 3 are identical to those of fig. 4 of the latter plate.

fig 7. **Diagram of the movements of the hand.**

The circular motion of the hand, showing first the 4 principal ones a d [flexion], d a [extension], b c [adduction] and c b [abduction], and in addition to these four principal movements, one makes mention of the non-principal motions which are infinite.

By circular motion of the hand, Leonardo does not mean pronation and supination but that the hand may be carried in a circle or circumducted. To those unfa-miliar with mediaeval handwriting the letter d at the bottom of the figure resembles the numeral 4 and the letter e, our D (actually reversed because of Leonardo's mirror-writing). In the right margin appears the note:

Wrist (rasetta): 7 bones.
The 8th is the base of the thumb.

For the origin of *rasetta*, cf. 10. The only bone of the carpus which Leonardo names is the multangulum majus which he calls the basilar bone. Doubtless he is disagreeing with some traditional source since many early anatomists held that there were only seven bones in the carpus, the pisiform being regarded as a so-called "cartilaginous" bone and therefore akin to a ses-amoid. Celsus (VIII:i) whose *De medicina* was one of the first medical books to be printed, Florence 1478, and therefore available to Leonardo, states that the number of carpal bones is uncertain. Mundinus and Avicenna, Leonardo's other sources, write that there are eight bones.

43

myology of shoulder region

The series of illustrations shown here is concerned chiefly with the surface anatomy of the shoulder region and its modification with movements of the extremity. However, the notes found occupying the upper left-hand margin are entirely unrelated to the figures and consist of certain remarks on the vascular system which read as follows:

THE NATURE OF THE VEINS.

The origin of the sea is the contrary of that of the blood, for the sea receives into itself all the rivers which are caused exclusively by the aqueous vapors that have ascended into the air, while the sea of the blood is the source of all the veins.

OF THE NUMBER OF THE VEINS.

There is only one vein [vena cava] *which is subdivided into as many main branches as there are principal places which it must nourish, branches which proceed to ramify infinitely.*

The above image on the sea of blood is a development from the statement of Aristotle, *De partibus animalium*, III:5:668a, where the system of blood-vessels is compared to irrigation channels springing from a single source. Galen held that the liver, the blood-making organ, was this source and that the cava arose from it to be distributed by ramification to all parts of the body.

fig 1. Surface anatomy of the left shoulder: lateral aspect.

fig 2. Surface anatomy of the shoulder region: anterior aspect.

Observe the fasciculation of the pectoralis major as often seen in spare individuals and which caused Leonardo to regard the muscle as consisting of four separate muscles. The neurovascular bundle and coracobrachialis muscle are clearly delineated on the right axilla; the posterior belly of omohyoid and the cephalic vein, in the left posterior triangle.

fig 3. Diagrammatic sketch of anterior aspect of shoulder region.

a n m, a conjunction at n, of the two muscles (lacerti) a n [left sternomastoid] *with n m* [fasciculus of right pectoralis major] *which assist* [or] *oppose one another when the clavicle threatens to be drawn out of place by one or other of the muscles.*

As mentioned above, Leonardo regarded the pectoralis major as four separate muscles. One of these fasciculi, he believed, opposed the action of the sternomastoid of the opposite side and thus prevented displacement of the clavicle at the sternoclavicular joint. He uses the term *lacerta* usually for long, slender, fleshy muscles. It was practically synonymous with muscle but was used more frequently for the long muscles of the arm because of their fancied resemblance to a lizard. In modern anatomy the word has survived as lacertus fibrosus, the tendinous expansion from the biceps brachii to the fascia of the forearm.

fig 4. Outline drawing of the clavicle and spine of the scapula as seen from above to illustrate the course of supraclavicular veins.

a b, is a vein [transverse cervical] *which is found under the large muscle* [trapezius] *which covers the acromion (l'omero della spalla).*

The acromion is called literally "the humerus of the shoulder" by which is meant the mythical third ossicle thought to exist between the scapula and the clavicle, and called the summus humerus by mediaeval anatomists, cf. 1. The word "humerus" referred classically to the shoulder and three bones, the humerus, the clavicle and the scapula, which have at different times received this name.

figs 5-6. Surface anatomy of the shoulder region from above.

The first of these illustrations shows the change in surface contour of the deltoid muscle, the elevation of the clavicle and prominence of the medial angle of the scapula when the arm is carried into abduction. The second drawing contrasts the appearances when the arm rests at the side of the body.

fig 7. Surface anatomy of the shoulder region: anterior aspect.

The surface modeling of the shoulder region is shown abducted forty-five degrees and in slight flexion. The clavicular head of the pectoralis major is contracted, and the sternocostal portion of the muscle is in relaxation. The posterior belly of the omohyoid muscle in the posterior triangle is rendered prominent.

fig 8. Superficial dissection of the posterior triangle.

a [posterior belly of omohyoid] *arises from the bones of the clavicle deep to the origin of the large muscle of the shoulder* [trapezius] *which arises from the aforesaid clavicle.*

This figure supplements fig. 7, to show the omohyoid muscle, the upper trunks of the brachial plexus and the levator scapulae muscle lying in the floor of the posterior triangle and which would modify surface appearances in certain positions.

fig 9. Superficial dissection of the musculature of the shoulder region.

The purpose of the figure is to reveal the superficial muscles producing the surface appearances. The twisted bilaminar insertion of the pectoralis major rounding the lower border of the anterior axillary wall is exceptionally well portrayed.

fig 10. Sketch of the clavicle and interclavicular ligament.

a b is a small sinewy muscle which binds the part a, of the bone of the clavicle [sternal end] *and arises from the bone of the clavicle at b, and is inserted into the bone of the thorax* [sternum] *at a, and I wish to say that it arises at a, and ends at b.*

The muscle described is identified as the subclavicus by Piumati (1898) and Holl (1905), but this could only be the case if this drawing were to be regarded as

(continued on page 492)

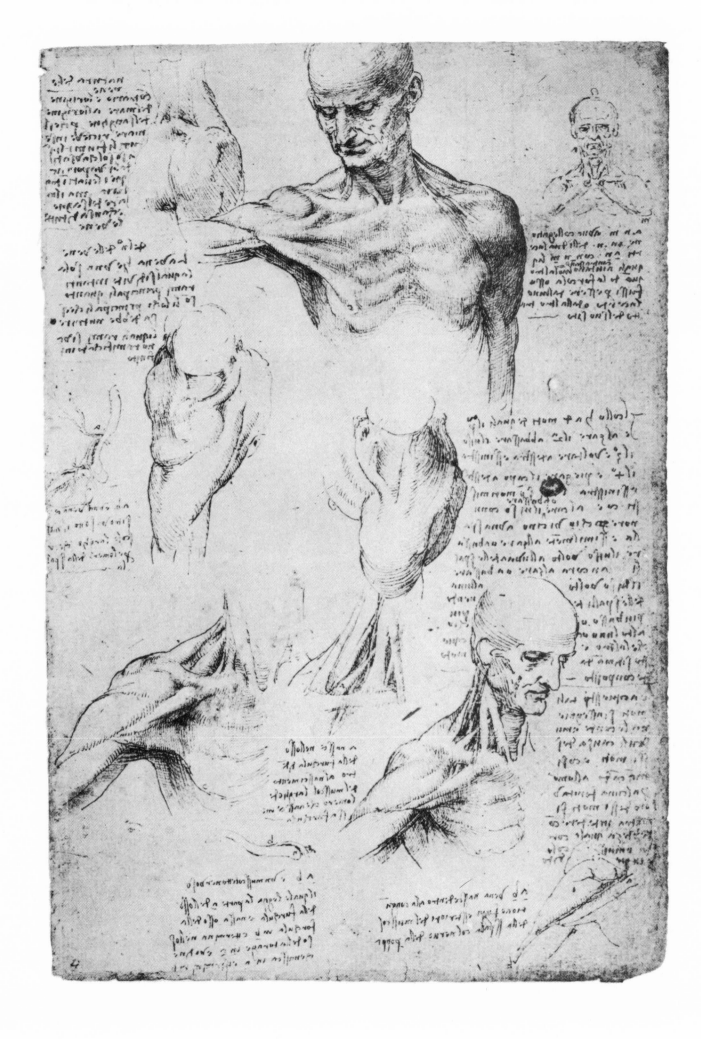

myology of shoulder region

This page devoted to the surface appearances of the muscles about the shoulder is obviously the companion to 43, where the same subject has been employed.

figs 1-6. **Surface anatomy of the shoulder region and neck: various aspects.**

Leonardo here follows his proposed scheme of representing various regions of the body progressively from the anterior to the posterior aspect as though the observer were slowly walking around the subject. The figures further reflect Leonardo's dependence on spare

subjects for much of his anatomical knowledge, which in turn is probably responsible for the division of major muscle masses into multiple fasciculi as in fig. 7 below.

fig 7. **The pectoral muscles.**

Pectoralis major and minor, m n, muscles are shown artificially divided into several fasciculi as is common in many of Leonardo's figures and perhaps is due to the appearances often seen, on contraction of these muscles, in the living subjects.

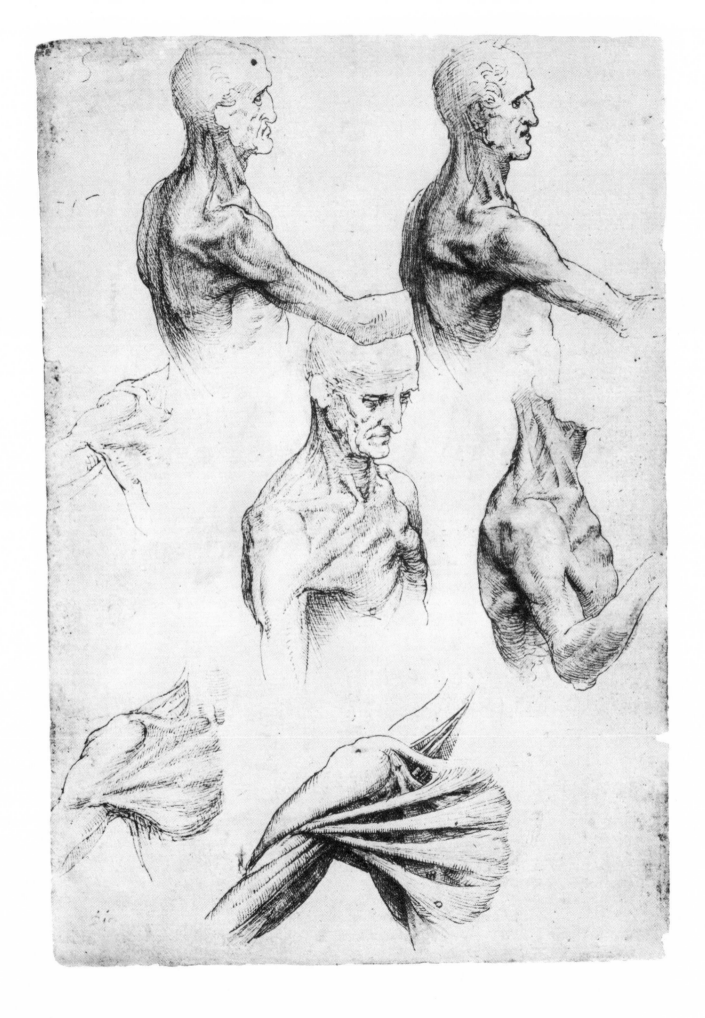

To judge from the likeness of the subject at the top of the plate, these figures are possibly a continuation of the series shown in 40, and 41, after removal of the skin to reveal the most superficial structures. In arranging the plates of this section, we have followed approximately Leonardo's intentions as expressed in the note on the left-hand side which reads:

First represent the muscles of the neck, of the shoulder and of the chest above the axilla, which move the shoulder, then the muscles of the shoulder which move the humerus. . . .

Follow with the muscles of the humerus which flex and rotate the arm, and then the muscles of the [fore-] arm which move the hand, and the muscles which move the fingers.

fig 1. Head and neck to show surface modeling of submental region.

fig 2. Outline of lower jaw and surface contours of submental region.

fig 3. Two line diagrams, the significance of which is undetermined.

fig 4. Superficial dissection of muscles of the shoulder, arm and elbow region.

The muscles of the proximal portion of the upper extremity are beautifully portrayed. As Leonardo customarily proceeded from right to left, this figure in reality follows figs. 5-6, where the extremity is still clothed by the deep fascia and the superficial veins have not been removed.

fig 5. Superficial dissection of the arm exhibiting the cephalic vein. This figure follows fig. 6, and its purpose is to show the termination of the cephalic vein as it passes into the delto-pectoral triangle to join the axillary vein.

fig 6. The superficial veins of the upper extremity and trunk.

The essential features of the venous pattern of the trunk and upper extremity are superbly illustrated. The cephalic, median, basilic, external and internal mammary, thoraco-epigastric and superficial epigastric veins are all readily identifiable. The accuracy of this representation should be compared with the fanciful expression made in a very early drawing of the venous arrangement (116), where Leonardo was still dominated by Avicenna's description. As an artist Leonardo was greatly interested in this subject and provides several other sketches of the superficial veins. For details of the termination of the basilic vein, cf. fig. 9, below.

fig 7. The superficial muscles of the upper extremity: anterior aspect.

fig 8. The superficial muscles of the upper extremity: posterior aspect.

fig 9. The basilic vein and axillary veins.

From the vein m e [axillary v.], *the vein e b* [distal part of axillary v.] *which descends between e and b, where the arm separates itself from the chest, at which place b, a branch* [external mammary, labelled a], *separates off and ramifies between the skin and the flesh of the breast; and the branch b* [subscapular v.] *arises opposite, which ramifies between the flesh and the skin* [periosteum] *of the body (paletta) of the scapula. Above* [for below] *there arises the vein c* [thoraco-epigastric] *which ramifies between the flesh and the skin which covers the ribs. Laterally a little further down arises the vein o* [brachial vena comites] *which enters between the biceps (pesce del braccio) and its skin, and the master vein from which these ramifications are given off, is called the basilic vein.*

Parallel to the main trunk is written *basilic vein*. Since the lettering is in reverse and both basilic and axillary vein are regarded as the basilic, it may help the reader desirous of understanding the diagram and Leonardo's note to trace the vessels from above downwards in modern terms. The letter m, lies at the junction of the axillary and internal jugular veins forming the innominate. The first part of the axillary is shown extending horizontally to the point e, where it is shown receiving the cephalic. The axillary vein is there shown descending vertically to the point b, and receiving three tributaries. On the lateral or left-hand side is the subscapular vein labelled b (letter reversed). On the medial or right-hand side are two tributaries. The uppermost represents the lateral thoracic or external mammary vein labelled a, (resembling the letter p). The lower vein, designated c, is the thoraco-epigastric. The second vein on the lateral side at a lower level, noted by o, is probably the venae comites of the brachial artery. The main trunk of the basilic vein is indicated by the letters n q. The confusion of the basilic vein with the axillary was inherited from Avicenna, and Leonardo is attempting to straighten out the difficulties derived from this earlier source. The word "basilic", despite similarity, is not derived from the Greek but is of Arabic origin. In Gerard of Cremona's translation of Avicenna's *Canon* we read that "the first vein which is separated from the shoulder vein [axillary] is the cephalic; . . . the rest is the basilic". Thus Leonardo is following his source rather closely.

The term *paletta* is sometimes used to mean the entire scapula, but here refers obviously to the body of that bone. The biceps muscle is called *pesce del braccio*, literally "fish of the arm". Muscles of a certain shape, especially those with bifurcated tendon of origin, as the biceps brachii and the rectus femoris, were called *pisciculus* in Latin, and the biceps is still called *il pescetto* in Italian.

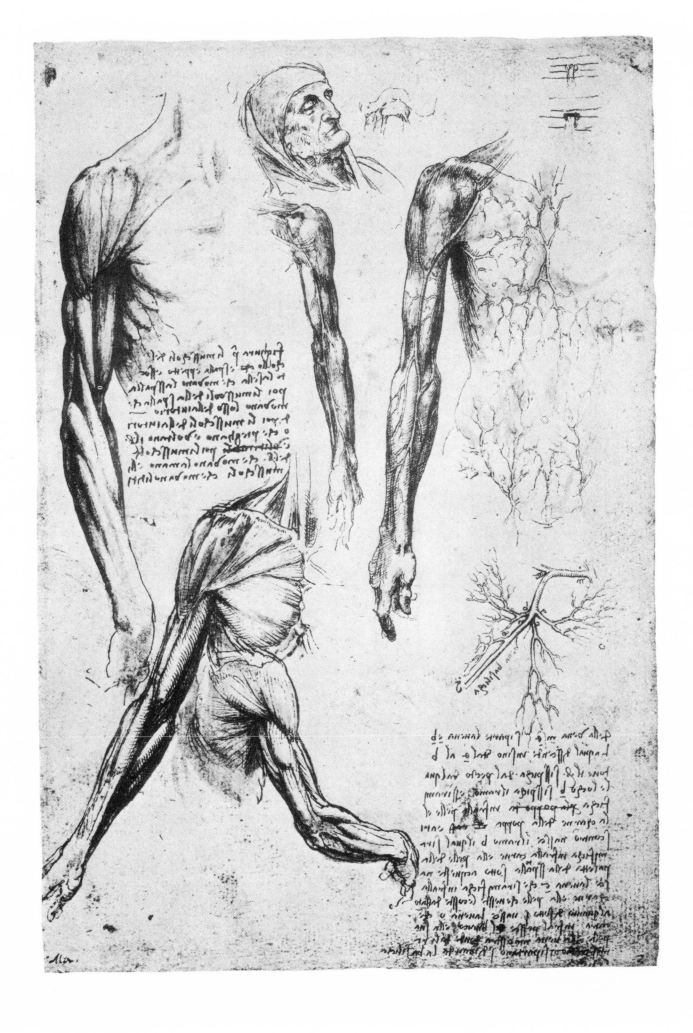

The four figures showing the superficial muscles of the upper extremity form a continuous series with those of 47, so that every aspect of the limb is revealed from the full posterior to the anterior view. A similar manner of representation is to be adopted for the arm which is to be turned through 360 degrees as described in the diagram fig. 8, at the bottom right-hand side of the page.

Since Leonardo wrote and sketched from right to left, the figures should be followed in this direction, but we have followed the customary order of left to right in numbering them. At the top right of the plate is an unrelated note reading *What are the veins which border on the bones?* By "veins" Leonardo often means "vessels", as will be evident from an examination of other illustrations.

figs 1-3. **Muscles of the posterior aspect of the neck.**

These three figures are labelled from right to left: *1st and 2nd demonstration, 3rd demonstration, 4th demonstration.* The demonstrations illustrate layer by layer the attachment of the muscles to the spinous processes of the cervical vertebrae. They are similar to the more detailed demonstrations of 16, of which they are, perhaps, the precursors. On the right side of fig. 3 a portion of the trapezius is shown. On the left side of the same figure are possibly the rhomboid muscles labelled a b and b c. In fig. 2, which corresponds to fig. 4 of 16, splenius capitis is suggested, and in fig. 1, spinalis might be hazarded.

figs 4-7. **The superficial muscles of the upper extremity from the lateral to the anterior aspect in turning through a right angle.**

Emphasizing the importance of a knowledge of the superficial muscles to the artist, Leonardo asks the following questions: *What are the muscles which are never hidden either by corpulence or by fleshiness?*

What are the muscles which are united in men of great strength?

What are the muscles which are divided in lean men?

The last two questions refer to the greater prominence of the muscle fasciculi in spare individuals. Leonardo regarded the fasciculi of the deltoid and pectoralis as separate muscles but believed them to be fused in robust subjects. This was no doubt suggested to him by the examination of living subjects where the muscle bundles during contraction frequently appear to be distinct.

In the lateral view the only muscles indicated are the triceps at n, the brachialis at m, and the biceps brachii at o, and in the anterior view the letters refer

to the same muscles except that the pronator teres is indicated by p. The identification of the unlettered muscles presents no difficulty owing to the accuracy of representation. Leonardo recognized that the triceps was the chief extensor and the brachialis, the important flexor of the elbow. He appreciated that the biceps was the chief supinator and only secondarily a flexor, a view which has come to be recognized only in recent years. Although the action of the pronator teres is not discussed here, Leonardo describes it elsewhere (212) as a pronator and antagonist to the biceps. But here below are his opinions on the action of these muscles.

All the muscles which have arisen from the chest and the outer aspect of the scapula serve the movement of the humerus, that is, the bone placed between the shoulder and the elbow.

But the muscles which have arisen from the anterior aspect of the scapula serve in part the movement of elevating the focile [radius or ulna: error for humerus] *and in part to fix the scapula to the ribs of the chest.*

All the muscles which have arisen from the humerus serve the movement of the two fociles [radius and ulna] *of the arm.*

The muscle n [triceps] *does not show itself either relaxed or contracted if the arm is not extended, because it is attached to the tip of the elbow made to assist the extension of the arm.*

The muscle m [brachialis] *is made for the purpose of flexing the arm.*

And the muscle o [biceps brachii] *is appointed to rotate the arm from the elbow downwards, and it rotates it whether the arm is extended or flexed; and if the hand presents its dorsal surface* [i.e., pronated], *this muscle then assists the power of the muscle m* [brachialis].

There are as many muscles as there are cords, or rather, I wish to say, there are as many as there are bones to be moved by them.

There are as many divisions of the cords and of one and the same muscle as there are of attendant movements possible to the bone itself.

fig 8. **Perspective diagram of the arm.**

This diagram, resembling a star, represents the eight points of view from which Leonardo intended to illustrate the anatomy of the arm, apparently when freed from the trunk. His plan is indicated in the accompanying notes.

I rotate an arm in 8 aspects, of which 3 are outwards and 3 inwards, and one to the back and one to the front.

And I rotate it in 8 others when the arm has its fociles [radius and ulna] *crossed.*

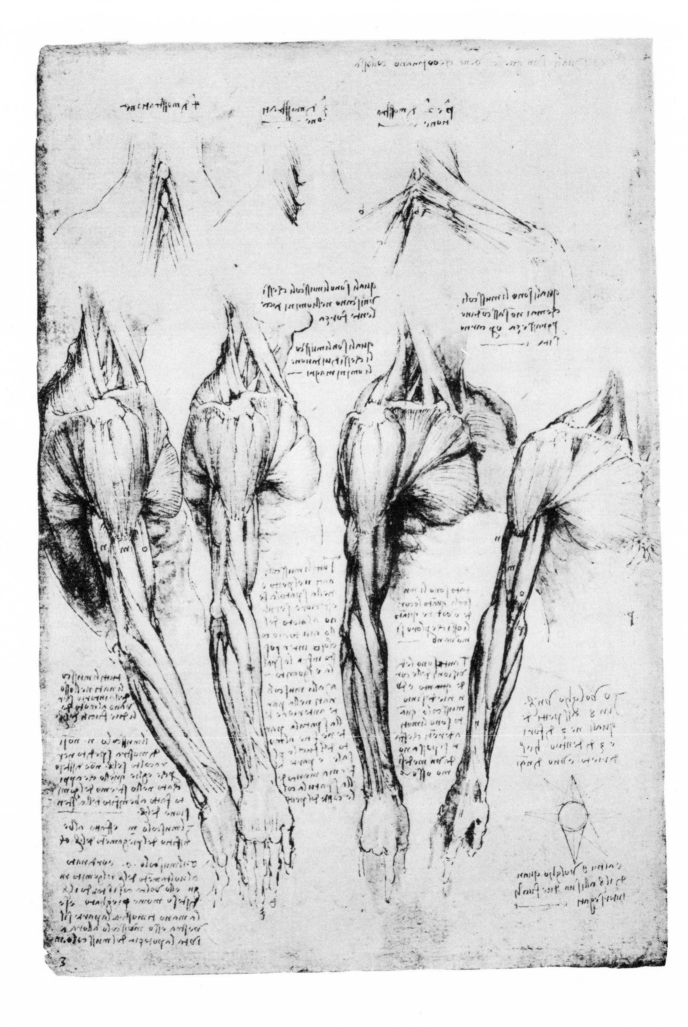

47

myology of shoulder region

The four figures of the upper extremity on this plate should be viewed in conjunction with those of 46, in order to appreciate in continuity Leonardo's magnificent conception of representing the extremity from every aspect by turning the body through 180 degrees. The impression given is almost cinematographic and not unlike the representations of human movements seen in the Codex Huygens which, as Panofsky has shown, developed from the Leonardine tradition. Leonardo's note below on the representation of circular movements of the shoulder clearly indicates the purpose of this technique to display the action of all the muscles during movement. Further, it was his intention to provide a similar series with the arm in abduction, extension and flexion as well as in adduction. This is expressed in the statement below fig. 2, reading: TO BE NOTED.

Make an arm elevated and one depressed, one [carried] backwards and one forwards, and sketch each of them from 4 aspects, and do the same with the elbow bent.

fig 1. Superficial muscles of the upper extremity: posterior aspect.

fig 1a. Inset outline of the bones of the elbow.

n m, the muscle turning the arm to the front from behind [i.e., lateral motion].

It is curious that Leonardo nearly always shows the posterior portion of the deltoid as a slip separated by an interval from the rest of the muscle. On the olecranon is placed the letter a, with the notation *a, is the movable bone of the elbow.* The inset drawing below the main figure shows the outline of the underlying humerus and ulna at the elbow.

fig 2. Superficial muscles of the upper extremity: posterior aspect after a quarter turn.

Describe the extreme movements of the borders of the scapula, that is, the movement from below upwards and from right to left.
And do the same for each movement of each member.

Leonardo refers in his note to the rotation and elevation of the scapula, and this is illustrated to some extent in fig. 5, where the scapula rotation is shown at right angle abduction.

fig 3. Superficial muscles of the upper extremity: posterior aspect after a half turn.

See if the muscle of the shoulder [. . .]
Elevate the muscle b [middle deltoid] and thus having raised it, sketch successively the other muscles down to the bone from each of 4 aspects.

The deltoid muscle is divided into four distinct portions which are designated from before backwards by the letters a,b,c,d. Apparently Leonardo regarded the fasciculi of the deltoid as four separate muscles.

In the forearm the tendons of the long abductor and extensor of the thumb are indicated by the letters a b, and referred to in the following reminder.

Remember to represent the origin of the two cords a b, by uncovering the muscles which are connected with them.

And you will do the same for all the muscles, leaving each separately bare upon the bone so that not only does one see the origin and termination, but so that it may be demonstrated how it moves the bone for which it is intended; and concerning this it will be necessary to give a scientific explanation by means of simple outlines.

fig 4. The oral cavity and fauces.

n, is the uvula, m, is the tongue, o p, are the last molars.

fig 5. Superficial muscles of the shoulder region: posterior aspect.

This arm, from the elbow a, as far as b, must be made in 4 movements, that is, in extreme elevation and extreme depression, and [carried] backwards as far as possible and likewise forwards; and should it seem desirable to you to do this in more ways, the function of each muscle will be the more understandable. And this will be advantageous to sculptors who must exaggerate the muscles which cause the movements of the members more than those which are not employed in such movement.

Represent the arm from the shoulder to the elbow when it makes a circular movement by fixing the shoulder against the wall, and making the hand with a piece of charcoal turn around the shoulder, the arm being extended; and it will make in this circumduction all the actions of the muscles which move the shoulder. But make this shoulder from the dorsal spine to the thorax of the chest.

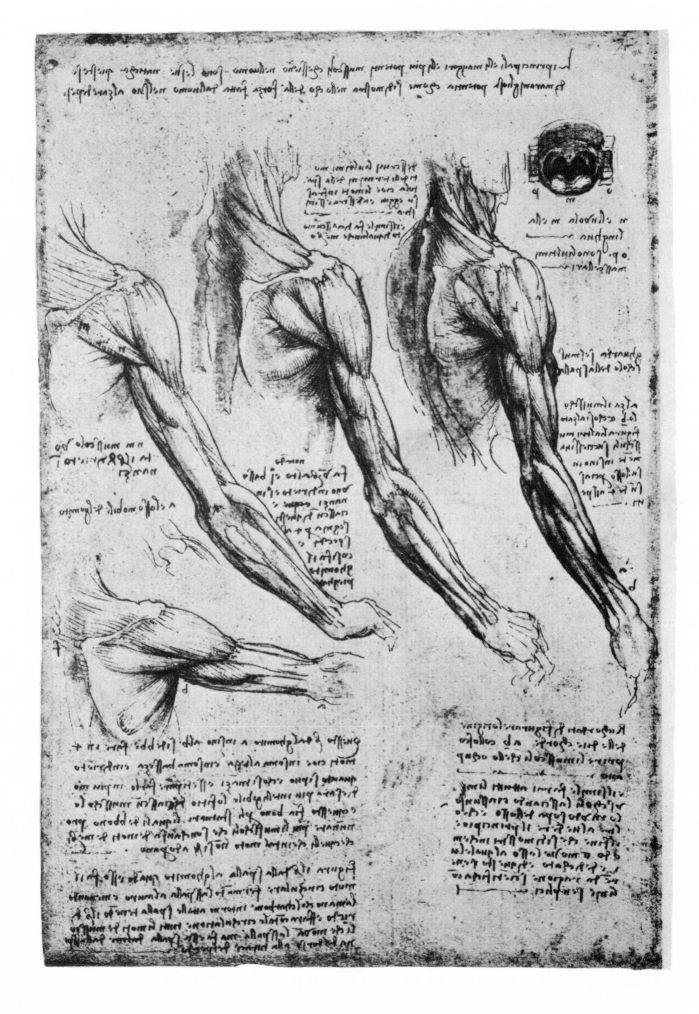

myology of shoulder region

One possesses a true conception of all figures if one knows their breadth, length and thickness; therefore, if I observe the same in the figure of man, I shall present a true conception in the judgment of all of sound intelligence.

Explain these words for they are confused.

fig 1. The shoulder seen from the back which covers the ribs behind the shoulder.

Above and to the right of the figure appears the reminder to include illustrations of the articulations and bones in various positions: *You will make all the movements of the bones with their joints after the demonstration of the first three figures of the bones; and this must be done in the first book.*

For lack of terminology the muscles are seldom named. In the figure the trapezius has been partially detached and its tendon and insertion on the acromion indicated by the letter a (resembling a lambda). The letter m, marks the levator scapulae; n, the supraspinatus; o, the infraspinatus; p (reversed); the teres minor; q (reversed), teres major; r, latissimus dorsi; S, rhomboideus minor, and above it, unlettered, the rhomboideus major. Note that the posterior portion of deltoid is shown as a separate muscle as in many other figures. Below the illustration is written the word *spine*.

fig 2. Muscles of the shoulder and neck: lateral aspect.

No comment accompanies this figure. The pectoralis major is divided into four fasciculi which are treated as separate muscles.

fig 3. Wire model of the direction of the fasciculi of the shoulder muscles.

Make it [the figure] *twice as large with the same thickness of ribs and muscles, and it will be easier to understand.*

Again, this figure would be confused unless you first made at least 3 demonstrations before this with similar wires; the first of such demonstrations should be simply of the bones, then follow with the muscles which arise in the breast above the ribs, and finally the muscles which arise together with the ribs from the thorax, and last that [figure] *which is above.*

Make the ribs so thin that in the final demonstration made with wires, the position of the scapula can be shown.

The wire or cord model is a unique characteristic of the work of Leonardo and serves two purposes. The first is to provide an understanding of the relations of the underlying to the surface structures, and the second to demonstrate muscle action. His preoccupation with function no doubt gave rise to a particulate theory of muscle action, and the breaking up of major muscle masses into their fasciculi as demonstrated in several of the drawings in this series as well as elsewhere.

fig 4. Deep muscles of the shoulder: anterior aspect.

First make the ribs.
Draw the ribs where the scapula n, is detached.

It will be observed that the outline of the ribs has been added secondarily to the figure.

In the subscapular region appears the word *dimestica* or "ventral". The letter n, indicates the subscapular muscle. Other structures readily recognized are the coracoid process and tendons of pectoralis minor and coracobrachialis, the suprascapular foramen, teres major, latissimus dorsi, the long heads of triceps and biceps. The serratus anterior muscle is described in the following note: *At n there is another muscle which intervenes between the cartilage* [?fascia] *which covers and binds the ribs, and the muscle n* [subscapularis] *which lies within the body of the scapula. . . .*

fig 5. Superficial muscles of the shoulder and axilla.

Before you represent the muscles, make in place of them wires which will show the position of these muscles, [and] *which will terminate at their extremities in the middle of the attachment of the muscles upon their bones. And this will provide a more ready understanding when you wish to represent all the muscles, one above the other. And should you do it in any other way, your representation will be confused.*

The teres major n, and latissimus dorsi m, are well shown. Their action as medial rotators will be commented upon in the next figure. The superb rendering of the trapezius and deltoid in contraction during abduction should be observed.

fig 6. Deep muscles of the shoulder and axillary region: anterior aspect.

The pectoralis minor is shown divided into two portions, the lower of which is labelled d f, and extends a little too low to the sixth rib. On this rib and its cartilage are the letters a h c, which will be referred to in Leonardo's note below. There he indicates the presence of the costal cartilage is to permit the rib to straighten out under the pull of the pectoralis minor. He must, therefore, be thinking of this muscle as an accessory muscle of respiration, an idea which was not fully developed until the time of Sir Charles Bell (1774-1842). Latissimus dorsi is indicated by m, and teres minor by n. The other structures, including the neurovascular bundle, are easily identified.

Why has the cartilage a h, been made to join with the rib h c? This occurs so that the cartilage may be bent by the voluntary movement of the muscle d f [pectoralis minor] *which by pulling on the arc* [of the rib and cartilage] *a h c, widens it and increases the cord of this arc, that is, the interval a c; and by the increase of these spaces in the entire chest* [. . .]

The illegible words no doubt lead to a fuller development of the idea of the pectoralis minor acting as an accessory muscle of respiration. This is also evident from the final note on this plate.

The muscles n [teres major] *and m* [latissimus dorsi] *are the cause of the turning motion of the humerus.*

Show here what muscles are the cause of respiration [and] *what occurs through the muscles and sinews* (nervi) *which are attached. to the external aspect of the ribs* [and] *which elevate those ribs, the cartilages allowing it.*

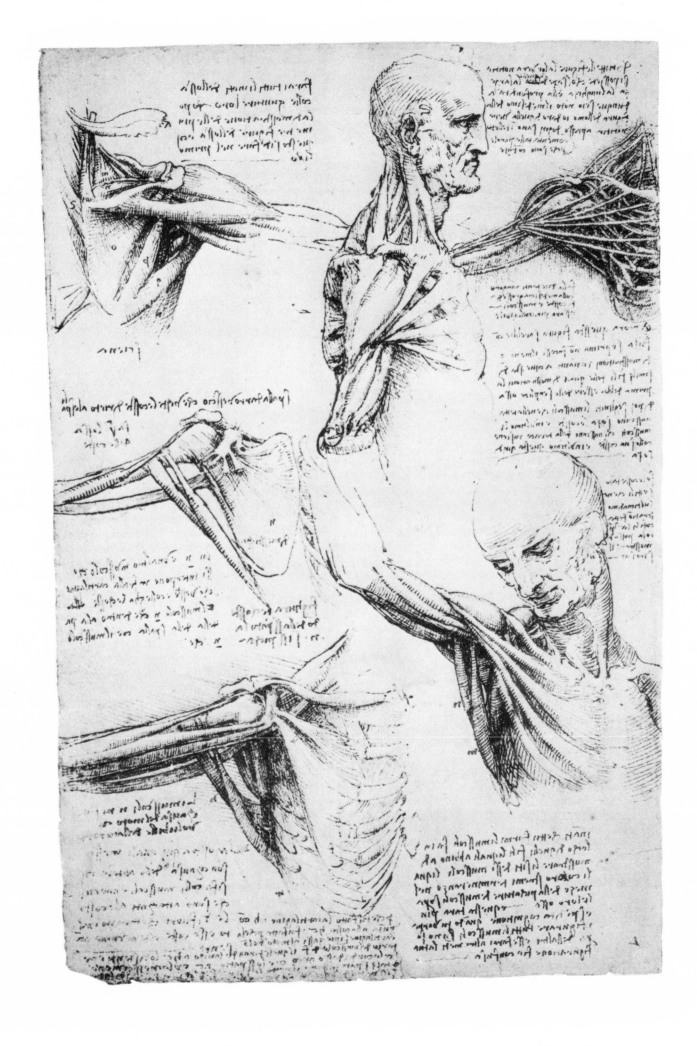

myology of shoulder region

At the top of the page appear the following comments on the superiority of the illustration combined with text for the presentation of human anatomy and function where words alone would fail.

And you who claim to demonstrate by words the shape of man from every aspect of his membral attitudes, dismiss such an idea, because the more minutely you describe, the more you will confuse the mind of the reader and the more you will lead him away from a knowledge of the thing described. Therefore it is necessary both to illustrate and to describe.

Should the actual object being in relief seem to you to be more recognizable than that which is represented—an impression which arises because one can see the object from different aspects—you must understand that in these my illustrations one obtains a like effect from the [several] similar aspects, hence no part of these members will be hidden from you.

Referring to this comment there appears below fig. 2, the note: *One will never understand the shape of the shoulder without this rule.*

fig 1. **Deep dissection of the muscles of the shoulder region: posterolateral aspect.**

The first demonstration of the deep muscles of the shoulder, figs. 4 and 6 being the second and third. The outline of the deltoid which has been elevated as in the other figures of this series is partially obliterated by the written note. These three figures have evidently been made from the same dissection and show three different aspects of it. The letters n, o, indicate clavicular and acromial portions of the trapezius muscle and p, the lateral end of the clavicle. It will be observed that the acromion is shown as a separate bone, the summus humerus, for the significance of which cf. 1. The quadrilateral space bounded by teres minor, teres major, the long head of triceps and the humerus, is beautifully shown. The purpose of the illustration is to demonstrate the action of teres minor and major as apparent extensors of the shoulder joint when the scapula is carried anteriorly around the thorax in flexion of the humerus and, in addition, to show the antagonism of these muscles as rotators when assisting the long head of triceps.

fig 2. **Superficial muscles of the shoulder, arm and forearm: anterior aspect.**

Write how each muscle can swell and shorten or become thinner or thicker, and which is the most or least powerful.

In this otherwise accurate drawing of the muscles of the upper extremity, there is some confusion in the region of the posterior triangle of the neck. The trapezius muscle is once again divided into separate fasciculi representing the clavicular, acromial and spinous portions of the muscle. The posterior belly of the omohyoid is duplicated, but the upper of these, placed at too high a level, may be a "trial" which the artist intended to erase as in fig. 3, where the muscle is again duplicated but the upper muscle not clearly outlined. The upper trunk of the brachial plexus is indicated in the floor of the triangle. The remaining muscles are clearly and accurately defined.

fig 3. **Superficial muscles of the shoulder, arm and forearm: lateral aspect.**

First draw this shoulder with its bones only and then opposite, draw it with the muscles shown here.

The only muscles indicated in this illustration are the abductor pollicis longus and extensor pollicis brevis with the remark: *Note where in the elbow, the two muscles n [abductor pollicis longus] and m [extensor pollicis brevis] arise. Describe each muscle, what finger it serves and what member; represent it therefore simply without any obstruction from any other muscle that is placed over it and so that afterwards one can recognize the parts which have been damaged.*

As in fig. 2, the trapezius has been divided into separate portions and the posterior belly of the omohyoid duplicated, although the upper of the two muscles is less distinct as though corrected for position by the lower representation. One can only admire the detailed accuracy of the drawing which with fig. 2 partially fulfils the promise of Leonardo's greater plan expressed in the preliminary note at the top of the page.

fig 4. **Deep dissection of the muscles of the shoulder region: anterior aspect; the second demonstration of the series shown in figs. 1 and 6.**

The muscle a b [pectoralis major] and the muscle d c [latissimus dorsi] serve to draw the arm towards the ribs so as to break away vigorously from the hands of anyone who grasps the arm, and this is the reason why they are such large muscles.

The shoulder, stripped of its largest muscle f [deltoid], has uncovered the muscle S t [pectoralis minor] which elevates the ribs of the chest when the lung within these ribs enlarges, and this muscle is drawn to the bone q, the coracoid process of the scapula (rostro della spatola), where it is attached; and this process together with the scapula is bound to the cartilage g [ligaments and capsule] the forepart of the clavicle p, and the clavicle itself is moved by the two muscles of the neck n o [portions of trapezius].

Leonardo seems to have believed that the primary action of the pectoralis major is to serve as an accessory muscle of respiration working in unison with the serratus posterior superior as discussed by him in 16. The chain of action is through the insertion of the muscle into the coracoid, the coraco-clavicular ligaments (better shown in fig. 6), the clavicle and the trapezius muscle to the vertebral column. This idea is further illustrated in the cord diagram of fig. 5.

fig 5. **Wire or cord diagram illustrating accessory muscles of respiration.**

The sinews or muscles [trapezius] which have arisen from the last cervical vertebrae serve the purpose of respiration when man stands upright, and they serve respiration together with the muscles of the neck [serratus posterior superior] which arise from the last vertebra of the spine of the back and [with] the action of these muscles of the chest which are o r, o t, o q [pectoralis minor shown as 3 cords],

(continued on page 493)

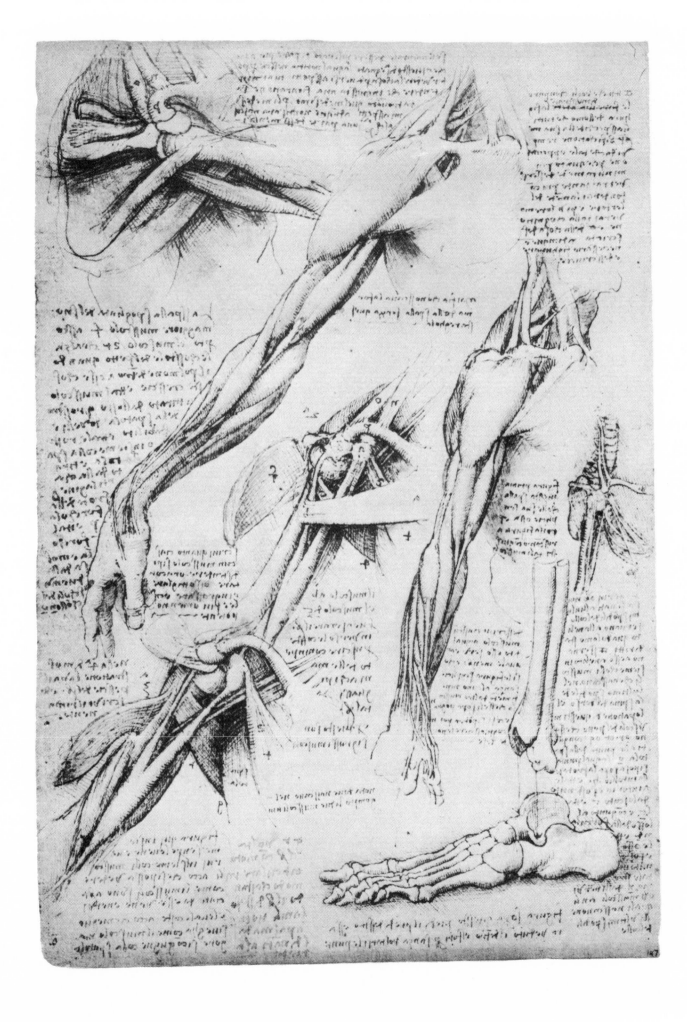

147

And thou, man, who, by these my labors dost gaze upon the marvelous works of nature, shouldst thou judge mutilation to be am impious thing, reflect then that it is of infinitely greater impiety to take the life of a man. Though his structure seem to thee a marvel of artifice, consider that it is as nothing compared to the soul which abides within this dwelling, and in truth, wherever it is, it is a divine thing which lets the soul dwell within its works and at its good pleasure and will not that anger and malignity should destroy such a life since, in truth, he who values it not, deserves it not.

For it parts from the body so unwillingly and I, indeed, believe that its tears and anguish are not without cause.

It will be recalled that Leonardo while in Rome in 1513 was afforded opportunities of continuing his anatomical studies at the Ospedale di Santo Spirito, but owing to reports of sacrilegious motives, maliciously spread by the jealous German mirror-maker, Giovanni degli Specchi, these privileges were withdrawn by Pope Leo X. The above passage may have been written following this incident. If this is the case, some of the illustrations may have been drawn as late as 1514, although other evidence suggests an earlier date.

Apparently unrelated is a further note on the preservation of health which is in part a paraphrase from the *Regimen sanitatis* of Arnold of Villanova, or one of the numerous modifications of that work such as the tract of Ugo Benzo. Milan, 1481. It is not difficult to discern from the Italian version that the note arose by word association from that given above.

Endeavor to preserve thy health in which thou wilt succeed the better the more thou guardest thyself from physicians.

For their mixtures are a kind of alchemy on which there are no fewer books than there are remedies.

figs 1-3. Three outline sketches to illustrate relative shortening of the forefoot on dorsi-flexion.

What are the members of man which lengthen or shorten on flexion; and what are those which, when one portion lengthens, the other shortens, and what are those which, when one portion shortens, the other lengthens.

In the first of these sketches, the interval between the great toe d, and the tip of the lateral malleolus c, is shown to undergo a relative increase on dorsiflexion when compared to the same interval on plantar flexion as shown in the second figure where the same points are labelled b, and a, respectively. In the third figure the bony outlines show this more clearly, and the following points are indicated by letters: f, the distal phalanx of the great toe; m, the tibia; a, the lateral malleolus labelled at the axis of motion; n, the tip of the lateral malleolus; o, the calcaneus. Leonardo's note referring to the third of these small figures reads as follows:

When m [tibia] approaches f [the toes], a, the axis of the foot, remains constant and a [error for n, the tip of the malleolus] departs from the aforementioned f.

The figures illustrating the muscles of the shoulder region are a continuation of the series seen in 49. For the most part, the dissections have been carried a stage further so as to expose the joint itself. Among the notes is a reminder to express the physical attitudes of the emotions, for which Leonardo employs the mediaeval term sentiments, by emphasizing the muscles which contract in their expression. This information would be of great value to the artist and sculptor. The note is thus quaintly expressed:

One must make the sentiments which employ force, more evident in their muscles than those which do not employ these forces.

fig 4. Dissection of the muscles of the shoulder: posterior aspect.

In this figure the following structures are indicated by the lettering. A portion of the trapezius muscle is reflected and its tendon n, detached from its point of insertion on the acromion, also n. On the muscle is written the word *omero*, an abbreviation for *musculo del omero* or muscle of the shoulder which is used by Leonardo variously for the trapezius or deltoid. The origin of the deltoid is indicated by the letters a d, placed on the spine and acromion of the scapula and on the corresponding margins of the detached muscle. The deltoid itself carries the single word *spalla* standing for *musculo del spalla*, or muscle of the shoulder which is likewise variably used. The humerus is identified by the word *osso*, bone. The letters r h, mark the brachialis muscle which in the note given below is established as the pure flexor of the forearm. Other structures easily recognized are the levator scapulae, coraco-clavicular ligament, supraspinatus, infraspinatus, teres minor and major, latissimus dorsi, long and lateral heads of triceps, long head of biceps, and the radial nerve. Observe that the long head of triceps is shown incorrectly arising from the base of the spine of the scapula. Leonardo's note on the action of the brachialis muscle follows:

r h [brachialis] is the muscle which bends the [fore-]arm in an angle, and it is alone in this office, and it arises from the middle of the humerus (aiutorio) and is attached to the [proximal] quarter of the ulna (fucile maggiore).

For the origin of *aiutorio* and *fucile maggiore*, cf. 11, and 12.

fig 5. Dissection of the shoulder as viewed from above.

The shoulder viewed from above, the eye occupying a position more towards the loins (le reni) than towards the anterior parts; and one sees the internal part of the scapula of this shoulder, that is, that part which is in contact with the ribs; and I have done this to expose the very large muscle m n o [subscapularis].

The articulation of the clavicle with the acromion is indicated by guide lines. The subscapularis is well shown passing below the coracoid process to its insertion. The structures attached to the coracoid are, posteriorly, the coraco-clavicular ligament; anteriorly, pectoralis minor constituted of the three medial tendons representing the three fasciculi into which Leonardo divided this muscle; the fourth and most

(continued on page 493)

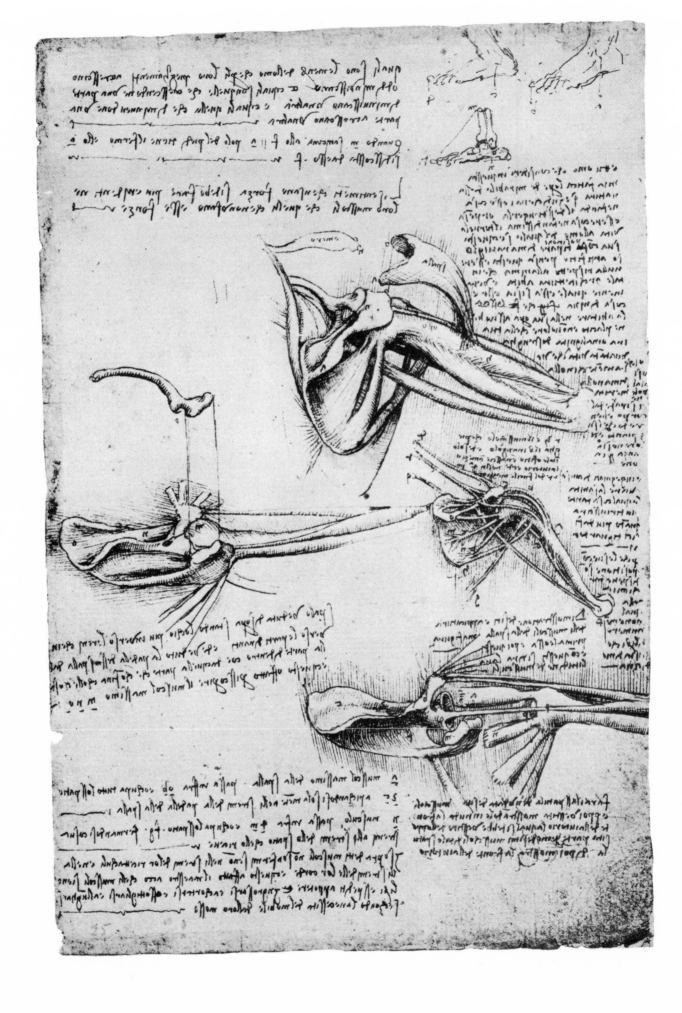

figs 1-2. **Surface modeling of the arm in extension and flexion.**

When the arm is bent in an angle at its elbow or forms an angle of any sort—the more acute this is, the shorter the muscles within this angle, and the opposed muscles are extended to a greater length than they ordinarily are, as you might say in the example a [for n, biceps brachii], *c* [brachialis], *e* [brachio-radialis] *are greatly shortened and b* [triceps], *n* [extensors of forearm] *greatly lengthen themselves.*

In fig. 2, the other structure lettered is the lateral epicondyle d.

The vigor and freedom of the drawings, quite unlike that of a later period, have suggested that they were done around the time of the Anghiari cartoon and therefore c.1504. The modelling, though reasonably accurate, is not nearly so detailed as that of both earlier and later date. They should be compared to those of 52, which are very similar in style.

fig 3. **Small sketch of torso indicating a study of spinal balance.**

Extraneous to the subject is a sketch of a watermill in black chalk and upside down.

Although intended to be read from below upward and from right to left, the figures will be enumerated in the opposite direction except for that lying above and to the right which will be considered last.

fig 1. Bones of the arm and forearm showing the brachialis muscle.

All the muscles have been removed except the brachialis which is shown passing from its origin in the distal two-thirds of the humerus to its insertion into the coronoid process of the ulna. Leonardo correctly regarded this muscle as the only pure flexor of the forearm, cf. 54.

fig 2. The biceps muscle has now been added. The sketch is full of errors, suggesting that it was done from memory. The radius and ulna appear to have been transposed, and the tendon of biceps passes beneath that of brachialis. It is clear that at this stage the middle period of his anatomical investigations, Leonardo had not yet appreciated the mechanism of pronation and supination, cf. 54, 212.

fig 3. Similar figure to the above in which some of the extensors of the forearm have been added, but a very rough and confusing sketch.

fig 4. The deltoid, triceps, flexors and extensors of the forearm have been added providing an outline which is reasonably accurate. Leonardo was evidently more familiar at this time only with the general arrangement of the superficial muscles.

fig 5. Superficial muscles of the arm and forearm posterior view.

A fairly accurate sketch of the superficial muscles but not nearly so detailed as those of a later period.

fig 6 [top right]. Enlargement of a portion of the above fig. 5.

In style these figures resemble those of 51, and probably date from c.1504 when Leonardo was dissecting in Florence. They are transitional between the traditional sketches of the earliest period and the more detailed anatomy of a few years later when the idea of a textbook had more fully developed.

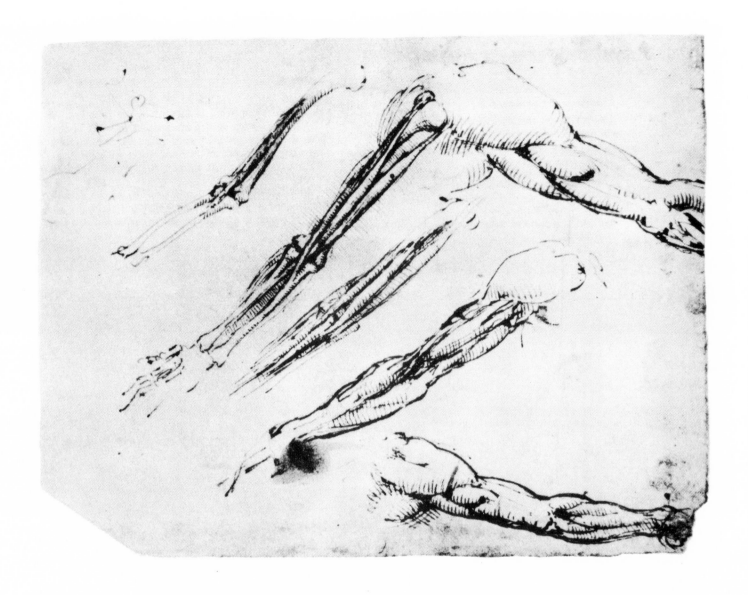

myology of upper extremity

fig 1. **Superficial dissection of root of neck, arm and forearm: anterior aspect.**

The dissection reveals the superficial veins and muscle masses with great faithfulness.

fig 2. **Deep dissection of superficial muscles of arm and forearm.**

The dissection has been carried a step further. The superficial veins have been removed, and the muscles are more clearly delineated.

figs 3-4. **Superficial muscles of arm and forearm: lateral aspect.**

These figures should be compared with those of 42, especially fig. 4 of that plate, where the surface appearance of these muscles is shown. No difficulty should be encountered in identifying the various muscles since they are well portrayed. At the foot of the page is a note on the function of the muscles and their relative power. The comparison with birds reflects Leonardo's great interest in the mechanics of flight.

No movement of the hand, or of its fingers, is produced by the muscles which are found from the elbow upwards; and it is the same in birds, and it is for this reason that they are so powerful because all the muscles which lower the wing arise from the chest and have in themselves a greater weight than those of all the rest of the said bird.

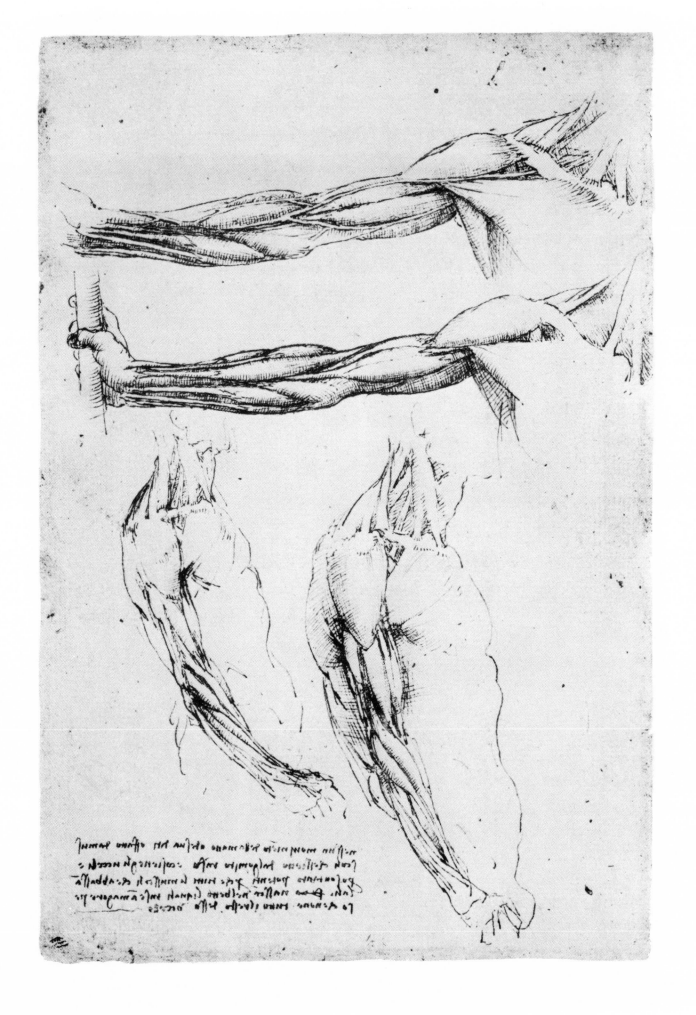

myology of upper extremity

fig 1. **A small sketch of a seated figure.**

fig 2. **Flexor muscles of the arm: anterior aspect.**

This rough sketch of the arm flexed and pronated at the elbow is apparently to illustrate the change of shape and position of the biceps brachii muscle when it acts as a supinator. It will be observed that the muscle possesses a double outline, the inner or medial of which would correspond to its position in flexion and pronation, the outer lateral being that occupied by the muscle in flexion and supination. The action of brachio-radialis as a flexor when the forearm is pronated is clearly expressed.

At the foot of the page is a note which is not in Leonardo's holograph but has been identified by Calvi as that of Francesco Melzi. It reads:

ON THE OCEAN.

If the water becomes so salt through the earth being scorched by the sun, it should follow that earth boiled in water would make the water salty.

This folio is in reality a portion of a large sheet which was once folded but is now divided into two. The other half, reproduced in the Quaderni edition as f. 20v, contains a note in Leonardo's hand on the motion of the wind. This has been omitted here as not pertinent to the present subject.

T

feLomano

fe Laqua fetuoffi falfa p La terra rearfa oiso llo effiguurochi
chella terra folua nella aqua farebe falfo nela aqua

myology of upper extremity

figs 1-2. **Sketches comparing the leverage of the muscles of the upper arm in man and monkey.**

The first figure is labelled *monkey*, the second, *man*. The note reads: *The nearer the hand the sinew c d* [flexor muscle] *flexes the bone o p* [ulna] *the greater the weight the hand can lift; and it is this which*

makes the monkey proportionately more powerful in his arms than man.

fig 3. **Diagram to illustrate the proportional advantages with the increase in length of the lever arm.**

The forces are indicated by the numerals 2,3,4,6, as the fulcrum is approached.

myology of upper extremity

At the top of the page Leonardo attempts to classify muscles into various morphological types according to the nature of their origin and insertion. One of these types is illustrated by a sketch of the subclavius muscle.

There is a type of muscle which begins in a cord and terminates in a cord, and this is divided into two classes, one of which has its cord expanded and converted into cartilage [not cartilage in our sense, but a flat aponeurotic-like tendon], *and the other has its cord rounded in the form of a cord.*

The 2nd type of muscle has its cord only at one end, and this is further divided into two classes, of which one has expanded cords converted into cartilage, the other remaining quite round.

fig 1. **The clavicle and subclavius muscle.**

The faint sketch buried in the text shows the clavicle p n, to which is attached the subclavius muscle a b n, spreading out like a fan.

There is another type of muscle [e.g., subclavius] *which is attached by its lower part over its entire length to the bone covering it, and in this type each of its smaller parts has a different length, and the shortest is the most powerful.* [Thus in] *a b p n, the* [subclavius] *muscle lies as shown at a b n, attached to the bone of the arm p n* [clavicle] *so that the portion a b, is longer than the portion b n.*

Another type is that which begins in flesh, arising from a bone and terminates in a cord, or I may say, begins in a cord and terminates in flesh.

The above considerations lead Leonardo to the idea of representing the muscles attached to each bone separately.

Make for each bone taken separately, its muscles, that is, the muscles which arise from it.

fig 2. **The superficial muscles of the arm and forearm: lateral aspect.**

This figure, like fig. 5 below, seems to belong to the series found on 45, 46, 47. However, the features of the subject are identical with those of the specimen found on 43, 48, and therefore is probably derived from a separate dissection.

figs 3-4. **Superficial and deeper dissection of the facial muscles.**

In these remarkable figures many of the important facial muscles are clearly identifiable. The second figure is a deeper dissection in which the masseter muscle and a portion of the ramus of the mandible have been removed to expose the insertion of the temporals and the buccinator muscle, a. The lettering in the two figures is as follows: p, median portion of frontalis; h, lateral portion of frontalis; g and p, temporalis; o t, procerus and nasalis; b r, o r, and c s, angular, infraorbital and zygomatic heads of quadratus labii superioris; c a, zygomaticus; m n, masseter; a (in both jaws), buccinator; n, ramus of mandible; f, zygomatic bone. In the second figure caninus may be discerned. Of these various structures Leonardo remarks:

h [lateral portion of frontalis] *is the muscle of anger; p* [median portion of frontalis] *is the muscle of*

sadness; *g* [part of temporalis] *is the muscle for biting; g n m* [temporalis and masseter] *is one and the same muscle* [in function]; *o t* [procerus] *is the muscle of anger.*

Note which nerves are those which serve the muscles b o c [heads of quadratus labii superioris] *of the human cheek, placed here above.*

a [buccinator] *is the muscular flesh which arises from the gums above and terminates in the gums below, and it ends in the jaw and in the mouth.*

The muscle m [masseter] *is larger than the muscle p* [posterior portion of temporalis] *because it has to do more work.*

I elevate the muscle m, and its position remains as is seen in the other head [fig. 4] *at n.*

And I elevate the muscles o c [heads of quadratus labii superioris], *and the bone f* [zygomatic] *remains* [in fig. 4].

Represent all the causes of motion which the skin, flesh and muscles of the face possess and [see] *if these muscles receive their motion from nerves which come from the brain or not.*

And do this first for the horse which has large muscles and clearly evident parts.

Notice whether the muscle which raises the nares of the horse is the same as that which lies here in man at f, and which emerges from the [infraorbital] *foramen of the bone f.*

fig 5. **Superficial muscles of the arm and forearm: anterior aspect.**

A single note draws attention to the fasciculi of the deltoid, a b c d.

Note where the lowest parts of the muscles of the shoulder a b c d [deltoid fasciculi] *are attached and which of them are attached to the bone called the aiutorio* [humerus] *and which are attached to other muscles.*

fig 6. **The distribution of the median and ulnar nerves in the hand.**

This splendid figure of the digital distribution of the median and ulnar nerves shows the great attention paid by Leonardo to the mechanism of the hand, and his simple experiment recounted below, how great was his insight. The margins of the fingers are lettered c a n m b, in relationship to the experiment. But first he asks whether masking of sensation occurs.

See if you think that this sense [of touch] *is affected in an organ player while at the same time the mind is attentive to the sense of hearing.*

Why does the same object touched by the side of the finger b, and by the side of the 2nd finger a, appear to be double and if touched by n m, appear single? It is because n m, derive from a single nerve and a b, arise from two nerves.

Here is motion and sensation.

Here, following a cut in the hand, sometimes the sensation and not the motion of the fingers is blocked, and sometimes the motion and not the sensation. Sometimes it is both sensation and motion.

If one and the same object is touched at c and n, it appears to be two.

(continued on page **494**)

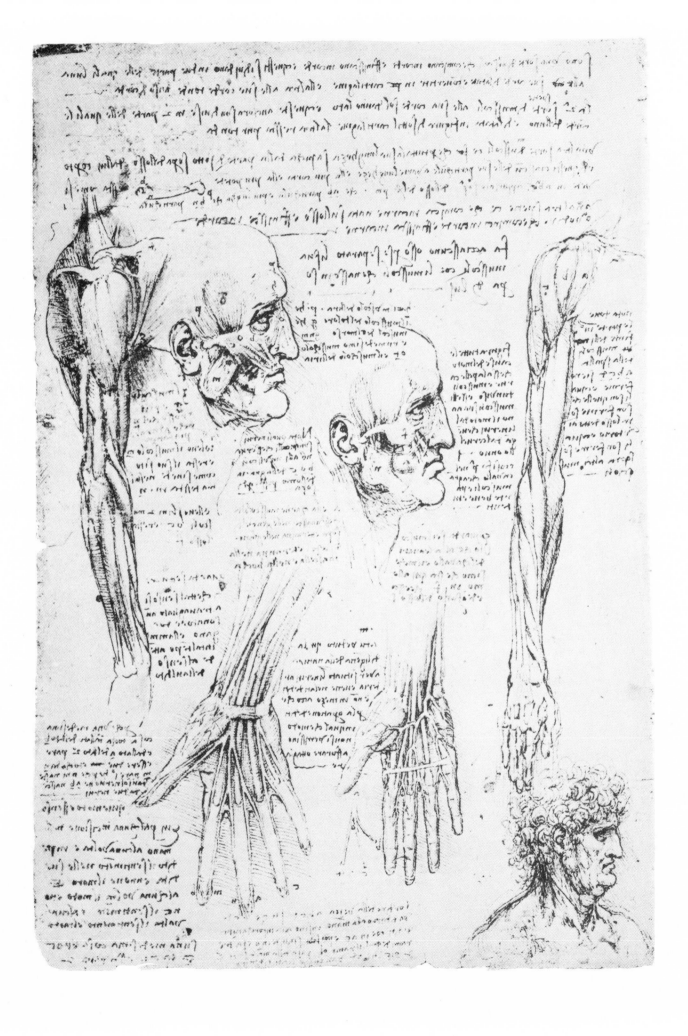

These 10 demonstrations of the hand would be better turned upwards, but my first general demonstration of man obliges me to do otherwise having had to draw it with the hands directed downwards, and in order not to discard my principle, I am obliged to make them turned downwards.

Only 4 of the 10 demonstrations mentioned in Leonardo's note appear on this page. They are in order, figs. 7,8,1,3, of our numeration. The fifth and sixth demonstrations of the series are to be found on 56, where they constitute figs. 5-6. Demonstrations 7 to 10 have not been identified. This passage should be compared with that of 10 where Leonardo discusses his intended method of presenting the anatomy of the hand, likewise in ten demonstrations but not corresponding entirely to those numbered here. We may assume from his statement that the first illustration of his anatomy was to have been the intact figure in the upright posture but, if such a figure was constructed, it has not survived.

fig 1. Third demonstration. Deep dissection of the palm of the hand.

The tendons of flexor digitorum profundis and flexor pollicis longus are shown passing beneath the transverse carpal ligament, in the form of two bands, p q, to gain their insertion into the terminal phalanges of the digits. Attention is called to the expansion of the tendons at their insertions by the letter b. Flexor carpi ulnaris and flexor carpi radialis are easily identified. The structure, resembling a tendon and passing to the base of the thumb on the radial side of flexor pollicis longus, is probably the radial artery. The ulnar nerve, dividing into its two terminal branches, is seen in faint outline reflected over flexor carpi ulnaris to the medial side of the forearm. The following general notes are appended to the illustration:

Show and describe what cord in each finger is the most powerful and the largest, and arises from the largest muscle and the largest sinew and is placed upon the largest digital bone.

The cords of the palm of the hand together with their muscles are very much larger than those of its dorsum.

TO BE NOTED.

Note how the muscles [interossei] which arise from the bones of the palm of the hand are attached to the first bone of the digits, how they flex them and how the nerves are distributed there.

Leonardo's reminder to describe the tendon arising from the largest muscle and largest nerve needs explanation. In Aristotle's view, *Historia animalium*, III:5:515a; *De partibus animalium*, III:4:666b ff., the nerve formed the connective tissue of a muscle and was the active element producing the contraction, and the flesh, the inactive. Galen and the mediaeval anatomists held that muscle was formed by the interweaving of nerves, arteries and veins, intermixed with ligament. The tendon was a mixture of ligament and nerve. Hence, according to both theories the

nerve was proportional in size to the muscle and an indication of its "power".

Describe how many coverings (panniculi) intervene between the skin and the bones of the hand.

In connection with this note it should be observed that in the six demonstrations of this plate and of 56, the palmaris longus and the palmar aponeurosis are not represented.

The final note on this figure concerns the innervation and sensation of the fingers. Leonardo was aware of the distribution of the median nerve to the lateral $3\frac{1}{2}$ digits and of the ulnar nerve to medial $1\frac{1}{2}$ fingers, cf. 56, fig. 5. He provides the following interesting experiment on confusion in localization of a painful stimulus to the crossed fingers:

If you cross the digits c d [ring and middle fingers] so that a [ulnar border of ring finger] and b [radial border of middle finger] touch one and the same object between them, and this object stimulates them so that the 2 fingers are made painful, I say that the object will give rise to pain in 3 places although applied to 2.

And this occurs because a, is provided with sensation by the nerve [ulnar] which passes below the elbow, and b, has its sensation from the nerve [median] which passes the joint in the interior of the elbow.

fig 2. The digital bones illustrating the insertion of the long flexor tendons.

The penetration of the tendon of flexor digitorum sublimis by flexor digitorum profundus greatly interested Leonardo because of the mechanical principles involved. Therefore, around and about the sketch he writes the reminder to include in his projected work a section on mechanics with examples before taking up the action of muscles.

Arrange it so that the book on the elements of mechanics, with its practice, comes prior to the demonstration of movement and force of man and of other animals, and by means of these [examples] you will be able to prove all your propositions.

fig 3. Fourth demonstration. Intermediate dissection of the palm of the hand.

This dissection is carried to a position intermediate between that of fig. 1 on this plate and fig. 5 of 56. The median nerve has been reflected laterally and the ulnar nerve, medially. The arrangement of the flexor digitorum sublimus and profundus muscles entering the flexor sheaths to pass to their insertions is admirably displayed. The four lumbrical muscles are clearly indicated. In the hypothenar eminence the abductor, flexor and opponens digiti quinti may be identified. The structure on the radial side of the tendons of flexor pollicis longus and flexor carpi radialis is the radial artery. The transverse carpal ligament is again shown as two cords extending from p to q, but is a single structure in fig. 5 of 56. From the accompanying note it is impossible to determine whether Leonardo mistakenly regarded the transverse carpal ligament as a muscle or is referring to the action of the muscles of the thenar or hypothenar eminences.

(continued on page 494)

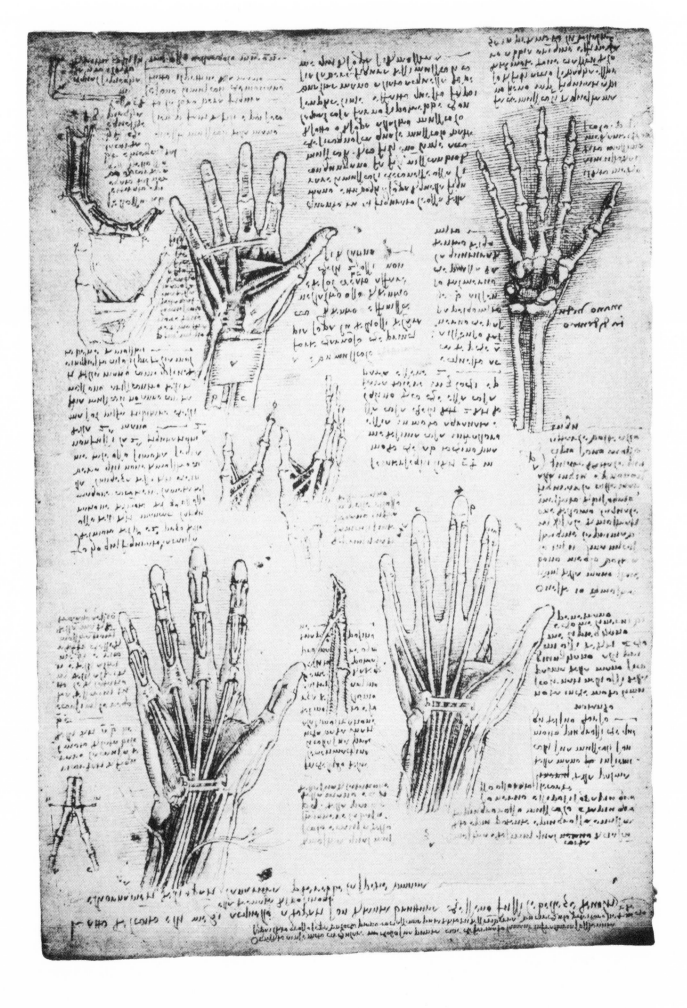

It was Leonardo's intention, as stated on 60, to introduce illustrations of the surface features prior to the figures of the anatomical dissections. On the plate mentioned above he was to compare the human leg with that of the frog and of the hare. Here he compares it with the hind limb of a horse. The similarity of subject matter suggests, despite differences in style, that these two plates are companion pieces of the same date. And since he calls 60 the second demonstration, perhaps this is the first.

fig 1. **Surface anatomy of the lower extremity: lateral aspect.**

Below the figure is the note:

Describe which muscles disappear upon [the man] *growing fat, and which muscles are uncovered, on growing lean.*

And note that those regions on the surface of a fat man which will be more concave, will become more elevated when he grows thin.

fig 2. **Surface anatomy of the lower extremities: posterior view.**

The pose and proportions of this figure are identical with those of 60, with which it should be compared. In fact, so close are the proportions that it is fairly safe to assume that the figure on the plate mentioned and figs. 1-3 of this plate were obtained from one another by the method of transformation or parallel projection in which any required figure may be developed from any two others provided they are in planes at right angles to each other. This method was highly developed by the Milanese artists and entirely familiar to Leonardo who illustrates the technique (Clark, 12605r).

fig 3. **Surface anatomy of lower extremity and torso: lateral aspect.**

In this more finished drawing, the left leg is a repetition of that in fig. 1. It will be observed that errors in surface contour of the gluteal region are the same as those seen in fig. 1 of 20, where the gluteus medius muscle is shown as two distinct muscles. It appears that Leonardo failed to distinguish the outline of the fat of the buttocks from that of gluteus maximus and manufactured his muscles to conform to surface appearances with which he was more familiar. The pose of these several figures is similar to that of those made for the Anghiari cartoon. Beside the figure is the notation:

Where the muscles are separate from one another, you will make profiles, and where they fuse together: and you will draw only with a pen.

This statement as it stands is almost unintelligible. The key to the meaning is provided by the notes on muscles given on 20. There we learn that by "profiles" Leonardo meant outlines in pen and ink of the individual muscles to show their shape and cross-sectional appearances.

fig 4. **Wire or cord diagram of the muscles of the hind-limb of a horse.**

fig 5. **Wire or cord diagram of the hip muscles of man.**

fig 6. **The bony skeleton of the pelvis and thigh, ostensibly of man.**

These three figures are for comparative purposes. In fig. 5, the cords show diagrammatically the position and attachments of the adductors, sartorius, tensor fasciae latae, gluteus medius (as two muscles), gluteus minimus and maximus. The supposedly corresponding muscles of the horse are shown in fig. 4, but very inexactly. Presumably the cords represent the adductor, sartorius, tensor fasciae latae, gluteus superficialis or gluteus medius and gluteo-biceps of the horse. The elongation of the innominate bone and the length of the coccyx in fig. 6, suggest the pelvis of an animal rather than of man. In addition, the observer will note a trochanter tertius below the greater trochanter. From these appearances fig. 6 seems to have been derived by the expansion of animal bones to the approximate proportions of the human. The notes read from right to left:

Fusion of fleshy muscles [as the vasti] *with the bones, without any sinew or cartilage—and you will make the same in several animals and birds.*

Make a man on tip-toe that you may better compare man with other animals.

Draw the knee of man flexed like that of the horse.

To compare the skeleton of the horse with that of man, you will make the man on tip-toe, in drawing the legs.

On the correspondence which the shape of the bones and muscles of animals have with the bones and muscles of man.

First make the bones separated with the sockets where they join and then join them together, and especially the hip-joint (scia) or the joint of the thigh.

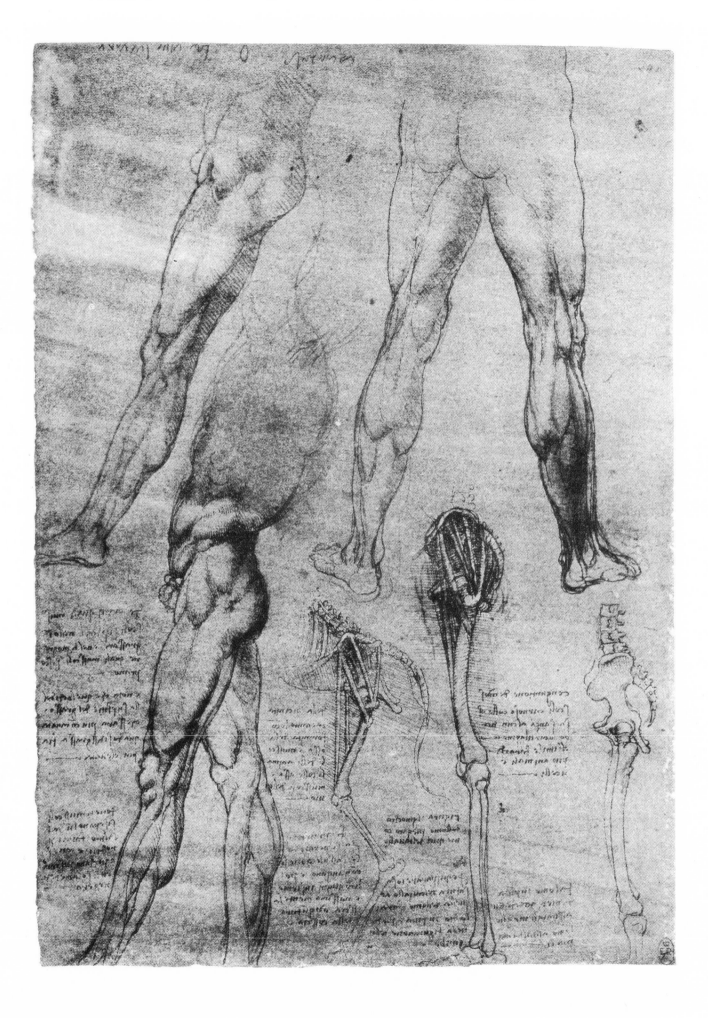

myology of lower extremity

fig 1. **Surface anatomy of lower leg: lateral and posterior aspects.**

This exquisite drawing was evidently designed to show the surface contours of the lower leg as indicated in the note below. The drawing dates from probably the period of the Anghiari cartoon, c.1504-05, or perhaps even later. Note the greater accuracy exhibited in the modeling of biceps femoris and the ilio-tibial tract as compared with the earlier drawings of 64 and 65.

Above and to the left is written, *the feet*. The note reads:

Nature has made all the muscles appertaining to the motion of the toes attached to the bone of the leg and not to that of the thigh, because when the knee-joint is flexed, if attached to the bone of the thigh, these muscles would be restricted and bound under the knee-joint and would not be able, without great difficulty and fatigue, to serve the toes; and the same occurs in the hand owing to the flexion of the elbow.

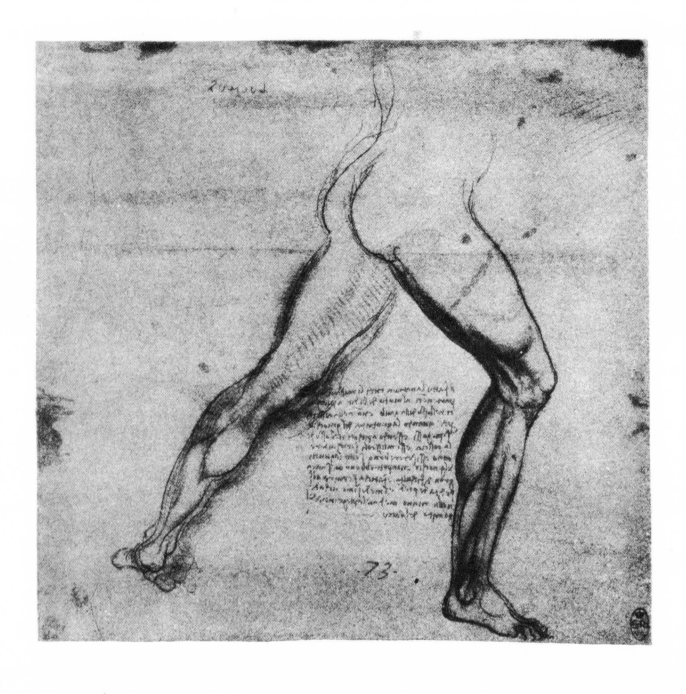

60

myology of lower extremity

fig I. **Surface anatomy of the lower extremity: anterior aspect.**

A second demonstration interposed between the anatomy and [the representation of] the living.

As indicated in Leonardo's caption, this beautiful representation of the surface anatomy was intended as a transition between the representation of the living body in motion, as described in his discussions on "the order of anatomy" in 71, and views of the dissection of the surface muscles as in 61 and 63. Closely allied to the present drawing is 62 where the right leg only is shown in almost the identical pose of the left leg seen here. A note on comparative anatomy follows the caption.

You will represent for a comparison the legs of a frog which have a great resemblance to the legs of man, both as to bones and to their muscles; then you should follow with the hind limbs of a hare which are very muscular and which have active muscles because they are not encumbered with fat.

Very similar ideas have been carried out in 58, a drawing of slightly earlier date, where the hind limb of a horse is compared to the lower extremity of man. The general style and pose of the present drawing suggest a study of the Anghiari period and therefore sometime between 1505-08. The plate bears the number 55 believed to be that assigned by Pompeo Leoni after he obtained possession of the note-books.

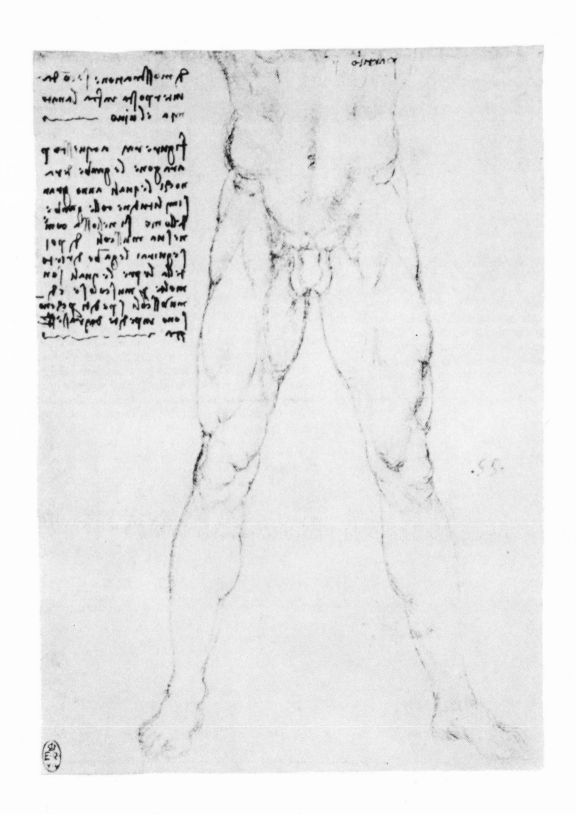

61 myology of lower extremity

fig 1. Dissection of axilla and arm (badly rubbed charcoal drawing).

Make a demonstration with lean and thin muscles so that the interval which develops between one another makes a window to show what is formed behind them.

As in this sketch of a shoulder made here in charcoal.

This practice was no doubt responsible for the division of certain of the larger muscles into separate fasciculi, as may be observed in the case of the pectoralis major muscle in 48.

fig 2. Superficial muscles of the lower extremity: anterior aspect.

This figure is one of several posed in similar manner suggestive of Leonardo's studies for the Battle of Anghiari. The muscles are accurately represented if somewhat exaggerated in size, cf. 47 on reason for the exaggeration. In the thigh Leonardo largely confines his investigations to the superficial muscles and is very unclear on their deeper attachments. In the accompanying notes he classifies muscle attachments generally into three types: first is direct insertion by means of a tendon; second, indirect attachment through a common insertion; third, described for the case of the tensor fasciae latae, is a combination of the first two. In the latter portion of the note, which is directly related to the figure, he states that the tensor fasciae latae is attached to the vastus lateralis, presumably through the deep surface of the ilio-tibial tract, and thus indirectly to the femur. In addition, he believes that the tensor has a direct attachment into the femur in this region of the greater trochanter possibly referring to the fascia which extends from the deep surface of that muscle. This is his third method of attachment as it is both direct and indirect.

NATURE OF MUSCLES.

As the cords of muscles are of greater or lesser length, so man has a greater or lesser amount of flesh. And in a lean individual the flesh always retreats towards the origin of its fleshy part. And in taking on robustness (pinguedine), [the flesh] extends down towards the origin of the cord.

HOW MUSCLES ARE ATTACHED TO THE JOINTS OF THE BONES.

The end of each muscle is converted into a cord which binds together the joints of the bones and to which this muscle is attached.

ON THE NUMBER OF THE CORDS AND OF THE MUSCLES.

The number of cords which successively one above the other cover each other and all of which together clothe and bind the bony joint to which they are attached, is the same as the number of muscles which run together at the same joint.

As the attachment of the muscle b [tensor fasciae latae] is made with the bone of the thigh and, in truth, with the muscle a [vastus lateralis] or, rather, the muscle b, and the muscle a, since they are united and are attached to and fixed upon the bone of the thigh. And this 3rd method [of attachment] is more useful for the benefit of the motion of this thigh, and more secure, because if the muscle a, were cut or otherwise injured, the muscle b, would itself move the thigh which it could not do if it were not united to the bone between b and a [at the base of the greater trochanter].

In the first portion of the above note, Leonardo uses the term *pinguedine*, literally "fat". However, all mediaeval anatomists, following Aristotle and Galen, recognized two kinds of corpulency, that due to fat proper and that due to flesh. Hence we have rendered the term "robustness" to provide a better feel of the sense.

The final note, found in the lower right-hand margin, reads: *The muscles are of two shapes with two different names, of which the shorter is called "musculus" and the longer is called "lacertus".*

Here Leonardo mentions two of the three terms commonly employed by mediaeval anatomists to describe a muscle in terms of its shape. It should be remembered that the terms at this period still contained the imagery of their derivation so that *musculus* meant "a little mouse" (from μῦs) and was reserved by some for a short muscle, while *lacertus*, a lizard, was used for long muscles, cf. 43. This distinction was not always followed, and the terms were frequently regarded as synonymous. In the case of muscles possessing two heads of origin, the third term *pisciculus*, diminutive of *piscis*, a fish, was common and is so used by Leonardo in 45.

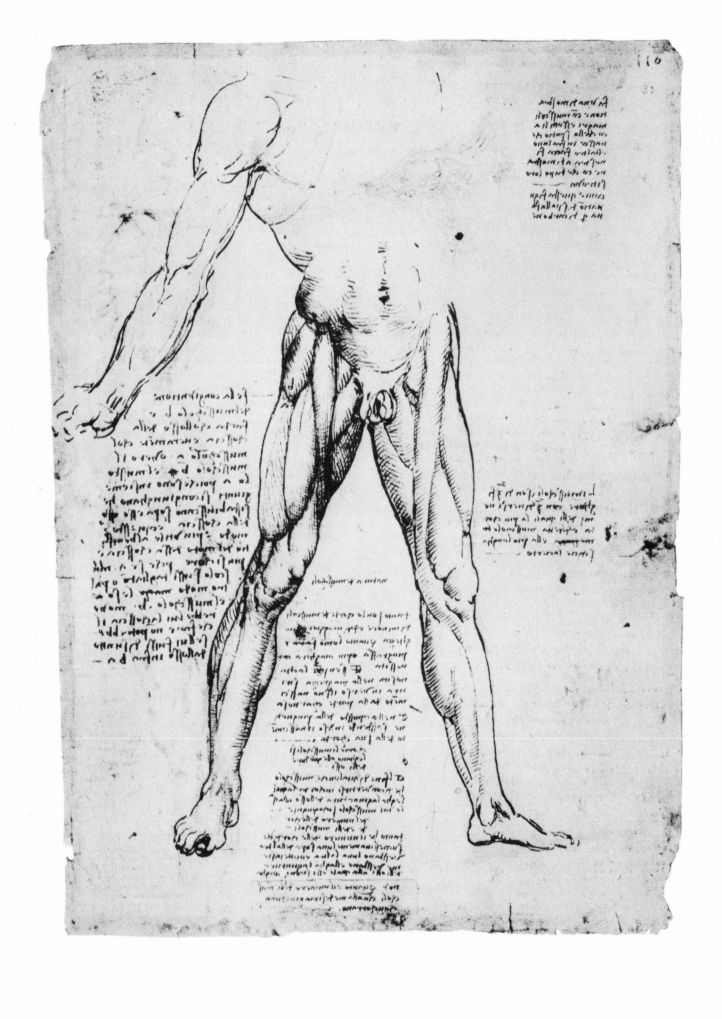

myology of lower extremity

fig 1. **Surface anatomy of lower extremity: anterior aspect.**

The figure is very similar to 60 and was numbered by Pompeo Leoni to follow it, and with good reason since not only are they related stylistically but are drawn on the same paper. The modelling of surface muscles is carefully done and differs from the preceding in that the limb is in moderate lateral rotation to reveal the outline of the gracilis muscle medial to the adductor mass.

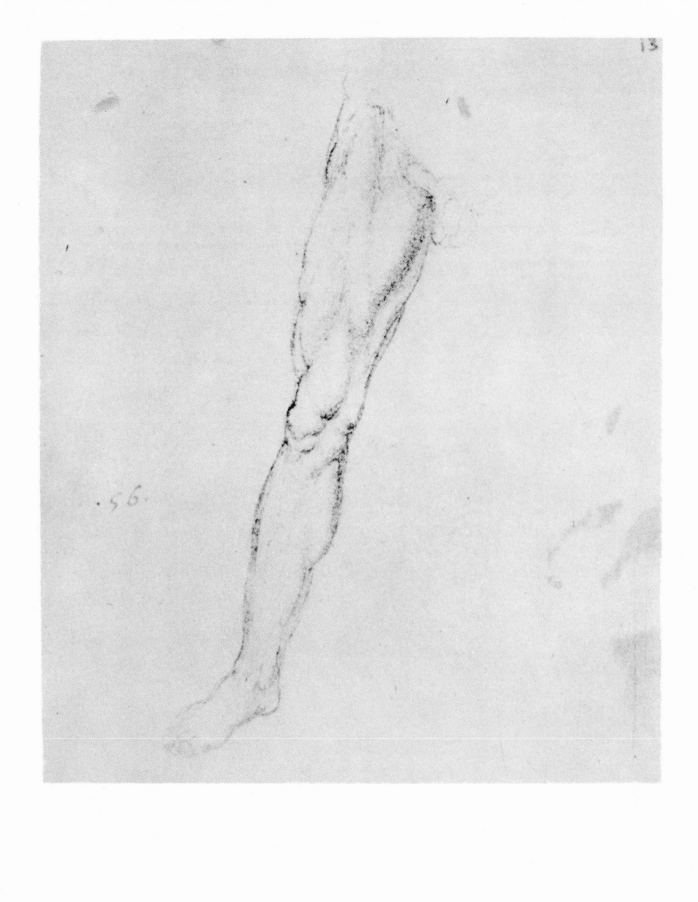

·56·

fig 1. **Superficial muscles of the thigh and calf: anterior aspect.**

The figure is very similar to those on 20, 61, 169, of approximately the same date. The pose is a favorite one and suggestive of the series for the Anghiari cartoon. The muscles are represented with some accuracy except for the upper end of the rectus femoris muscle.

fig 2. **The external and internal intercostal muscles.**

The direction of the fibres of the intercostal muscles is indicated by the letters a b, a c, but it is evident that Leonardo is confused since the fibres of the external intercostals run in the opposite, instead of the same direction in contiguous intervals. This error leads to a curious statement as to their action which contradicts the opinion held elsewhere, although reference is made to the tendons rather than to the muscles themselves.

The mesopleuri [intercostal muscles] *are those sinews which bind the ribs together. Not only do they bind them and prevent their dilatation, but they also prevent transverse movements.*

fig 3. **The interosseous muscle of the foot.**

This figure is a continuation of the series on the dissection of the foot found on 80.

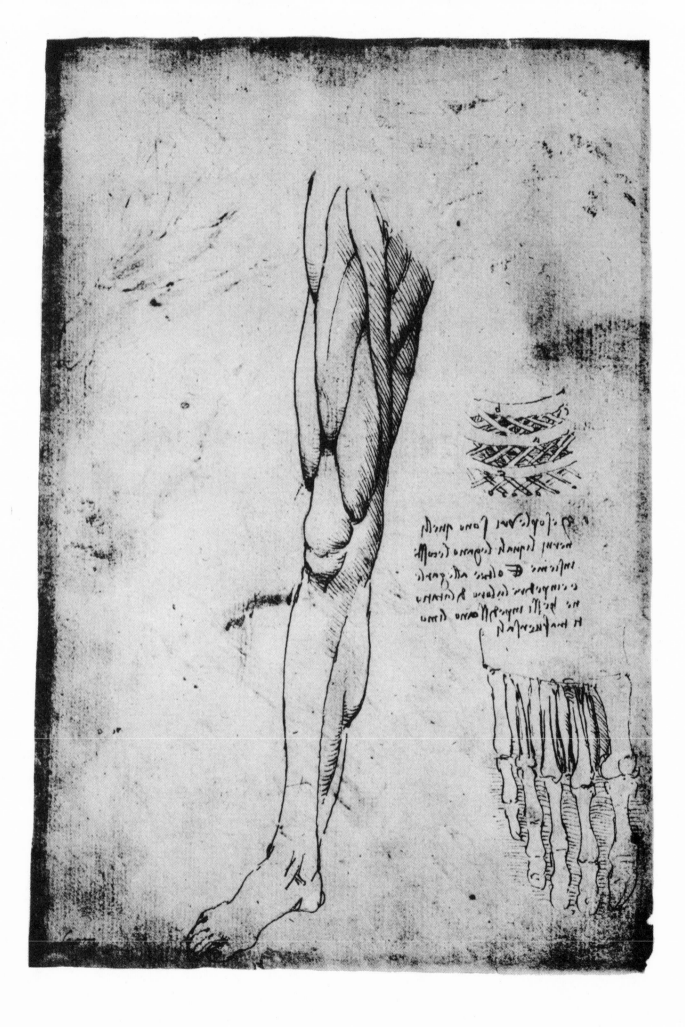

64

myology of lower extremity

fig 1. **Mechanical diagram, significance unknown.**

fig 2. **Surface anatomy of lower extremity and torso: lateral aspect.**

The inscription written in a more elaborate and formal gothic hand indicates the early date of this sketch, made possibly around 1490. The page is part of the same sheet as 65 on which similar studies appear. The modelling of the gluteal region differs con-siderably from the surface studies shown in 58. However, at the knee we have the same exaggeration of elevations produced by the biceps femoris muscle, the vastus lateralis and the ilio-tibial tract. The accompanying note reads:

Robust nudes will be muscular and thick.

Those who are of less strength will be lacertus and thin.

For the meaning of *lacertus*, cf. 61.

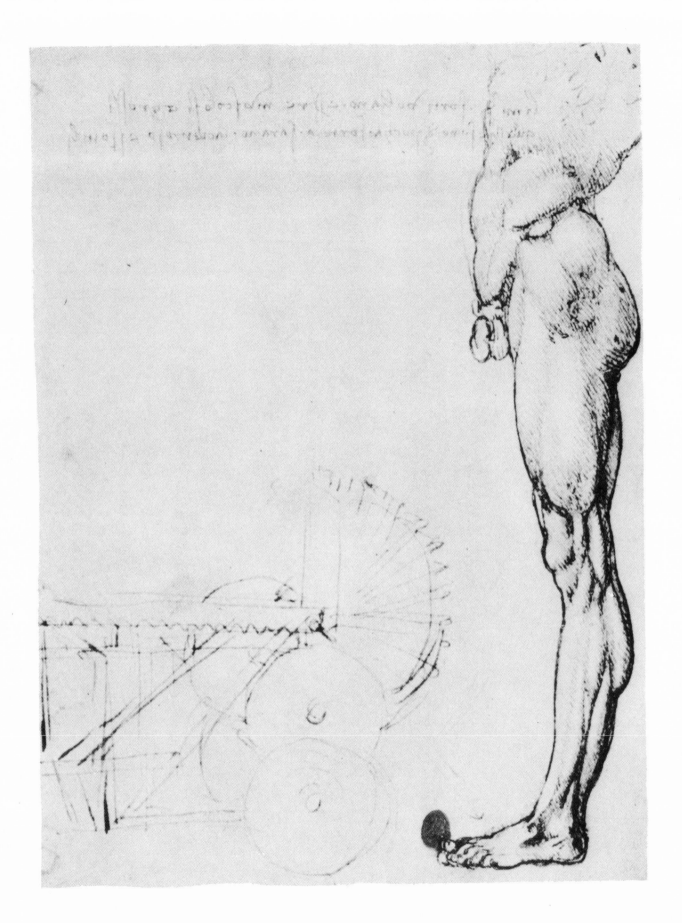

myology of lower extremity

figs 1-2. **Surface anatomy of the lower extremity: lateral aspect.**

This page was originally a part of 64 and the sketches very similar. In the thigh there is less modelling, and the rectus femoris is not differentiated from the vastus lateralis by shading as in the previous figure, which gives to the thigh an unpleasant heaviness. The outline of the biceps femoris is less correct and there is the same exaggeration of its tendon which is now misrelated. One gains the impression that these are largely sketches done from memory and based, no doubt, on the previous more finished work. It is doubtful if Leonardo possessed much anatomical knowledge at this period, and he appears to have depended for the most part on living models. In any case the comparison should be made with the more accurate rendition of surface contours about the knee seen in 59.

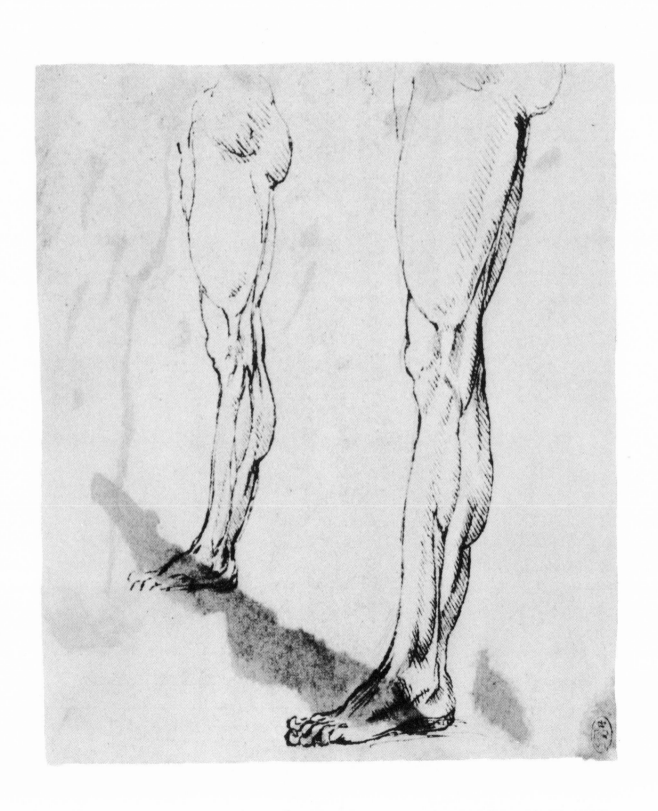

66

myology of lower extremity

figs 1-2. **Surface anatomy of lateral and medial aspects of lower extremity.**

These preliminary sketches of the lateral surface of one leg and the medial surface of the other limb in the same posture carry out the idea mentioned in the note accompanying fig. 1 of 13, of representing portions of the body to show opposed surfaces even if this necessitated reversing one of them. In other words, the student would by this means be able to see and

to compare the two opposed sides as though he had walked around the model.

fig 3. **Surface anatomy of lower limb: medial aspect.**

fig 4. **Surface anatomy of lower limb: lateral aspect.**

These figures, together with 62, complete the series on the surface anatomy of the lower limb. They should be compared with the similar studies of an earlier date, 64, 65.

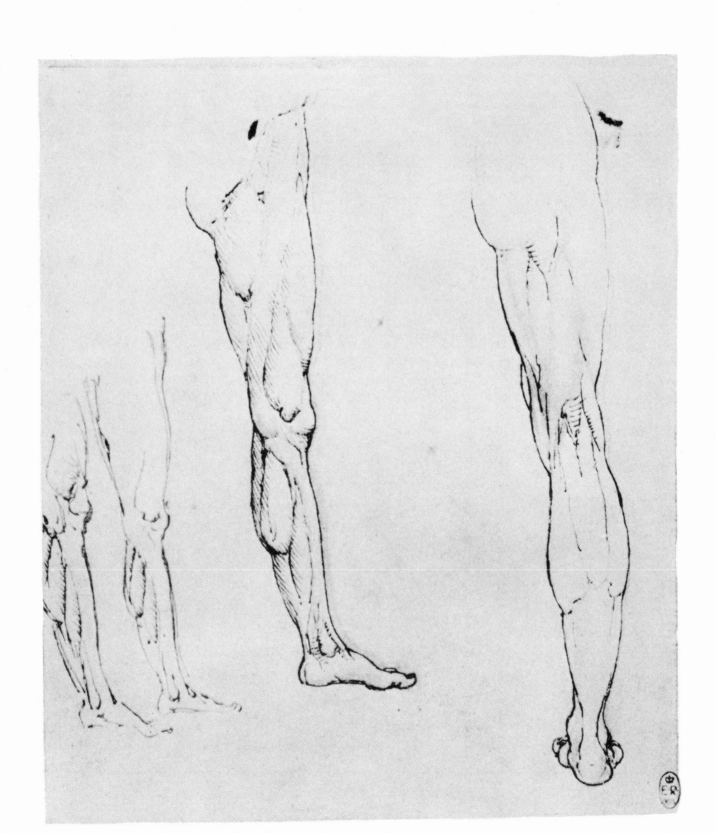

myology of lower extremity

fig 1. **Small figure ascending a hill.**

fig 2. **Small figure walking downhill.**

He who descends takes short steps because the weight rests upon the hinder foot. And he who mounts takes long steps because his weight remains on the forward foot.

Both as an artist and as a scientist Leonardo was intensely interested in locomotion and its mechanics. A number of drawings and notes on this subject are to be found scattered through his works but are concerned more with the representation of body balance during motion than with anatomical or physiological pursuits. More extensive notes on this topic are to be found in Ms. A of the Institut de France, 28v, and in FB21r.

figs 3-4. **Surface anatomy of lower extremity and torso (sketch of eye below).**

These drawings are remarkably similar to those of 64 and 65, with the same exaggeration of the lower end of the ilio-tibial tract. They are presumably of the same date.

fig 5. **Drawing of stick resting in the fork of another: significance unknown.**

The remaining notes concern aerial perspective in painting and the behavior of forces in water. Since these are not concerned with the topic, they have been omitted. On the folio is a faint chalk drawing of a profile and other writing which has either rubbed or was partially erased.

68

myology of lower extremity

fig 1. **Superficial muscles of the thigh: medial aspect.**

I wish to detach the muscle or lacertus a b [sartorius] *and show what passes beneath it.*

This desire has been carried out, and fig. 2 of the recto of this folio shows the sartorius resected to expose the femoral vessels lying in Hunter's canal. Long muscles were called *lacertus*—an abbreviation of this word, *il lace*, is observed written just below the perineal region of the figure. Cf. 43.

All the muscles of the thigh arrive upon the knee and are converted first into sinew (nervi) *and then, below the sinew, each is transformed into thin cartilage by which the knee-joint is bound with as many skins or membranous coverings as there are muscles which descend from the thigh to the knee. And these fasciae extend for four fingers' breadth above the knee-joint and 4 below.*

fig 2. **Superficial muscles of the thigh: anterior aspect.**

The long muscle (lacerto) *a b* [sartorius] *and the long muscle a c* [tensor fasciae latae] *serve to raise the thigh forwards.*

And they also give lateral movements to the thigh, that is, on abducting and adducting the thighs. On abducting the thigh, the muscle a c, undergoes thickening and shortening, and the lacertus a b, acts by its shortening.

ON THE ROTATORY MOVEMENT OF THE THIGH.

The rotatory part of the movement of the thigh to the right and to the left [in abduction and adduction] *is caused by the above-mentioned muscles, that is, the muscle a c, turns the thigh inwards and the lacertus a b, returns it outwards, and the two together raise the thigh.*

Between the figures are placed generalizations and a reminder of work to be done.

The muscles always arise from and terminate in the bones touching one another, and they never arise from and terminate in one and the same bone, because it would be able to move nothing unless it itself were not in a rarified or dense state.

What are the muscles one part of which arises from a bone and the other attaches to another muscle?

Leonardo refers to compound muscles such as the quadriceps of the thigh and calf muscles, the action of which greatly interested him.

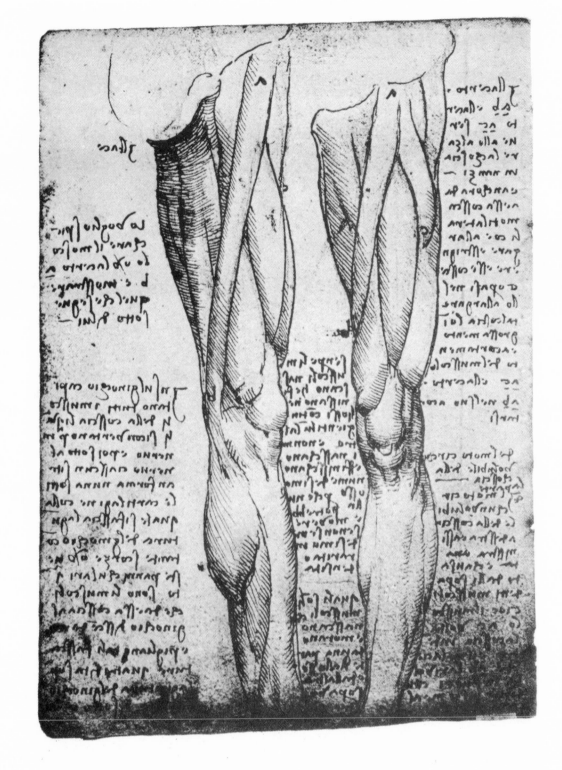

69

myology of lower extremity

fig 1. **Superficial muscles of the thigh: lateral aspect.**

The gross exaggeration of the outlines of the tensor fasciae latae and vastus lateralis is characteristic of several of Leonardo's sketches presumably made around his middle period of anatomical studies. The illustration should be compared with the related drawings on 68.

fig 2. **Superficial muscles of the thigh: posterior aspect.**

The figure, like its companion, appears not to have been made from an actual dissection and possibly represents an attempt to show the structures responsible for surface contours. The two structures in the popliteal space are doubtless the common peroneal nerve on the lateral side and the tendon of semimembranosus on the medial side.

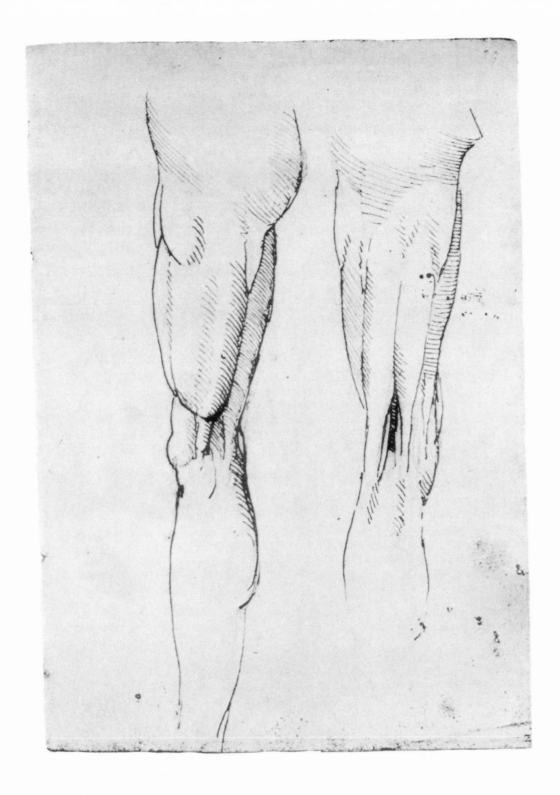

70

fig 1. **Superficial muscles of the thigh: posteromedial aspect.**

fig 2. **Superficial muscles of the thigh: medial aspect.**

These figures are continuous to the series found on 69, and like them, appearances suggest that they were derived from other drawings and not from dissection itself. The arrangement of the gracilis and other muscles at their pelvic attachment is obviously erroneous.

The note is unrelated to the drawings. Leonardo mistakenly divided certain muscles into several fasciculi regarded as separate muscles, as in the case of the pectoral in 43. He believed that these fasciculi fused together to form single muscles in those of greater muscular development.

What muscles are those which, when they become lean, divide themselves into several muscles and form one from many when they become fleshy.

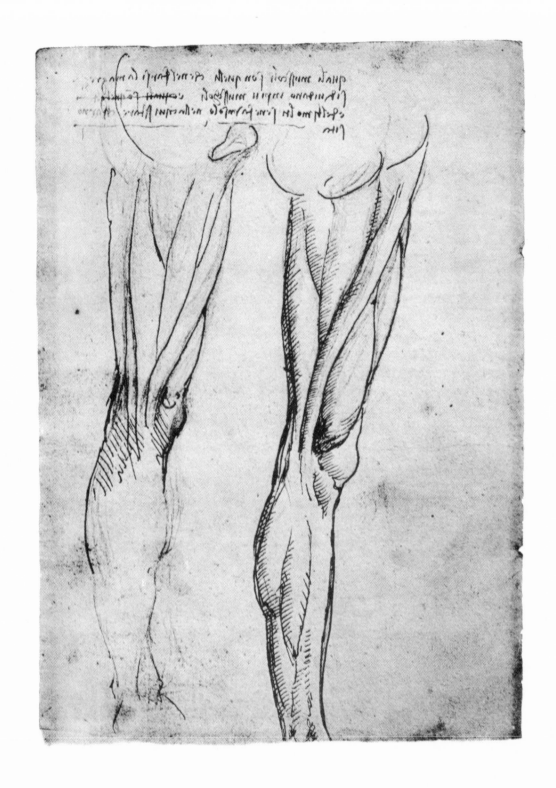

myology of lower extremity

figs 1-2. **The anatomy of the thigh on flexion at the knee.**

The purpose of these illustrations is to show the changing relationship of the sartorius to the semitendinosus muscle on flexion of the knee and, further, to show the action of sartorius as a medial rotator of the flexed knee. A similar diagram is to be found on 11. Leonardo points out the value of this information to the artist and to the surgeon.

In this demonstration made from different aspects take account of all the muscles which move the leg, which muscles are attached to the lips of the pelvis where also arise the muscles which move the thigh from the knee upwards.

And also of those which bend the knee when one kneels.

TO BE NOTED.

Different muscles are uncovered in the different movements of the animals, and there are different muscles which are hidden in such diversity of movement. It is necessary to make a long treatise on this subject for the purpose of understanding the regions injured by wounds and also for the sake of sculptors and painters, etc.

TO BE NOTED.

All the movements of the leg arise from the muscles of the thigh, which movements are the cause of the flexion of the leg, of its extension and of its rotation to the right or to the left.

But the movements of the feet are caused by the muscles arising in the leg; as to the movements of the toes, some arise in the leg and others in the foot.

And of the motor muscles of the leg, some arise from the hip and others from the thigh; and of all you will give the true position.

Interspaced between the figures are other notes which refer directly to them.

The muscles which elevate and lower the foot arise from the leg; that is, those which elevate the anterior part [of the foot] arise from the outer (silvestra) part of the leg and are attached at the origin of the great toe of the foot.

Note which are the principal cords and cause the greater injury to the animal when they have been cut, and which are of less importance; and you will do this for each limb.

Note the proportion of the bones to one another. And what purpose each serves.

At the top of the page are certain notes written in an earlier handwriting, c.1492. These seem to be a continuation of the jottings found on FB21r, and related to the note on the order of Leonardo's contemplated book written on the verso of the present sheet and given elsewhere.

The ramification of the veins from the shoulders upwards, and from the spleen to the lungs.

The ramification of the nerves and of the reversive [recurrent] nerves to the heart.

Of the shape and position of the intestines.

Where is the umbilical cord attached?

Of the muscles of the body and of the loins (reni).

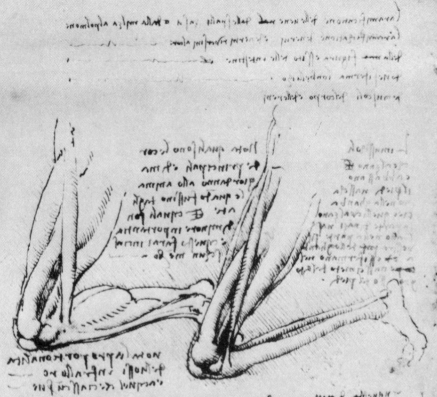

myology of lower extremity

figs 1-4. **Cross-sectional anatomy of the leg.**

The major interest of these figures depends upon the fact that they constitute the first known example of the use of cross-sections for the study of gross anatomy and thereby anticipate modern technique by several hundred years. As might be expected in the absence of hardening reagents or methods of freezing, it was apparently found not entirely satisfactory by Leonardo since he seldom uses it. Moreover, he no doubt found that his knowledge of anatomy was scarcely sufficient to enable him to identify the various structures on cross-section. Unfortunately no text accompanies the illustration and no explanation is given of the lettered section. This section is from the mid-thigh region but of no accuracy. Presuming that the section is maintained in the same position as its counterpart in the series, it is suggested that the letters identify the following structures: d, the femur; a, vastus medialis; b, adductor magnus; c, adductor longus; e (like D), vastus lateralis, e, f, biceps femoris; g, semimembranosus and semitendinosus.

The drawing is believed to date from an early period, c.1487, and a similar illustration is to be found on 151.

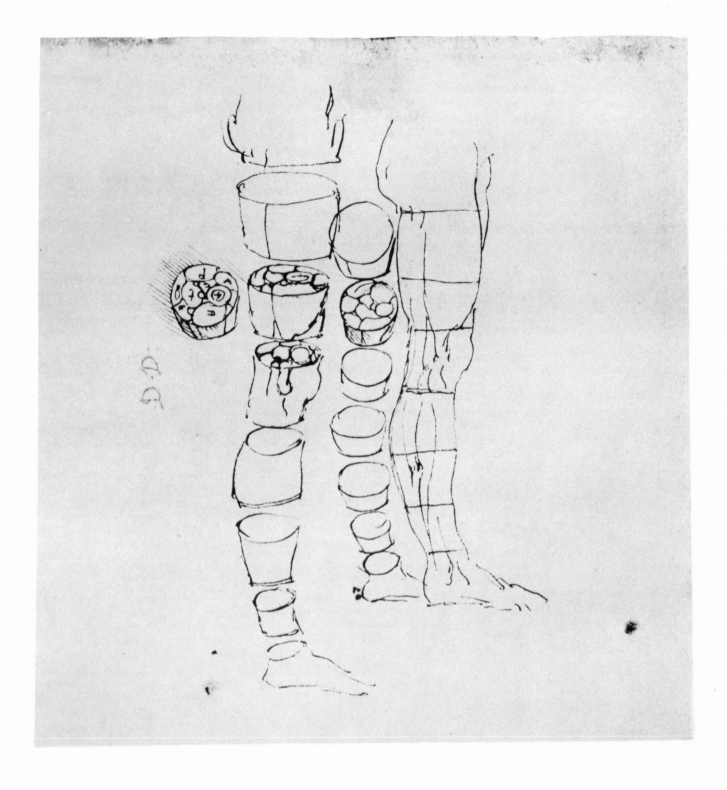

myology of lower extremity

This 2nd is the demonstration of the muscles with their cords which relate only to force and movement.

And there will be four [illustrations], *that is from behind, from in front, in profile from the outer aspect, and in profile from the inner aspect.*

First make these 2 demonstrations without their cords.

As these illustrations are said to form the second demonstration, we may assume that they were to follow similar figures of the muscles themselves. Only three of the four contemplated figures appear on this page. They were to be preceded by drawings of the bones alone. The various notes have been rearranged somewhat.

figs 1-3. Wire diagrams of the muscles: medial, anterior and lateral aspects of the lower extremity.

Here Leonardo specifically states that these models showing the outlines or lines of force of the muscles are to be made of copper wire. Elsewhere in discussing similar figures he mentions linen threads or cords. It is doubtful that such models were ever constructed. Their purpose was to show not only the action of the muscle but also the relations of the muscles to one another. On their construction he writes:

Make this leg in full relief, and make the cords of tempered copper, and then bend them according to their natural form. After doing this, you will be able to draw them from 4 sides. Place them as they exist in nature, and speak of their uses.

I put only the number of the muscles with their origin and termination, and the places where their extremities are attached.

These four legs are to be on one and the same sheet of paper so that you may better understand the position of the muscles and be able to recognize them from several aspects.

The wires or cords are to indicate the lines of tension developed by the muscles, as shown by the words: *All the lines of force of man.*

Leonardo, lacking a descriptive terminology for the muscles and other structures, expected to follow the clumsy method of Galen and number the various structures.

Having finished with the bones of the leg, give the number of all the bones and at the termination of the sinews put the number of these sinews; and you will do the same for the muscles, cords, the veins and the arteries, saying: So many has the thigh, so many the leg, so many the foot, and so many the toes. And then you will say: So many are the muscles which arise from a bone and terminate in a bone, and so many are those which arise from a bone and terminate in another muscle. In this way you will describe every detail of each member and especially the ramifications which some muscles make which give rise to different cords.

To facilitate the above plan, he asks the question:

How many are the muscles which arise from the hip-bone (alchatin), and which are created for the motion of the thigh.

For the origin and use of *alchatin*, in this instance meaning the innominate bone, cf. 12.

A functional classification of the muscles of the extremity into primary and secondary groups is suggested by the remark: *The immediate causes of the motions of the legs are entirely separated from the immediate cause of the motion of the thigh, and the same makes for power.*

Compound muscles such as the quadriceps of the thigh and the triceps of the calf pose mechanical problems which greatly interested Leonardo and are mentioned on several occasions as in one of the notes above where they are called "ramifications" giving rise to a different tendon and again in the statement: *Many are the muscles which arise from the bones and terminate in another muscle.*

In fig. 1, the only muscle indicated by letters, p q, is the sartorius which is discussed in conjunction with the ilio-tibial band and tensor fasciae latae, fig. 3, r o. These tendons are believed to produce medial and lateral rotation respectively of the leg on the thigh, but only when the knee is flexed.

After the leg is bent at the knee, then the sinew p q [sartorius], *of the leg in profile from the internal aspect* [fig. 1], *and r o* [tensor fasciae latae] *of the other leg in profile from the external aspect* [fig. 3], (*besides the straight movement of the leg from the knee downwards), further serve the movement causing the rotation from the knee downwards. When these are not operating, the extended leg cannot turn without turning the thigh, the leg being extended. And this occurs because in the extended leg the sinews mentioned do not have leverage upon the bone of such a leg in the same way that it has when bent. And the reason is that when the leg is straight, the cords pull the leg directly towards the joint of the knee.*

In fig. 3, a number of structures are indicated by letters. However, it should be recognized that there are many inaccuracies in these drawings so that the identifications which can be made are only approximate. a b r, outlines the gluteus medius; r b c n, tensor fasciae latae with r o, and m o, indicating the ilio-tibial tract; a second r and v, gluteus maximus; K, the patella; s, the sole of the foot. A note on the proportional relationship of the length of the foot to the leg and to the thigh accompanies fig. 3, which is drawn to the dimensions mentioned.

The length of the foot is half that of the leg from the knee to the ground, that is, from K [patella] *to s* [sole of foot], *which is as long as K to c* [anterior superior spine of ilium]. *Thus the foot goes four times into c s. And know that such feet are of esteemed dimensions since they are inclined to be a little small because an attractive leg has* [a foot] *rather smaller than large.*

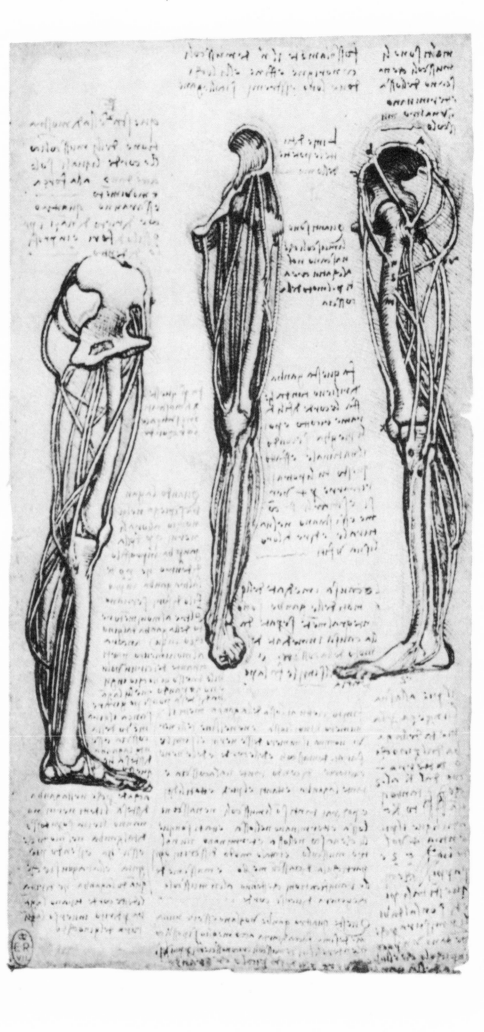

fig 1. Muscles of the anterior aspect of the leg and dorsum of the foot.

The muscles indicated by letters are m, tibialis anterior; S and r, extensor digitorum longus, which is described as two muscles due to artificial separation; t, extensor hallucis longus; n, peroneus tertius; h, the medial malleolus; a b c d, extensor digitorum brevis (with extensor hallucis brevis); f, peroneus longus; g, (concealed in shadow), peroneus brevis. Unlettered are the margin of soleus and gastrocnemius and the digital branches of the anterior tibial nerve.

The muscles which move the foot solely to elevate it anteriorly [dorsi flexion], *are m n* [tibialis anterior and peroneus tertius] *which arise in the leg from below the knee, and those which evert it to the outer side of the ankle are the muscles f n* [peroneus longus and peroneus tertius]; *therefore n* [peroneus tertius] *is common to both these movements.*

Leonardo's acute appreciation of the action of synergistic muscles in the patterns of movement is clearly evident in the above observation.

The muscles n m [peroneus tertius and tibialis anterior] *serve only to move the whole foot upwards* [dorsi flexion].

Mundinus says that the muscles which elevate the digits of the feet are found in the external part (parte silvestra) of the thigh, and then adds that the dorsum of the foot has no muscles because nature wished to make it light so as to move with ease, for if it were fleshy it would be heavier. In this regard experience shows that the muscles a b c d [extensor digitorum brevis] *move the second pieces of the bones of the toes* [phalanx II], *and the muscles of the leg r S t* [extensor digitorum longus *and* extensor hallucis longus] *move the tips of the toes. Now the question here is to see why necessity has not caused them all to arise in the foot, or all in the leg; or why those of the leg* [long extensors] *which move the tips of the toes should not arise in the foot instead of having a longer path to reach the tips of the toes, and likewise why those* [short extensors] *which move the second joints of the toes* [should not] *arise in the leg.*

Leonardo either misread the work of Mundinus or was quoting from memory or from a corrupt text. Mundinus actually said, "Yet thou shouldest know that the cords extending to the toes arise in the muscles which are in the pars silvestris [external part] of the leg . . . ," and that "those which expand the toes could not be placed in the upper part [of the foot] because the upper part must be free from flesh so that it might not add to the weight of the foot" [ed. Singer, p. 99].

Avic[enna]. *The muscles which move the digits of the feet are 60.*

fig 2. Detail of the dorsal aponeurosis of the extensor tendon of insertion of the toe.

In this superb illustration is shown the membranous expansion of the extensor tendon on the dorsum of the toe and the collateral slips formed by the tendons of extensor digitorum brevis, the lumbricals and interossei. Nothing approaching such detail is to be found until comparatively recent times. Leonardo cor-

rectly notes how these muscles eventually pass to insert into the distal phalanx.

All the sinews (nervi) on the front of the leg serve the tips of the digits of the feet as is shown in the great toe.

The notes pertain to the illustrations themselves, to the methods of illustrating the anatomy of the leg and foot, and to general physiological observations. Since they are scattered in disorderly fashion, they have been rearranged in the above order.

FIRST.

First set down the two fociles of the leg [tibia and fibula] *between the knee and the foot, then represent the first muscles which arise from the said fociles and so continue to place one upon the other in as many different demonstrations as there are steps in their superposition. And you will do so until completion of the same side and do the like for the four sides in continuity with the entire foot, because the foot is moved through the cords arising from these muscles of the leg, but the region of the sole is moved by the muscles which arise in the sole. However, the coverings (panniculi) of the bony joints arise from the muscles of the thigh and leg.*

On the use of the term focile for one or both bones of the leg, cf. 11. By panniculi or coverings of the joints Leonardo means the fascial expansion of the tendons or other ligamentous structures associated with the muscle tendon or the joint capsules as indicated in the succeeding note.

When you have made the bony demonstration, then show how it is clothed by the panniculi which intervene between the cords and these bones.

To make certain of the origin of each muscle, remember to pull on the tendon produced by this muscle in such a way as to see this muscle move and its origin on the ligaments of the bones.

TO BE NOTED.

You will cause nothing but confusion in the demonstration of the muscles and of their position, origin and termination if you do not first make a demonstration of thin muscles by using threads, and so you can represent them one upon the other as nature has placed them. Thus, you can name them according to the member which they serve, that is, the mover of the end of the great toe, of its middle bone, of the first bone, etc. And after you have presented these ideas, you will illustrate on one side of it the true shape, size and position of each muscle. But remember to make the threads which represent the muscles in the same position as the central lines of each muscle, and so these threads will demonstrate the shape of the leg and [provide] *a clear idea of their extent.*

Examples of these wire or cord diagrams will be found on 16, 48, and elsewhere. The terminology which Leonardo contemplates using, but seldom does, is derived from Galen who numbered the muscles according to their action, thus: the first, second and third muscles moving the leg.

(continued on page 495)

myology of lower extremity

This plate is of first importance, being one of the few in the anatomical series of drawings to carry a date. "This winter of 1510", says Leonardo, "I believe I shall complete all this anatomy", so that we may assume the drawing was made during his second stay at Milan at which time, it has been said, he was associated with the physician Marcantonio della Torre in anatomical pursuits, perhaps conducted at nearby Pavia where the physician was established. The drawings are identical in style and character with those of 74 and 76, and are obviously part of the same series.

fig 1. **Rough sketch of forearm and base of hand: anterior aspect.**

This very rough sketch of the forearm seems to have been intended as a reminder in connection with the accompanying notes. The fragments of muscles seen in the region of the elbow cannot be identified but are meant to represent the muscles of the upper arm acting upon the forearm.

When you draw the hand, draw with it the [fore-] arm as far as the elbow; and with the [fore-]arm, the sinews and muscles which come to move it from above the elbow. And do the same in the demonstration of the foot.

All the muscles which arise from the shoulder, scapula and chest, serve the movement of the arm from the shoulder to the elbow. And all the muscles which arise between the shoulder and the elbow, serve the movement of the arm between the elbow and the hand. And all the muscles which arise between the elbow and the hand, serve the movement of the hand. And all the muscles which arise from the neck, serve the movement of the head and of the shoulders.

fig 2. **Muscles of the leg: lateral aspect.**

The figure should be compared with its companions, 74 and 76, which are all drawn from the same specimen. Again, as in the anterior view, the extensor digitorum longus is subdivided into two muscles as may occur very easily in dissection.

When you represent the muscles of the thigh, draw with them the bone of the leg so that one may recognize where these muscles are attached to the bones of the leg.

You will then make the leg with its muscles attached to the bones of the foot, and make these bones bare. And you will carry out the same plan for all the sinews.

The muscles of the foot serve the movement of its toes and are assisted in this movement by the cords derived from the muscles of the leg.

The above note refers to the common insertion of the tendons of extensor digitorum brevis with those of extensor digitorum longus and hallucis longus by means of the membranous expansions on the dorsum of the toes as illustrated in 74.

What are the muscles of the leg which serve only the simple movements of the foot, and what are those of this leg which serve only the simple movements of the digits of this foot? And remember, when clothing the bones of the leg with their muscles, do draw first the muscles which move the feet and which you will attach to the feet.

Draw here the foot of a bear, of a monkey and of other animals and how they differ from the foot of man; and also put in the feet of some birds.

As indicated here and elsewhere, the comparative approach to anatomical problems greatly interested Leonardo, although like Galen, he often fell into the error of transferring the parts of animals to man on the assumption that they were identical. Four brilliant drawings of detailed dissections of the foot of a bear have survived (81-84), and the above note may be a reference to them. However, on stylistic grounds authorities have assigned them to the years 1490-93, which is highly doubtful since the anatomical skill suggests a much later date. Leonardo had also dissected monkeys and represents the bones of the hand from one of these specimens on 152.

The muscles of the leg between the knee and the joint of the foot are as many in number as the cords which are attached to the upper [dorsal] part of the toes and it is the same underneath [i.e., on the plantar aspect], adding those which move the feet up and down and from side to side, and of these [cords] those which elevate the toes are five. And the muscles of the feet above and below [i.e., dorsal and plantar] are as many as double the number of the digits, but as I have not yet finished this discourse, I shall leave it for the present, and in this winter of 1510 I believe I shall complete all this anatomy.

The cords which lower [flex] the toes are derived from the muscles arising in the sole of the foot, but the cords which elevate the same toes, do not arise from the outer (silvestra) part of the thigh as someone has stated in writing, but arise from the upper part of the foot, called the dorsum of the foot. And if you wish to prove this, grasp the thigh with your hands a little above the knee and elevate the toes and you will perceive that the flesh of your thigh has no movement within itself, in any of its cords or muscles—so it is quite true.

In a note on 74, Leonardo states that it was Mundinus who said that the long extensors of the leg arose from the lateral aspect of the thigh. No such statement is to be found in the works of Mundinus, so that we must assume that Leonardo either misread his source or was working from a corrupt version of this famous medical text.

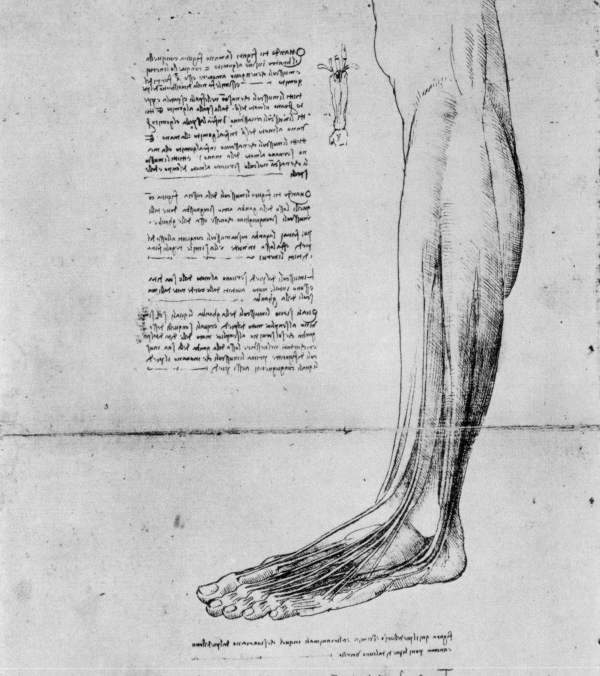

76 myology of lower extremity

fig I. Superficial dissection of the muscles of the leg: medial aspect.

The character, style and dimensions of the figure are identical with fig. 2 of 75, and therefore may be dated c.1510. Undoubtedly the drawing on 74, although proportionately somewhat larger, is a member of the same series.

The structures lettered are from above downwards: h, lateral head of gastrocnemius; K, medial head of gastrocnemius; m, soleus; c, tendon of gastrocnemius prior to its fusion with the tendo calcaneus at S; n, flexor digitorum longus; o, tibial nerve observed dividing into medial and lateral plantar branches at its lower end; f, tendon of tibialis anterior; a, the medial malleolus. Other structures unlettered are the tendons of tibialis posterior and extensor hallucis longus, abductor hallucis muscle, dorsal arch and long saphenous vein, digital branch of superficial peroneal nerve. The notes pertaining to this illustration read:

K [gastrocnemius] *serves to elevate the heel, and this muscle becomes hard when drawing up the heel as well as when releasing it.*

The calf of the leg has several muscles which are joined together longitudinally, that is, the muscle h [lateral head of gastrocnemius] which serves to flex the knee, also serves the heel in part, assisting the muscle K [medial head of gastrocnemius] with which it is united.

Also m [soleus] serves at c, as does K; thence K m c [tendo calcaneus] serves the heel. And here one asks why nature has not put a single muscle there, which would be worth as much as these three.

The sinews which move the foot inwards at the ankle, or joint of the foot, are n f [flexor digitorum longus for tibialis posterior and tibialis anterior]; f [tibialis anterior] is then common to two movements, that is, of elevating and of bending [inverting] the foot. And here you observe the sagacity of nature, because she has provided each member with two agents of motion so that when one is lacking, the other substitutes in part if not entirely.

Observe from the fibres [fasciculi] of the muscles which are united, as shown on the internal aspect (dimestiche) of the calf of the leg made by m [soleus] with c [tendon of gastrocnemius] at the position S [tendo calcaneus], and see which fibres are common and which are individual.

From the above considerations Leonardo arrives at a generalization on the value of compound muscles which is appended to the foot of the page but is properly related here. He makes a similar remark in connection with the biceps brachii on 54. The idea expressed is perhaps not too far removed from the observation of Beevor (Croonian Lectures, 1904) that a muscle which participates in more than one action may be paralyzed for one movement but not the others since the motions may have separate cortical representation.

It often occurs that two muscles are joined together although they have to serve two members; and this has been done so that if one muscle were to be incapacitated by some lesion, the other muscle would in part supply the place of that which is lacking.

Below the foot of fig. 1, Leonardo makes a note to represent the bones of the foot without their periosteal and other connective tissue coverings so that the relationships of the various small joints to overlying structures may be made apparent.

Make a demonstration of these feet without the panniculus [periosteum] which clothes the bones—a panniculus which occupies the bones there interposing itself between these bones and the muscles and cords which move them. In this way you will be able to show under what cords, nerves, veins or muscles the joints of the bones lie.

fig 2. Diagram illustrating the action of the gastrocnemius on the foot as a lever of the second class.

Noteworthy is the error of placing the fibula on what is obviously intended to be the medial side of the leg, an error perhaps excusable in a diagrammatic representation but typical of the uncertainty of Leonardo's anatomical knowledge in the absence of a specimen and when relying upon memory. Mistakes of this sort are very common in his figures. The lettering is as follows: f, lateral head of gastrocnemius; d, medial head of gastrocnemius; o, tendo calcaneus; n, calcaneum; v, line of weight transmission; g, the dorsal aspect of the foot; m, ball of the great toe; a, fulcrum, b, weight, and c, power of a lever of the second class.

Here is a given calculation of the strength and fatigue which muscles experience.

When the muscle d, and those attached to it [triceps surae] relax, it is stretched and elongated until the heel descends to the ground at c.

When man raises himself on tip-toe, the muscle f d [gastrocnemius] in contracting experiences half the weight of the man on one foot. This is proved by the equilibrium a b c, the center of which is at b, and the ends equidistant from this center are at a and c. Since on placing m, the ball of the foot, upon a, the center of the foot, v, cannot descend because the sinew f d [tendo calcaneus], which is attached to the heel, does not want to be stretched, so the ankle, or joint of the foot v, supports a weight of two hundred pounds, of which 100 of natural weight is at m, or that is, at a, and 100 of accidental weight is at n [the heel]. One or other of the forces is directed upwards, for m, attempts to go to g [dorsally], and n, is drawn upwards by the calf of the leg.

In dealing with levers and balances, Leonardo, following Aristotelian tradition, refers to the weight as natural, and the force or weight added to counterbalance it, as accidental.

figs 3-4. Diagrams to illustrate the leverage exercised by the processes of a vertebra, as seen from the side and above.

In the first of these diagrams a force acting upon the extremity of the process is indicated by the letters a b, and a similar force acting on the base by c d. In the second diagram these forces are shown by the lines m n, and a b, respectively, while the body of the vertebra is noted by the letter c.

Why are the muscles of the neck attached to the tips of the spinous processes of their vertebrae.

(continued on page 496)

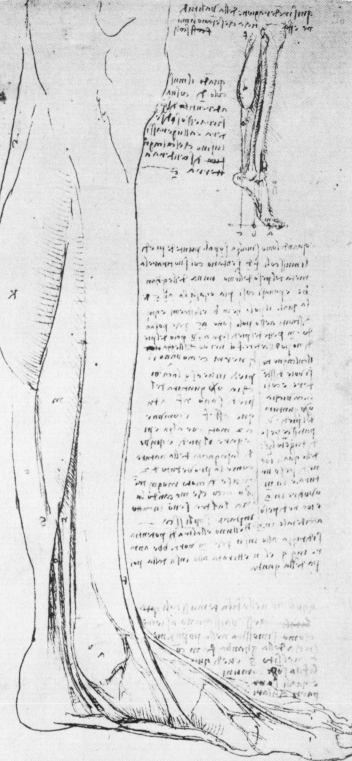

figs 1-2. **Illustrations of the medial aspect of the leg and foot to demonstrate the relationship of the tendon of tibialis anterior to the medial malleolus on flexion and extension of the ankle.**

The letter a, indicates the tendon of tibialis anterior, b, the medial malleolus and n, the ball of the great toe.

a b. On raising the heel, the sinew [tendon of tibialis anterior] *and ankle (tallone) approach one another by a finger's breadth, and lower* [the heel], *they are separated by a finger's breadth.*

In the above passage Leonardo uses the term *tallone* for ankle or perhaps more specifically, the medial malleolus. The term is derived from the Latin *talus*, but like the French *talon*, came to mean the heel in non-technical speech. Usually Leonardo calls the ankle-joint *cavicchia*.

While the present plate had been dated by Clark as belonging to 1513, it should be pointed out as coincidence if nothing more that fig. 2 bears a striking resemblance to fig. 2 of 76, which is definitely assigned to the year 1510.

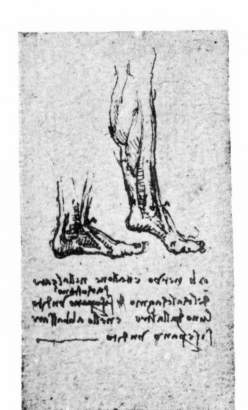

myology of lower extremity

The great majority of the notes on this page are concerned with problems of mechanics especially on the purchases of pulleys, and are consequently not translated here. The anatomical drawings and note appear to have been added at a later period.

figs 1-3. **Sketches of the abdominal vessels, large intestine and small intestine.**

fig 4. **Diagram to illustrate the mechanism of balance at the ankle joint.**

The centre a [ankle joint] *is that where man balances his weight by means of the cords n m* [tendo calcaneus] *and o p* [extensors of foot] *which are to the axis of the leg above the said centre as the shrouds are to the masts of ships. And one pound of his weight which man throws to any part outside of the said centre a, will carry great weight to the opposite cord, as will be shown in its place, namely on the function of the members.*

The above comparison of the action of muscles to the shrouds supporting the mast of a ship is also used by Leonardo in discussing the function of the muscles of the neck in their support of the head in 18.

79

myology of lower extremity

This series of dissections of the sole of the foot is continued in 80. Almost every aspect of the anatomy of the region will be found to have been covered in these two plates.

fig 1. **Sole of the foot illustrating the distribution of the medial and lateral plantar nerves.**

It will be noted with what detail Leonardo has followed the branchings of the medial and lateral plantar nerves and that he has indicated the distribution of the medial plantar nerves to three and a half toes and the lateral to the remainder. Beside the nerve is the outline of the posterior tibial artery dividing into its terminal, medial and lateral branches, but the drawing is too indistinct to follow their distribution.

fig 2. **Dissection of the sole of the foot: superficial layer.**

The abductor hallucis is indicated by the letter a, and flexor digitorum brevis by b. Posterior to the medial malleolus, the following structures may be recognized from before backwards: tibialis anterior, flexor hallucis longus, posterior tibial artery, posterior tibial nerve dividing into medial and lateral plantar branches, flexor digitorum longus. The perforation of the tendons of flexor digitorum brevis by flexor digitorum longus is well shown. An anastomosis between branches of the medial and lateral plantar nerves is seen lying superficial to the tendons of flexor digitorum brevis. Of his plans Leonardo writes:

Make a demonstration of this foot with the bones only; then, leaving in place the panniculus which clothes them, make a simple demonstration of the nerves; and then, upon the same bones you will make one of the cords and then, of the veins and arteries to-gether. And finally, a single demonstration which contains the artery, vein, nerves, cords, muscles and bones.

Referring doubtless to the action of the interossei and other small muscles, he asks the question: *What are the sinews (nervi) or cords which spread and press the toes against one another?*

fig 3. **Dissection of the sole of the foot: second layer.**

A portion of abductor hallucis has been resected and flexor digitorum brevis retracted to reveal the long flexor tendons. The crossing of the tendons of flexor digitorum and hallucis longus, including the slip given by flexor hallucis to flexor digitorum, are beautifully shown. Leonardo once again calls attention to the origin of the long flexors and extensors from the bones of the leg in contradistinction to an opinion derived from a misreading of Mundinus that they arose from the thigh, cf. 74.

The muscles which move the toes at their tips, both above and below the toe, all arise in the leg from the knee-joint to the joint of the foot; and those which move the whole toe up and down, arise from the upper and under aspects of the foot, and so make the hand related to the arm as the foot to the leg.

fig 4. **Dissection of the sole of the foot to show quadratus plantae muscle.**

In this sketch the abductor hallucis and flexor digitorum brevis have been divided leaving short segments attached to the calcaneum. The quadratus plantae muscle is shown passing to its attachment into the flexor digitorum longus tendon. Medial to this tendon is that of the flexor hallucis longus which is seen giving off its slip to the long flexor of the toes.

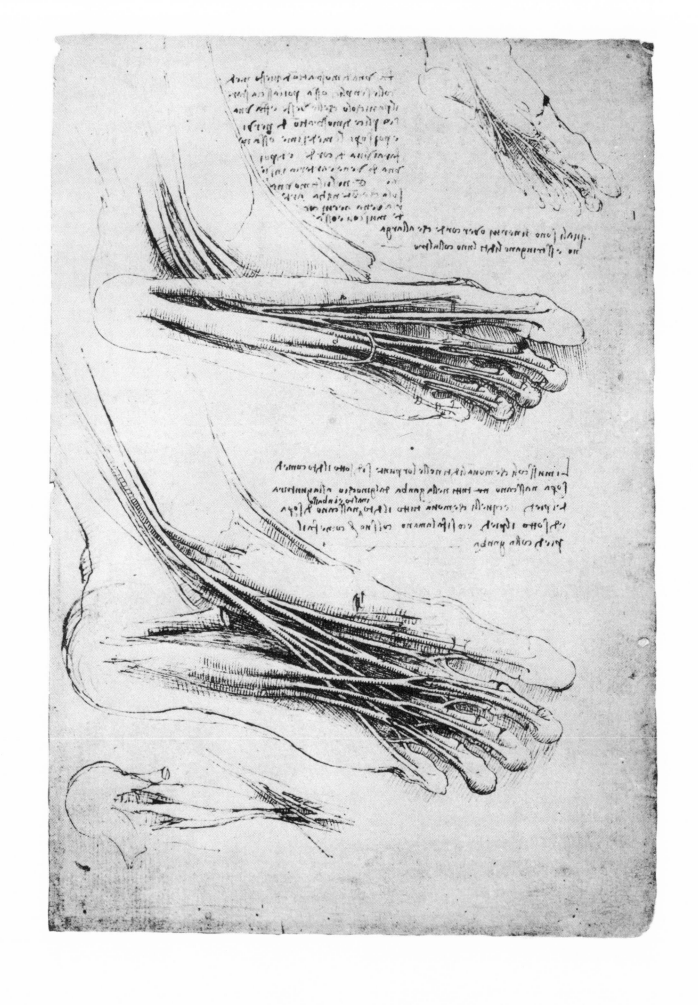

myology of lower extremity

This series of dissections of the sole of the foot is continued from 79.

fig 1. **Detail of some of the muscles attached to the great toe.**

The tendons of peroneus longus and tibialis anterior are observed passing to their insertion on the lateral and medial sides respectively of the first cuneiform and first metatarsal. Tibialis posterior is shown reaching its attachment at the tubercle of the navicular bone. Flexor hallucis brevis is labelled n, and lateral to it is the oblique head of abductor hallucis covered by the medial two lubricles arising from the tendon of flexor digitorum longus. Leonardo refers to the sesamoid bones in the two heads of flexor hallucis brevis in his note and shows these exceedingly well in fig. 4.

The muscle n [flexor hallucis brevis] *thrusts the two petrous* [sesamoid] *bones under the joint m* [metatarso-phalangeal I].

fig 2. **Detail of some of the deeper muscles attached to the great toe.**

The figure illustrates the tendon of peroneus longus crossing the sole of the foot and giving origin from its sheath to the oblique head of abductor hallucis, which is shown as two muscles and wrongly inserted. Flexor hallucis brevis and abductor hallucis, turned back, may be identified as before.

fig 3. **Lateral aspect of foot to show peroneal tendons.**

The illustration is designed to show especially the tendon of peroneus longus winding around the cuboid into the sole of the foot where it may be followed in figs. 1-2. Flexor digiti quinti has been turned back and peroneus brevis and tertius are also shown. The note reads: *Represent clearly these muscles which bind the bones together, and then make the muscles and the cords of movement and define the nature and power of motion of each member.*

fig 4. **Detail of the sesamoid bones in the tendon of flexor hallucis brevis.**

Flexor hallucis brevis, labelled *muscle*, has been turned back to show the sesamoid bones m n, at the metatarso-phalangeal joint of the great toe. These bones are shown in profile in the inset above. For a discussion of these small bones and their special interest to mediaeval anatomists, cf. 12. The tendon of the peroneus longus muscle may now be followed to its termination.

fig 5. **Sketch of the soles of the feet.**

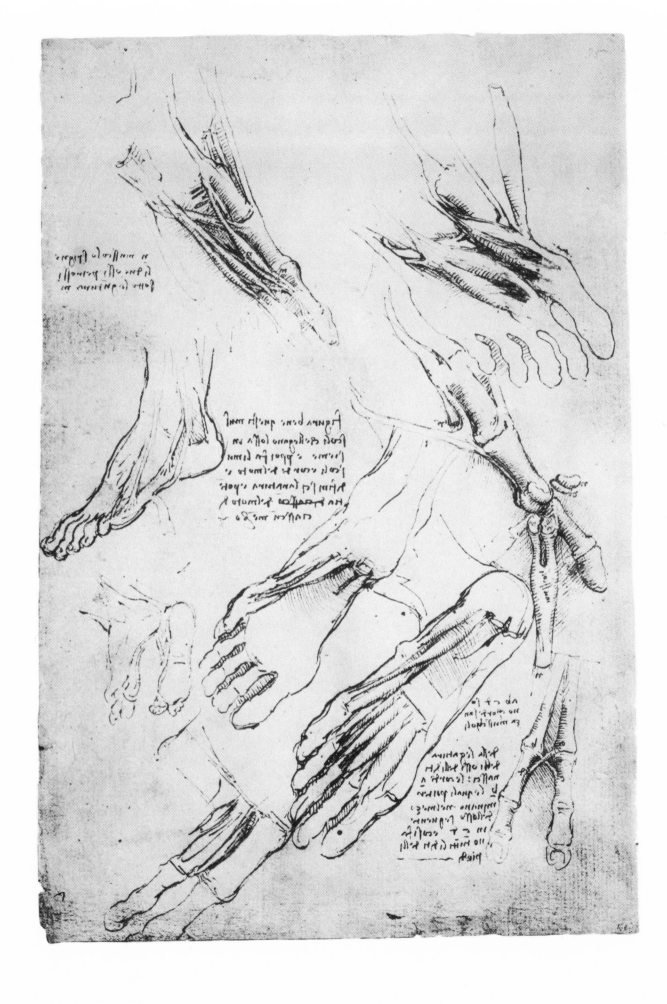

COMPARATIVE ANATOMY

figs 1-2. **Dissection of the leg and foot of a bear viewed from the lateral aspect.**

This exquisite drawing in silver-point is one of a series of four, other members of the series being 82-4.

The drawings represent a dissection of the left leg and foot of a bear as originally pointed out by the anatomist, William Wright. There can be no question that the identification is correct. In two memoranda (75, 81) Leonardo mentions the foot of the bear as though he had dissected it. In one of these notes (81) when discussing a proposal to present the comparative aspects of the hand he appears to have in mind this specific drawing showing the crural ligament or extensor retinaculum with the words, *as in the bear in which the ligaments of the cords of the toes connect over the neck of the foot.* Nonetheless, with that curious lack of critical evaluation which everywhere characterizes the writings on Leonardo, these figures are frequently put forward as typical examples of how he united science with fantasy in the construction of the foot of a monster.

The drawings differ in spirit from the great bulk of Leonardo's anatomical figures since they are purely representational and of great accuracy, and in no way are intended to illustrate some physiological principle or function which so often caused him to distort his anatomy for quasi-diagrammatic purposes. Here he is functioning as an artist pure and simple. The reader should compare similar drawings from this early period such as the representational figures of the skull (7, etc.) with the theoretical diagrams as 209, to appreciate the power of faithful drawing alone in Leonardo's biological pursuits.

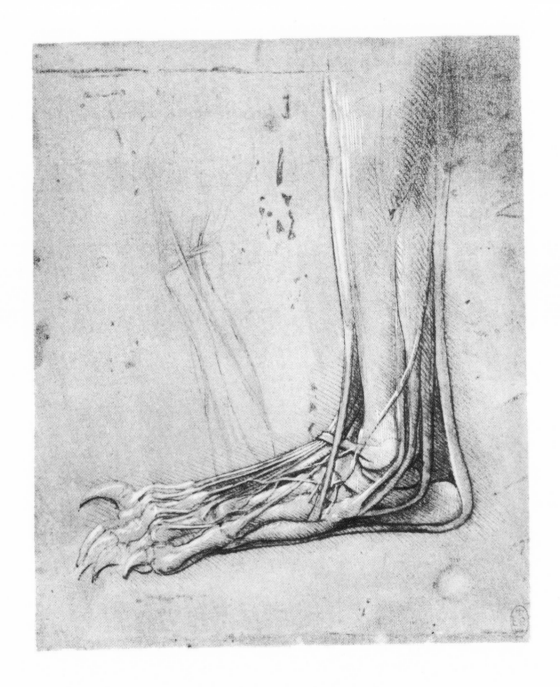

comparative anatomy

fig 1. **The tendon apparatus of the claw of a bear.**

fig 2. **Dissection of the leg and foot of a bear: lateral aspect.**

These drawings are part of a series on the dissection of the leg of a bear, for which cf. 81. Fig. 2 is almost identical to that of 81 and may have been a preliminary to it. There would have been little difficulty in obtaining such dissection material in Florence where a zoo was maintained, and presumably Milan in its efforts to develop the material aspects of urban sophistication may have developed a similar institution. The lions and bears of Florence are frequently mentioned in the diary of Luca Landucci which covers the years 1450-1516, and as late as the mid-sixteenth century Gabriel Fallopius was to make use of such animals, notably in a study of the bones of lions. Elsewhere Leonardo also mentions the animals of the Florentine zoo, cf. 37.

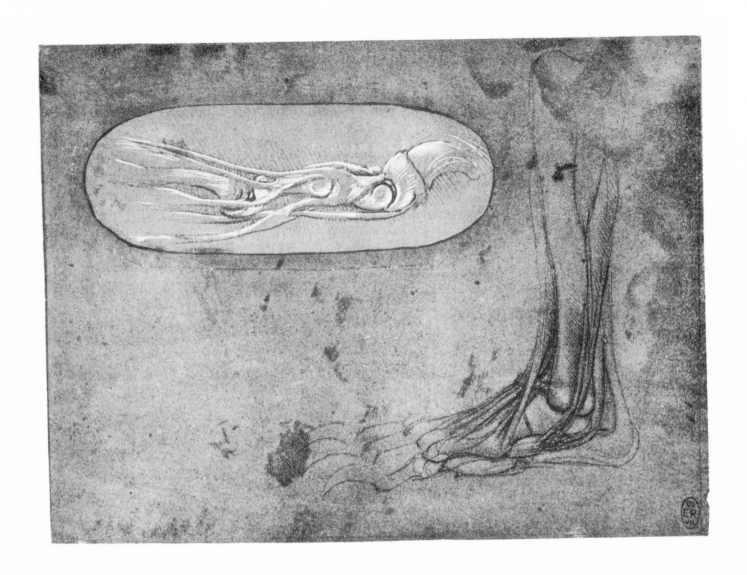

comparative anatomy

Clark 12374r / Q V 13r / c. 1490-93 **208**

figs 1-2. **Dissection of the leg and foot of a bear from the lateral aspect.**

The figures are part of the same series as 81-4. For a discussion cf. 81.

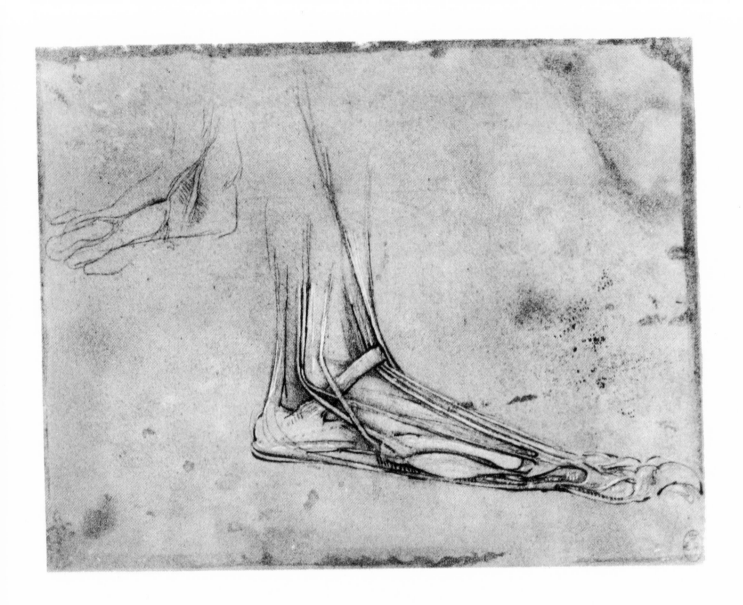

fig 1. **Dissection of the sole of the hind foot of a bear.**

For a discussion as well as the other plates in this series, cf. 81.

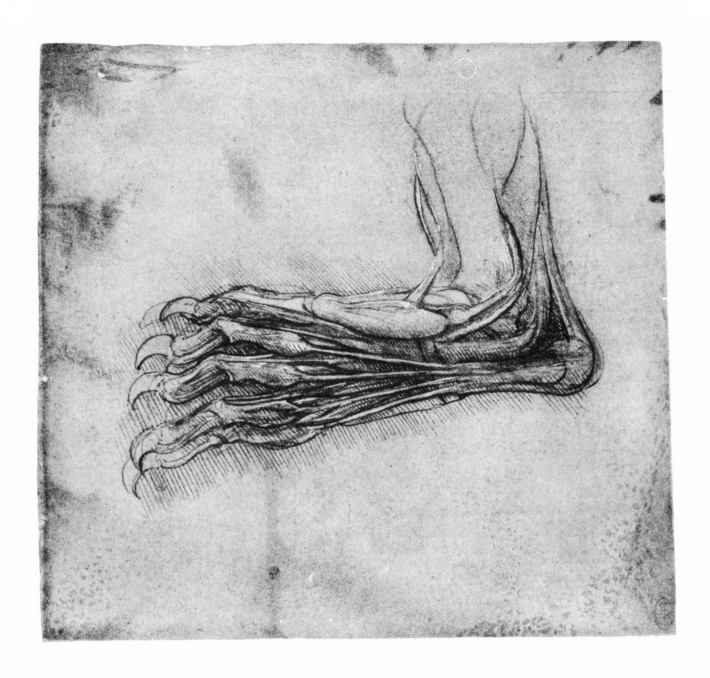

comparative anatomy

This page may be dated with some confidence as c.1513. Clark points out that the drawings and writing are in Leonardo's later style. The anatomical study of a bird's wing immediately suggests the "Codice sul volo dei uccelli", which is dated 1505, but there is no resemblance in style. However, Leonardo again took up the study of the flight of birds in Ms. E of the Institut de France (ff.35-63) dated 1513-14.

figs 1-3. **Dissection of a bird's wing and the action of the tendons in flight.**

This excellent study shows the bones, tendons and attachment of the feathers in a bird's wing. The humerus, radius, ulna, second and third metacarpals, and phalanges are all readily recognizable. An accompanying memorandum states that, *The cord a b, moves all the points of the feathers towards the elbow of the wing, and it does this on folding the wings. But on extending it by means of the pull of the muscle n m, the feathers direct their length towards the tip of the wing.*

The first comprehensive study of birds was the celebrated treatise on hawking by the Emperor Frederick II, composed between 1244 and 1250, in which the muscles of flight and the true homologies of the bones of the wing and leg were established with reasonable accuracy. The anatomical section of this work was not published until 1596. However, Leonardo appears to have been the first to recognize the bastard wing or alula attached to the thumb which, owing to its independent movement (this mechanism is illustrated), he believed to be of first importance in propelling the bird forward.

CARDIO-VASCULAR SYSTEM

heart: superficial view

Originally this page was part of the same sheet as 87 on which similar drawings of the heart appear. The folded sheet was torn apart but is now mounted as one. The drawings belong to Leonardo's latest period and can be dated from fig. 179 with considerable accuracy as c.1513. By now Leonardo had begun to modify somewhat orthodox Galenical views on the fundamental mechanism of the heart. These differences will become apparent as the series of drawings and notes are followed. In the examination of the figures it must be borne in mind that almost all are based upon appearances in the bullock's heart and not that of man. The figures are not easy to interpret because of the displacement of the great veins which are pulled upwards.

fig 1. **The interventricular septum of the heart.**

For the technique employed to demonstrate the interventricular septum in this manner, cf. 104. The lateral walls of the ventricles have been displaced after sectioning the heart, thus exposing the septum. The interventricular septum was of great importance in the Galenical system since it was through its pores (cf. 91) that some of the blood which ebbed and flowed in the right ventricle passed to become refined or subtilized in the left ventricle as the vital spirits giving rise to the so-called natural heat of the body. The note accompanying the figure brings forward the Galenical system, but an ingenious attempt is made to explain the origin of the mysterious innate heat of the ancients on mechanical principles. Earlier Leonardo had paid little attention to the auricular appendages which he calls auricles or *additamenti*, terms borrowed from Mundinus, or the external ventricles, a term likewise derived, but by extension, from the statements of the same author. It is the mechanical stirring or beating of the blood in these appendages which helps to subtilize the blood. A great deal of confusion is avoided if it be remembered that up to the time of William Harvey (1578-1657) and beyond, the heart was considered as a two-chambered organ consisting of right and left ventricles. Thus following Mundinus, the ventricles are called intrinsic or internal. On the other hand, the atria were regarded as forming the stems of the veins, cava and pulmonary vein respectively, so that the auricles themselves were thought of literally as appendages to the venous stems and therefore *additamenti* or additions, external or extrinsic in position. Likewise, the heart muscle was divided into external and internal or extrinsic and intrinsic, the ventricular wall forming the first and the papillary and pectinate muscles, the second.

The blood is more subtilized where it is more beaten. This beating occurs through the flux and reflux of the blood which are generated in the two internal ventricles of the heart to the two external ventricles, called the auricles or additions of the heart. The latter are dilated and receive into themselves the blood driven from the internal ventricles and then contract to return the blood to the internal ventricles. The internal [papillary and pectinate] muscles, capable of contraction, are of one and the same nature in the 4 ventricles, but the external muscles [of the ventricular wall] are solely for the internal ventricles of the heart

and, for the external, form only a single, continuous dilatable and contractable coat.

fig 2. **The ventricles of the heart divided at the interventricular septum.**

This rough figure, now almost obliterated, shows the ventricles divided at the interventricular septum prior to the displacement of their lateral walls as in fig. 1 above.

fig 3. **Mechanical drawing to illustrate the function of the cardiac valves.**

The figure is apparently designed to show the action of the muscular forces controlling the ventricular valves. The base of the triangle is supported by ropes passing over pulleys to which are attached the weights S f. At the apex of the triangle is another rope carrying a weight g. The triangle represents a ventricular valve, the base of which is stretched by the contraction of the muscle of the ventricular wall corresponding to the forces S f, and the valve closed. However, when this muscle is relaxed on diastole, the pull of the papillary muscle, represented by g, opens the valve. Thus Leonardo's theory was that the contraction of these muscles alternated in systole and diastole. In diastole, relaxation of the two ventricles and the contraction of the papillary muscle to open the atrio-ventricular orifice allows ventricular filling, while in systole the opposite closes the orifice.

fig 4. **The heart from the left and posterior side.**

In this figure of the heart, that of an ox, the root of the pulmonary artery has been severed and laid back to expose the root of the aorta giving rise to the left coronary artery. The left coronary is observed dividing into its descending and circumflex branches. A portion of the left auricle is displaced to reveal the branch to the roots of the great vessels. The aorta is also observed giving off a common brachiocephalic trunk. Behind and to the right of the aorta are the posterior vena cava pulled upwards and the anterior vena cava.

fig 5. **The heart from the right side.**

The same heart as in fig. 4 has now been turned to view from the right side. The root of the sectioned pulmonary artery has been removed to expose the pulmonary orifice and the medial, lateral and posterior semilunar valves guarding it. From the aorta spring the right and left coronary arteries. *a b, are two vessels* [coronary] *which arise from the two external openings* [i.e., aortic sinuses of Valsalva] *of the left ventricle.* Leonardo uses the term *usscioli*, openings, which is also employed for the valves themselves and for the cavities completed by the valves, forming what we now call the aortic sinuses of Valsalva. The distribution and branches of the coronary arteries are displayed with some accuracy, and the gradual diminution in calibre of these vessels as they pass distal is observed with the remark: *The branches of the vessels are always larger in proportion to their origin from a larger trunk, that is, from the principal ramification; the same continues in the ramifications of the ramifications up to the end.*

(continued on page 497)

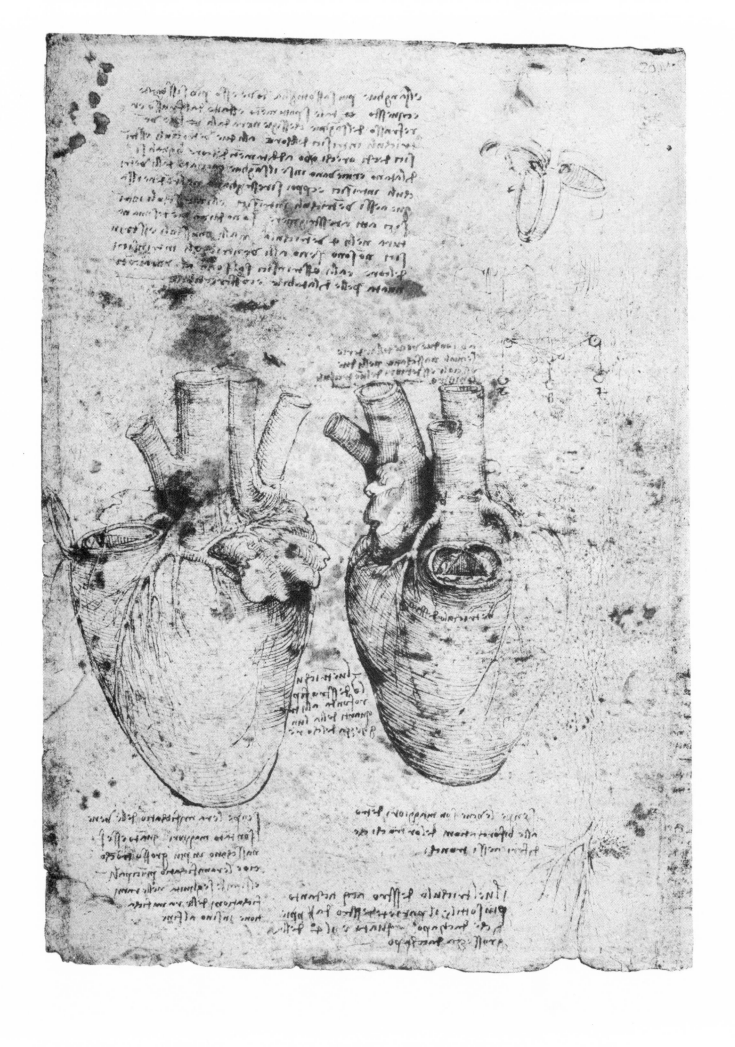

The figures of this page are a continuation of the series found on 86 since originally the page was part of the same sheet which has become divided into two. The drawings belong to Leonardo's latest period, and like those of 86 the figures are all based upon dissections of the heart of the ox.

fig 1. The heart from the right posterior aspect showing the distribution of the great cardiac vein.

The dissection is that of an ox heart viewed from the right side and somewhat posteriorly. The posterior vena cava is pulled upwards, and at its root is the great cardiac vein or coronary sinus S G, receiving at S, the middle cardiac vein. The circumflex branch of the left coronary artery is lettered H. Of these vessels Leonardo states, *S G, is the vein* [great cardiac] *which encounters the artery S G* [left coronary], *and that, the artery is always beneath the vena nera* [cardiac vein]. The vessel lettered O is the anterior vena cava and, *p is the auricle of the left ventricle.* The apex of the heart is indicated with the letter T.

figs 2-3. The heart from the left anterior aspect showing the distribution of the left coronary artery.

The figures of an ox heart are said to be of, *the heart seen from in front.* In fig. 2 the words, *right side,* are written on the right ventricle, and above the letter N, we are told that this region is the left ventricle, by which is meant in Leonardo's terminology, the left external ventricle or auricle. Leonardo is confused. At M, is the left coronary artery dividing into r f, its interventricular branch and its circumflex branch associated with the great cardiac vein N. However, the left coronary artery springs from a vessel labelled the *vena arteriale,* i.e., pulmonary artery, which is undoubtedly the aorta shown giving off its brachiocephalic trunk. The pulmonary artery proper is roughly indicated displaced to the right of the specimen. This error is therefore found in the description of the left coronary artery. *M, a vein, arises from the vena arteriale* [pulmonary artery, in reality the aorta] *and is that which nourishes the substance of the heart.*

The interventricular vessels are described: *r f, a vein, and the front of the wall* [septum] *placed between the right and left ventricles of the heart.* At *S T, in the other heart* [fig. 1] *are the vein and artery placed on the opposite side of the said wall, that is, on the back of the heart.* Improvements are to be made in the drawing, *Make the vein r f, more arched.* The great cardiac vein N, carries the notation, *N, a vein, arises.* Of figs. 1-3, Leonardo reminds himself, *Make these 3 demonstrations with all the vessels* [elevated] *from the heart upwards* [as in fig. 11].

fig 4. An abortive sketch.

The sketch lying to the left of the letter D, is now too badly rubbed and faded for its nature to be determined.

fig 5. The heart: right anterior aspect.

The *right ventricle* is so labelled just below the origin of the pulmonary artery. Behind the pulmonary artery the aorta gives off a brachiocephalic trunk as

in the heart of the ox. The right and left coronary arteries are shown passing from the aorta to embrace the stem of the pulmonary artery. On the left is the posterior vena cava, pulled upwards; and the anterior vena cava, and at their root, the lesser cardiac vein. The auricles have been turned back on either side. It will be noted that this, as well as several of the other drawings has an asterisk, formed by a circle with four lines running through it, placed above it. The significance of the asterisk is indicated by a note on 88 where we are told that such drawings are to be made enclosed by their capsule, i.e., the pericardium.

figs 6-9. Diagrams of the heart and coronary vessels.

The significance of these diagrams is revealed in the accompanying note in which attention is called to the crossing of the interventricular branch of the left coronary artery and the great cardiac vein as observed when the heart is examined from the left side and somewhat anteriorly as in the first, third and fourth of the diagrams. The second of this group of figures presumably shows the heart encased in the pericardium.

The heart seen from the left side will have its veins and arteries intersecting like one crossing his arms— and they will have above them the left auricle and within them the gateway [aortic orifice] *of triplicate triangular valves and the open gateway will remain triangular* [as shown in figs. 14-15 below].

fig 10. The heart viewed from the right and posteriorly to demonstrate the distribution of the right coronary artery.

The heart of the ox is shown as viewed from the right and somewhat posteriorly to reveal the extent of the right ventricle a b c, in relationship to the surface. The lateral wall of the right ventricle is indicated by the words written on it, *The cover of the right ventricle.* The aorta, which has again been confused with the pulmonary artery in the notes, is shown giving off a brachiocephalic trunk and providing at o, the right coronary artery o p. The right coronary artery passes between the pulmonary orifice exposed by resection of the root of the pulmonary artery, and the right atrio-ventricular or tricuspid orifice which is revealed by division and displacement of the right auricle from its attachment to the region of the coronary groove. Above the right auricle are the roots of the anterior and posterior venae cavae, the latter being pulled upwards. Below the right auricle is the middle cardiac vein b s, dissected free and elevated from the inferior interventricular groove. The left auricle is lettered f, and below it the course of the interventricular branch of the left coronary artery or great coronary vein is observed. The apex of the heart is indicated by m. The accompanying note discusses the distribution of the coronary vessels.

The vessels a c [anterior interventricular] *and b c* [inferior interventricular] *enclose the extremities of the right ventricle, and the vena arteriale* [pulmonary artery, in reality the aorta] *sends forth the branch*

(continued on page 497)

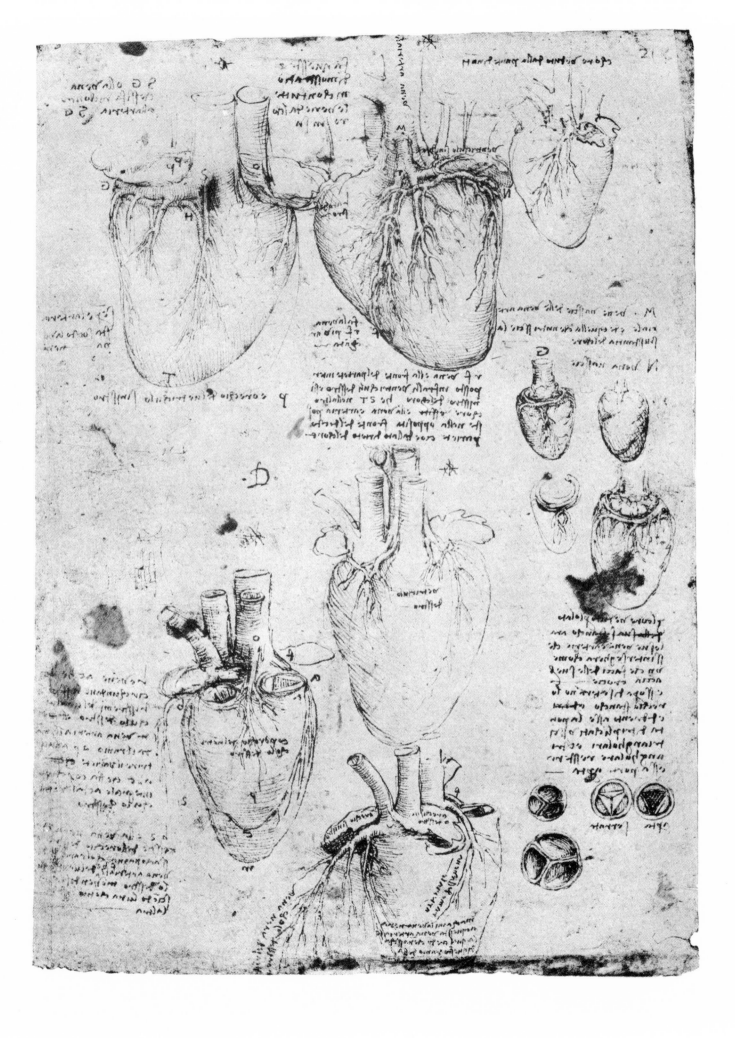

heart: superficial view

fig 1. **The heart, interventricular septum and great vessels.**

A very rough sketch or diagram of the ventricles separated by the interventricular septum a b, through the pores of which Galenical physiology taught that some of the blood passed from the right to the left ventricle to be converted into vital spirit. Hence Leonardo notes that *a b* [interventricular septum] *is the sieve or common wall.* To the left is the vena cava receiving the hepatic veins below from the liver, indicated roughly by a circle, and entering the heart at a, the right atrio-ventricular or tricuspid orifice, since the heart was regarded as consisting of two ventricles only, and so the right atrium itself is part of the cava. The vena cava is named *vena del chilo*, i.e., vena chilis. Above the term vena chilis appear the words *The vein called the nourisher of the heart*, which have been deleted to be replaced with the notation on the right atrio-ventricular orifice: *a, the gateway of the vena chilis: the vein which nourishes the heart.*

Above the heart is the arch of the aorta providing a single branch, the brachiocephalic trunk. The descending aorta may be followed to the region below the heart. On either side the lungs are roughly represented and passing to them the pulmonary arteries. The hilum of the right lung and right pulmonary artery is indicated by the letter S.

S, the gateway of the lung, and it is named the vena arterialis; it is called vena because it carries blood (to the lungs [deleted]), and arteriales, because it has two tunics. It has three valves which open from within outwards with perfect closure, and these are in the right ventricle.

The vena arterialis, i.e., pulmonary artery, following Galen's physiology, was necessarily part of the venous system although morphologically an artery. The information provided by Leonardo is to be found in all his sources. A further note discusses the left ventricle and its orifices.

The right [for left] *ventricle has two orifices, one at the aortic vessel (vena aorta)—they open from within outwards—the other orifice is at the arteria venalis* [pulmonary vein-left atrium] *which goes from the heart to the lung. It has a single tunic and is called arteria because of the spirituous blood and is named venalis through its being a simple vein.*

It is unfortunate that Leonardo has written "right" instead of "left" ventricle. This has given rise to much speculation. However, from the context it is obviously a *lapsus calami*, as first pointed out by Boruttau (1913), and the substitution of right for left and vice versa is an error common in Leonardo's notes, doubtless due to his mirror-writing.

fig 2. **The heart and pulmonary artery: posterior aspect.**

fig 3. **The trachea, right bronchus and its branches.**

The above two figures appear to be preliminary stages of the drawing on 173 where the two figures are fused into one to show the distribution of the branches of the pulmonary arteries and bronchi in the lung.

On the heart is written the word *behind* for what is in reality the inferior or diaphragmatic surface of the heart, but the figure is somewhat diagrammatic. The absence of any indication of the left atrium is noteworthy. The vessel on this surface is presumably the right coronary artery providing interventricular and marginal branches, or perhaps the middle coronary vein. Above, the pulmonary artery is shown dividing into right and left branches, and thereafter subdividing in a purely fanciful or impressionistic manner. Behind and to the right of the pulmonary artery is the stem of the aorta. The right bronchus is likewise shown subdividing in a fanciful pattern. The drawing is marked by an asterisk below which is written: *First make the capsule.* Below the drawing is a memorandum reading: *First make the heart with its vessels from two aspects, that is, from behind and in front.*

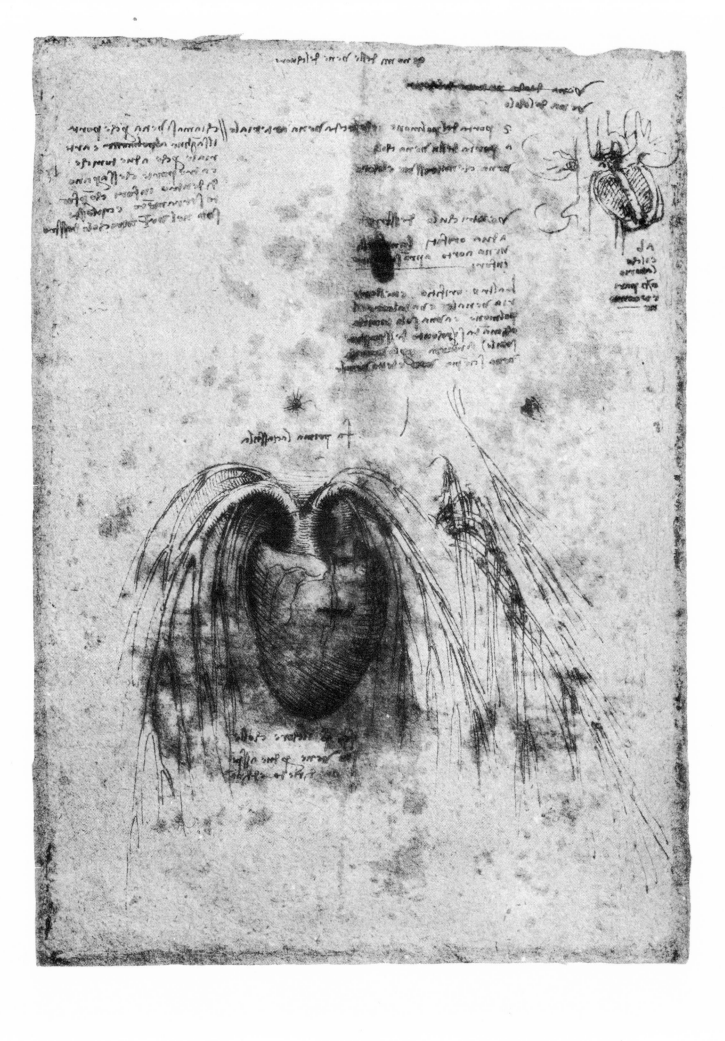

fig 1. **The heart, great vessels and principal viscera.**

Both ventricles are opened exposing a series of moderator bands and the interventricular septum which contains the channels required in Galenical physiology for the transmission of blood from the right to the left side for the formation of vital spirits. The heart is regarded as consisting of ventricles only, but there is a suggestion of the left auricle. The branches from the aorta are presented as in ruminants. The right atrium is regarded as part of the vena cava, and reflecting Leonardo's highly speculative and traditional views at this time, the pulmonary veins open directly into the cava. The five-lobed liver of tradition is shown giving off the hepatic vein to the cava along which flows the new blood manufactured in that organ. Splenic vessels pass from the spleen directly to the liver and are supposed to carry the black bile. An umbilical vein extends to the porta hepatis. Other structures are easily recognized, but note the relatively correct arrangement of the spermatic veins especially the left. The discovery that the left spermatic vein drains into the left renal has been claimed for Vesalius, Berengario da Carpi, Achillini and many others.

The primary purpose of the illustration is to express in diagram the manner in which the so-called pneuma passed from the lungs to the heart. Leonardo's opinions are adapted from Galen, and how they differ will be discussed with the notes accompanying this illustration. The first of these notes brings to the fore the controversy between the Aristotelians and the Galenists. Primacy was placed by Aristotle in the heart which was also the seat of the intelligence or sentient soul. In Galen's scheme, held by the physicians, the vital spirit was carried from the left ventricle to the brain where it was transformed into the animal spirit which brought the nervous system into action through the supposedly hollow nerves. The vagus, since it gives off the recurrent, was commonly called the reversive nerve.

Do not leave the reversive nerves until the heart, and see whether these nerves give motion to the heart, or if the heart moves of itself. If its motion comes from the reversive nerves which have their origin in the brain, then you will clarify how the soul [i.e., animal spirit] has its seat in the ventricles of the brain and the vital spirits have their origin in the left ventricle of the heart. And if this motion of the heart originates in itself, then you will say that the seat of the soul and similarly, that of the vital spirits, is in the heart. So you should attend well to these reversive nerves and likewise to other nerves because the motion of all the muscles arises from these nerves which with their branches are diffused through the muscles.

In the Galenical physiology the basic principle of life was the pneuma, anima or spirit drawn into the lungs by the act of respiration. From the lungs it passed via the pulmonary veins to the left side of the heart to join with the refined blood which had passed through the interventricular septum to form the vital spirit distributed by the arterial system as the living force. Meanwhile, the blood in the right heart having picked up the impure exhalations from the organs, carried these so-called "sooty vapors" via the pulmonary artery to the lung whence they passed to the outer air. In this way the excess of heat generated by the heart was dispersed.

Many are the times that the heart attracts to itself the air which it finds in the lung, and after heating it, returns it without the lung taking in other air from without.

Leonardo attempts to relate the movements of systole and diastole of the heart to the transference of the pneuma and sooty vapors to and from the heart. Respiration and the movements of the heart are coordinated except when one is voluntarily suppressed. The difference in rate is accounted for in part since he held that the ventricles contracted alternately thus producing two pulse beats in the cycle.

It is proved that of necessity it must be as here set forth. This is that the heart which moves of itself does not move except on opening and closing. Its opening and closing cause a motion along the line which extends between the apex (cuspide) and the base or crown of the heart. It cannot open without drawing into itself air from the lung which it immediately blows out again into the lung. In the lung it will then be seen that the lung is restored anew by the vigorous motion of sudden respiration of cold, refreshing air, and this happens when a fixed thought in the mind banishes into oblivion the respiration of the breath.

It is difficult to follow Leonardo's thought in the next passage. He attempts a mechanical explanation of how the pneuma and vapors pass to and from the heart and lungs. At a later period he comes to realize that there is no free passage of air to the heart and that the respiratory movements are due to the action of the muscles of the rib cage. Here, however, he seems to imply that respiration is fundamentally due to the movements of the heart which in diastole create a vacuum which by drawing out the air from the lung causes its collapse. With systole, the heart *pulls* the lung tissue open through the medium of its vascular connections which then creates a vacuum in the lung which is immediately filled by vapors from the heart. These ideas he later discards, indicating that these remarks are of early date.

In closing itself [i.e., in systole] the heart with its sinews and muscles draws behind the sinewy veins [pulmonary] which unite the heart to the lung. This is the chief cause of the opening of the lung, because it cannot open if the vacuum does not increase. The vacuum cannot be increased if it is not refilled, and finding the air speedier for this restoration of the vacuum, it refills itself with it. The heart after contracting comes to open again and on reopening relaxes the drawn out sinews and vessels of the lung, from which it follows that the lung closes again and at the same time replaces the increases of the vacuum of the heart with the air which it blows out of itself. In part it sends out through the mouth the superfluous air for which there is no room either in it or in the heart.

The liver being the blood-making organ, the heart

(continued on page 497)

ventricles of the heart

fig 1. **Faint chalk sketch of stomach, spleen and vessels.**

fig 2. **Left ventricle of heart and action of the papillary muscles.**

THE MARVELOUS INSTRUMENT INVENTED BY THE SUPREME MASTER.

The heart is probably that of an ox in which the left ventricle has been partially laid open by an incision along its left posterior border thus exposing the anterior papillary muscle N. At B, is the left atrio-ventricular or mitral orifice, leading into the left atrium which is regarded as the root of the pulmonary vein since the heart was thought of as a two-chambered organ consisting of ventricles only. Thus at C, is an orifice entering the auricle S, considered to be an appendage of the pulmonary vein. In the shadow to the right of the papillary muscle is concealed the letter M, indicating the aortic vestibule. Since the left ventricle generated the vital spirits distributed by the arteries, it is so designated in the note which follows. In the Galenical physiology the pulmonary vein led air to the left heart which combined with the blood transmitted through the interventricular septum to form these vital sipirts.

The heart opened into the receptacle of the [vital] spirits, that is, into the artery.

At M [aortic orifice], it takes, or rather it gives the blood to the artery. By the opening B [mitral valve], it refreshes the air from the lung and through C, it fills the auricle S, of the heart. N, is a hard muscle [papillary] which is contracted. It is the first cause of the motion of the heart. On contraction it thickens and on thickening it shortens and draws behind it all the superior and inferior muscles, and closes the gateway M [aortic vestibule]. It shortens the space intervening between the base and the apex of the heart and consequently comes to evacuate it and attract fresh air to itself.

As Leonardo mentions elsewhere, the function of the auricle is to produce the innate heat of the body by friction with the ebb and flow movements of the blood. This idea is used to explain the association of fever with an accelerated pulse.

ON THE CAUSE OF THE HEAT OF THE BLOOD.

The heat is generated through the motion of the heart and this is shown because the more rapidly the heart moves the more the heat is increased, as the pulse of the febrile, moved by the beating of the heart, teaches us.

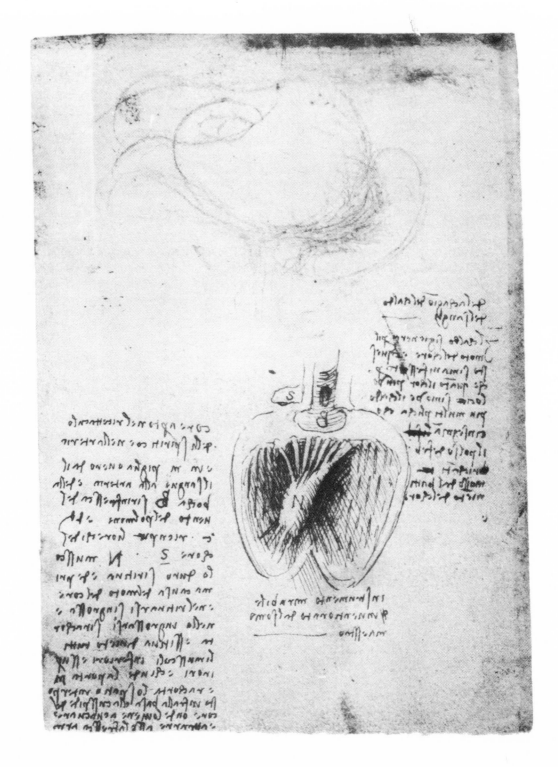

ventricles of the heart

fig I. **The auricles and ventricles of the heart.**

Leonardo takes issue with traditional authority as to the number of chambers making up the heart. From Galen's time anatomists regarded the heart as consisting of ventricles only and contended that the auricles were no more than appendages of the veins. However, Leonardo is willing to accept such ancient ideas as the existence of pores in the septum of the heart, as illustrated, and the belief in the flux and reflux of the blood. Surrounding the illustration are some of his arguments by analogy for a four-chambered organ.

If you should state that these 4 ventricles are 2 because each pair leads from one to the other, I will say that all the veins are one and the same structure because one leads into the other, and likewise the intestines, since they are separated by openings like these.

If you contend that the 2 upper [auricles] and lower ventricles are one and the same, even if separated by such openings placed in their walls, I will say further that a chamber and a room are one and the same although they are separated only by a small passage.

The argument continues with a lengthy discussion on the function of the auricles in the ebb and flow of the blood. The position taken suggests that these notes derive from a late period in Leonardo's studies on the mechanism of the heart. A date of c.1507-09 has been suggested, but the work shows every evidence of having been composed in his final period, c.1513.

ON THE VENTRICLES OF THE HEART.

The heart has four ventricles, that is, two lower in the substance of the heart and two upper [auricles] outside the substance of the heart, and of these, two are on the right and two on the left. Those on the right are much larger than those on the left. The upper [auricles] are separated by certain openings (or gateways of the heart) from the lower ventricles. The lower ventricles are separated by a porous wall through which the blood of the right ventricle penetrates into the left ventricle and when this right lower ventricle closes, the left lower opens and draws into itself the blood which the right provides. The upper ventricles [auricles] continually causes a flux and reflux of the blood which is repeatedly drawn or forced by the lower ventricles from the upper. Since these upper ventricles [auricles] are more able to drive from themselves the blood which dilates them than to attract it to themselves, Nature has so made it that by the closure of the lower ventricles (which close of their own accord) the blood which escapes from them is that which dilates the upper ventricles. These [auricles] being composed of muscles and fleshy membranes are able to dilate and to receive as much blood as is forced into them, or also capable by means of their powerful muscles of contracting with energy and driving out the blood into the lower ventricles of which one opens when the other closes. The upper ventricles [auricles] do the same in such a way that when the right lower ventricle opens, the left [for right] upper contracts and when the left lower ventricle opens, the right [for left] upper closes. And so, by such a flux and reflux made with great rapidity the blood is heated and subtilized and becomes so hot that but for the help of the bellows

called the lungs which by dilating draw in fresh air, compress it and bring it in contact with the coverings of the branchings of the vessels and cools them, the blood would become so hot that it would suffocate the heart and deprive it of life.

Riposte of the adversary against the number of the ventricles, stating that there are 2 not 4, because they are continuous and joined together—the 2 right together making one and the same structure and the left doing likewise.

It is here replied that if the right and left ventricles form a single right and a single left ventricle, it is necessary that these perform one and the same function at one and the same time and not opposite functions on the right side as is shown by their flux and reflux. Furthermore, if it [ventricle] is one and the same structure, it is not necessary for sinewy valves to separate them from one another, and, if it is one and the same structure, it is not necessary that when one part opens the other should close. This is proved further by the essence of a member in that one and the same member is designated as that which carries out one and the same function at the same time. As in the case of the body of a bellows or of the bagpipes in which, although it may appear to be one and the same with the human body when being inflated by him, it is not actually united to him nor does it carry out one and the same function at the same time, for when the man's lungs are emptied of the air, the bag of the bagpipes is at the same time filled with the same air. Therefore it is concluded that the upper ventricles [auricles] of the heart are different in their functions, in their substance, and in their nature from those below, and that they are separated by cartilage [fibrous trigone] and various substances interposed between one another, that is, the sinewy membranes and much fat.

The upper ventricles [auricles] of the heart do not dilate of themselves but are dilated by the other ventricles. However, their contraction is generated intrinsically by means of their muscles. Owing to their diverse obliquities and concatenation or interwoven state without any flesh between their intertwinings, these muscles are without any villi so as to be capable of stretching longitudinally in accordance with the requirements of the superabundance of blood that sometimes beats against [? i.e., stretches or tears] the external membrane which clothes these muscles. Hence the auricle is membranous, fleshy and extremely dilatable.

Prove how the upper ventricles [auricles] are not one and the same ventricle with the lower ventricle.

At one and the same time in one and the same subject two opposite motions cannot take place, that is, repentance and desire. Therefore, if the right upper [auricle] and lower ventricles are one and the same, it is necessary that the whole should cause at the same time one and the same effect and not two effects arising from diametrically opposite purposes as one sees in the case of the right upper ventricle with the lower, for whenever the lower contracts, the upper dilates to accommodate the blood which has been driven out of the lower ventricle. The upper ventricle [auricle] does

(continued on page 497)

ventricles of the heart

The discussion of the function of the heart is continued from 91. The action of the right ventricle is now examined in terms of the ebb and flow theory of Galen.

fig I. Diagram of the heart.

In this purely diagrammatic representation the atrium a, contrary to traditional theory, is shown as a separate chamber receiving blood from the venous system d, which may then pass through the atrio-ventricular orifice b, to the ventricle c, whence it enters the arterial system d. However, in the note below it is explained that in the right heart the tricuspid valve must be partially incompetent to allow of the ebb to the auricle and perfect closure occurs only when the ventricle has lost a part of its content so as to permit the development of sufficient force on systole to squeeze some of the blood through the mythical pores in the interventricular septum into the left ventricle. This filtered or subtilized blood forms the vital spirits of the left heart.

ON THE RIGHT VENTRICLE.

The right ventricle having to eject rather than to retain more of the blood received, its three valves [tricuspid], *which are closed from within, are so arranged that they do not close perfectly except when the ventricle on its contraction is found to have reserved that quantity of blood which it desires to retain. These three valves being then entirely closed, the walls* [of the ventricle] *next contract around the escaping blood with such force as to compel the greater part of it to escape from this ventricle and penetrate through the passages of the intermediate wall and enter the left ventricle. This* [blood] *being subtilized by penetrating these narrow passages, is converted into the vital spirits, leaving all impurities in the right ventricle.*

Misled by appearances in the right ventricle and owing to the rapidity with which the blood clots in that chamber, Leonardo describes the presence of fibrin fibres which he believes constitute the impurities left by filtration of the blood through the interventricular septum. He employs this finding to explain the cause of death in old age and refers to the case of the centenarian, cf. 156.

On the gross viscosity of the blood which collects in the right ventricle.

The blood of the right ventricle which remains after the subtilization of the blood which penetrates into the left ventricle, is viscous. Part of it is formed into minute fibres [fibrin] *resembling those of the vermis* [choroid plexus] *of the ventricle in the middle of the brain. These fibres multiply in the manner of thick and short oakum, and in the course of time wrap themselves around the cords of the membranes which close the right ventricle in such a way that with the aging of the animal the valve cannot close fully, and a large part of the blood, which should pass through the narrow passages of the intermediate wall into the left ventricle for the creation of the previously mentioned* [vital] *spirit, escapes through the imperfectly closed valve into the right upper ventricle* [auricle]. *For this reason the total* [vital] *spirit is lacking in old age, and they often die while speaking.*

A further curious conclusion is reached on the function of the pericardial cavity. This cavity is regarded as a real rather than a potential space and is supposedly filled with air. On the principle that "nature abhors a vacuum" Leonardo is of the opinion that contraction of the right auricle creates a space which is filled by air from the pericardium to fulfil its needs. In Galen's theory air may pass directly to the left auricle but, as Leonardo points out, this is impossible in the case of the right auricle. Thus the pericardium is required in turn to draw air from the lungs so that the volume taken in by the lungs is greater than that required to fill the lungs alone.

ON THE FUNCTION OF THE LOWER AND UPPER [AURICLE] LEFT VENTRICLES.

The function of the lower and upper [auricle] *right ventricle. The lower gives on deposit to the upper the blood which prevents its contraction, and it would not be able to dilate later if it did not get back from the upper ventricle the blood which previously filled its cavity. This* [auricle or upper ventricle] *is able to contract because it cannot obtain the air which should fill it. The air which replaces the space occupied by the upper ventricle when it held on deposit the blood of the contracted lower ventricle, runs in to fill the place of the upper ventricle when it contracts* [in turn] *and is that of the capsule* [pericardium] *of the heart. This capsule giving up its air to the space left by the upper ventricle is restored by drawing more air through the trachea into the lung than was its requirement and, therefore, the air which is drawn into the lung cannot always be equal* [to it in volume].

The latter part of the note is classified by the following two lines which were probably intended as a marginal comment for the finished work:

Why the air which is drawn into the lung cannot always be of equal measure.

The argument is continued on 93.

ventricles of the heart

The notes from 92 are continued on the important subject of the function of the heart, presenting an expansion of the theory of the ebb and flow movements and the formation of vital spirits in the left ventricle. In the margin is the statement: *Not abbreviators but forgetters should those be called who abbreviate such works as these.* Since the term "abbreviators" was applied to the secretaries of the Vatican chancery, this note may be directed against Leonardo's detractors in Rome and may therefore indicate the time of this and the related group of plates, mostly from Q I, as c.1513. While the contents of the notes supports this date, Clark suggests c.1507-09 on stylistic grounds. The notes are self-explanatory.

ON THE HEART.

Whether on its reopening the right lower ventricle draws in all the blood of the upper right ventricle [auricle] *or not.*

All the blood which the right lower ventricle gave on deposit to its upper right ventricle when it contracted, is returned by the upper when the lower dilates with the aid of its longitudinal muscles. This is assisted by the transverse and oblique muscles of the upper ventricle which contract and force out the blood. During this time the vena cava gives no blood to it because there would be a vacuum. Neither does the lung, which has its own vessel [pulmonary artery], *the valves of which at the same time close from without inwards towards the base of the heart. Nor does the liver provide any of it, as it would be necessary for it to attract it* [from elsewhere], *but only the upper ventricle which remains open immediately above the mouth of the lower ventricle and forces some of it into the body* [of the lower ventricle] *by its contraction. However, since the heart by the complete contraction of its openings when it elongates and forces the blood remaining in it through the narrow passages into the left ventricle, the right ventricle is not entirely refilled, as it was before it closed. The longitudinal muscles again carry out the same function which they customarily perform on the reopening of their ventricle and, because there would be a vacuum which is impossible, necessity draws blood from the liver of an amount equal to that which was driven out of the right into the left ventricle.*

The right lower ventricle does not always attract to itself one and the same quantity of blood from the lung.

When it so happens that the lung dilates at one and the same time as the right lower ventricle also dilates, then the lung increases in the interior towards the diaphragm, contracts and squeezes the blood out of the vena cava which lies between the lung and the dorsal spine. Some of this blood enters the right lower ventricle, and the more this vein pours into the ventricle, so much the less is drawn from the gibbosity of the liver.

The argument continues on the dictum, also in Galen, that nature does nothing in vain; a phrase which seems greatly to have appealed to Leonardo. The term "capillary veins" will also be noted in the next passage. It has been said that Jean Fernel (1497-

1558) was the first to introduce the term, but it had long been current and may be found in much earlier writings. It meant "hair-like" in the true sense of the word.

HOW IT IS IMPOSSIBLE FOR ANY BLOOD TO REMAIN IN THE RIGHT UPPER VENTRICLE WHEN ITS LOWER VENTRICLE OPENS.

It is impossible for any part of the blood to remain in the right upper ventricle [auricle] *when its lower ventricle dilates, and this is proved thus. It has been stated that Nature always accomplishes her effects in the easiest way and in the shortest time possible. Therefore, since at the time of the dilatation of the lower ventricle the valves, which form the base and support of the blood retained by its upper ventricle, are open, it is necessary that the lower ventricle fill itself first with the blood which is in contact with it, rather than with that contained in the liver which is at a distance from it. And it is necessary for it to be filled more swiftly with the blood which the upper ventricle squeezes and forces into its body through a wide passage than by any other distant blood which must be drawn and sucked from capillary veins dispersed in the gibbosity of the liver.*

If you were to say that these upper ventricles are formed solely to retain the superfluous blood which is sometimes generated in this part, I would reply to you that this is impossible because if it were so, the heart would fill its right ventricle with that blood most convenient to it, which, as I have said, is retained in its upper ventricle. If the lower ventricle were full of blood, which is given it and forced into it from above, the heart would not be able to draw more blood from the gibbosity of the liver. Consequently if this were to continue on many occasions, life would be destroyed. It might be possible for the heart to distribute by a few beats a part of this superfluous blood which remains in the upper ventricle as the right lower ventricle would force it into the left lower ventricle, but during that time the liver would not give any blood to the heart.

WHETHER THE LIVER HEATS ITSELF INTRINSICALLY OR IS HEATED BY OTHERS.

The liver cannot heat its own self but is heated by others, that is, by the artery [hepatic] *which enters the gateway of the liver and gives it life.*

Whether the lung is hotter or colder than the heart, [i.e.] *than the left* [heart].

As the heat of the heart is generated by the swift and continuous motions made by the blood with the intrinsic friction caused by its churnings and also with the friction which it produces with the cellular wall of the right upper ventricle into or out of which it continually enters and escapes with impetus, these frictions caused by the velocity of the viscous blood proceed to heat, subtilize and cause the blood to pass through the narrow passages [into the left ventricle] *giving life and spirit to all the members into which it is infused. This cannot occur in the case of the*

(continued on page 498)

As in 93 we find a marginal note reading: *Make a discourse on the censure which is deserved by scholars impeding anatomy and the abbreviators thereof,* which once again and more pointedly seems to refer to Leonardo's difficulties in Rome and appears to confirm the date as c.1513. Leonardo continues with his discussion on the function of the heart employing a typically mediaeval type of argument in support of the Galenical theory.

ON THE HEART. WHETHER NATURE COULD HAVE MADE THE RIGHT VENTRICLE LARGER AND OMITTED ITS UPPER VENTRICLE [AURICLE] OR NOT.

Nothing is superfluous and nothing is lacking in any species of animal or product of Nature unless the defect comes from the means which produce it. It therefore follows that the right upper ventricle [auricle] was necessary for the flux and reflux of the blood which is generated by the aid of this ventricle. Through this flux and reflux of the blood and by its impetuous motion from one ventricle to the other, when one drives it out, the other receives it and the one which has received it, forces it back into that which previously drove it out. And so between successively raging up and down it never ceases to scour through the cavernous cells interposed between the muscles [pectinate] which contract the upper ventricle. The revolving which occurs in the blood itself as it rages in diverse eddies, the friction which it makes with the walls and the percussions in these cells, are the cause of the heating of the blood and of making the thick, viscous blood thin and capable of penetrating and streaming from the right to the left ventricle through the narrow passages of the wall interposed between the right and left lower ventricles. This could not occur if there were but a single ventricle on the right side, for the reason that when it contracted it could not contract except for [i.e., to leave] a small amount of space equal to the blood which had escaped from it into the right [for left] ventricle and would again open to an amount equal to the blood drawn from the liver to restore its re-acquired volume. Thus the flux and reflux of the blood would take place because it [i.e., auricle] gave up from itself to the right ventricle as much blood as that which it received from the liver. This motion of the blood behaves like a lake through which flows a river, receiving from one end as much water as it loses at the other, but the only difference is that the motion of the blood is discontinuous and that of the river flowing through the lake is continuous. Owing to the lack of flux and reflux the blood would not be heated, and in consequence the vital spirits could not be generated and for this reason life would be destroyed.

Furthermore, it follows that at the escape of blood which occurs from the lower ventricle into the upper [auricle] and lasting until its valves can join to make a perfect closure, there is an interval of time which together with the time during which the expulsion of blood from the right to the left ventricle occurs and with the time which increases during the reflux caused by the upper ventricle, is so prolonged that the lower part of the liver can give to its upper part

as much blood as that taken from the latter by the right ventricle. And so the double function of the right upper ventricle is proved, that is, to heat the blood through the flux and reflux and to provide time for the liver and miseriaic [portal] vein to create and restore to the gibbous part of the heart [or liver] that portion of blood of which the right ventricle robbed it.

WHY THE UPPER VENTRICLE [AURICLE] WAS NOT ADDED TO THE RIGHT VENTRICLE SO AS TO RECEIVE THE SUPERABUNDANT BLOOD.

Superfluous blood is not received by the right ventricle because it is the structure which attracts it and attracts only the quantity for which it has room. The amount which enters it is equal to the amount of space produced by its dilatation. At this time the upper ventricle is deprived of its blood because if there were any in it, it would be easier for the lower ventricle to draw blood first from the upper ventricle than from the gibbous part of the liver through the narrow ramifications of the capillary veins. Furthermore, it of necessity first draws blood from the upper ventricle rather than from the liver, because this blood above is united to and in continuity with the blood below over a large interval. The volume lost by the upper ventricle is equal to the quantity of blood which descends from it into the lower ventricle because this ventricle [auricle] contracts behind the blood which is forced out by means of its muscles.

In the margin is an additional note referring to the above which reads: *Superfluous blood cannot be received by the right ventricle because it is that which attracts and only attracts the quantity for which it has room. The quantity entering it is equal to the amount of space produced by its dilatation.*

In the next note Leonardo discusses the position of the heart at death. The argument is similar to that used to account for diastole by the active lengthening of the transverse fibres and contraction of the longitudinal. Vesalius employed a model to show how this occurred. It consisted of a ring representing the base of the heart to which a number of osiers were tied and then gathered at their ends to form an apex. A piece of string was tied to this apex and passed to the outside through the center of the ring. The string, representing the longitudinal muscles of the septum, when pulled caused the osiers to budge and diverge thus widening the lumen. William Harvey in his *De motu cordis,* commenting upon the apparatus, reminds us that the experiment is invalid and only seems to prove what it was intended to prove.

HOW THE HEART WIDENS ITSELF ONLY ON THE DEATH OF MAN WITHOUT CHANGING ITS POSITION [AT ITS BASE].

The heart widens and shortens on the death of man because its transverse muscles elongate and the longitudinal contract, and so only the inferior part is elevated and not the superior.

(continued on page 498)

ventricles of the heart

Among the most important contributions of Leonardo are his experimental observations on the heartbeat in which he adopted a method employed by Tuscan farmers for slaughtering pigs. The animal was tied and placed on its back. A spile (*spillo*) or sharp-pointed instrument, still used in essentially the same design to draw wine from a cask and to tap maple trees for syrup, was thrust through the thoracic wall into the heart. The point of the instrument moves with the systolic and diastolic movements of the heart and the handle is elevated or depressed on the fulcrum of the thorax so as to reveal the cardiac motions. E. C. van Leersum (*Janus*, 1913) shows that the method was first re-introduced by Jung of Basel in 1835, using a needle in place of the spile, and by Schiff in 1849 for studies on the innervation of the heart. Richard Wagner, Johann Czermak, the younger, Niddeldorpf, Moleschott, and several others found the method very useful in their researches into the function of the heart, and J. Berry Haycraft, 1891, by attaching a light straw to the needle, developed the cardiograph.

fig 1. **Diagram of an experiment on the heart-beat.**

A sharp-pointed instrument called a spile, f a, is thrust through the thoracic wall m n, of a pig at the point e, into the heart just above its apex while in diastole h a. At systole, h b, the point of the spile is carried upwards depressing the handle through the fulcrum e, to the new position g b. At death the heart remaining in partial systole, the instrument occupies the mid-position p o. For Leonardo's discussion cf. note below.

fig 2. **Diagram illustrating the effects on piercing both walls of the heart.**

The figure compares the shortening of excursion of the lever when thrust through both walls of the heart. The fulcrum of the thoracic wall is at p. The spile is shown to have a greater movement when its point is in the anterior wall of the heart at c and d, than when in the posterior wall at a and b, owing to the shortening of the distance from the handle to the fulcrum g p, n p. For discussion cf. below.

ANATOMY.

WHETHER THE HEART AT ITS DEATH CHANGES ITS POSITION OR NOT.

The change in the heart at its death is similar to the change which it makes during the expulsion of blood, and is a little less. This is shown when one sees the pigs in Tuscany where they pierce the hearts of the pigs by means of an instrument called a spile (spillo) with which wine is drawn from casks. And so, after turning the pig over and having tied it up well, they pierce its right side together with its heart by means of this spile, thrusting it straight inwards. If the spile passes through the heart while it is elongated, the heart in shortening itself on the expulsion of its blood draws the wound upwards together with the point of the spile. The point of the spile on the inside is elevated the same amount that the handle of the spile is depressed on the outside. And then

when the heart expands and forces the wound downwards, the part of the spile on the outside makes a movement opposite to that of the part within, which moves in unison with the motions of the heart. And this it does many times in such a way that at the end of life the external part of the spile remains between the two extremes which were the maximum opposite movements of the heart when it was alive. And when the heart becomes quite cold, it retracts very slightly and shortens an amount equal to the space occupied when warm, because heat either increases or decreases a body when it enters or leaves. I have often seen this and have noted such measurements, having allowed the instrument to remain in the heart until the animal was cut up.

Therefore let the expanded heart [in fig. 1] be h a, and the contracted heart, h o; and this when the animal is alive. If the spontoon or the spile finds the heart elongated when it is pierced with the spile f a, as the heart shortens, the point of the spile a, is carried to b, and the part of the point of the spile a, is carried to b, and the part of the handle of the spile on the outside descends from f to g. When the heart is dead, the spile remains in or about the middle of the two extremes of movement, that is, at o p.

From the maximum to the minimum motion of the heart, there is about a finger's breadth. At the end [of the experiment] the heart rests with its apex out of its usual position by about the width of half a finger. Take heed lest you make a mistake in taking this measurement, because sometimes the handle of the spile will make no change from the life to the death of the heart. And this happens when the heart is wounded mid-way in its course on shortening where it rests when dead. Sometimes the handle makes a greater excursion. This happens when the heart is wounded at its maximum or minimum length. And so it will cause as many differing displacements as there are variations in the length or shortness of the heart when it is wounded. Furthermore, the handle will make a greater or lesser excursion depending upon whether the point of the spile penetrates the heart to a greater or lesser degree, because if the iron point pierces the entire heart [fig. 2], it makes a smaller movement from the centre of its motion, that is, from the fulcrum, than it would do if the iron had wounded the heart only in the anterior part of its first wall. I will not dwell further on this point because a complete treatise on such motions has been compiled in the 20th book on the forces of levers. If you should contend that when the entire heart is transfixed the length of the spile could not reveal the above-mentioned motion owing to its being obstructed by the anterior wall of the heart, you must then understand that on contraction and dilation of the heart it pulls or pushes the point of this iron along with its own motion and the iron which lies in the anterior wall [of the heart], enlarges its wound both upwards and downwards or, to speak more accurately, moves it, since the rounded thick part of the iron does not enlarge [the wound] as it does not cut, but carries with it the anterior wound in the heart compressing the part of the heart in contact with it,

(continued on page 498)

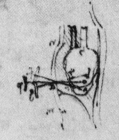

This page was originally part of the same sheet as 86 and 106, and although called the verso in the Quaderni, it is in fact part of the recto of a single sheet. As a consequence of the separation, the extensive note occupying the upper left hand portion of the page is misrelated since it refers to an illustration on 106. Therefore this note will be transposed to the discussion concerning its related figure.

fig 1. **Cross-section of the ventricles of the heart.**

The uppermost of the two ventricles is, as may be judged from its thinner wall, *The right ventricle,* and is so labelled. The thicker walled *left ventricle* carries that notation. The interventricular septum is called *The sieve of the heart,* once more drawing attention to the Galenical notion that a portion of the blood passes through the invisible pores of the septum from right to left ventricle. This modicum of filtered or refined blood was thought to mix with the pneuma from the lungs to provide the vital spirits. The interventricular and marginal branches of the coronary vessels have been severed as they lie beneath the visceral pericardium and are indicated at four points by the letters d a n c, reading from above downwards and to the right.

fig 2. **Cross-section of the left ventricle of the heart in diastole.**

The left ventricle and interventricular septum only are shown although small portions of the attached wall indicate the position of the right ventricle. The intention is to show this cavity in diastole for comparison with fig. 3 where the heart is in systole. The interventricular septum is marked by the letters a c. The lateral wall of the ventricle is indicated by b d, but these letters also point to the papillary muscles shown bulging into the cavity and correctly disposed. For Leonardo's ideas on the function of the roots of the papillary muscle as buttresses to prevent obliteration of the ventricular cavity on systole, cf. note under fig. 3. In the note attendant to this figure Leonardo mentions his theory on the production of the so-called innate heat. He modified ancient beliefs by suggesting that the friction from the flux and reflux of the blood gives rise to this heat and that the beating of the auricles assists in its production, cf. 86.

The muscles branching from a b, and c d [in fig. 2] act to prevent the heart from dilating excessively when it reopens, because if it were dilated too greatly, it would be compelled to draw back too much blood from the vessels into which it first forced it. The passage of this [blood], owing to its velocity, would cause overheating from the friction made through the density of the artery where it moves.

fig 3. **Cross-section of the ventricles of the heart in systole.**

This figure shows the ventricular cavities in systole and is to be compared with figs. 1 or 2. The circular objects in the cavity of the right ventricle, above, represent the papillary muscle in section. The interventricular septum is indicated by b. The letters a c, point to the buttresses formed within the left ventricle

by the papillary muscles which on systole prevent the entire obliteration of the cavity, leaving a v-shaped space a d c, into which the refined blood passing through the interventricular septum may be received. This is explained in the following note:

WHICH INSTRUMENT IS THAT WHICH PROHIBITS THE COMPLETE SHUTTING OF THE VENTRICLES OF THE HEART.

The muscles interposed in the cavities of the ventricles are those which by their extreme density prohibit the complete shutting of the right and left ventricles. If this were not the case, the blood which penetrates [the interventricular septum] from the right to the left ventricle on expulsion [systole], would not be able to penetrate [the septum] at the same time that the left ventricle drives out its blood from itself, because if it were to drive it all out, it would remain without a cavity to receive the new blood. For this reason the penetration of blood through the intermediate wall would be prohibited. But the aforementioned muscles interposed in the ventricles do not allow these ventricles to close entirely, but they behave as demonstrated at a b c d, and their interposed muscles are a b c d.

fig 4. **The ventricles of the heart in longitudinal section: semi-diagrammatic.**

The figure is semi-diagrammatic to explain Leonardo's theory of the action of the auricles and the ventricles in the flux and reflux of the blood in the production of the innate heat. The cavities of the right and left ventricles containing their papillary muscles are exposed in longitudinal section. At the top of the figure on the right are b, representing the pulmonary artery and orifice and d, the vena cava to which the ovoid outline is attached as a diverticulum to represent the auricle. The atria of our terminology were not recognized. From the left ventricle emerge a, the aorta and aortic orifice, and c, the pulmonary vein, likewise presenting an auricular appendage. Of the drawing Leonardo writes:

a b [aortic and pulmonary orifices] are the gateways, the valves of which open outwards.

c d [right and left atrio-ventricular orifices] are gates opening inwards and shutting after the escape of blood forced out by its ventricle whence the ventricles [auricles] placed behind these gates receive the impulse of the blood. Their dilation [of the auricles] is the reason why the percussion, which the impulse of the escaping blood produces in them, is not of too great power.

The idea of the flux and reflux of the blood being due to alternate action of the auricles and ventricles is described further.

ON THE CONTRACTON AND DILATION OF THE TWO VENTRICLES OF THE HEART.

Of the two lower ventricles arising at the root of the heart, their dilation and contraction are made at one and the same time by the flux of the blood. The reflux of the blood is made at one and the same

(continued on page 498)

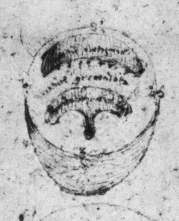

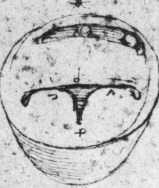
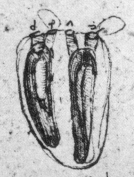

ventricles of the heart

figs 1-2. **The heart and its ventricles.**

The first of these sketches is somewhat unique in that Leonardo here shows the right atrium and its auricle as an integral part of the heart. In the fifteenth and sixteenth centuries the heart was regarded as a two-chambered organ formed by the ventricles alone. In most of his figures and notes Leonardo follows the common tradition, but later, in the series of which this figure is one, he begins to refer to the auricles as the upper ventricles, but these are still treated as appendages of the veins. Here for the first time the right atrium is represented as an independent chamber receiving the openings of separate superior and inferior venae cavae instead of a common vena cava. Other structures represented are the hepatic veins or vein entering the inferior vena cava, tricuspid valve and orifice, the moderator band, the mitral valve, aortic orifice and aorta.

The second sketch is essentially the same as the first except that the heart is shown more anteriorly, and the pulmonary artery is represented. The third vessel, on the extreme right, is the left superior pulmonary vein displaced upwards as may be done in a specimen from the ox which undoubtedly was the form employed. The figure is marked by an asterisk to indicate that it is to be the first in this group.

The extensive notes are in no way related to the figures. Since they provide, however, some indication of his state of mind at this period, they are given here in full.

He who blames the supreme certainty of mathematics feeds on confusion and can never silence the contradictions of the sophistical sciences which occasion an everlasting clamor.

Leonardo often expressed his belief that "no human investigation can be termed true knowledge if it does not proceed to mathematical demonstration", and implored his students to "study mathematics and do not build without foundations", for, "there is no certainty in sciences where one of the mathematical sciences cannot be applied". In the next passage Leonardo proceeds to moralize:

And in this case I know that I shall acquire few enemies as no one will believe that I can speak of him since there are few who are displeased at their own vices. On the contrary, they displease only those who are opposed by nature to such vices. Many hate their fathers and destroy their friendships when reproached for their vices, and examples to the contrary are of no value to them nor has any human counsel.

Leonardo follows the above with a note on human weaknesses and folly. The passage is also of interest in that some of the statements have been interpreted as indicating that Leonardo was a vegetarian, but this cannot be substantiated by reference to the work of Platina mentioned, *De arte coquinaria*, published in Italian translation under the title *De la honesta voluptate e valetudine*, Venice, 1487. The tirade, is, however, concerned with cannibalism. Richter suggests that the passage was inspired by the second letter of Amerigo Vespucci to Piero Soderini, Gonfalonier of Florence, in which he describes the inhabitants of the Canary Islands after staying there in 1503. Although there appears to be some substance to the suggestion, it raises difficulties since the work known as the *Letter from Amerigo Vespucci to Piero Soderini, Gonfalonier, the year 1504* is a patent forgery and Leonardo is believed to have been personally acquainted with Amerigo.

But let such as these remain in the company of beasts. Let their courtiers be dogs and other animals full of rapine. These be their company ever pursuing following the flight of innocent animals which driven by hunger in times of great snows come to your house begging alms as from a guardian. If you are, as has been written, the king among animals (but you shall rather say king of the beasts as you are the biggest!) why not help them so that they may later give you their young for the benefit of your throat which you have attempted to make the tomb of all animals? And I say still more, if I am allowed to speak the entire truth. But let us not leave the subject of man without speaking of that supreme form of wickedness which does not exist among terrestrial animals because among these there is none which devours its own kind except through lack of brains (for there are lunatics among them as among men, although they are not so numerous). This does not occur except among rapacious animals such as the leonine species, leopards, panthers, lynxes, cats and the like which sometimes devour their young. But you devour not only your children but father, mother, brother and friends, and this is not enough, but you go to foreign islands to capture other men and mutilating their penes and testicles to fatten them up, you cram them down your throat. Indeed, does Nature not produce a sufficiency of simples that you can satiate yourself, and, if you are not content with simples, can you not with a mixture of these make an infinite number of dishes as Platina and other authors for gourmets have written.

figs 1-2. **Diagrams of the heart and great vessels.**

The ventricles are opened to show their relative capacity, and a moderator band is demonstrated in the right ventricle. The aorta, pulmonary artery, pulmonary veins and vena cava may be identified. The auricles are shown as appendages to the veins. At the top of the page is a statement indicating that Leonardo is departing from the traditional concept of the heart as a two-chambered organ: *The heart has four ventricles, that is, two superior called auricles of the heart, and two inferior to these called the right and left ventricles.* Below this is a memorandum to *draw the heart from 4 aspects.* However, the real purpose of the diagrams is to show the difference in capacity and thickness of walls of the ventricles in connection with the question of the bilateral symmetry of the body with respect to weight. This question is more fully analyzed and discussed on 99. Another conclusion is reached, but in this respect it should be remembered that the blood was supposed to ebb and flow from ventricles to auricles.

The right was made heavier than the left ventricle in order that the heart might lie obliquely. As the blood rises out of the right ventricle and lightens it, this blood with respect to its center of gravity goes to the left side when it is in the upper ventricles.

A further series of notes discuss the question of ventricular output in terms of the Galenical theory of ebb and flow, the liver as the blood-making organ, and the passage of blood through the interventricular septum to the left ventricle for the formation of the vital spirits.

When the heart [i.e., ventricles] in systole gives its blood on deposit to its auricles, which return it to the heart, that which was given to them is less by the amount of which they were deprived by the upper vessels [pulmonary artery and aorta]. Since the heart must be compensated by the entire quantity which formerly filled its vacuum, it is necessary that the left ventricle borrow from the right and the right ventricle be compensated by the liver for that of which it was deprived by the vena arterialis [pulmonary artery] and the left ventricle. Therefore, the right ventricle has a double loss compared to that of the left ventricle.

The liver being the blood-making organ in the Galenical theory, Leonardo speculates that it makes up any deficit in blood volume necessitated by nutritive requirements with each ebb and flow cycle.

If the heart in systole decreases its capacity and gives the blood driven out of it on deposit to the ventricles [i.e., upper ventricles or the auricles], these [upper] ventricles restore it to the heart less an amount equal to that which is contributed to the nutritive requirements of life. The latter is paid back by the liver, the treasurer.

I say that the greater volume the ventricles customarily receive is the amount of blood which escapes from them when they contract. This amount is received on deposit in the upper ventricles called the auricles of the heart, and it is retained in these until it is returned at the succeeding dilatation of the heart, but less by a quantity equal to that which was extracted by the vital requirements of nutrition. The

loss is compensated for by the liver, the generator of such blood.

Leonardo then attempts to explain how the blood supposedly passes through the interventricular septum from right to left ventricle. To generate enough force on systole, the right ventricle must be closed. Since the papillary muscles open the tricuspid valves, he assumes that they must be relaxed at this time.

The heart drives out the blood on contraction, and the more it contracts itself, the more perfectly the membranes which shut from within outwards [tricuspid valve] close. Therefore the blood is not entirely voided, but that which remains is forced from the right ventricle into the left. As it cannot penetrate the openings, it is consequently necessary that the muscles of the membranes [papillary muscles] lengthen themselves at that time.

The discussion of the septal transit of blood from ventricle to ventricle continues with an examination of the structure of the valves of the right ventricle.

figs 3-4. **Rough diagrams of the valves and chordae tendinae.**

Leonardo describes the valves or membranes, as he often calls them, as being largely made up by the expansion of the tendinous fibres of the papillary muscles.

Why the principal valves of the right ventricle are made of so little membrane and so much interlacing of the cords.

This thing was ordained by Nature so that when the right ventricle begins to close, the escape of blood from its large cavity would not cease abruptly since some of the blood had to be given to the lung, and none of it would be given if the valves prevented its escape. However, this ventricle is closed when the lung has received its quantity of blood and the right ventricle can squeeze [blood] through the passages of the intermediate wall into the right [for left] ventricle. At this time, the right auricle is made the depository of the excess of blood beyond that which advances to the lung. This [excess] suddenly returns on the opening of the right ventricle replenished by the blood which the liver adds to it.

The final notes on the page are of great importance as the first, though misguided, attempts to apply the quantitative method in physiology. Since the liver constantly manufactures new blood Leonardo makes an estimate of the amount based upon 2000 cycles per hour which would at first seem to be far too low, corresponding approximately to 33 beats per minute. However, it should not be forgotten that in the Leonardine cycle there were two separate systoles, of the right and left ventricles respectively, so that the number of systoles per hour would correspond to 66 pulse beats per minute.

How much blood is the liver able to contribute owing to the opening [diastole] of the heart? It replaces as much as is consumed, that is, a very small quantity because in an hour approximately two thousand openings of the heart take place. There is a great weight.

The "small quantity" is explained by the sum given

(continued on page 498)

fig 1. **Outline of the heart and its ventricles in diastole.**

The figure is overwritten by a later note on the effects and appearances of secondary shadows in a field of view. For the note on the immediate subject cf. fig. 2.

fig 2. **A diagram to illustrate the effects of diastole on the dimensions of the heart.**

The figure, with figs. 1 and 5, is explained in the accompanying incomplete note.

An object which contracts increases the distance from the middle to its extremities. On being restrained, the walls increase upwards, drawing behind them the apex of the heart. . . .

Since contemporary Galenical principles insisted that diastole was an active process under the influence of the so-called attractive force of the longitudinal muscles, Leonardo is seeking an explanation as best shown in fig. 5 below. He realized that in systole the heart elongated, and the apex rose against the chest wall, and that in diastole the opposite occurs. He apparently believes the longitudinal muscles constitute the interventricular septum as well as being the papillary muscles. His error, if it can be called one, is his failure to recognize that Galen's view did not consider the heart to be a strictly muscular organ and therefore his longitudinal fibres of the heart exercised their attractive faculty by something akin to magnetic force and not altogether by muscle contraction.

fig 3. **Abortive sketch of a papillary muscle and cardiac valve.**

fig 4. **The chordae tendinae and a valve of the heart.**

fig 5. **The ventricles in systole and diastole.**

For a discussion of this figure cf. fig. 2 above.

figs 6-8. **Sketches of the ventricles in systole and diastole.**

A then current doctrine was that the body is δίδυμος, twin, that is, bilaterally symmetrical. The idea arose from Hippocrates and is expressed by Galen in connection with the testicles. And so the ventricles, as well as the testicles, are hung like the bottles of John Gilpin on either side "to make his balance true". The note is undoubtedly inspired by a statement from Mundinus to the effect that blood in the right ventricle being heavier than the spirit in the left ventricle, the heart would not be "evenly balanced". "But that it might be of equal weight, the left wall was made

thicker to compensate thereby the weight of the blood in the right ventricle". The doctrine is examined in the illustrations of the heart in systole and diastole and in the notes and is discarded. The *De ponderibus* mentioned is that by Jordanus Nemorarius (d.1237), founder of the mediaeval school of mechanics, and deals with the fundamental notion of static moment and its application to levers. First published in 1523, it was known to Leonardo only in the manuscript which he borrowed from the library of the monastery of Brera, now the Palazzo delle Scienze et Arti.

And if you say that the left external wall [of the ventricle] was made thick in order that it might acquire greater weight to counter-balance the right ventricle which has a greater weight of blood, you have not reflected that such a balance is unnecessary, for all terrestrial animals, except man, carry their hearts in a horizontal position, and likewise the heart of man is horizontal when he is lying in bed. But you would not be balancing it properly inasmuch as the heart has two supports descending from the root of the neck and, according to the fourth [proposition] of the De Ponderibus, the heart cannot be balanced except upon a single support. These two supports are the aorta and the vena cava. And in addition to this, when the heart is emptied of the weight of blood on its contraction, and deposits this in its upper ventricles [auricles], the center of gravity of the heart would then be on the right side of the heart and so its left side would be lightened. But such a balancing is not true because, as stated above, animals while lying down or standing on four feet have their hearts horizontal as they are themselves and the balancing of the heart is not required in them. And if you say that the testicles are made only to open and close the spermatic vessels, you are mistaken because they would only be necessary in rams and bulls, which possess very large ones, and when the testicles had re-entered the body owing to cold, then coitus could not be performed. And the bat which sleeps and always perches upside-down, how is its heart balanced with respect to the right and left ventricles?

fig 9. **Sketch of a nude: postero-lateral aspect.**

At first glance this figure seems to be irrelevant to the discussion. However, it will be observed on closer inspection to be a study in balance, the compensatory curve of the spinal column being well shown and therefore related to the statements made above on the balancing of the heart.

ventricles of the heart

fig 1. **A patent foramen ovale.**

This rough sketch is apparently intended to represent the right and left auricles in communication with one another by means of a channel a b, passing through the septal wall and therefore presumably an observation on a patent foramen ovale. It is not uncommon to find a degree of patency of this foramen which is, however, not functionally open. In reading Leonardo's note it should be remembered that he sometimes calls the auricles the upper ventricles of the heart and, in this instance, simply ventricles.

I have found from a, left ventricle [auricle], to b, right ventricle, a perforating channel from a to b, which I note here to see whether this occurs in other auricles of other hearts.

fig 2. **The mitral and aortic valves, from above.**

A related note deals with the Galenical theory on the flux and reflux of the blood. Leonardo holds that that portion of the blood lying between the cusps of the antroventricular valves is forced into the auricles by closure of the valve and is the reflux. The auricle responds by first dilating to accommodate this blood and then contracts to open the valve and fill the ventricle. The contraction of the auricles and ventricles therefore alternates. However, in the Galenical system, dilatation and retention, as well as contraction, were all active processes. Hence, at the end of the note we find mention of longitudinal, oblique and transverse muscles, for the longitudinal cause active dilatation and thus attract, the oblique retain the blood and the transverse expel it.

ON THE CLOSING OF THE GREAT VALVES OF THE HEART.

The cusps of the great valves of the heart are closed by the percussion of the blood which escapes from the lower ventricles [ventricles proper] of the heart to the upper ones [auricles] lying outside the heart. They are reopened by the reflux of the blood being squeezed from the upper ventricles into the lower. The vacuum which would be generated by the opening of the lower ventricles when they [the valves] reopen, is the cause of the return to them of the blood of the upper ventricles when they empty themselves. The latter could not empty themselves if they were not flexible and did not have longitudinal, oblique and transverse muscles which contracted them.

fig 3. **The right ventricle showing the moderator band, papillary muscle and tricuspid valve.**

The moderator band of the right ventricle was first described by Leonardo who suggests (96) that its action is to prevent over-dilation of the ventricle. In the horse and ox, moderator bands vary in number, thickness and position, and we find Leonardo showing (89) as many as three. As expressed in the note below, Leonardo speaks of the chordae tendinae expanding to form the membranous portion of the cusp which he says elsewhere forms the ventricular surface of the cusp.

WHAT THE CORDS OF THE MUSCLES OF THE HEART SERVE.

The chords which arise from the muscles of the heart and are converted into the membranes which become the cusps of the great valves of the heart are those which hold the cusps of the valve so that they do not pass out of the opening, but by their tension enlarge and oppose them and make perfect closure.

Further notes discuss the function of the heart, but in the margin he asks: *Which orifice is deeper at the base of the heart?*, a question also written in red chalk near the foot of the page, where it has been overwritten by the longer note, in the form: *Which orifice descends more deeply at the base of the heart?* The first of the longer notes describes the sequence of events occurring between one heart beat and the next. The note is almost incomprehensible unless one understands the speculative theory on which the statements are based. Galen's assumptions, accepted by Leonardo, required some of the blood to pass from the right to the left ventricle through invisible pores in the interventricular septum. The passage of this blood would be quite impossible if the ventricles were to contract simultaneously since the left ventricle must be in diastole to receive such blood. In consequence, Leonardo concludes (91) that the ventricles contract alternately, the one being in diastole as the other is in systole. The cycle of events between two beats is thus right ventricular systole, left ventricular diastole, left ventricular systole, or as Leonardo puts it, *the heart closes twice and opens once* between beats. On the other hand, starting with right ventricular diastole, in the interval between two diastoles *the heart opens twice and closes once*, and it is from this point the cycle begins. The reader should remember that both systole and diastole were regarded as active processes.

Owing to its violent motion the heart is very hot from the middle downwards. This motion is made twice at each of its beats as appears at the pulse. Of these motions, one is made when the heart contracts and the other when it dilates and these motions are caused by two sorts of muscles, that is, the transverse and the longitudinal, for the transverse are those which contract the thickness of the heart and the longitudinal stretch out its length. The heart makes its beat when it is stretched out so that then it may contract with forceful motion and drive the blood out of itself into the destined vascular passages. The time interval between two beats of the pulse is half of a musical tempo. Between one and the next beat of the pulse the heart closes twice and opens once, and between one and the next opening the heart opens twice and closes once. Therefore the heart began the first motion at its opening and the last at its closing.

Accordingly in every harmonic or, we might say, musical tempo, the heart has three motions, as is contained below, of which tempi there are one thousand and eighty in one hour. Therefore the heart moves three thousand five hundred and forty times in each hour while opening and shutting. This frequency of motion is that which heats the dense muscle of the heart which in turn heats the blood continually beating within it. It is heated more in the left ventricle

(continued on page 498)

ventricles of the heart

This page was originally part of a single sheet now divided in two, the other half being 107, 108.

fig 1. **Right ventricle laid open to expose the moderator band, papillary muscles and tricuspid valve.**

Above the moderator band is the word *catena*, i.e., beam or band, Leonardo's term for this structure. For description of the band, cf. fig. 5 below.

fig 2. **Right ventricle laid open to expose the trabeculae carnae and moderator band.**

Leonardo believed that the trabeculae carnae created multiple eddies in the blood stream causing friction which was responsible for the innate heat of the body. In reading his note it should be recalled that the chordae tendinae of the papillary muscles formed the cusp of the valve by the expansion and fusion of these tendons. The very minute fibres mentioned in the note are undoubtedly fibrin filaments mistakenly identified as muscle fibres from their elastic properties, cf. 92. The *vermis* or "worm" is the choroid plexus which supposedly acted like a muscle to isolate parts of the cerebral ventricle during the process of thought, cf. 112. The rete mirabile, the vascular plexus at the base of the brain is found in ruminants and nonexistent in man, was the organ in the Galenical scheme which transformed the natural spirits into animal spirits distributed by the nervous system and the active factor in the conduction of impulses.

Between the cords and fibres of the muscles of the right ventricle are interwoven very minute fibres of the nature and shape of the minute muscles which form the vermis [choroid plexus] of the brain, and of those which weave the rete mirabile. These wind themselves around the most minute and almost insensible sinews and are interwoven with them. Muscles of this kind are very extensible and in themselves capable of contraction. They are interposed in the furor of the impetus of the blood which passes in and out between the minute cords of the muscles before they are converted into the membranes of the valves.

fig 3. **A rough diagram of the aortic valve and its cusps.**

fig 4. **The right ventricle opened to expose the moderator band.**

fig 5. **Diagram of the heart showing the position of the moderator band.**

The moderator band a r, is shown attached a quarter of the distance along the line d e, extending from the base of the heart to its apex. The width of the heart is indicated by the letters b c, and the band is said to be a third of this width. The accompanying note is confusedly written:

The band (catena) of the right ventricle [moderator band] originates at a 3rd of the width of the middle wall and at a 4th of its depth. Thus for this ventricle d b c e, b c, is the width and d c, is the length or, you might say, height because of its position. Therefore I say that the band a r, which joins the dilatable wall of the left ventricle at a, a third part of the width of this ventricle a c [for b c] and a fourth part of the depth d e.

Leonardo terminates with a note in which he reminds himself to estimate the volume of the cardiac chambers and discusses the production of innate heat. The condition called suffocation of the heart was a well-recognized clinical entity in the humoral doctrine and covered many things, probably including coronary disease. A method, proving whether the heat is engendered by its friction of motion, is discussed on the verso of this page.

Before you open the heart inflate the auricles of the heart beginning from the aorta. Then tie it off and examine its volume. Then do likewise with the right ventricle or right auricle. Thus you will see its shape and its function. It was created to dilate, to contract and to revolve the blood in its cells, full of tortuous passages separated by rounded walls without any angles so that the motion of the blood, not finding sharp obstructions, will make an easier revolution in its swirling impetus. And so it proceeds to warm itself with proportionately more heat as the motion of the heart becomes more rapid. Thus it sometimes becomes so hot that the heart suffocates itself. I once saw a case where it burst as a man was fleeing before his enemies, and he poured out sweat mixed with blood through all the pores of the skin. This heat forms the vital spirits, and so heat gives life to all things as you see that the heat of the hen or turkey gives life and birth to chickens, and the sun when returning causes all the fruits to blossom and to burgeon.

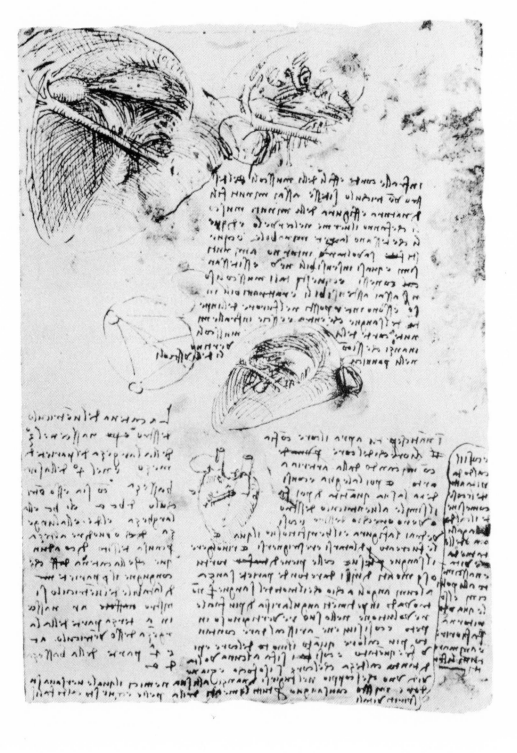

ventricles of the heart

The page was originally part of a single sheet, the other half being 107-8. The arguments presented here are consequently similar since they date from the same time.

fig 1. **Sketch of the ventricles of the heart to show coronary vessels.**

The accompanying note is self-explanatory. The three veins mentioned are probably the great, middle and small cardiac veins.

The heart has its surface divided into 3 parts by 3 veins descending from its base. Of these veins, two [great cardiac and small cardiac] delimit the boundaries of the right ventricle and have two arteries [right and left coronary] in contact beneath them. Of the 3rd vein [middle cardiac], I have not yet seen whether it has an accompanying artery, wherefore I am going to flay it to vouch for its presence. However, the surface interval of the heart enclosed between these arteries occupies half of the outer circular boundary of the heart and forms the external wall of the right ventricle, etc.

fig 2. **Diagram to illustrate the area occupied by the right ventricle on the surface of the heart.**

In this figure the base of the heart is represented by a rough circle a n b (or S) c, at the center of which is the apex d, so that the heart is being viewed from its apex. The letters n, and m, indicate the right and left coronary vessels with their interventricular branches delimiting the area on the surface occupied by their interventricular branches.

Let a n b c, be the circumference of the heart. The two veins and arteries which surround the lateral borders of the right ventricle are a S. The external wall of this ventricle will be a n S and the interval or area of the ventricle will be a n m S. d is the apex (cuspide) or point of the heart.

fig 3. **Preliminary outline of a dissection of the right ventricle drawn in detail in fig. 4.**

fig 4. **The right ventricular cavity and tricuspid valve.**

The lateral wall of the atrium has been resected so as to expose the tricuspid orifice from above. Below is the remaining portion of the auricle exhibiting the musculi pectinati. In the middle of the figure is a papillary muscle a b c, seen through the orifice. From it extend the radially disposed chordae tendinae f e d n m o p q r, passing to the cusp. At the base of the papillary muscle a moderator band is shown. The dissection is based upon the heart of an ox.

fig 5. **The right ventricle and tricuspid valve.**

We are informed that this is the *right ventricle,* and that A *is united with A,* which indicates that the heart was opened by means of a transverse incision and the two halves hinged back upon one another. The three papillary muscles and their chordae tendinae passing to the tricuspid valve are revealed, as well as the beginning of the infundibulum. Further notes read: *If you inflate the auricles of the heart, you will see the shape of its cells.* This technique is discussed at greater length on the recto of this page in connection with the idea that the innate heat is produced by friction as the blood eddies among the various irregular bands lying within the cavities of the heart. Leonardo suggests a method of determining the truth of this idea, so important in the Galenical physiology.

Observe whether the churning of milk when butter is made causes heat. And by such means you will be able to prove the efficacy of the auricles of the heart, which receive and expel the blood from their cavities and other passages, [and that they] are made solely to heat and subtilize the blood and make it more fit to penetrate the wall through which it passes from the right into the left ventricle, where owing to the thickness of its wall, that is, of the left ventricle, it conserves the heat which the blood carries to it.

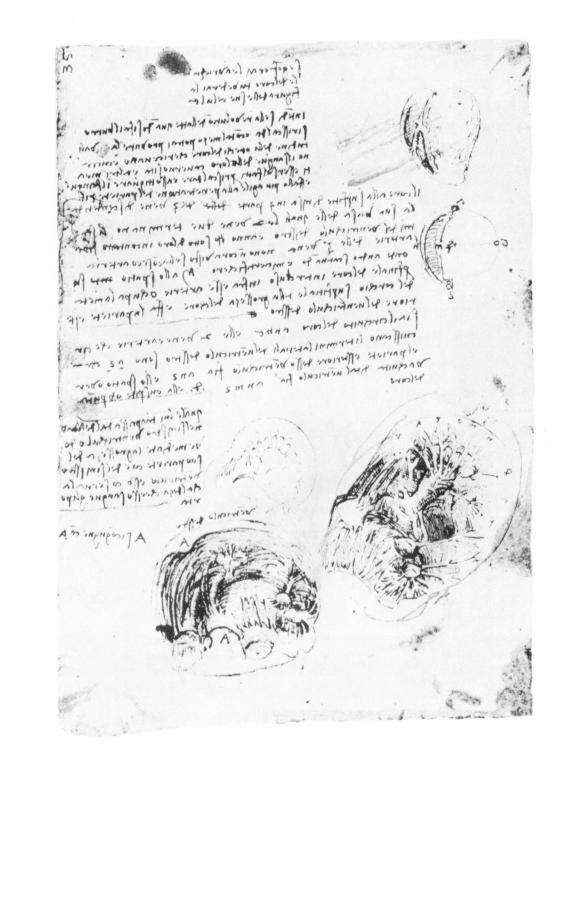

fig 1. **Diagram of an atrio-ventricular orifice, valve and papillary muscle.**

The various parts of the diagram are labelled, reading from above downwards, *bone, cartilage, membrane sinew, muscle sinew.* Since Leonardo dissected the heart of a ruminant, the bone is the os cordis and the cartilage the dense connective tissue of orifice which was commonly called cartilage at this time. The papillary muscle was supposed, by analogy with other muscles (cf. below), to possess a tendon at either end. The accompanying note reads: *There are 6 things which take part in the composition of a motor, that is, bone, cartilage, membrane, cord, muscle and sinew, and these 6 things exist in the heart.*

fig 2. **The papillary muscles of the heart.**

The papillary muscle is indicated by n; the severed ring of the atrio-ventricular orifice by m; and the cusp of the valve by f. Leonardo describes a papillary muscle as having a tendon at either end. He believed it to contract during diastole to open the valve and to relax during systole—a logical assumption but now disproved. The action of the muscle on the cordae tendinae is both active and passive since on diastole the whole heart shortens, thus permitting the entire papillary muscle to ascend, cf. 99.

When the heart enlarges itself, n [papillary muscle] shortens, drawing itself by means of its cords towards f [the valve], and is the cause of the shortening and opening of the heart. When the heart contracts, n is elongated and is carried still further upwards. Between its elongation and its being carried upwards, it relaxes the membranes [cusps] and the blood, which beats against them from within, closes them.

I say that when the muscle n thickens, it shortens itself and this shortening would freely draw the ends towards its middle, that is, if it were to shorten by half of its length, the inferior and superior quarters would proceed towards its middle. . . .

fig 3. **The chordae tendinae of a papillary muscle.**

The chordae tendinae are often found to be somewhat twisted upon one another, hence the statement beside the drawing, *plaited cords.* For Leonardo's views on the significance of this arrangement, cf. 98.

figs 4-5. **Figure of a young man in profile and a heart dissected to expose the ventricular cavities.**

If these two drawings are intended to show the heart in situ, then the heart is very badly misplaced. But it is more likely that the drawings are separate, the figure of the young man having been added later.

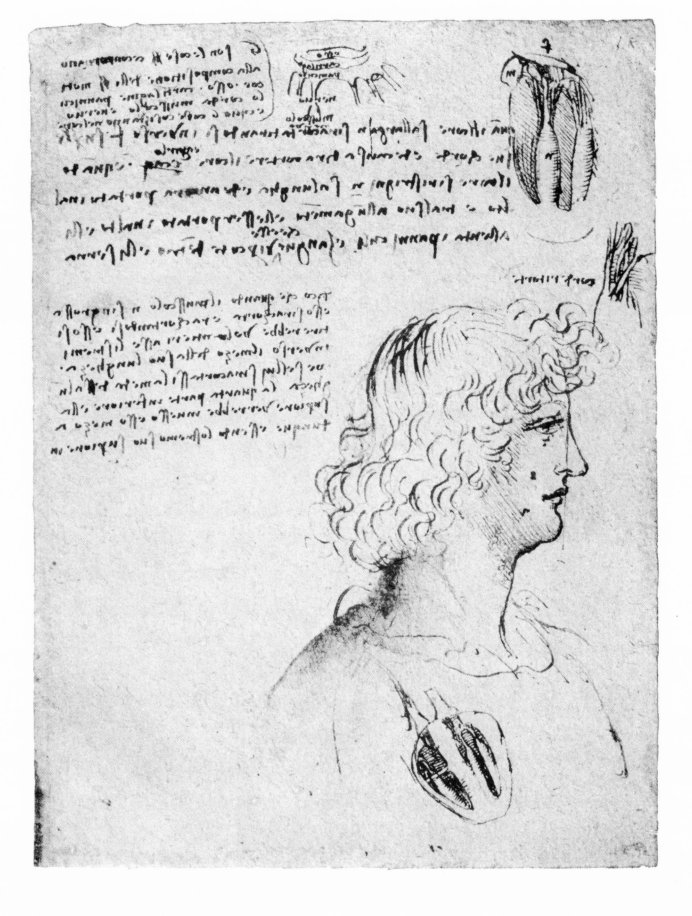

figs 1-2. **Rough sketches of the heart and coronary vessels.**

Above the figures we read: V*essels of the heart.* In fig. 1, the two vessels arising from the aorta are indicated by the word *artery,* and that on the right as vein.

fig 3. **Diagram of the heart with lines for section.**

The lines for sectioning of the heart to expose the ventricles and interventricular septum as shown in the figures below are indicated by the letters a c, b c. The auricles are identified by the letters a c. This is called the *first* of the two contiguous figures.

fig 4. **Coronal section of the heart to expose the ventricles and interventricular septum.**

This figure is indicated as the *second.* Above it are the words *a, angle of the circumference* [?], which perhaps means that the section is to be cut from the point a, below the auricle on the left upper margin of fig. 3, in order to obtain the section as shown.

fig 5. **Abortive figure of the papillary muscles and mitral valve.**

fig 6. **Transverse sections of the heart.**

The upper portion of the figure labelled *base of the heart,* shows the four orifices, mitral, aortic, tricuspid and pulmonary, which carry the letters a b c d. The lower portion reveals the septum and the ventricular cavities, and the section is indicated as being *below the base.*

fig 7. **Heart divided as in fig. 3, to expose the interventricular septum.**

This is indicated as the *3rd* figure of the series, and the legend reads *Demonstration of the sieve* [interventricular septum] *from the left* [for right] *side.* The moderator band is clearly shown.

fig 8. **Heart divided as in fig. 3, to expose the interventricular septum.**

The figure is indicated as the *4th* of the series. The legend reads *Demonstration of the sieve from the right* [for left] *side.* It will be observed that left and right are reversed which is not uncommon in Leonardo's notes and may be the result of his habit of mirror-writing.

fig 9. **The chordae tendinae of a papillary muscle and the valve.**

Leonardo here illustrates his belief that the chordae tendinae form the ventricular surface of the valve by spreading out as a connective tissue layer.

fig 10. **Abortive figure of the papillary muscle and a valve.**

fig 11. **The posterolateral wall of the left ventricle hinged back to expose the mitral valve and its papillary muscles.**

The technique is expressed thus: *This is the wall of the left ventricle which is opposite the wall* [septum] *interposed between the right and left ventricles.* Leonardo nowhere uses the term "mitral" which seems to have been introduced by Andreas Vesalius in 1543.

fig 12. **Detail of the papillary muscles of the mitral valve.**

fig 13. **Rough, unfinished sketch of an atrio-ventricular valve.**

fig 14. **The mitral and aortic orifices: from above.**

The legend reads: *The left ventricle which goes to the auricle of the heart is seen from without when closed.* Between and below the mitral and aortic orifices is written the word bone which points to the os cordis found in this position in the hearts of ruminants.

fig 15. **Incomplete sketch of aortic orifice and valve.**

fig 16. **Unfinished sketch of papillary muscle, chordae tendinae and cusp.**

fig 17. **Diagram of mitral valve to illustrate closure of its cusps.**

The junctional lips of the membranes are bent downwards in this manner.

fig 18. **The four cardiac orifices.**

The sketch clearly illustrates the nature and position of the mitral, aortic, pulmonary and tricuspid valves from left to right. Between the mitral and aortic orifices is the os cordis, labelled bone. In shape and position the os cordis once again indicates that the source of Leonardo's material was the ox.

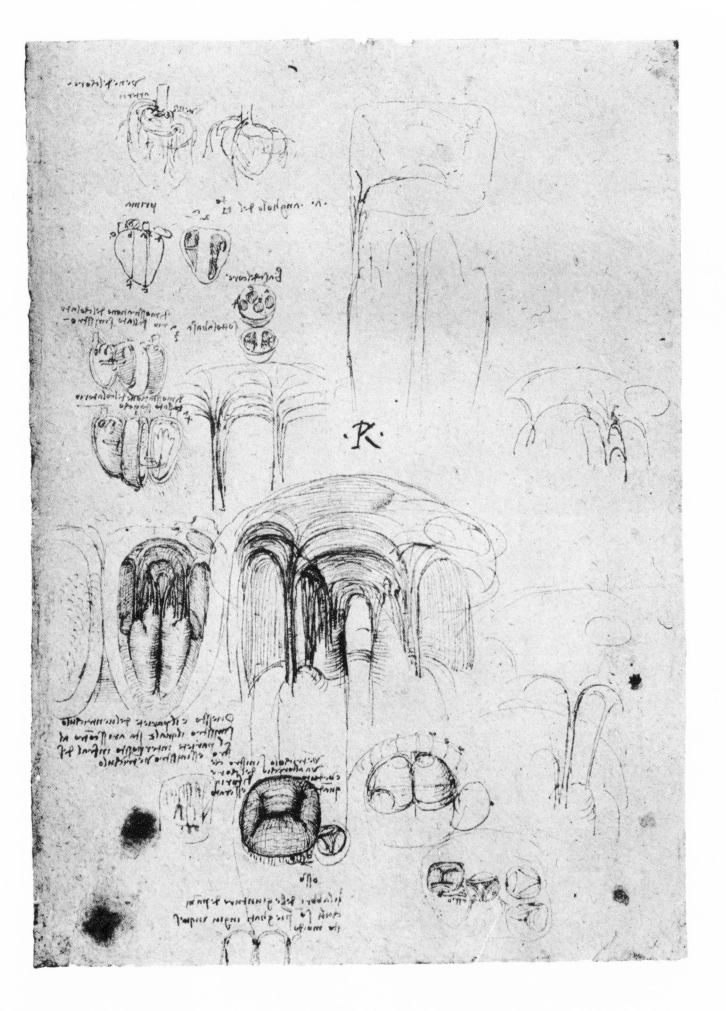

GEOGRAPHY OF THE HEART.

fig 1. **A papillary muscle and its chordae tendinae.**

The chordae tendinae are shown expanding at their attachment to the ventricular surface of the valve. Leonardo held that the cusp consisted of two layers. The atrial surface is smooth and formed by the fleshy membrane or panniculus carnosus. The ventricular surface is "armed" or protected by a tendinous layer or panniculus nervosus established by the chordae tendinae of the papillary muscles.

In front [i.e., on the atrial surface] *the valves are found to be membranous and supported on the opposite side, that is, protected from within by threads* [chordae tendinae] *which prevent their flapping back. All the muscles stretch lengthwise in death, and this is the reason that animals die with the mouth, and other regions where the skin is lacking,* [open], *and so the interior of the ventricles of the heart and their valves* [are also open].

fig 2. **The tricuspid orifice laid open to expose the papillary muscles and valves.**

The three papillary muscles of the tricuspid valve are shown with their chordae tendinae extending to the margins of the cusps. The papillary muscle on the right is labelled *On the intermediate wall,* i.e., the septal muscle. The second is noted as lying *In the angle,* and therefore the inferior muscle. The third muscle at the left is said to occur *In the middle of the covering of the right ventricle,* and so is the anterior muscle of that wall. Below the papillary muscles on the right and on the left may be seen a moderator band which is shown divided in two. It occupies a position as commonly found in the heart of ungulates. Near the portion of the moderator band on the right are the words *The lowest filum of a simple membrane below,* which doubtless means that a second moderator band occurs below, as in the ox. The trabeculae carnae of the ventricle are also represented especially on the left. By including a portion of the right papillary muscle and its chordae on the extreme left, it will be observed that Leonardo has so designed the figure as to enable the reader to reconstruct the orifice. Attention is called to this in the note above the figure.

Cut out these 3 muscles with their cords and valves and then join them in the manner in which they exist when the right ventricle closes itself, and then you will see the true shape of the valves [and] *what they do with their cords when they shut themselves.*

The technique suggested in this note must be the first example of the use of paper cut-outs in the teaching of anatomy. The method became popular in the second quarter of the sixteenth century.

figs 3-4. **The papillary muscles, tricuspid valve and right ventricle.**

Diagrams to show the closure of the tricuspid valve when the wall of the ventricle has been removed.

fig 5. **Tricuspid valve and the three papillary muscles from below.**

The figure is badly faded but the outlines are still discernible.

fig 6. **The ventricular surface of the tricuspid valve, chordae tendinae removed.**

The points of attachment of the severed chordae tendinae are indicated on the upper cusp by the letters d c b a q f e, now almost illegible, and the note above the figure reads: *a b c d e f g are the places where the chords which support the large valves of the heart are situated.* Below the figure is the legend: *The simple membranes without cords.*

figs 7-8. **The tricuspid valves, chordae tendinae and papillary muscles from below.**

Leonardo's note adequately describes the figures: *The valves of the heart which the right ventricle sees from within.*

fig 9. **Adjacent cardiac valves to illustrate the influence of margins on closure.**

The area of overlap of adjacent cusps is indicated by a, the thinner margin, by c, and the apex, by b. The purpose of the illustration is to demonstrate that the margins of the cusp consist of a single layer, the panniculus nervosus, and the body of two layers, panniculus nervosus and carnosus, so that on closure the area of overlap will consist of two and not four thicknesses as described in 106. Thus nature's law that nothing is superfluous is demonstrated.

WHY THE CUSPS OF THE RIGHT VENTRICLE ARE NOT ENTIRELY DOUBLE.

The cusps (uscioli) of the right ventricle are not entirely double because it would follow, as has been said [106] *in this treatise of mine, that at the place* [contiguous margins of the valves] *where it is not necessary, it would be doubled to four* [layers] *and where it is necessary, it would be twofold only: and in this case Nature would be wanting in her law, as was said at the beginning of this treatise.*

fig 10. **The mitral valve and left ventricle in longitudinal section.**

The legend on the figure reads: *The left* [ventricle] *sectioned through the arch of the membranes in side view.*

Attention has been called to Leonardo's opinion that the valves of the atrio-ventricular orifices consist of two layers. The atrial surface is a layer of "flesh" and thus, in the standard terminology of the times, a simple tissue. The ventricular surface of the valve is supportive and consists of "sinew" or "cord" established by the spreading out of the chordae tendinae to form this layer. An extensive note discusses the reason for this arrangement.

WHY THE SIMPLE MEMBRANE IS PLACED UPON THE POWERFUL CORDS OF THE SECOND LOWER MEMBRANE.

The thin membrane is stretched over the thick cords and extends on the outside [atrial surface] *of the lower membrane. It appears that Nature would fail here because on the expulsion of the blood which churns inside there* [in the atrium] *at the closing of the right*

(continued on page 499)

At one time part of a single sheet, now divided, the notes and drawings on this page continue to some extent the argument found on 96.

figs 1-2. **Abortive sketches of the right atrio-ventricular or tricuspid valves.**

fig 3. **The right atrio-ventricular or tricuspid valve of the heart opened out.**

The three valves are indicated by the letters g f a, a b c, c d e, from right to left. The letter h, on the extreme right corresponds to d, on the left, the point of section. The letters n m o p q, mark the terminations of secondary lines outlining the valvular margins when stretched by the action of the papillary muscles shown with their chordae tendinae lying in the intervals between the valves. *The three triangles, g f a, a b c, c d, e, shut the gateway* [tricuspid orifice] *of the right ventricle when that ventricle contracts.* A further note referring to this figure appears on 96, which became separated with the division of the sheet.

ON THE VALVES OF THE HEART.

On the shutting of the heart, the valves [mitral and tricuspid] *of the heart always give passage first to a quantity of blood before they shut from within outwards.*

And the valves [aortic and pulmonary] *which shut from without inwards return the blood to which they first gave passage. Those* [mitral and tricuspid] *which close from within outwards, before shutting completely, give passage to the impulse of that part of the blood which was within the lips of the opened valves c o* [in fig. 3]. *This part* [of the blood], *unobstructed, gives with its principal wave due nourishment to the vessels of the lung when, after being refreshed in the lung, it returns in large part to refresh the blood which was previously left in the ventricle where it was divided.*

The above note develops the Galenical theory on the flux and reflux of the blood. The portion of the blood which remains behind in the right ventricle is that which was supposed to pass through the interventricular septum to become vital spirits as explained on 96. A further note is a recapitulation of the function of the auricles in this process of reflux discussed at length on 96.

fig 4. **A papillary muscle and its chordae tendinae.**

The chordae tendinae of a papillary muscle are shown making a series of arches and spreading out to be attached not only to the apices and margins of a cardiac valve but also to its ventricular surface. Leonardo apparently considered a cusp to be formed of two layers. The first he calls the fleshy membrane and the second, which was established by the spreading out of the fibers of the chordae tendinae as a protective coat (armadura), he calls the sinewy membrane.

The [papillary] *muscles which draw the membranes are without cords until near the membrane, which membrane being also fleshy, forms for itself a protective coat which is the sinewy membrane of these muscles in place of their cords.*

figs 5-7, 9, 12. **Diagrams of the right atrio-ventricular or tricuspid valve.**

In fig. 6, the tricuspid valve is seen from below receiving the attachments of the chordae tendinae of the papillary muscles which are greatly foreshortened. In the other diagrams the valve is shown both opened and closed. In fig. 9, the intervals between the cusps are lettered at their base a b c, and the apices of the cusps c d f. A note attempts to explain in terms of the theory of flux and reflux why the chordae tendinae are attached to the ventricular surfaces of the cusps.

Nature has made the chordae [to attach] *on the reverse side of the fleshy membrane of the three cusps with which the gateway of the right ventricle is shut. She has not made them on the posterior aspect because these cusps experience more effort when they draw the blood in than when they squeeze it out.*

fig 8. **The tricuspid valve opened out to demonstrate formation of the margins of the cusps.**

fig 10. **Papillary muscle, chordae tendinae and cusp (greatly foreshortened).**

To follow the accompanying note, figs. 8 and 10 must be taken together. In the first three illustrations the papillary muscle is shown giving off four chordae tendinae indicated by the letters s t v n, which blend to form the thinner margin of the cusp at a c, b d, over the interval of adjacent cusp contact r o, and at the apex of the cusp h h. Thus the margin of the cusp is formed by a single layer which Leonardo calls the *panniculo nervoso.* Since the margins of adjacent cusps overlap, on closure of the valve, the region of overlap consists of a double layer, each of which is formed by the extension of the connective tissue of the chordae tendinae. On the other hand, the remaining central portion of the cusp being thicker is said to be formed by a double layer, the *panniculo nervoso* on the ventricular surface and the *panniculo carnoso* on the atrial surface. It is necessary to recognize this distinction, which incidentally approaches the truth, to understand the note below.

In the second figure, a papillary muscle n, is shown attached to the overlying ventricular wall, labelled *The thickness of the right ventricle,* and also indicated by the letters f g. The papillary muscle blends with this wall at e, and two of its chordae tendinae are indicated by a b, at the muscle, and c d, where their fibres spread out to form the margin of the cusp and Leonardo's *panniculo nervoso.*

n [in fig. 10] *is the muscle of the heart which is divided into two muscles* [papillary, and muscle of ventricular wall]. *These muscles are in contact and continuous and then separate each by itself, into their branchings made up of sinewy cords* [chordae tendinae] *clothed by the thinnest of flesh* [endocardium?] *until they are converted into the sinewy membrane covered by flesh* [Leonardo's panniculo carnoso of the cusp]. *But just as the muscles* [of the ventricular wall] *from which they arise form a cover, one for the other, their cords do the same and* [form] *membranes. But their motions in pulling upon the cords and stretching the membranes are not equal because the upper mem-*

(continued on page 499)

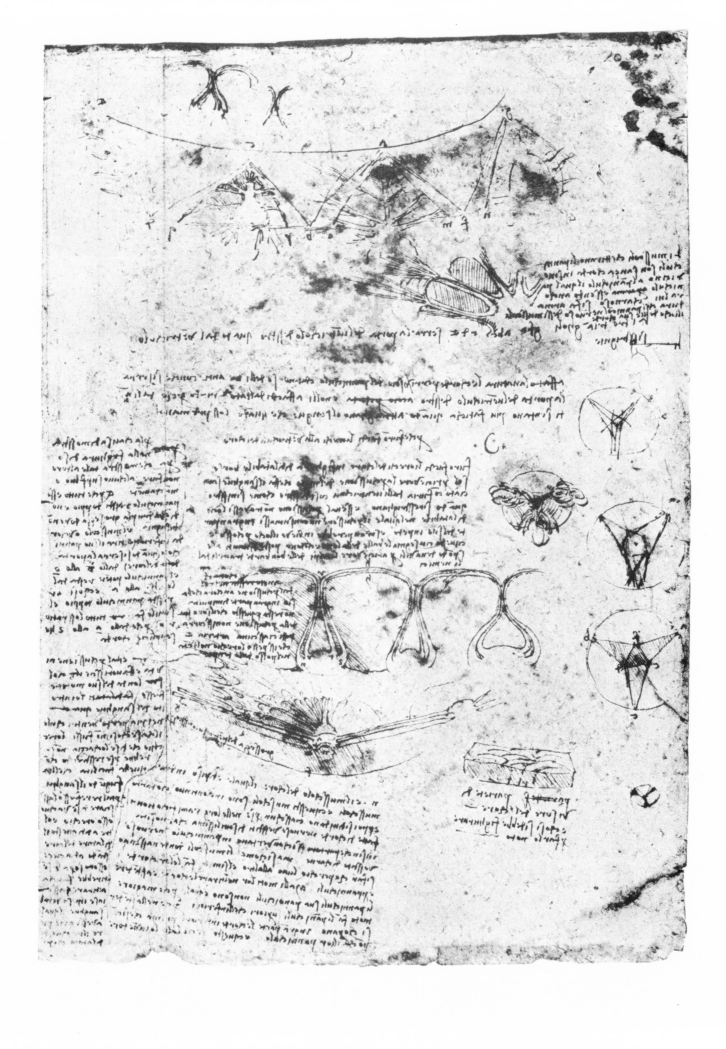

aortic pulmonary valves

This page was originally part of a single sheet, the other half being 101-2. Although called the recto in Q, it is actually the verso.

fig 1. Base of ventricles of heart showing atrio-ventricular and arterial orifices.

The heart is resting upon its left side so that the orifice on the right represents the mitral valve and is therefore labelled left ventricle. To the left of the mitral is the aortic valve, called the aortic artery, which shows the cusps correctly related and indicates the position of their lunules. The pulmonary valve on the left of the aortic is marked by the letter a. The cusps are likewise correctly disposed, and above is the tricuspid valve. Lacking fixatives, the specimen is somewhat flattened. The outlines above and below on the right indicate the position of the auricles.

fig 2. Base of ventricles showing position of the four orifices.

The figure is similar to fig. 1.

fig 3. Mitral valve and aortic orifice.

This is one of the few occasions in which Leonardo represents the mitral valve. The papillary muscles, chordae tendinae and cusps are clearly revealed as well as the relationship to the aortic valve. The legend reads: *Left ventricle and its valves or shutters, and here there are always sinews, muscles, cords and membranes* [valves].

fig 4. Abortive figure of the ventricular orifices.

Identical with fig. 1.

fig 5. The four ventricular orifices.

Similar to fig. 1. The aortic valve is labelled *aortic artery*, and the pulmonary as *arteria venale*, that is, the vein-like artery, the customary term.

figs 6-7. Bones of the upper extremity to illustrate pronation and supination of the forearm.

It is shown that true pronation and supination of the forearm have a range of 180 degrees which is increased in extension to 270 degrees by rotation at the shoulder.

The arm when flexed at its joint can show [when viewed] *from one and the same aspect its entire dorsal side and, in addition, its entire volar side without altering the position of the bone called the aiutorio* [humerus], *that is, it will by its revolution be able to make a half-turn. And if you extend the arm, it will make three-quarters of a turn.*

For *aiutorio* meaning humerus, cf. 12.

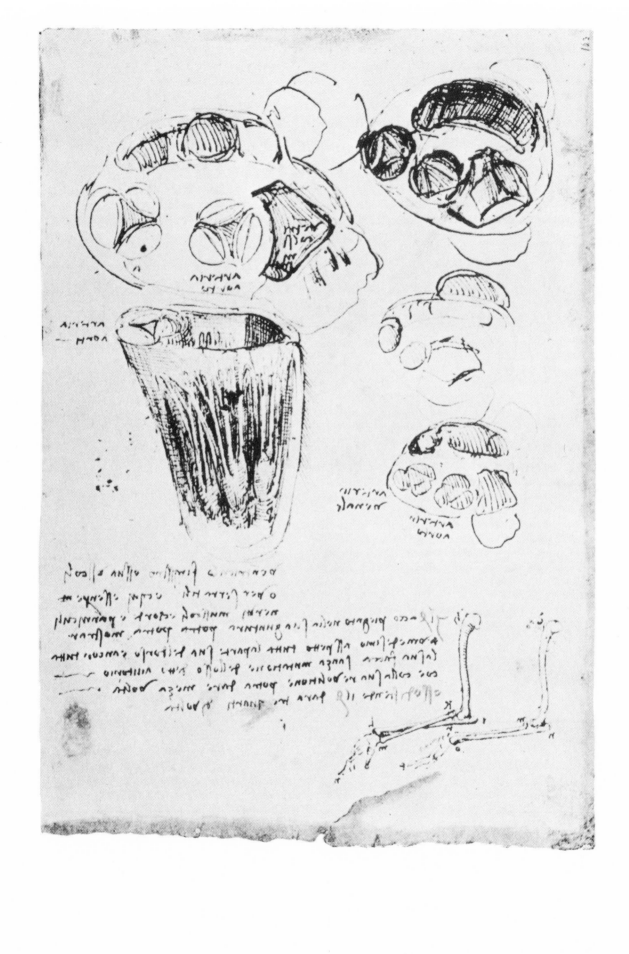

LET NO ONE READ ME WHO IS NOT MATHEMATICIAN OF MY PRINCIPLES.

This opening statement emphasizes Leonardo's mechanistic approach to the problem of the function of the heart. Accepting Galen's theory almost in its entirety, it is Leonardo's endeavor to explain and extend the theory from his knowledge of physical principles. The page is part of a larger sheet which has become divided, the other half being 101-2. In Q this is called the verso although actually the recto.

Leonardo proceeds with a discussion on the aortic and pulmonary valves which he regards as being morphologically part of the vessel wall and not of the heart itself. It should be remembered in reading his note that he is thinking in terms of the reflux of blood in the aortic sinuses, causing closure of the valve. Thus he contends that the arrangement must be so since only the vessels possess the necessary elasticity to absorb the momentum of the blood stream which would otherwise rebound from an inelastic wall with such force as to damage the delicate membranes of the valves.

The valves are constructed in association with the vessels immediately at the termination of the substance of the base of the heart. This was ordained by their Author so that the reflected blood with its momentum might not tear away the membranes of which these valves are composed. This momentum, seeing that it must expand in the membranes at the base of the vessels, does no damage to these valves, but is cast horizontally to beat against and expand with ease the tunics of the blood [vessels] in which the aforesaid momentum is expended.

And if these valves had been constructed within [the ventricular substance] at the base of the heart, which is very strong and resistant, it would necessarily follow that the revolution of the blood would turn back from this resistance and beat against the weak valves which in a short time would be staved in and destroyed.

fig 1. **Diagram of the aortic valve.**

The aortic valve is nearly always shown in relationship to the aortic sinuses since these structures are regarded as an integral part of the valvular mechanism serving to direct the eddying blood into the cusp during closure, cf. fig. 2. Within the sinuses are the triangular bases of the cusps n q r, which being thicker, are considered to be part of the aorta. At the margins of the cusps are the delicate lunules p q r, which make the final closure of the orifice and are joined together at the angles of the aperture marked a b c.

The right [aortic] valve.

The circumference a d b f c e, is the base or origin of the coat of the vessel [aorta]. The interval a d b n [aortic sinus], is that where the coat of the vessel covers over the base of the heart. Immediately beyond the origin of the vessel arises a thin membrane [the cusp] which is joined to it and which itself covers the interval a n b p. From its excess it gives rise to one of the sides of the valve a b c. This valve is duplicated by another similar membrane [pulmonary valve] which covers the purse or right ventricle within the heart. Both ventricles are similarly constructed.

fig 2. **Diagram of the vortices of blood in the aortic sinuses and valve.**

The diagram illustrates Leonardo's favorite conception of the function of the aortic sinus in the creation of eddies of the blood stream which sweep through the concavities of the cusps to roll out their lunules which make the final perfect closure of the valves. The diagram is complementary to fig. 1.

fig 3. **Diagram of the base of the heart.**

The rough outline represents the base of the heart which is indicated as being approximately triangular in shape. At the angles are shown the positions of the branches of the coronary vessels as represented by the anterior interventricular branches of the left coronary artery and great cardiac vein, the right coronary artery and the small cardiac vein, and the inferior interventricular branch of the right coronary artery and the middle cardiac vein. It is pointed out that the first two pairs of vessels mark the boundaries of the right ventricle. The aortic orifice with its valves is correctly, although diagrammatically, shown as occupying the center of the base which is regarded as right and proper, being the paramount vessel, since, according to theory, the most "noble" structure should occupy the most "noble" position.

The shape of the base of the heart is somewhat similar to a triangle as shown by c d f. At each angle are two vessels, that is, a vein on the outside and an artery on the inside beneath the vein. These are the veins a c f, and the arteries b d [for d] e. Between c, [and] f, is the right ventricle. In the middle of the base of the heart is the origin or base of the aorta established upon the middle of the base of the heart occupying pre-eminence of position at the base of the heart just as it occupies pre-eminence in the life of the animal. And the angles of the valves of this artery face the angles of the base of the heart, and the sides of the valves, the sides of the heart.

fig 4. **Diagram of the heart as viewed from its apex.**

Since a to b, is indicated as being the right ventricle, the diagram shows an anastomosis between the marginal branch of the right coronary artery and the anterior interventricular branch of the left or of the corresponding veins. The third vessel at c, will be the inferior interventricular artery or its corresponding vein.

a b, is the right ventricle, and there are many occasions in which the right and left vessels are joined together in the region of the apex of the heart.

109 aortic pulmonary valves

fig 1. **The cusps of the aortic valve.**

The legend reads: *Figures of the cusps (aorti) of the gateway which the left ventricle possesses when it closes itself.*

fig 2. **The closed aortic valve: from above.**

fig 3. **The closed aortic valve: from below.**

fig 4. **The ventricular aspect of the aortic cusps.**

Below the figure the aspect is identified by the word back.

fig 5. **The open aortic valve: from above.**

fig 6. **The open aortic valve: from below.**

fig 7. **The aortic valve partially open: from above.**

fig 8. **A portable Turkish bath.**

The object beneath the bath is the kettle. The legend reads: *A dry sudatory and moist sudatory, very small and portable weighing 25 pounds.* The significance of the various arithmetical sums is unknown.

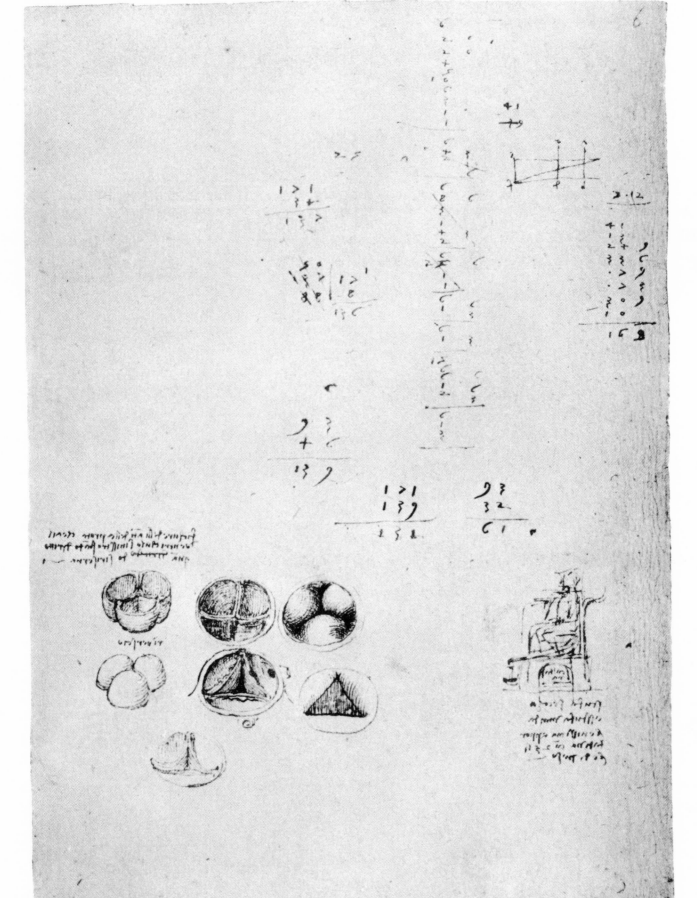

The figures on this page are concerned with the data necessary for the construction of a glass model of the heart to study the mechanism of the semilunar valves of the pulmonary and aortic orifices. In order to maintain a logical sequence the figures are numbered from right to left.

fig 1. **A mould for the fashioning of a glass model of the pulmonary or aortic valves.**

The upper end of the cast is lettered a, and the lower, n. The mould appears to be based on the appearances at the root of the aorta, aortic vestibule of the left ventricle and the aortic orifice as shown in longitudinal section in fig. 11 below. The notes make it doubtful that the model was ever made.

A plaster mould to be blown with thin glass inside and then break it from head to foot at a n.

But first pour wax into this valve of a bull's heart so that you may see the true shape of this valve.

fig 2. **Diagram of a collapsed cusp to illustrate the note below on valve closure.**

How the blood which turns back when the heart reopens is not that which closes the valves of the heart. This would be impossible because if the blood beat against the valves of the heart while they are corrugated, wringled and folded, the blood which presses from above would weigh and press down the front of the membrane upon its origin, as is shown at the valve r o [in fig. 2], the folds of which, being weighted down from above, would close in solid contact, whereas Nature intended it to be stretched in height and width.

fig 3. **Rough sketch of vena cava entering the base of the heart.**

figs 4-8. **Designs for the construction of artificial semilunar valves.**

The designs are no doubt related to the construction of an artificial valve for the contemplated glass model mentioned above.

fig 9. **Deleted figure.**

Below these figures are the words, *Bad company,* also deleted.

fig 10. **The right ventricle, papillary muscle and tricuspid valve.**

The ventricle is identified by the words written on it, *Right ventricle.* Leonardo suggests a picturesque nautical terminology for the chordae tendinae, papillary muscles and atrio-ventricular valves.

Give names to their chords which open and close the two sails, that is, call the principal one the brace and capstan and the like.

The function of the chordae tendinae is again discussed:

The membranes exist here [tricuspid valve], which alone close the gateway of the right ventricle so that with the beating of the violent flood into the membraneous valves the closure of the ventricle may not be overcome and the valves reopened from behind. Necessity provided them with hard and powerful chords which could support a blow of such violence. The muscles of these chords are very hard, almost like cartilage.

fig 11. **The aortic vestibule, orifice and valve in longitudinal section.**

The lateral walls of the aortic vestibule are indicated on either side by the letters a b c, a d e, and the aortic orifice and semilunar cusps by a. The aortic sinuses, named for Antonio Valsalva (1666-1723), are clearly shown containing the vortices produced by the blood stream which Leonardo explains as filling out the cusps in closure of the valve, cf. 111. Within the cavity of the left ventricle is a moderator band as commonly found in the heart of the ox.

In conjunction with this illustration, Leonardo presents an interesting theory on the function of the walls of the aortic vestibule as a sphincteric mechanism to assist the aortic valves in preventing regurgitation of the blood into the left ventricle during diastole. As is mentioned in connection with fig. 3 of 100, it must be understood that they require the left and right ventricles to alternate in systole and diastole. Diastole is an active, not a passive, process which on the left side provides the *vis a fronte* to assist the *vis a tergo* of the right ventricle in forcing a portion of the blood through the mythical pores in the interventricular septum. How this is done is explained in the appended note.

The flesh a b c, and the opposite flesh a d c, are those fleshy parts which expand and diminish within the gateway of the heart. When the heart dilates, they diminish, and when the heart contracts, they expand, because dilation increases its capacity and contraction diminishes it. On increasing its capacity it [the left ventricle] attracts with surpassing force and impetus that blood which is necessary to replace the vacuum. This attraction forces with vehemence the blood through the fine pyramidal passages which are placed in the wall between the right and this left ventricle. In addition, part of the blood which this left ventricle first thrust up into the cusps of the [aortic] gateway of the heart when it contracted, would attempt to turn back, bending back and almost overcoming the aforesaid membranes of the valve of the heart. But necessity, at the time of the attraction of the blood through the dilation of the heart, has provided that the walls [a b c and a d c of fig. 11] of the gateway expand against one another in such a way that the gateway of the heart is closed by these [walls], as well as the closure of the valve by the aforesaid thin membranes. And so the resistance at the gateway is made equal to the power of attraction of the heart.

fig 12. **Diagram of aortic vestibule and aortic valve.**

The lateral walls of the aortic vestibule are now shown closed to support the semilunar cusps of the aortic valve. This is supposed to occur during diastole of the left ventricle (cf. note, fig. 11). In the aortic sinuses, the vortices o p are shown filling the cusps, and these cusps are also exhibited in the inset below the figure as they would appear from the ventricular surface when closed. The letter n, is placed in the mid-line above the vortices. The accompanying note reads: *If the wave o p, fails to send blood through the valves, the wave n, will pass straight on and lose the two secondary vortices.*

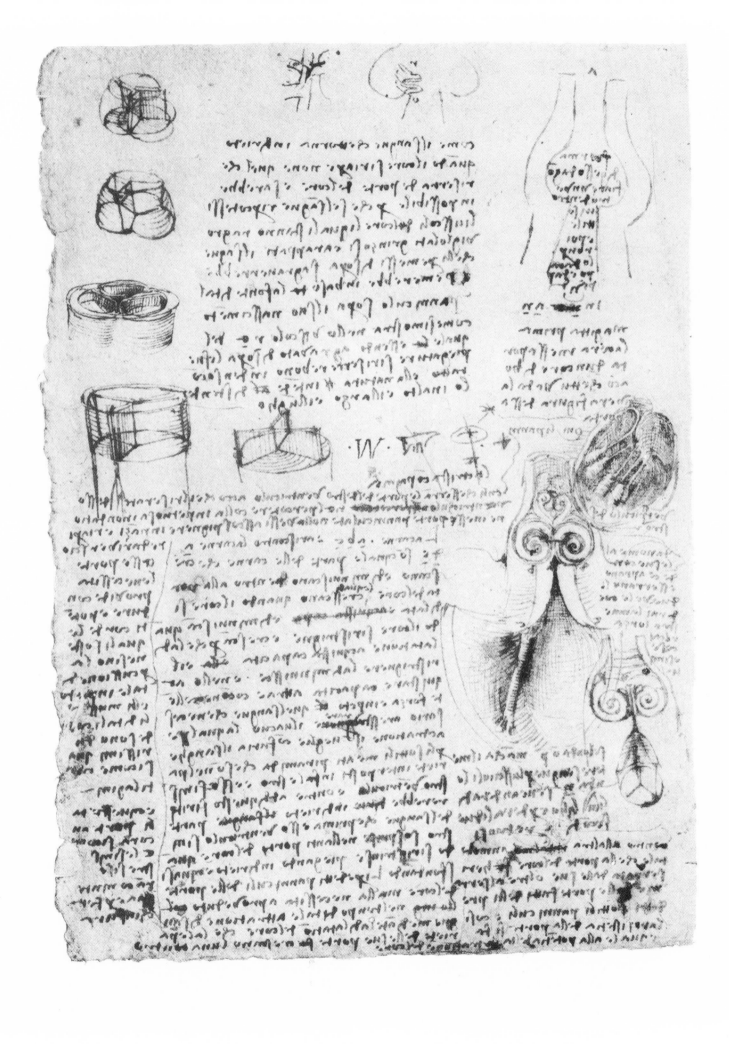

aortic pulmonary valves

The series of figures and notes on this page examines the question of the influence of blood eddies in the closure of the aortic valve. Hydraulics or what Leonardo called "the nature of water" was a subject of abiding interest, and here we find an extension of these studies to problems of haemodynamics. Because of their scattered nature, it is simpler to consider the studies in three groups rather than treat them individually.

Figures of group I. The centrally placed figures are, perhaps with one exception, analyses of the structure of the possible blood vortices produced in the aortic sinuses and which Leonardo holds are responsible for the filling out of the semilunar cusps of the aortic valve in its closure. The exception is the larger figure to the left of the middle of the page which seems to be an examination of the blood streams in the auricle although this is not specifically indicated. The centrally placed note describes with considerable insight the effect of these eddies or vortices established by the after-coming blood at the termination of the systolic thrust in closing the aortic valves.

The beating of the heart occurs by impulsions as the pulse shows.

We have demonstrated that the beating of the heart occurs by impulsions. If this were not the case, the left [aortic] valve would not be able to close and the blood which lay first above the valve would immediately descend. But as such a valve opens through the impetus and percussion of the blood which the ventricle forces out of itself, the valve remains open for as long a time as a small quantity of blood, which escapes from the heart, keeps it barred. At the same time the blood above it [the valve] cannot descend because the wave of blood which drives through it proceeds with the opposite motion throughout the entire artery. Simultaneously the remainder of the impetus of the blood which [originally] opened the valves, closes them with its reflux motion and the heart [i.e., ventricle] is reopened.

Figures of group II. The group of figures, three in number, occupy the middle of the left margin. Their purpose is to illustrate that it is the vortices described above which fill out the cusps in closure of the aortic valve and not the pressure. If, Leonardo argues, it were the pressure or weight of the column of blood alone, the cusp would be folded back upon itself as shown in the third figure of this group. The adverse opinion is discussed in the note, cf. fig. 2, 110.

The adversary states that this part [aortic valve] of the left ventricle of the heart is of necessity closed when the ventricle reopens. This takes place because the blood which descends upon the valve, beats against the valve and presses it shut. The shape of the valves denies this as they would rather be flattened out than shut.

It is to be asked whether in the opening of the valves and sending the blood out of the gateways of the heart, an amount escapes equal to the diminution which occurs in the left ventricle when it closes.

Figures of group III. This group of figures occupying the lower right-hand portion of the page show the aortic vestibule, aortic valve and root of the aorta. The vortices in the aortic sinuses are demonstrated in the neighboring detail opening out the cusp. Below, the vortices are shown in relationship to the blood stream when the aortic valve is open and when closed. Above and to the right of these figures are two parallel structures labelled a d, b c. These probably represent the walls of the aortic vestibule which Leonardo supposed acted as a sphincter in diastole to support the valve as described on 110. The latter is indicated by the note pointing to the base of the aortic valve and reading:

When the heart is dilated at the left ventricle, this [aortic vestibule] contracts at its base to close the entrance to the gateway of the aortic artery.

A note pointing to the aortic eddy of the main figure of the group, and also to the detail figure beside it, states as in a note above, that closure of the valve is effected by the terminal part of the blood stream injected into the aorta at systole.

The valves close when the heart opens and they close by means of the remainder of the impetus imparted to the blood.

However, some doubt is expressed as to the correctness of the above view since the eddies might be produced at the head of the systolic blood stream which theoretically would require division of the stream into two, a main stream and a back eddy.

It is doubtful if the percussion made by the impetus in front of the upper curve [aortic surface] of the semilunar valve divides the impetus into two parts, one of which revolves upwards and the other turns downward. Doubts of this sort are subtle and difficult to prove and to clarify.

Having expressed his thoughts in the above notes and diagrams, Leonardo arrives at a final conclusion in the last note to be penned on the page but placed in the upper right-hand margin.

This, the last [note] written on this sheet concludes that on the reopening [diastole] of the left ventricle the blood contained in it ceases to escape from the ventricle, and at that time the escaping blood would attempt to return into this ventricle together with that which lies above it. But the remainder of the revolving impetus which still exists in the escaping blood is that which with this revolving beats against the sides of the three valves and closes them so that the blood cannot descend. If there were no revolving by the aforementioned circular motion of the blood recently forced out of the left ventricle, without doubt the penultimate blood forced out of the ventricle would return to the ventricle since this penultimate blood does not lie upon the sides of the valves which close the opening, but on the margins of the thickness of the said valves.

aortic pulmonary valves

Originally this folio together with Q IV 12 (114) was part of a single sheet, three-quarters of which was devoted to a series of observations on the anatomy and function of the aortic valve. Leonardo seeks an explanation for the triangular shape of the orifice and its three semilunar valves in terms of the vortices set up by the current of blood passing into the aorta on systole.

fig 1. **Diagram of the flow of water at the outlet of a level pipe.**

The central stream is lettered a d; the upper and lower marginal streams n e, and m f, respectively; the point of intersection of the marginal streams, c; and at b, the central stream passing beyond the point of intersection and therefore further from the outlet at the point of intersection. Leonardo notes:

Of the water which pours out through a level pipe, that part of its intersection which originates nearer the middle of the mouth of the pipe will fall further away from the mouth of the pipe.

Having established this principle and having in mind the slit-like intervals between the cusps of the aortic valve, Leonardo reminds himself to *Try it with a straight cut in a vessel.*

The application of the above principle is illustrated on 113, where it is used to explain the production of the vortices in the aortic sinuses which he believes close the cusps.

fig 2. **Diagram of the flow of water from the outlet of a vertical pipe.**

As in fig. 1, the principle of frictional loss is applied to a vertical stream. *The water which surges through a pipe goes higher the further it is from the walls of that pipe.*

fig 3. **Diagram of the aortic orifice, valves and sinuses.**

The triangular opening of the aortic valve is indicated by the letters a b c. The larger semicircles are the aortic sinuses, lettered d e f, and within them are the semilunar outlines of the cusps. Leonardo employs the term *emicicle* for the hemispherical concavity formed by both the cusps and the corresponding aortic sinus of Valsalva. We are not always consistent in rendering this term which we sometimes translate as cusp, at others as sinus or semicircle, as best suits the meaning. The function of the aortic sinuses was to permit the formation of lateral eddies of blood which filled the semilunar valves and thus forced their closure.

The concavity of the semicircle (emicicle [=aortic sinus and cusp]) reflects the percussion of the blood with a large and speedy momentum towards the center of the triangle a b c [aortic aperture] where it presses against the apex of the cusp.

The friction produced by the eddying of the blood in the closure of the valves is used to explain the so-called innate heat of the body, and so when the pulse rate is increased in illness, to the production of fever. *This [aortic] valve emits blood as often as the heart beats; and for this reason the fevered become heated.*

fig 4. **The vortex of blood in the aortic sinus viewed from the apex of the triangular aortic aperture.**

fig 5. **The vortex of blood in the aortic sinuses viewed from the base of the triangular aperture.**

The principles as developed from the behavior of a jet of water passing through a level and a vertical pipe are now applied to the theory of the formation of vortices of blood in the aortic sinuses, and the concavities of the cusps in explanation of their closure. Since the peripheral portion of the blood stream is moving more slowly it not only turns back but is compelled to revolve in the aortic sinus by the faster moving more centrally placed portion which is reflected from and follows the hemispherical concavity of the wall of the aortic sinus. This is shown diagrammatically in 113. The swirling blood, revolving upon itself, opens out the cusp and ensures closure of the valve.

The closure [systole] of the heart, the percussion of the border [or the aperture] by the cusps, the beating of the pulse and the entrance of the blood into the antechamber [aortic sinuses] of the heart occur at one and the same time.

The middle of the blood [stream] which surges through the triangle a b c [aortic aperture, cf. fig. 3] rises to a much greater height than that which surges along the sides of this triangle. This occurs so that the blood in the middle of the triangle directs its momentum upwards and that which surges along the sides distributes its momentum by lateral motion, beats against the front of the curve of the semicircle [aortic sinuses], and follows the concavity of this semicircle, constantly passing downwards, until it beats against the concavity at the base of this semicircle [i.e, concavity of the cusp] and then by reflected motion turns upwards and continues to revolve upon itself with a circular motion until it expends its momentum.

The least height is that achieved by the last blood which entered the antechamber of the heart, immediately followed by the perfection of the closure made by the valve of the heart.

The several vortices of the blood stream in its ebb and flow movement are believed to cause not only the final closure of the valves but by friction the mysterious innate heat of the body. It would require the passage of centuries before Joseph Priestley (1733-1804) and Antoine Lavoisier (1743-1794) could offer the fundamental knowledge for the solution of the latter problem.

The revolution of the blood in the antechamber [aortic sinuses] of the heart, at the base of the aorta, serves two purposes. The first of these is that this revolution, multiplied on many aspects, causes great friction in it which heats and subtilizes the blood and augments and vivifies the vital spirits which are always kept hot and humid. The second effect of this revolution of the blood is to shut again the open valve of the heart making by its primary reflected motion a perfect closure.

Galen's theory required blood to pass through the interventricular septum to be refined into the vital spirit. Leonardo holds that this occurs during diastole of the left ventricle which creates a vacuum enabling

(continued on page 499)

aortic pulmonary valves

This page was originally part of a common sheet, the other half being 114.

fig 1. **Diagram of the aortic valve and sinuses.**

The diagram is similar to that on 112. The centrally placed triangle a b c, is the aortic aperture. The larger semicircles about its three sides represent the aortic sinuses of Valsalva. Within them, the smaller arcs on the same base indicate the cusps, actually the thin lunules of the cusp, lettered r,r,r. From the center of the triangle d, pass five lines: d b, d c, to the base of the triangle: d e (like D) to the middle of the larger semicircle intersecting the cusp at r: and two other lines not lettered. Beside the figure is N to draw attention to the fact that this figure and note are inserted as a continuation of the discussion labelled N below. From the principles laid down in 112 on the behavior of liquids passing through a pipe, the meaning of the note is clear.

In the figure N below, placed here once more, is demonstrated how the blood, or the momentum, which moves backwards from the center d, along the line d e, has a much greater revolution than the momentum d b [since the latter is further from the center]. *Consequently its reflected motion has to turn further downwards to complete its circular motion than the blood d b.*

I doubt that all the principal orifices of animals open themselves because of death, that the orifice m o p h [aortic orifice, lettered in fig. 6] *does not open in the triangle a b c* [aortic aperture] *and whether, in the living, this orifice would close itself without the membranes a b r, a c r, b c r* [aortic cusps] *and swell like the flesh of the tongue or penis.*

In the above note he has in mind the possible action of the aortic vestibule of the left ventricle assisting as a sphincter (cf. 110) and reminds himself to *Draw and define the pyloris of the stomach.*

figs 2-3. **Diagrams to illustrate formation of the aortic vortices of blood.**

THE MOTION OF THE IMPETUS.

From the principles derived from observations made on the flow of water through a pipe described on 112, the formation of the vortices in the aortic sinuses is analyzed. In the second of the two diagrams, three streams a b c, lying successively nearer to the center of the orifice are shown. From fig. 1 on 112, stream b, intersects stream a, at e, since b, is nearer the center. From fig. 2 of the same page, stream c, rises higher than a or b, being still nearer the center but is deflected at the point d, where it comes in contact with the curved wall of the aortic sinus. This stream in consequence passes lateral to the others until curved upward by the curve of the cusp, thus causing the whole to revolve and form a circular eddy of blood as shown below.

figs 4-5. **Figures of the aortic orifice, valves and sinuses to be made of glass.**

On several occasions Leonardo mentions the making of a glass model of the aortic orifice and valves in order to study the closure of the cusps and the formation of blood eddies. While we do not know if it was ever constructed, these figures suggest such a model. Below the figure is a further note: *Make this trial in the glass* [model] *and move in it . . . the membranes.*

fig 6. **Three diagrams of the aortic orifice and valves.**

In O, the valve is shown closed by its three semilunar segments p n o, o n m, m n p. In M, the triangular aperture a b c, is added thus defining the lunules of the cusps a d b, a d c and b d c. The base of each cusp is looked upon as being part of the adjacent aortic sinus, and these are indicated by e f g. In N, the valve is open. Lines are drawn radially from the center of the aperture f, to the walls of the aortic sinus at o n p r t u. These lines intersect the base of the cusp at r o q s, and represent the various lengths of the blood stream which will be reflected from the walls of the sinus to roll back the cusp in closure of the valve. It is possible that these diagrams are in part related to the construction of a valve for the model illustrated above. In the accompanying note the reason for the presence of the thin lunules of the cusps is discussed in terms of Leonardo's law that Nature makes nothing in vain.

Here is replied: closure by means of the entire thickness of the base of the semicircle b g c [in fig. 6, N] *as far as the middle d, is not necessary, because Nature, seeking the greatest brevity in her operations, has found shorter expedients by closing the gateways of the heart with the membranes rather than with the substance of the heart which opens at the time that the membranes are closed. And besides, from the compound motion of the first thereof, which causes the revolution of the impetus introduced into the blood which expands and elevates while stretching the said membranes, clashing and opposing them against one another making a perfect closure, we can conclude is an easier way for this closure to occur than to move the aforementioned substance of the heart.*

fig 7. **The left ventricle and aortic valve during systole.**

fig 8. **The aortic valve during systole.**

These two figures are complementary. In fig. 7 the left ventricle e f g, is separated from the aortic vestibule c d f e, by the line e f. The aortic sinuses and cusps containing the primary blood eddies are lettered a b, and the rest of the aorta receiving the main stream and secondary eddies is noted by m n. On the ventricle is the statement: *The heating of the blood is augmented by the continual revolution which is caused by the momentum introduced into the blood at the base of the artery.* Below fig. 8, we are once again informed that *The incident motion opens the valves of the heart, and the reflected motion closes them.*

These notes are followed by a lengthy discussion on the formation and function of the vortices of the blood in the aortic sinuses following systole of the heart. The majority of Leonardo's observations on the flow of water are to be found in the Codex Atlanticus with several suggestions as to arrangement. But in the Leicester Codex is one of his latest notes on the

(continued on page 500)

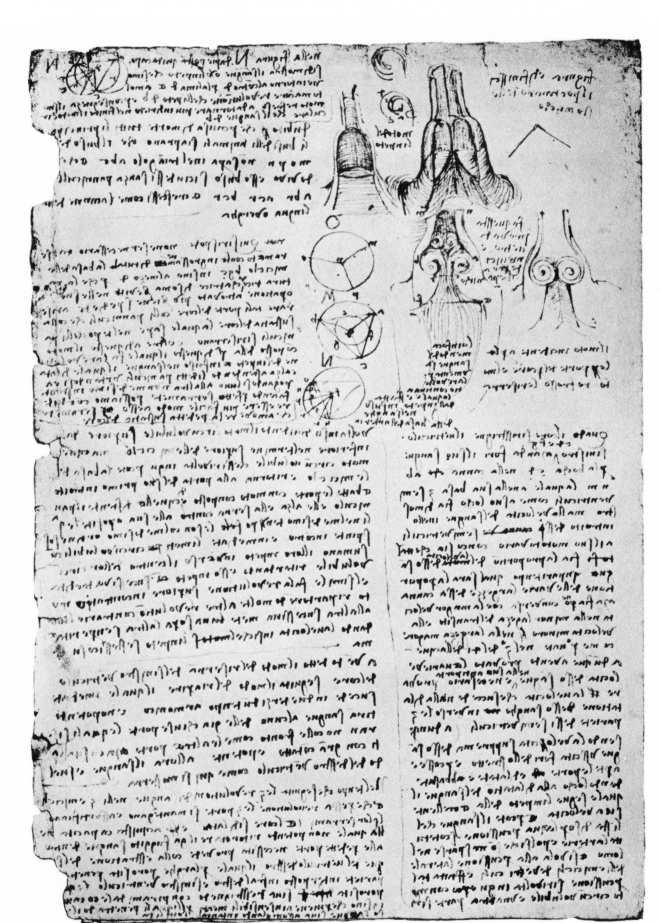

Owing to the number and arrangement of the drawings on this page it is easier to consider them in three groups enumerated in the usual manner from left to right within each group. This page, originally part of a larger sheet, the other half being 112-13, is also the verso although called recto in Q.

GROUP I. UPPER RIGHT CORNER.

figs 1-3. **Diagrams to illustrate a note on the triangular shape of the aortic aperture.**

In fig. 1 the aortic orifice is shown closed by four hypothetical semilunar valves, one of which is lettered e h f, and its base w. In fig. 2 the aortic orifice, the customary three cusps are illustrated, and one is lettered c a b, and its base S. In fig. 3 only two cusps fill the orifice. The accompanying note is explanatory.

Nature made 3 valves and not 4, because the pellicles which close such valves make greater angles, being 3 in number, as the angle c a b [fig. 2] shows, [being greater] than the angle formed by e h f [fig. 1], where there are 4 valves. Now for this reason the more obtuse angle is stronger than the right angle of the square [valve], inasmuch as the cathetus [i.e., altitude of a triangle] a s [in fig. 2] is shorter than the cathetus [in fig. 1], and the square aperture is more capacious than the triangular in one and the same circle. Consequently the membranes [lunules] of the 4 valves are weaker than those of the 3 valves because at their angles they are further removed from the base of their triangle than those of the 3 valves.

fig 4. **The aortic valve.**

The cusps of the aortic and pulmonary valves were regarded by Leonardo as consisting of two parts. The membranes or pellicles corresponding approximately to the lunules of modern terminology made up one part and were attached, not to what we would regard as the base of the cusp, but to what he regarded as the base or continuation of the aortic sinus. The note below the figure tells us, as explained more fully in 113 that *It [aortic valve] opens itself through the incident motion and closes itself by the reflected motion.*

GROUP II. UPPER LEFT CORNER.

figs 1-4, 6. **Sketches of the aortic valve and sinuses, many incomplete.**

The largest of these figures shows the aortic vestibule, valve and base of the aorta to illustrate the vortex of blood in the sinus which it was believed closes the cusp. The mechanism is described in the note below and fully on 113.

fig 5. **Diagram of aortic valve and sinus to demonstrate the formation of a vortex of blood.**

In this diagram, the lower left member of the group, we are shown how a vortex or eddy of blood forms in the aortic sinus to assist in closure of the cusp. It will be noticed that the aorta is referred to as a conduit, tube or pipe. This suggests that Leonardo may perhaps be describing an observation made on the glass model, and the large fig. 6 may represent this.

When the blood n b m o a, revolves with a circular motion around its center of motion r, it wants to maintain its momentum along the line of the beginning of its revolving motion and tends to enlarge following the curvature of the beginning curve n b m. However, by percussion against the wall m o [of the aortic sinus], it becomes of lesser curvature and proceeds to follow the wall until it strikes against a, where is found the simple membrane of the valve a b. This momentum of blood would rupture it [valve] in a very short time, but sagacious Nature provided a very durable resistance at the lowest part of the circle of momentum by thickening the wall of the conduit [aorta] at o, by the mass o a h L. Consequently, when from the motion of this blood its percussion is delivered against a resistant place, the revolving motion is suddenly turned upwards at the end of this wall at the point a, where it encounters the membrane of the valve. The membrane, in order to close its third [of the opening], necessarily must make a compound motion, that is, partly towards the middle of the tube and partly upwards. This compound motion must be created by another compound motion which will be the revolving motion of the blood a b, which according to the 4th [book] "on revolving motion"—where it is stated: The weight which moves around the attachment of a string, where it is joined, pulls and stretches this string with great force, and if such a string is severed from its attachment, the weight carries with it the said string along that line into which it was drawn at severance from its attachment. Therefore, the blood which beats against this valve with its momentum, being unable to rupture it, continues its motion upwards, enlarges and expands the fold [lunule] upwards, and drives it against the other two valves which, for similar reasons, advance to meet it. Thus, the 3 valves are joined together at the same time in the center of the aorta.

GROUP III. MIDDLE OF PAGE.

figs 1-2. **Abortive figure of aortic valve.**

fig 3. **The aortic valve shown fully opened at the beginning of systole.**

To the right of the figure it is stated, *The momentum which remains in the blood closes the valve.*

figs 4-5. **The aortic valve shown about to close at the end of systole.**

The primary and secondary vortices discussed above are shown developing in the aortic sinuses and root of the aorta. In fig. 4 the aortic orifice is lettered a b, and discussed in the note where reference is again made to the treatise *On the nature of water. a b* [aortic valve], *according to the 6th [book] on the percussion of liquids, where [it is stated] reflected motion: combine to form a common percussion, will be the region of greatest percussion which can take place at the entrance which the blood makes into the aorta. It is this which by its motion beats against the valves and shuts them with perfect closure.*

(continued on page 501)

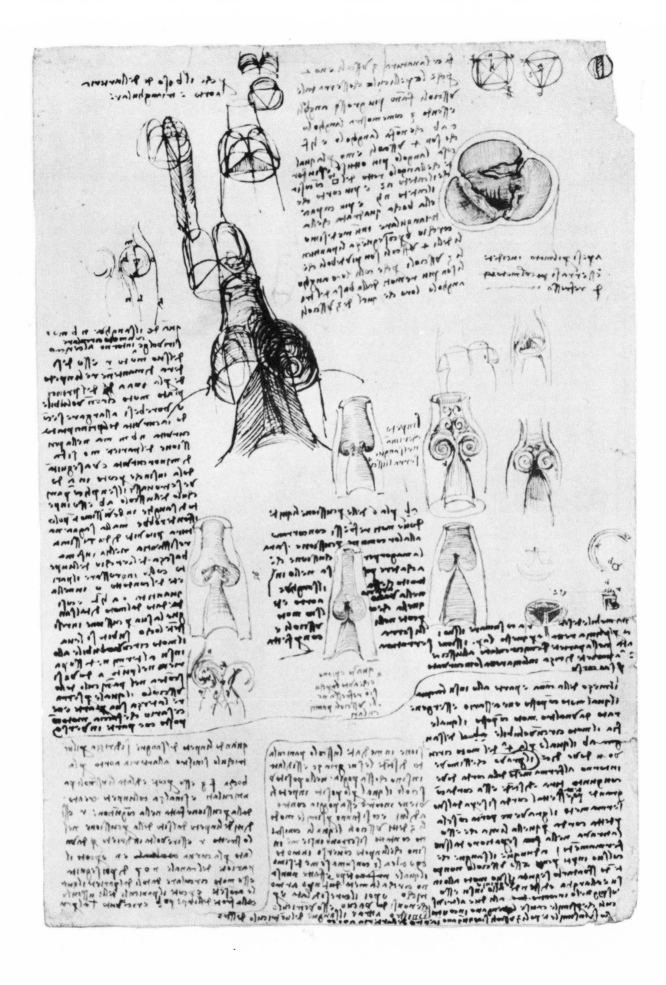

fig 1. **The extensor tendons on the dorsum of the foot.**

The tendons of the tibialis anterior, extensor hallucis longus and extensor digitorum longus muscles are clearly defined, as well as the elevation produced by the extensor digitorum brevis. The illustration draws attention to the modelling of the surface produced by the underlying tendons. The accompanying note is likewise concerned with the surface features and calls attention to the gentle concavities of the lateral borders of the phalanges which are believed to exist for the accommodation of the enlargement at the level of the interphalangeal joint.

Each swelling produced at the joints of the digits of the foot and of the hand has in the digits contiguous to them a concavity which receives within it this rounded structure. Nature has done this so as not to deform their width. For if the swellings mentioned were to be in contact between them, the feet would become too great in width. Further, one of two effects would necessarily occur, that is, either the digits would all be of one and the same width or one would have two joints and another one, as will be shown in its place on the bones.

figs 2-3. **The blood vortices and aortic valve of the heart.**

The words above the drawing, *It follows here,* indicate these figures as a continuation of a series such as those on 110 and 111. The note refers to the same haemodynamic theory.

The movement of liquid, made from one direction, proceeds in the original direction as long as the force remains in it which was given to it by its first mover.

These considerations lead to a lengthy discussion on the function of the blood in the body economy based upon the physiology of Galen.

HOW THE BODY OF THE ANIMAL CONTINUALLY DIES AND IS RENEWED.

The body of anything whatsoever is nourished, continually dies and is continually renewed, for nourishment cannot enter except into those regions where the preceding nourishment has expired and, if it has expired, it no longer has life. If you do not supply nourishment equal to the nourishment which has been consumed, then life fails in its vigor, and if you deprive it of that nourishment, life is totally destroyed. But if you supply as much as is destroyed daily, then life is renewed by as much as is consumed: just as the flame of a candle—a light which is also continually restored with the speediest of assistance from below by as much as is consumed above in dying, and the brilliant light is converted on dying into murky smoke. Such a death is continuous as long as the smoke continues: and the continuance of the smoke is equal to the continuance of nourishment and in the same instant all the flame is dead and all regenerated simultaneously with the motion of its nourishment. Its life also receives from it its flux and reflux as is shown by the flickering of its tip. The same thing happens in the body of animals by means of the beating of the heart which generates a wave of blood through all the vessels which continually dilate and contract. The dilatation occurs on the reception of superabundant blood, and the contraction is due to the departure of the superabundance of the blood received, and the beating of the pulse teaches this to us when we touch the aforesaid vessels in any part of the living body with the fingers.

But to return to our purpose, I say that the flesh of animals is made anew by the blood which is continually generated by their nourishment and that this flesh is destroyed and returns through the miseriaec artery [portal vein] and passes into the intestines where it putrefies in foul and fetid death as they show us in their excreta and ashes like the smoke and fire given for comparison.

cardiovascular system

fig 1. **The vascular tree.**

To one side of the figure are the words *spiritual parts*, i.e., the Galenical vascular system carrying the natural spirits on the venous side and the vital spirit on the arterial. Below this is a reminder to construct a more elaborate picture of the vascular system such as that of 202. *Cut through the middle of the heart, liver and lung and the kidneys so that you can represent the vascular tree in its entirety.*

On the ureter is written *vena cilis,* possibly not in Leonardo's hand, since it is of course not the ureter but the vena cava, and this would be an unusual error for Leonardo judging from his use of the term even in his earliest period. Clark dates the figure as c.1504-06 on stylistic grounds but admits that the pen and ink work as well as the rather ornamental writing look much earlier. In terms of the anatomical knowledge displayed we date the drawing c.1490-1500.

The ideas expressed in the figure appear to be based on a reading, possibly of Plato or of one of his commentators, possibly by way of translation from the Arabic version of the *Timaeus,* to which have been added findings derived from animal dissection and the surface inspection of the body. The caval system is represented as arising in the liver like the sprouting of a seed with roots extending downwards and the stem upwards. This is the Aristotelian conception which Leonardo later discarded in favor of the Galenical view that the venous system had its origin in the heart. No atria are shown, but the heart was regarded as a two-chambered organ consisting of ventricles only—a conception from findings in animals where the cava appears as a continuous vessel passing through the heart. The arch of the aorta and its branches show the ungulate arrangement, not the human. Leonardo had the support of Avicenna for this statement which he did not correct until the dissection of the centenarian, cf. 128. The superficial veins of the extremities show astonishing inaccuracies since they were open to surface inspection whereas the arteries of these members are portrayed in a manner to be expected from the reading of Mundinus and Avicenna. The arrangement of the kidneys is as in animals. Other structures recognizable are the spleen, right spermatic vessels arising from the inferior cava and descending aorta and the left spermatic, origin not shown. The bladder receives cystic branches from the common iliac veins, and the urethra has been laid open.

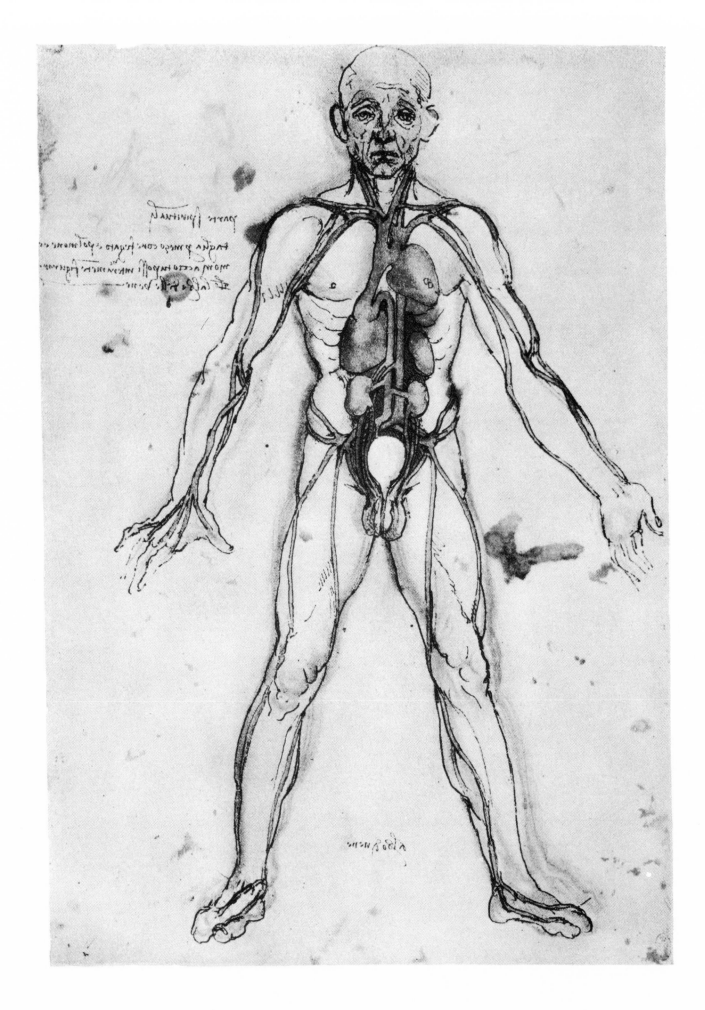

cardiovascular system

From the note given below, which may refer to the statue of Francesco Sforza, and the style of the writing, Clark dates the drawing as c.1493, which places it among the few of this date. The dating is supported by the fact that the dissection is probably that of a horse, a preparatory measure for the statue.

fig 1. **Faint sketch of the vertebral column and testis.**

The testis is shown connected to the spinal column by a structure which Leonardo says is, *A nerve having its origin from the spine which joins the vessels of the testicle.* The rough figure is accompanied by a memorandum: *When you make this spine, first place the bones, then the bones and the loins, then the vessels, then other parts in separate figures.*

fig 2. **Dissection of the viscera and dorsal vessels of an animal.**

The outline, viscera and arrangement of vessels in the main figure are obviously taken from the dissection of an animal, possibly the horse. Very few of the notes refer to the dissection itself. The right psoas muscle carries the notation, *muscle of the omentum,* but the connection is not clear. At the level of the knee we are told that the vessel shown, *Passes on the other side,* i.e., dorsally and consequently the popliteal and posterior tibial vessel, whereas lower down it is said that the vessel, *Returns to this side,* i.e., anteriorly and therefore the anterior tibial. The remaining notes refer largely to techniques for anatomical studies.

ON THE KNOWLEDGE OF THE SINEWS IN THE CONFUSION OF THE SHOULDER.

Where you find many sinews which are converted into the ligaments of the shoulder or in other osseous joints, you will strip the bones of the said sinews and let them dry or unravel them while fresh. The unravelled bundle will tell you where and what sinews are converted into these [joints], *where they are directed and where "the cartilages" once again are converted into sinews.*

A tendon which widens out into an aponeurosis such as the passage of the palmaris longus into the palmar fascia, is usually called "cartilage" by Leonardo.

The final note is that which has been interpreted as a reference to the statue of Francesco Sforza, but the identification is very uncertain.

When you have finished building up [lit., increasing] *the man* [? in clay], *you will make the statue with all its superficial measurements.*

cardiovascular system

fig 1. **The great vessels of the thorax and neck.**

The superior vena cava is observed receiving the azygos and innominate veins. The arch of the aorta gives off two vessels as in the dog. The first is probably a brachiocephalic artery since it divides symmetrically into right and left common carotids. The second is doubtless the left brachial artery providing branches which although difficult to identify with certainty, suggest the vertebral, dorsal, cervical and external thoracic. The arrangement is certainly not characteristic of the human subject.

fig 2. **Infra-orbital vessels or nerves.**

fig 3. **The facial or external maxillary vessels.**

Note the labial and lateral nasal branches which are clearly shown. The shading of the figures, especially in the region beneath the chin, follows the various contours which, according to Clark, is a later characteristic of Leonardo's style. The drawings are, therefore, dated c.1504-06. If the dating can be accepted, the continued dependence on animal anatomy is interesting since we know that Leonardo was dissecting the human subject in and about this period.

At the bottom of the page is written, *Of the human species,* which may have some relation to the remarks above, i.e., his determination to pay greater attention to the anatomy of man.

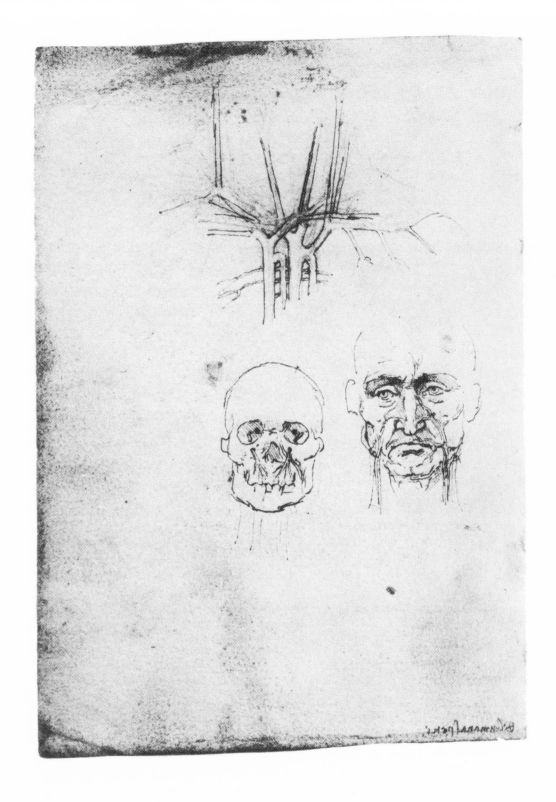

cardiovascular system

In this series of figures Leonardo supports the Aristotelian position that the heart is the origin of the embryo and the source and origin of the vessels. Aristotle's conception, in direct opposition to Galenical views, divided the "philosophers" from the physicians. Galen contended that the liver was the first of the principal organs to be formed and was the source and origin of the vessels as well as being the bloodmaking organ. The blood itself was made from the chyle carried from the intestines to the liver by the portal system.

figs 1-3. **The heart and vessels compared to a seed with its roots and branches.**

In fig. 1 the ovoid body is labelled the *heart* and in fig. 2, the *seed*. In fig. 3, the heart and vessels are shown from the left side. The analogy is modified from Galen. Galen compared the liver and vessels to a dicotyledonous plant, the seed corresponding to the liver, the roots to the inferior vena cava and the branches below the hepatic veins and the stem to the upper portion of the cava and its branches. The heart was like the fruit of a plant, an appendage to the venous tree. The Aristotelian position is taken in the explanatory notes placed below the figures.

The plant never arises from the branchings, for the plant first exists before the branches, and the heart exists before the veins.

The heart is the seed which engenders the tree of the veins. These veins have their roots in the dung, that is, the meseraic [mesenteric-portal] veins which proceed to deposit the acquired blood in the liver from which the upper [hepatic] veins of the liver thereafter receive nourishment.

fig 4. **The great vessels: vena caval, aortic and azygos systems.**

The general arrangement of the vessels suggests that the figure is based upon animal dissection, probably the ox. There are numerous errors, the majority of which are identical to those found in similar figures of about the same period. At m, pulmonary veins are observed entering the cava. However, it should not be forgotten that the heart, seen in outline, was regarded as a two-chambered organ and therefore that this region corresponds to the atria. At o, is the entrance of the hepatic veins, called the "upper veins of the liver" by Leonardo. The azygos vein is clearly delineated and no equal illustration is to be found until the epochal work of Vesalius in 1543. At n, is the ascending aorta, the arch of which gives off a brachiocephalic trunk as in animals. The left spermatic vein is excellently shown entering the left renal vein. The lengthy note once again defends the Aristotelian view on the origin of the vessels. The argument is very similar to that of Vesalius, who took a like position against Galen.

All the veins and arteries arise from the heart. The reason for this is that the maximum thickness found in the veins and arteries occurs at the junction which they make with the heart. The more removed they are from the heart, the thinner they become and divide into smaller branches. And if you say that the veins arise from the gibbosity of the liver, because they have their ramifications in that gibbosity, as the roots of plants have in the earth, the reply to this comparison is that plants do not have origin in their roots, but the roots and other branchings have their origin in the lower part of the plant which lies between the air and the earth. And all the lower and upper parts of the plant are always less than this part which borders upon the earth. Therefore it is clear that the whole plant has its origin from this thickness, and, in consequence, the veins have their origin from the heart where their thickness is greatest. Nor does one ever find a plant which has its origin from its roots or other branchings, and one sees an example of this in the sprouting of the peach which arises from its seed as is shown above at a b and a c [in fig. 2].

Memoranda on additional drawings to be made include the coronary vessels (cf. 86) and the relations of the vessels to the bone.

Draw the veins which are in the heart and also the arteries which give it life and nourishment.

First draw the branchings of the veins by themselves and then the bones by themselves. Then join the bones and the veins together.

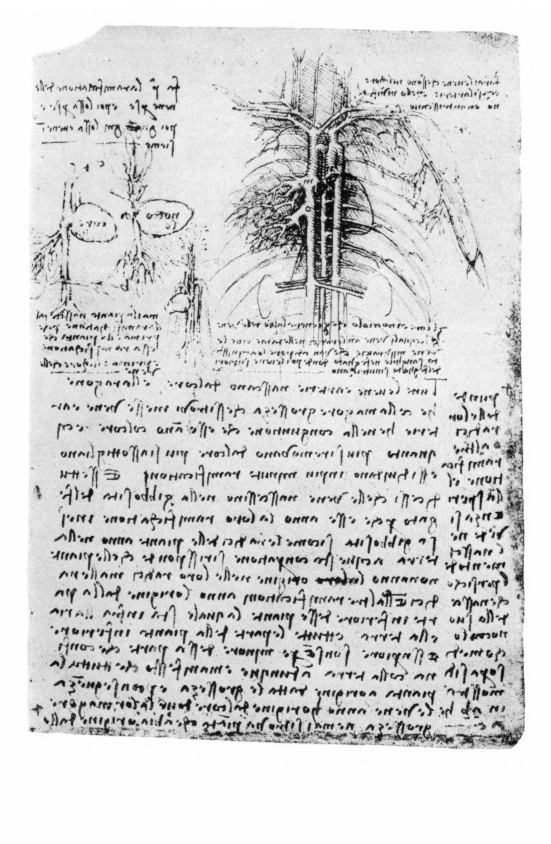

Clark 19050r / FB 33r / c. 1504-06 284

fig 1. **The arteries of an old man.**

THE ARTERIAL VESSELS.

The arch of the aorta and its branches as shown are undoubtedly human, unlike many similar diagrams which are just as evidently drawn from lower animals. The vertebral artery and vein entering and leaving the vertebral canal are clearly defined. The drawing is one of a series based on the dissection of the centenarian, cf. 128.

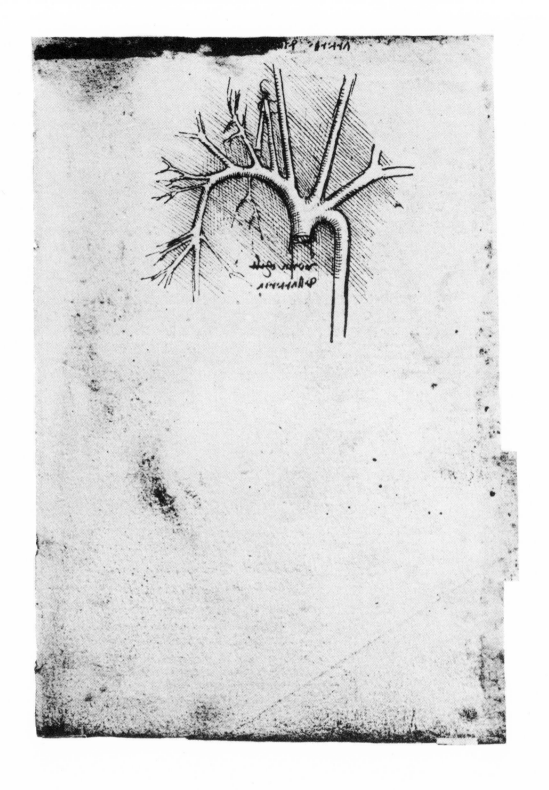

ON THE OLD MAN.

fig 1. **The great vessels at the root of the neck.**

The figure is one of the series based on the dissection of the centenarian, cf. 128. It is among the few representing the findings in man. Almost all the others on the vascular system are derived from animals. Above the figure is the reminder: *But make this demonstration from three different aspects, that is, from in front, from the side, and from behind.*

The figure is very imperfect. Leonardo provides a guide to the various structures: *a* [ascending aorta], *These are the ramifications of the arteries; b* [superior vena cava], *This is the ramification of the veins; c, This is the cephalic vein; n, These are the two vessels* [vertebral] *which enter the vertebrae of the neck to nourish them; o, This is the basilic vein; S, These are the apoplectic* [carotid or jugular] *vessels.*

In connection with the so-called apoplectic vessels an additional note states:

If you compress the 4 vessels m [carotids and jugulars] of either side where they are in the throat, he who has been compressed will suddenly fall to the ground asleep as though dead and will never wake of himself; and if he is left in this condition for the hundredth part of an hour, he will never wake, neither of himself nor with the aid of others.

Leonardo uses the word *vene* to mean either vein or vessels. His apoplectic vein or vessels thus means either the jugulars, the carotids or both. These vessels, especially the carotids, were commonly called the "sleep-inducing", "apoplectic", or "lethargicae" from the notion that compression of these vessels produced insensibility. In fact, the term carotid is derived from the Greek κάρειν, to stupefy. The earliest source of this observation appears to have been Aristotle, but Galen, following experiment, denied any such effect. Rufus of Ephesus stated that the insensibility was due to pressure on the vagus nerve. Leonardo is thus echoing traditional information.

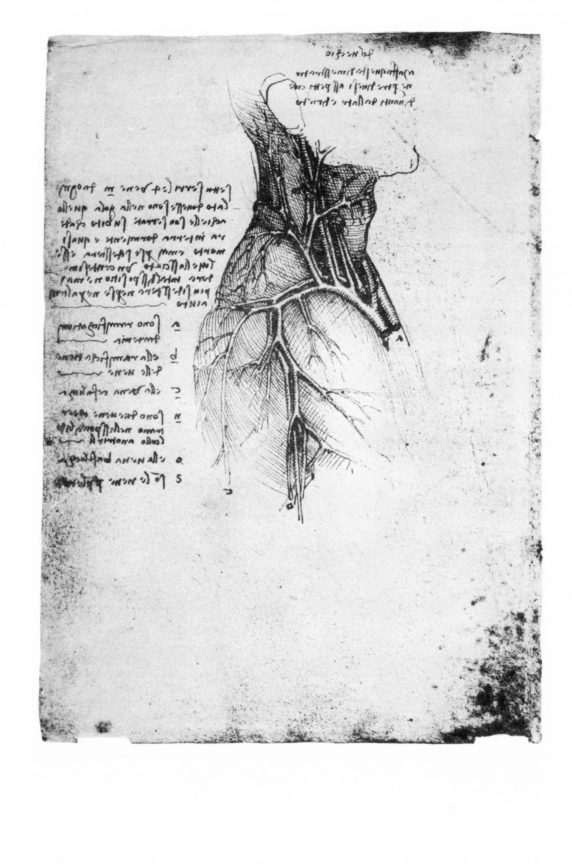

ON THE OLD MAN.

The figures belong to the series based on the dissection of the centenarian, cf. 128.

fig 1. **The veins at the root of the neck.**

The figure appears to represent the subclavian vein receiving the external jugular passing superficial to the outlined sterno-mastoid muscle, the cephalic and axillary veins.

fig 2. **The vessels at the root of the neck.**

While we are informed that the figure is from the dissection *of the old man,* nevertheless it is very difficult to interpret. The outlines of the trachea and cervical spine can be recognized. We are told that the vertical structure is *a nerve descending to the covering of the heart, between the artery and vein,* and that *a, is the vein, b, is the artery.* This suggests the pericardiaco-phrenic vessels and phrenic or an accessory phrenic nerve as seen in greater detail in 149, of which this figure seems to be a preliminary sketch. On this basis the oblique structure on the right giving origin to the nerve would be the upper trunk of the brachial plexus and so the nerve, an accessory phrenic. However, the pericardiaco-phrenic vessels are usually branches of the internal mammary which seems to be represented on the left. Presumably the other structures are the subclavian vessels, the external and internal jugular veins.

A note on the left and above reads: *Note whether the artery is thicker than the vein, or the vein than the artery; and do the same in children, the young and the aged, males and females, and the animals of the earth, of the air and of the water.*

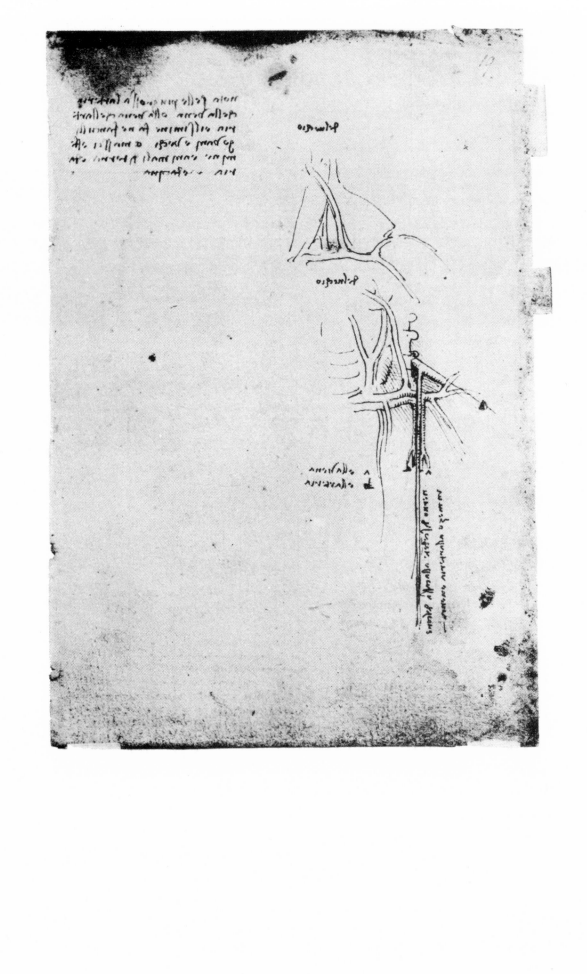

fig 1. **Diagram of heart, liver and urinary system.**

The purpose of this diagram is to illustrate the extension of a theory expressed on 98 in which Leonardo, following Galen, assumes that the amount of blood manufactured by the liver is equal to that lost by passing through the interventricular septum of the heart into the left ventricle with each systole. Therefore he reasons that there may be some relationship between the urinary output and the amount of new blood so formed.

The quantity of urine shows the quantity of blood which is produced and goes to the kidneys but first passes through the opening of the heart. However, not all since a large part of the blood is that which descends through the vena chilis [vena cava] and goes to the kidneys, and this does not pass through the heart.

fig 2. **Rough diagram of the stomach and intestines.**

fig 3. **Rough diagram of the lungs and abdominal viscera.**

The note in juxtaposition to figs. 2-3 indicates that Leonardo is thinking of methods to illustrate the distribution of the vessels. "The instruments of the blood" are the heart and vessels taken collectively since following the Galenical definition, an instrument is a part of the body capable of performing a complete action.

The instruments of the blood, that is, the ramification of all the veins seen from 4 aspects, that is, from the front, from behind, from the right and from the left: with all the measurements and made a little opened up, that is, expanded that they may be more intelligible. Then let a single one be made from the front with its proper shape and position, that is, drawn to show opposite which ribs and which vertebrae it is related and what distance it is from the centre of the dorsal spine.

fig 4. **Diagram of the liver, umbilical vein and dorsal vessels of a foetus.**

The great vessels are lettered a, and the umbilical vein b, with the notation: *The intestines are situated between the larger vessels a, and the vein b, which extends from the umbilicus to the gateway of the liver.*

Other notes, written in the same color of ink, occupy the right margin and pertain to embryology.
You will make the liver in the embryo different from that of a man, that is, with the right part equal in size to the left.
But first make an anatomy of incubated eggs.
State how in 4 months the infant is half of its length, that is, 8 times less weight than when it is born.
The thin which is cooled by motion.

fig 5. **Rough sketch of heart, lungs and great vessels.**

This figure is undoubtedly an experimental sketch related to the note under fig. 3.

fig 6. **The superficial muscles of the neck.**

The mid-line structures are lettered a,b,c, with a note reading: *Describe which and how many muscles are the muscles which move the larynx (epiglotto) in the creation of the voice.*

The term *epiglotto* was the customary mediaeval word for the larynx.

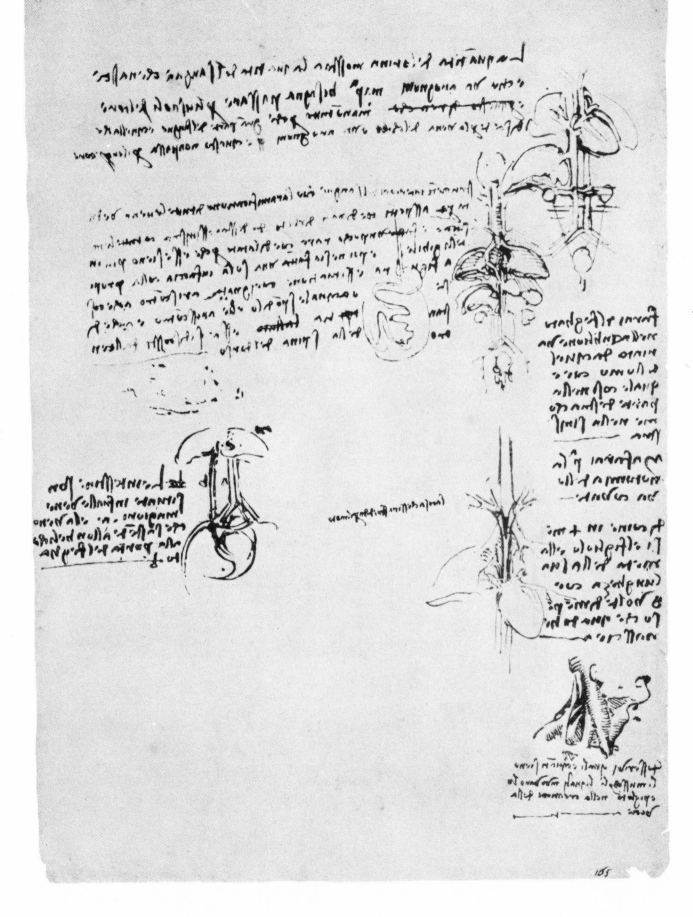

124 cardiovascular system

In the enumeration of the figures on this page the geometrical drawings will be omitted as not germane to the subject.

fig 1. The viscera of the abdomen and thorax viewed from behind.

A rough sketch showing the trachea, bronchi and lungs, the stomach and duodenum, the descending aorta and the large intestines as they would appear if viewed through the torso from behind.

fig 2. Thoracic and abdominal viscera viewed from behind.

A rough sketch similar to the above. The oesophagus and liver are other structures discernible, but the outline of the torso is omitted.

fig 3. The arch of the aorta, trachea and bronchi from behind.

The aorta is shown emerging from the heart and arching over the more horizontally placed left bronchus.

fig 4. Rough sketch of liver, stomach, heart and aorta viewed from an oblique left lateral position.

fig 5. The trachea, bronchi, lungs and oesophagus viewed from behind.

The anterior portion of the neck is shown in partial section. Beside the figure are the words, *First make the lungs from behind,* which have been deleted.

fig 6. The heart, arch of aorta and other viscera from behind.

The figure is interesting since the branches from the aortic arch are arranged as in man instead of the ungulate pattern used in earlier drawings. Apart from style, this indicates a later period.

The heterogeneous notes, all of which have been deleted by a stroke of the pen, are concerned with the art of painting and the appearances of drapery. The only note of biological interest is here rendered:

Describe the nerves from 4 aspects in any member and how they are diffused through the muscles and how the muscles give rise to the tendons and the tendons to the ligaments, etc.

This note refers to the commonly held Galenical notion that the nerves eventually split up in the substance of the muscles to form fibres which were eventually gathered together to form the tendons and ligaments. For this reason the term nerve long persisted for both nerve and tendon. Gabriel Fallopius was one of the first to challenge this idea and propose a concept of the irritability of muscle.

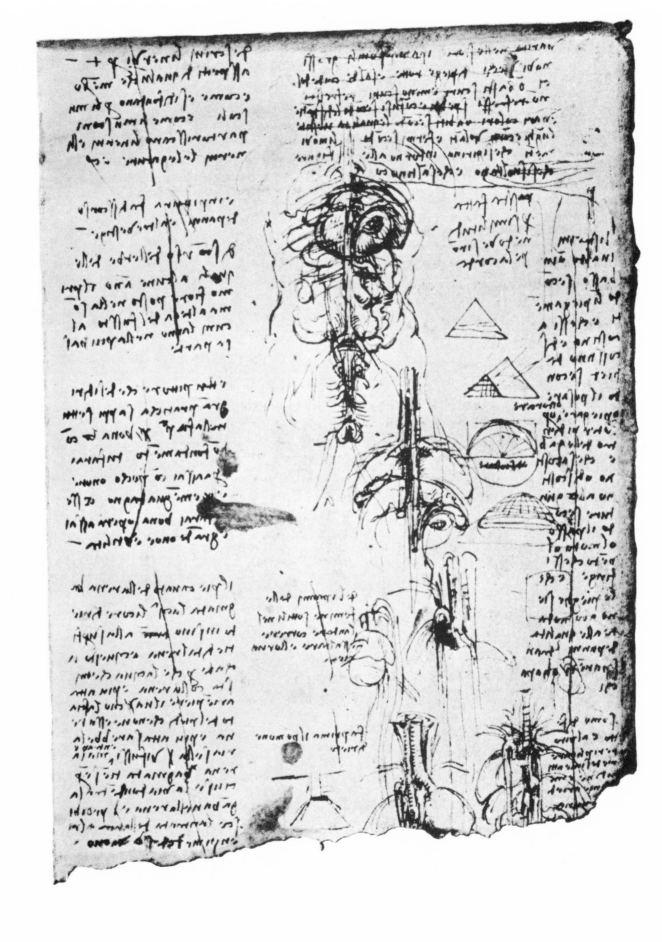

cardiovascular system

These figures belong to Leonardo's early period and by comparison with 5, may be dated 1489 with some accuracy. Clark believes that the writing was added later, c.1500, which is supported by the fact that the notes are quite unrelated and appear to be a continuation of the heterogeneous memoranda on the verso of this leaf.

fig 1. Unfinished or preliminary outline of head and face.

fig 2. Superficial veins of the facial region.

The frontal, supraorbital and anterior facial (angular) vein with its external nasal branch are clearly shown. Leonardo at this time believed that the anterior facial vein began by emerging from the infraorbital foramen. It is, therefore, not unlikely that the drawing was made from the living subject since the venous pattern illustrated is observable through the skin in some subjects. On the other hand the figure may have developed from the dissection of the head found on 5. The frontal vein was familiar as a common site for venesection in headache and cerebral disorders and was frequently called the "straight vein of Hippocrates" from his aphorism of the fifth book, "For one suffering pain in the back of the head it is helpful to cut the straight vein in the forehead".

Below the figure is a deleted note, *You will do it in the last part of your book*, which possibly refers to the unfinished drawing, fig. 1. Above the figures is the observation, *I find that the veins* [or vessels] *perform no other office than to heat, just as the nerves and things are to give sensibility*. The note is a reflection of Galenical concepts on the natural heat being conveyed by the blood vessels.

fig 3. Surface anatomy of the torso: lateral view.

The remaining notes are unrelated to the drawings and outline future projects, partially fulfilled. The tabulation of projects suggests a continuation of those appearing on the verso of the leaf.

On the sinews which elevate the shoulders.
And those which elevate the head.
And those which depress it.
And those which rotate it.
And those which flex it transversely.
To incline the spine.
To flex it.
To rotate it.
To elevate it.
You will write on physiognomy.

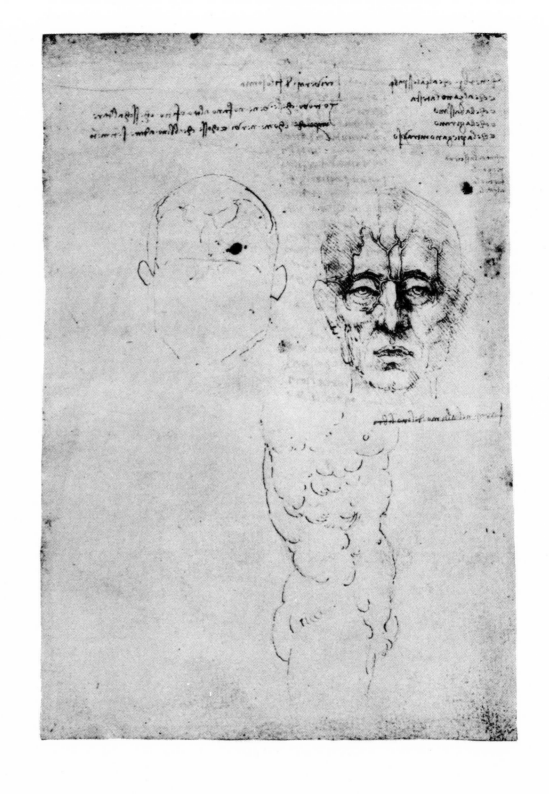

cardiovascular system

fig 1. **Veins of the scalp.**

The pattern produced by the anastamosis of superficial temporal, posterior auricular and occipital veins is clearly recognizable. The figure may have been sketched from appearances in a bald-headed subject or from the dissection of the head shown. During this period the venous system occupied a position of first importance in relationship to Galen's physiological notions and the practice of venesection.

The notes, in the Galenical tradition then current, group together what were called the natural sections of the body. An action or function was defined as the active motion proceeding from a faculty. Actions were of two types, natural or voluntary. Natural actions are called so because they are performed of their own accord and not by will, hence are the equivalent of involuntary functions as exemplified in the list.

The causes of respiration.
The cause of the movement of the heart.
The cause of vomiting.
The cause of the descent of food into the stomach.
The cause of the evacuation of the intestines.
The cause of the movement of superfluities through the intestines.
The cause of deglutition.
The cause of coughing.
The cause of yawning.
The cause of sneezing.
The cause of numbness of different members.
The cause of the loss of sensation in some members.
The cause of tickling.
The cause of sensuality and other necessities of the body.
The cause of urination.
And so all the natural actions of the body.

cardiovascular system

fig 1. **The superficial vessels of the upper extremity.**

The superficial veins of the arm are repeatedly repre-
sented by Leonardo. The best of these figures from an
anatomical point of view is that of 45 which was un-
doubtedly based upon dissection. The remainder sug-
gest studies on the arms of the living but are somewhat
stereotyped. Accompanying the basilic vein is nearly
always represented a vessel which we suppose is in-
tended to represent in its upper part the brachial artery
but which is shown, as in the figure above, run-
ning beside the superficial ulnar vein and its branches.
This fanciful vessel is to be found in many drawings
dating from Leonardo's early and middle period of
anatomical studies. Above the figure is a note: *Rep-
resent the arm of Francesco the miniaturist*, which
shows many veins, and the drawing is possibly that
of this fellow artist. In connection with the figure
Leonardo makes a memorandum on the principles to
be followed.

*In demonstrations of this kind you will draw accu-
rate outlines of the members with a single line, and in
the middle place the bones with the exact distances
from their skin, that is, from the skin of the arm. Then
you will do the veins which may be in full on a clear
ground. Thus will be given a clear notion of the posi-
tion of the bones, veins and nerves.*

figs 2-3. **Veins in old age and in youth.**

Above the figures are the words old man and youth, re-
spectively. The sketches and text, as well as the style,
suggest that they belong to the series based on the dis-
section of the centenarian at Florence, cf. 128.

NATURE OF THE VEINS IN YOUTH AND IN OLD AGE.

*When the veins become old they lose the straight-
ness of their branchings and become more folded or
tortuous and the covering thicker as old age increases
with the years.*

This note is followed by generalizations on the dis-
tribution of the vessels and nerves.

*You will find almost universally that the course of
the veins and the course of the nerves occupy a com-
mon path, are directed to the same muscles and ramify
in the same manner in each of these muscles, and that
each vein and nerve pass with the artery between one
or other muscle and ramify in them with equal branch-
ings.*

In the final note he discusses a case of traumatic
aneurysm or possibly a haematoma. In addition, the
dissection of the centenarian at Florence is specifically
mentioned.

*The veins are extensible and dilatable. On this evi-
dence will be given because I have seen an individual
in whom the vena commune* [median vein of forearm]
*was accidentally wounded, and being immediately
bound up with a tight bandage, in the space of a few
days a bloody aposteme was produced as large as a
goose egg, full of blood and so remained for several
years. I have also found in a decrepit man the mesaraic*
[mesenteric-portal] *vein constricting the passage of the
blood and doubled in length* [cf. 128].

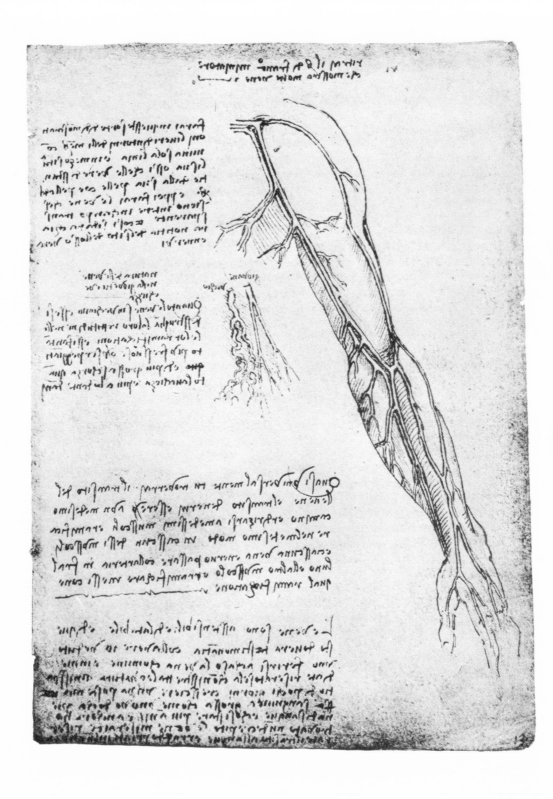

cardiovascular system

ON THE VESSELS OF THE AGED AND ARTERIOSCLEROSIS.

fig I. **The portal vessels in old age.**

In his search for the secrets of life and death, Leonardo reports his observations on the autopsy of a centenarian and vividly describes the condition now termed arteriosclerosis. For other drawings and memoranda based on the findings in this subject, cf. 120-2, 127-9, 131-2, 149, 156, 183, etc.

Great attention is here paid to the portal and hepatic vessels (following the translators of Avicenna called the meseraic vessels) which were believed, according to Galenical physiology, to carry chyle from the intestines to the liver where it was converted into blood. However, Leonardo is very confused as to the arrangement of the portal system which he usually represents as running from the spleen to the liver alone. He differs from Galenical teaching in that he regards the heart and not the liver to be the origin of the vessels, although he accepts the idea of the liver being the blood-making organ.

In his remarkable description of arteriosclerosis, he observes not only the tortuosity of the vessels, but calcification of the great vessels, aneurysm and thickening of the vascular walls. Coronary occlusion is mentioned perhaps for the first time in the history of pathology. In addition, he employs the term "capillary vessels" which is an exceedingly early use of the term. Cirrhosis of the liver, so clearly described, was no doubt responsible for the enlargement of the umbilical veins since they were noted. But let us allow Leonardo to describe his findings in his own words:

The artery and the vein which in the aged extend between the spleen and the liver, acquire so thick a covering that it contracts the passage of the blood which comes from the meseraic [mesenteric-portal] veins. By means of these veins the blood runs through the liver to the heart and the two major veins [cava] and consequently through the entire body. These veins, apart from the thickening of their covering, grow in length and twist like a snake, and the liver loses the sanguineous humor which was carried there by this vein. Thus the liver becomes desiccated and like congealed bran both in color and in substance, so that when it is subjected to the slightest friction, its substance falls away in small particles like sawdust and leaves behind the veins and arteries. The veins of the gall bladder and of the umbilicus which enter the liver through the porta hepatis remain entirely deprived of liver substance, like millet or sorghum when their grains have been separated.

The colon and the other intestines become greatly contracted in the aged, and I have found there stones in the vessels which pass beneath the clavicles of the chest. These were as large as chestnuts, of the color and shape of truffles or of dross or clinkers of iron. These stones were extremely hard, like these clinkers, and had formed sacs attached to the said vessels, in the manner of goiters.

And this old man, a few hours before his death, told me that he had passed one hundred years, and that he was conscious of no failure of body, except feebleness. And thus sitting upon a bed in the hospital of Santa Maria Nuova at Florence, without any untoward movement or sign, he passed from this life.

And I made an anatomy to see the cause of a death so sweet, which I found to proceed from debility through lack of blood and deficiency of the artery [aorta] which nourishes the heart and the other lower members. I found this artery very desiccated, shrunken and withered. This anatomy I described very carefully and with great ease owing to the absence of fat and humor which rather hinder recognition of the parts. The other anatomy was that of a child of 2 years in which I found everything to be the opposite to that of the old man.

Leonardo continues in the margin:

The aged who enjoy good health die through lack of nourishment. This happens because the lumen of the meseraic [mesenteric-portal] veins is constantly constricted by the thickening of the coverings of these vessels; a process which progresses as far as the capillary vessels (vene chapillari) which are the first to close up entirely. As a consequence of this, the old dread the cold more than the young and those who are extremely old have a skin the color of wood or of dry chestnut because the skin is almost completely deprived of nourishment.

The tunics of the vessels behave in man as in oranges, in which the peel thickens and the pulp diminishes the older they become. And if you say that it is the thickened blood which does not flow through the vessels, this is not true, for the blood does not thicken in the vessels because it continually dies and is renewed.

cardiovascular system

This page deals chiefly with questions raised following Leonardo's autopsy on the centenarian, cf. 128. He was greatly impressed not only by the arteriosclerosis but also by the changes in the liver. Since the liver was regarded as the organ which converted the chyle from the intestines into blood, he here gives special attention to the portal system of vessels in arteriosclerosis.

fig 1. The portal and coeliac vessels.

A very poor and confused diagram. The vertical vessels represent the inferior vena cava on the left, and the abdominal aorta on the right. The aorta is observed giving off the coeliac artery which in turn is shown dividing into the splenic, a, and the hepatic artery, b. The hepatic provides what is presumably the gastroduodenal artery. Below the coeliac is a vessel arising from the aorta opposite which is written, *It nourishes the base of the omentum (zirbo)*, and which must, therefore, be the superior mesenteric artery. The term *zirbus*, a corruption of the Arabic *tsarb*, was long standard for omentum. Below the superior mesenteric artery the renal arteries are easily recognized. The structure lying below and parallel to the splenic and hepatic branches of the coeliac artery is the splenic vein continued on the left into the stem of the portal vein which is shown receiving a branch, probably the superior mesenteric vein. The renal veins are evident below. Leonardo writes:

The vessels (vene) a b, are so constricted in the aged that the motion of the blood through them is lost and so usually becomes foul. For it can no longer, as formerly, enter into the new blood which carries it away, as it comes from the gate of the stomach. Hence the good blood is corrupted on leaving the bowels, and so the old fail without fever when they are of great age.

fig 2. Small figure (buried in text) showing tortuous portal vessels.

The tortuosity of the portal vessels associated with the arteriosclerotic cirrhosis of the liver as found at the autopsy of the centenarian is explained in terms of Galenical physiology.

One asks why the veins in the aged acquire great length and those which were formerly straight become folded and their covering becomes so thick that they occlude and prevent the motion of the blood. From this arises the death of the old without disease.

I judge that a structure which is nearer to its source of nourishment, grows the more; and for this reason these veins being the sheath for the blood which nourishes the body, it nourishes the veins in proportion to their proximity to the blood.

fig 3. The portal, coeliac and renal vessels.

A diagram essentially the same as that of fig. 1, except that the kidneys themselves are illustrated. Leonardo noted in the centenarian that the intestines were small and constricted. That he was seeking an explanation of this finding in terms of the mesenteric vascular supply is indicated by a note placed on the right of the figure: *And why the bowels are greatly constricted in the aged.*

fig 4. The portal circulation.

The vessels are similar to those shown in fig. 1. The inferior mesenteric vein is illustrated passing to its junction with the splenic vein. The hepatic veins lead from what was known as the gibbosity of the liver to the inferior vena cava. Gastric veins are observed passing directly to the upper pole of the spleen. These hypothetical vessels were considered by Galen to empty the black bile directly into the stomach in order to whet the appetite by the sharpness and acridity of this humor. For this reason Leonardo contends that splenectomy will cause death. He probably refers to the belief that the Greeks carried out excision of the spleen in athletes to prevent the stitch. Experimental splenectomies were carried out in the dog by Florian Matthis (Master Florian) in 1602 and by Paul Barbette in 1672. Splenectomy in the human subject was not attempted until 1857 by Gustav Simon.

Here it is shown that it is impossible to remove the spleen from man, contrary to the belief of those who were ignorant of its essence, because as is here demonstrated it cannot be excised from the body without death. And this occurs because of the veins through which it nourishes the stomach.

In his description of the illustration Leonardo follows Galen in ascribing five lobes to the liver, thus once again emphasizing his dependence upon animal anatomy.

The vein [portal] which extends from the porta of the liver to the porta of the spleen has its roots in the 5 branchings which ramify in the 5 lobes of the liver. At the middle of its trunk there arises a branch [superior mesenteric] which branches in the nourishment of the base of the omentum and extends to all its parts. A little further away, a branch [inferior mesenteric] ascends upwards and joins its left portion below the stomach and then terminates somewhat further on in 2 branches [splenic] at the junction of the spleen and proceeds to ramify through its entire substance.

fig 5. The portal and coeliac vessels in arteriosclerosis.

A sketch of the tortuous vessels found in the dissection of the centenarian.

Vessels which (in the elderly) through the thickening of their tunics, restrict the transit of the blood and, owing to this lack of nourishment, the aged failing little by little, destroy their life with a slow death without any fever.

And this occurs through lack of exercise since the blood is not warmed.

An unrelated note on mensuration of the body in terms of finger breadth reads: *Give the measurements in fingers of man, anatomized in every member and their positions.*

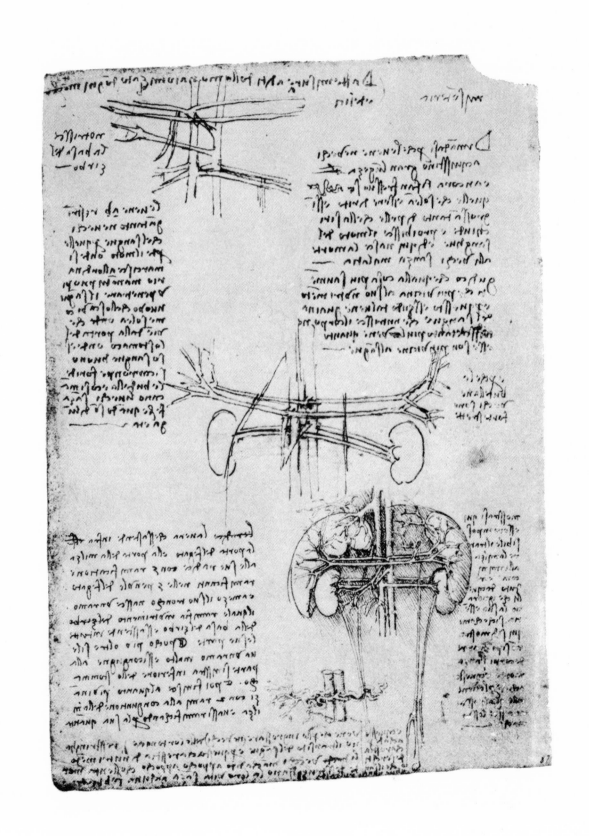

fig 1. The portal and coeliac vessels, of the old man.

These are by far the best of Leonardo's illustrations of the portal and hepatic vessels, cf. 129. They are based on the dissection of the centenarian as indicated by the notation above each of the figures *of the old man*, cf. 128.

fig 1. The portal and coeliac vessels, of the old man.

The oesophagus is cut short. Behind it the abdominal aorta is shown providing the coeliac artery from which the splenic, hepatic, left gastric, with oesophageal branches, and possibly the inferior phrenic arteries are given off. The hepatic artery provides the gastro-duodenal which is observed terminating in the superior pancreatico-duodenal at m, the right gastro-epiploic at p, and the right gastric at o. These vessels are accompanied by corresponding veins. However, Leonardo was somewhat confused as to the venous tributaries of the portal system. Below the branching coeliac artery is the splenic vein continuing as the portal to the liver. Leonardo regarded this as a single straight vessel. The vein n, must be intended as the superior mesenteric but he is very uncertain of this vessel. Concerning them he says: *n m, are the vessels which ramify through the mesentery, c p, through the omentum.*

The hepatic artery and portal vein after dividing into right and left branches are seen dissected out of the liver substance. He tells us (128) that the liver in this specimen was so desiccated as to crumble away exposing the ramifications of the vessels. Opposite these branches he writes: *Ramification which the artery and vein make in the porta of the liver.*

fig 2. The portal, hepatic and biliary vessels of the liver, of the old man.

The figure is in part the same as that above. The outlines of the liver and stomach are given. In addition, the gall bladder, cystic duct, hepatic ducts and common bile duct passing to the duodenum are amazingly portrayed. The third vessel, passing into the porta hepatis with the hepatic artery and portal vein, is presumably the umbilical vein enlarged owing to the cirrhosis of the liver. This is indicated in the legend:

Ramification which the umbilical makes, and the vein and the artery in the porta of the liver.

Future illustrations to be made are mentioned in a further memorandum: *Represent first of all the ramifications of the vessels which arrive at the porta of the liver, all together, and then each by itself in 3, or if you prefer, 4 demonstrations. I said 3 because the vein and artery take the same course.*

fig 3. The hepatic veins and the vena cava, of the old man.

On the right the cava is shown opening into the base of the heart. The atrium is a part of the caval system since the heart was regarded as consisting of the ventricles only. In the note above the drawing, Leonardo opposes the Galenical view that the liver is the source of the vessels and argues with Aristotle that the origin is the heart.

The root of all the veins is in the gibbous part of the heart, that is, the covering of the blood. And this is clear because it [i.e., the covering] *is thicker there than elsewhere and goes on to ramify infinitely through every member of the animal.*

Again the anti-Galenical position is indicated by the statement referring to the illustration of the hepatic veins: *How this vein* [the cava] *passes away and does not arise in the liver as many say.* In Mundinus, one of Leonardo's sources, the cava is called the *vena chilis*, meaning "belly-vein". Thus the second legend to the figure reads: *Ramification which the vena chyli* [cava] *makes in the liver.*

It was long held that the excess of black bile from the spleen was excreted into the bowel by way of portal radicles. This idea is expressed in the note below the figure.

Of the two thick vessels [splenic] *which go from the liver to the spleen* [and] *which come from the larger veins of the spine, I consider to be those which collect the superfluous blood. This, being evacuated every day by the mesaraic* [mesenteric-portal], *is deposited in the bowels causing the same stench when it has reached there as arises from all the dead in the sepulchres, and this is the stench of the faeces.*

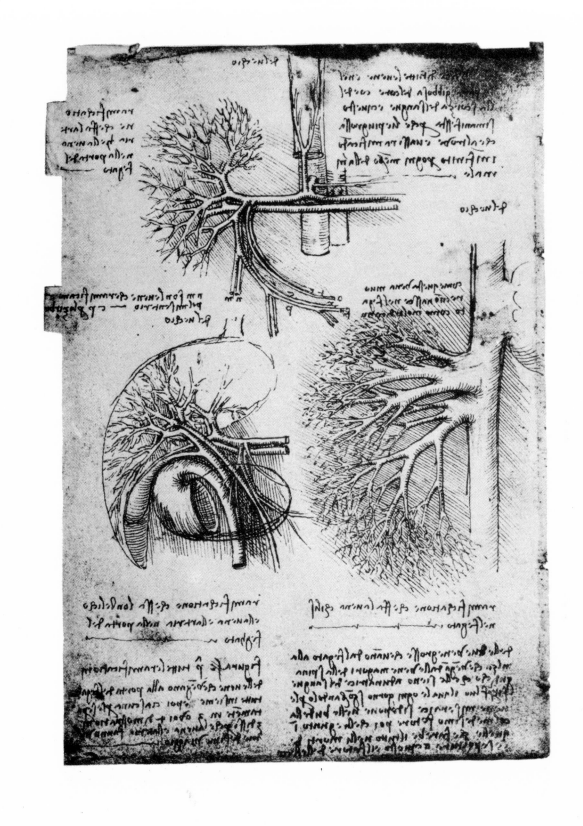

cardiovascular system

For other members of this series on the dissection of the centenarian, cf. 128.

fig 1. Schematic drawing of upper portion of the thorax, clavicles and cervical spine.

The cervical spine is shown in coronal section to reveal the medullary and vertebral canals. Above the drawing is the numeral 4, indicating that the figure is the fourth of the series of which the other three members are found on the verso of the sheet. The figure may be earlier in date than the remainder.

fig 2. The umbilical vessels.

Opposite the umbilicus is written *The umbilicus of the old man*. Four vessels are shown converging on the umbilicus. These are derived in figs. 3-4 from the hypogastric vessels and therefore represent the obliterated umbilical artery and an imaginary accompanying vein which was perhaps introduced on the supposition that all arteries are accompanied by corresponding veins, cf. 127. The upper portion of the umbilical artery is reduced to a fibrous cord, the lateral umbilical ligament, which obviously puzzled Leonardo who notes below the figure:

I believe that these 4 sinews (nervi) are those of the kidneys (reni [i.e., loins]) or of the arteries, and again: *I have found that they are the larger vessels (vene) of the kidneys [i.e., loins]*.

Passing from the umbilicus to the liver is the round ligament of the liver or obliterated umbilical vein. Since the subject suffered from cirrhosis of the liver, the accompanying para-umbilical veins may have been greatly enlarged, giving rise to the appearances displayed. Beside the figure Leonardo concludes with a generalization: *The umbilicus is the gateway from which our body is composed by means of the umbilical vein, etc.*

fig 3. The hypogastric and umbilical vessels: diagrammatic.

Beside the figure appear the words *of the old man*, i.e., centenarian. The lettered structures are n, the aorta giving off hypogastric arteries d,p. The inferior vena cava dividing into hypogastric veins q,v. The left umbilical artery and imaginary vein accompanying it are given off at a and d, but also noted by c,f. The corresponding right vessels are labelled S,t. The umbilicus extends from x to v, and the round ligament of the liver or umbilical vein v,y. For the significance of the latter structures, cf. fig. 2 above. Leonardo remarks that the interval between the great vessels and the umbilicus, i.e., m to v, is occupied by the peritoneal cavity.

The sifac [peritoneal cavity] is entirely contained between m v. He further asks whether the obliterated umbilical vessels are the same in both male and female and are four in number as shown: *Note if the umbilical vessels are 4, that is, in the male as in the female.* Finally, he again generalizes on the umbilicus.

Through x v, the umbilical vein, is composed the life and body of every animal with 4 feet which is not born of the egg, such as frogs, tortoises, chameleons, lizards and the like.

fig 4. The hypogastric and umbilical vessels.

This figure is essentially the same as that above except for the anterior projection and slight differences in the lettering. The aorta and inferior vena cava are again indicated by n and m respectively; the hypogastric arteries by b and q; the hypogastric veins by p and r. The origin of the obliterated umbilical arteries and accompanying imaginary veins carry the letters a b o p, and the vessels themselves are c d e f. The umbilicus is v, and the umbilical vein of the foetus extends from v to S.

n b q [aorta with right and left hypogastrics] is the artery, m p r [vena cava and both hypogastrics] is the vein, and r e f o p [for c d e f] are the umbilical veins mixed with the artery, which run together to the umbilicus and are joined to the womb of the mother through the veins v S.

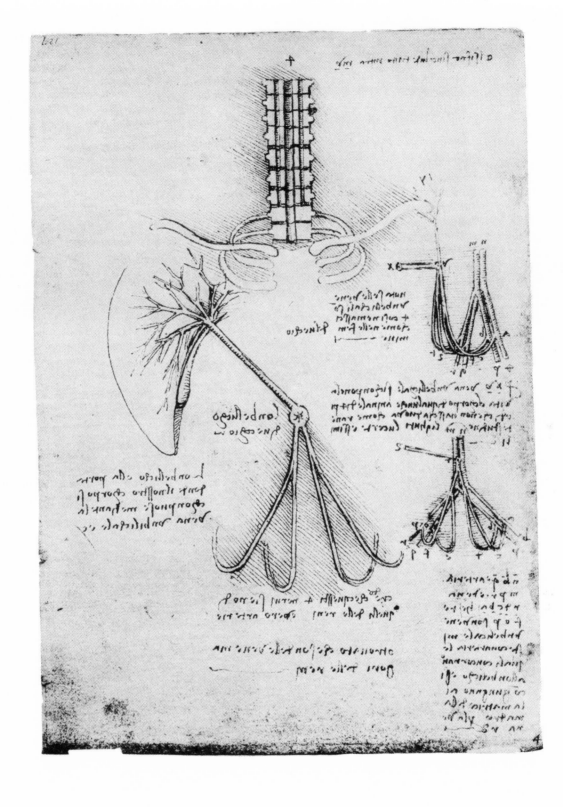

With the exception of the first three figures, the remaining illustrations are part of the series based on the dissection of the centenarian, cf. 128.

figs 1-3. Diagrams of the cervical spine and skull to illustrate the action of the lateral flexor muscles.

In the second and third figures the spheres representing the skull each carries the word *anterior*. In the third figure the spine is labelled n m, and the lateral muscles a b and a c. The significance of these figures is explained in the note.

If nature had added the muscle a c to bend the head towards the shoulder, it would have been necessary for the cervical spine to bend as a bow is bent by means of its cord: hence nature, to avoid such an inconvenience made the muscle a b which draws the side of the skull a, downwards with little bending of the bone of the neck. Since a b, the muscle, draws the side of the skull a, towards b, the root of the cervical spine, and as the skull is placed on a small axis upon the front of the bone of the neck, it bends itself very easily to right and left without too much curvature of the bone of the neck, etc.

fig 4. Scapula and long head of the biceps muscle.

Above the figure is written, *Of the old man*. The accompanying note reads: *a is the biceps (pesce) of the arm from the elbow upwards, b, is the body of the scapula (paletta della spalla), c [glenoid] is where the bone of the arm is joined to the shoulder.*

The labrum glenoidale is clearly shown. For the use of the word *pesce* for the biceps muscle, cf. 45.

fig 5. The iliac and hypogastric vessels.

As in the figure above, this illustration is stated to have been derived from the dissection *of the old man*.

The marginal notation indicates, *a, the artery*, and *b, the vein*. The illustration is obviously very diagrammatic, and the third branch of the common iliac is possibly the ilio-lumbar.

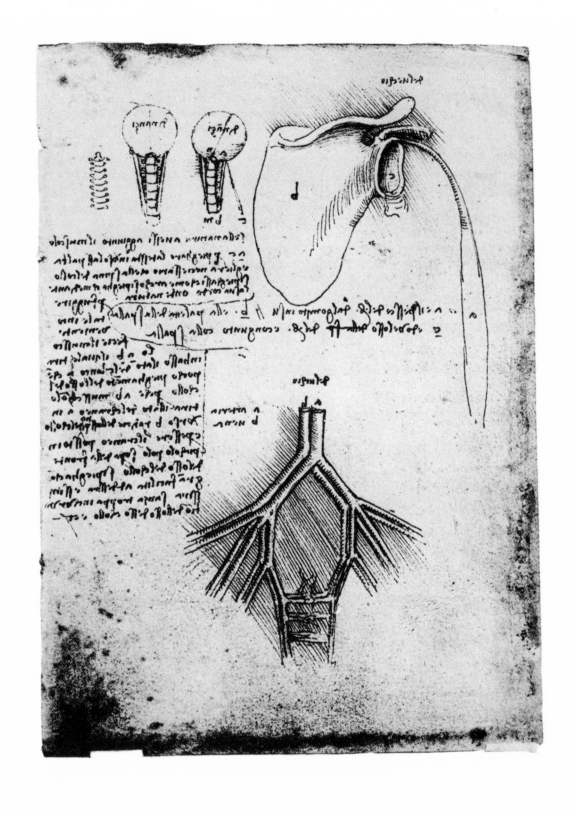

fig 1. **The common iliac vein and its branches.**

The sagittal section of the pelvis allows demonstration of the veins on its lateral wall. The lower end of the inferior vena cava, the common iliac veins, one of which is cut short, the external iliac, hypogastric and obturator veins are illustrated with some accuracy. Sections of this type are very necessary for the dissection of pelvic structures and Leonardo reminds himself to use them for a demonstration of the haemorrhoidal veins.

Cut the subject through the middle of the spine, but first tie off the [vena] chilis [cava] and the artery so that [the blood] may not pour out, and thus you will be able to see the haemorrhoidal veins in halves, that is, in each segment of the subject.

The real purpose of the drawing, however, is to demonstrate a point in the Galenical physiology. It was believed that the chyle was carried from the alimentary by way of the portal system to the liver for the making of the blood. Some of this blood then passed to the spleen where it was refined by the natural heat to provide the melancholic juice or black bile which was carried to the stomach to excite the appetite. The crude portion or any excess of black bile returned to the intestines for evacuation. The haemorrhoidal veins played an important role, especially in the evacuation of an excess of black bile, and so frequently became enlarged producing haemorrhoids. Owing to an anatomical error, the haemorrhoidal veins were thought to be exclusively branches of the caval system. Vesalius, in one of his early contributions, the *Venesection Letter of 1539*, destroyed this notion by demonstrating that the superior haemorrhoidal veins communicate with the portal and not with the caval system.

Elsewhere Leonardo indicates that he accepts the Galenical opinion and here expounds upon it with some modifications.

ON THE NOURISHMENT WHICH CAUSES PUTREFACTION.

I say that the termination of the mesaraic [mesenteric-portal] veins which attract to themselves the substance of the food contained in the intestines, are enlarged by the natural heat of man, because heat separates and enlarges, but cold aggregates and constricts. But this would be insufficient if to this heat were not added the fetor which is formed by the corruption of the blood and returned by the arteries to the intestines; which blood acts in the intestines not otherwise than in those buried in tombs. This fetor enlarges the viscera and penetrates into all the porosities and swells and inflates the bodies into the shape of casks. And if you were to say that this fetor was caused by the heat in the bodies, this would not be supported in the case of inflated bodies covered by snow. The power of the fetor is much more active and multiplies more than the heat.

fig 2. **The figure accompanying the above passage is so badly rubbed that it cannot be deciphered. However, the faint outlines examined with the text in mind, suggest a sketch of the rectum with the haemorrhoidal veins. These veins would be shown as branches of the caval and not the portal system.**

cardiovascular system

fig 1. **Terminal branches of the abdominal aorta and inferior vena cava.**

a [aorta] *is the branching of the arteries.*
b [inferior vena cava] *is the branching of the veins.*
 The aorta and inferior vena cava are shown dividing into common iliac vessels which in turn give off external iliac and hypogastric branches. The vessels ascending on either side are undoubtedly the ilio-lumbar. It would be too hazardous to attempt identification of the other minor branches. The pattern strongly suggests the arrangement found in animals.

fig 2. **The common iliac vein or artery and its branches.**

A preliminary outline possibly for the drawing above.

fig 3. **The right common iliac artery and vein and their branches.**

An enlargement of the vessels as observed in fig. 1.
 a [common iliac artery] *artery.*
 b [common iliac vein] *vein of the groin to the haunches.*

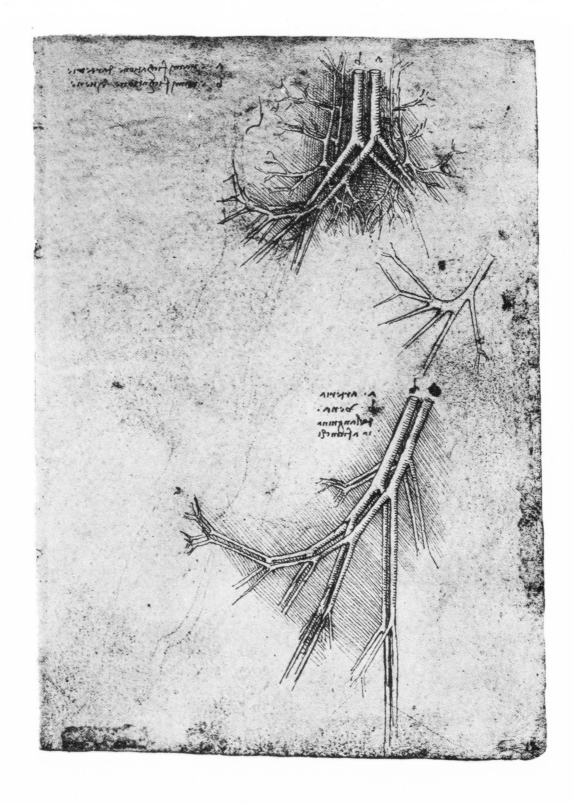

cardiovascular system

fig 1. **Subcostal veins and the formation of the azygos system.**

fig 2. **The iliac vein and its branches.**

The left common iliac is shown passing from the right side of the vertebral column and extending as the external iliac over the brim of the pelvis to the thigh. An opening is present in the vessel wall corresponding to the position of the hypogastric vein and which, therefore, probably represents the point where this vein was cut off. If the specimen were very fresh the margins of the severed vein would retract giving rise to the appearances illustrated. Two ascending branches are shown. The more medial is doubtless the ilio-lumbar vein which gives off lumbar branches, and the more lateral is the circumflex iliac which in turn divides into two branches as in the horse or cow. The two descending branches are the lateral sacral vein which receives obturator veins as in the horse, and what appears to be a posterior gluteal vein. It will be noted that there are six lumbar vertebrae. All these features make it certain that the drawing was made from a dissection of some animal, possibly the cow. As though to point up anatomical differences in man or perhaps to draw attention to the error of showing six lumbar vertebrae, Leonardo notes: *There are 5 vertebrae of the back, behind the kidneys.*

To the left of the figure Leonardo provides a list of drawings of the entire body which were apparently to be shown in anterior, lateral and posterior projections as mentioned elsewhere. However, there is no evidence that these figures were ever completed.

3 complete men.
3 with bones and veins.
3 with the bones and nerves [possibly tendons].
3 with the bones alone.
These are the 12 demonstrations of the entire figure.

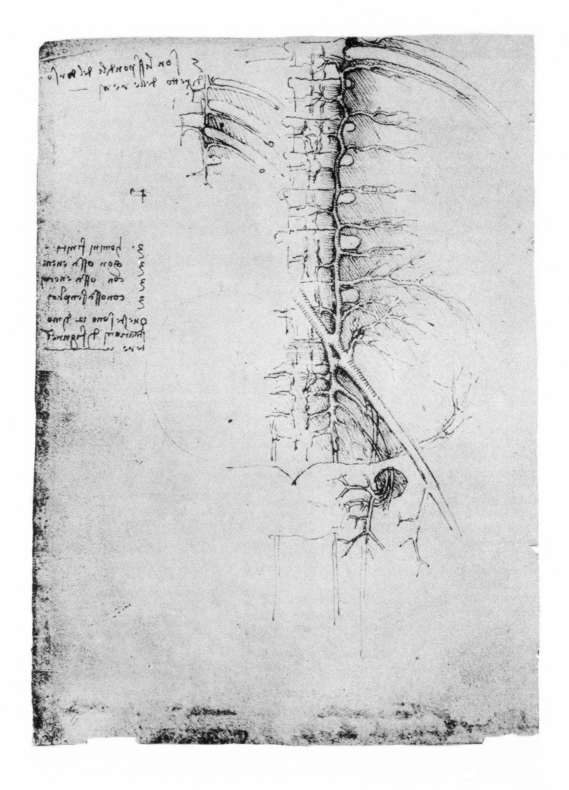

fig 1. **The veins of the femoral triangle.**

The femoral vein and artery have been exposed in the femoral triangle and upper portion of the thigh. The great saphenous vein is illustrated receiving as tributaries, superficial circumflex iliac, superficial epigastric and superficial external pudendal veins. Branches of the superficial epigastric anastamose by a branch n, with suprapubic veins m and o, which in turn pass to the dorsal vein of the penis p, the last being an unusual course for this vessel. The drawing is evidently based on a dissection. The note placed above the figure reads: *From the soft parts of the arms and of the thighs go veins which ramify from their main stems and run through the body between the skin and the flesh.*

And remember to note where the arteries leave the company of the veins and the nerves.

Referring to the figure, Leonardo attempts to classify the veins into anastamotic and terminal vessels:

The branchings of the veins are of two kinds, that is, simple and compound. The simple is that which goes on ramifying infinitely; the compound occurs when a single vein is formed from two ramifications, as you see n m [branch of superficial epigastric] and m o [suprapubic vein], branches of two veins which join at m, and establish the vein m p [dorsal vein of penis] which goes to the penis.

fig 2. **Sketch of lower abdomen illustrating course of the superficial epigastric veins.**

An unrelated memorandum is jotted down at the foot of the page. The figures on 139 and 140 may be the outcome of the reminder: *When you represent the vessels (vene) upon the bones, demonstrate which vessels lie on either side of these bones.*

cardiovascular system

fig 1. Outline of surface features of the lower extremity: anterior view.

The series of outlines of the lower extremity presents the limb from the anterior, medial and posterior aspects. One of these, fig. 4, includes the course of the great saphenous vein. It was Leonardo's plan to present an object from several projections cf. 182, so that we assume these outlines to be unfinished drawings intended for this purpose.

fig 2. Fanciful distortion of a man's head.

It was a conceit of the times to produce drawings or models of monstrous and fantastic creatures for decorative purposes. However, the classical writings on poetry, painting and sculpture, while recognizing the rights of fiction and imagination, required that such imaginary scenes or figures seem credible in the sense that they should be conceivable as occurring in actual physical life. In general, Renaissance writers and artists accepted this classical view. Here Leonardo presents a formula whereby these aims may be accomplished in the graphic arts, and his imaginary monsters conform to these tenets. In the Ashburnham Mss. he writes:

HOW ONE MAY MAKE AN IMAGINARY ANIMAL APPEAR NATURAL.

You know that you cannot make any animal without its having its own members such that each of itself has a resemblance to that of one of some other animal.

Hence if you wish to make an imaginary animal appear natural—let us say a dragon—take for its head that of a mastiff or hound, for eyes those of a cat, the ears of a porcupine, the nose of a greyhound, the eyebrows of a lion, the temples of an old cock with the neck of a turtle.

In the present figure verisimilitude is preserved by exaggeration and elongation of natural features as the dew laps, the upper lip and cheeks and the eyebrows.

fig 3. Outline of surface features of lower extremity: medial aspect.

fig 4. The great saphenous vein.

The great saphenous vein is viewed in its entirety. It will be noted that apart from the error of transposing the vein to the femoral artery, the vessel is accompanied by what is intended to be a saphenous artery as in ungulates. This error introduced from animal anatomy is frequent, cf. 139, 140. It is probable that the figure was derived in part from surface inspection of the vein and in part from dissections made on the ox.

fig 5. Outline of surface features of lower extremity: posterior aspect.

At the top of the page are notes on possible titles for the projected book:

ON THE HUMAN BODY.
ON THE HUMAN BODY AND FIGURE.

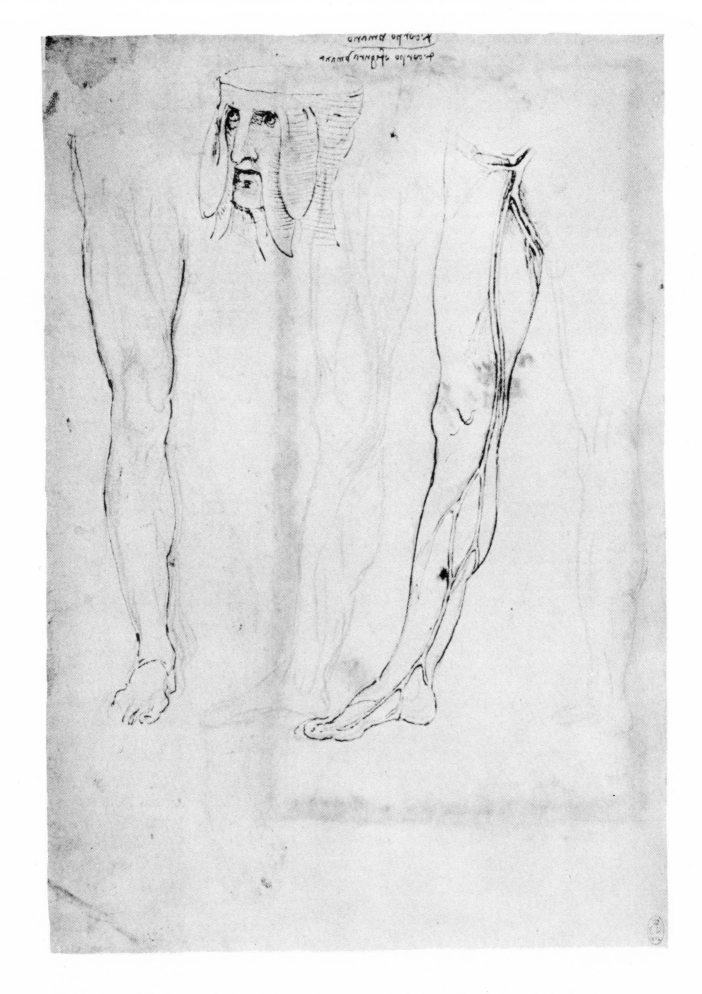

Clark 19024v / FB 7v / c. 1504-09 **320**

figs 1-2. **The great saphenous vein.**

The lower portion of the great saphenous vein is illustrated, thus completing the views of this structure in its entire extent, cf. 136, 139.

The saphenous vein was not only of importance to the artist because of surface appearances but also to the physician since it was one of the vessels most frequently employed in venesection for diseases affecting the pelvic organs. For the origin and meaning of the word saphenous as used by Leonardo, cf. 139.

139

cardiovascular system

fig. I. The femoral artery and vein.

The femoral vessels and their main branches are shown with reasonable accuracy for ungulates but not for man. The superficial circumflex iliac, circumflex femoral, profunda and perforating arteries can be identified. The arteria genu suprema and perhaps the lateral geniculates may be recognized. However, it will be noted that an artery is shown accompanying the great saphenous vein which immediately identifies the source as being the horse or cow. Leonardo notes:

This saphenous vein (vena safena) with its other collaterals and adherents which serve the nutrition of the thigh, should be enclosed by the lines forming the boundaries of the entire body.

The *vena saphena* is one of the two or three vessels of the lower extremity to carry a name in mediaeval times. The term was adopted from Avicenna and appears in the work of Mundinus. It was derived from the Arabic *al-safin*, said to mean "concealed" or "hidden", but the significance of the term is as hidden as its meaning. Charles Singer and C. Rabin believe it to come from the word *safana*, to stand with the heels raised above the ground, applied especially to horses, but what this posture has to do with the vein is unclear. In any case the term *vena saphena* was very loosely applied and refers not only to the saphenous vein of our terminology but also to the femoral vein. Leonardo obviously used it to mean femoral vein in the thigh and saphenous vein in the leg and regarded the one as a continuation of the other. It is therefore possible that the name "hidden" was used in reference to the femoral portion of the vein. The vessel was very important to early physicians as a site for venesection since it was thought to draw in the pelvic structures through its branches. Disorders of the uterus were so treated, and hence it was also called the *vena matricis*.

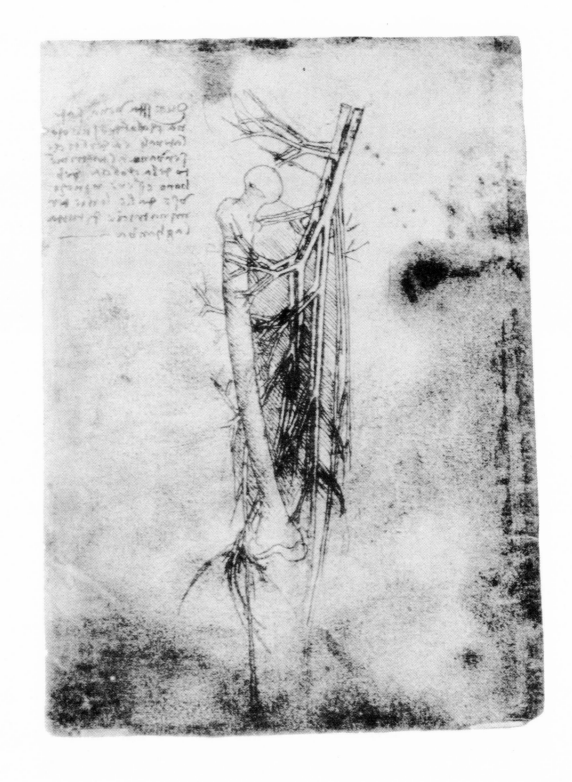

fig 1. **The femoral vessels and their branches in relationship to the femur.**

This figure seems to be a more finished version of that appearing on 139, and similarities in style suggest that they were done during the same period, c.1504. The arrangement of the branches is not quite identical. Again a saphenous artery arising high up in the femoral triangle from the femoral artery is seen to accompany the great saphenous vein. This, as well as other features, makes it almost certain that the vascular pattern is taken from the cow where the saphenous artery is large and prominent. It will also be observed that the lesser saphenous vein is shown as a main continuation of the femoral.

The accompanying notes are unrelated to the figure and take up questions of body proportions:

The knee does not increase or decrease on flexion or extension.

The knee-cap has a breadth made up by three-fifths of the breadth of the whole knee.

The breadth of the entire knee includes towards the outer (silvestra) side the three-fifths of the width of its cap.

For the use of the term *silvestra*, cf. 74.

The final note, written in black chalk, has become too illegible to make coherent translation possible.

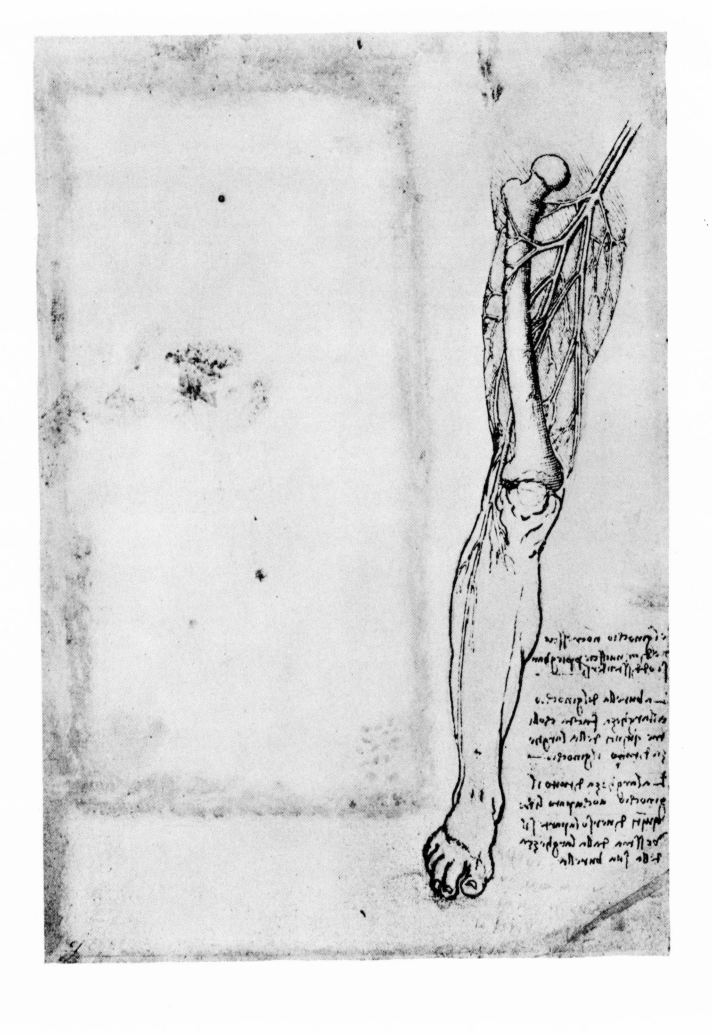

cardiovascular system

fig 1. **Schematic diagram of the popliteal vessels and tibial nerve.**

On the right of the figure is the popliteal artery a, and on the left the vein c. Between them is the tibial nerve b. The vessels are shown dividing at m and n, into two branches which seem to represent the posterior tibial and peroneal arteries and veins. The two branches on either side suggest medial and lateral, superior and inferior geniculate arteries and veins, but may be muscular branches only since they are given off below the bifurcation of the popliteals. On the drawing Leonardo writes:

The nerve b f [tibial n.] *which is behind the knee has on the right* [for left] *the vein c h, which bifurcates and throws a branch to the left* [for right] *at m e. On the left* [for right] *it has the artery a d, which also bifurcates and throws a branch to the right* [for left] *at n h. Such a bifurcation was necessary because no other way was shorter than this if it was desired that each side of the calf of such a leg possess a vein and an artery, that is, nourishment and life.*

fig 2. **The popliteal vessels and tibial nerve: diagrammatic.**

The drawing is essentially the same as in fig. 1, except that the popliteal vessels show their true obliquity above.

fig 3. **The popliteal vessels and tibial nerve.**

A more realistic representation of these vessels and the nerve in relation to the leg as a whole. The drawing is evidently based upon a dissection.

fig 4. **The common peroneal nerve and its branches.**

The significance of this figure is at first sight difficult to determine. The upper tend of the tibia is represented above and the lateral malleolus of the fibula below. The key to the identification of the common peroneal nerve is the note on the left indicating the terminal branch of the structure shown, which reads, *In the muscle* [extensor digitorum brevis] *of the instep of the foot.* Therefore, we conclude that the deep or anterior tibial and the superficial or musculo-cutaneous branches of the common peroneal are those illustrated. The remaining structures are undoubtedly the popliteal vessels and perhaps the tibial nerve.

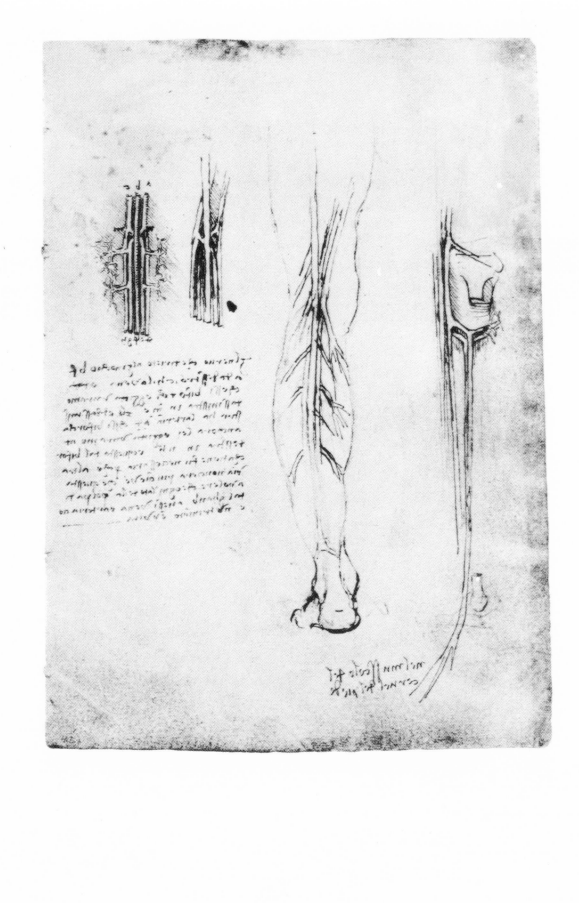

NERVOUS SYSTEM

142

central nervous system and cranial nerves

The diagrams on this page are an attempt to translate into drawings the descriptions of the brain given by Avicenna and therefore belong to a relatively early period in Leonardo's development. On stylistic grounds Clark believes that the drawings are typical of the period c.1500, but the internal evidence suggest a somewhat earlier date, c.1490.

fig 1. **Longitudinal section of an onion.**

A diagram explanatory of the sort of appearances to be expected in sections, as in the sagittal section of the head.

If you should cut an onion through the middle, you could see and enumerate all the coats or skins which circularly clothe the center of this onion.

Likewise if you should cut the human head through the middle, you would first cut the hair, then the scalp, the muscular flesh [galea aponeurotica] and the pericranium, then the cranium and, in the interior, the dura mater, the pia mater and the brain, then again the pia, the dura mater, the rete mirabile and their foundation, the bone.

These various layers are illustrated in figs. 2 and 4. Avicenna, misunderstanding Galen, believed the galea aponeurotica to be entirely muscular. The rete mirabile, introduced into human anatomy by Galen from his dissection of cattle, was to elaborate the animal spirits or psychic pneuma from the vital spirits in the arteries. It is portrayed by Leonardo in 147.

fig 2. **Diagrammatic sagittal section of the head.**

The various layers are indicated by leaders reading from above downwards, hair; *scalp (codiga)*; *muscular flesh*; *pericranium arises from the dura mater*; *cranium, that is, bone*; *dura mater*; *pia mater*; *brain*. The leaders cross the cranial cavity to point to similar layers at the skull base and are overwritten with the letters *a,b,c,d*, corresponding to the pia, dura, bone and skin from within outwards. As though experimenting with methods of labelling the various layers Leonardo indicates some of them again by the terms above the vertex, *hair, scalp, flesh or skin* and by the letters *f,e,d,b,r,e,f,* in red chalk overwritten by the terms in ink. A further such experiment is observed in fig. 4 below.

Extending from the eye is the optic nerve which enters the anterior of three cavities or ventricles labelled O,M,N. The tripartite division of the brain with a corresponding division of the mental functions was familiar to all mediaeval philosophers. Galen had attempted to differentiate sensory and motor nerves by their relative consistency. He held that the softer sensory nerves sprang from the softer anterior portion of the brain and therefore localized the sensory centre, or *sensus communis*, in the frontal lobes where also lay the imaginative faculty which combined the sensations. The harder motor nerves were connected with the posterior part of the brain, cerebellum, which became the centre of voluntary control and the seat of memory. The functional centres were transferred to the ventricles themselves, various arrangements and elaborations being introduced by

the Arabs. These ideas were popularized by Albertus Magnus (1206-1280) who drew chiefly from al-Ghazali (1053-1111). Generally the anterior vesicle contained the *sensus communis* with which was associated *fantasia* and *imaginatio*, the middle vesicle with *cogitatio* and related powers of *estimatio* or judgment, and the posterior vesicle with *memoria* and the control of voluntary motion. Judging from fig. 6 below, we believe that this is the arrangement accepted by Leonardo at this time, but later he gradually altered his opinion following further investigation (cf. 72, 145, 147) and placed the *sensus communis* in the middle vesicle. He likewise attempted to localize the position of the *sensus communis* relative to the body as a whole and placed it immediately above the pituitary fossa but only after this function had been transferred to the middle ventricle, cf. 145.

fig 3. **Diagrammatic section of the eye and orbit.**

The figure is a detail from the drawing above. At this time Leonardo was fully aware of the existence of the frontal sinus since a skull was available to him for study, cf. 7. The diagram is derived from Avicenna. The membranes of the brain were supposed to form the sheath of the optic nerve and thereafter expanded as the coats of the eyeball called the *secundina* (the choroid) from the pia and the *tunica dura* (sclera) from the dura. The optic nerve expands to form a net-like membrane called the *retina* which lines the interior of the eyeball and extends forward to form a septum, the *tela aranea* (iris), separating the anterior from the posterior chamber as in fig. 2. The iris is perforated by a canal leading to the centrally placed crystalline humor or lens which in mediaeval physiology was the actual site of visual sensation. It was Realdus Columbus, Vesalius' pupil and successor at Padua, who displaced the lens from the center of the eyeball, c.1559, although this honor is more frequently accorded to Felix Plater (1536-1614) who not only recognized the true position of the lens but also appreciated the real nature of the retina in his work of 1583.

fig 4. **Diagram of the layers on section of the head.**

Another experiment on the use of leaders to designate the various layers is shown in the sagittal section of fig. 1. The layers read, *hair; scalp; lacertous flesh [falea aponeurotica]; pericranium; cranium; pia mater; dura mater; brain.* The terms pia mater and dura mater have been inadvertently transposed.

fig 5. **Diagram of level of horizontal section shown in fig. 6.**

fig 6. **Diagrammatic horizontal section of the head.**

The three vesicles or ventricles described under fig. 1, are again shown by means of a hypothetical horizontal section of which the upper half has been folded back. The optic nerves lead to the anterior vesicle which also receives on either side the acoustic nerves, thus clearly indicating in terms of then current theory that this vesicle is the site of the *sensus communis*.

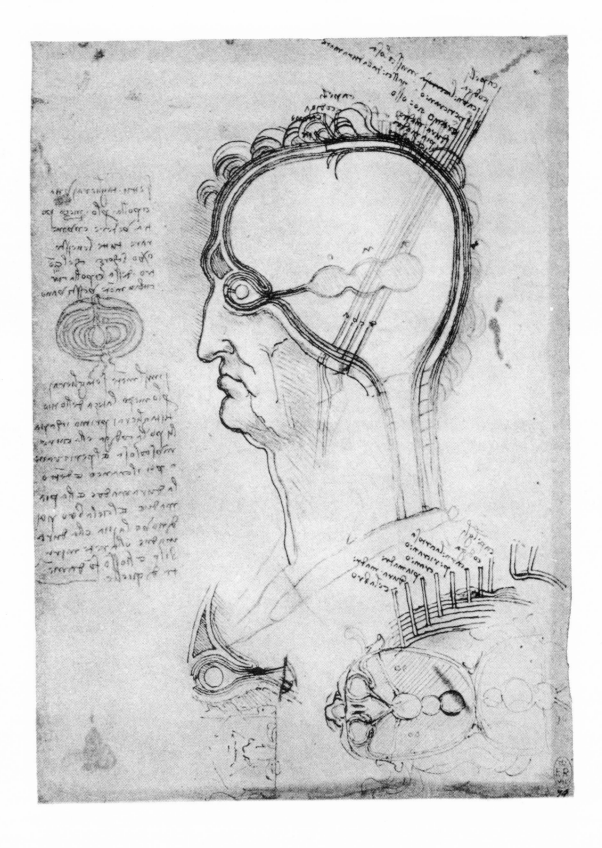

central nervous system and cranial nerves

The drawings on this page are of interest only in their demonstration of some of the methods employed by Leonardo in the construction of his illustrations.

fig 1. **Sketch of an old man's head: full face.**

figs 2-4. **Rough diagrams to illustrate appearances in horizontal sections through the head.**

Leonardo seems to be experimenting with methods of portraying appearances on cross-section. The head has been diagrammatically sectioned in the horizontal plane just above the level of the orbits, leaving the upper half of the head in situ. On the sectioned surfaces the optic and acoustic nerves are seen converging towards the so-called *sensus communis* or hypothetical centre for sensory impressions. The figures are similar to fig. 6 on 142, except for the anterior projection. In fig. 4 the positions of the cerebral vessels are also indicated. For the significance of these figures, cf. 142.

figs 5-7. **Diagrams on technique of cross-sectional representations of the head.**

It may be judged from these figures that Leonardo contemplated the construction of a series of drawings of the head in cross-section as viewed from above, from the side and anteriorly. However, these diagrams are important for another reason since they demonstrate the technique of "transformation" or parallel projection whereby any required diagram can be developed from any two others provided that the latter occupy planes perpendicular to one another. Thus in the figures the construction line passes from the vertex of the anterior projection to the vertex of the lateral projection through the center of the figure representing the head as seen from above. This method of *construzione legittima* had already been employed by mediaeval architects but was restricted to buildings and architectural details. Its application to the human figure developed into a special branch of renaissance art-theory and, according to Giovanni Paolo Lomazzo (1584) it became almost a speciality of the Milanese such as Vincenzo Foppa and Bramantino. Panofsky (1940) points out that the first known parallel projection of an inclined head is found in a drawing by Leonardo (Windsor, 12605r) belonging to his Milanese period and that it is probable that Albrecht Dürer, although he greatly advanced and extended the technique, derived it from his north Italian colleagues. The present figures provide some insight into Leonardo's methods and explain many of the puzzling features in his early anatomical drawings.

fig 8. **Profile lying at right angles to the rest of the page.**

The poor profile is not by Leonardo.

central nervous system and cranial nerves

At the top of the page is a note by Leonardo on the development of the nervous system in which he expresses the Aristotelian theory on the primacy of the heart.

The entire body has its origin from the heart insofar as the first creation is concerned. Therefore the blood, the veins and the nerves do likewise although these nerves are clearly seen to arise entirely from the medulla (nucha), remote from the heart, and that substance of the medulla is the same as that of the brain from which it is derived.

The term *nucha*, meaning spinal medulla or, more literally, marrow, is of Arabic origin and was apparently introduced into mediaeval Latin by the great translator Constantine the African at Monte Cassino and became the standard term until eventually displaced by the medical humanists in favor of medulla spinalis, first used by Alessandro Benedetti (1460-1525), author of an anatomy (1497) and Leonardo's contemporary.

figs 1-2. The brain, spinal cord and peripheral nerves in lateral and anterior projections.

Leonardo describes these figures of the general arrangement of the nervous system:

Tree of all the nerves; and it is shown how all these have their origin from the medulla and the medulla from the brain.

The pair of nerves descending vertically from the brain are the vagi.

fig 3. Small diagram of a projected illustration on the nervous system.

The significance of this small diagram is made clear by the appended note. *In each demonstration* [above] *draw the entire extent of the nerves; the external outlines* [of] *which* [will] *denote the shape of the body.*

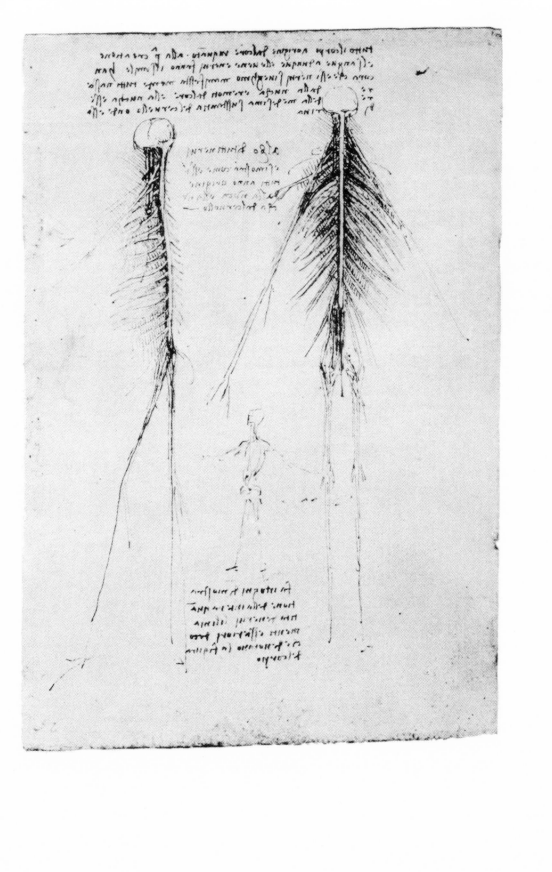

central nervous system and cranial nerves

On the basis of style and other grounds Clark dates these drawings c.1504, but the anatomical content suggests a somewhat earlier date, c.1490-1500.

figs 1-3. **The brain and cerebral nerves.**

The three figures are closely allied to one another, the first showing the cranial nerves springing from the base of the brain; the second, the cranial nerves in relationship to the ventricular system; and the third, the cranial nerves and their distribution to the head and neck. It is evident that Leonardo's knowledge of these nerves was extremely defective at this stage in his anatomical development. Later as he became more familiar with the works of Galen, who had described seven pairs of cranial nerves, his observations become more accurate, cf. 148.

In the illustrations we find the paired olfactory tracts clearly shown. These were not counted, according to Galen, among the cranial nerves. Then come the optic nerves. The optic chiasma is well portrayed, and these are probably the earliest figures in existence of this important structure. The earliest published figure of the chiasma is to be found in a fugitive sheet dated 1517 and bound up in the *Spiegel der Artzney* (1518) of Laurentius Frisius and believed to have been cut by Johann Waechtelin, a pupil of the elder Holbein. Below the optic nerves are two pairs of nerves which from their distribution appear to represent divisions of the trigeminal nerve. Galen had counted the trigeminal as two separate pairs. Behind these are the vagi, usually called the reversive nerves by Leonardo, following the custom of mediaeval anatomists. Finally, there is the spinal cord flanked on either side by parallel channels connecting them to the brachial plexus below. These channels require special comment.

Leonardo, owing to some faulty observation on the vertebral vessels, held that a spinal channel occupied the vertebral canals of the cervical region. He believed that these channels carried the animal spirit to the brachial plexus and through this medium conveyed the sense of touch to the brain and motor power to the nerves. They are illustrated and described on 131, 154, and 155, which bring these illustrations into relationship with the present and indicate that they all belong to approximately the same period.

In the central picture three ventricles are shown which differ in shape and relationship from those of 72, 142, and 159. Presumably the upper ventricle represents the lateral ventricle, but there is no indication, as in 147, that it is a paired structure. Below the lateral is the third ventricle which exhibits an infundibular recess, a detail which makes it certain that Leonardo had viewed a preparation of the parts at this time. Finally comes the fourth ventricle connected presumably by the aqueductus cerebri of Sylvius to the third. It will be noted that Leonardo shows these various nerves aggregated in the region of the middle ventricle which doubtless causes him to transfer the *sensus communis* to it from the anterior ventricle and thus break with tradition, cf. 72, 142, 159, and also 147, where touch is localized in the posterior ventricle.

The notes and diagram above the figures show through from the verso owing to a large grease spot. They concern certain principles of proportional weight and are not germane to the present subject.

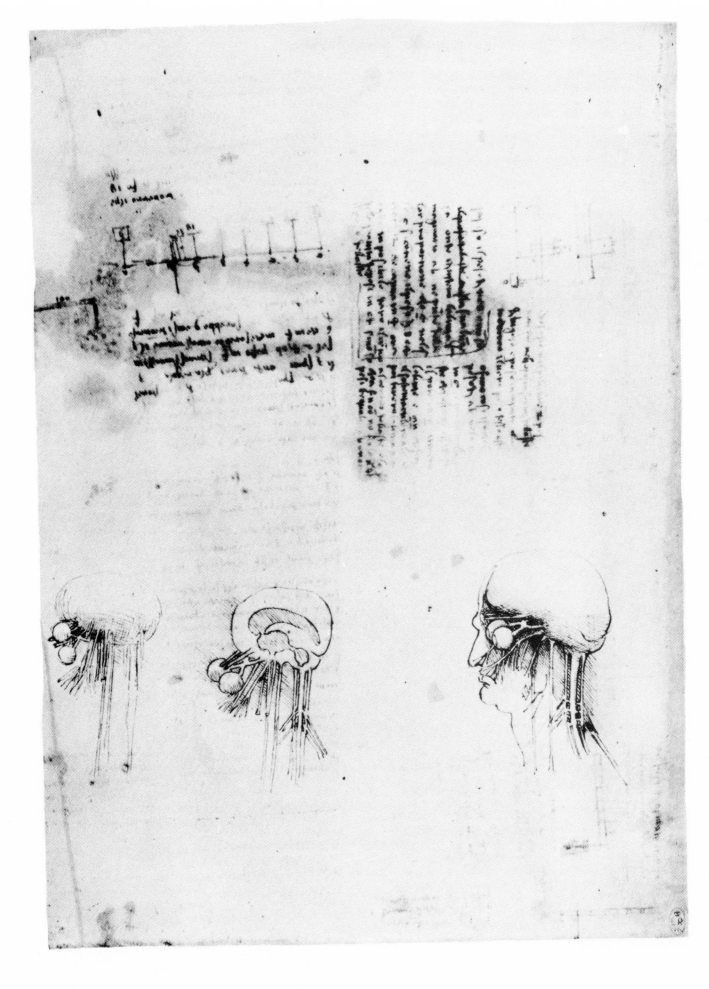

The page is filled with a heterogeneous group of notes, the majority of which are unrelated to figures but concern Leonardo's biological studies. A few notes are of the nature of personal memoranda or reflections and, since they add nothing to the subject at hand, will be omitted.

fig 1. The brain and the cranial nerves.

This figure of the cranial nerves is closely allied to that found on 145 and was doubtless drawn about the same time. The olfactory nerves are shown at a and n. Below them are the eyeballs, f m, optic nerves and optic chiasma. Then come the mandibular branches of the trigeminal g,h,i, and the vagus nerves of either side. Behind is the spinal cord and on either side of it parallel vertebral ducts which Leonardo believed to carry the sense of touch to the brain, cf. 145. At this period he was changing his opinion on cerebral localization and, contrary to tradition, held that the common sensory centre or *sensus communis* lay in the middle or third ventricle of the brain owing to its close relationship to the points of attachment of the cranial nerves. He reminds himself to examine the "porosities" of the brain by which he presumably means the hypothetical channels which were supposed to convey the animal spirit or psychic pneuma throughout the central and peripheral nervous system.

Examine the porosities of the substance of the brain where there is more or less of them. Do this from 3 aspects on one and the same surface.

His explanation of the recurrent course of the recurrent branch of the vagus is mechanical.

The reversive nerves are bent upwards solely because they would be broken in the extensive motion which the neck has in bending forwards, and further because it [the neck] partly carries with it the trachea by means of these nerves.

fig 2. Sketch of the skull.

This sketch is more in the nature of a graphic reminder related to a note on personal needs, such as spectacles, cardboard, drawing materials, penknife, etc., among which is the statement, *Try to get a skull.* This should remind us of the great difficulty of acquiring osteological specimens for study in the fourteenth and fifteenth centuries. The preparation of human skeletal material by maceration was prohibited "because of the sin involved", says Mundinus.

fig 3. An abortive sketch.

fig 4. The cerebral ventricles and cranial nerves.

As in the wax injections of 147, the ventricular system is shown but in relationship to the cranial nerves. The olfactory nerves connect with the lateral ventricles. The optic and part of trigeminal are placed nearer the middle or third ventricle which also receives the vagi. The posterior or fourth ventricle is connected to the spinal cord and by means of lateral channels to the brachial plexus, cf. 145. For these reasons Leonardo modified traditional views on cerebral localization, placing the sensus communis in the third ventricle and memoria with voluntary motion in the fourth. The vagus nerve is brought into relationship with the *vena meserica* or mesenteric vein

which is shown with its branches below. Perhaps Leonardo has confused the vagus and the splanchnic nerves of the sympathetic chain: an association which is commonly found well into the sixteenth century. Even Eustachius (1524-1574) who published by far the best illustration of the sympathetic system makes this error.

In attempting to establish the centres for sensory perception Leonardo is led to reflect in terms of the materialistic psychology of the time on the difference between objective and speculative reasoning.

Mental matters which have not passed through the sense [sensus communis] are vain, and they give birth to no other truth than what is harmful. And because such discourses spring from poverty of intellect, their authors are always poor and, if they were born rich, they will die poor in their old age. For it seems that Nature revenges herself on those who desire to work miracles, and they come to have less than other less ambitious men. And those who wish to grow rich in a single day will live for a long time in great poverty, as happens and will happen for all time to the alchemists, would-be creators of gold and silver, to the engineers who would have dead water give to itself motive life with perpetual motion, and to those supreme fools, the necromancers and the enchanters.

fig 5. Rough sketch of the heart and vascular tree.

fig 6. The pelvic and umbilical vessels of a mother and child.

Above the drawing is the cryptic statement, *Give the measurements of the dead* [subject] *in fingers.* The figure of the pelvic vessels on the left is labelled, *mother,* and that on the right, *child.* The umbilical vessels of both appear to pass to a common umbilicus as though Leonardo believed that the foetus in utero was supplied by a junction of these vessels. However, he was very confused and represents various possible modes of foetal attachment to the maternal circulation.

fig 7. The iliac and hypogastric vessels.

As a sort of afterthought Leonardo squeezes into the page some random notes on the protection of the lung from the pressures developed with great exertion. Much of the note will remain obscure unless it is recalled that the inspired air carries with it the pneuma or spirit which is the basic principle of life. This pneuma passes from the lungs to the heart to be transferred into vital spirits and thence to the brain to become the animal spirits which is the motive force for muscle contraction. Therefore, in extreme exertion it is necessary to retain in the lung a supply of pneuma to give rise to an adequate amount of animal spirit requisite for the maintenance of the muscular effort. This explains why the breath is held on lifting heavy weights.

The muscles which compress the ribs are made so that in establishing the force for the lifting of weights, the wind (vento [i.e., pneuma]) which thickens the muscles to shorten them and which arises from the lung that drives the vital spirits [for animal spirits] that command the nerves, may be very securely re-

(continued on page 501)

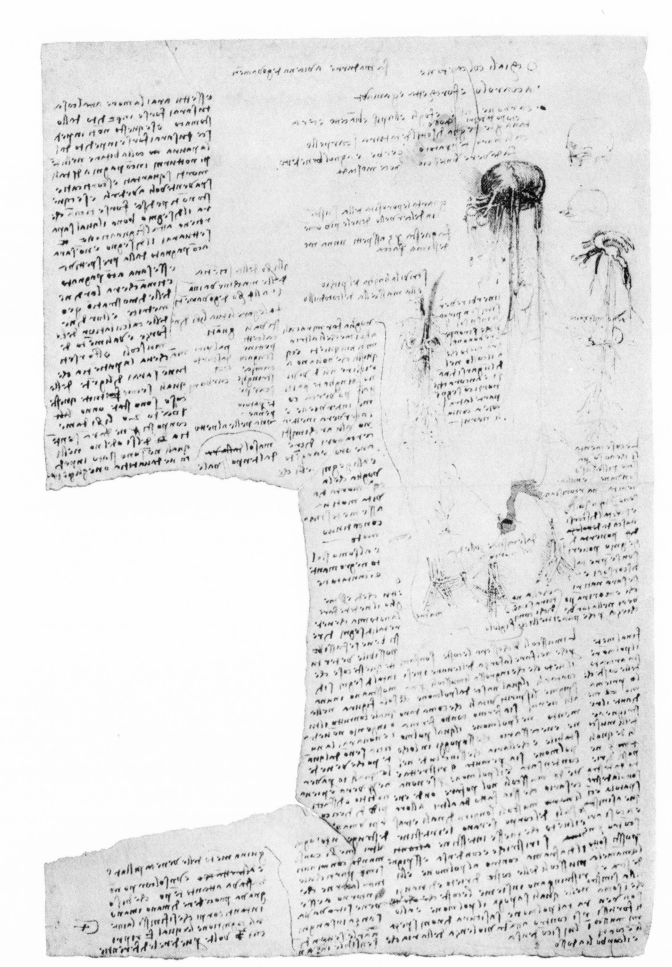

central nervous system and cranial nerves

The illustrations and notes of this page contain some of the most important observations made by Leonardo on the central nervous system and its ventricles. Here, for the first time in the history of biology clear mention is made of the use of a solidifying injection mass to determine the shape and extent of a body cavity, cf. also Leonardo's remarks on wax injections of the heart, 110. The history of anatomical injections has been traced in some detail by F. J. Cole (1921) who curiously omits Leonardo's contribution. Galen in his *De anatomicis administrationibus*, IX:ii, studied the distribution of the cerebral vessels by inflating them with air, and Alessandro Giliani of Persiceto (d.1326) is said, without confirmation, to have used solidifying injections of different colors to fill the blood vessels. However, it was not until the seventeenth century that the method came into general use and reached its apogee with Fredrick Ruysch (1638-1731) whose contributions were deemed, with perverse judgment, by the French Academy of Science to be of such merit as to warrant his being the worthy successor of Isaac Newton.

fig 1. Wax injection of the cerebral ventricles: lateral view.

The vent-holes for the injection are observed at the base of the third ventricle. The method of injection and the figure are described thus:

DRAWING OF THE SENSUS COMMUNIS.

Cast in wax through the hole n, at the bottom of the base of the cranium before the cranium is sawn through.

The lateral ventricles carry the word *imprensiva*, the perceptual centre. The third ventricle is labelled *sensus communis* or general centre for the special senses, and the fourth ventricle, *memoria*. For the origin of these notions of cerebral localization, cf. 142.

fig 2. Wax injection of the ventricular system as viewed from the base.

The brain, undoubtedly that of an ox, after injection of the ventricular system has been laid open thus exposing the connections of the lateral to the third ventricle by way of the interventricular foramina eponymously named for Alexander Monro primus (1697-1767) who minutely described them although they were well-known by Galen, Vesalius, Varolio and many others before him. The aqueductus cerebri is divided in two as it runs back to connect with the fourth ventricle, and named after Jacobus Sylvius (1478-1555) although it, too, was described long before his time. At m, the region of the infundibulum of the third ventricle, is the site of the injection described as follows:

Make 2 vents in the horns of the great ventricles and inject melted wax with a syringe, making a hole in the ventricle of the memoria [IVth ventricle] and through such a hole fill the 3 ventricles of the brain. Then, when the wax has set, take away the brain [substance] and you will see the shape of the ventricles perfectly. But first put narrow tubes into the vents so that the air which is in these ventricles can escape

and make room for the wax which enters into the ventricles.

The distortion of the ventricles as evident in the figures is to be anticipated in ventricular injections of the unfixed brain.

fig 3. Dorsal view of the cerebral hemispheres.

This small pencil sketch shows the brain viewed from above. The longitudinal figure, sulci and gyri are indicated by scattered wavy outlines. On the assumption that the figure represents the human brain, McMurrich (1930) states that the sulci of the surface give the general effect but not the actual arrangement. However, closer examination of the drawing reveals that, like the rest of the figures of the page, the brain of the ox is represented, and it is possible to define the coronal, transverse, marginal, entomarginal, ectomarginal, supra-sylvian and lateral sulci or fissures of the brain of that animal.

fig 4. Outline sketch suggestive of the base of the brain.

fig 5. The base of the brain and the rete mirabile.

The rete mirabile, a plexus of vessels at the base of the brain, is found in ruminants and is prominent in calves. It played an important role in the Galenical physiology since it is the apparatus which was supposed to distil the animal spirit or psychic pneuma from the vital spirit contained in the arteries. The animal spirits are distributed throughout the nervous system as the motive force of "sensibility", both motor and sensory, and the nerves were therefore held to be hollow for this purpose. In the figure the frontal, temporal and occipital poles of the cerebrum, as well as the cerebellum, are distinctly shown, but there are no details of structure.

fig 6. Figure of unknown significance.

This curious figure may possibly represent the vermis of the cerebellum. In common with most mediaeval writers, Leonardo elsewhere regards the choroid plexus as the vermis which was supposed to move within the ventricular system acting as a valve to permit or interrupt the flow of thought and sense impressions within the system. This idea was derived through a misunderstanding from Galen and elaborated by the Arabs. However, anatomists of the period were beginning to recognize that the vermis of the cerebellum more closely resembled a segmented worm and thus altered their interpretation of Galen's opinion.

fig 7. Wax injection of the cerebral ventricles, viewed laterally.

The fourth, third and lateral ventricles are lettered a,b,c, respectively. The site of the injection, as in fig. 1, has been the third ventricle from the base. In the accompanying note Leonardo localizes the sense of touch to the fourth ventricle which he holds to be in close communication with the brachial plexus as well as with the spinal medulla, cf. 131, 145, 155.

Since we have clearly seen that the ventricle a [IVth ventricle] is at the end of the medulla where all the nerves which provide the sense of touch come to-

(continued on page 502)

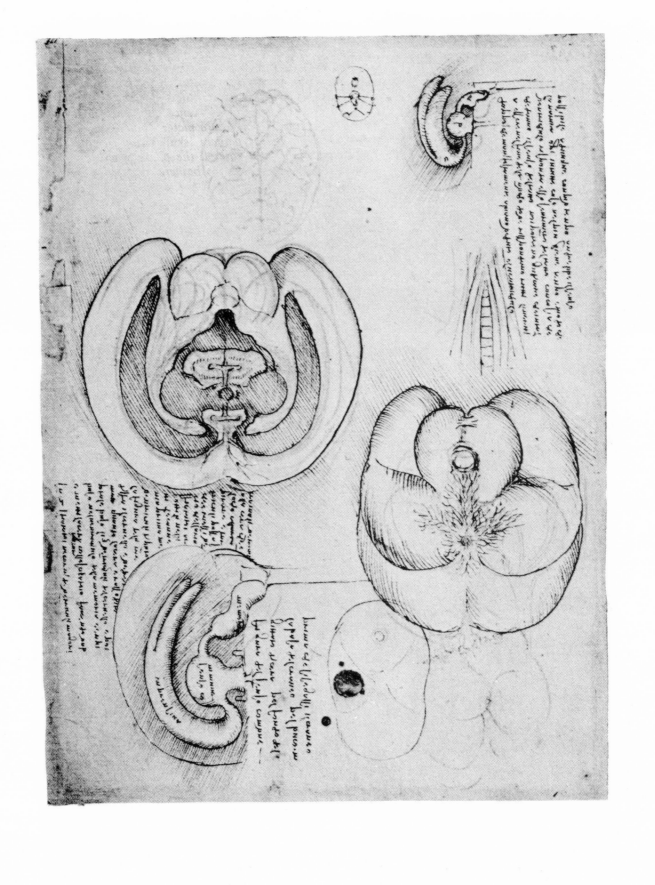

central nervous system and cranial nerves

fig 1. The optic and related cranial nerves.

Above the optic chiasma are the olfactory tracts indicated by the statement that, *a b c d are the nerves which carry the odors.* The optic nerves, optic chiasma and optic tracts are labelled e n. The remaining nerves can only be identified by reference to fig. 2 and appear to be from lateral to medial side, the oculomotor, abducens, and ophthalmic division of the trigeminal nerve. Below the figure is the statement that, *The nerves arise from the last membrane [pia] which clothes the brain and medulla.*

fig 2. The base of the skull to show the optic and related cranial nerves.

In this very remarkable figure the olfactory and all the cranial nerves except the trochlear, passing to the eye, are represented for the human subject, although their relative sizes are poorly shown. It should be recalled that Galen and almost all mediaeval anatomists recognized only the optic, the oculomotor and the ophthalmic division of the trigeminal, so that Leonardo had little assistance from traditional sources. The olfactory nerves were not classified among the cranial series of nerves. The olfactory nerves are lettered a b. Between their anterior extremities lies the cribriform plate of the ethmoid, c, through which the odors passed upwards to the brain. The optic tracts carry the letters e n. Of these nerves Leonardo writes:

e n, nerves, are the optic nerves which are situated below the nerves [olfactory] called the caruncular, but the optic nerve the visual faculty and the caruncular, the olfactory faculty.

The term caruncular nerves, referring to the olfactory bulbs which are very large in animals, was apparently borrowed from Mundinus, who states that at the fore-end of the brain "At once will be seen two carunculae, like nipples".

The anatomist will have little difficulty in recognizing the oculomotor nerve, lateral to which is the abducens. Still further laterally is the root of the trigeminal providing its ophthalmic division. Leonardo was rightly dissatisfied with the then current description of the arrangement of the cranial nerves and therefore proposes a plan whereby he might unravel this difficult matter and determine variations if any.

You will take away the substance of the brain as far as the confines of the dura mater which is interposed between the os basilare [skull base] and the brain substance. Then note all the places where the dura mater penetrates the os basilare together with the nerves clothed by it and at the same time by the pia mater. This knowledge you will obtain with exactness when you carefully elevate the pia mater little by little, commencing at the extremities and noting bit by bit the position of the aforementioned perforations, beginning first on the right or left side and sketching this in its entirety. Then you will follow the opposite part which will give you information as to whether the foregoing is correctly placed or not, and it will also enable you to determine whether the right side is similar to the left, and, if you find it to differ, you will look again in other anatomies whether such a variation is universal in all men and women, etc.

The term os basilare is derived from Mundinus where it means the entire base of the skull.

fig 3. The uterus and its blood supply.

The *womb* is so named and is shown receiving two branches on either side, the uterine and vaginal vessels possibly, from the hypogastric artery. However, one of these vessels may represent a uterine vein. The hypogastric is also shown providing the umbilical arteries which are carried to the upper circle, named the *umbilicus*, but the drawing has been corrected, and the umbilicus lowered to a point opposite the bifurcation of the great vessel. A further vessel, the umbilical vein, is shown passing to the left to the position of the porta hepatis. A note reads: *Note where the external parts come in contact with the inferior parts.*

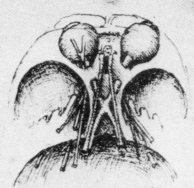

central nervous system and cranial nerves

At the top of the page we encounter the words, *On the old man*, indicating that the drawings were made from the dissection of the centenarian, cf. 128.

fig 1. **The course and distribution of the vagus nerve.**

The vagus nerve, called the reversive nerve by mediaeval anatomists because of its recurrent branch, is here shown on the right side in its course and distribution to the larynx, trachea, oesophagus and stomach. Leonardo believes that the left vagus supplies the heart, but seems to be uncertain of its relations. The recurrent branch of the right vagus is clearly shown, but it passes around what is presumably the subclavian vein in the wrong direction. Behind the vagus is the brachial plexus giving off the phrenic nerve n m, which is accompanied by the pericardiophrenic vessels in the lower part of its course. The internal jugular vein and common carotid artery parallel the vagus on its lateral side. The vessel extending to the subclavian from near the point b, is presumably the external jugular vein. Leonardo describes the vagus nerve as follows:

The reversive [vagus] nerves arise at a b, and b f [right vagus] is the reversive nerve descending to the pylorus of the stomach. And the left nerve, its companion, descends to the covering of the heart, and I believe that it may be the nerve which enters the heart.

The above passage immediately turns his mind to the nature of the heart in which he breaks with tradition and arrives at the important conclusion that the heart is a muscle. Moreover, Leonardo reverses his initial Aristotelian position that the heart is the beginning of life. In order to appreciate fully the meaning of the note, it should be recalled that the venous blood carries the natural spirits providing nourishment for the tissues. The heat of the heart subtilizes or distils some of this blood in the left ventricle into a higher form of spirit, the vital spirits, which is the essence of life carried by the arterial system.

The heart of itself is not the beginning of life but is a vessel made of dense muscle vivified and nourished by an artery and a vein as are the other muscles. It is true that the blood and the artery which purges itself in it are the life and nourishment of the other muscles. The heart is of such density that fire can scarcely damage it. This is seen in the case of men who have

been burnt, in whom after their bones are in ashes the heart is still bloody internally. Nature has made this great resistance to heat so that it can resist the great heat which is generated in the left side of the heart by means of the arterial blood which is subtilized in this ventricle.

Leonardo reminds himself to make further investigations on the distribution and function especially of the left vagus nerve. He is aware from his Galenical sources that the recurrent branch of the vagus supplies the muscles of the larynx which produce the voice but would like to examine the theory that pitch is due to the narrowing of the trachea. Further, Galen held that the sensory portion of the brain and sensory nerves were soft whereas the motor region and its nerves were hard so that he must examine the texture of the brain to determine function. Thus he says:

Note in what part the left reversive nerve [i.e., its recurrent branch] turns and what office it serves.

And note the substance of the brain whether it is softer or denser above the origin of the nerve than in other parts. Observe in what way the reversive nerves give sensation to the rings of the trachea and what are the muscles which give movement to these rings to produce a deep, medium or shrill voice.

fig 2. **The trachea and its rings.**

In connection with the examination of the vagus nerve and its recurrent branch in supplying the larynx, Leonardo proceeds to an examination of the trachea itself to see what influence it may have on the production of the voice. Around the figure he writes:

How the rings of the trachea are not united for two reasons: the one is because of the voice, and the other is to provide space for the food [passage] between them and the bone of the neck.

He reminds himself to, *Count the rings of the trachea,* and answers in part the question raised in a note above as to how the trachea may influence the pitch of the voice.

Differences of voice arise from the dilatation and contraction of the rings of which the trachea is composed. The dilatation is produced by the muscles which are attached to these rings, and the contraction, I believe, is produced by itself because it is made of cartilage which bends of its own accord in order to return to the original shape given it, etc.

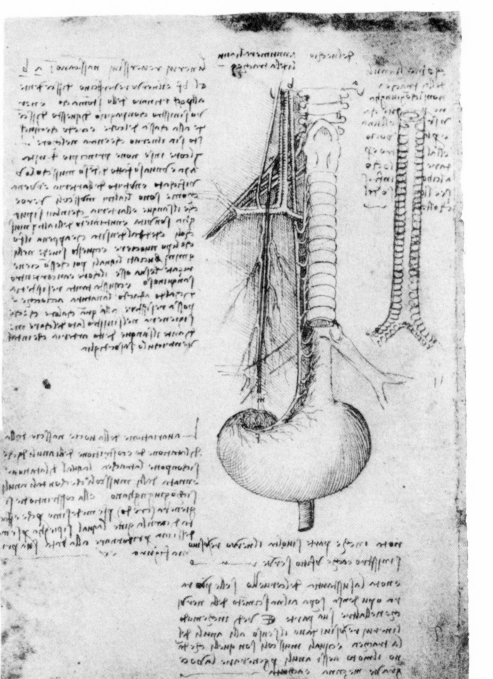

ANATOMY

ON THE NERVES WHICH GIVE SENSIBILITY
TO THE MESOPLEURI [INTERCOSTAL MUSCLES].

fig 1. **The intercostal nerves.**

*The small muscles placed obliquely, descending from
the upper part of the spine and terminating towards
the xiphoid process (pomo granato), are called the
pleuri. They are interposed between one and the
other rib for the sole purpose of contracting the in-
tervals between them. The nerves which give sensi-
bility to these muscles have their origin from the
medulla which passes through the dorsal spine. Their
lowest origin from the medulla is where the back
borders upon the kidneys.*

The term *mesopleuri* for intercostal muscle is de-
rived from Galen, intercostal being almost a literal
translation of the original Greek word. For the use of
the term *pomo granato* for xiphoid process as well as
for the Adam's apple, cf. 23.

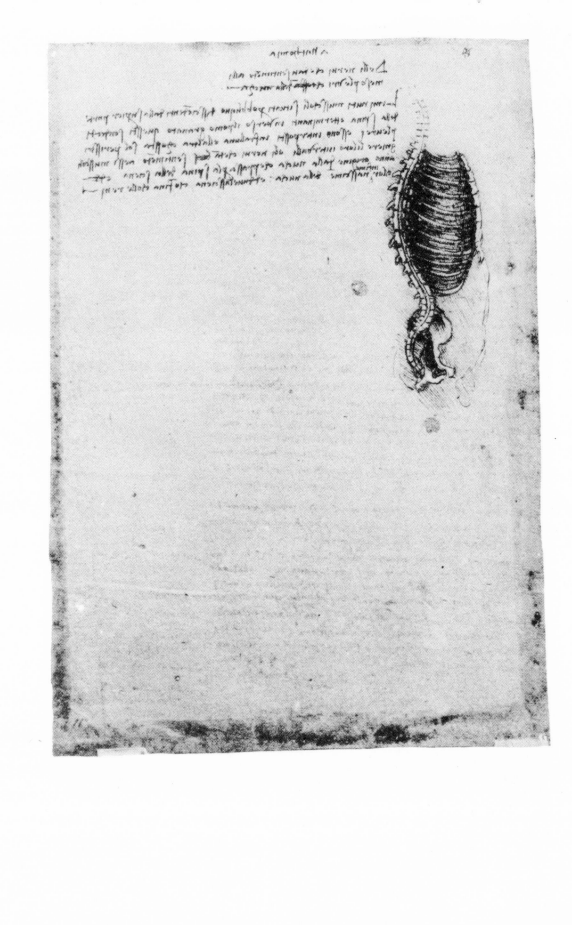

peripheral nerves: upper extremity

This rather heterogeneous group of figures is believed by Clark to belong to Leonardo's earliest anatomies and to pre-date the 1489 drawings. The content certainly substantiates this belief. By comparison with similar drawings on 152, 153, and 160, we are led to the conclusion that most of these studies were based on the dissection of monkeys and the findings projected onto human outlines. Since most of the drawings on this page are concerned with the distribution of the peripheral nerves, the plate is placed under that system. In considering the figures the architectural plans of a courtyard are omitted.

fig 1.　**The brachial plexus.**

The plexus is very roughly indicated and arises from six roots. The only nerves which may be identified with any certainty are the median and ulnar. The outlines of the surface muscles are well defined.

fig 2.　**The distribution of the femoral and sciatic nerves and their branches.**

In the right leg the sciatic nerve may be followed into its two major terminal divisions, the tibial and common peroneal nerves. In the left leg, the femoral nerve is also shown. A branch of the femoral, presumably the saphenous nerve, appears to join the common peroneal, but this is a fault of draughtsmanship since the latter nerve is shown shining through from the lateral side. Selected positions for cross-sections of this leg are inked in over the original silverpoint drawing.

fig 3.　**Cross-section of the middle of the leg.**

No key to the reference letters is provided. The arrangement of structures in the section appear to be based on guess-work from the superficial appearances. The tibia is not lettered. o, is the fibula; b a, a part of soleus which is not shown extending to the lateral side; c and d, the medial and lateral heads of gastrocnemius; f a, the deeper structures of the calf; h g, probably the peroneal muscles; h i, probably the extensors; m l, probably the tibialis anterior.

fig 4.　**The ventral aspect of the trunk, probably of an animal.**

The oblique and rectus muscles of the abdomen are roughly indicated as cords. In the axillary region a nerve or vessel is outlined.

fig 5.　**The lower abdomen, scrotum and penis.**

The illustration shows the spermatic cords on either side passing to the scrotum. These structures were regarded as part of the nervous system since the semen was thought to come from the spinal cord, cf. 153.

fig 6.　**The upper extremity and its peripheral nerves.**

The median, ulnar and radial nerves may be identified passing distally to the forearm. The outlines of the bones suggest the monkey as the source.

figs 7-8.　**The lower extremity and the femoral nerve.**

In the first of these figures the sartorius muscle has been severed and turned back. The femoral nerve is shown providing a branch, the saphenous nerve, accompanying the saphenous vein.

peripheral nerves: upper extremity

Like most of the dissections of this early period, these were carried out almost exclusively on the monkey or other animal forms. Owing to the scattering of the drawings, they have been enumerated in three groups lying on the left, center and right of the page.

GROUP I, ON LEFT OF PAGE.

fig 1. **The brachial plexus and its branches in relation to the skeleton.**

Again the shape of the humerus clearly shows that the dissection is that of a monkey. The arrangement of the brachial plexus is shown in very approximate fashion. However, the position of the median, radial and ulnar nerves is demonstrated with considerable accuracy. The other peripheral nerves in the axilla are presumably the subscapular. A portion of the serratus anterior muscle is clearly outlined. The accompanying note is so faded as to be almost illegible. It is also unusual in that although undoubtedly in Leonardo's hand, it is written from left to right.

In this manner originate the nerves of motion above [. . .] *of the spine.*

fig 2. **The median and ulnar nerves in relation to the soft parts.**

A companion sketch to fig. 1 and like it doubtless from the monkey. The median and ulnar nerves are shown correctly related to the surrounding muscles.

fig 3. **Detail of the brachial plexus.**

Like most of Leonardo's illustrations of the plexus, there is considerable confusion as to the arrangement of this difficult piece of anatomy.

fig 4. **Rough sketch of spinal cord entering the neural canal of a few vertebrae.**

The figure is badly faded. Two spinal nerves are shown emerging from an intervertebral interval. The note indicates that the sketch is based upon a dissection of the frog, cf. notes on 153.

Whichever of these [spinal cord or nerve] *be picked, is lost in the frog.*

A longer note at the top center of the page, written at some other time also discusses some remarkable observations on the pithing of frogs.

The frog immediately dies when its spinal medulla [midolla della sciena] *is perforated. And previously it lived without head, without heart or any entrails or intestines, or skin. It thus seems that here lies the foundation of motion and life.*

GROUP II, CENTER OF PAGE.

fig 1. **Outline of thoracic and abdominal viscera of an animal.**

fig 2. **Faded drawing of unknown significance.**

GROUP III, RIGHT OF PAGE.

fig 1. **Hand of a monkey.**

The presence of epiphyses at the end of the radius, ulna, metacarpals and phalanges indicates that the specimen came from a young animal. However, it should be noted that there is no great pretence to accuracy in defining the position and number of these epiphyses nor in the arrangement and number of the carpal bones.

fig 2. **The peripheral nerves in relationship to the bones of the upper extremity in the monkey.**

The shape and curvatures of the bones clearly identify the monkey as the source of the material for the study. The median, radial and ulnar nerves are shown in approximately their correct relationships to the bones.

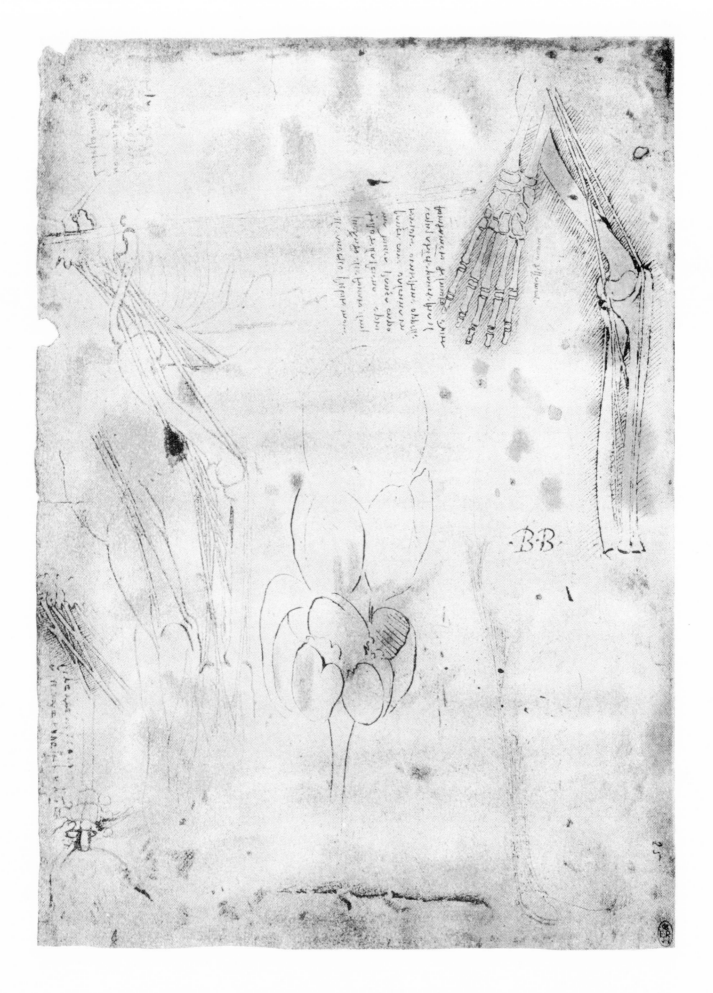

peripheral nerves: upper extremity

fig I. **Diagram of the spinal cord and vertebral canals.**

This curious diagram represents the spinal cord and its dural sheath issuing from the foramen magnum to enter the neural canal of highly schematized vertebrae. On the cord are written the words *Generative power*, which has reference to the ancient theory that the spinal medulla was concerned in the formation of sperm. Leonardo may have obtained this idea directly or indirectly from the Hippocratic treatise *On generation*, the fourth book of *On diseases*, where it is stated that "the most active and thickest part" of the semen comes from the spinal cord and passes by means of vessels from the lumbar region to the testes. Leonardo later gave up this notion and accepted the Galenical thesis that the sperm was concocted from the blood in the testes.

On either side of the spinal cord, occupying the position of the vertebral vessels, is a hypothetical tube of dura which was supposed by Leonardo to carry animal spirits from the brain to the spinal nerves, one of which is shown on the right. This tube is said to convey *the sense of touch*, and to be *the cause of motion, the origin of the nerves*, and *the passage for the animal powers*. It acts as a sort of reservoir for the ebb and flow of animal spirits into the presumed hollow peripheral nerves. This canal

and its relations to the brachial plexus are best seen in 154 and 155. Other notes describe the effects in the procedure of pithing a frog.

The frog retains life for some hours when deprived of its head, heart and all its intestines. And if you prick the said nerve [spinal medulla] *it suddenly twitches and dies.*

All the nerves of animals derive from here [spinal medulla]. *When this is pricked, it immediately dies.*

figs 2-3. **Surface features of the lower extremities and the nerves of the thigh.**

These are doubtless companion figures. Fig. 3 shows the distribution of the femoral and sciatic nerves. It is interesting to note that the principal figures on this page and 152 were the only anatomical illustrations known to have been copied by Albrecht Dürer. They are to be found in his Dresden Sketch Book.

figs 4-5. **The surface features of the upper extremity and its nerves.**

These figures are also companions and illustrate the position of the nerves in relation to the bones in pronation. The median, ulnar and radial nerves are easily identified. The appearance of the humerus demonstrates beyond question that the dissection was made on the monkey and applied to man.

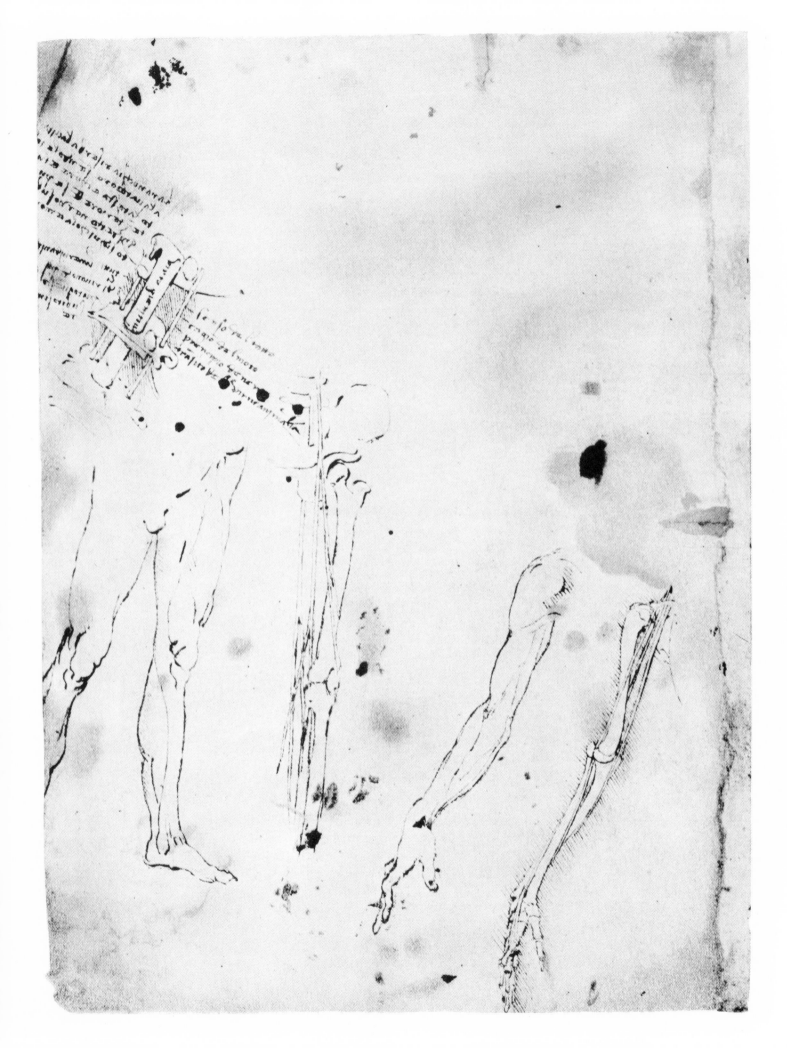

peripheral nerves: upper extremity

fig 1. **The brachial plexus.**

This figure should be compared with the much more accurate sketch of the brachial plexus based on an actual dissection, 156. Here the plexus arises from only four roots which very inaccurately form possibly the three trunks, but these are evidently confused with the cords. We suspect that the diagram is based on a reading of Galen. The figure is indicated as being the first of a series and Leonardo says of it:

In this demonstration it is sufficient to represent only 9 vertebrae, of which 7 go to form the neck.

fig 2. **A diagram of what appears to be the vertebral vessels but regarded as a dural canal.**

The base of the skull, the dural coverings of the brain and spinal cord and a cervical vertebra are shown to illustrate the course of a hypothetical canal conveying the motor spirit to the brachial plexus. For a fuller discussion of this hypothetical passage, cf. 155.

fig 3. **Diagram of the course of a hypothetical canal.**

The figure, similar to fig. 2 above, is perhaps even more schematically shown. The accompanying note suggests that the diagrams were intended for the use of artists and may be related to some contemplated discussion on the movements of the head and neck.

This demonstration is as necessary for good draughtsmen as the derivation of Latin words is for good grammarians, for he will needs draw badly the muscles of figures in the movements and actions of those figures, if he does not know what are the muscles which are the cause of their movements.

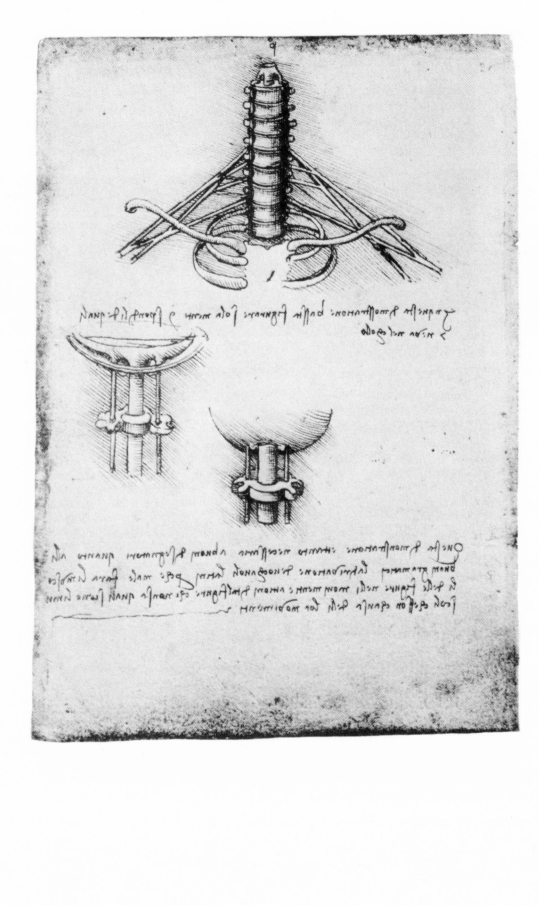

These figures are evidently related to those on 154 and would therefore date from an early period, c.1490. They are arranged by Leonardo to read from right to left so that this order will be followed in their enumeration.

fig I. The segment of the spinal cord, its coverings and a nerve root.

On the figure is written *Medulla and a nerve which has arisen from it*. It will be noted that the spinal nerve appears to have been represented as arising by means of two roots from the spinal cord. However, careful inspection of the figure reveals that these are not nerve roots but the extension of the pia-arachnoid as is made clear in the note below. The nerve roots were not recognized for several centuries. Attention is called to the coverings of the cord and their extension along the nerve root with the note:

These two coats which envelop the medulla are the same as those which cover the brain, that is, the pia and the dura mater.

fig 2. Second [demonstration]. A diagram of the spinal cord and brachial plexus.

The accompanying legend reads: *Spondyles* [vertebrae] *of the neck, sawn through and removed from the middle in front, and the position of the medulla revealed and how it inhabits and ramifies outside these spondyles.*

On the manubrium sterni is written the word *thorax*. The figure and arrangement of the brachial plexus is almost identical with that on 154. The vertebral canal is exposed and its content shown as though an integral part of the plexus and spinal cord. It is evident that these structures are not regarded as being the vertebral arteries. McMurrich (1930) suggests that they may represent ganglionated cords, probably a part of the sympathetic trunk which has been confused with memories of the vertebral arteries in a diagrammatic figure. Holl (1917) and Hopstock (1919) agree that they are not the vertebral arteries; the former suggesting that they have been borrowed from some ancient unknown work and the latter, that they are purely products of Leonardo's imagination. They are again shown in 145 and 153 where they are obviously regarded as tubes of dura extending from the cranial cavity through the vertebral canal. They are said to transmit the animal (i.e., nervous) powers of touch and motion whereas the

spinal cord is for the generative power. We may therefore be fairly certain that Leonardo has misinterpreted certain statements made by Galen in the difficult ninth book of his *De usu partium* and applied these to the vertebral canal and its vessels.

Galenical theory required the nerves to be hollow for the passage of animal spirits conveying motor "sensibility" to the muscles. Leonardo apparently believed that the vertebral canal allowed the ebb and flow of this spirit. The note describes this theory, cf. 156.

The substance of the medulla enters for some distance into the origins of the nerves and then follows the hollow nerve as far as its terminal ramifications. Through this perforation sensibility is carried into each muscle. The muscle is composed of as many other minute muscles as there are fibres into which this muscle can be resolved, and each of the smallest of these muscles [i.e., fibres] is covered by an almost imperceptible membrane into which the terminal ramifications of the aforementioned nerves are converted. These obey in order to shorten the muscle with their withdrawal and to expand it again at each demand of the sensibility which passes through the hollow cavity of the nerve. But to return to the medulla, this is enveloped by 2 membranes of which only one [pia mater] clothes the marrow-like substance of the medulla itself and on issuing from the hollow cavity of the spondyles [vertebrae], is transformed into nerve. The other [dura mater] clothes the nerve together with its principal branches and ramifies together with each branch of the nerve and thus forms the second investment of the medulla interposing itself between the bone of the spondyles and the first membrane of the medulla.

fig 3. Third [demonstration]. A diagram of the spinal cord, brachial plexus and their dural coverings.

The legend written on the dural covering of the brain reads, *source of the nerves*. From the brain descends the spinal cord sheathed in dura and the vertebral canals conveying animal spirits to the nerves as discussed above. The brachial plexus is represented in very primitive fashion.

The medulla is the source of the nerves which give voluntary motion to the members.

We are again informed that, *The pia and the dura mater clothe all the nerves which proceed from the medulla.*

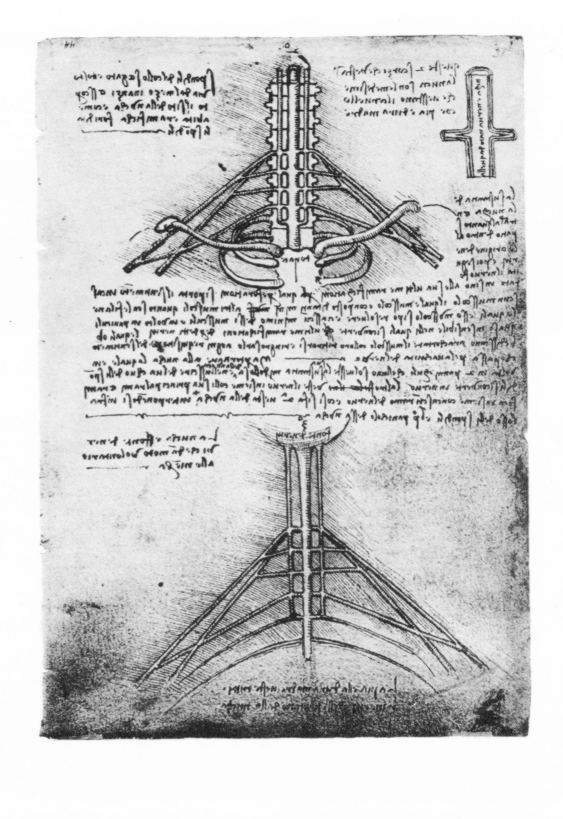

peripheral nerves: upper extremity

The figures and notes on this page are based upon the dissection of the centenarian (cf. 128) who died while conversing with Leonardo from a bed in the Hospital of Santa Maria Nuova at Florence. The page opens with a note on the problem of how the nerves produce muscle contraction. According to Galen, the motor nerves, believed to be formed of minute hollow tubes, enter a muscle near its origin which was consequently nervous, i.e., sinewy, and thereafter spread throughout the body of the muscle, the interstices between the nerve fibres being filled with flesh. These nerve fibres once again aggregate to form the tendon which is consequently called a cord or nerve. The animal spirits distilled in the brain from the vital spirits of the arteries flowed through the hollow nerves to the periphery providing sensibility, both motor and sensory, to the muscles. This spirit gives rise to the contraction and is the muscular force.

ON THE FORCE OF MUSCLES.

If any muscle be pulled out lengthwise, a slight force ruptures its flesh, and if the nerves of sensibility should be drawn out lengthwise, little power tears them from the muscles in which their branches are interwoven, spread out and consume themselves. The same thing is seen to occur in the nervous (sinewy) coat of the veins and arteries which are intermingled with the muscles. What then is the cause of the great force in the arms and legs such as one sees in the actions of any animal? One can say only that it is the membrane investing them, which when the nerves of sensibility thicken the muscles, these muscles shorten themselves and draw after themselves the cords into which their extremities are converted. In the process of thickening they fill out the membrane and cause it to draw and become hard. They cannot lengthen unless the muscles become thinner, and by not becoming thinner they are the cause of resistance and of giving strength to the aforesaid membrane within which the swollen muscles perform the function of a wedge.

fig 1. **The brachial plexus.**

At the head of the figure are the words, *Of the old man,* indicating that the figure is one of the series on the dissection of the centenarian, and like most of the figures from this source, it is by far the most accurate representation of the findings in man.

The jugular veins and carotid arteries are identified by the letters a b c d. The brachial plexus is correctly shown as arising from the anterior rami of C 5 6 7 8 and T 1, labelled a b c d e, uniting to form the upper, middle and lower trunks. The trunks divide into their divisions and reunite to form the cords, but this region and the branches of the cords are somewhat confused. Nonetheless this difficult region is remarkably well portrayed. Other structures indicated by Leonardo and identifiable are:

e is said to lie *under the axilla,* and these nerves are probably the upper and lower subscapular and nerve to latissimus dorsi displaced upwards and laterally

from behind the plexus. Above them, arising from the upper trunk and lateral cord are the suprascapular and lateral anterior thoracic nerves.

a has written above it the word *behind,* i.e., the humerus, and is the radial nerve, with a branch, the dorsal interosseous, to the *two fociles* (radius and ulna). Below the radial is a nerve, possibly the musculocutaneous with the lateral cutaneous nerve of the forearm which are said to pass to the *flexure of the elbow.*

b, the median nerve, is indicated by the word *elbow.* Its two heads of origin from the lateral and medial cords may be observed, and it gives off a branch in an unusual position as well as being drawn out of proportion. The words *b, flexure of the arm,* have been deleted.

r, the ulnar nerve, is said to be passing *to the elbow.* Above, also from the medial cord, the medial cutaneous nerve of the forearm is shown.

Placed on the plexus, over the root of C 8, is a second letter I which leads to a statement referring to the five roots of the plexus and reading: *Any one of the 5 branches which is preserved from the cut of a sword suffices for the sensibility of the arm.*

Below the plexus within the thoracic cavity, the upper intercostal nerves are illustrated. From them and crossing the necks of the ribs is a series of nerves labelled s which are undoubtedly meant to represent the sympathetic chain and formation of the splanchnic nerves. If this is so, this illustration is the earliest representation of this important system known. The figure appears to be only a rough sketch preparatory to a more finished drawing since accompanying memoranda read:

In this demonstration represent only the first upper rib and this will be quite sufficient to show where the neck is separated from the trunk.

Represent the proportional length and thickness which the nerves of the arm and leg have to each other.

fig 2. **Rough sketch of the root of the neck and superior aperture of the thorax: anterior view.**

The figure carries the legend, *Neck with the oesophagus (meri).* In the mid-line the oesophagus and spinal column are represented. On either side are the common carotid artery, the internal jugular vein and the vagus nerve.

fig 3. **Rough sketch of the root of the neck and superior aperture of the thorax: posterior view.**

The legend to this figure reads, *the neck and spine.* The laterally placed structures are as in fig. 2 above.

fig 4. **The superior aperture of the thorax: diagrammatic cross-section.**

Below the figure Leonardo writes, *the neck foreshortened,* and on the figure below the central structure the word, *oesophagus.* The other structures are presumably the vessels and related muscles. On the above figures (2-4) Leonardo makes a comment:

(continued on page 502)

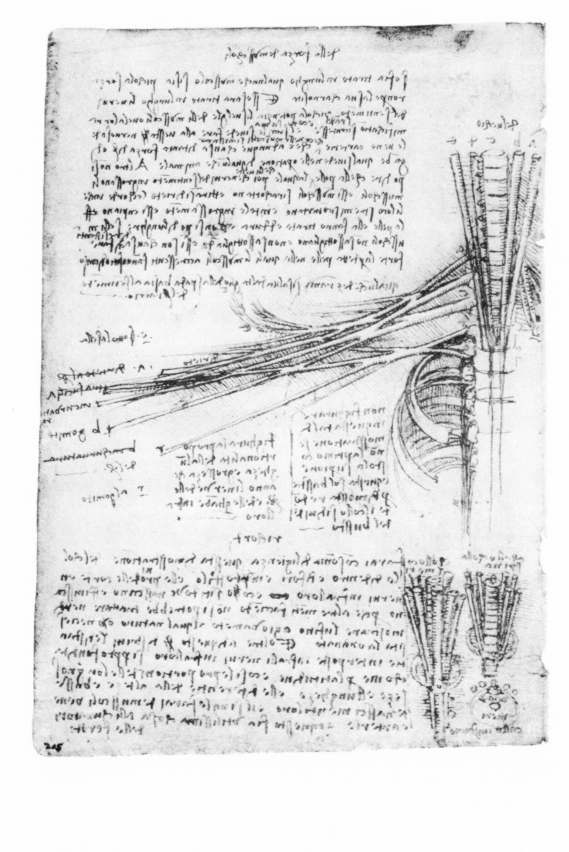

peripheral nerves: upper extremity

The style and content of this page strongly suggest that this is another of the series of dissections made on the body of the centenarian, cf. 128.

fig 1. **The brachial plexus and its branches.**

Although the plexus itself is shown with no great accuracy, many of the nerves illustrated are easily recognized. Only four roots establish the three trunks which confusedly subdivide into divisions to form the cords. The sensory distribution of the ulnar and radial nerves to the dorsum of the hand is illustrated with extraordinary accuracy. By careful study and reference to the companion figures the following nerves may be identified: medial cutaneous of arm, ulnar, median, radial with its dorsal interosseous branch, musculocutaneous, axillary and suprascapular.

fig 2. **The brachial plexus and some of its motor branches.**

The figure is identical to a portion of fig. 3. The muscle shown are, from above downwards, the supraspinatus, part of deltoid and biceps brachii. The notes lying to the right of this figure read:

Here each nerve of the arm is joined with all four nerves which issue from the medulla.

The significance of the above note is explained by reference to 156. Leonardo holds that owing to the apparent intermingling of the nerves at the plexus, in wounds of the plexus the preservation of a single root is sufficient to preserve the "sensibility" of the arm. *Here will be shown all the muscles of the arm with the nerves and vessels.*

fig 3. **The brachial plexus and its muscular branches.**

The muscles shown are labelled from above downwards as follows: *Shoulder* muscle, i.e., supraspinatus; *Humerus* muscle, the deltoid: the word humerus also means the shoulder region; *Pesce del braccio* muscle, the biceps brachii of fish-like shape: for the use of this term, cf. 45; *Muscle of the elbow*, the triceps muscle.

The few muscles of the forearm shown are not identified. Further illustrations contemplated are described in the following words:

You will make a ramification of the nerves with all their muscles attached. And then you will make this ramification with the muscles attached to the nerves and to the bones which constitute the entire arm.

The final note and list of projects is probably a part of 181, where Leonardo gives another of his several outlines on the order and arrangement of his contemplated anatomical work.

Make the man with arms open and with all his nerves and their purposes according to the list [below]. You should employ the very greatest diligence for the reversive [vagus] nerves in all their ramifications.

A demonstration of the omentum (zirbo) without the bowels.

A demonstration of the bones sectioned.

A demonstration of simple bones.

A demonstration of bones and sinews.

A demonstration of bones and vessels.

A demonstration of nerves and muscles.

A demonstration of vessels and muscles.

A demonstration of bones and of intestines.

A demonstration of the mesentery.

A demonstration of the members and spiritual muscles [for members, i.e., thoracic contents].

A demonstration of woman.

A demonstration of the bones, nerves, and vessels.

A demonstration of the nerves alone.

A demonstration of the bones alone.

A demonstration of the sinews (nervi) in sectioned bones.

A demonstration of sinews in unopened bones.

A demonstration of bones and sinews which join one another together, which sinews are very short and especially those which join the vertebrae within.

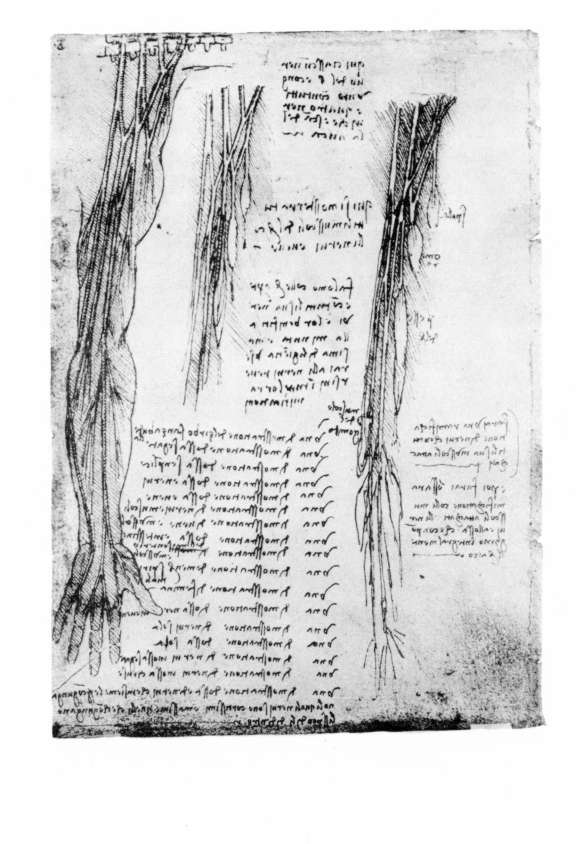

peripheral nerves: upper extremity

fig I. **Outline of the pelvis and pelvic vessels.**

In this rough figure, now badly faded and rubbed, the outline of the pelvis and terminal branches of the aorta and accompanying branches of the inferior vena cava may be traced. The common iliac, hypogastric and external iliac vessels are shown in relatively correct relationship to one another. The accompanying note emphasizes the difficulties found by Leonardo in examining the pelvic viscera.

At about the middle of the height, width and thickness of man, there is more artifice than in any other of his parts, and it is greater in the female who has in the same place the bladder, womb, testes [ovaries], rectum, haemorrhoidal veins, nerves, muscles and the like.

fig 2. **The sensory distribution of the median and ulnar nerves to the palmar aspect of the hand.**

The peripheral distribution of the digital branches of the median and ulnar nerves is shown with remarkable accuracy. The ulnar artery may be followed into the formation of the superficial palmar arch with its digital branch. The relationship of these structures to one another is considered in the notes:

The vessels are uncovered before the nerves of sensation, and the nerves of sensation are found before the cords of power of the muscles.

a b, are the nerves of the inner [palmar] aspect of the hand, of which a [ulnar n.] comes from the fork [ulnar groove] of the elbow, b [median n.] comes from the inner aspect of the bend of the arm and c [ulnar artery] is a vessel.

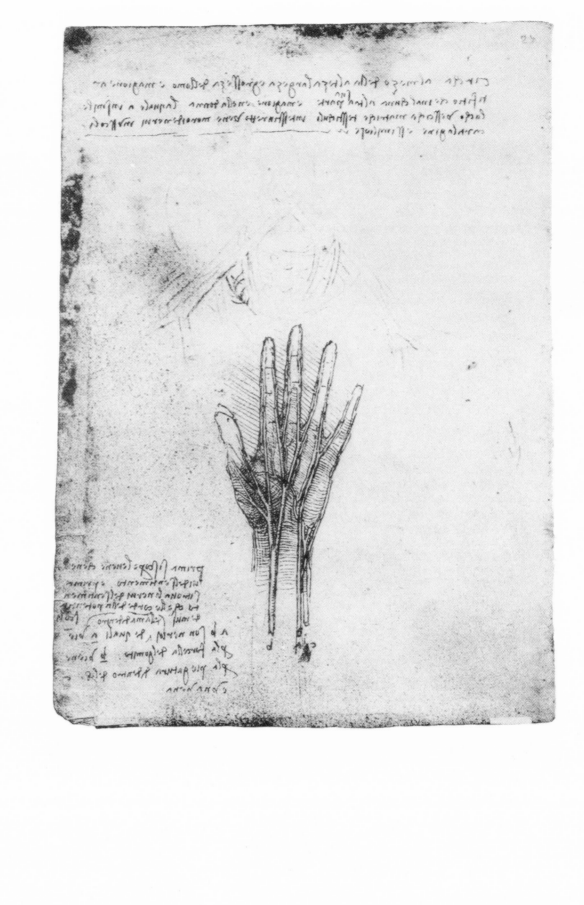

peripheral nerves: lower extremity

fig 1. **Posterior aspect of thigh and leg showing distribution of the sciatic nerve.**

The sciatic nerve is shown dividing at the customary level into its terminal branches, the common peroneal and tibial nerves. The tibial nerve looks as though it continued into the leg superficial to the gastrocnemius muscle but close inspection reveals that this structure is the lesser saphenous vein which is accompanied by the sural nerve branching from the tibial.

figs 2-8. **Series of incomplete sketches of the lateral and posterior aspects of the thigh and leg.**

In some of these sketches the sciatic nerve or its branches are outlined.

fig 9. **Dissection of the anterior aspect of the thigh to reveal the femoral nerve.**

The sartorius muscle has been resected leaving its upper and lower ends in positions marked a and r. The vastus lateralis muscle is lettered m n, and the tensor fasciae latae, f f. The femoral nerve, lying lateral to the artery, is shown dividing into two main divisions. The lateral is lettered r, and its intermediate cutaneous branches pass superficial to the rectus femoris muscle. The motor branch to vastus lateralis is observable. The medial division passes into the adductor canal and is doubtless the saphenous nerve. The drawings are probably based on dissection of the monkey, cf. 151-3. The accompanying note reads:

I have removed the muscle a n [sartorius] *which is half a braccio in length, and have uncovered r t* [?femoral nerve]. *Now attend to what lies beneath m o* [vastus lateralis].

fig 10. **Sketch of a domed edifice.**

fig 11. **Sketch of the posterior aspect of the head and neck.**

The muscle shown is possibly a portion of the trapezius. Leonardo frequently divides the flat muscles into a series of slips.

fig 12. **Diagrammatic cross-section of the head to demonstrate cerebral localization.**

The three vesicles or ventricles shown on 142 are again demonstrated but with certain differences—the outcome of greater knowledge of the attachment of the cranial nerves, cf. 145. The optic nerves pass from the globe to the anterior vesicle. The bilateral ink lines represent the olfactory nerves which are attached to the middle vesicle. Likewise, the acoustic nerves now pass to the middle ventricle. Consequently this ventricle now becomes the *sensus communis* or common center for sensation. The motor cranial nerves are also regarded as being attached to the middle instead of the posterior ventricle since it is also labelled *volonta*, i.e., the center for voluntary motion. The function of the other ventricles is therefore modified, the anterior carrying the center for the *intellect* and *imprensiva*, in place of fantasy, doubtless to emphasize its receptive function. The posterior ventricle remains as the seat of *memory*. The drawing should be compared with 145 to follow the manner by which these changes have come about. Furthermore, these modifications make it certain that the drawings are later than those on 142.

fig 13. **Lateral aspect of head and neck illustrating facial and neck muscles.**

The facial muscles are represented as cords as was Leonardo's common practice. The temporal, sternomastoid and a portion of trapezius muscles are readily recognized.

fig 14. **Rough sketch of the bones of the lower extremity with the sciatic nerve and popliteal vessels.**

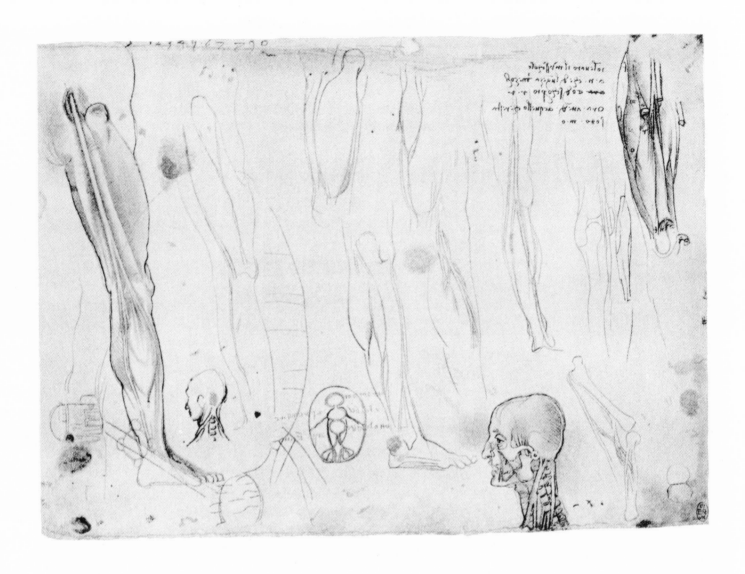

figs 1-3. **Posterior, medial and anterior aspects of lower extremity.**

The only figure in this group of immediate interest is the second demonstrating the course of the great saphenous vein and the saphenous nerve. The various structures are labelled from left to right: *lacertus, nerve, vein, muscle.* For the use of the term lacertus, cf. 43.

fig 4. **The lumbo-sacral plexus and sciatic nerve in relationship to the bones of the lower extremity.**

The figure is in many respects similar to that on 162 and, like it, is probably based on animal anatomy. The plexus and nerves are very approximately shown. The sciatic nerve divides within the pelvis into its terminal divisions and of these the common peroneal appears to pass around the medial instead of the lateral aspect of the leg.

fig 5. **Outline of the viscera of an animal.**

The outline suggests a sketch of appearances in the ox. Below is the thoracic cavity which was apparently full of blood since on either side we have the word *blood.* In the middle is a multiple lobed *liver* and so labelled. Above is the *stomach.*

fig 6. **Diagram of the respiratory and alimentary systems.**

The figure is clearly indebted to animal anatomy as indicated by the shape and lobes of the liver. The various structures named are from above downwards on the left of the figure: *channel for food, air passage, lung situs spiritualis, heart, liver, stomach, belly, umbilicus, bladder,* and on the right from above downwards, *spleen, kidneys.* The thorax was called the site of the spiritual members, *situs spiritualis,* since here was supposedly distilled from the blood by the action of the heart and lungs, the vital spirits carried by the arteries to all the parts of the body.

fig 7. **Diagram on cerebral localization.**

The diagram represents a cross-section of the head and brain to show the supposed vesicles which contain the psychic faculties. The optic nerves pass from the eyes to the anterior vesicle said to contain the *imprensiva* or perceptual center. The middle vesicle receives the olfactory nerves anteriorly and the acoustic nerves laterally and so is regarded as the *sensus communis* but is labelled *comocio* which is probably a misspelling of *conoscio* indicating the center for thought. The posterior ventricle is said to contain the *memoria.* The diagram follows the traditional beliefs of the tripartite division of cerebral function described on 142, but the arrangement is an advance corresponding to that found on 159.

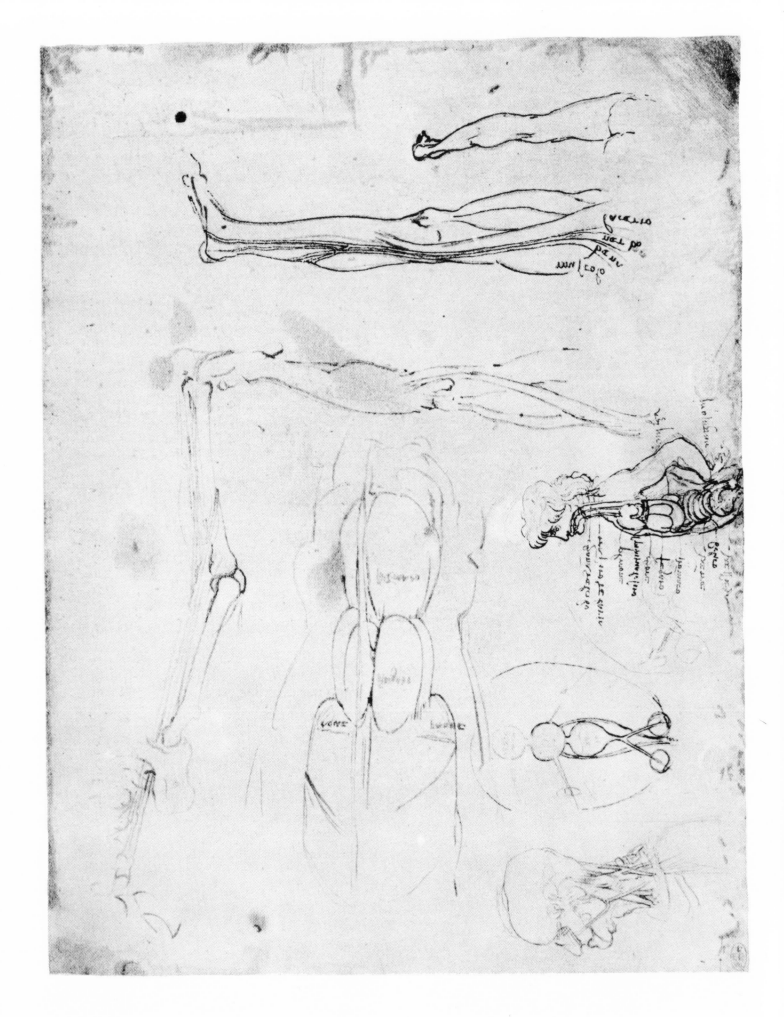

peripheral nerves: lower extremity

The representation of the peripheral nerves to the lower extremity probably dates from c.1490-92 with the figures and notes in the right-hand margin added somewhat later.

fig 1. **The sacral plexus and the sciatic nerve.**

The arrangement is very similar to that found on 166. The representation of the plexus is not even approximately correct, and the sciatic nerve is shown making a high division which is more commonly found in animals such as the horse and cow. Of the figure Leonardo notes:

At f g h [sacral plexus] *arise the nerves the branches of which are parcelled out* (fasciare) *among the muscles of the hams behind the leg, under the knee at a b, and lower down are parcelled among the second* [group of] *muscles at c d. Finally, they bend behind the malleoli* (noci) *of the foot at e f and then pass beneath the foot.*

The expression *noci de' piedi* is the vernacular term for the ankle-bones. However, literally it refers to the "knobs or bolts" of the foot and therefore the equivalent of malleoli or little hammers introduced by Vesalius in 1543. The use of the verb *fasciare*, literally "to swathe" from the Latin equivalent, giving *fascia* and *fascis*, a bundle or parcel, reminds us that Leonardo is thinking in terms of the theory that the nerve breaks up in the muscle to give rise to what we would call the connective tissue elements. These, in turn, constitute the tendon which is therefore also called a nerve.

fig 2. **The relationships of the femoral nerve in the thigh.**

The sartorius muscle has been resected leaving its proximal portion a, and its distal tendon b b, in position to expose the femoral nerve, chiefly its saphenous branch, and one of the femoral vessels. The rectus femoris muscle is also indicated by the letter a, vastus medialis by c (g deleted), and the insertion of the strap-like muscles at the pes anserina, by e.

figs 3-4. **Diagrams of the lower extremity to illustrate the note below.**

Remember never to alter the outline of any limb by [the removal of] *any muscle which you have lifted away in order to uncover another. Even if you remove muscles of which one of the borders forms the boundary of a part of the limb from which you have detached it, then you must mark with numerous dots the border of that limb which was removed by the separation of some muscle. You will do this so that the shape of the limb which you describe will not remain a monstrous thing from having had its parts taken away. In addition to this, there follows a greater knowledge of the whole, because after the part is removed, you will see in the whole* [outline] *the true shape of the part whence it was taken.*

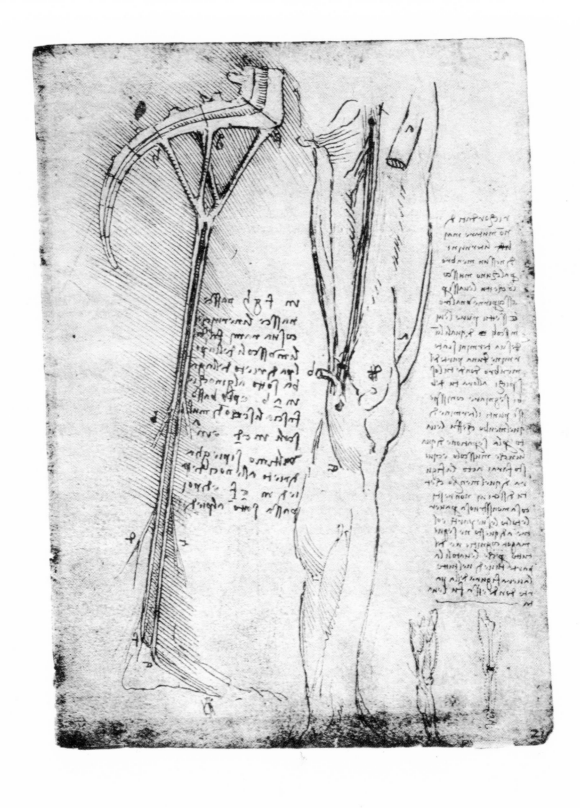

peripheral nerves: lower extremity

The style suggests an early period, c.1495-99, but the similarity of these studies to those on 165 makes a later date a strong possibility.

fig 1. **An abortive figure of the lumbo-sacral plexus.**

The outline suggests an animal form which is confirmed by the figure below.

fig 2. **The lumbo-sacral plexus and its peripheral branches.**

The figure carries the words, *Tree of the cords or nerves.* The shape and appearance of the vertebral segments make it almost certain that the sketch is based on the dissection of some animal. The femoral and sciatic nerves and their branches are very roughly indicated.

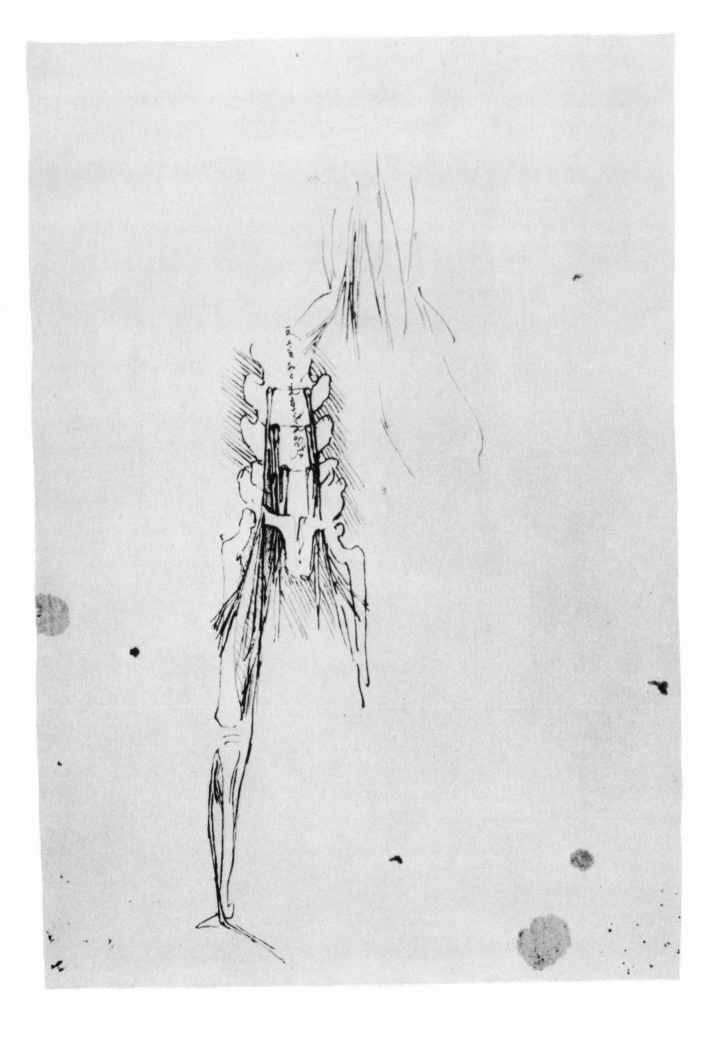

163

peripheral nerves: lower extremity

The anatomical figures were evidently drawn at the same time as those on the recto, 162.

fig 1. **The common peroneal and tibial nerves in relationship to the bones of the lower extremity.**

Numerous muscular branches are shown being given off by the nerves just below the knee-joint. Superficial and deep branches of the common peroneal nerve are indicated and the superficial (musculocutaneous) is carried to the dorsum of the foot. The figure is probably based on animal dissection.

fig 2. **The lumbar-sacral plexus.**

The pencil drawing is almost obliterated, but its outlines correspond closely to the upper portion of fig. 2 on 162.

fig 3. **A series of geometrical figures of unknown significance.**

Some of these figures, especially the last on the right, relate to the note on balance.

The end of the beam consisting of 2 parts placed in balance against its other end of 3 parts, will be found ⅕ of the entire beam nearer to the axis.

peripheral nerves: lower extremity

Clark 12618 / Q V 10r / c. 1497 *374*

These studies appear to belong to the same series as those on 162 and 163.

fig 1. **The femoral nerve in the thigh.**

The femoral nerve is shown dividing into two branches, one of which passes to the rectus femoris muscle and the other is the saphenous nerve exposed by reflection of the sartorius.

fig 2. **Abortive sketch of the femoral nerve.**

The outline suggests a preliminary or abortive sketch similar to fig. 1 above.

fig 3. **The sciatic and femoral nerves in the thigh from the lateral aspect.**

Although badly faded, the outlines of the thigh as viewed from the lateral aspect may be traced. The upper portion of the femur intervenes between the sciatic and femoral nerves.

peripheral nerves: lower extremity

Clark 19023r / FB 6r / c. 1504-06 **376**

fig 1. **The lumbar plexus.**

The lumbar plexus formed by the anterior primary rami of 1, 2, 3 and 4, is shown with some accuracy. The femoral obturator and genitofemoral nerves are easily identified. The lateral cutaneous nerve of the thigh is a notable omission, and the general appearances suggest that the illustration is based on the dissection of some animal form. The note is a reminder for another dissection, while the use of the word tail (corda) again suggests animal dissection.

Cut this tail (corda) through the middle as you have done for the neck so that one can see how the nerves of the medulla arise.

fig 2. **The lumbar plexus and its peripheral distribution.**

As in the figure above, the femoral, obturator and genito-femoral nerves are identifiable. It is observed that, *The nerves in some parts of man are round and in other parts, flat;* and that in the case of the lumbar plexus, *The nerves originate at a lower level than the vessels of the kidneys.* The femoral nerve, at its point of division into multiple branches, carries the numerals 3,3,7, from medial to lateral side which doubtless is concerned with the note which reads, *There are as many nerves as there are muscles in the thigh.* The radicles of the femoral nerve corresponding to lateral, intermediate and medial divisions, are lettered, a,b,c. The saphenous branch is indicated by the letter e, and the knee, by d. The obturator nerve divides into its anterior and posterior branches as in man, but again we suspect that the dissection has been made on some animal forms and projected onto the outline of the human leg.

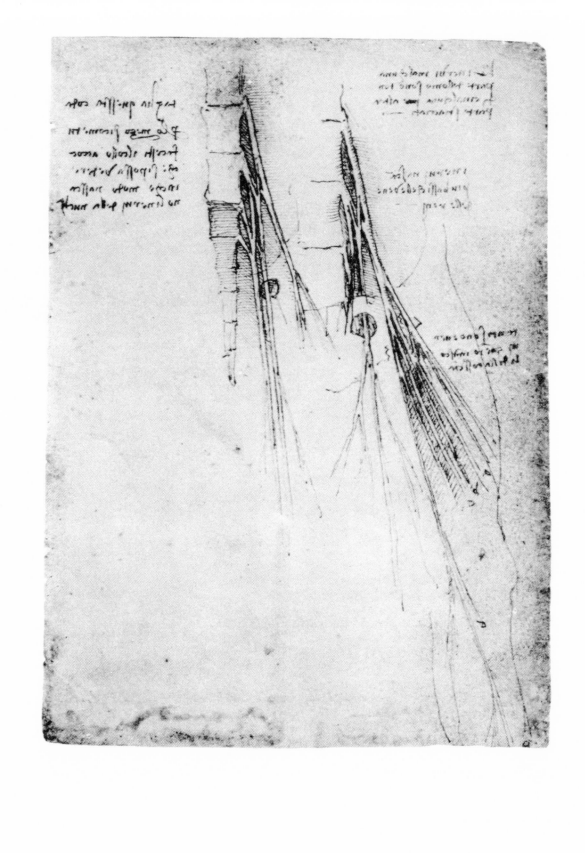

peripheral nerves: lower extremity

Clark 19114r / Q IV 9r / c. 1495-99 **378**

On the left of the page may be seen the marks where 136, a sketch of the superficial vessels of the inguinal region, was formerly pasted on. The drawing has been presumptively dated c.1490 by Clark, but the content makes this date highly unlikely. The study is later and may possibly be related even to those conducted at Florence as late as the period 1504 and after; there is support for this from the figure formerly pasted to it which shows an arrangement of superficial inguinal vessels identical to that of the present figure but of different projection.

fig 1. **Sagittal section of the body demonstrating the spinal cord, pelvic vessels and nerves, and the intercostal muscles.**

The spinal cord is carried the entire length of the neural canal instead of terminating at its customary level at the lower border of the first lumbar vertebra. In addition, there is an excessive number of pre-sacral vertebrae. The abdominal aorta and inferior vena cava provide the common iliac vessels which are shown dividing into branches, all of which are easily identified except for the branch of the hypogastric passing through the perineum into the posterior aspect of the thigh. The large size of the middle sacral artery is noticeable. Like the branches of the hypogastric artery, the arrangement of the sacral plexus is only approximate. From it springs the sciatic nerve which divides into its terminal divisions high within the pelvis. Between the ribs the internal intercostal muscles are shown and the direction of their fibres indicated by the oblique line a b. The line c d, corresponds to the obliquity of the fibres of the external intercostal muscles. The function of these muscles in respiration is described at length in the notes below.

The drawing is undoubtedly a composite figure. The more superficial structures are derived from human appearances, and the deeper are more suggestive of animal anatomy. The automaticity of respiration is explained by an interesting hypothesis, which contains the germ of the idea of reflex action, as being due to the stretching of the intercostal nerves.

The fibres of the [internal intercostal] muscles interposed between the ribs of the breast are disposed on the inner side of the chest solely to constrict the ribs about the lung in order to drive the contained air out of it. Similar fibres [external intercostal] are placed on the external side of the ribs at an obliquity along the line c d, opposite to that of the internal fibres so that they can dilate the previously constricted ribs to open the lung and take in new air. Through these spaces interposed between the ribs, the nerves of sensibility are stretched in order to move the muscles interposed between them for the contraction and dilatation of the aforesaid ribs. Between these ribs are the veins and arteries which puts the nerve in the middle.

The alternate actions assigned to the intercostal muscles in elevating and depressing the ribs during inspiration and expiration were clearly recognized from classical times. However, the subject had great fascination for Leonardo, and he discusses it on several occasions. Here he notes that elevation of the upper ribs tends to raise all those below successively, and he comments upon the factors of leverage.

ON THE STRONG SITUATION OF THE MUSCLES WHICH OPEN THE RIBS.

Of extraordinary power is the upper situation of the small muscles [external intercostal] interposed between the ribs on the external aspect and lying in the obliquity c d. This obliquity experiencing greater fatigue at its superior part where the entire force of the lower muscles is concentrated, is for this reason close to the origin of the upper ribs, towards c, because if such a force were situated at a, the ribs at a, could not draw the lower ribs upwards but the lower would draw the upper behind them [i.e., downwards]. Consequently, they [i.e., intercostal muscles] were well placed along the line c d, since when the first fibres above contract, they draw all the lower ribs behind them, and each muscle below as far as the penultimate does likewise; every force concentrating upon the first, etc.

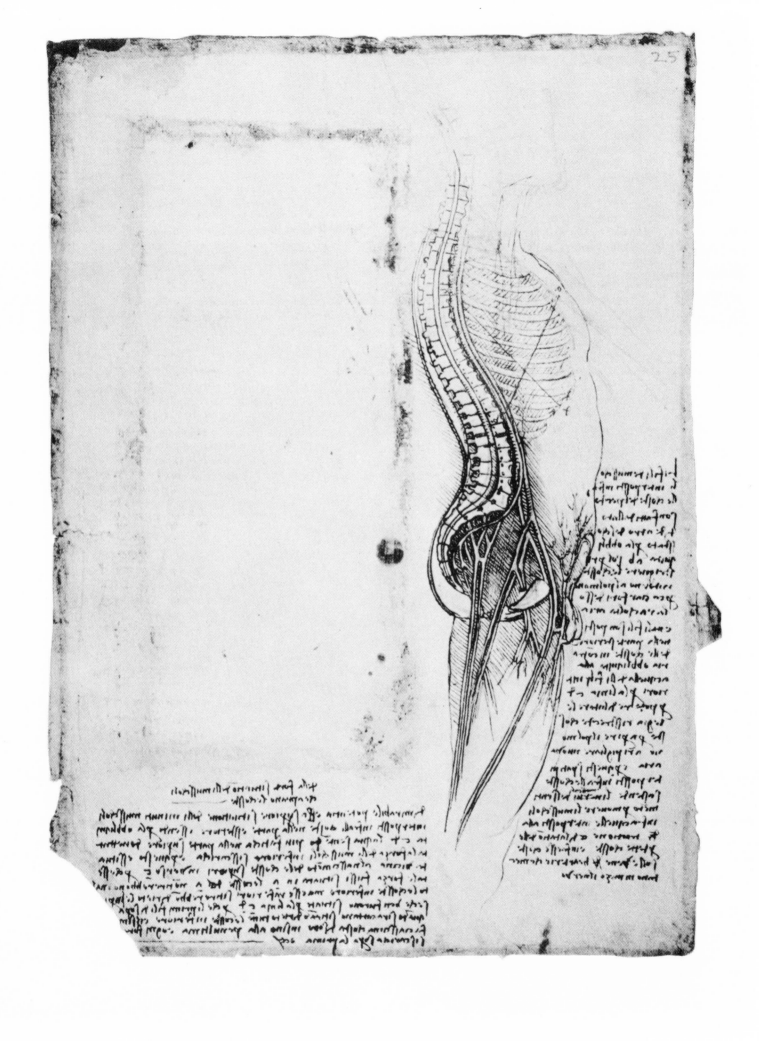

peripheral nerves: lower extremity

These studies are part of the series continued on 168.

fig 1. **The terminal branches of the sciatic nerve.**

The sciatic nerve is shown dividing into its two terminal divisions, the common peroneal and tibial nerves. The common peroneal nerve gives off its two motor branches to the tibialis anterior before dividing into its superficial (musculocutaneous) and deep (anterior tibial) divisions. The tibial nerve is illustrated providing motor branches of which those to the triceps surae are evident. At the lower end of this nerve the words *more underneath* direct Leonardo to a revision to be made in the final drawing.

fig 2. **The sciatic nerve and its terminal branches.**

The origin of the sciatic nerve from the sacral plexus is roughly indicated. It is shown dividing at the usual level in the middle of the thigh into the common peroneal and tibial nerves. On the lateral aspect of the thigh is represented what appears to be the terminal portion of the lateral cutaneous nerve of the thigh. A posterior branch of this nerve is shown joining the anastamotic branch of the common peroneal to form the sural nerve, which must be an error of observation since the sural branch is correctly shown arising from the tibial nerve. The superficial peroneal nerve may be followed all the way to the dorsum of the foot.

fig 3. **The popliteal vessels and tibial nerve.**

The popliteal vein and artery are shown in the popliteal fossa correctly related to one another and providing branches passing dorsally to the heads of the gastrocnemius muscle. The other structure running obliquely and in a dorsal direction is possibly the branch of the lateral cutaneous nerve of the thigh discussed under fig. 2.

fig 4. **Sketch of the lateral aspect of the foot to show the termination of the superficial peroneal nerve.**

The superficial peroneal nerve is illustrated from the point where it pierces the deep fascia to break up into its dorsal digit branches.

fig 5. **Detail of posterior tibial artery or vein and tibial nerve.**

The structures are labelled *vessel* (or vein) and *nerve*. The vessel is probably the posterior tibial artery or vein giving off its peroneal branch which is said to lie *under* the accompanying branch of the tibial nerve.

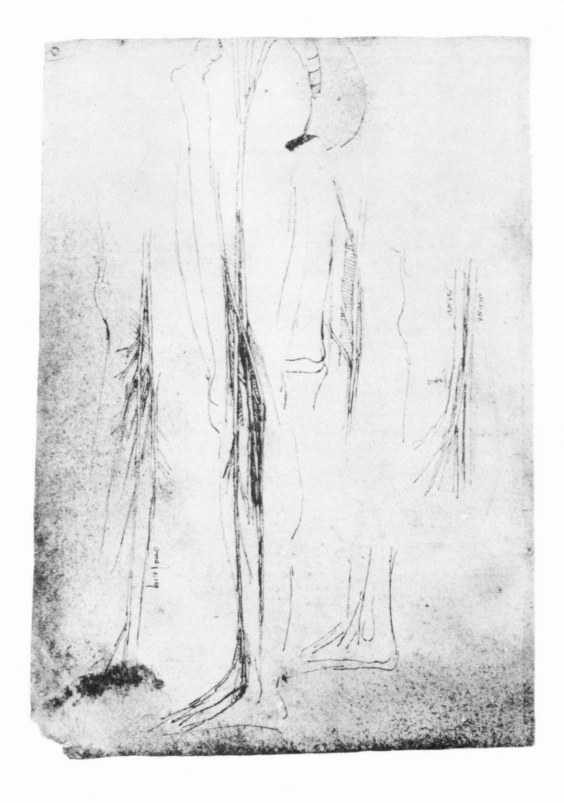

peripheral nerves: lower extremity

These studies are a continuation of the series found on 167 and date from Leonardo's intermediate period.

fig 1. The popliteal vessels and their terminal branches.

The figure is a companion to fig. 2 illustrating the more deeply placed vessels. The caption reads: *The vessels of the medial aspect, and from the knee down they go laterally.*

The popliteal vein is shown receiving the lesser saphenous vein accompanied by a disproportionately large superficial sural artery. The fibula has been divided to expose the anterior tibial vessels, and the anterior tibial recurrent artery is readily recognized. Behind the posterior tibial artery and vein is observed the tibial nerve. Attention is drawn to the more protected position of the vessels in the note on the right.

Nature has placed the major vessels of the leg at the middle of the thickness of the knee-joint, because on flexing that joint the vessels are less compressed than if they passed in front of or posterior to the knee.

fig 2. The distribution of the common peroneal and tibial nerves.

The figure is intended to represent a slightly more superficial view than that of its companion. The legend reads, *Nerve of the lateral aspect,* and the fibula is indicated by the word *focile,* i.e., lesser focile.

The common peroneal nerve passes around the neck of the fibula and having given off muscular branches is seen to divide eventually into its superficial (musculocutaneous) and deep (anterior tibial) divisions. The tibial nerve is shown providing a number of muscular twigs, and on these Leonardo comments:

There are as many branchings of the nerves as there are muscles, and there cannot be more nor less since these muscles are shortened or enlarged only because of the nerves from which the muscles receive their sensibility. And there are as many cords, the movers of the limbs, as there are muscles.

fig 3. Detail of the contents of the popliteal space.

The common peroneal nerve, labelled *nerve,* passes obliquely around the neck of the fibula, called the *focile.* The popliteal vessels are observed dividing into anterior and posterior tibial vessels of which the latter are observed supplying the peroneal vessels. The lesser saphenous vein and a rather large sural vessel are shown closely related to the tibial nerve which has been displaced.

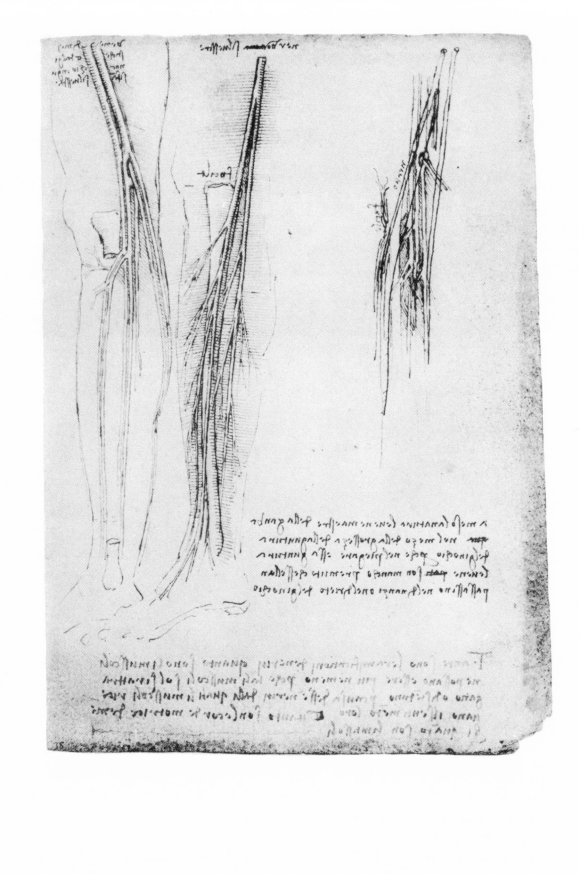

RESPIRATORY SYSTEM

In order to facilitate description of a page crowded with figures, they will be enumerated in order following their vertical arrangement in four groups occupying the left margin, left center, right center, and right margin.

GROUP I, LEFT MARGIN.

fig 1. **The tongue, fauces, larynx and pharynx: lateral aspect.**

The figure is a composite one. Overlapping the main figure and in continuity with it is an inset showing the uvula, oropharyngeal isthmus and thyroid eminence, the purpose of which is apparently to show the vertical relationship of the uvula to the larynx, since it was then thought that the function of the uvula was to allow the phlegm to drip into the larynx to lubricate the voice and lungs, although Leonardo himself discards this notion in the following statement:

The uvula is the drip-stone whence drips the humor which descends from above and which falls by way of the oesophagus into the stomach. It has no occasion to go by way of the trachea to descend to the spiritual regions [i.e., thoracic contents].

In mediaeval physiology the phlegm or pituita was believed to be secreted by the brain, thence passing through the infundibulum to the pituitary gland. The excess reached the nose through the cribriform plate of the ethmoid and thence to the lungs. Thus if the humor were altered in quantity or quality it caused pulmonary diseases. The contents of the thorax were referred to as the spiritual members since they were the seat of the pneuma and vital spirits. The main portion of the figure is probably derived from animal anatomy. The hyoid, thyroid, cricoid cartilages and upper end of the epiglottis may be identified, and below the cricoid is a very small thyroid gland suggestive of the dog or pig. The cords or tendons cannot be identified with any certainty, but may represent the stylo-hyoid ligament and stylo-pharangeus muscle, cf. fig. 3 below. Other surrounding notes read:

Break the jaw from the side so that you see the uvula lying in position, to what it attaches and how it is related to the mouth of the trachea.

One cannot swallow and breathe or emit sound at the same time.

One cannot breathe through the nose and through the mouth at the same time; and this is proved if one should attempt to play a whistle or a flute with the nose and another with the mouth at the same time.

Why does the voice become thin in old age?

The voice becomes thin in old age because all the passages of the trachea are contracted, as occurs in the other entrails.

fig 2. **The hyoid bone and laryngeal aperture from above.**

On the right side behind the epiglottis and resting upon the upper border of the cricoid lamina, the arytenoid cartilage is clearly portrayed. These cartilages are said to have been described first by the famous Bolognese physician and anatomist, Berengario da Carpi (1470-1530) in his *Commentaria*, 1521, but

this illustration shows that they were known to Leonardo. Below the figure Leonardo writes: *Write on the cause of the voice without sound as do those who whisper.*

fig. 3. **The tongue, larynx, pharynx, trachea and oesophagus.**

The figure is very similar to fig. 1 above, but the epiglottis is more clearly shown. Above the drawing is the single word *epiglotto* which was the common term for the larynx as a whole and not for the epiglottis. The thyroid cartile is called *scutale*, a literal translation of thyroid, meaning shield-like. Its shape clearly indicates that the drawing is based on the dissection of some animal. The thyroid gland is noted with the statement, *These glands are made to fill in the interval where the muscles are lacking and hold the trachea away from the sternal notch (forcula), as though they were a cushion.* The size of the glands suggests animal material. For *forcula,* cf. 1.

The tendons or cords, a b c d, possibly the stylo-hyoid ligament and glossopharyngeal muscle, may have been thought of as nerves, especially since Leonardo in the accompanying note mentions their arising from the ventricles which would be the 3rd ventricle, or site of the common sense center. The term os basile is from Mundinus.

And attach the whole [drawing to the skull]. *At the same time note the nerves or cords a b c d, arising from the os basilare* [base of the skull] *and from that ventricle.*

And employ the greatest diligence to demonstrate the process of deglutition and also of a high and a deep voice.

Other surrounding notes are: *When one swallows or gulps down a mouthful, one cannot breathe. You will show what are the muscles which thrust the tongue so far out of the mouth and in what way,* cf. 39.

First you will make each part of the instruments which move and define them separately, and then join them together bit by bit so that one can reconstitute the whole with clear knowledge.

In the terminology of the times an instrument was almost but not quite the equivalent of an organ since it had to be a part of the body capable of performing a complete action.

fig 4. **The larynx and upper portion of the oesophagus: posterolateral aspect.**

Accompanying notes read: *Draw this trachea and oesophagus sectioned through the middle so as to be able to show the shape of their cavities.*

And again demonstrate how control of the tongue has been placed in it.

Write on the cause of a high and of a deep voice.

GROUP II, LEFT CENTER.

fig 6. **The hyoid bone and larynx: lateral view.**

The cartilages resemble more closely the human shape than those in figs. 1 and 3. Below the drawing is the

(continued on page 502)

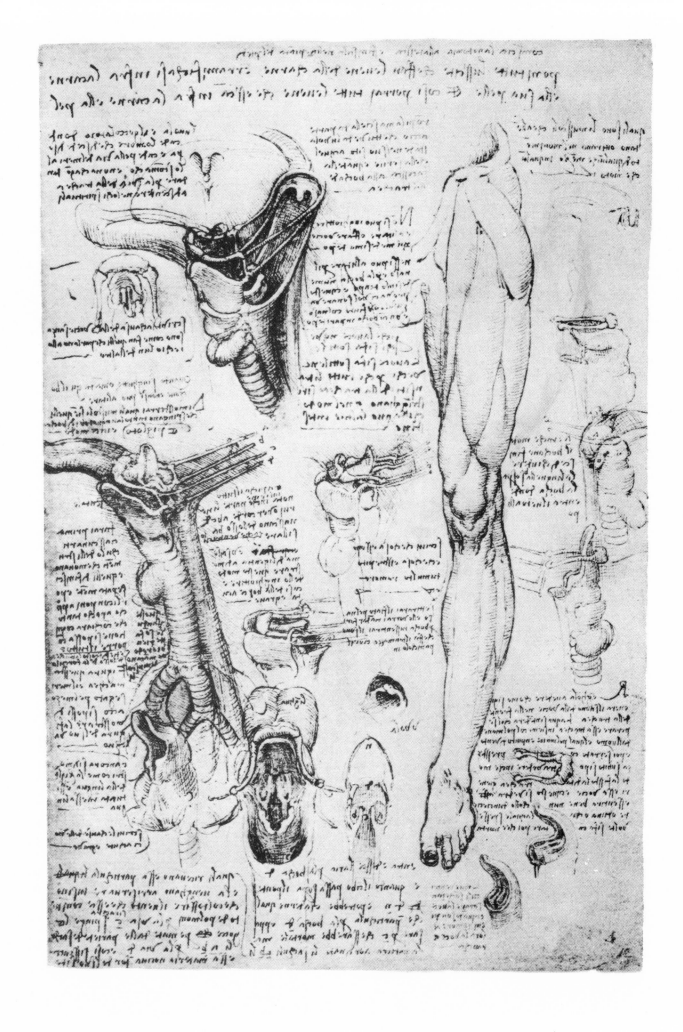

At this period Leonardo believed that the pleural cavities were filled with air. Since neither of his usual sources, Avicenna or Mundinus, mentions this idea, it is possible that the opinion was derived from Galen who states that on inspiration a small quantity of air seeps through the lungs into the pleural cavities. Leonardo, having accepted this opinion, is obviously puzzled and asks such pertinent questions as where this air comes from and where does it go to allow of the expansion of the lungs. He proceeds to theorize and thus arrives at the conclusion that the lungs enlarge laterally, but not downwards, so as to leave a space for the accumulation of this pleural air, which, in turn, causes the downward thrust of the diaphragm. This view is illustrated in the figure. Later, 179, he begins to doubt the existence of this air and definitely states, 31, that expansion of the lungs occurs in all directions and chiefly downwards.

When the lung has driven out the wind and so is diminished in size by an amount equal to the wind which has left it, one ought then to consider from where the space of the capsule [pleura] of the diminished lung attracts to itself the air which fills it on its enlargement, since in nature there is no vacuum.

Furthermore, on enlargement of the lung, one asks whither does it drive out the air of its receptacle [pleural cavity], by what route does this air escape, and, after it has escaped, where is it received?

The lung always remains filled with a quantity of air, even when it has forced out that air which is required for expiration. And when it refreshes itself with new air, it presses upon the ribs of the chest, expands them a little, and forces them outwards, as one sees and feels on holding the hand on the chest while breathing, that the chest expands and contracts, and even more so when one heaves a big sigh. Nature has caused this force to fall upon the ribs of the chest and not on the [pleural] membrane which bounds the substance of the lung, in order that through an extraordinary inspiration of air to create some excessive sigh, the membrane may not happen to rupture or burst.

The diaphragm or thick membrane which lies below the poles of the lung is neither displaced nor pressed upon in any part by the enlargement of the lung, be-cause the lung increases in width and not in length unless the diaphragm were to be driven down by the wind, or rather air, which makes room for the enlargement of the lung. It would then be possible for the diaphragm, driven by the air, to make room for its enlargement. The air would push upon the liver and the liver, the stomach which is covered by it, and so the pressure upon all the intestines would follow. This continuous motion would cause the evacuation of the intestines and with as much more rapidity as the exercise of man is performed with greater vigor.

Of the wind which is generated in the intestines, we shall say that it is caused by the superfluity which collects in the straight intestine [rectum]. The more this becomes dessicated, the more its moisture vaporizes. This vapor, in the form of air, distends the viscera and produces pains when it is restrained within the colon.

fig 1. **The pleural cavities and lungs.**

The pleural cavities a and b, are shown filled with air to illustrate the theory propounded in the notes above. The displacement of this air within the pleural cavity by the expanding lung was presumed to be the cause of the descent of the diaphragm which in turn drives on the content of the alimentary tract. The theory is further elaborated in the note below in which the curious conclusion is reached that the pleural air by pressing upon the pericardium serves to lubricate the heart by displacing the pericardial fluid.

The enlargement of the lung when it is filled with air occurs in width and not in its length, as can be seen by inflating the lung of a pig. The air which is interposed between the deflated lung and the ribs which surround it, with the enlargement of the lung, escapes into the part below, between the lung and the diaphragm. It causes the diaphragm to expand downwards against the stomach, whereas the stomach being compressed sends its contents into the intestines.

Furthermore, this air compressed between the lung and the diaphragm, presses upon the capsule which covers the heart and the small quantity of humor which lies in the base of that capsule is lifted up and bathes the entire heart. And so the heated heart is continually moistened by this bath which prevents its becoming dessicated by its very great motion.

respiratory system

fig 1. **The trachea, bronchi and lungs.**

The primary purpose of the figure is to show the structure of the lung. The position of the heart, the presence of cardiac and intermediate lobes all point to the animal source of the specimen, probably the pig. The three structures observed at the diaphragmatic surface are presumably from left to right, the inferior (posterior) vena cava, the oesophagus and the aorta. On the substance of the parenchyma of the lung, Leonardo writes:

The substance of the lung is dilatable and extensible. It lies between the ramifications of the trachea [i.e., bronchi] *in order that those ramifications may not be displaced from their position, and this substance is interposed between these ramifications and the ribs of the chest to act as a soft covering.*

Since Leonardo assumed that the total cross-sectional area of the terminal bronchi was equal to the cross-sectional area of the trachea (cf. 177), he considered the tidal and complemental air but not the residual air. Thus the parenchyma plays a passive role in respiration as related above. However, elsewhere the residual air is recognized. Proposed methods of illustration follow in the notes:

Remember to represent the mediastinum with the capsule of the heart in 4 demonstrations from 4 aspects in the manner which is described below.

First make the ramification of the lung and then make the ramification of the heart, that is, of its veins and arteries. Afterwards make the third ramification of the combination of one ramification with the other. You will make these combinations from 4 aspects and you will do the same for the said ramification [as in the figure], *so that there will be 12. Then make a view of each from above and one from below that there will be in all 18 demonstrations.*

You will first draw this lung intact, seen in 4 aspects, in its entire perfection. Then you will represent it as seen permeated by the ramification of its trachea only, from 4 aspects. Having done this, do the same in the demonstration of the heart: first intact, and then with the ramifications of its veins and arteries.

Afterwards you will do it from 4 aspects to show how the veins and arteries of the heart intermingle with the ramification of the trachea. Then make a ramification of the nerves alone from 4 aspects, and then interweave them in 4 other views of the heart and lung combined together. Observe the same rule with the liver, spleen, kidneys, womb, testicles [ie., gonads], *brain, bladder and stomach.*

fig 2. **The lungs, diaphragm and subdiaphragmatic viscera in relationship to the spinal column.**

The following structures are named: lung, liver, stomach, spleen, diaphragm, spine, from above downwards. Animal features are again in evidence as in the lobulation of the lung and liver. Above the figure is written, *You will make this demonstration.* The key to the lettered structures is given as follows:

a, trachea whence the voice passes.

b, oesophagus whence the food passes.

c, apoplectic arteries [carotid] *whence the vital spirits pass.*

d, dorsal spine whence the ribs arise.

e, spondyles [vertebrae] *whence the muscles arise which end in the nape of the neck (nucha) and elevate the face towards the sky.*

The *arteriae apoplecticae*, or as Leonardo calls them *ipopletiche*, is the old term for the carotid arteries as employed by Mundinus and so named as the cause of apoplexy. The carotid arteries, of Greek origin, meaning sleep-inducing, were sometimes translated as *arteriae somni*, or *arteriae soporales*.

Always interested in the relative proportions of the human body, Leonardo proposes to give the sizes of the viscera in terms of the length of a finger.

Describe all the heights and widths of the entrails and measure them by fingers, and by halves and thirds of a finger of the dead man's hand. In all these, put down the distance which they have from the umbilicus, or the nipples of the flanks of the deceased.

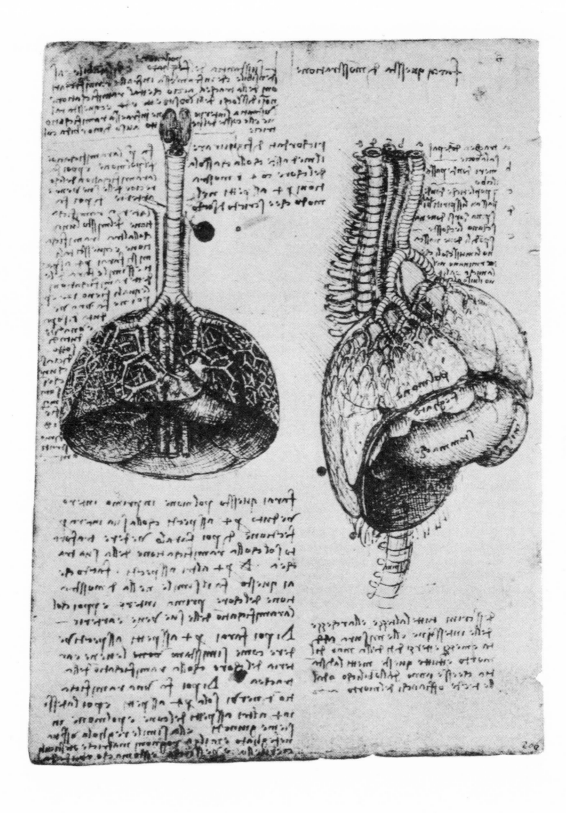

The figures on this page will be enumerated from right to left in the intended sequence. In general the illustrations are typical of the period when Leonardo was attempting to fit the findings of animal dissection both to traditional theory and to the body of man.

fig 1. **The great vessels of the heart and lung.**

The purpose of the figure is to illustrate the supposed pathways for the passage of air to the heart. In Galenical physiology the basic principle of life, the pneuma, is drawn into the lungs with air. It then passes by way of the vein-like artery, arteria venalis, or our pulmonary vein to the left ventricle where, together with the blood which sweats through the interventricular septum, it forms the vital spirits for distribution by way of the arterial system. From the heart, impurities or so-called "sooty vapors" are carried back to the lung by way of the artery-like vein, vena arterialis, or our pulmonary artery, to be exhaled to the outer air. In order to fit the theory to anatomical structure, Leonardo shows the heart, considered to be a two-chambered organ, providing a pulmonary artery above and a pulmonary vein below on either side to the hilus of the lung. On the left side these vessels are lettered m and n, respectively. Not only is his anatomy in error, but his knowledge of Galenical theory is at fault since Galen and his mediaeval followers have the pulmonary artery correctly passing from the right ventricle and the pulmonary vein to the left ventricle. Above the heart we observe a common brachiocephalic trunk arising from the arch of the aorta, which reminds us how great was Leonardo's dependence upon animal anatomy for his knowledge of the distribution of the vessels. The vena cava, hepatic vein, and other structures are easily identified. However, two vessels are shown passing from the spleen. One of these is undoubtedly the splenic vein regarded as the portal vein, and the other represents perhaps the splenic and hepatic arteries in continuity. At any rate, these vessels are shown very diagrammatically.

Below the figure is a note, much of which is lost, but in which the physiological theory discussed above is presented, although later Leonardo discards the notion that air can pass directly to the lung. Above the figure is a brief remark, *Dust causes damage*, doubtless with reference to the lung.

The air sent back from the lung to the heart cannot enter the heart if it has no opening. Therefore it is necessary that there be two passages. When the lung sends forth the air through the trachea, at the same time it must also send air through one of these passages into the cavity of the heart, and through a second passage the air must escape from the heart and return, together with the other air which leaves through the aforesaid trachea, the passage of the lung. Necessity causes the air to be distributed through the spongy entrails of the lung [and], *on being pressed out, every vesicle to be closed in that region. . . . When joined together* [presumably the passages to the heart], *they are much narrower than the trachea* [and], *thus it happens that when one and the same quantity of air*

is forced at the same time through a narrower passage than it enters, it moves more speedily the narrower the passage, and, consequently, the more . . . the speedier it is.

fig 2. **General schema of the cardiovascular system as seen from behind.**

The arrangement of the vessels in the upper part of the figure is essentially the same as that of fig. 1, except that the structures are viewed from behind. Below, the inferior vena cava, descending aorta and their branches are shown. It will be noted that the right kidney lies at a higher level than the left, as in animals. The bladder, seminal vesicle, ductus deferens, epididymis, testis, ejaculatory duct and urethra are all evident, but the prostate, relatively inconspicuous in animals, is lacking. Written on the testis is the remark, *Here the sperm is concocted and it was first blood*, which again reflects Leonardo's acceptance of Galenical theory and change from his earlier quasi-Aristotelian opinions. Arteries were distinguished by their possession of two tunics, and veins only one. The second coat is regarded as supplying a suspensory apparatus for the cardiovascular system.

Owing to its being double [coated], *the artery by its sinewyness (nervosità) performs in many places the office of simple sinews.*

It is observed further that, *The heart is exactly in the middle between the brain and the testicles.*

fig 3. **The heart and the pulmonary vessels.**

The figure is complementary to fig. 1. The right and left ventricular cavities are shown separated by the interventricular septum containing the mythical pores through which the blood sweats in the creation of the vital spirits. From each cavity a pulmonary artery and a pulmonary vein pass to and from the lung as required by Leonardo's incorrect interpretation of Galenical theory. In the right ventricular cavity three moderator bands, Leonardo's unique discovery, are illustrated.

fig 4. **The trachea and ramifications of the bronchi.**

Above and to the right Leonardo reminds himself to draw a figure such as this.

First draw the entire ramification which the trachea makes in the lung and then the ramification of the veins and arteries separately. Next draw everything together, but follow the method of Ptolemy in his geography in reverse. Then you will better understand the whole put together.

In his proposed "order of the book" on anatomy Leonardo states that it is his intention to adopt the plan used in Ptolemy's cosmography, from which Leonardo quotes almost verbatim. The Ptolemy Cosmography was first printed in 1462 and thereafter there were numerous editions, the later ones containing the maps to which Leonardo refers.

At the top of the page is a note, probably written at a much earlier date, on a plan of illustration. *First place the bones, next put upon them successively* [the structures] *further removed from the bones.*

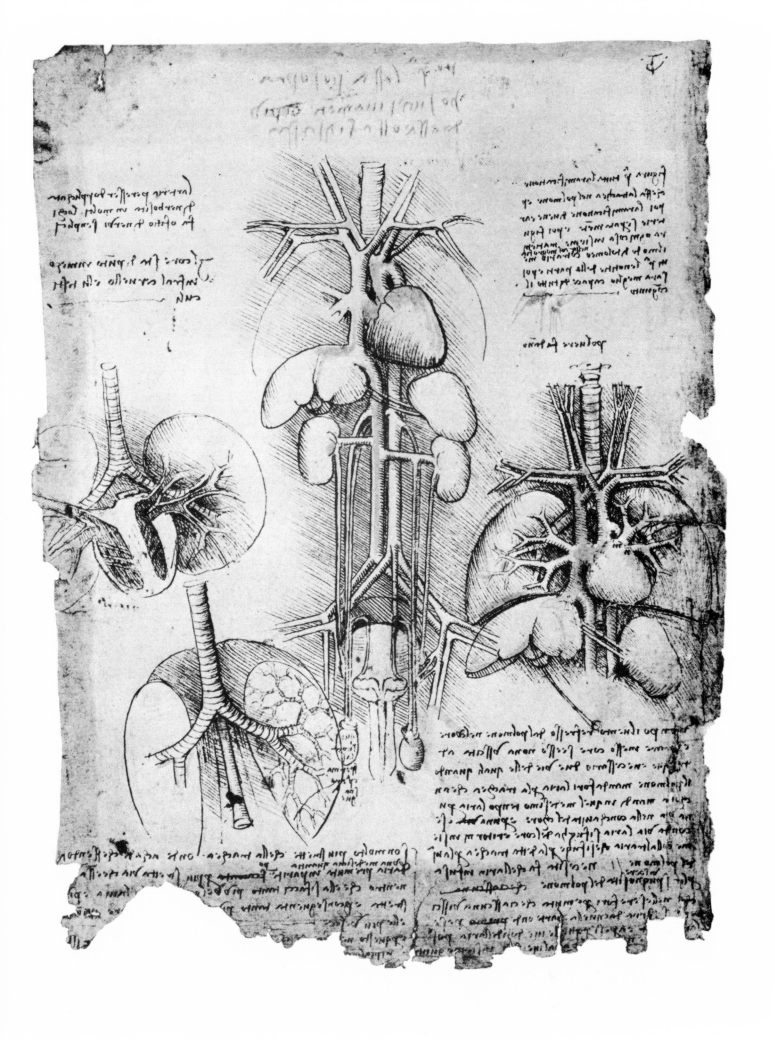

In this, among the latest of Leonardo's anatomical studies, we find far less reliance upon written traditional authority and greater dependence upon direct observation. This is expressed in a marginal note on the superiority of the illustration, and especially composite illustration, over the written word in biological investigation.

With what words, O Writer, will you describe with like perfection the entire configuration which the drawing here does? Lacking knowledge, this you describe confusedly and leave little conception of the true shape of things which you, in self-deception, make believe that you can fully satisfy your auditors when you must speak of the configuration of some bodily structure bounded by surfaces. But I counsel you not to encumber yourself with words unless you are speaking to the blind. If, however, you wish to demonstrate in words to the ears and not to the eyes of men, speak of substantial or natural things and do not meddle with things appertaining to the eyes by making them enter through the ears, for you will be far surpassed by the work of the painter.

With what words will you describe this heart so as not to fill a book? The longer you write on the details, the more you will confuse the mind of the auditor. You will always be in need of commentators or be required to return to experience, which in your case is very brief, and gives knowledge of but few things concerning the whole subject of which you desire an entire knowledge.

fig 1. **The heart, trachea and bronchial tree: posterior aspect.**

The notes pertaining to the figure are scattered irregularly and are here rearranged in some degree of logical sequence. The figure is based upon the findings in the ox. The posterior aspect of the heart is shown as noted by the words, *Seen from behind,* and *right* and *left* placed upon the respective ventricles. The great and lesser cardiac veins and the inferior interventricular and circumflex branches of the right coronary artery are shown ramifying on its surface. Leonardo makes a number of notes on the coronary vessels.

ON THE VESSELS WHICH NOURISH THE HEART.

They always lie naked upon the heart and their lateral portions are surrounded by suet-like fat, that is, dense fat.

Here he follows the traditional classifications of fat into hard and soft. He reminds himself that, *There is the vein and the artery of the heart, and then draw them in position.*

The atria are not shown. Arising from the base of the heart are presumably the pulmonary artery on the left and the superior (anterior) vena cava on the right. Bronchial arteries, n m, spring from the pulmonary to pass to the bifurcation of the trachea, and branches follow the ramifications of the bronchi. To distinguish the bronchial arteries from branches of the pulmonary vessels, they are called vessels of the first order. *The first [i.e., bronchial] artery divides at its point of contact with the first division of the trachea. . . .*

A dual blood supply to the lung by way of the bronchial as well as pulmonary vessels was a source of puzzlement. Leonardo correctly concludes that the bronchial vessels supply the parenchyma. On reading his note it should be remembered that the term trachea is applied to the entire bronchial tree.

A REMINDER.

You have to consider the second order [i.e., pulmonary] of veins and arteries which cover the first [i.e., bronchial] veins and arteries which nourish and vivify the trachea, what material is it that interposes itself between the first and second [order of] veins and arteries, and why in such an instrument did Nature duplicate artery and vein, one upon the other, finding themselves for the nourishment of one and the same member. You could say that the trachea and the lung had to be nourished, and if you had to do this with a single large vein-like artery (venarteria [=pulmonary vein]), this [vessel] could not remain attached to the trachea without great hindrance to the motion which occurs with the expansion and contraction of the trachea in length as well as in width. Consequently, for this reason she [i.e., Nature] gave such [bronchial] veins and arteries to the trachea as were needed for its life and nourishment, and separated a little from the trachea the other large [pulmonary] branches to nourish the substance of the lung with greater convenience.

Further details on the arrangement of the pulmonary vessels within the substance of the lung are described.

The [pulmonary] veins and arteries, which are united, have a membrane which clothes them. If this membrane finds such a vein and artery applied to some other flesh, it clothes half their width and the other half will be clothed by the flesh to which they are applied. But if they are not applied to this flesh, then the membrane surrounds them or in addition to this is continued into the space interposed between the bifurcation of these vessels, and especially in the substance of the lung.

The [pulmonary] artery lies somewhat below the vein, although some of its ramifications sometimes lie above the vein.

By the above statement Leonardo means that the artery is more closely related to its bronchus. We learn elsewhere that this arrangement is needed since the artery conveying heat requires to be cooled by the incoming air more than the vein.

The bronchial tree and parenchyma of the lung are described:

These [bronchial] ramifications are interwoven with the substance of the lung. This substance is in itself dilatable and extensible like the tinder made from a fungus. But it is spongy and if you press it, it yields to the force which compresses it, and if the force is removed, it increases again to its original size. This substance is clothed by a very thin membrane [pleura] which is opposed to the rib space. When it [i.e., lung] enlarges, it never ruptures because it is never entirely filled with air.

Along the right margin of the lung the pennate appearance of the first, second and third orders of

(continued on page 503)

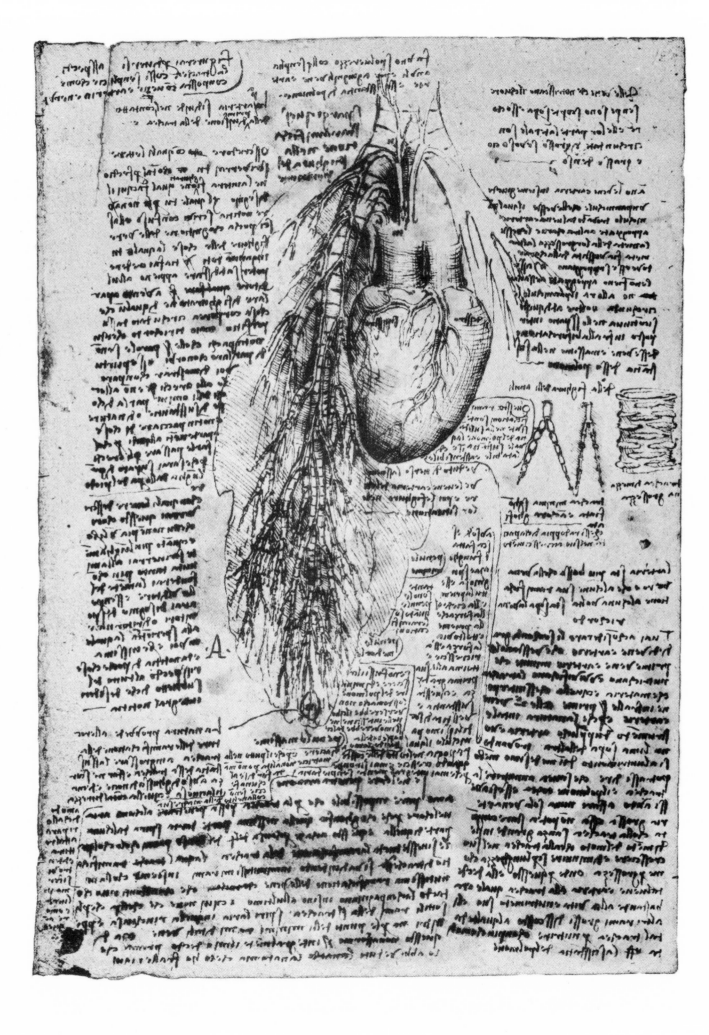

This series of sketches of segments of the minor bronchi are details closely related to the more general illustration of the bronchial tree found on 173, and of approximately the same date. It should be noted that the term trachea is applied to the entire respiratory tract.

fig 1. **A bronchial segment and its nerves.**

Below the figure is the legend *Ramification of the nerves upon the ramification of the trachea* [bronchus]. The difficulty of demonstrating the fine nerve bundles accompanying the bronchial tree from the pulmonary plexuses, and the fact that connective tissue strands were classified as nerves, makes their identification dubious.

fig 2. **A bronchial segment and accompanying pulmonary vessels.**

The close relationship of the pulmonary artery to the bronchus is explained:

The vein always lies upon the artery, and the artery is refreshed by the air of the trachea [bronchus] *more than the vein, because the artery being warmer has greater need for this.*

Leonardo was willing to accept the Galenical teaching that the lungs cooled or "refreshed" the arterial blood, but at this period he denied the existence of any free communication of air with the vessels, cf. 173.

fig 3. **Rough sketch of the bronchial tree and related vessels.**

Make 3 figures of the trachea, that is, first of the simple trachea from behind and in front, and from the right and the left side: then one with the nerves and one with the veins and arteries.

fig 4. **A bronchus.**

The figure carries the legend, *The simple trachea.*

figs 5-6. **A bronchial segment and bronchial artery.**

The legend reads, *Trachea* and *artery*; reference to 173, identifies the vessel as a bronchial artery.

figs 7-8. **A bronchus in inspiration and expiration.**

The trachea a b, is full of air, and the trachea b c, is empty of air.

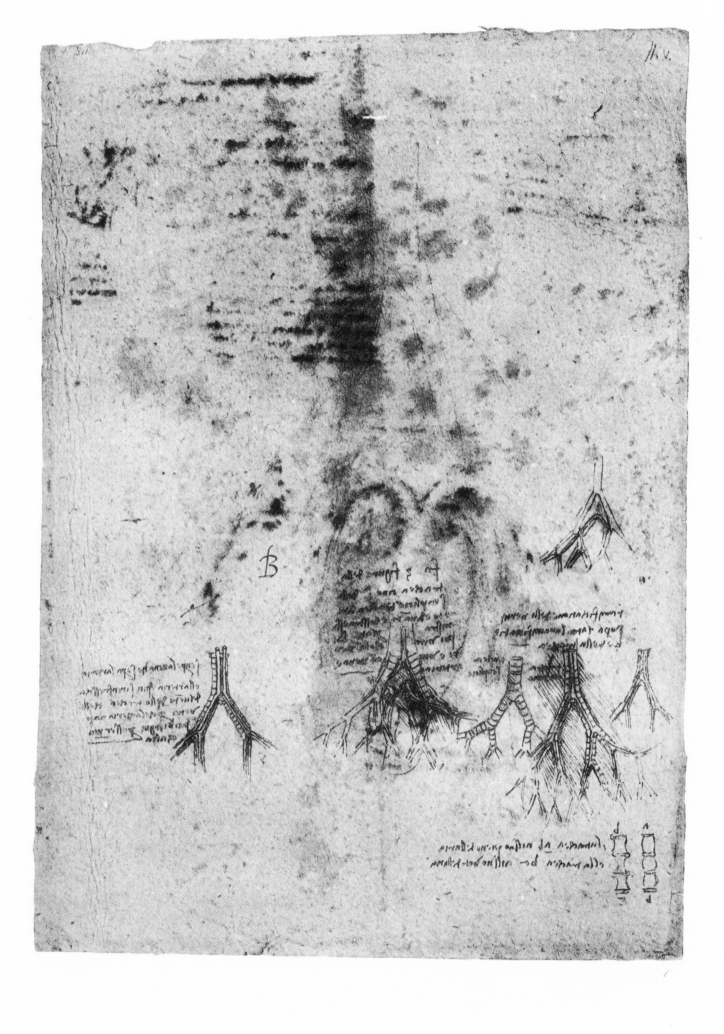

It is necessary, owing to Leonardo's arrangement, to follow the columns vertically from right to left in the enumeration of the figures.

Leonardo was greatly interested in the mechanics of respiration and in his earlier studies for the most part followed and elaborated upon the Galenical conception that the external intercostal muscles act on inspiration, and the internal on expiration. Here in his latest writing he modifies and extends his views on the action of these muscles in forced respiration. The intercostal muscles are now regarded as acting in opposition to the transverse muscles of the anterior abdominal wall. But first of all he considers the action of the abdominal muscles in forced expiration.

ON FORCED RESPIRATION.

When the lung is contracted beyond the ordinary, this contraction is not caused by it but by the abdominal wall (mirac) which with its transverse muscles compresses and elevates the intestines beneath the diaphragm. The diaphragm forces the lung against the concavity of the chest, compresses it, drives a large quantity of air from it and causes it to decrease in size by an amount proportional to the air which is removed from the lung.

The term *mirac*, from the Arabic *maraqq*, most commonly meant the anterior abdominal wall or simply the abdomen, although it was sometimes applied more specifically, but variously, to the epigastrium, the hypogastrium or to the umbilicus. It is employed by Avicenna and Mundinus.

fig 1. **Diagram of internal intercostal muscles.**

fig 2. **Serratus posterior inferior muscles or serratus anterior, labelled a n m.**

fig 3. **Opening of the contra-lateral intercostal spaces on lateral bending.**

The above three figures illustrate the argument of the note below in which forced inspiration is discussed.

ON THE MAXIMUM EXPANSION OF THE LUNG.

The maximum expansion of the lung is caused by the greatest shortening of the diaphragm and by the greatest tension of the transverse muscles of the abdominal wall.

But at this time the [intercostal] muscles [cf. fig. 1] interposed between the ribs of the chest are expanded, and the [serratus posterior inferior] muscles [fig. 2] which clothe the ribs below the nipples towards the flanks are shortened and draw the ribs behind them in such a way that they expand them. But, as for me, I judge that the maximum expansion of the ribs is caused by the transverse muscles of the abdominal wall, because if you hold your breath, you will observe that it is impossible for you to increase and enlarge the chest, and if you appear to enlarge it, it is because you force your shoulders backwards and increase the extent of the chest interposed between the shoulders, and, besides, you arch and bend in the spinal column. However, if you would observe the expansion of the chest by the aid of its muscles, attempt to expand it

by force, and hold the thumbs along the borders of the flanks against the transverse muscles, and you will feel that the force of the expansion of the chest is caused by the force of these transverse muscles and not by the [intercostal] muscles of the chest. The latter [intercostal muscles] are made solely so that the ribs may not expand more than they should in the transverse [i.e., lateral] motions made to the right and left, in which the ribs, while restrained on one side, are strongly expanded on the other, and they would open up the chest if it were not for the muscles [as in fig. 3].

At this point is interposed a note, possibly of earlier date, on the motion of water, but omitted here for lack of concern with the present subject.

fig 4. **Diagram of the external and internal intercostal muscles.**

The diagram is to illustrate the accompanying note in which it is contended that the intercostal muscles oppose rotatory motions of the body but assist these motions when the body rotates freely.

These [intercostal] muscles between the ribs are in a position to oppose the transverse [rotatory] motions, that is, if you jump upwards and spin round with the aid of the motion of the arms made in the same direction, the force of these [muscles] draws the body behind them on turning around.

fig 5. **Sketch of a figure in a squatting position for defecation.**

figs 6-7. **Diagrams of torso in flexion to show shortening of ventral muscles.**

These diagrams illustrate the accompanying note in which Leonardo attempts to show that defecation is not due to the action of the abdominal muscles but, by inference, to the diaphragm. An important physiological observation is made on the length-tension relationship of muscle as it was eventually to be established by Blix in 1895.

The [anterior] longitudinal muscles do not act on evacuation of the intestines, because the more a man flexes himself, the more these muscles relax in such a way that they diminish by half their length, as you may observe is done by those who desire to generate great force in this evacuation. These muscles having been shortened by half, are compelled to relax and without any strength remain useless. Therefore these muscles do not act on such exertion.

fig 8. **The quadratus lumborum muscle.**

This sketch shows the attachments of the quadratus lumborum muscle which are called the muscle of the *lonbi*, that is, the lumbar muscles. Its purpose is to illustrate the note discussing antagonistic and synergistic (*adeventi*) muscles. Having discussed the action of the transverse muscles of the abdomen, Leonardo now proceeds to a consideration of the longitudinal.

FOR WHAT SERVICE WERE THE LONGITUDINAL MUSCLES OF THE BODY MADE.

The longitudinal muscles of the body were made to flex the body forwards with unvarying power and an-

(continued on page 504)

The figures on this page are to illustrate various statements on the function of the diaphragm discussed in the notes. However, they are very haphazard in arrangement, and in order to bring them into relationship with the appropriate note, although they will be numbered from left to right in the customary manner, they will not be discussed sequentially. At the top of the page is a remark on the heart written as though Leonardo had intended to continue his discussion on this subject in uniformity with a previous page, 93-4, but failing to do so, has filled the rest of the page with observations on the diaphragm. These remarks on the heart are very tantalizing for the question asked, but not answered, carries one to the threshold of a discussion on the pulmonary circuit or lesser circulation of the blood. It should be remembered that the air was supposed in the Galenical system to pass to the left side of the heart.

ON THE HEART.

Whether the veins of the lung do not return the blood to the heart when it contracts after driving out the air.

figs 5-8. **The diaphragm, to show its spoon or ladle-like shape.**

The diaphragm has a shape similar to a very hollow spoon.

In fig. 7, not only is the diaphragm shown but also some of the other respiratory muscles. Extending from the cervical spine to the thorax are the scalene muscles, and it will be noted that the scalenus anterior muscle is shown inserting at the level of approximately the sixth or seventh rib, an arrangement found in animals but not in man. Attached to the lower rib are, presumably, digitations of the serratus anterior muscle with which Leonardo apparently includes the serratus posterior inferior. He invariably fails to realize that the serratus anterior is inserted into the vertebral border of the scapula but believes it to be attached to the vertebral column. Consequently, he maintains that this muscle with its fellow compresses the lower ribs and thus relaxes the diaphragm, aiding in its ascent as described in the related note. However, he immediately discards this notion and contends that these muscles stabilize the lower ribs as described a little further on.

When the [serratus anterior] *muscles which lie below the nipples and are attached to the ribs, compress these ribs, then the diaphragm becomes highly concave and contracts at its borders which exist at the cartilage or tips of the ribs, etc.*

figs 3-4, 9. **Diagrams on the action of the scalene and serratus muscles in respiration.**

These diagrams are to illustrate the lengthy note below in which Leonardo reverses the opinion stated above on the action of the scalene and serratus muscles. In fig. 3, are shown the scalene muscles. Fig. 4, represents an articulated pair of ribs in which o p, and n m, indicate the anterior scalene muscles, and m r, and f g, behind and above, the serratus anterior. It is now held that these muscles prevent the collapse of the lower ribs on contraction of the diaphragm, and so they are regarded as stabilizing muscles. It should be remembered that the scalenus anterior is visualized as extending to insert at the level of the costal margin as in animals. These views are more clearly illustrated in fig. 9. The diaphragm h a b, is attached to the costal margins at h and b. The vertebral column is lettered r m a. The thoracic walls are shown in two positions, m c b, and m f h, on expiration, and expanded to m c n, and m f g, on inspiration through the action of the scalene muscles, r c, and r f. In this way the fulcrum is stabilized to resist the contraction of the diaphragm. Below is the alimentary tract, the contents of which are forced on in spurts, analogous to peristalsis, by the rhythmic descent of the diaphragm.

I have found why necessity strengthens the cartilages where the anterior borders of the diaphragm are attached. When this [diaphragm] *expands and drives the gibbosity of the intestines downwards to increase the space in the chest for the lung, so that the lung can retain in this space the air taken in by it, the diaphragm could not do this if the internal muscles of the chest did not contract simultaneously with those in front of and behind the ribs* [Quaderni incorrectly transcribes *collo* for *costo*]*, as is seen* [fig. 4] *in the muscles in front n m, o p* [scalenus anterior]*, and those behind f g, m r* [serratus anterior and posterior]*. Since the muscle called the diaphragm would contract from the middle towards its circumferential borders,* [and] *it could not do so unless these borders were well stabilized, because if this stability did not occur there, the borders of the diaphragm would proceed towards its middle and so would pull after it the cartilages and, successively, the tips of the ribs and the thorax to which they are united. Consequently the chest would be contracted instead of its necessary dilatation. Hence Nature provides it with the above mentioned 4 groups of lacerti* [strap-like muscles] *and muscles to prevent the chest from being contracted and drawn inwards by the contraction of the diaphragm and that it may be opened and expanded with ample enlargement by the aforementioned muscles and lacerti.*

In the 5th [book] *"On forces" is proved what is contained above, that is, if the force of the diaphragmatic membrane is unable to drive the intestines downwards by its contraction, the diaphragm will then pull towards itself the sides where it is attached by its borders. Let the diaphragm be h a c* [in fig. 9] *which is attached by its borders to the ends of the ribs m c b, and m f h. I state that if this diaphragm contracts in itself with its own force to obliterate its curvature h a b, and to straighten out, and if this were prevented by the gibbosity of the intestines on which it rests and which it presses down, then the diaphragm in the process of its advancing contraction will draw towards itself the ends h b, of the ribs m f h, and m c b, and draw them along the line a b, and a h, and so contract the space h b. But Nature has provided against this by means of the* [scalene] *muscles r f, and r c, which bend and elevate these ribs from m c b, to m c n, and from m f h, to m f g. In this way the pulmonary cage is dilated and its capacity increased together with the lung which increases with it. As there is no vacuum*

(continued on page 504)

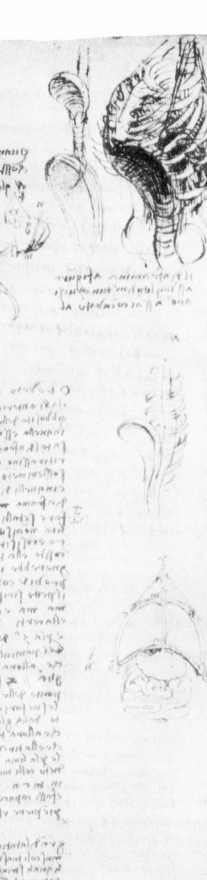

fig I. Diagram on the functional relationship of the diaphragm to the stomach.

The figure is purely diagrammatic to illustrate Leonardo's discussion. The oesophagus is lettered a d, the stomach and duodenum, b, and the spinal column, f. The notes are devoted not only to the function of the diaphragm but also to its presumed effect on the stomach. The descent of the diaphragm is held to be an active process due to the contraction of its muscles. Ascent of the diaphragm is a passive recoil produced by expansion of the gases within the intestines previously compressed by diaphragmatic descent and by the active contraction of the anterior abdominal wall. The rhythmic ascent and descent compress the stomach and cause rhythmic expulsion of the chyle. The terms, spiritual and natural members, are those customarily employed by mediaeval anatomists for the contents of the thorax and abdomen; in the Galenical physiology the lung and the heart are responsible for the formation of the vital spirits, and the alimentary tract for the chyle which is elaborated by the liver into venous blood charged with the natural spirits. The ideas expressed are taken almost wholly from Mundinus.

ON THE MUSCLE CALLED THE DIAPHRAGM AND ITS FUNCTION.

The uses of the diaphragm are four. The first, that it be the source of the dilatation of the lung by which the air is attracted. The 2nd, that it compress the stomach which is covered by it and expel from it the digested food into the intestines. The 3rd, that it constrict and help to compress, with the aid of the abdominal wall, the intestines to drive out the superfluities. The 4th, that it separate the spiritual [thoracic] members from the natural [alimentary].

The above-mentioned four uses exercised by the diaphragm are achieved by it through one and the same cause, which is solely by its expulsion [i.e., ascent] and attraction [i.e., descent]. By its expulsion the air is driven out of the lung. This expulsion is not caused by the diaphragm but by the rarefaction [expansion] of the air which was previously condensed in the intestines when the diaphragm retracted and increased the capacity of the lung, drawing in the air behind it. When the diaphragm relaxes it is not in itself capable of curving and forming a large hollow if the compressed intestines did not dilate and enlarge under the diaphragm. At this time the intestines press the stomach from below upwards against the diaphragm and compel it to expel part of the chyle which is generated in it. Then when the diaphragm retracts, it presses the stomach from above downwards and again compels it to expel a part of this chyle. If you were to say that it is not possible for the air to be condensed in the intestines by the pressure of the diaphragm, because if an intestine is compressed from above it dilates transversely, and hence the air is not condensed, to this it is replied that dilatation is prevented by the walls of the intestine which, even if they are dilated, are compressed inwards by the contraction made by the abdominal wall. Hence, although the intestines have been stretched, the air in them is condensed.

But the compression of the stomach from below up-

wards against the diaphragm which forms a cover for it is not as great as the force which presses from above downwards, because on being pressed from below upwards the diaphragm is relaxed and allows itself to be forced to enlarge by the air of the bowels. It does not find any obstruction above because the lung itself is composed of a very light substance and its passages remain continually open, hence air escapes from the lung with ease.

Leonardo next discusses the tidal air, ignoring the residual air which remains in the lungs after expiration, although he was aware of its presence, cf. 170. He erroneously assumes that the total, cross-sectional area of the ultimate branches of the bronchi is equal to the cross-sectional area of the trachea to allow for the free flow of air. However, he believes that the respiratory tree is constricted at the larynx to permit the development of the pressure needed not only for the production of the voice but also, as was the common notion, to fill the ventricles of the brain.

WHETHER THE AIR WHICH ESCAPES FROM THE TRACHEA IS CONDENSED DURING ITS TRANSIT OR NOT.

The total amount of air which enters the trachea is equal to the total number of stages [i.e., divisions] which are generated from its ramification, like the branches produced in the annual rings of a plant in which each year the total estimated size of its branches, when added together, is equal to the size of the trunk of the plant.

However, the trachea is constricted at the larynx (epigloto) to condense the air which appears to come from the lung for the creation of various types of voices and also to compress and dilate the diverse passages and ventricles of the brain. Consequently, if the trachea were to be enlarged at its upper end, as it is in the throat, the air could not condense and perform the uses or offices essential to life and to man, that is, in speaking, singing and the like. The gust of wind driven out of the lung in the generation of a large breath comes from the aid of the abdominal wall which compresses the intestines, and they elevate the diaphragm which compresses the lungs.

In the final note Leonardo returns to the question of the influence exercised by the diaphragm on the motions of the stomach. Unless one is familiar with the ramifications of the humoral doctrine the meaning of this note will remain obscure. Leonardo is commenting upon, only to discard, a fundamental theory on what was called "natural action and motion". The ideas were derived from Aristotle and Galen. An action or function proceeds from one or other of the three principal faculties, animal, vital or natural related to the nervous, cardio-vascular or alimentary systems. These actions are further classified as either voluntary or natural, that is, involuntary. Natural or involuntary motions include the motions of the heart as well as of generation, growth and nutrition, called the powers. The alimentary tract has therefore the specific power of nutrition which depends upon the ability of its tissues to attract, retain and expel food and its products. These functions are supposedly effected respectively

(continued on page 505)

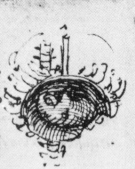

178

respiratory system

Clark 19065v / Q I 6v / c. 1504-09 **404**

Leonardo continues in greater detail the argument presented in 177, on the influence of the respiratory movements of the diaphragm in the emptying of the stomach, and he offers a mechanical explanation in opposition to the Galenical theory.

figs 1-2. **Diagrams to illustrate the interaction of the diaphragm and anterior abdominal wall in respiration, and on the alimentary canal.**

In the upper or inset figure the diaphragm, the boundaries of which are lettered a b c d, is viewed from below to demonstrate its cupola o. The lower figure shows the body in diagrammatic, sagittal section to illustrate the changes in abdominal capacity on ascent and descent of the diaphragm. The figure is fully described in his note which follows:

ANATOMY.

HOW THE NUTRIMENT OF MAN LEAVES THE STOMACH, ITS DISPENSOR, IN SPURTS.

The nutriment of the body of animals escapes or is expelled from the stomach, its dispensor, in spurts or, let us say, by impulses separated by intervals of quiet. This is caused by the motion of descent of the diaphragm and by the return motion of the abdominal wall. It is proved thus:

HOW THE DIAPHRAGM OF ITSELF HAS NO OTHER THAN A SINGLE MOTION.

The diaphragm of itself has only a single motion which is that which causes it to leave the lung as the lung follows behind it. The second motion is produced by other structures and is that which as it retreats causes the lung to return. The force which causes the retreat is produced by the abdominal wall. Thus the natural motion which is generated by the diaphragm n m f, is demonstrated by [the movement of] n m f, to n g f. This would leave vacant behind it the space a, were the lung not to occupy it by its enlargement as it fills with air. At the same time the abdominal wall f h s, retreats to f c s, and the intestines b, which are expelled from the space a, are withdrawn into the space c, that is, when the intestines at a, descend to b, those at b, descend into the space c. Now the small curvature n g f, of the diaphragm cannot of its own accord increase [i.e., re-establish] its former large curvature, that is, n m f, because the function of muscles is to pull and not to push. Hence, if it is to occupy the position n m f, it is necessary that its incurving be assisted by another incurving that it may withdraw and distend with a smaller [for larger] curvature. This the abdominal wall will do, and when it has been pushed forwards from f h s, to f c s, by the descent [Leonardo has astenstione, ascent, for attensione, descent] of the diaphragm, will return presently back to f h s, by its ascent. This will drive the diaphragm n g f, into the position n m f. And so these two opposite motions acting like a flux and reflux, are made by the diaphragm against the abdominal wall and then by the abdominal wall against the diaphragm.

Leonardo concludes that the primary movement of respiration is diaphragmatic contraction and its sec-

ondary movement is relaxation since at death the diaphragm is always found relaxed.

Which was the first to extend into the human body —the inward curvature of the diaphragm or the inward curvature of the abdominal wall, and which was the last?

Of the two motors of the food and of the air within the human body, the diaphragm was the first on straightening out to draw the air behind it by means of the enlargement of the lung and to compress the intestines against the abdominal wall. At the same time the abdominal wall was compelled to curve [outwards] and, on the second occasion, straightens and restores the previous roundness of the diaphragm. And so it will act successively throughout life with this successive flux and reflux. The final motor will be the abdominal wall which by discarding its accidental curvature, first given it by the diaphragm, will at last straighten and return to the diaphragm its previous natural curvature for ever, etc.

The ascent and descent of the diaphragm compresses the stomach rhythmically forcing its contents onwards. The food cannot return by what we would call reverse peristalsis owing to the action of the pylorus and flexures of the duodenum.

fig 3. **The stomach and duodenum.**

The flexures of the duodenum are lettered a b. They are present to prevent the return of chyle into the stomach. Expiration causes the gases within the intestines to expand, and this expansion constricts the duodenal flexures.

A CONCLUSION FROM WHAT HAS BEEN STATED, HOW THE FOOD ESCAPES FROM THE STOMACH BY IMPULSES.

From what has been stated it can be concluded with certainty that the flux and reflux of the 2 powers created by the diaphragm and abdominal wall are those which compress the stomach and produce interrupted expulsion, that is, impulses separated by periods of quiet with short intervals of time during which the food is [alternately] expelled and retained by the stomach. It cannot return to the stomach because the pylorus (portinaro) shuts at the time of the flux made on the re-acquisition of the power of the diaphragm [i.e., during diaphragmatic ascent].

I shall also say of the abdominal wall that it drives the wind from below upwards, because the abdominal wall first contracts from below where it possesses a smaller space between the pubis (pettine) and the loins (reni) than exists above at the level opposite the stomach. Therefore the twistings of the duodenum are placed at the fundus of the stomach and constrict one another in such a way as to close against the pylorus.

These motions [of the stomach] are simultaneous and cease simultaneously. The first natural motion begins at the diaphragm, and the second natural motion terminates in the abdominal wall. But they cease at the same time, that is, the abdominal wall terminates its natural motion on retraction when the diaphragm relaxes from its contraction.

On the significance of the term "natural motion", cf. 177.

This sheet is of the greatest importance for the chronology of Leonardo's studies since it carries at the top of the page the date, *On the 9th day of January 1513.* This is the last date found on any of his drawings. At the end of the year he was in Rome where he continued his anatomical studies although frustrated by the complaints of the German mirror-maker. Thereafter Leonardo's anatomical investigations appear to have ceased. In addition to the anatomical drawings there are various architectural studies including the plan of a fortress on the bend of a river. These will not be considered.

figs 1-3. **Diagrams of the diaphragm in expiration and inspiration.**

The first of these figures shows the diaphragm in full expiration. The zig-zag slips or origin of the diaphragm from the ribs suggest an animal source, possibly the dog, as implied below. The method of illustrating the diaphragmatic origin is very similar to that on 30 and 31, of the same date. In the second figure the diaphragm is shown in inspiration and in the third in some intermediate position. At this period Leonardo had begun to modify and correct earlier views on the action of the diaphragm in respiration. He formerly believed, in accordance with Galen, that the pleural cavities contained air (cf. 170) which led to erroneous conclusions. He now doubts that this is so with the statement: *Whether any quantity of air is interposed in any part between the lung and the chest or not.*

figs 4-5. **The diaphragm and its relations to the alimentary tract.**

These rough diagrams relate to Leonardo's theory on the mechanism of diaphragmatic ascent and descent. He saw that descent of the diaphragm was due to its contraction, but how to explain its ascent? He offers the opinion that since diaphragmatic descent caused a compression of the gases within the intestines and protrusion of the anterior abdominal wall, its ascent must be due to the expansion of the intestinal gases assisted by the elastic rebound and active contraction of the belly wall. This is shown in fig. 7 below. However, he was becoming dissatisfied with this explanation as may be seen from 31, and is apparently looking for some other mechanism. Thus he remarks:

The ureters and the kidneys, the spermatic vessels [ductus deferens] and the diaphragm are outside the peritoneum, and so are the greater and emulgent [renal] vessels. The intestines are within the peritoneum.

The term emulgent vessels, or veins (venae emulgentes), for renal vein is from Mundinus, and derived from the same root as the word "milk" since these veins were believed to milk off the watery element of the blood, containing impurities such as the yellow bile, through the kidneys to form the urine.

fig 6. **Posterior wall of thorax.**

We have been unable to determine what the structures lying parallel to the spinal column are intended to represent. They may be the levatores costarum muscles or perhaps the crura of the diaphragm or even the psoas muscles, of which Leonardo was uncertain of the position for he says below the figure: *See the dead dog, its loins and diaphragm and the motion of the ribs.*

fig 7. **The diaphragm and subdiaphragmatic organs in expiration.**

The diagram shows the ascent of the abdominal organs in full expiration. The action of these organs in the production of the diaphragmatic ascent is discussed above. Leonardo realizes that the respiratory movements of the diaphragm are enhanced by those of the ribs.

The compound motion which the diaphragm possesses is the reason why the lung gathers into itself more air than the dilatation of the ribs gives off, and that the dilatation of the ribs gives more air to the lung than the dilatation of the diaphragm gives it.

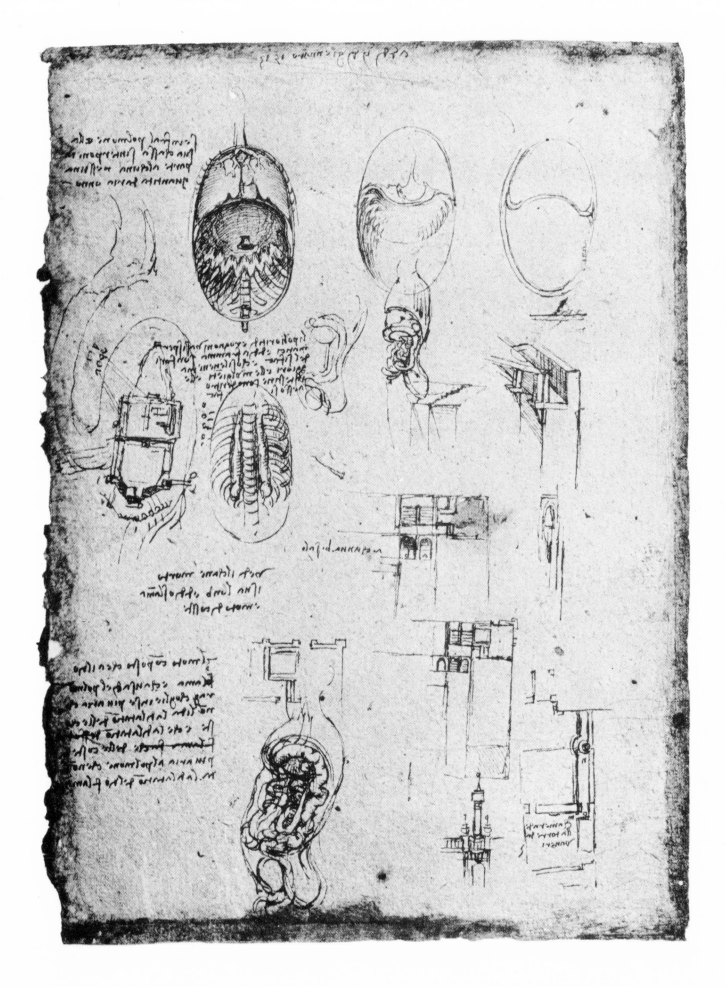

ALIMENTARY SYSTEM

alimentary system

THE MUSCLES WHICH MOVE THE LIPS OF THE MOUTH.

fig 1. **The lips pursed.**

The lateral angles of the lips are lettered n m, and the middle, o p. In juxtaposition to the region of the orbicularis oris, shown pursing the lips, is the remark, *Here the lips become muscular moving with them the lateral muscles,* and on the cheek, lateral to the angle of the mouth and drawing attention to the antagonists of the orbicularis oris, is written, *And then the lateral* [muscles] *move the lips.* This is illustrated in the next figure.

fig 2. **The lips stretched by retraction of the angles.**

The figure complements that above. The angles are lettered c b, and the middle or median tubercle by a. The action of the antagonists to the orbicularis is illustrated. Below the figure Leonardo writes:

It must first be noted on the bones of the face in which part they arise and whence the sinews go which first open and then close the lips of the mouth and where the muscles penetrated by these sinews are attached.

fig 3. **Diagrammatic sagittal section through the lips to show the position of the orbicularis oris muscles.**

A lengthier note discusses the matter illustrated in the above three figures.

The muscles [orbicularis oris] *called the lips of the mouth, on contraction towards their middle, draw behind them the lateral muscles. When the lateral muscles retract towards themselves on shortening, then they draw behind them the lips of the mouth, and so the mouth is stretched, etc.*

The maximum shortening of which the mouth is capable is equal to half of its greatest extension and is equal to the greatest length of the nostrils of the nose and of the interval interposed between the lacrimators [naso-lacrimal ducts] *of the eyes.*

figs 4-5. **The lips retracted to expose the teeth in anterior and lateral views.**

The frenulum of the upper and of the lower lips are lettered o p, and n m, respectively, and these folds of mucous membrane are considered to be the tendons of muscles which close the lips against the teeth.

The sinew n m [frenulum] *in the lower lips and the sinew o p* [frenulum] *of the upper lip are the cause of the closure of the mouth with the aid of the muscles of which the lips of the mouth are composed.*

fig 6. **The womb of the cow.**

In this slight sketch of the uterus and vagina of a pregnant cow the outline of a foetus in the interior may be observed. The bicornuate nature of the uterus in this animal is not indicated. The vessels are presumably the uterine.

fig 7. **The lips retracted between the teeth.**

The sketch shows the lips g h, retracted into the oral cavity and lying between the teeth. Laterally at r, is presumably the buccinator muscle which is supposed in part to effect this action.

ON THE SINEWS WHICH CLOSE THE LIPS.

There are two motions which effect the closure of the lips. One of these is that which closes and compresses one lip against the other. The 2nd motion is that which constricts or shortens the length of the mouth. But that [muscle] *which compresses one lip against the other, lies upon the last molar of the mouth. When these contract they have such power that on holding the teeth a little open, they draw the lips of the mouth within the teeth, as is shown in the mouth g h* [fig. 7], *being drawn by the* [buccinator] *muscles r, at its sides.*

fig 8. **The presumed action of the buccinator and orbicularis oris muscles in retracting the lips.**

The sketch shows what is probably the buccinator muscle t r, extending into the orbicularis oris of the upper, m o n, and lower lip, d c s. Their conjoint action is believed to retract the lips from the teeth as shown.

fig 9. **The lips constricted or pursed.**

fig 10. **The buccinator and orbicularis oris muscles.**

The muscles are lettered as in fig. 9 above. t v, is presumably the buccinator, m o n, and d c s, the orbicularis oris. A note on the action of the buccal muscles provides rules for the determination of the action of these muscles and refers principally to fig. 9.

WHAT ARE THE MUSCLES WHICH CONSTRICT THE WIDTH OF THE MOUTH.

The muscles which constrict the mouth along its width as is shown above [fig. 9] *are the lips themselves which draw the sides of the mouth towards its centre. This is shown by the 4th* [rule] *on this subject which states: The skin, the covering of the muscles which contract, always points by means of its wrinkles to the place where the cause of the motion exists; and by the 5th* [rule] *no muscle employs its power to push but always to pull towards itself the structures which are connected to it. Therefore the centre of the muscles called the lips of the mouth pulls towards itself the extremities of the mouth with a part of the cheeks, and for this reason the mouth in this function is always filled with wrinkles.*

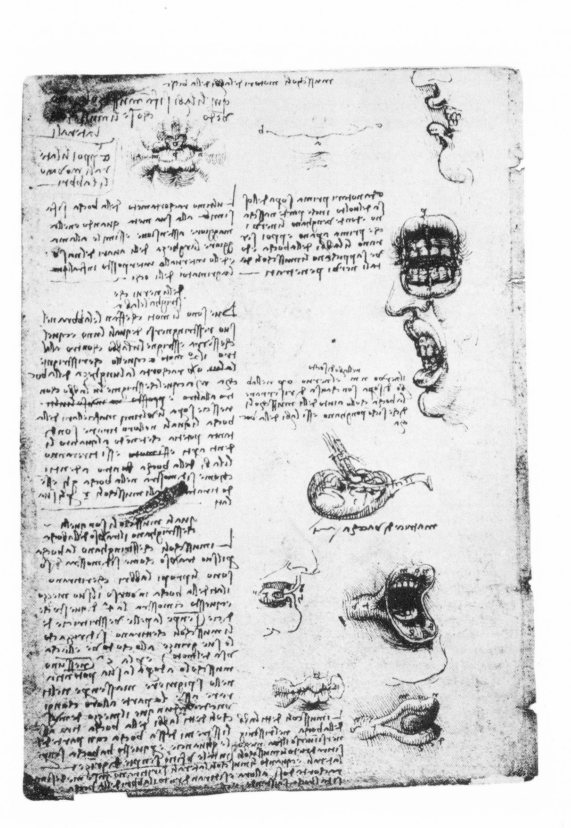

181

alimentary system

Although the page opens up with a note on proposed methods of illustrating the structure of the upper extremity, it has been classified with the alimentary system since more than half is devoted to the function of the teeth. In the note on methods of illustration Leonardo employs the curious but descriptive term "motors" for the muscles and their tendons as the engines of motion. He also uses the word "lines" of attachment which was a favorite technique of representing the muscle by a cord so as not to obscure underlying structures and to provide a clearer conception of the action of the muscle. Numerous examples of the technique are to be found in his words such as those seen in 18, 73, etc.

ORDER OF ANATOMY.

First make the bones, that is, the arms, and the place the motors from the shoulder to the elbow with all of their lines [of attachment]; next, from the elbow to the arm; then from the arm to the hand and from the hand to the fingers.

In the arm you place the motors which open the fingers, and you will place these in their demonstration alone. In the 2nd demonstration you will clothe these muscles with the second motors of the fingers and you will do this step by step so as not to confuse. But first place upon the bones the muscles which unite the bones without further confusion by other muscles. With these you will place the nerves and vessels which nourish them, having first made the vascular and nervous tree upon the simple bones.

fig 1. **Diagram of the leverage of the front and back teeth.**

The lines a d, and a c, represent the upper and lower jaws with the axis at a, and teeth at the points d e, and b c. Unfortunately, from the point of view of the proportional leverage exerted, the position of the power is not indicated. He employs mechanical principles to explain the morphology of the teeth, elaborating upon a Galenical description of their function.

ON THE NATURE OF THE TEETH AND THEIR POSITION AND DISTANCE FROM THE AXIS OF THEIR MOTION.

A tooth has less power to bite off the further it is removed from the centre of its motion. Thus if the centre of motion of the teeth is at a, the axis of the jaw, I say that the more distant these teeth are from the centre a, the less powerful the bite. Therefore the bite at d c, is less powerful than that of the teeth b c. From this follows the corollary which states: that tooth is more powerful the nearer it is to the centre of its motion or axis of its motion, that is, the bite of the teeth b c, is more powerful than that of the teeth d e. (Nature makes the teeth less able to penetrate the food and with blunter cusps, the more powerful they are). Therefore the teeth b c, will proportionately possess more obtuse cusps as they are moved by a greater power. For this reason, the teeth b c, will be more obtuse in proportion to the teeth d e, as they are nearer to the axis a, of the jaws, a d, and a c. Consequently Nature has made the molars with large crowns, suitable for mastication and not to penetrate or cut the food. She has made the teeth in front for cutting and penetrating and unsuitable for mastication of the food, and she has made the canines (maestre) between the molars and the incisor teeth.

The figures and notes on this page date from an early period, c.1489, but to them has been added a note, c.1504-06, "on the erection of the penis."

figs 1-2. **Sketches of the intestinal coils.**

These slight and inconsequential sketches of the intestines exhibit only the slightest acquaintance with the arrangement of the alimentary tract even if judged as no more than graphic reminders. However, they should be examined since they are among the very few studies of the alimentary system dating from this early period. The note is a reminder to make other studies.

As to these [intestines], *you will better understand their windings if you inflate them. Remember that after you have drawn them from 4 aspects as arranged* [in the figures], *then draw them from 4 aspects when extended, in such a way that you can understand the whole, that is, the differences in their size, their segments and openings.*

Brief notes, derived from Mundinus, mention the supposed function of the liver and the gall-bladder. The liver manufactures the blood from the chyle absorbed from the intestines and thus carries the nourishment to the tissues. The excrements are collected and discharged by the gall bladder.

The liver is the distributor and dispenser of nourishment vital to man. The gall bladder is the familiar or servant of the liver which sweeps up and carries off all the filth and superfluities remaining after the nourishment has been distributed to all the members by the liver.

From the early period come some brief notes on the nervous system: *How the nerves sometimes act of themselves without the command of other functions or of the mind.*

This is clearly apparent for you will see paralytics, cowards and the benumbed move their trembling members, such as the head or the hands, without permission of the mind. The mind with all its powers cannot prevent these members from trembling. This also happens in epilepsy and in members which have been severed, as in the tails of lizards.

The idea or the imagination (imaginativa) is the helm or bridle of the senses, for the thing imagined moves the senses.

To pre-imagine is to imagine things which will be.
To post-imagine is to imagine things past.

On reading the above notes it should be remembered that in the materialistic psychology of the times the imagination or *imaginativa* was usually localized in the middle ventricle of the brain and closely related to the *sensus communis* which not only received sense impressions but also initiated motor action, cf. 142.

The final note on erection of the penis was added at a later date, c.1504-06, when Leonardo had access to Galen's *De usu partium* and was critical of mediaeval authorities. The opinion expressed is in contradiction of a statement of Mundinus that "the penis is quite hollow and these hollows are filled with wind formed in the above-mentioned [penile] arteries and when they are filled with wind the penis is erected". Leonardo had witnessed several hangings, and his sketch of the death of Bandino Baroncelli from hanging survives in the collection of the Musée Bonnat, Bayonne.

Of the virile member when it is hard, it is thick and long, dense and heavy, and when it is limp, it is thin, short and soft, that is, limp and weak. This should not be adjudged as due to the addition of flesh or wind, but to arterial blood. I have seen this in the dead who have this member rigid. For many die thus, especially those hanged of whom I have seen an anatomy, having great density and hardness, and these are full of a large quantity of blood which has made the flesh very red within, and in others, without as well as within. And if an opponent contends that this large amount of flesh has grown through wind which causes the enlargement and hardness as in a ball with which we play, this wind provides neither weight nor density but makes the flesh light and rarefied. And again, one observes that the rigid penis has a red glans (testa) which is a sign of an abundance of blood, and when it is not rigid, it has a whitish appearance.

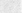

alimentary system

The drawings are probably based upon the dissection of the centenarian, as indicated by the notes, the style of the drawings and the obvious fact that the human subject is illustrated, cf. 128.

fig 1. The superior epigastric vessels.

The xiphoid process is marked with the words *pomo granato*, for which cf. 23. Likewise the *umbilicus* is indicated. Of these vessels, possibly the arteries, although they may be the veins since the subject suffered from cirrhosis of the liver, Leonardo writes: *Vein, placed upon the peritoneum (sifac) and interposed between the abdominal wall and the peritoneum.*

fig 2. The greater omentum and abdominal viscera.

The structures labelled are the liver, stomach and spleen. The ligamentum teres passing from the umbilicus to the liver is disproportionately long and the doubling of the umbilical vessels a fanciful addition. The notes read:

MEMORANDUM.

Remember to indicate how high the stomach lies above the umbilicus and with the xiphoid process, how the spleen and heart stand in relation to the left breast, how the kidneys or reins are related to the flanks, the colon, bladder and other intestines and how far they are, more or less, from the spine than from the longitudinal [rectus] muscles, and so describe the entire body with the vessels and nerves, etc.

In the aged the colon becomes as thin as the middle finger of the hand, and in the young it is equal to the greatest width of the arm.

The net [greater omentum] which lies between the peritoneum and the intestines in the aged uncovers all the intestines and withdraws between the fundus of the stomach and the upper part of the bowel [transverse colon].

Of the several geometrical diagrams and figures on this page, there is only one which need be considered directly as pertaining to Leonardo's anatomical studies. However, among the other figures is a small half-effaced study believed by Clark to represent Leonardo's first idea of a Leda and which is connected with a similar study found in the Codex Atlanticus, f.156r. From these Clark deduces that the page is datable c.1504. This provides an important clue to the dating of the drawings of the alimentary system, not only of 183, 188, but also of 185, 192, since they are in the same style as the anatomical figure found here. Clark's opinion is confirmed by the internal evidence that the figures of Fogli B mentioned are based upon the dissection of the centenarian at Florence. Therefore we may assume that the anatomical studies mentioned were made no earlier than 1504 and probably 1504-06.

fig 1. Rough sketch of the alimentary tract in situ.

The rounded structure in the pubic region is labelled, *bladder.* The figure is undoubtedly a preliminary to that worked up in greater detail on 185, and it will be observed that the intestines are similarly arranged. The preliminary nature of the sketch is indicated by the note which points to the completed drawings not only of 183, 188, and 185, 192, but also to that of the mesentery on 189 and possibly 186.

Sketch the bowels in their position and [then] *detach them cubit by cubit, having first ligated the ends of the detached and remaining portions. When you have removed them, draw the margins of the mesentery from which you have detached this part of the intestines. Having drawn the mesentery in position, sketch the ramification of its vessels and so continue successively to the end. You will begin at the rectum and enter on the left side at the colon, but first elevate the bone of the pubis and of the flanks* [ilium] *with a chisel the better to observe the position of the intestines.*

Above the figure is a quotation based on Horace's lines, Nil sine magno/ vita labore dedit mortalibus (Saturnalia, I:ix).

ORACLE

God sells all good things at the price of labor.

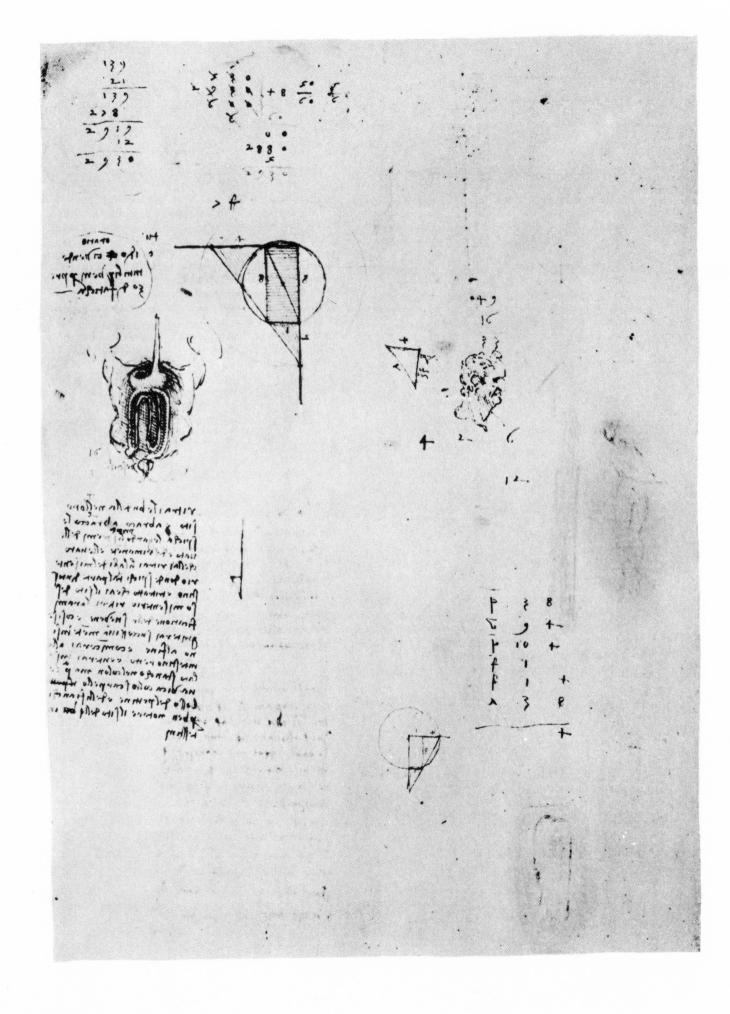

alimentary system

The drawings on this page are part of the series continued on 192, and appear by style and content to be based on the dissection of the centenarian, cf. 156.

fig 1. The alimentary tract.

The *oesophagus (meri)* is so indicated. Other organs identified are: *a b, the straight intestine* [rectum]; *a c, colon; d o, ileum; o n, on right, jejunum* [so-called] *because it is empty; n r, duodenum; d c, caecum (monoculus).*

The jejunum, as Leonardo remarks, was so called because it is often found empty. The monoculus or one-eyed gut was the old term for caecum but sometimes means appendix. Leonardo compares the alimentary tract of reptiles with that of man and concludes that the human intestines, because of the upright position of man, are highly coiled to delay the descent of their contents.

Animals without legs have a straight bowel, and this is because they always remain horizontal and because an animal which has no feet cannot raise itself upright and, even if it did, it immediately returns to the horizontal. But in man this would not be the case since he stands quite vertically, for the stomach would immediately empty itself if the tortuosities of the intestines did not retard the descent of the food. And if the bowel were straight, each part of the food would not come in contact with the bowel as occurs in a tortuous bowel. And much of the nutritive substance would remain in the superfluities, which would not be sucked up by the substance of the bowels and transported in the portal (miseraice) veins.

fig 2. The subdiaphragmatic organs: liver, stomach and spleen.

The hepatic and portal or miseriaic veins are especially well shown because of their importance to then current theory. Galen held that the chyle or intestinal juice was sucked up by the portal vein to be transported to the liver where it was transformed into blood to renew the continual metabolic loss. The figure is to be supplemented by others.

I wish to cut the liver which covers the stomach in that part which covers the stomach as far as the [portal] vein which enters and then emerges from the liver [as the hepatic vein] and to see how this vein ramifies in the liver. But first I will illustrate how the intact liver lies and how it clothes the stomach.

These ideas are carried out in part in 130. Peristalsis and evacuation are due, according to Leonardo, to the compressive action of the diaphragm and anterior abdominal wall on the stomach and intestines in the movements of respiration, cf. 178, 187. This theory is referred to in the accompanying note.

As the superfluities are forced out of the intestines by means of the transverse muscles of the body, these muscles would not fulfill their office well or with power if the lung were not filled with air. Since, if the lung were not filled with air it would not occupy in its entirety the diaphragm. Hence the diaphragm would remain relaxed and the intestines, compressed by the said transverse muscles, would bend outwards the region which gives way to them. This would be the diaphragm. But if the lung remains entirely full of air which you do not allow to escape above by expiration, then the diaphragm remains taut and hard, and resists the upward ascent of the intestines compressed by the transverse muscles. Thus of necessity the intestines rid themselves of a great part of the superfluities which are contained within them by way of the rectum.

fig 3. The caecum and vermiform appendix.

The auricle [appendix] n, of the colon n m, is a part of the monoculus [caecum] and is capable of contracting and dilating so that excessive wind does not rupture the monoculus.

Owing to the assumption that the anatomy of certain animals, especially the pig, was identical to that of man, there was great confusion among mediaeval anatomists as to the distinction between the appendix and the caecum. The above illustration is one of the earliest representations of the human appendix known. The earliest published figure of this organ appears in the *Anatomica mundini*, Marburg, 1541, of Johann Dryander.

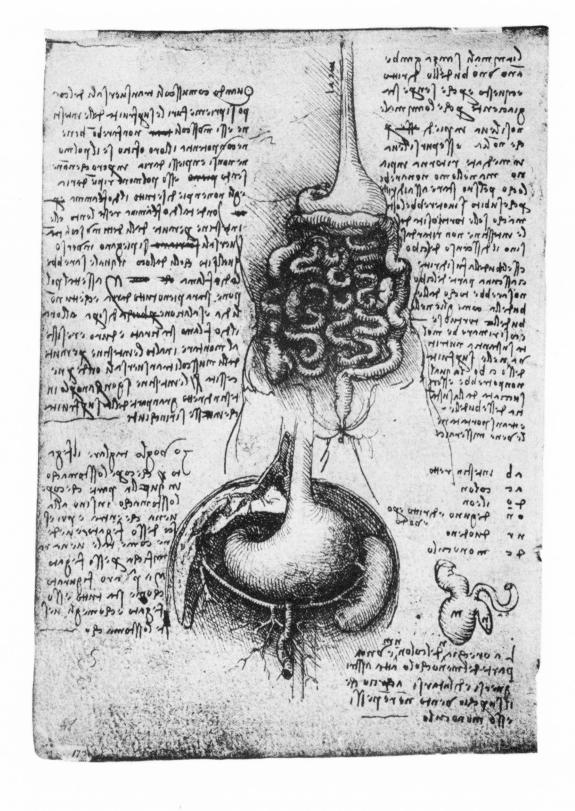

alimentary system

fig 1. **The abdominal viscera in situ.**

This study in black chalk of the intestines shows the haustrations of the large bowel and the appendix very well. It probably belongs to the series of dissections made upon the centenarian, cf. 128.

figs 1-2. **Diagrams on the functional relationship of the diaphragm to the alimentary tract as viewed from in front and behind.**

Peristalsis and evacuation of the intestines were believed by Leonardo to be due to the alternate contraction of the diaphragm and anterior abdominal wall during respiration which by compression of the stomach forces its contents on by spurts, cf. 178. Simultaneous contraction of these structures occurs in evacuation which explains why the breath is held during the process, cf. 185. He is now concerned with the question of what we would term reverse peristalsis. The flexures of the duodenum are believed in part to prevent regurgitation, cf. 178, and he now considers that it is perhaps the collapse of the duodenum and jejunum which rapidly empty.

INTESTINES.

What is the cause which prevents the food from returning through the pylorus (portinaro) backwards into the stomach when expulsion of the superfluities contained in the intestines occurs?

When the intestines are constricted and compressed from above by the diaphragm and from the sides and in front by the transverse [abdominal] muscles, it is necessary that the material which is contained in them escape through those regions which are provided as exits, that is, by the anus. But what prevents some of the material from returning upwards into the stomach, finding there an exit provided for its convenient passage?

It is replied that the upper and neighboring entrails, as the duodenum and jejunum, being the first occupied by the softer material are the first emptied since they are near the stomach which is forced against them by the diaphragm. At this time the stomach cannot empty itself because its pylorus is enclosed below between the stomach and the intestines or between the former and the duodenum. Owing to the pressure, the more the duodenum is compressed, the more the stomach presses against it (and the more it empties).

WHY THE INTESTINE CALLED THE JEJUNUM IS ALWAYS FULL OF WIND.

From what has been said above, it follows that the intestine suddenly empties itself of its material and sends it into the other intestines after the escape of other superfluities in order to refill in part the regions from which these superfluities have been removed. This is the real cause of the evacuation of the jejunum.

alimentary system

At the top of the page are the words, *On the old man,* which refer to the dissection of the centenarian at Florence, cf. 128. The relationship of these figures to the statement on 181 has already been discussed and shows that almost the entire series on the alimentary tract having human characteristics is based upon this single dissection. Furthermore, the plate is important as revealing that Leonardo employed the technique of maceration to unravel the vascular tree and so had great difficulty in distinguishing arteries from veins in the abdomen.

fig 1. The gall bladder and related vessels.

The caption to the figure reads: *The vessels which here and there outline the fundus of the stomach and proceed to ramify through the omentum (rete) which covers the intestines.*

It is sometimes difficult to determine whether Leonardo means actually a vein or a vessel by the word *vena* since the term is used indiscriminately for both. Here, however, he seems at times to confuse arteries with veins. The vessel lettered a b c, is obviously the splenic and hepatic arteries in continuity. The cystic artery passing to the *gall bladder* (so labelled) is easily recognized. From the hepatic artery the gastroduodenal and its right gastro-epiploic branch passing to the region of the greater curvature of the stomach and giving off omental twigs are clearly identified. Leonardo recognizes that these vessels lie in the attachment of the greater omentum. The splenic and portal veins are shown lying deep to the arteries, and this relationship is remarked upon with the statement, *Below* [i.e., posterior] *lies the vein and above* [i.e., anterior] *this lies the artery.* Deep to and parallel to the right gastro-epiploic artery is a vein which at first sight might be thought to be a companion vein. However, from the note below, this vessel is probably the middle colic vein since it is described as lying in the mesocolon which is regarded as being a part of and in continuity with the posterior layers of the greater omentum as shown in figs. 2-3.

a b c [hepatic and splenic arteries in continuity] *is the vessel (vena) which extends from the spleen to the porta hepatis and passes behind the stomach. From a,* *separate the vein and the artery which ramify through the omentum covering the intestines; that is, from a, separate two vessels which pass below the fundus of the stomach, one behind, between the ribs and the stomach, and the other, in front. They proceed as has been said, to ramify through the omentum (zirbo) behind* [the mesocolon] *and through the omentum in front* [greater omentum], *for it is double as the figure shows* [figs. 2-3]; *and that which the veins do is found to be done by the artery.*

figs 2-3. The stomach, illustrating the greater omentum and mesocolon.

It will be noted that the peritoneum extending from the posterior aspect of the stomach passes anterior to the duodenum which identifies it as the mesocolon. Dissection of the mesocolon and peritoneum of the posterior wall of the omental bursa permits exposure of the splenic vessels and their passage to the porta hepatis. The tortuosity of the splenic artery with or without arteriosclerosis is always a striking phenomenon which gives rise to the outburst.

I have found in the decrepit [Leonardo's centenarian] *how the vessel (vene) which leaves the porta hepatis and crosses behind the stomach to ramify in the spleen—that these ramifications, the vessels in the young being straight and full of blood, in the aged are tortuous, flattened, folded and devoid of blood.*

Dissection of the centenarian revealed a cirrhotic liver (cf. 128) which readily disintegrated. Since the liver was regarded as the blood-making organ, the finding was regarded as of enormous significance in explaining death from old age. Moreover, the friability of the liver permitted maceration, exposing the intrahepatic course of the vessels and formed the basis of the figures on 130. Leonardo continues:

And so the liver which in youth is usually colored and of equal consistency, in the aged is pale without any of the ruddiness of blood, and the vessels remain empty amidst the substance of the liver. This substance can be compared in its looseness to bran steeped in a little water. Thus it readily disintegrates on being washed, leaving the vessels which ramify within it freed . . . from the entire substance of the liver.

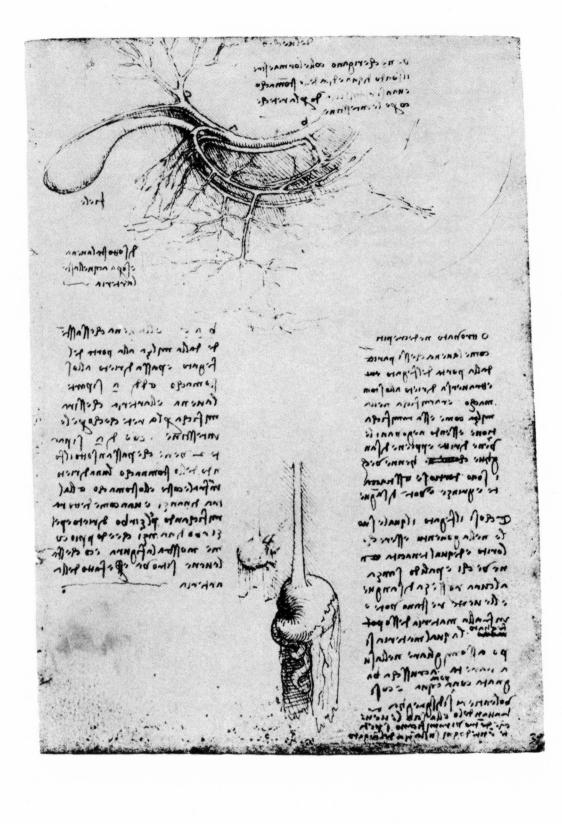

These figures are evidently a continuation of the series shown on 188, etc., as outlined in the note on 184.

fig 1. The mesenteries and the portal vein.

The colon and small intestine have been resected leaving a pattern of mesenteric attachment corresponding exactly to the arrangement of the intestines found on 185, 192. The mesenteries are, therefore, those of the small and large intestines somewhat artificially represented as though derived from some animal in which an unfixed dorsal mesentery of the colon exists. The superior mesenteric vein is observed receiving as tributary a gastro-epiploic or colic vein and joining the splenic to form the portal vein. The arrangement again suggests animal anatomy. The portal vein and its tributaries are regarded as a continuation of the hepatic vein and thus of the vena chilis or vena cava.

Through the ramification of the vena chilis [vena cava] in the mesentery the nourishment from the corruption of the food in the intestine is drawn. Finally, it returns through the terminal ramifications of the artery to the intestines where this blood, now having been mortified, is corrupted and acquires that foetor which is given off by the faeces.

fig 2. The portal vein and its tributaries.

The splenic vein is represented as joining the superior mesenteric at a, to form the portal vein. The superior mesenteric receives the vein b c, which from Leonardo's description, is the right gastro-epiploic, although it may be the middle colic.

a [superior mesenteric vein], is the ramification of the mesentery. It is united with all parts of the intestines, returning to them the blood which dies and receiving from them the new nourishment, similar to the roots of every herb and plant mingled with the earth covering them, by which they suck up the humor which nourishes them.

b c [right gastro-epiploic vein] is the vein which nourishes the greater omentum (zirbo). It lies in front of the vein a n [superior mesenteric] which is that which nourishes the mesentery. The intestines are contained between the mesentery· and the greater omentum.

And b c [right gastro-epiploic vein] is joined to the outer border of the stomach and descends by means of its ramifications to nourish the greater omentum which covers the intestines and the spleen.

Details of the distribution of the mesenteric vessels are to be added later: *Make this vein with its terminal extremities in every member.*

The common term for the greater omentum was *zirbo* or *zirbus* which is a corruption of the Arabic *tsarb*, a rete or network, introduced by the translators. In Albertus Magnus it is almost unrecognizable as *girbum.*

fig 3. The mesentery.

The pattern of arrangement of the mesentery is similar to fig. 1 above. It is further described:

The mesentery is a thick, sinewy and fatty membrane in which ramify 12 master veins and which is united to the inferior part of the diaphragm.

In this mesentery are planted the roots of all the veins which unite at the porta hepatis and purge the blood from the liver. It [portal and hepatic veins] then enters the vena chilis [vena cava] and the later vein goes to the heart which makes more noble the blood which passes through the arteries as spirituous blood.

Leonardo in following the pathway of the portal blood according to Galenical ideas, is apparently uncertain as to whether the mesentery contains arteries or not, for he adds, *See whether the mesentery has arteries or not.*

fig 4. Diagram of the greater omentum and its venous drainage.

In the upper border of the greater omentum labelled zirbo the right gastro-epiploic or possibly the middle colic vein is shown to amplify the description given in fig. 2. The diagram is a reminder to draw a more detailed figure. *Try to delineate the whole omentum, that is, the net, having shown the veins there.*

At the top of the page Leonardo introduces a note on the social significance of long nails in the Far East: *Among Europeans long nails are regarded as shameful. Among Indians [Chinese] they are held in great veneration, and they have them painted with penetrating fluids and decorate them with various tattoos. They say that they are a mark of gentlefolk and that short nails are a mark of laborers and mechanics in various trades.*

GENITO-URINARY SYSTEM

genito-urinary system

DEMONSTRATION OF THE BLADDER OF MAN.

fig 1. The kidneys, bladder and urinary tract.

The key to the lettering is as follows: c, right kidney; L p, and h b, the ureters; d, the apex of the bladder or median umbilical ligament; n f, the points corresponding to the internal openings of the ureters; a g, the urethra.

The oblique course of the ureter within the bladder wall was fully appreciated and is represented by the interval p n, and b f, as well as in the inset diagram, cf. fig. 4 below. However, this was not an original observation, cf. 192. Leonardo provides a full description of these figures which he calls demonstrations.

FIRST DEMONSTRATION.

Of these three demonstrations of the bladder, in the first is represented the ureters (pori ortidi), in what way they depart from the kidneys L h, and unite with the bladder two fingers higher than the origin of the neck of the bladder. A little internal to this point of union, from p, and b, to n, and f, the ureters discharge the urine into the bladder in the manner partly represented by the channel S [fig. 4], from where it is then discharged through the conduit of the penis a g [urethra]. It remains for me in this instance to represent and describe the position of the muscles [sphincters] which open and close the urinary passage at the mouth of the bladder neck.

fig 2. The blood supply of the bladder.

The arteries a b, and the veins m n, are shown running parallel to the urethra to ramify on the surface of the bladder. Apparently Leonardo did not see the vesicle and understandably confused them with the penile vessels in the region of the prostatic flexes. His description of the second demonstration follows:

SECOND DEMONSTRATION.

In the second demonstration are represented 4 ramifications, that is, of the right and left veins which nourish the bladder and the right and left arteries which give it life, that is, spirit. The vein is always above [i.e., superficial to] the artery.

fig 3. Urinary tract: lateral view.

The right ureter m n, is shown entering the bladder at n, to show its vascular encirclement. The error in origin of the cystic vessels is again apparent.

THIRD DEMONSTRATION.

In the third demonstration is represented how the vein and the artery surround the origin of the ureter m n, at the position n, and the interweaving of the ramification of the vein with the ramification of the artery is shown.

fig 4. Diagram of the intramural course of the ureter.

The oblique course of the ureter through the vesicle wall is demonstrated and its possible valvular action discussed. The conclusions are supported with reference to his proposed work "On the nature of water", cf. 113. The conclusions reached agree with modern opinion that the valvular nature of the openings has been greatly exaggerated. For another discussion, cf. 192.

ENTRANCE OF THE URINE INTO THE BLADDER.

The urine, having left the kidneys, enters the ureters and from there passes into the bladder near the middle of its height. It enters the bladder through minute perforations made transversely between tunic and tunic. This oblique perforation was not made because Nature doubted that the urine could return to the kidneys, for that is impossible from the 4th [book] on conduits where it is stated: water which descends from above through a narrow vessel and enters under the bottom of a pool, cannot be opposed by reflux movement if the magnitude of the water in the pool is not as great as the magnitude of the vessel which descends, or the height of the water greater than the depth of the pool. If you were to say that the more the bladder is filled the more it closes, to this I should reply that these perforations being compressed by the urine which closes the wall, would prevent the entrance of other urine which descends. This cannot be according to the 4th [book] mentioned above which states that the narrow and elevated [stream of] urine is more powerful than the low and wide which lies in the bladder.

Finally, in the margin is a reminder to discuss the comparative anatomy of the alimentary tract: *Describe the differences in the intestines of man, of monkey and similar species. Then how the leonine species differs, next the bovine, and finally birds, and make this description in the form of a discourse.*

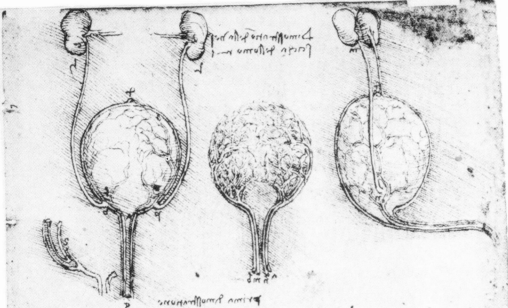

genito-urinary system

fig 1. **The left kidney and its vessels.**

The shape and dimensions of the kidney suggest an animal source. The renal vein, artery and ureter are shown in correct relationships to one another. The left kidney was apparently chosen for the illustration to show the left spermatic vein entering the renal, an arrangement claimed as a new discovery by several sixteenth century anatomists but previously known to Galen. The small vessel ascending from the renal vein is presumably the left supra-renal vein. Inscribed on the body of the kidney is the reminder: *Cut it through the middle and depict how the passages for the urine are closed and how they distil it* [i.e., urine].

The papillae of the kidney were commonly thought to resemble minute alembics for the distillation of the urine. However, a filtration theory introduced by the Paduan physician Gabriele Zerbi (d.1506) was gaining wide acceptance at this time. Below the figure Leonardo writes: *Describe at what distance the kidney lies from the flanks and the false ribs.* A note in the margin is a continuation from 192, and will be considered there. The rest of the page is devoted to a series of notes on the special senses of vision and olfaction in which man is compared to certain animals.

I have found that in the composition of the human body as compared to the compositions of all animals, it is of duller and blunter sensibility as it is composed of less ingenious instruments and of regions less capacious for the reception of the faculties of the senses. I have observed in the Leonine species that the sense of smell, which forms a part of the brain substance, descends to a very capacious receptacle [ethmoid] to make contact with the sense of smell. This enters among a large number of cartilaginous vesicles [ethmoid air cells] with many pathways leading to the afore-mentioned extension of the brain.

The eyes of the Leonine species acquire a large part of the head for their receptacles [orbits], and the optic nerves unite directly with the brain. In man the opposite is seen because the orbital cavities are only a small part of the head and the optic nerves are thin, long and weak. As a result of their weakness of action we see by day but poorly at night, and the aforesaid animals see as well at night as by day. An indication of this is observed by the fact that they prey at night and sleep by day, as nocturnal birds also do.

In order to appreciate the note below on the reaction of the pupil to light, the reader should be aware of the so-called emanation theory on the nature of vision, prevalent at that time and accepted by Leonardo. According to this view, popularized through the *Timaeus* of Plato, the eye projects from its interior the visual spirit or power which collides with the species or impalpable shells given off by all visible objects. The collision returns the emanation back to the eye as the visual image. Thus in nocturnal animals relatively larger "instruments" are required to provide the necessary visual power or emanation as mentioned in the note above.

The light, or pupil of the human eye, on its expansion and contraction, increases and decreases by half its size. In nocturnal animals it increases and decreases more than a hundred fold in size. This may be seen in the eye of an owl, a nocturnal bird, by bringing a lighted torch near its eye, and more so if you make it look at the sun. Then you will observe the pupil which previously occupied the whole eye, diminished to the size of a grain of millet. With this reduction it compares to the pupil of man, and the clarity and brightness of objects appear to it of the same intensity since at this time they appear to man in the same proportion because the brain of this animal is smaller than the brain of man. Hence it happens that the pupil in the night time increases a hundred times more than that of man, and it sees a hundred times more light than man in such a way that its visual power is not then overcome by the nocturnal darkness. The pupil of man which only doubles its size, sees little light, almost like the bat which does not fly at times of too great darkness.

The final note brings forward the "Ladder of Nature" or "Chain of Being" idea which, originating with Plato's *Timaeus*, and developed by Aristotle, was spread by the neo-Platonists and had acceptance from the middle ages to the eighteenth century. In this primitive evolutional theory the top of an inferior class touches upon the bottom of a superior and so extending to man who by touching the next class above occupies the lowest rank in the spiritual order. Likewise, there is a progression in the way that the alimental or natural elements nourish plants, plants beasts, and the flesh of beasts, man. Further, the faculties advance in order from the inanimate to the first creatures possessing touch and so on to those with touch, movement, hearing and vision, as in the higher animals. But man has not only all these faculties of sensibility but also understanding and the creative spirit.

In fact, man does not differ from animals except in what is accidental, and in this he shows that he is a thing divine. For where Nature finishes the production of her species, there man begins with natural things to make, with the assistance of Nature, an infinity of species which not being necessary to those who govern themselves perfectly as do animals, it is not in the habit of these animals to seek after.

genito-urinary system

fig 1. **The abdominal cavity to demonstrate relationships of the kidneys to the alimentary tract.**

The figure is primarily to demonstrate the relative position of the kidneys, the outlines of which are observable in the background. We are told that the distance *a b* [colon] *is three braccia, c b* [small intestine] *is* 13 *braccia*, that is approximately six and twenty-six feet respectively. The appendices epiploicae are prominently shown, but the appendix is not.

figs 2-3. **Diagrams of the course of the ureters in the wall of the bladder.**

The diagrams purport to show the oblique intramural course of the ureter, the *interior of the bladder*, and the *ureter* being indicated on the diagram. The drawing is similar to that on 190.

figs 4-7. **Diagrams of the relationship of the ureteric orifices to the urine of the bladder in various positions of the body.**

These small figures are related to the discussion on the question of the valvular action exercised on the lower end of the ureter by its oblique entry. Above the figures is the remark, W*hen man lies upside down, the entrance for the urine is closed.* Below each figure, from above downwards, is indicated the corresponding position of the body. *Upside down. Erect. On the side. On the belly;* thus demonstrating a changing relationship of the fluid content of the bladder. Leonardo's arguments are not very good, and he ignores the fact that the bladder is a contractile organ.

The authorities say that the ureters in carrying urine to the bladder do not enter it directly but enter between layer and layer in such a way that they are not opposed, and that the more the bladder is filled, the more they are closed. They say that Nature has done this solely because when the bladder is full, it would return the urine back whence it came. Hence on finding its way between membrane and membrane to enter the interior [of the bladder] *through a narrow passage not corresponding to* [the point of entry in] *the first membrane, the more the bladder is filled, the more it forces one membrane against the other, and thus has no cause to reverse and turn back. This proof is not true for the reason that if the urine in the bladder were to rise higher than its entrance, which is near the middle of its height, it would follow that this entrance would be closed immediately, and it would be impossible for more urine to enter the bladder, and it would never exceed half*

the capacity of the bladder. Therefore, the rest of the bladder would be superfluous, and Nature makes nothing superfluous. Consequently we shall state, according to the 5*th* [section] *of the* 6*th* [book] *"On water", how the urine enters through a long and tortuous passage into the bladder and then when the bladder is full, the ureters remain full of urine. The urine of the bladder cannot rise higher than their surfaces* [of the intramural portion of the ureters] *when man is standing erect. But if he remains lying down, it can return back through the ureters and even more so, if he places himself upside down, which occurs infrequently, although recumbency is common. Whereas if a man lies upon his side, one of the ureters remains above, the other below, and the entrance of that above opens and discharges the urine into the bladder. The other duct below closes because of the weight of the urine. Hence a single duct gives its urine to the bladder, and it is sufficient that one of the emulgent* [renal] *veins purifies the blood of the urinary chyle mixed with it, since the emulgent veins are opposite one another and do not proceed entirely from the vena chilis* [vena cava]. *And if a man lies with his back to the sky, the* 2 [the note continues in the margin of 191] *ureters pour urine into the bladder. They enter through the upper part of the bladder* [when prone], *since the ducts are attached to the posterior part of the bladder, the part which when the body is lying downwards, remains above. Thus the urinary entrances can remain open and contribute to the bladder as much urine as required to fill it.*

On the "emulgent" vein, cf. 179. It is sufficient to say that this vessel was supposed to drain off the watery element of the blood mixed with the choler or yellow bile, which gives to urine its color, and not chyle as Leonardo has it. Further, Leonardo seems to think that the vena cava was called the *vena chilis* because the contained blood was mixed with chyle. Actually the term *vena chilis* is derived from the Greek κόιλη φλέω, the exact equivalent of the Latin vena cava, i.e., hollow vein. Thus the term κοίλια came to be applied to the hollow belly or abdomen giving rise to our terms coeliac and coelum and therefore vena cava or *chilis* is the equivalent of abdominal or belly vein. Leonardo constantly uses the phrase *li pori uritidi*, or simply *pori* (lit., ureteric ducts) for the ureters. This term is also found in the works of Nicolo Massa [c.1480-1569] but not in Mundinus, Leonardo's favorite source. For the projected work "On water", cf. 113.

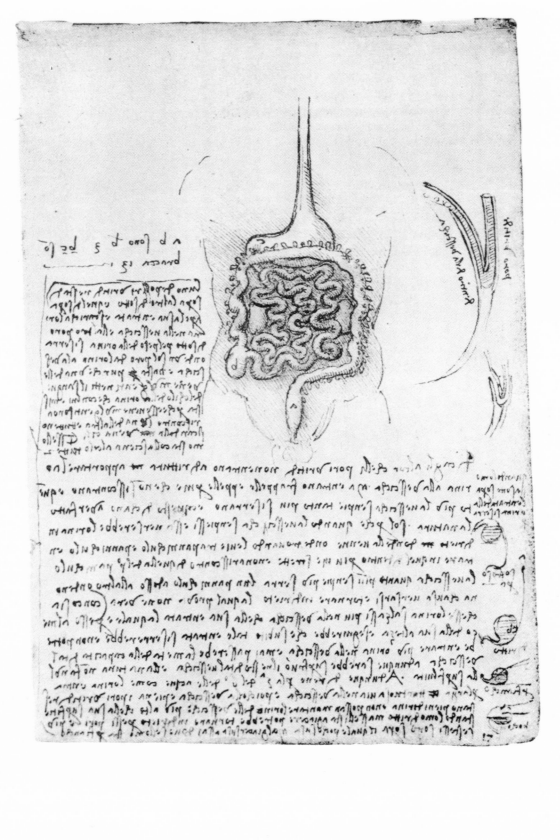

genito-urinary system

fig 1. **The genito-urinary system of the male.**

This figure bears all the earmarks of being derived from traditional sources and therefore possibly dates from a relatively early period. This is indicated by the symmetrical arrangement of the spermatic veins which pass to both right and left renal veins. Both Mundinus and Avicenna recognized the asymmetry of these vessels. Mundinus quotes Avicenna as his source, and Avicenna doubtless derived his knowledge of the arrangement from a passage in Galen's *De venarum et arteriarium dissectione*. However, almost all the contemporary diagrams, including those in the printed editions of Mundinus, show the spermatic or ovarian veins symmetrically attached to the renal veins. In later figures Leonardo himself illustrates the correct arrangement.

The key to the lettering is as follows: a p, the inferior vena cava; b m, the aorta giving off at b, the spermatic arteries; s and t, the ureters; n and e, the spermatic veins entering the renal veins symmetrically.

The passage of the spermatic vessels through the inguinal canal is indicated diagrammatically by a mark. From the testis and epididymis a line representing the ductus deferens may be traced bilaterally to a pisiform structure indicating the seminal vesicle which, in turn, is shown opening as the ejaculatory duct into the urethra.

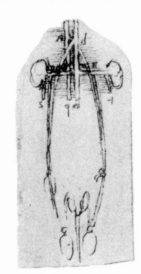

genito-urinary system

fig 1. **The lungs and heart.**

Employing the usual term, spiritual members, for the contents of the thorax as the site for the formation of the vital spirits, Leonardo appends the reminder: *Let these lungs together with all the spiritual members be shown from four aspects.*

fig 2. **The pelvic vessels.**

The common iliac vessels and their branches are outlined with approximate accuracy. It will be noted that a large artery is shown arising from the ventral surface of the aorta just above its terminal bifurcation. Since this vessel passes on to the posterior surface of the rectum, it may represent the inferior mesenteric artery. However, there are features which suggest animal anatomy.

fig 3. **The spermatic vessels and ductus deferentes.**

The course of the constituents of the spermatic cord are displayed including the seminal vesicles and testes, but these are better shown in the figures below. The accompanying memorandum reads:

Note well the spermatic vessels [ductus deferentes] from their origin to their termination, that is, from the artery and vein [spermatic vessels] as far as the mouth of the penis, how near they are to the anus and how nothing is lacking for their motion and requirements, and for how many coitions their store of sperm is sufficient.

fig 4. **The pelvic viscera and genito-urinary tracts of the male.**

All the structures represented are easily identified and require no discussion. Two important notes relate to the figure, one of which considers the pathway of the inguinal hernia and the other, the differences in the dimensions of the male and female pelvis.

Represent here the abdominal wall and peritoneal membranes (sifac panniculi) which separate the intestines from the bladder, and demonstrate by what way the intestines descend into the sac of the testicles and how the gateway of the bladder is closed.

Measure how much less the pubis of the female is than the pubis of the male, that is, because of the space which exists from the lower part of the pubis to the tip of the coccyx because of parturition.

fig 5. **The genito-urinary tract of the male.**

The figure is very similar to fig. 4 above. There are many errors of detail. One is struck by the relatively large size of the bladder, even if full, its curious shape, more animal than human, the mis-relationship of the ductus deferens to the ureter and the absence of the prostate. These figures are of a type typically found in the works of Leonardo. They do not ring true. From the errors of detail it is obvious that he is not drawing from the specimens themselves but from a conception which is often an admixture of human and animal appearances. Doubtless this is due to his desire to illustrate functional concepts rather than purely anatomical structure and the paucity of human material in a day when fixatives were unknown. Functional considerations are uppermost in the note.

One cannot expel the urine and the residue of the food at one and the same time, because the more powerful passage restrains and occupies the less powerful which is in contact with it.

fig 6. **Small sketch of the genito-urinary tract of the male.**

The sketch is a graphic memorandum for some future illustration as indicated by the remains of the note: *First represent . . . of the bladder . . .*

fig 7. **Rough sketch of the pelvic bone in sagittal section.**

The shape of the innominate bone, granting that the sketch is very rough, is nonetheless reminiscent of that of an animal. Future illustrations are projected in notes.

First make half of the sacral bone from within and then give it the bladder and other parts.

Make this case of bone [i.e., pelvis] without the bladder.

The term pelvis was not introduced by Realdus Columbus (1510-c.1559) and Gabriel Fallopius until the mid-sixteenth century. The lack of a suitable term gave rise to a great deal of confusion since the whole may be called by one of its several parts. No name having been given to the pelvic bone by Galen it came to be called the innominate.

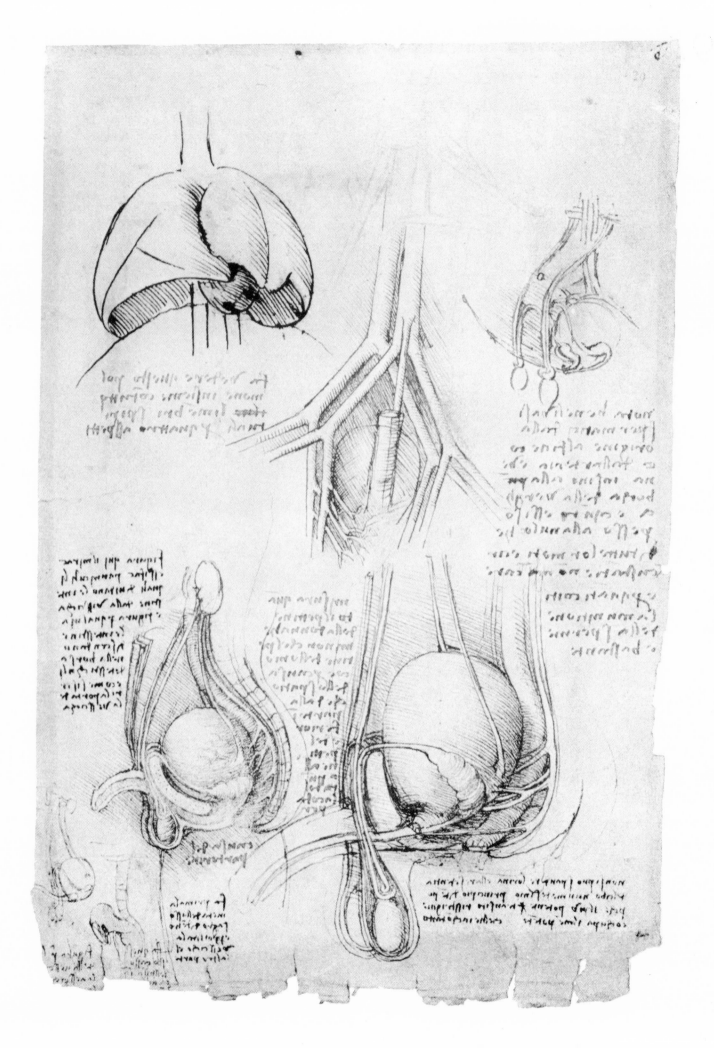

genito-urinary system

fig I. **The genito-urinary system of the male.**

The illustration is part of the same series represented on 194 and 196. The bladder and urethra are shown in coronal section in order to demonstrate the termination of the ductus deferentes as ejaculatory ducts in the posterior portion of the urethra. The drawing is also of interest as one of the few in which the right kidney is shown occupying a lower level than the left as in man. It will be noted that the splenic vessels pass straight to the liver as is customary in most of Leonardo's figures of this region.

fig 2. **An abortive pencil sketch of the testicle and spermatic cord.**

This figure has been variously interpreted as a representation of the inguinal canal or an hernial sac. However, it seems to be purely semi-diagrammatic to explain the physiology of fertilization. The ductus deferens is again shown incorrectly related to the ureter.

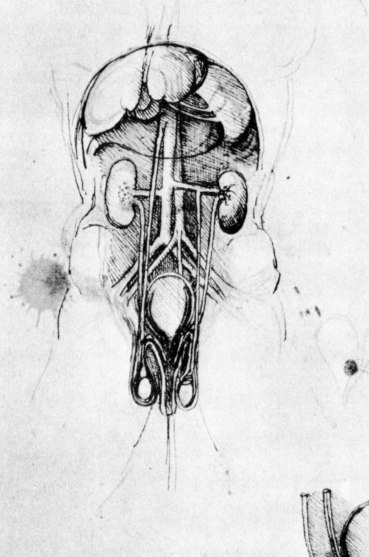

genito-urinary system

fig 1. **The genito-urinary system of the male.**

These figures are part of the series which includes 194 and 195. The bladder is represented as full of urine in contrast to fig. 2 below. The scrotum is lettered a, the testis and epididymis m, and the spermatic vessels n. The seminal vesicle and course of the ductus deferens are clearly shown although incorrectly related to the ureter. The internal sphincter of the bladder also seems to be represented. The prostate is always a notable omission in Leonardo's studies.

fig 2. **Rough sketch of the bladder while empty.**

figs 3-4. **Details of the testis and epididymis.**

197 genito-urinary system

The notes on geometry with illustrative diagrams are concerned with problems on surfaces of equal area but unequal shape and proportion.

figs 1-4, 6. **The genito-urinary system of the male.**

These several sketches present the ductus deferens, seminal vesicles and ejaculatory ducts and their relationships to the urinary bladder and urethra. Their primary purpose is to illustrate diagrammatically the position of the internal sphincter of the bladder which is represented in some of the figures by a circle placed below the neck of the bladder. Attention is drawn to the sphincter by a note reading, *Where the neck of the bladder shuts and why*. The why reminds us that it was the common belief that the bladder must possess a sphincteric mechanism above the point of entry of the ejaculatory ducts into the urethra to prevent contamination of the "seed". The external sphincter remained undiscovered for centuries since the finding of an internal sphincter fulfilled all theoretical requirements.

fig 5. **Cross-section of the penis disclosing the corpora cavernosa.**

genito-urinary system

This page is of the very greatest interest in that it contains in the top left-hand corner the famous remark, *The sun does not move*, which has been interpreted and accepted by some as an anticipation of the Copernican theory. Such an assumption is scarcely tenable. According to Clark, the words are contradicted by the drawings of the solar system in Windsor, 12326v and Ms.F (Institut de France), 64r-v, where the sun is clearly shown moving around the earth as a center. Since Leonardo was in the habit of working on his observations repeatedly, it is almost inconceivable that he should never again have mentioned such a momentous conception. Possibly the words represent a quotation or possibly a note for a pageant. Since Ms.F is datable 1508-10, and the present page is earlier, it cannot be argued that the words represent a later contradictory opinion. However, Clark dates the present sheet c.1496-98, which in view of the anatomical figures is obviously too early. These figures, undoubtedly related to those on the injection of cerebral ventricles and on the genito-urinary system of the male, are c.1504-07.

fig 1. **The cerebral ventricles.**

The lateral, third and fourth cerebral ventricles are roughly shown but evidently based upon the knowledge gained from injection as described in 147, since unlike earlier and somewhat similar diagrams the lateral ventricle is shown as a bilateral structure. For the significance of these ventricles, cf. 101, 112.

fig 2. **Rough diagram of the genito-urinary system of the male.**

The diagram illustrates the urinary tract and its relationship to the testis, epididymis, ductus deferens, seminal vesicle and ejaculatory ducts. The handling of the details is identical to those of 194-6, and consequently must date from approximately the same period.

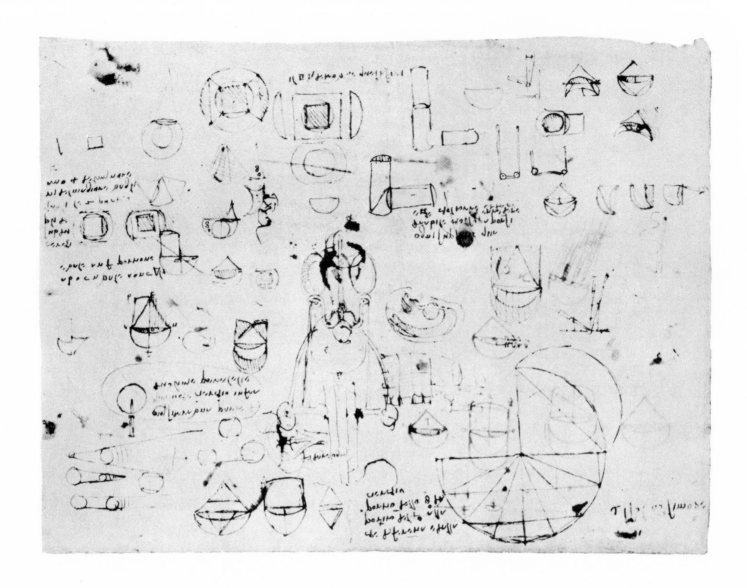

genito-urinary system

fig 1. **Diagrammatic sketch of the urinary system.**

On stylistic grounds the figure is believed to date from a late period. It is obviously very rough and as an anatomical drawing far inferior to similar figures of the middle period of Leonardo's studies. We have been unable to determine the significance of the en-circled area but presume that this represents the heart, in which case the diagram may have been intended as illustrative of some theory of the physiology of urinary excretion. The various structures portrayed are readily identified except for the urethra extending from the bladder.

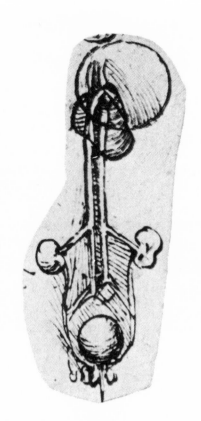

fig 1. **The external genitalia of the female.**

Although the vestibule and external urethral orifices are clearly depicted, the labia minora and clitoris are not represented, cf. 213. An adequate description of the last structures had to await the publication of the *Observationes anatomicae* of Gabriello Fallopius in 1561. The accompanying notes reflect beliefs of the bagnio rather than scientific information.

Let the cause be defined why in the female the labia of the vulva open on the closing of the anus, and in the male, in similar case, the penis becomes erect and ejects the urine or the sperm with force or, as you may say, in spurts.

Leonardo states on more than one occasion that the existence of sphincter-like muscles about the orifices of the body may be determined by the puckering of the skin. In this case he employs the term *portinario*, i.e., door-keeper, and the same term is used to designate the pylorus. The puckering of the skin or mucous membrane is to be used to define a sphincter.

ON THE VULVA.

The wrinkles or folds of the vulva have indicated to us the position of the gate-keeper (portinario [i.e., muscular sphincter]) of the castle which is always found where the meeting of the longitudinal wrinkles occurs. However, this rule is not observed in the case of all these wrinkles but only in those which are large at one end and narrow at the other, that is, pyramidal in shape.

Definition of a sphincter (riferramento) by puckering of the skin, that is, the eyes, nares, mouth, vulva, penis and anus—and the heart although it is not made of skin.

Finally observations are to be made on the genitalia at different age periods.

DESCRIBE THE GENITALIA OF THE OLD, YOUNG AND MIDDLE-AGED.

figs 2-3. **The sphincteric mechanism of the anus, closed and open.**

Apparently based upon the appearances of the skin creases about the anal orifice, as described above, the sphincteric muscle is presumed to be arranged in the form of a series of petals as illustrated. Above the figure is the word anus and the action of this hypothetical sphincter is described as follows:

DEFINITION OF THE ACTION OF THE MUSCLES OF THE ANUS.

The five muscles which shut the anus are a d f m n. When they shorten, they draw behind themselves the part which lies in common contact with the circumference, that is, the part o c [wall of the anal canal] which forms the thickness of the anus. Then, by pulling on the thickness [of the wall] which is equal to the distance o c, it comes to shorten and thicken and the thickening increases towards the center of the circumference of these muscles. It increases to such an extent that it closes the anus with considerable force when it has been dilated. All animals employ just such an instrument. When the muscle a, thickens, it pulls behind it the internal part o c. Thus when it shortens internally, it necessarily distends the external part, which is made to project with a convex gibbosity as is shown in the margin [figs. 5-6].

fig 4. **The sphincter ani.**

Having sketched a presumptive arrangement of the sphincter of the anus, Leonardo apparently decided that it could not be so since he has written next to the word *false*. Perhaps he is commenting upon an arrangement suggested by others.

figs 5-6. **The sphincter ani open and closed.**

These figures show the action of a purely fanciful sphincter ani opening and closing the orifice as described above under figs. 2-3. The legends to these figures read:

Anus dilated at a b.
Anus contracted at d f.

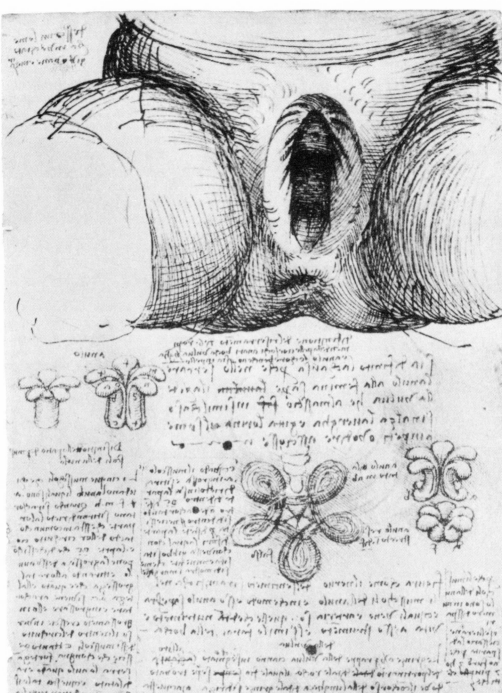

201

genito-urinary system

The purpose of the illustrations on this sheet is chiefly to attempt to establish homologies between the two sexes. Such attempts extend back to the time of Galen, with many erroneous parallelisms, chief of which was the idea that the bladder and urethra of the male corresponded to the uterus and vagina of the female. However, before considering the homologies as represented in the illustrations, it is necessary to consider briefly the conflicting opinions on the subject of generation which established the basic theories from which such parallelisms were sought.

In the Aristotelian view, as promulgated by interpreters such as Averroes, the female played a purely passive role as the soil in which the seed, a product of the male alone, was planted. Consequently to this group the ovary was of little importance and is totally ignored by Albertus Magnus in his popular work on generation. Opposed to this opinion was the view, held from the time of Diocles of Carystos, c.350 B.C., to that of Haly Abbas and especially Avicenna, that both male and female contributed equally to the formation of the future individual. Both groups called upon Galen for support of their conflicting teachings, while the opinion of Avicenna received added support from the discovery of a manuscript of the *De rerum natura* of Lucretius by the Italian humanist Poggio in 1417. We have the evidence of Leonardo's own writings that he too had studied the epicurean and was influenced by the statement that the foetus "is always fashioned out of the two seeds" (IV: 1229).

figs 1-2. The homologies of the male and female generative organs.

The first of these figures represents the vagina and uterus. On either side is the ovary—or testicle of then current terminology, the upper pole of which receives the spermatic vessels. At the lower pole is a hypothetical duct, the vas seminarium and evidently what we now call the suspensory ligament of the ovary, which was supposed to convey the sperm to the uterus and is regarded as the homologue of the ductus deferens.

With the aid of the second figure the following homologies may be established: male urethra and vagina, seminal vesicles and uterus, testis and ovary, ductus deferens and vas seminarium (suspensory ligament of ovary), spermatic vessels and ovarian vessels. It should be remembered that there was great confusion on the function of the various female adnexa so that opinion fluctuated from time to time. Of the penis, Leonardo remarks:

The origin of the penis is situated upon the pubic bone so that it can resist its active force on coition. If this bone did not exist, the penis in meeting resistance would turn backwards and would often enter more into the body of the operator than into that of the operated.

fig 3. The uterus and adnexa.

This figure of the uterus is not easy to interpret. It has undoubtedly some objective basis which is, however, overlaid by traditional notions. The body of the uterus and the cervix with its os are easily recognized.

Three paired structures extend to the lateral border of the uterus. The most inferior of these is the vas seminarium which carries sperm from the ovary to which it is attached. Entering the upper pole of the ovary are the ovarian vessels which carry blood and vital spirit to the ovary to be transformed into sperm. The intermediate structure which might be regarded as corresponding to the round ligament of modern terminology extends upwards to the region of the kidney and might be mistaken for the ureter. It is a hypothetical vessel which extends to the anterior abdominal wall as shown in fig. 8 below, and passes as the equivalent of the superior epigastric vein to the mammary gland. The blood of the retained menses during conception passed by way of this vessel to be converted by the breasts into milk. The third pair of structures are undoubtedly the uterine tubes giving to the uterus its bicornuate appearance as required by a tradition which had based its opinions on animal appearances. Nonetheless, the figure is far and away the best representation of the human uterus although distorted somewhat to fit the current physiological theory.

fig 4. The urethra, seminal vesicles and ejaculatory ducts.

Leonardo makes a note to determine the point of entry of the ejaculatory ducts in relationship to the bladder. This question is correctly decided at a later date, cf. 197.

See which is the first in the urinary canal [urethra], *either the mouths of the spermatic vessels* [ejaculatory ducts] *or the mouth of the urinary vessel* [bladder]. *But I believe that that of the urine is first so that it can then clean and wash out the sperm which makes the urinary canal sticky.*

fig 5. Diagram of the vulva, vagina, uterus and so-called seminal vessels.

The figure carries the legend, *The womb which is seen from without.* For a description of the structures, cf. fig. 1 above.

fig 6. Diagram of the vagina, uterus and adnexa.

The legend reads: *The womb looking into the interior.* The structures are as in fig. 1.

fig 7. The male generative organs.

The structures are as in fig. 2 above. Attention is drawn to the fancied homology between the seminal vesicles, labelled a b, and the uterine cavity.

The female has her 2 spermatic vessels in the shape of the testicles [equivalent of ovaries with suspensory ligaments, cf. above] *and her sperm is at first blood like that of the male. But when one inseminates the other, the testicles receive the generative faculty but not one without the other. Neither one* [sperm] *nor the other is preserved in the testicles but one in the womb and the other, that of the male, is preserved in the two ventricles a b* [seminal vesicles] *which are attached behind the bladder.*

fig 8. The genito-urinary system of the female.

(continued on page 505)

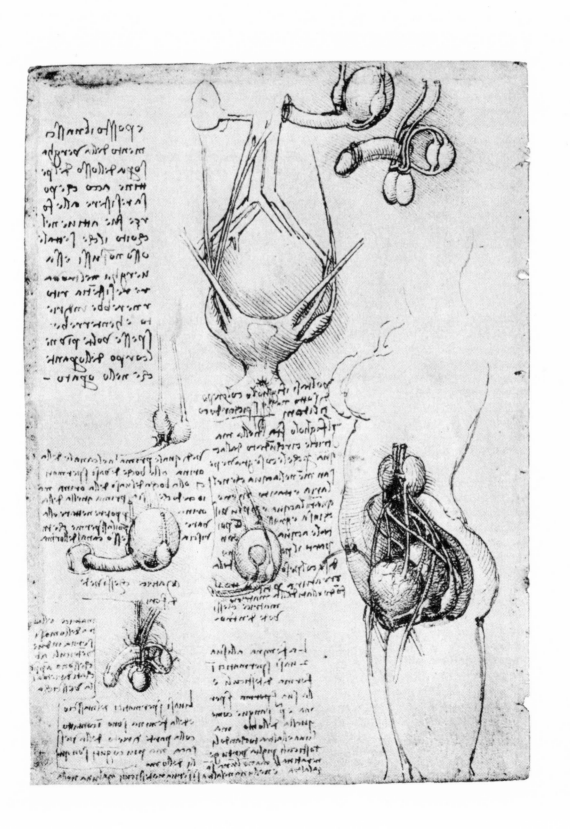

This, the most famous of the Leonardine anatomical illustrations, belongs to the period when Leonardo was coming more decidedly under the influence of Galenical teachings. It will be noted that the outlines of the figure have been pricked for transfer, giving rise to the incomplete copy on 203.

The illustration is a unique attempt to represent in graphic form both anatomical detail and certain of the principles of the Galenical physiological system. In this respect it fore-shadows the method adopted by Vesalius in the first three of his *Tabulae anatomicae* of 1538. The representational aspects are, however, to receive fuller treatment as evidenced by the note at the top of the page.

Also make this demonstration as seen from the side so that knowledge may be given how far one part lies behind the other. Then make one from behind that knowledge may be given of the veins possessed by the spine and by the heart, and of the greater vessels.

These figures illustrating the general physiology and anatomy of the female were perhaps to consti-tute an introduction to the embryological section of his proposed work. This is suggested by an accom-panying note which points to figures of somewhat later date such as 210, 213-14, of the foetus in utero.

Your series shall be with the beginning of the for-mation of the child in the womb, stating which part of it is formed first, and so successively putting in its parts according to the periods of pregnancy until birth and how it is nourished, learning partly from the eggs laid by hens.

Several features of the illustration should not be overlooked. In the first place it should be recognized that the anatomical details are drawn for the most part from dissections made on animals. This will be-come apparent as the figure is discussed from above downwards in association with Leonardo's marginal memoranda. The trachea and bronchi remind us that Leonardo is thinking of the pneuma or world-spirit drawn in with the inspired air to be carried to the left ventricle for the formation of the vital spirit. The heart is characteristically represented as a two-cham-bered and solely ventricular organ containing, as in the ox, moderator bands in both ventricles, and the interventricular septum shown prominently since through its supposed pores blood sweats to the left side for the completion of the vital spirits. The atria exist as auricular appendages only to participate in a complicated way in the formation of the natural heat as described.

The vena cava opens directly into the right ven-tricle and is associated with the ebb and flow move-ment of the blood containing the nutritive natural spirits. It receives the azygos vein thought to nourish the thoracic walls, but the arrangement of this and other branches reflect animal anatomy. The blood is drawn by the hepatic veins from the liver, the blood-making organ, which has received the chyle by way of the portal system for elaboration into blood and natural spirits. The relations of these systems is to be elucidated in further detail. *Represent how and what ramification of the vessels of the liver enters one be-neath the other* [i.e., relations of hepatic artery to portal vein].

The gall bladder and the spleen are shown since they form the yellow and black bile respectively, as well as remove the so-called excrements or waste products of metabolism. The yellow bile is filtered out by the kidneys, thus coloring the urine. The kid-neys occupy the relative positions found in animals. Their ureters pass to the bladder which is indicated as a circle lying anterior to the uterus. The black bile or melancholia is discharged in part through a hypo-thetical vein to the stomach to whet the appetite, but the most part is eliminated by way of haemor-rhoidal veins into the rectum upon which Leonardo remarks: *The fullness of the rectum, being dense, is expelled entirely by the wind contained in the colon. All the faeces of which the intestines empty them-selves, are almost entirely driven out by this wind. This causes a noise when it is in excess following the filling up of the vacuum left by the aforementioned superfluities.*

Like the vena cava, the branchings of the aorta are of the ungulate type. Not only does a typical brachio-cephalic trunk spring from the aortic arch, but the pattern of arrangement of the external iliac vessels is also derived probably from the ox. The major vessels are to be represented from behind. *The vena chilis [cava] and arteries: it is necessary with respect to that part where they follow the spine to represent them from the reverse, that is, make them visible from the side where they touch the spine because the smaller veins which nourish the bones of the spine cannot be shown in the figure demonstrated.*

The representation of the uterus is a curious ad-mixture of traditional notions and accurate observa-tion. It is a globular or pisiform structure of exagger-ated size possibly to indicate the organ in pregnancy. From the fundus extend on either side two structures which may be interpreted as the uterine tubes and round ligaments but certainly not recognized as such. It is more than probable that these structures derive from some confused prototype and are the so-called cornua of earlier authorities. The ovarian or spermatic arteries and veins may be traced to the ovaries or "testicles". These vessels carry blood and vital spirit to the organ which is converted into semen. The semen leaves the ovary by way of a short passage also called the "spermatic or seminal vessel" to enter the uterus in the region of the cervix. Elsewhere (201) Leonardo shows this passage entering at a higher level in approximately the position of the suspensory ligament of the ovary. Leonardo now discards the Aristotelian view on generation as reflected by Mun-dinus that the seed is from the male alone, the fe-male acting only as the soil, and adopts the teaching of the Arabic writers that both sexes contribute in equal part. *It is you, Mundinus, who states that the "spermatic vessels" or testicles [ovaries] do not ex-crete real semen but only a certain saliva-like humor which Nature has ordained for the delectation of women in coition, in which case, if it were so, it would not be necessary that origin of the spermatic vessels derive in the same way in the female as in the male.*

On the right side, a vein in part corresponding to

(continued on page 505)

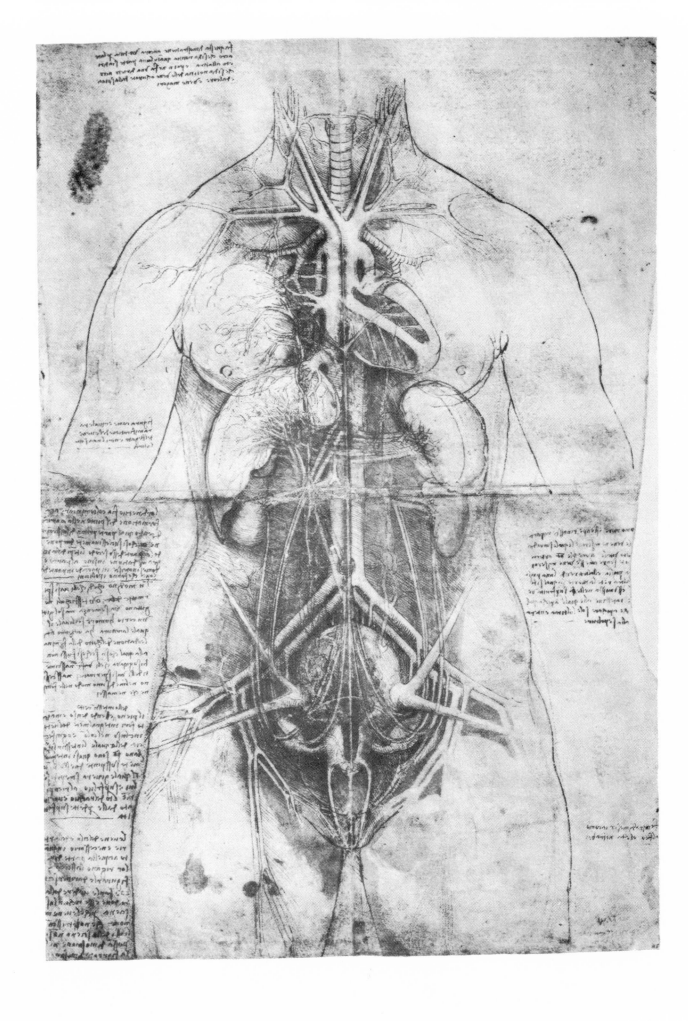

203 genito-urinary system

This outline is the tracing made from 202. It should be examined in conjunction with the more detailed illustration since the origin and source of some of the vessels can be viewed more clearly here.

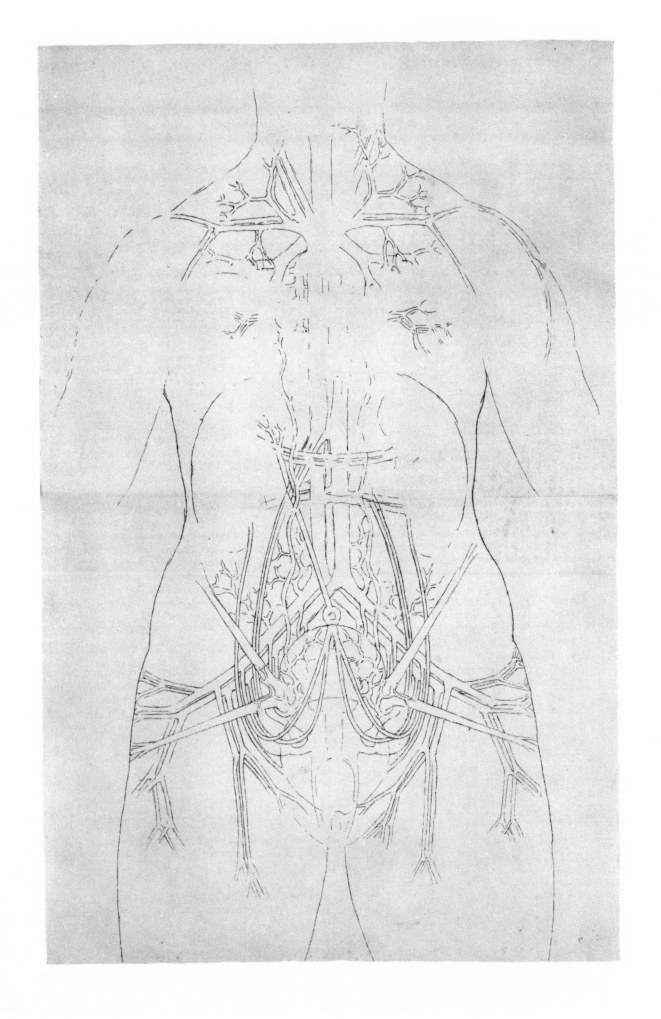

From a note on the recto of this folio which may refer to the statue of Francesco Sforza, Clark dates the drawings as probably c.1493, in which case they are among the very few anatomical studies from this period. This interpretation of the note is open to question although it must be conceded that the anatomical content of the plate suggests a relatively early date, possibly c.1500. The plate is of further interest since it is one of the earliest of the anatomical series to be reproduced in facsimile. Engraved by Bartolozzi for John Chamberlaine, the print was in circulation for some years prior to its inclusion in the *Imitations of original designs by Leonardo da Vinci*, 1796, as may be gathered from a note in Johann Friedrich Blumenbach's *De generis humani varietate nativa*, 1795.

fig 1. **The alimentary tract.**

A very crude diagram of the alimentary tract, no doubt inspired by appearances in animal dissections. The structures labelled are the *umbilicus* connected to an unknown structure, possibly the abdomasum or true stomach of ruminants, and a structure called the *matron*, of unknown significance.

fig 2. **Figures in coition.**

I display to men the origin of their second—first or perhaps second cause of existence.

Below the figure is the legend, *Here two creatures are cut through the middle and the remains are described.*

The figure expresses almost entirely traditional notions on the generative act in an attempt to harmonize opinions derived in part from Avicenna and in part from Galen. From Galen would come the belief that the sperm is derived from the testes, the "first cause", and from Hippocrates by way of Avicenna, the idea that the soul, the "second cause" is infused from the spinal cord, the site of the generative faculty, cf. 153. Thus we observe that the penis contains two canals, better seen in figs. 4-5 below. To the upper of these canals passes a nerve conducting the animal spirit or soul to the future embryo, and the lower canal is that related to the passage of the sperm as well as of the urine. These notions are later to be discarded. The corrugated appearance of the uterus reflects the mediaeval idea that its cavity was divided into seven cells. This extraordinary idea came doubtless from Mundinus who, in turn, obtained it from the works of Michael Scot (d.c.1235). The uterus itself was supposed to expand during coition as shown, and the cervix opened, according to some of the Arabs, to embrace the glans penis. On conception the blood of the retained menses is carried by way of the epigastric veins, as illustrated, to the breasts for the formation of milk. That Leonardo is somewhat uncertain as to the truth of these physiological beliefs is indicated in the note.

Note what the testicles have to do with coition and the sperm. And how the infant breathes and how it is nourished through the umbilicus. And why one soul governs two bodies as you see the mother desiring a food and the infant remaining marked by it.

And why an infant of eight months does not live.

Here Avicenna supposes that the soul begets the soul and the body, the body and every member, per errata.

How the testicles are the cause of ardor.

Which animal [parts, i.e., nervous system] *give rise to what parts of the members of man—simple or mixed?*

With reference to the male figure, Leonardo points to the diaphragm with the notation that this is the, *division of the spiritual parts* [i.e., thoracic contents] *from the material* [i.e., alimentary].

A final note is of considerable importance since it recognizes the venereal source of disease. It will be recalled that syphilis began to assume epidemic proportions following the conquest of Naples in 1495, initiating the great unsettled controversy on the Columbian versus European origin of the disease. The reader should remember that the word ulcers (*serite*) here used may not necessarily refer to syphilis and that dating of this folio as 1493 is very uncertain.

Through these figures will be demonstrated the cause of many dangers of ulcers and diseases.

fig 3. **Sketch of torso, squared for enlargement.**

figs 4-5. **Longitudinal and transverse section of penis.**

These sections are quite fanciful and present a traditional view that there are two penile passages, one above for the transmission of animal spirit from the spinal cord (see above) and the other below for the urine and sperm. The notion is derived from Avicenna.

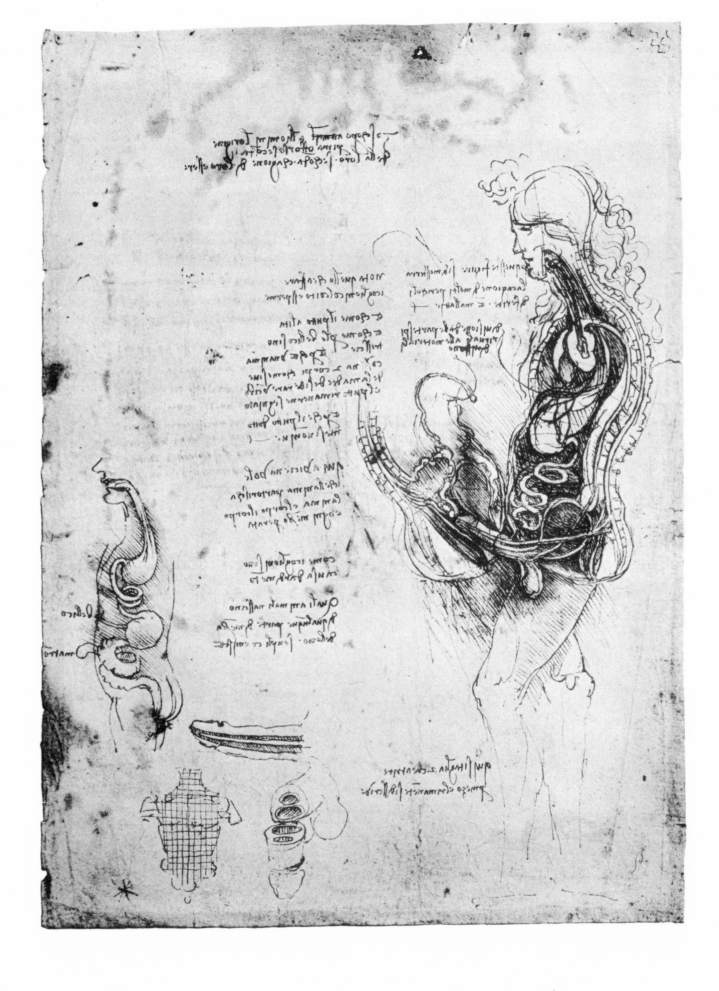

The mechanical drawings and calculations will not be discussed except to draw attention to the now familiar device of a chain of buckets used for elevating water, dredging, etc.

figs 1-3. **Coition figures in sagittal section.**

These figures are variants of that found on 204, and doubtless are preliminary to it since there is less detail. Again it will be observed that the penis is shown as containing two passages: an upper for the infusion of animal spirit or the soul from the spinal cord and the lower, for the emission of semen or urine. For the source and explanation of this curious notion, cf. 204. The uterus is poorly represented, and the intromittent organ is shown depositing the sperm directly into its cavity through the opened cervix, an idea derived from Arabic sources. At the upper end of the uterus three of the seven ovoid cells are represented. These are better seen in 204 and 206. The division of the uterus into seven cells was a popular notion gained from Mundinus and Michael Scot, cf. 206.

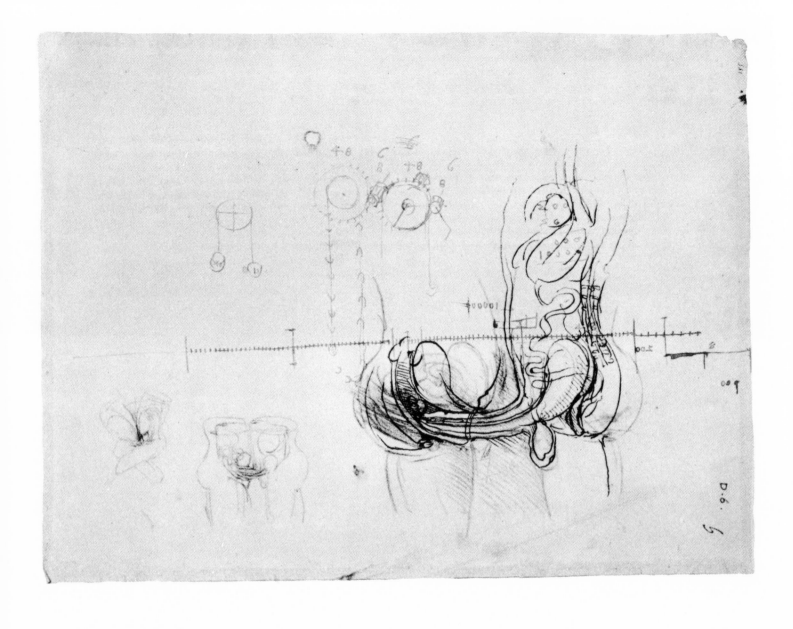

The mechanical drawings of cranes, pulleys, etc., are not discussed.

fig 1. **Rough sketch of the uterus.**

fig 2. **The male and female generative organs in coition.**

These drawings are similar in content to those of 204 and 205. Their special interest lies in the representation of a number of cells at the upper end of the uterus. It was a common notion of mediaeval times that the uterus was subdivided into seven cells. The idea was popularized by the widely read *Liber physiognomiae* or *De secretis naturae* of Michael Scot, one of the founders of Latin Averroism. It is repeated in Mundinus, whence no doubt Leonardo picked it up, and figures in the *Anatomia* of Gui de Vigevano (1345) and in the works of Magnus Hundt (1501). The doctrine led to the idea that there were as many cells in the uterus as there were mammary glands and was used to support the statement of Avicenna that the uterus was a bilocular organ in man since there are but two mammary glands. The latter notion continued late into the sixteenth century and gave rise to a theory of sex determination in which the left cell came to be regarded as giving rise to a female infant and the right to a male. Although Leonardo later figures the human uterus as containing a single chamber (cf. 201), it must not be forgotten that the upper angles of this chamber in relationship to the uterine tubes came to be regarded as representing in fact a bilocular arrangement.

The dating of this page is problematical. It is not unlikely that the various sketches and notes were made at slightly different periods. However, all the anatomical sketches bear an affinity to 201 and suggest a date of c.1503. Several of the notes and diagrams are studies on wave formation. Another is the ground-plan of a house. These will not be discussed.

The anatomical sketches, although important from the point of view of Leonardo's developing knowledge on generation, are so slight as scarcely to warrant individual description. They will therefore be divided into two general groups.

group I. **Sketches of the stomach and duodenum from anterior, posterior, right and left aspects.**

These sketches occupy the upper left-hand corner of the page, and nothing remarkable is exhibited ex- cept as indications of how Leonardo intended to represent this organ.

group II. **Sketches of the male and female organs of generation.**

This scattered series of sketches show the sexual organs either separately or in coition. Their impor- tance lies in the advance shown over traditional me- diaeval concepts represented in 204, 205, 206. That Leonardo was dissatisfied with earlier notions is sug- gested by a note which from a deletion refers to gen- eration, *I have wasted my hours.* The uterus is no longer shown as a multilocular organ, but the Arabic notion persists that the glans penis passes through the os of the cervix into the body of the uterus and that this organ enlarges on coition. The figures are in some respects similar to those of 201 and seem to be preliminary to them.

EMBRYOLOGY

fig I. **Diagram of the umbilical vessels in the ox or sheep.**

The figure is difficult to interpret unless it is realized that both the extra- and intra-foetal course of the umbilical and allantoic vessels of the ox or sheep are diagrammatically illustrated, cf. 211. The horizontal, paired, umbilical and allantoic vessels are shown passing from the foetal membranes. From them extend a number of branchings, some placed vertically and said to come from the chorion, and others placed obliquely or horizontally and stated to be from the amnion. The two pairs of umbilical vessels pass to the umbilicus to terminate in a single umbilical vein shown passing upwards to end in the liver. Descending from the umbilicus are a pair of vessels on either side which correspond to the umbilical arteries in their intra-foetal course, the vein being entirely imaginary. These vessels reach horizontal segments which represent iliac vessels. It is not always clear whether Leonardo was able or not to distinguish the allantois, which makes precise identification of structures more difficult. The appearance of the umbilical arteries after birth is doubtless responsible for his calling them sinews or nerves. Leonardo would be especially interested, as mentioned in the notes, in cases where the membranes remained unruptured at birth since he himself is said to have been born with an intact caul.

These four sinews [?umbilical arteries] *do not themselves contain any part of the blood, but when they enter the umbilicus, they are converted into a large vein* [umbilical vein] *which then extends to the gateway of the liver and proceeds to ramify through its inferior part. Each of its terminal ramifications ends in this part* [of the liver] *and does not extend higher.*

Of the above-mentioned four umbilical vessels, the 2 on the outside [infra-foetal umbilical vessel] *lie upon the peritoneum, the membrane contiguous to the omentum. They then turn downwards and end in the first ramification* [iliac vessels] *of the great vein and artery which lie upon the dorsal spine.*

The external ramification of the umbilical vessels [extra-foetal] *is enclosed between the first* [chorion] *and second membrane* [?amnion] *with which the infant is frequently born.*

This umbilical vein is the origin of all the veins of the animal which is engendered in the womb. It does not have its origin in any vein of the gravid female because each of these vessels is entirely separate and divided from the vessels of the gravid woman. These are the veins and arteries placed together in pairs, and it is very rare to find one without the other in company. Almost always the artery is found above the vein because the blood of the artery is the passage of the vital spirits, and the blood of the vein is that which nourishes the animals. Of these ramifications represented, those which extend upwards are arranged for the nourishment of the 3rd thin membrane [chorion] *of the womb, and the vessels lower down, placed obliquely, are those which nourish the final membrane* [?amnion ?allantois] *which is in contact with the animal and which clothes it. One or other of these membranes frequently emerges together with the creature out of the womb of the mother. This happens when the animal cannot rupture them so that it then emerges clothed by them. This easily occurs because these 2 very thin membranes, as has been said above, are nowhere united to the said womb which, in turn, is composed of 2 membranes* [uterine wall and maternal placenta] *which are very thick, fleshy and sinewy.*

fig 2. **Diagram of a cotyledon.**

Diagram showing the villi and sinuses of the maternal placenta a, and the foetal placenta n; probably the cotyledonous placenta of the ox. Leonardo clearly perceived that half of each cotyledon remains with the foetus.

The cotyledon a, is female and it remains with the uterus. The cotyledon n, has male elements which enter into the concavities of the cotyledon which remains attached to the uterus. There is no other attachment.

The little sponges [cotyledons] *which unite the uterus of the woman to the secundines* [chorion] *of the infant are divided through the middle of their thickness, and half remains with the uterus and the other half remains with the 2nd* [membrane-chorion] *which covers the infant. Here one must note whether the half which remains has the teeth or the sockets of these teeth in it, as* [in fig. 2, where are] *a, the sockets, and n, the denticulations.*

fig I. **The relationship of the maternal to the foetal vessels.**

Here Leonardo asserts that no continuity exists between the vascular systems of foetus and mother. This fact was again put forward by Arantius (1564) but denied by Laurentius (1598) and Fabricius (1600), reaffirmed by William Harvey (1651) and Walter Needham (1667) and not fully established until proved by the injection experiments of Hoffmann (1681), confirmed by Ruysch (1701), Monro *primus* (1734) and William Hunter.

The portion of the figure to the right is stated to show, The *vene massime* [i.e., caval system] of the woman, and that on the left, The *vene massime of the child in the uterus.* Note that the umbilical arteries within the subject are accompanied by corresponding veins and that these vessels terminate in a single umbilical vein passing upwards to the liver, cf. 208. The umbilical cord appears to be represented by a single vessel, but judging from other illustrations of the period we must assume that this is not a vessel but the cord itself. In any case Leonardo's views were colored by his dependence on the foetal anatomy of animals, especially the ox, as the note indicates.

The uterine veins and arteries of the woman have the same intermingling by contact with the terminal vessels of the umbilical cord of her child at a b, as the miseriaic [portal] veins ramifying in the liver have with the ramifications of [hepatic] veins descending from the heart into the same liver, and as the ramification of the pulmonary vessels have with the ramification of the trachea [bronchi] which refresh them. But the vessels of the infant do not ramify in the substance of the uterus of its mother but in the secundines which take the place of a shirt in the interior of the uterus which it coats, and to which it is connected (but not united) by means of the cotyledons, etc.

fig 2. **Sketch of the uterus and uterine vessels.**

The sketch is in the nature of a reminder to: *Provide information how the uterine vessels ramify in the uterus and of what sort and number they are, and which enter the secundines and which of them are ruptured at the separation of the child from the uterus.*

The following passage seems to be a continuation of the lengthy statement given on 74 on the order to be adopted for the arrangement of the contemplated book on anatomy and jotted down on this page as an after-thought. Mechanical and physical principles such as potential and kinetic energy in the operation of the economy of the body are to be discussed but in the terms of Aristotle's *De physica* such as accidental quality, local motion, the action of contraries which Leonardo calls percussion, etc.

ON MACHINES.

Why Nature cannot give motion to animals without mechanical instruments is shown by me in this book On Motive Agents Made by Nature in Animals. For this reason I have laid down the rules of the 4 powers of Nature without which nothing through her can give local motion to these animals. Therefore we shall first describe this local motion and how it produces and is produced by each of the other three powers. Then, we shall describe natural weight, although no weight can be said to be other than accidental, but it has pleased us so to call it, in order to distinguish it from the force which in all its operations is of the nature of weight, and for this reason termed accidental weight. This force is produced by the 3rd power of Nature or is natural. The fourth and last power will be called percussion, that is, the termination or opposition to motion. We shall begin by stating that every involuntary local motion is generated by a voluntary motion, just as in a clock the counterpoise is lifted up its motor, man. Furthermore, the elements repel or attract one another as one sees water expelling air from itself and fire entering as heat at the bottom of the kettle and escaping through the bubbles on the surface of the boiling water. And again, a flame attracts air to itself, and the heat of the sun draws water upwards in the form of moist vapor which then falls as scattered heavy rain. But percussion is the immense power of things which is generated within the elements.

fig 1. **The foetus in utero.**

This large drawing of the foetus in utero is the first of the series as indicated by the asterisk. Two features of the illustration require comment. First, Leonardo had no knowledge of the coverings of the human foetus and therefore illustrates their attachment by a stylized cotyledonous placenta of ungulates shown in detail in figs. 2-5, and more realistically in 211. Second, the ovary is connected to the uterus by a so-called spermatic duct implanted immediately above the cervix but in other drawings corresponding to the suspensory ligament of the ovary, cf. 201 and 202. The accompanying note is unusual in its denial of the presence of the foetal heart beat, but subscribes to a common mediaeval notion on the transmission of the soul to transform the animal body into man.

The heart of this child does not beat nor does it breathe because it continually lies in water. If it breathed it would drown and breathing is not necessary because vivified and nourished by the life and food of the mother. This food nourishes this creature not otherwise than it does with other members of the mother, that is, the hands, feet and other members. One and the same soul governs these two bodies, and the desires, fears and pains are common to this creature as are all other animal [nervous] members. From this it occurs that the thing desired by the mother is often found impressed upon those members of the infant which the mother herself holds at the time of the desire, and a sudden fright kills both mother and child. Therefore, one concludes that one and the same soul governs the bodies and one and the same nourishes both.

On the connection between the maternal and foetal circulation, a question which was to take some centuries to answer, Leonardo is at this stage uncertain.

See how the great vessels of the mother pass into the uterus, then to the secundines and then to the umbilical cord.

figs 2-5. **Details of the ungulate placenta.**

As previously mentioned, Leonardo knew little or nothing of the discoidal placenta of man, cf. 173. Here he illustrates the details of a cotyledonary arrangement as in the ungulates. The first of the smaller illustrations is quaintly called, *The mother of the cotyledons, that is, female cotyledons.* The second and fourth figures of the group show, *The male cotyledons,* and in the larger or third figure we are shown, *How the three membranes of the uterus tie themselves together by means of the cotyledons.*

Leonardo was greatly interested in what happened to the cotyledons at parturitions and raises the question whether the maternal or foetal cotyledon remains attached to the uterus. *The cotyledons have male and female [parts]. You will now note whether the male or female remains attached to the uterus of the woman or not.* An answer is sought from the conceptus of a calf, *Obtain the secundine of calves when they are born and note the shape of the cotyledons and if they keep the male or female cotyledons.* The question is finally resolved on 211.

fig 6. **An unrelated diagram and note on the behavior of an eccentrically weighted sphere.**

fig 7. **Minute sketch of uterus, ovaries, and indications of cotyledons.**

fig 8. **Preliminary sketch of foetus in utero to show successive coverings.**

fig 9. **Uterus laid open to expose the conceptus.**

The so-called "male and female" cotyledons are shown. On either side are the ovaries and the presumed "spermatic duct" extending to the interior of the uterus, cf. 202. *Note how the testicles [ovaries] pass their faculty into the uterus.* In answer to the question raised under figs. 2-5, Leonardo states, *I note how the secundines are united to the uterus and how they separate from it [on parturition].*

fig 10. **Diagram of the interdigitating cotyledons.**

On the figure is written the word, *cotyledons.*

figs 11-13. **Diagrams of the uterus and foetal membranes laid open.**

These preliminary sketches are to show the membranes by laying each open successively. In the first, fig. 11, the uterine wall and chorion have been split to expose the amnion with the foetus shining through. Leonardo's intention is expressed thus: *Make it so that the uterus has as many demonstrations as there are membranes of which it is composed.*

fig 14. **Diagram on binocular vision.**

Why a picture seen with one eye will not demonstrate such relief as the relief [customarily] seen with both eyes. This is because the picture seen with one eye will have the degree of relief, as a relief proper having the same amount of light and shade. Let the relief c, be seen with both eyes [m and n]. If you were to observe the object with the right eye m, keeping the left eye n, closed, the object would appear to the eye in, or would occupy, the space a. If you were to close the right eye and open the left, the object would occupy the space b. And if you were to open completely both eyes, the object would no longer occupy a and b, but the space e r.

Other memoranda: *Place in every member what is closer to the surface of the member, either the nerves, the cords, the vessels or the muscles and how far. This will serve for [the appreciation of] the depth of wounds.*

The book "On water" to Messer Marco Antonio.

For Leonardo's book on water, cf. 113. This may or may not be a reference to Marcantonio della Torre, the anatomist whom Leonardo presumably met at Pavia. However, the name Marcantonio was a very common one.

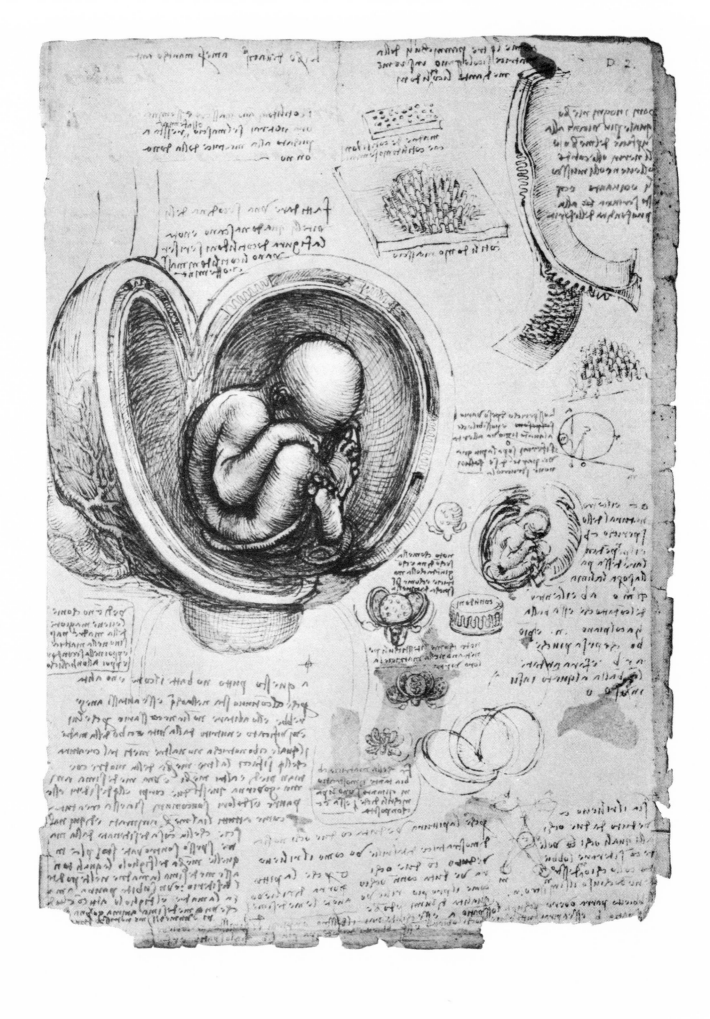

embryology

The figures are enumerated from right to left.

fig 1. **The gravid uterus of a cow.**

This excellent drawing illustrates the vagina and bicornuate uterus of a gravid cow. The uterine and ovarian vessels are labelled a b c d, and the suspensory ligament of the ovary, believed to be a seminal duct, is clearly shown.

THE UTERUS OF THE COW.

The testicles [ovaries] *are not attached to the vascular part but to its covering* [peritoneal] *which does not show vessels. The former together with its covering mentioned, constitutes the true womb.*

The 4 vessels, a b c d, are two arteries and two of blood [i.e., veins] *and are those which carry the menstrua to the uterus. They are enclosed between the first membrane* [peritoneal tunic] *and that which is the second* [uterine wall]. *The testicles are attached to the first membrane.*

fig 2. **Diagram of the uterine cotyledons on uterine contraction.**

Leonardo states that these hexagonals, c b a d, f e g, h i, k, show, *The manner in which the rosettes or little sponges* [cotyledons] *of the uterus are joined together when it is contracted after birth.* However, the figure suggests the spongy appearance due to the numerous crypts which receive the villi of the chorion. A reminder to show the interdigitation of villi and crypts is appended: *Note what part of the little sponge is that which enters by means of its teeth into the other part.*

fig 3. **Outline sketch of the umbilical vessels of the calf in their extra-foetal course.**

fig 4. **The foetal calf and its membranes.**

To find the equal of this superb illustration of the cotyledonary placenta of the ruminant we must go to the *De formato foetu* (1604) of Fabricus ab Aquapendente, the father of modern embryology. For detail of the umbilical vessels shown, cf. 208. Of the cotyledons and membranes Leonardo says:

This [figure] *below contains the 3rd* [chorion] *and 4th* [? amnion or allantois] *coverings of the animal enclosed with the uterus. These coverings are united, that is, are in contact and that which is above* [i.e., more superficial] *unites with that* [uterus] *by means of these fleshy rosettes* [cotyledons] *which interlock and are attached as do burrs among each other. At birth the foetus carries with it these 2 coverings together with half the thickness of these roses, the other half remaining in the uterus of the mother. Then when the uterus contracts, they are compressed together and attached by their sides to one another* [fig. 2] *in such a way that they appear never to have been separated. The covering which is in contact with the animal at birth has none of these fleshy roses.*

fig 5. **Diagram of the maternal and foetal elements of a cotyledon.**

Leonardo's description of the interdigitation of the cotyledonary villi of the ruminant is fully explanatory.

How the little sponges which unite the middle membranes to the two outermost are going to separate one half from the other. One half goes with the foetus when it is born with its coverings, that is, the part which is below [in the figure]. *The other half, which lies above, remains with the uterus; these being distributed 6 to 6. When the uterus contracts, all these small fleshy sponges come in contact at their margins and finally are joined together by hexagonal sides* [fig. 2] *and are united and reduced to a single piece of flesh. These then separate again and spread out with the following impregnation.*

Just as the fingers of the hand are interwoven, one in the interval of the other, lying straight and facing, so the fleshy villi of these little sponges [cotyledons] *are interwoven like burrs, one half with the other.*

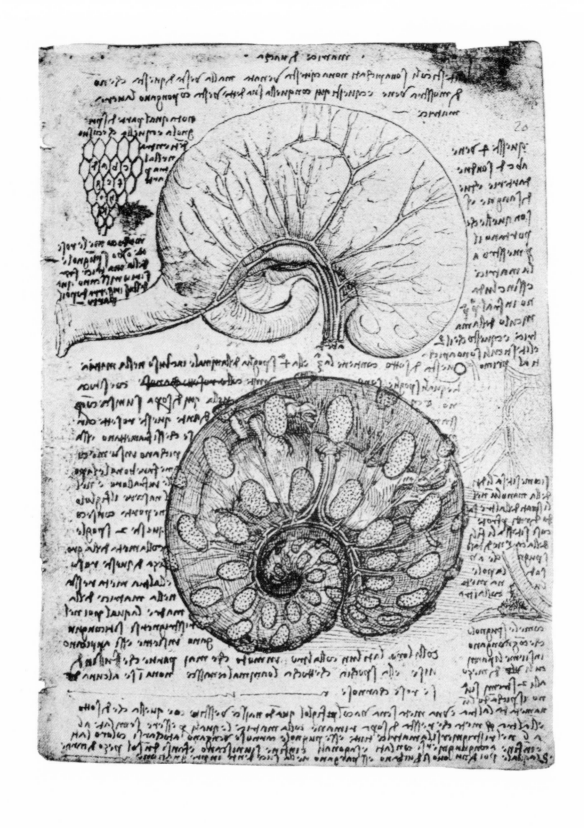

ON ALL THE FORCES AND ACTION OF THE MUSCLES OF THE [FORE-]ARM, THAT IS TO SAY, WHICH MUSCLE ROTATES IT, WHICH FLEXES IT.

Although containing illustrations and notes on myology, this folio is primarily concerned with the embryology. Differences in handwriting and subject matter suggest that the studies on the arm are of earlier origin and completed around 1505. To these were added at a later date the sketches and notes on the foetus and its coverings corresponding with the series on 210, which are similar in style and were executed around 1511. Therefore the notes and annotations deal with the upper extremity, figs. 1-2, followed by the figures of the foetus and uterus.

fig 1. **The bones of the upper extremity illustrating the action of the brachialis, biceps and pronator teres muscles.**

Let this demonstration be made from 4 aspects, in extension as well as in flexion.

Draw the very same arm when the hand shows its palmar (domesticha) surface [supination] and likewise its dorsal (silvestra) surface [pronation] maintaining the humerus without any degree of rotation.

The terms *domesticha* and *silvestra* are taken over from the Latin of Mundinus and were common terms derived from Arabic words. They correspond to inner and outer respectively, especially in connection with the surfaces of the limbs, but if rendered "smooth" and "hairy", perhaps the word imagery would be better preserved.

ON THE INSTRUMENTAL USE OF THE MEMBERS.

The muscle a b c [biceps brachii] serves to rotate the bone m f [radius] through a half revolution; and it was made double at its upper origin for the reason that if there should be a failure of one, the other would supply the said motion of the arm.

And the 2nd muscle r p [brachialis] is made to bend the arm into any degree of angle. It is attached to the humerus b n, and to the non-revolving fucile of the arm, that is, the fucile maggiore [ulna]. It is very strong because it has to support a very large weight; and it cannot rotate the arm like the muscle a b c [biceps] and the muscle d e [pronator teres] in opposite motion [acting] like the cords of a trephine, an instrument for drilling.

When the muscle r K L [for r K, brachialis] elevates the fucile h g [ulna], it is supported, owing to its tortuosity, upon the humerus at the part K. Hence this muscle, because of such support, is relieved of much of the stress at the attachment of the muscle, the other half of which arises directly from the said humerus.

It is evident from the statement that the ulna is supported directly by the humerus in flexion, that Leonardo's opinions on the action of these muscles were derived from an examination of the bony specimen and appreciation of the attachments of these muscles rather than by reference to the dissection itself.

c [tendon of biceps] is twisted around [the radius], as shown in the figure. Other structures indicated are o, the head of the humerus; d (like the numeral 4),

the medial epicondyle of the humerus; n, the lateral epicondyle of the humerus; h g, the ulna; m f, the radius; b, long head of biceps; a (like the letter p), short head of biceps; f L e (e, like the letter D, pronator teres.

fig 2. **Illustration of the action of the biceps brachii and pronator teres muscles.**

The two muscles a b [long and short heads of biceps] which join at d [tendon of biceps] and unite with the bone h f [radius], are made to rotate the bone h f, with a half turn, turning it in the concavity [radial fossa] of the bone b h [humerus], placed near its head h. But if the muscle c e [pronator teres] holds with its own power, then this cord or muscle [biceps] is unable to rotate the bone: and if this muscle a b d [biceps] has already rotated the bone h f [radius] from within outwards, then the muscle c e [pronator teres] will perchance rotate it from without inwards. These two said muscles are arranged by their Author that they may turn the hand to the front and to the back without having to rotate the elbow of the arm.

The two muscles a b d [biceps] and c e [pronator teres] are wrapped around the bone h f [radius] in opposite directions, of which when one pulls and unwraps itself, the other wraps itself around the bone like the ropes which revolve a trephine.

The antagonistic action of biceps and pronator teres in supination and pronation is clearly described and illustrated. The mechanism of these motions must have greatly interested Leonardo since he discusses these movements on numerous occasions.

Added at a later date is the following general note on the functional advantages of antagonistic muscles and of these which possess two heads of origin. It is clear that Leonardo has chiefly the biceps brachii muscle in mind.

Many are the members which are moved by two muscles arising from different sites. They unite at the side of the bone which is to be moved by these muscles and on which both muscles are attached by one and the same cord. This occurs because the same site where the cord attaches itself has to be moved by two almost similar motions; secondly, because if one of them were to be cut, the other would substitute since such rotary motion is especially necessary in eating as the fingers which pick up the food turn their dorsal surface towards the mouth and when they put the food into the mouth, they rotate in the opposite direction in the manner in which their tips, together with the food, is directed to the mouth of the person.

figs 3-4. **Two outline sketches of cotyledonary placenta.**

Leonardo like his contemporaries derived his ideas on human placentation from his investigations of animal forms, especially the calf. Hence he assumes that the human placenta is of the cotyledonary type as in ungulates. It has already been mentioned that the embryological series shown here are of the same period as 210, where this subject was discussed more fully.

fig 5. **Foetus in utero.**

(continued on page 505)

fig I. **The external genitalia of the female.**

The vulva and labia minora, omitted in 200, are now shown with greater accuracy of detail. The surface outlines of the adductor longus muscles are a prominent feature of the drawing, and their action is discussed in the adjoining figure. A note discusses the comparative size of the female organ in relationship to other animals and the infant at birth.

The woman commonly has a desire quite the opposite of that of man. This is, that the woman likes the size of the genital member of the man to be as large as possible, and the man desires the opposite in the genital member of the woman, so that neither one nor the other ever attains his interest because Nature, who cannot be blamed, has so provided because of parturition. Woman has in proportion to her belly a larger genital member than any other species of animal. It [the belly] is generally in a straight line from the fontanelle of the [. . .? costal angle] to the anus, one braccio [2 ft.] in length. The bovine species has a belly three times longer than that of woman so that by multiplying cubically one body by the other you would have to say that 3 times [3 makes 9], and 3 times 9 makes 27. But such a multiplication has no place here as a cow would have this member 7 times larger. Experience in the dead shows that it is a quarter of a braccio in its greatest length in a woman as well as in the ox and horse species, these being the largest animals in Europe. Still, you can say by the rule of three: if one braccio of the belly of a woman gives me ¼ of a braccio of member, how much will 3 braccia of the belly of a cow give me? You will say that if 4 quarters, that is, one braccio, give one quarter of member in a woman, how much will 12 quarters in the cow give me? They will give me three-quarters of a braccio. Thus, such an animal would have a member of [three-quarters] of a braccio in proportion to a woman who has one quarter. The significance of these dimensions is apparent when applied to the foetus.

The length of a child when it is born is usually one braccio, and it commonly grows 3 braccia, that is, in the medium size of the human species.

fig 2. **The muscles attached to the pubic bone.**

The illustration is a companion to fig. 1, showing the surface features. Its purpose is to establish the supposed synergistic action of the adductor longus muscles, m t and n S, and the recti abdominales, n f and m g, in preventing the displacement of the pubic bone on elevation of the leg. Leonardo is obviously confused as to the attachment of the recti muscles which are shown to cross above the pubis in a manner not infrequently illustrated in early anatomical diagrams, so that the figure may have a traditional basis. The external oblique, internal oblique and transversus abdominis muscles are shown on either side.

If it were not for the muscle n f [rectus abdominis] which is attached to the chest and to the pubis at n, the weight of the thigh with the leg which is supported at n, by means of the muscle n S, would draw the pubis downwards. And likewise the muscle S n [adductor longus] supports the pubis when the spine is bent [backwards] in an arch, because the muscle f n

[rectus abdominis] *draws the pubis upwards, etc.*

In what appears to be a later addition, Leonardo decides to put this theory of muscle action to a test.

And concerning this question, you will make an experiment by arching the spine backwards and throwing the chest forwards.

fig 3. **The foetal position in utero: anterior aspect.**

Leonardo depended entirely upon animals for his knowledge of the foetal coverings. Thus he describes the allantois and urachus.

ON THE PISSING OF THE CHILD.

During a great part of the time [of conception] of the child, its pissing is done through the umbilical cord. This happens because the heel of the right foot lies between the anus and the virile member and completely closes the urinary passage. Nature has provided for this state by making a channel [urachus] at the fundus of the bladder through which the urine goes from the bladder to the umbilical cord and from the umbilical cord to the mouth of the womb.

figs 4-5. **The foetus in utero: anterior aspect.**

Observations are made on the length of the umbilical cord: *The length of the umbilical cord is equal to the length of the child in every stage of its age, but not to that of other animals.*

figs 6-7. **The foetus in utero: right and left lateral aspects.**

Leonardo comments on the question of foetal respiration. It is only very recently that foetal respiratory movements have been shown to occur.

The infant does not respire in the body of its mother, because it lies in water, and he who breathes in water is immediately drowned.

And as a corollary, the question of phonation arises.

Whether an infant in the body of its mother can weep or produce any sort of voice or not.

The reply is no, because it does not breathe nor is there any kind of respiration and where there is no respiration there is no voice.

In order to understand the process of development, Leonardo contemplates turning to the incubation of the egg, but there is no evidence that he ever found time for such a study. *Ask the wife of Biagino Crivelli how the capon rears and hatches the eggs of hens when he is unplucked (inbricato).* The question was apparently asked and the reply noted. *Their chickens are given in care of a capon which has been plucked on the under side of the body and then urticated with nettles and placed under the basket [i.e., on a nest]. And then the chickens go under it, and it experiences pleasure and is pacified by the heat. Thereafter it leads them about and fights for them, jumping into the air against the hawk in ferocious defence.*

Biagino Crivelli was a favorite of the Duke Lodovico Sforza and head of his crossbowmen. Leonardo is reputed to have painted a portrait of Lucrezia Crivelli, perhaps his wife. He continues with a practical suggestion for his study. *Chickerns are hatched by means of*

(continued on page 506)

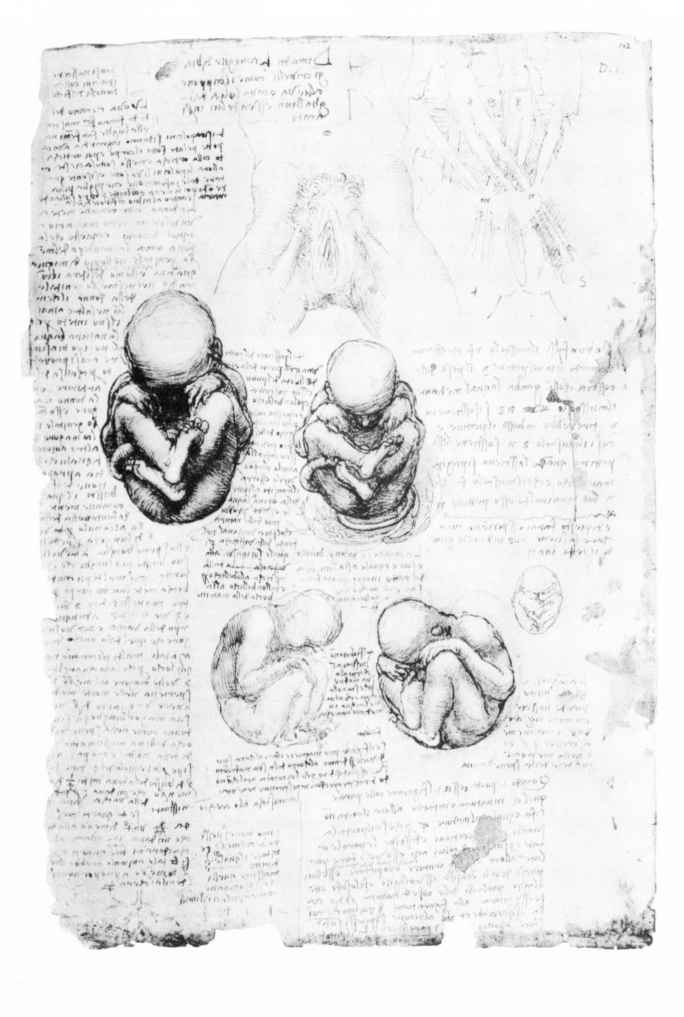

This page is the protocol of one of the few human dissections carried out by Leonardo. The subject was apparently that of a foetus of six to seven months (Leonardo says four months). The dissection enabled him to correct certain erroneous conclusions on the arrangement of the umbilical vessels and to make some quantitative observations on foetal growth.

figs 1-3. Segments of the umbilical cord.

The diagrams are labelled *umbilical cord*. It contains only a single vessel, and the representation suggests the presence of air-bubbles in the umbilical vein. Among the scattered notes it is stated that *The umbilical vein is always as long as the length of the child.*

fig 4. Sketch of human foetus.

This is probably a sketch of the specimen dissected.

figs 5-6. Sketches on the action of the biceps brachii and brachialis muscles.

Leonardo was fascinated by the mechanics of pronation and supination. Here he distinguishes between the action of the brachialis, a, as a pure flexor and the biceps, b, as a supinator.

The muscle a [brachialis] holds the arm in flexion only.

Represent here only the [brachialis] muscles which serve flexion of the [fore-] arm and reduce it to a right angle, and likewise the [biceps] muscles which cause the hand to revolve forwards and backwards. Do not encumber the above but simply represent the uses which the muscles arising between the shoulder and the elbow and those arising from the humerus alone have.

This intention has been carried out in 212.

fig 7. The umbilical cord, umbilical and iliac vessels.

In all earlier illustrations Leonardo shows imaginary umbilical veins accompanying the umbilical arteries from the umbilicus to the iliac vessels. The opportunity of dissecting a human foetus enabled him to correct the error in this and the succeeding figures. However, the umbilical cord is now envisioned as containing the umbilical vein only. This vein is shown extending to the liver to carry, according to Leonardo, nutritive products derived from the menstrual fluids of the mother. Unable to find, as in animals, an extension of the urachus to an allantois, he now believes that the urachus empties the urine into the umbilical vein of the cord which therefore serves a dual function, cf. below.

fig 8. Sketch of the umbilical vessels.

A dual function of the umbilical vein as a passage for nutritive products and urine is suggested in the accompanying note.

Let a b [umbilical vein] be the channel for the food and the passage for the urine, and it acquires two opposite motions but not at one and the same time.

fig 9. The umbilical vessels and cord.

The notes read: *This figure goes in the embryo, and do not make it elsewhere.*

Note well the umbilical vein, where it ends in the uterus.

fig 10. The umbilical vessels and cord.

In this figure Leonardo grafts his findings in the human foetus onto the placenta of an ox. The umbilical cord is shown terminating in ovoid bodies which are labelled *cotyledons*. Notes on the findings at dissection and conclusions reached surround the figure.

Large is the liver, and the kidneys.

We found that the chyle and the stomach of this child did not differ from that of a man. The child was less than half a braccio [under 1 ft.] and was nearly four months. I judged that this chyle was made from the menstrual blood which it took from the liver, which was given it by the umbilical vein.

Therefore the miseriaic [portal] veins are those which give through their ramification what they first received through these ramifications, and the arteries receive through the ramifications what customarily they first pour out.

fig 11. The umbilical and iliac vessels.

Similar to the other sketches of the series, the figure shows in addition the testes with spermatic veins extending erroneously to both renal veins. Leonardo reminds himself to illustrate the ductus deferens and seminal vesicles as seen on 202.

Let there be seen from the posterior aspect, the bladder with the spermatic vessels [ductus deferentes] in order that the position of these vessels may be observed. Give the dimensions of, and how far removed these vessels are from the anus.

In addition, Leonardo comments on the arrangement of the iliac vessels.

The first branching of the great vessels below the emulgents [renal vessels] is where the spine is joined to the sacrum. The second are the branches which divide to nourish the caudal spine. The third is into the menstrual of the woman and the uterus, and the fourth into the bladder. The 4, one and a half fingers further on, go to the testicles. The 4 which arise one and a third fingers more distant to these escape out of the peritoneal cavity and divide into two, one forming the saphenous and the other to the [. . .].

figs 12-13. The umbilical vessels and urachus.

In the note Leonardo returns to the idea that the umbilical vein carries menstrual blood to the liver which then passes by way of the portal system to the stomach to be converted into chyle.

The child forms excrements which arise from the blood which enters through the umbilical cord. The blood enters the liver and escapes from there through the gateway of the liver to enter the miseriaic [portal] veins and is converted into excrements [in the alimentary tract]. The . . . [hepatic] veins take some of it and carry the nourishment to the heart which at this time does not beat. And so when the child is in the uterus, the nutriment enters in a direction op-

(continued on page 506)

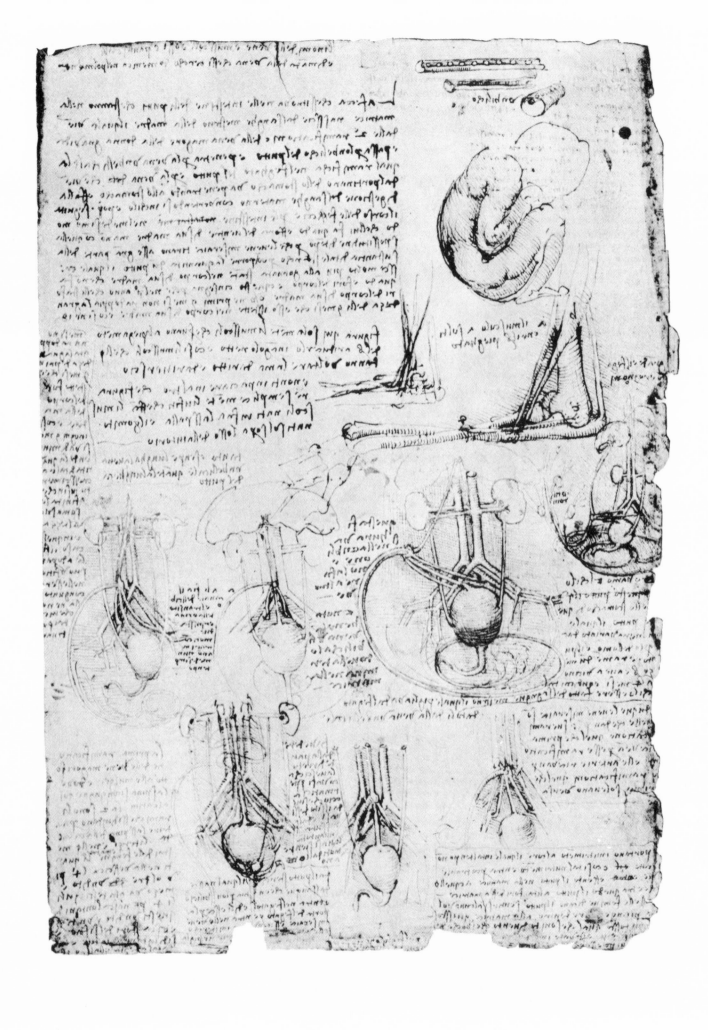

This page appears to be a continuation of the proto-col, 214, on the dissection of the human foetus. Two notes, one at the top and the other at the bottom of the page, have been added and are not in Leonardo's hand. The second of these, in a hand thought to be that of Francesco Melzi, is given below.

fig 1. **Sketch of a foetus in utero.**

A nearby note states that, *When they are small, the centre of the liver in children in the uterus lies below the centre of the heart and above the umbilicus, and when they are born, the liver withdraws to the right side.*

fig 2. **The umbilical vessels, umbilical cord and iliac vessels.**

The figure is identical in style to those on 214; Leonardo reminds himself to describe the uterine and umbilical vessels. For his theory, cf. 214.

Describe which branch of the great vessels is that with which the mother nourishes the child through the umbilical vein.

figs 3-5. **The liver and distribution of the umbilical, portal and hepatic veins.**

These figures illustrate the theory that menstrual blood is carried to the foetal liver by the umbilical vein, a portion passing to the heart by way of he-patic veins and another portion going via the portal system to the stomach to be converted into chyle, cf. 214. In the third of these figures the *heart, liver, stomach,* and *duodenum* are so labelled. The first group of related notes deals with morphological de-tails.

ON THE BOWELS.

I have found that the infant has 20 braccia [i.e., cubits] *of bowel, that is to say, 20 braccia of this child.*

The liver is lacking, or is diminished, on the left side when it [the foetus] *is full-grown, because the spleen and stomach increase on this side and not on the left* [for right] *side. Furthermore, it is to give room for the heart.*

The relative change in position of the liver from foetal to adult life is explained as being due to oblit-eration of the umbilical vein and the development of the spleen.

When the umbilical vein is in operation for what it was created, it occupies the principal position in man, that is, the middle of the belly, of the length as well as of the breadth. But when this vein was later deprived of its office, it was drawn to one side together with the liver, which was created and then nourished by it. This upper part of the umbilical vein was displaced from the middle by the change in position of the liver. Owing to the growth of the spleen created on the left side, the liver was driven into the right side and carried with it the upper part of the umbilical vein which was united to it.

The spleen which at first was a viscous watery or-gan, flexible and compressible, giving way to any-thing which pushed it out of position, later began to contract and condense and form its necessary shape. It needs must enter the place occupied by the left part of the liver when having filled . . . it withdraws to the right side, compresses and condenses the right part of the liver uniting with it [?umbilical vein]. *Thus the liver lacks ⅛ of its left part and retreats with its middle to the right side concentrating in this position.*

A further note elaborates on the theory of foetal nutrition, mentioned above. The theory required a two-way flow in the portal system between the liver and intestines. Leonardo calls upon his knowledge of back eddies in the flow of rivers to explain how this could occur. The bile duct was long unknown.

First cite a known comparison with the water of rivers and then with the choler [yellow bile] *which, when it wishes to enter the stomach, goes to the stomach against the course of the food which comes from the stomach. There are two opposite motions which do not penetrate but give way to one another as do rivers in their opposed currents. Thus does the choler which enters against the outlet of the chyle from the stomach.*

fig 6. **Diagram of the embryo and its coverings.**

This rough diagram has been interpreted from its shape as showing the development of the chick, but this is clearly not so as evidenced by the human fig-ure below and the line indicating its relationship. The various coverings are labelled from without in-wards, *uterus, secundines* [chorion], *allantois, amnion.* Pointing to the allantoic or amniotic fluid are the words, *Yellowish crystalline* [i.e., clear fluid] *in great quantity.* To this is added the note, probably in the handwriting of Melzi:

"The child in the uterus has three membranes which surround it. Of these, the first is called the amnion, the second the allantois, the third the sec-undine [chorion]. The uterus is united to this sec-undine by means of the cotyledons, and all join in the umbilical cord which is composed of vessels".

Notes on embryology, but unrelated to the figure; the first takes up the concept of the pneuma or world spirit, and the second shows Leonardo's retreat from the Aristotelian position on generation, cf. 201.

As one mind governs two bodies, inasmuch as the desires and the fears and the pains of the mother are common with the pains, that is, the bodily pains and desires of the infant lying in the body of the mother, likewise the nourishment of the food serves the child, and it is nourished from the same cause as the other members of the mother and the spirits, which are taken from the air—the common soul of the human race and other living things.

The negroes in Ethiopia are not caused by the sun, because if a negro impregnates a negress in Scythia, she gives birth to a negro, and if a negro impregnates a white, she gives birth to a grey. This shows that the semen of the mother has power in the embryo equal to the semen of the father.

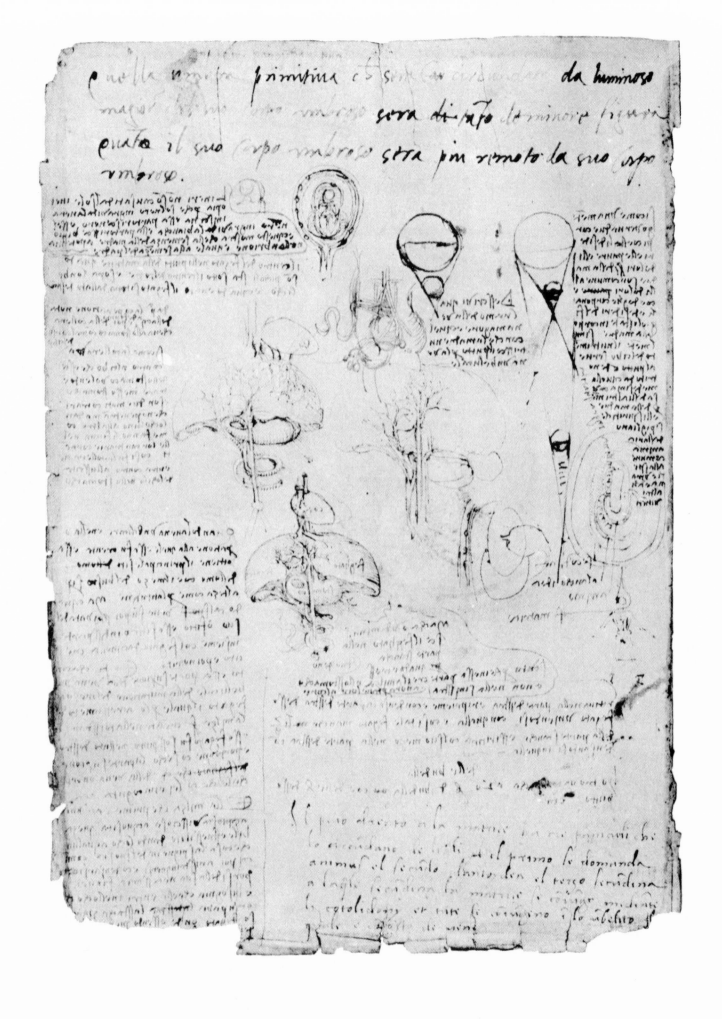

continued text

1

THE SKELETON

ossicle. However, in view of the other features in the present figure, it is more likely that Leonardo is carrying over mediaeval conceptions.

Leonardo employs the word *forcula, forchula,* or *furchola* for the clavicle. This term, properly *furcula,* is the diminutive of *furca,* a fork. In the Latin edition of Avicenna and in the work of Guy de Chauliac (1300-1370), Leonardo's sources, the word *furcula* is used to represent both clavicles diverging from the sternum like the two prongs of a fork. Such an appearance is more evident in birds where the clavicles are united by the interclavicle to form the "merrythought" which deservedly retains the name *furcula.* However, *furcula* for clavicle was the common term of mediaeval anatomists and surgeons. On the other hand, Mundinus (1275-1326), another of Leonardo's sources, specifically uses the word to indicate the fork-like appearance produced at the lower end of the sternum by division of the xiphoid process or diversion of the costal cartilages. The word has also been used to designate the suprasternal notch usually as *furcula superior* to distinguish it from the xiphoid called *furcula inferior.*

2

THE VERTEBRAL COLUMN

and all the other vertebrae of the neck, which are seven, do the same.

These three vertebrae must be designed in three aspects, as has been done in the three spines.

You will design these bones of the neck from 3 aspects, united, and 3 aspects, disunited; and then you will do the same for the two other aspects, that is: seen from below and from above, and thus you will give a true knowledge of their shapes, knowledge that neither ancient writers nor the moderns would ever have been able to give without an immense, tiresome and confused amount of writing and time. But in this very swift way of representing them in different aspects, one will give full and true knowledge of them, and for the sake of this benefit which I give to men, I teach the manner of reproducing it with order, and I pray you, you other successors, that avarice does not oblige you to make editions in [. . .]

In these two illustrations Leonardo portrays the cervical spine with wonderful accuracy. In the case of the first three cervical vertebrae shown separated from one another, he graphically illustrates the manner of their articulation and has designated the various elements entering into the construction of the joints by means of letters. However, nowhere does he provide a guide to his interpretation of the designated parts. Nonetheless, it is easy to supply the missing names in modern terminology owing to the accuracy of the drawings. It is rather amazing that Leonardo with his flair for mechanics failed to comment upon the movements of the atlantoid and epistropheal joints, since

the statements of Galen and his Arabic interpreters on their functions are highly inaccurate and quite absurd. This was a subject to which Andreas Vesalius devoted a great deal of attention. His investigations on the mechanics of the movements of the head and neck enabled him to expose the falsity of Galen's teachings, and he regarded his discoveries as one of his greatest triumphs.

8

THE UPPER EXTREMITY

nardo employed a specimen in which ossification was incomplete, it is highly unlikely that the line apparently separating the process from the rest of the scapula is intended to represent an independent bone, as evidenced by other drawings in the series. The last portion of Leonardo's statement on pronation accompanying fig. 4, is similar in phraseology to the description given by Avicenna.

fig 6. **Anterior view of the bones of the upper extremity to illustrate pronation.**

You will make each of these 4 demonstrations twice, and of this duplication you will make one for each sort in which the heads of the bones will be joined with their fellows as nature made them, and the other demonstration you will make with the bones separated; and in this way you will see the true shape of the heads of the bones which are joined together.

The arm is composed of 30 bony segments, for there are 3 in the arm itself and 27 in the hand.

The ordinary position of the palm of the hand is to be turned toward the horizon, and its ordinary extreme positions are to be turned toward the sky or toward the earth, that is to say, toward the head or the feet of the individual.

A further illustration of the mechanism of pronation in which the action of pronator teres is nicely demonstrated. The biceps brachii muscle and the collateral ligaments of the wrist joint are also exhibited.

The degree of accuracy of delineation of the bones appearing in this series of drawings is worthy of comment. For details of the carpal, metacarpal and phalangeal bones, cf. the figures on 10.

10

REPRESENTATION OF THE HAND

in a work to be entitled *Libro del moto actionale.* Erwin Panofsky in his study of the Codex Huygens shows how these ideas of Leonardo were eventually expressed in graphic form.

No explanation of the letters on the accompanying figure are given. b d, is undoubtedly the flexor carpi radialis muscle, and a c, palmaris longus. Laterally and medially the shading suggests that the ulnar and radial flexors of the wrist are also indicated. We assume,

therefore, that the diagram is to illustrate the muscles producing the four primary movements discussed in Leonardo's note.

12

THE LOWER EXTREMITY

to these are the 6 demonstrations of the bones separated from one another; and there are the bones sawn lengthwise in two ways, that is, sawn from the side and straight, to demonstrate the entire thickness of the bones.

fig 8. **Small inset drawing of lateral aspect of foot.**

At the end of each figure of the foot you will give the measurements of the thickness and length of each of the bones and its position.

16

MYOLOGY OF TRUNK

capitis, splenius capitis, longissimus cervicis and ilio costalis are shown.

fig 5. **The fifth demonstration of the deep muscles of the back.**

The vertebrae which form the dorsal spine in the 5th demonstration possess muscles which pull them in a motion opposite to that made by the muscles of the 4th demonstration; and this occurs because these vertebrae would break asunder when the head is bent if the muscles below did not exercise a force in the opposite direction.

You will observe whether the muscles [intercostal] which tie the ribs together and occupy their intervals are directed in their length towards the neck or not.

The muscles shown in this figure are held by Leonardo to be the antagonists of those in his fourth demonstration. The reasoning is a little difficult to follow unless Leonardo is thinking of the muscles in the fourth figure acting as an anti-gravity group opposed by those shown here to prevent separation of the vertebrae or of the group on one side opposing those of the opposite side in lateral movements. Again, it is difficult to identify with certainty the muscles illustrated, but from their direction and apparent attachments it is suggested that semispinalis capitis and spinalis thoracis are chiefly represented. The obliquity of the intercostal muscles is discussed more fully in other figures relating to respiration.

fig 6. **Line diagram of back muscles.**

The letters c d, point to the spine of the scapula and its vertebral border respectively. The spines of the lower cervical and upper thoracic vertebrae are noted by n m o p q r S t u, from above downwards. The lines indicate the direction of action of the trapezius, splenius capitis and spinalis thoracis, and the diagram is apparently a preliminary sketch for the development of the next figure.

fig 7. **Cord diagram of the back muscles.**

Make a similar figure of the internal [anterior] *aspect of the bone of the neck and of the shoulder.*

Make for each cord, the bones where they arise and where they terminate.

Each vertebra is the point of departure of 10 cords, that is, five on each side.

It will be recalled that in the general notes Leonardo stated that each muscle acts in the line of its fibres. The cord diagram graphically serves to demonstrate these lines of action and the mechanics of antagonistic groups of muscles. The trapezius, levator scapulae and other muscles of the back are represented. It will be observed that the spine of the seventh cervical vertebra is shown "stabilized" in all directions by the attachment of ten cords radiating from this point. This number he believed to be characteristic for each vertebra as will again be illustrated in the next figure.

fig 8. **Cord diagram of muscles attached to the vertebral spine.**

Each vertebra has 10 cords attached, that is, 5 on one side and 5 on the other.

ab, cd, fg, are the muscles which [. . .]

Leonardo, like all early anatomists, was greatly handicapped by not having a formal and systematic nomenclature for the many muscles of the body. Galen had introduced a clumsy system of numbering the muscles in groups according to their action, but it is to Jacobus Sylvius (1478-1555) that we owe the beginnings of the modern nomenclature which so greatly simplified the terminology of muscles. The ten cords are lettered in pairs aa, bb, cc, dd, ee, and shown radiating from the spine of the vertebra which Leonardo believed was thus dynamically stabilized as it were, by guy ropes. The second incomplete note given above relates to no figure in this series and is placed here quite arbitrarily.

17

MYOLOGY OF TRUNK

mast, to the extremities of which they are attached, the greater the angle at which they run to their attachment to this mast.

And this cord has less power of preventing the fall of the mast, the more unequal are the angles at which it attaches itself to this mast.

Consideration of the action of these spinal muscles and their effects on stability of the spine and on respiration prompted the following general note which is found sandwiched between the above observations but directly related to them.

First draw the motor muscles of the bone called the humerus; then make on the humerus the motor muscles of the [fore-] arm which cause its extension or flexion; then show separately the muscles arising on the humerus which serve solely to rotate the [fore-] arm when it turns the [palm of the] hand upwards or downwards; then in the arm draw only the muscles which move only the fingers in flexion, extension, abduction and adduction; but first represent the whole as is done in cosmography, and then divide it into the previously mentioned parts, and do the same for the thigh, leg and the feet.

However, faced by the complexity of the human body Leonardo was uncertain whether to present the subject regionally or by systems, although he seems to have favored the latter. The term "instrumental" corresponds to the modern "system". Hence Leonardo asks the question *Whether one treats of man according to the instrumental method or not,* and illustrates the difficulties of the regional versus the "system" methods when considering the function of muscles by the statement:

It happens almost universally that muscles do not move the member where they are fixed but move the member where the sinew which leaves the muscle, is attached, except that which elevates and moves the thorax (costato) in serving respiration.

20

MYOLOGY OF TRUNK

of the posterior surface of the tensor is shown, and in the second (similar to fig. 3) the muscle has been sectioned at its middle to show its triangular shape. The sectioned surface is indicated by the letter a. The captions read: *Reverse of this muscle* [i.e., tensor fasciae latae], in the case of fig. 7, and, *a, figure of the thickness,* for fig. 8.

fig 9. Superficial muscles of thigh: anterior aspect.

No notes accompany this drawing of the muscles of the thigh. The outline is almost identical with that of the right leg of the figure in 60, suggesting that both are related studies developed in connection with the Anghiari cartoon. The muscles lettered are a, adductor longus; b, pectineus; c, sartorius; d, tensor fasciae latae; e, gluteus medius.

figs 10-11. Illustrations of the action of the subcostal muscles (?) in respiration.

Fig. 11 replaces fig. 10 since in relation to the first we have the statement, *True position of the muscles,* and to the second, *These muscles are badly placed.* It is difficult to determine what muscles are illustrated, but the figures and the description below suggest the subcostals. However, Leonardo was greatly impressed by

the serratus posterior superior as respiratory muscles and nearly always indicates them by the letters n, m, o, as in 16, fig. 3, so that this muscle must be considered. However, the statement that there are seven such muscles favors the identification of the subcostals.

The muscles n, m, o [?subcostals] are 7 which bind the ribs a, b, c, attached to the thorax.

These muscles have a voluntary and an involuntary motion for they are those which open and close the lung. They open when they suspend their function, that is, of shortening, for meanwhile the ribs, which were first drawn up and compressed together by the shortening of these muscles, then remain free and return to their natural distance as the chest expands. And since no vacuum can occur in nature, the lung, which is in contact with the ribs internally, must follow their dilatation, and so the lung, in opening like a bellows, draws in the air which fills the space created for it.

fig 12. Diagram of the thoracic and abdominal cavities separated by the diaphragm to show the influence of the respiratory movements on the intestinal contents.

The shortening and lengthening of the [respiratory] muscles mentioned above are the cause which gives continual movement to the faeces of the intestines. This is proved: a b c d, is the space occupied by the lung in the chest; b a, and b c, are the ribs of the chest which expand and contract the interval a c. As was said above, on expansion of this interval a c, the diaphragm, a thick membrane which is interposed between the intestine and the lung, comes to be stretched by the expansion of the ribs and because of its stretching, it decreases the [abdominal] space a d c e, in which the said intestines are confined. And so, by the decrease and increase of the said space, the intestines themselves are expanded and then contracted when they are compressed; and this effect continues as long as life.

At the top of the page on the left-hand side is a note, probably written at an earlier date, on the origin of the sounds made by insects: *That flies have their voice in their wings, you will observe by cutting them a little, or better still, by daubing them with a little honey in such a way that they are not entirely prevented from flying. And you will observe that the sound made by the movement of the wings will become harsh and the note will change from high to low in proportion to the degree that their wings are impeded.*

Leonardo examined the fly very closely in the course of his studies on flight (Mss. G, 92r, Institut de France).

31

MYOLOGY OF TRUNK

The muscles a b c, at the sides, motors of the diaphragm, extend more towards the middle of the diaphragm, the fatter the animal is; and this they do in all the rest of the body.

figs 6-9. **Details of the costal origin of the diaphragm.**

These illustrations are much more accurate and may well represent human findings. In the first of the series the structure passing through the diaphragm is the oesophagus, very inaccurately placed. Of it, Leonardo says: *Opening, giving transit to the oesophagus (meri). Describe how it joins and unites with the diaphragm.*

The third figure of the series, fig. 8, demonstrates the lung occupying the costo-phrenic sinus, and the final figure, fig. 9, the phrenic vessels.

39

MYOLOGY OF HEAD AND NECK

turnings of the masticated food and consequently in the cleansing of the inside of the mouth together with the teeth. Its principal movements are 7, that is, extension, narrowing, retraction, thickening, shortening, expansion and straightening. Of these 7 motions, 3 are compound because one cannot be produced without the other being generated and of necessity conjoined to the first. This is the case with the first and second, which is its extension and narrowing, because you cannot distend an extensible material without its narrowing and straightening on all sides. The same occurs in the 3rd and 4th movements, opposite to the two first: that is, the thickening and shortening of the tongue. Following these are the 5th and 6th motions which make its 3rd compound motion consisting of 3 motions; that is, expansion, straightening and shortening. But here you could, perhaps, argue with the definition of the penis which receives in itself so much natural heat that, besides thickening, it lengthens itself considerably, etc.

Leonardo was a very accomplished musician and, says Lomazzo, "he surpassed all musicians of his time". Vasari suggests that it was this accomplishment which gained him the summons to Milan from Lodovico Sforza, and he won wide recognition not only as a performer but also for his ability in the construction and design of musical instruments, some of which may be seen in the form of sketches. He compared the passage of sound waves to the circular ripples caused by stones dropped into a pond of water. It was this simile which Helmholtz (1821-1894), the great physicist and physiologist, developed centuries later in his classic *On the physiological principles of musical harmony*. Consequently the digression in the above discussion is understandable. The treatise on musical instruments to which Leonardo refers is now lost, but we know from other sources that it once existed. Numerous other discussions, especially on the human voice as a musical instrument, have survived in his notes. For his opinion on the mechanism of erection of the penis, cf. 182.

Overcome by the contemplation of these various mechanisms, Leonardo breaks into a panegyric.

Athough human ingenuity in various inventions corresponds with various instruments to the same end, it will never find an invention more beautiful, more simple or more direct than does nature, because in her inventions nothing is lacking and nothing is superfluous. She needs no counterpoise when she makes the members adapted for motion in the bodies of animals, but places within the soul, the formative agent of the body, that is, the soul of the mother which first constructs in the womb the shape of man and in due time awakens the soul which is to be its inhabitant, and which first remains asleep under the guardianship of the soul of the mother who nourishes and vitalizes it through the umbilical vein with all her spiritual members. And so it will continue as long as the umbilical cord is joined to it by the secundines [chorion] and the cotyledons through which the foetus is united with the mother. This is the reason why any wish, any extreme desire, any fright which the mother has, or any other mental suffering, more powerfully influences the child than the mother, for there are many instances in which the child thereby loses its life, etc.

This discussion does not belong here but is required in treating of the composition of the animal body—and the rest of the definition of the soul I leave to the consideration of the friars, the fathers of the people, who by inspiration know all the mysteries. Let be the sacred writings, for they are supreme truth.

Leonardo recognized the foetal membranes as they occur in lower animals, but not in man, cf. 210, 211. So it is that he mentions the cotyledons as found in ungulates in the above note. The idea of a formative soul is undoubtedly of Aristotelian origin to which Galenical views are added, implying a recognition of the distinction between growth and differentiation. The "spiritual members" are the cardiovascular system providing Galen's natural spirit for nutrition through the veins, and vital spirits through the arteries.

figs 6-8. **Three geometric figures on perspective.**

The accompanying note fully explains the meaning of these figures.

Among equal things the more distant appears to be smaller, and the diminution will be proportional to the distance.

43

MYOLOGY OF SHOULDER REGION

upside down and even then, from Leonardo's description, the identification would be highly questionable. There can be little doubt that the structure is a portion of the interclavicular ligament which has been mistaken for a "small sinewy muscle". Leonardo's description substantiates this view.

fig 11. **Sketch of the cephalic vein in the delto-pectoral interval.**

a b, a vein [cephalic] which has arisen from behind the external conjunction of the muscle of the shoulder [deltoid] with the sinew of the breast [tendon of pectoralis major].

The extensive note occupying the left-hand margin is concerned with the movements of the neck and the value of such information for diagnosis of injury. The note reads as follows:

The neck has 4 movements of which the first is to elevate, the 2nd to depress the face, the 3rd to turn to the right and left, the 4th to bend the head to the right and left. The [?others] are compound motions, that is, to elevate or to depress the face with one ear near the shoulder, and likewise to elevate or to depress the face when turned to one of the shoulders with one eye lower or higher than the other, and this is called distorted motion.

And to such movements should be assigned the cords and muscles which are the cause of these motions, and so, if a man through some injury should lack one of these movements, one can diagnose with certainty which cord or muscle is damaged.

49

MYOLOGY OF SHOULDER REGION

attached to the point [coracoid] *of the scapula o, a point which projects above the front of the humerus h; and the humerus itself is supported by the shield c* [ligaments and capsule or separate acromion, summus humerus], *and c is connected to the clavicle n d, and this bone, at its extremity n, is supported by the sinews or muscles a n* [portions of trapezius] *which arise from the last vertebrae of the neck.*

The diagram and accompanying note largely repeat the ideas expressed in fig. 4. The identification of the *shield c*, is very uncertain. In fig. 4, the ligaments and capsule of the acromio-clavicular region seem to be meant, but here the use of the term *shield* suggests a separate acromion process or summus humerus as mentioned in connection with fig. 1.

fig 6. Deep dissection of the muscles of the shoulder region: anterior aspect; the third demonstration, cf. figs. 1 and 4.

This illustration is almost identical with fig. 4 except that the pectoralis major muscle has now been reflected to reveal the entire course of the long head of the biceps and the pectoralis minor, labelled S t, as in fig. 4. The tendon of latissimus dorsi indicated by the letters g r, is clearly shown and discussed in the following note.

g r [latissimus dorsi] *rotates the arm with a circular motion in such a way that where the arm is carried backwards, the hand turns the palm from the front to the back.*

Just anterior to the lower portion of the latissimus dorsi muscle and written on the drawing is the simple word *spatola*, indicating the axillary border of the scapula.

Apparently it was Leonardo's intention to add a fourth figure to the series on the deep dissection of

the shoulder region and, in addition, a figure or figures illustrating the relationships of the vessels and nerves to the muscles, as the following notes will show.

In the 4th demonstration elevate the biceps muscle of the arm (pesce del braccio) and describe what remains.

Draw here, always together, the veins and the nerves together with the muscles so that it is possible to see how the muscles are interwoven with these veins and nerves, and elevate the ribs so that one can better observe how the largest muscle [serratus anterior?] *is connected to the scalp.*

fig 7. The bones of the ankle and foot.

Draw above this foot, the right foot and one will see the inner and outer aspects without turning the ends.

This figure seems to belong to the series shown on 12 which suggests that the isolated drawing of some of the deep muscles of the shoulder region found on that page is a member of the group illustrated here. The note indicates that Leonardo was in some instances willing to abandon his more ambitious and laborious plan of illustrating every part of the body by turning it practically through a circle and showing step by step every aspect of the specimen.

50

MYOLOGY OF SHOULDER REGION

lateral divided tendon is the coraco-brachialis; supraspinatus and the two heads of the biceps brachii are very evident. The muscles shown in outline suggest teres major, latissimus dorsi and the long head of triceps. Note the clear rendering of the suprascapular foreman.

fig 6. Cord diagram of the shoulder muscles.

Demonstration of the position and attachments of the muscles of the shoulder; but first sketch the bones and then these muscles.

And with these one will discuss the strength of the muscles.

As is often the case, Leonardo provides no guide to the lettering of the figure. a b c, deltoid, shown as four fasciculi; d (like the numeral 4) and r, two fasciculi representing the upper portion of the trapezius; q, levator scapulae; p, supraspinatus; o, and m, two bands indicating the infraspinatus; n, teres minor; h, teres major; g, latissimus dorsi; f (placed at lateral condyle of humerus), long head of triceps shown incorrectly arising from the spine of the scapula; e (like the letter D), lateral head of triceps; S (in shadow), medial head of triceps.

fig 7. Dissection of the shoulder joint viewed from above.

Leonardo provides the following key to the lettering of the figure:

a [subscapularis], *the largest muscle of the shoulder,*

passes between o [glenoid] *and b* [coracoid] *and occupies all the space S c* [subscapular fossa] *attaching only to the borders of the scapula of the shoulder.*

The muscle n [supraspinatus] *passes between d* [supraglenoid tubercle] *and n* [acromion] *and occupies the space f g* [supraspinous fossa] *being attached by its extremities to the borders of the space which receives it.*

The above mentioned muscles are not attached except at the borders of their receptacles [the fossae] *and at the terminations of their cords; and the Master has done this so that the muscles might be free and unfastened so they can grow thicker and shorter or thinner and longer according to the needs of the lever (mobile) which they move.*

Other structures lettered but not noted are p, the head of the humerus, and the long head of biceps, also p. The remaining tendons identifiable are the infraspinatus and teres minor joining the other short rotators to form the musculo-tendinous cuff of Codman. Attached to the coracoid are the short head of biceps and coraco-brachialis together with pectoralis minor shown as two tendons. Passing to the spine of the scapula is the long head of triceps which Leonardo nearly always shows incorrectly attached as in most of the figures of this plate.

Further drawings in the series were contemplated as outlined in the final note.

You will make the scapula denuded of its muscles, and then clothed, showing the naked head of the humerus which, on the opposite side, one should clothe with these same muscles of the scapula; then show the head of the humerus.

56

MYOLOGY OF UPPER EXTREMITY

fig 7. The superficial palmar arterial arch.

The inset, a o b c d, shows the branching of the terminal portion of the ulnar artery in diagram which is described thus.

The arrangement of the vessel a b c d [ulnar artery] *is such that c and d, go within the hand as far as the clefts of the fingers, that is, a o* [ulnar artery] *then divides at o and form three branches of which the branch o b, passes to the outer* [medial] *side of the hand and two branches o c, and o d, proceed along the length of the digits within.*

Leonardo calls attention to the position of the digital vessels and nerves.

Have you observed here with what precaution Nature has placed the nerves, arteries and veins on the sides of the fingers and not in the mid-line, so that in the operations of the fingers they do not happen in some manner or other to be pierced or cut?

fig 8. A profile.

The portrait may be that of the subject dissected, but the features are those of a type which often appears in Leonardine drawings.

57

MYOLOGY OF UPPER EXTREMITY

Demonstrate what muscle is the cause of the contraction of the base p q, of the palm of the hand and likewise, of its separation.

fig 4. Digital bones to illustrate abduction and adduction of the fingers.

This sketch is to illustrate the movements of abduction and adduction at the metacarpo-phalangeal joints m n, by the digits a b, and c d. With reference to the movements of the fingers in flexion, extension, abduction and adduction, Leonardo notes at the top of the page:

Each digit is capable of circular movement at its tip, that is, when the hand is held in the air supported by the thumb on a flat surface, you may describe a circle with the tip of each finger because there are 4 cords in them. Below the figure he writes:

Remember to represent the cause of the movement of separation of the digits a b, and b c.

And by the same rule, describe the separation of all the other digits and other members; and remember that the demonstrations of the interior of the hand must be 10.

figs 5-6. Cord diagrams to illustrate the action of the first dorsal interosseous and adductor pollicis muscles.

In these diagrams the first dorsal interosseous muscle is shown as two cords intersecting with the deeper lying adductor pollicis, also shown as two cords representing either the two heads of the adductor or the adductor and deep head of flexor pollicis brevis. The purpose of the diagram is to illustrate the scissors-like movements of thumb and index fingers. These figures represent the cord or wire diagrams corresponding to the dissection in fig. 9.

fig 7. First demonstration. Bones of the hand and wrist illustrating adductor pollicis.

The figure is labelled in writing which is both reversed and upside down: *The hand seen from the internal aspect.*

The sketch was to have been the first in the series of ten representing the anatomy of the palm of the hand. A cord p q, demonstrates the position of the transverse head of the adductor pollicis muscle passing from the palmar surface of the third metacarpal to the first phalanx of the thumb. Calling attention to this muscle, Leonardo quaintly observes, *The middle digit has in custody the largest digit through the muscle p q* [adductor pollicis].

Leonardo apparently intended to use the figure as the base for a cord or wire diagram of the muscles and tendons. In addition to the adductor pollicis he shows the radial collateral ligament but did not finish the sketch as shown by his note: *make it so that the muscles of this hand are first represented by the use of wires, in order that one may easily see where each takes origin and terminates without the interference of one another.*

fig 8. Second demonstration. Deep dissection of palm of the hand.

a [pronator quadratus] *is a strong, fleshy muscle which arises from one of the bones of the* [fore-] *arm within and terminates on the other bone within, and it is created for the sole purpose of preventing the separation of the 2 bones b c* [radius and ulna].

Apart from pronator quadratus, the deep dissection reveals the short muscles of the thenar and hypothenar eminences, the two heads of the adductor pollicis, the interossei and the volar interosseous artery. The structure crossing the metacarpo-phalangeal joints transversely is presumably the transverse metacarpal ligament.

Again Leonardo suggests his favorite device of a cord diagram to show the position of the intrinsic muscles of the hand. In the note below he uses the term *pettine* for the metacarpus. This term, the equivalent of *pecten*, a comb, was commonly used for the metacarpus and metatarsus in the sense of the "rays" of the hand or foot and thus came to be applied to the palm of the hand or the sole of the foot.

Let these muscles of the hand be made first of threads and then according to their true shape.

And these are the muscles which move the entire metacarpus (pettine) of the hand.

When you have drawn the bones of the hand and wish to represent above this the muscles which are attached to these bones, make threads in place of muscles. I say threads and not lines in order to know what muscle passes below or above the other muscle, a thing which cannot be done with simple lines; and having done this, then make another hand at its side where there may be the true shape of these muscles as is shown here above.

fig 9. The muscles of the first interosseous interval of the hand.

This figure of the first interosseous interval from the dorsal aspect corresponds to the cord diagrams of figs. 5-6 above and was apparently drawn first as may be gathered from the note: *To demonstrate better where the muscles of the palm of the hand are attached to the bones, make them with threads.*

Leonardo was unhappy respecting his description of the muscles moving the first phalanges of the fingers (his third segment) and their correspondence with those of the thumb. It should be remembered that in the Galenical anatomy there are only four metacarpals. The first metacarpal is regarded as the first phalanx of the thumb, hence Leonardo's difficulty in finding any correspondence in the arrangement of the muscles. Furthermore, in reading the note below it should be borne in mind that fig. 10, illustrating the action of the long flexors and extensors of the fingers, was drawn before the note was written.

I have represented here [fig. 10] *the cause of the motion of the first* [phalanx III] *and 2nd segments of the digital bones; there remains the representation of the motion of the larger 3rd bone* [phalanx I] *which makes up half the length of the fingers, for, in truth, it could not have been shown here how this bone is moved if there had not already been the 2nd figure* [fig. 8] *of the 2nd hand.*

But this only makes me doubt that these muscles have no cords and that they are not in correspondence with the digits of the hand as may be seen here, and, in this case the foot has shown them exceptionally well.

fig 10. The action of the long flexors and extensors on the digital bones.

If the bone a b [phalanx III] *is drawn and flexed by the sinew or cord a g* [for a f, flexor d. profundus], *and the bone b c* [phalanx II] *is flexed by the cord h f* [for h g, flexor d. sublimis], *what is it that flexes the bone c d* [phalanx I]?

This question is partially answered by showing the interossei in fig. 8, but Leonardo is uncertain as to the action of the muscles in the metacarpo-phalangeal joints as discussed above under fig. 9.

fig 11. Diagram of the action of the lumbrical and interosseous muscles.

Leonardo inquires as to what flexes at the metacarpo-phalangeal joint and maintains the interphalangeal joints in extension—the classical action of the lumbricles and interossei. He gives no answer.

What flexes the finger, remaining extended at its three bones, in the angle m n o?

74

MYOLOGY OF LOWER EXTREMITY

Draw first the bones separated and displaced a little so that it may be possible to distinguish better the shape of each piece of bone by itself. Then join them together in such a way that they do not differ from the first demonstration except in that part which is occupied by their contact. Having done this, make the 3rd demonstration of those muscles which bind the bones together. Then make the 4th, of the nerves which carry sensibility. And continue with the 5th, of the nerves which cause movement or give sense to the first joints of the digits. And for the sixth, make the muscles which are upon [the dorsum] *of the foot where these sensory nerves are distributed. And the 7th will be that of the veins which nourish these muscles of the foot. The 8th will be that of the sinews which move the tips of the toes. The 9th, of the veins and arteries which are placed between the flesh and the skin. The 10th and last will be the finished foot with all its sensibility. You can make the 11th in the form of a transparent foot where it is possible to see all the above-mentioned things.*

But first make the demonstration of the sensory nerves of the leg and their ramification from 4 aspects so that one can see exactly whence these nerves are derived; and then make a drawing of a young and perfect foot with few muscles.

A portion of the above plan has been executed in 12 where the tibia and fibula are shown separated from the talus with guide lines to indicate the corresponding articular surfaces.

TO BE NOTED.

When you have made your demonstrations of the bones from various aspects, then make the membranes which are interposed between the bones and the muscles: and in addition to this, when you have sketched the first [layer of] muscles and have described and shown their action, make the 2nd demonstration upon these first muscles and the 3rd demonstration upon the second, and so on in succession.

Make here first the simple bones and then clothe them successively step by step in the same way that nature clothes them.

When defining the foot it must necessarily be joined to the leg as far as the knee, because the muscles which move the tips of the toes, that is, the terminal bones, arise in the leg.

In the 1st demonstration the bones should be separated somewhat from one another, so that their true shape may be known. In the 2nd the bones should be shown sawn in order to see which is hollow and which is solid. In the 3rd demonstration these bones should be joined together. In the 4th the bones should be tied together with one another. In the 5th should be the muscles which strengthen these bones. 6th, the muscles with their cords. 7th, the muscles of the leg with the cords which go to the toes. 8th, the sensory nerves, 9th, the arteries and veins. 10th, the muscular skin [deep fascia]. 11th, the foot in its final beauty. And each of the 4 aspects should have these 11 demonstrations.

The muscular skin may be variously interpreted. The panniculus carnosus of animals described by Aristotle had been ascribed to man by Galen who also used the equivalent term to mean the fascial covering of the muscles. This caused great confusion among mediaeval anatomists, a confusion compounded by Mundinus who states that beneath the skin and fat is the fleshy layer which "is not sinewy nor fleshy after the manner of muscles, but mixed of flesh and membrane". Around Leonardo's time it was coming to be recognized that the panniculus carnosus existed in animals only. However, the equivalent form was retained, even by Vesalius, to describe the deep fascia since it was believed that the confusion was perhaps due to semantic difficulties.

Use the same rule for the foot as employed for the hand, that is, represent first the bones from 6 aspects as posterior, anterior, inferior, superior, internal and external. The figures on 12 and 49 approximately carry this out.

I have stripped the skin from one who owing to an illness was so emaciated that the muscles were consumed and reduced to the state of a thin membrane so that the cords, instead of being transformed into muscle were converted into a wide sheet; and when the bones were clothed by the skin, they possessed little more than their natural size.

What is it that increases the size of the muscles so rapidly? It is said that it is air [pneuma]—and where does it go when the muscle diminishes with such rapidity? Into the nerves of sensibility which are hollow? Indeed, that would be a vast amount of air, that which enlarges and elongates the penis and makes it

as dense as wood, so that the whole great quantity of air [in the nerves] would not be sufficient for reduction to such a density; not only the air of the nerves, but if the body were filled with it, it would not suffice. If you will have it that it is the air of these nerves, what air is it that courses through the muscles and reduces them to such hardness and power at the time of the carnal act? For I once saw a mule which was almost unable to move owing to the fatigue of a long journey under a heavy burden, and which, on seeing a mare, suddenly its penis and all its muscles became so turgid that it multiplied its forces as to acquire such speed that it overtook the course of the mare which fled before it and which was obliged to obey the desires of the mule.

In the above passage Leonardo attempts to discredit some debased materialistic version of the pneumatic theory current in his day and possibly derived from the pseudo-Aristotelian treatise *On the pneuma* where the pneuma is regarded as a fifth element. Leonardo does not use the word pneuma itself but variously *vento*, *aria*, *spirito*, and these with little consistency. However, from the earliest times the Ionians used air, pneuma and wind synonymously, and the practice was continued by the pneumatist sect.

There is no need to trace the pneumatic theory through its many vicissitudes. The original idea of the relationship of air to some dimly perceived process of combustion was lost. In the Galenical physiology air was taken into the lungs during respiration whence it passed by the pulmonary vein to the left ventricle. Here a fraction of it was refined to form the "vital spirit" which was distributed together with the blood by the arterial system. That portion carried by the vessels to the brain was transformed into a higher or more ethereal substance called the "animal spirits" which flowed through minute channels believed to exist in the nerves to the various organs of the body. The animal spirit through its faculty was responsible for nervous action and could be regarded as the sensitive soul carrying out motor and sensory nerve functions. The theory was completely misunderstood by mediaeval physicians. Galen recognized that it was not air in the sense of its volume but some quality in it which constituted the spirit or pneuma. Aristotle had provided no precise definition of his terms and made no clear distinction between the pneuma, soul and energy, which added to the confusion. The above passage must be read with these conceptions in mind, and thus it is not difficult to understand the relationships discussed between the sexual act and muscular activity. It is interesting to note Leonardo's challenge is based not upon speculation but on the physical properties of air.

76

MYOLOGY OF LOWER EXTREMITY

c [in fig. 4] being the vertebra, n being the extremity of the spinous process, I say that nature has attached these sinews or cords to the ends of the spines of the vertebrae of the neck because if the cord were placed

at m n, it would turn the vertebra more easily than if placed at b a, since m n, is attached to a longer lever than b a, and has more power proportionate to the greater length, as is proved in the 5th [proposition] *of the 4th* [book] *on the elements of mechanics.*

At the bottom of the page is a later addition of the name *Leoni*, which can only be Pompeo Leoni, the sculptor who obtained, between 1588 and 1591, the greater part of Leonardo's manuscripts from Francesco Melzi's heir.

86

HEART: SUPERFICIAL VIEW

On the figure, below the pulmonary artery, is written, *right ventricle*. In the interval between the two drawings, Leonardo notes that the right ventricle is less extensive than the left. *The right ventricle extends to a depth of three-quarters of the length of the heart.* He also notes the difference in thickness of the infundibulum of the right ventricle. *The right wall of the right ventricle is that much thinner at the base than at the apex as to be equal to a 4th of the thickness at the apex.*

Other structures identifiable are the brachiocephalic trunk from the aorta, the anterior and posterior vena cava, and the right auricle.

fig 6. Sketch of a coronary artery.

One of the coronary arteries, probably the right, is sketched to show the reduction in calibre of the vessel with each succeeding branch. The reduction in size is very evident in the case of these vessels as indicated in the note: *The vessels are always larger internal* [i.e., proximal] *to the bifurcation of their trunks than outside* [distal to] *these trunks.*

87

HEART: SUPERFICIAL VIEW

o p [ventricular branch of right coronary artery] *to nourish the wall a b c, which forms the entire covering of the right ventricle.*

b S, is the vena nera [middle cardiac vein] *which issues from the right auricle and is accompanied by a branch f b c* [i.e., o b c, circumflex and interventricular branch of right coronary artery] *of the vena arteriale of the right ventricle* [pulmonary artery, in reality aorta], *progressing and increasing opposite to one another.*

fig 11. The heart viewed posteriorly to show the coronary sinus and right coronary artery.

The heart is again that of an ox. The stems of the great vessels are from left to right of the figure, the posterior vena cava, the anterior vena cava and the aorta. The auricles are labelled respectively *left auricle* and *right auricle*. The great cardiac vein and coronary sinus have been freed and elevated with

the notation, *Vena nera* [great cardiac vein] *of the right ventricle.* The right coronary artery is shown arising from the aorta, mistakenly called the pulmonary artery, and passing on the right side of the pulmonary orifice exposed by removal of the stem of the pulmonary artery. At f, is seen the stem of the left coronary artery. At the bottom of the figure Leonardo indicates the confusion resulting from his calling the aorta the pulmonary artery.

I lack the vena nera [small cardiac vein] *to this vena arteriale which I believe arises from the branch of the left vena nera* [great cardiac vein or coronary sinus].

figs 12-15. The pulmonary and tricuspid valves viewed from above.

The tricuspid valve is shown *closed* and *open*.

89

VENTRICLES OF THE HEART

by means of its diastolic vacuum sucks blood from it to make good that fraction supposedly expended in vital functions. *And it* [the heart] *draws to itself the blood sucked from the upper veins* [hepatic] *of the liver.*

The final note records an observation on the motions of a bird's wing in flight. The manuscript on the Flight of Birds is dated March-April 1505 which, with the internal evidence of the stage of his anatomical development, confirms the date of this study as c.1505. Between 1513-14 he again took up the study of flight, but the style and content of the present writing makes such a date out of the question.

91

VENTRICLES OF THE HEART

likewise when it returns the blood to the ventricle from which it was thrust, assisting the natural reflux somewhat with its contraction. The motion takes place more swiftly at the reflux of the blood in returning to the ventricle of the heart whence it was first expelled.

The descent of the heart makes the same impulse as that created by the impetus of the motion which beats against the bottom of the lower ventricle. From here, during the time that it rebounds from the bottom, the heart contracts which increases the motion made by the blood at the second beat against the covering of the upper ventricle. If you should say that the beat made by the descent of the blood to the bottom of the lower ventricle is greater than that which beats against the covering of the upper ventricle [auricle], *since one of these motions is natural and the other not, I shall here reply that a liquid in a liquid has no weight (except for the amount which the beat generates).*

We are told to turn the page, which leads to a further discussion on the heart found on 92.

93

VENTRICLES OF THE HEART

liver which is without motion and receives a small quantity of this warm blood with which it is heated. The liver cannot retain as much heat as the heart, being of a less dense substance than the heart, and the spleen is less dense than the liver, and the lung less dense than the spleen.

The discourse on the heart continues on 94.

94

VENTRICLES OF THE HEART

The final note is a carry-over from the discussion of the diaphragm on 176.

ON THE DIAPHRAGMATIC CURVATURE, WHETHER IT IS NATURAL OR NOT.

If the diaphragm were not curved in such a way that its concave part is able to receive the stomach and other intestines, it would then not be able to retract, distend and forcibly compress the intestines and drive the food from the stomach into the said intestines (here continues [in the margin] *that lacking below), and it could not assist the muscles of the body to squeeze and press the intestines for the expulsion of their contained superfluities. It could not by its distension increase the space where the lung is situated and compel its dilatation which occurs so it can draw in the air with which the veins distributed in it by the heart are refreshed.*

95

VENTRICLES OF THE HEART

alternately at the upper and lower part of the wound. This stretching and compression of the heart readily occurs when it is warm because it is then less dense [fig. 3].

fig 3. **Diagram to illustrate what happens on complete transfixion of the living heart as described above.**

c o, is the rib cage, b m a n, is the heart.
Here [in fig. 3] *if the heart moves upwards and downwards, the wound p* [in the posterior wall] *does not move away from the fulcrum of the point of the iron at the wound o* [in the thoracic wall], *but the wound m* [in the anterior cardiac wall] *moves together with the iron. And if the handle of the iron e, moves it, the heart will move* [the position of] *the wound—p will be moved and also the wound m, but p, more than m, because it is further from o, the immovable point, etc.*

96

VENTRICLES OF THE HEART

time, succeeding the first, by the reflux of the upper ventricles arising above the root of the heart.

fig 5. **Mechanical diagram to illustrate the effect of the cardiac impulse.**

A rod a b, is balanced at the point c, on a circular object with center at d. The cardiac impulse upsets the balance as shown by producing in Aristotelian terminology so-called accidental lightness. Presumably this is the mediaeval explanation of the alternate action of the ventricles and auricles in the flux and reflux of the blood as described: *The impulse causes accidental lightness and weight. Accidental lightness.*

98

VENTRICLES OF THE HEART

in the right margin reading $24 \times 12 = 200$ [approx.], *7 ounces per hour*, but how the amount is arrived at cannot be explained. The last sentence of the above passage is interesting. By a "great weight" was Leonardo thinking of the ventricular output? It will be remembered that a similiar line of reasoning became a crucial point in Harvey's argument and that it was the great weight of blood forced into the arteries every half hour which demonstrated the truth of his reasoning.

100

VENTRICLES OF THE HEART

where its walls are very thick than in the thin-walled right ventricle. This heat subtilizes and vaporizes the blood and converts some of it into air [gas or the sooty vapor of Galen, i.e., CO_2] *and would convert it into elementary fire if the lung with the coolness of its air did not aid at such excess.*

However, the lung cannot send into the heart, nor is it necessary because, as stated, air is generated in the heart which, being mixed with heat and inspissated moisture, evaporates through the terminations of the capillary vessels on the surface of the skin in the form of sweat. Furthermore, the air which is inspired by the lung constantly enters dry and cool, and leaves moist and hot. But the arteries, which are joined in continuous contact with the ramifications of the trachea dispersed through the lung, are those which pick up the freshness of the air which enters the lung.

The note on the motions of the heart continues with a discussion of the age-old question of the origin of innate heat, for which a mechanical explanation is offered. The greater part of the passage on the dissipa-

tion of heat is no more than a paraphrase of Galen except that Leonardo clearly recognizes that air cannot directly enter the heart but participates in a gaseous exchange. In his discussion of the heart rate there is something wrong with the mathematics. The three motions of the cycle are explained above where the interval between beats is said to occupy half of a musical tempo. Now it will be stated that the three motions of a cycle occur in one tempo of which there are 1080 per hour. Leonardo then concludes that the heart moves 3540 times per hour, but $3 \times 1080 = 3240$. From the first statement this should be 6480 since there would be six motions during this time. In any case, whichever calculation is taken, the result must be divided by three. The number is far too low. In extenuation it should be recalled that there were no time-pieces to allow of accurate counting of the pulse.

The question of foetal respiration and cardiac motion in utero is raised to be answered in the negative. This opinion is derived from Galen's *De usu partium*, where it is pointed out that the heart action is unnecessary without respiration since the pneuma is derived from the mother through the umbilical veins.

Why the heart does not beat nor the lungs respire at the time when the foetus is in the womb filled with water: because if it breathed this, it would immediately be drowned. But the breathing and the beating of the heart of its mother operate during the life of the foetus united to her (by means of the umbilicus) as they operate in other members.

105

VENTRICLES OF THE HEART

ventricle, the protective coat or support of the membrane should be on the outside, that is, on the front [atrial surface] of this membrane, at the proper place for the blow, and not on back.

But as it [the valve] endures a greater blow on its front than on its back [ventricular surface], Nature has placed them [chordae and their membrane] on the back and not on the front. The greater blow arises because the blood which turns back gives a greater blow to the membranes at their reopening than at their closing. The cause of this blow is that, apart from the reflux motion which the blood makes on being beaten back in the cavity of the auricles of the heart, the closing of the said auricles is added and, furthermore, the beginning of the reopening of the heart which draws this blood into itself. Therefore a single force drives the blood from the heart and three forces return it. For this reason it was necessary to place the cords as a protection of the valves on the inside and not on the outside.

fig 11. **The chordae tendinae and the formation of a valve.**

The chordae tendinae form, in Leonardo's opinion, the ventricular surface of the valve by the expansion of the tendons as shown here. In the note below the figure he attempts to explain the mechanism of the flux and reflux of the blood through the valves as required in the Galenical physiology. Traditional views were that the valves leaked a portion of the blood during systole whereas Leonardo holds that the reflux occurs with the closure of the valves and involves that portion of the blood lying between them.

And if it appears necessary to you that these valves should not close completely because of this blood [the reflux], if it is to escape to be given to the lungs, in this case the blood is provided for [by that] which escapes from the ventricle before it is entirely closed. This is proved since the blood which gives origin to the escape finds the valve barred, that which does not touch the cusps of the valves has free passage, and that which beats against the lips of the cusps is that which closes the valve with the cusps.

106

VENTRICLES OF THE HEART

branes make a greater motion than the lower since on stretching they in large part cover the inferior cords before their membrane is formed. The Creator did this for the reason shown in the above illustration [fig. 8] which demonstrates that the Almighty makes nothing superfluous or imperfect. In order that the entire membrane remain double and not quadruple in thickness where it is not required, the [papillary] muscle or the inferior cords, pulls its membrane (when the gateway of the heart is shut) from r to o, and the strong membrane [i.e., consisting of both the fleshy and tendinous layers] remains from h to o. Thus a r [margin of cusps on overlapping] remains a double membrane and likewise does the entire interval r o, because from a to s, there is a simple cord [i.e., single tendinous layer].

fig 11. **Detail of interventricular septum.**

The septal wall of the heart—and thus it must be represented to make it understood.

The diagram shows the trabeculae carnae of the septal wall of the ventricles and supposed perforations in it through which the blood supposedly passed from right to left.

112

AORTIC PULMONARY VALVES

the blood to be drawn through the septum aided by the systole of the right ventricle which alternates with that of the left. Closure of the valves is essential for the development of this vacuum, but Leonardo wonders whether the cusps themselves are necessary for this closure at the aortic orifice since he believes (110) that the sphincteric action of the walls of the aortic vestibule at the entrance to the aortic orifice together with the bulging of the aortic sinuses may

be sufficient for closure alone. He therefore concludes that the cusps make for a better, final closure as would be required to maintain a vacuum and to continue the vacuum when the vestibule is relaxed on diastole.

Here it is doubted whether the membranes which shut out the blood in the antechamber of the heart, that is, at the base of the aorta, could have been dispensed with by Nature or not, since one may clearly see how the 3 walls or hinges where the membranous valves of the heart are supported, are those which shut out the blood from the heart by their swelling when the heart reopens on the side below this valve. Nature makes this final closure [of the cusps] in order that the great forces which the heart develops in the left ventricle on its opening to attract into it the blood distilled through the minute channels of the wall, which separates it from the right ventricle, might not, through restoration of the vacuum, draw inwards the very thin membranes of the aforesaid valve of the heart.

As mentioned, this sheet is a portion of a larger sheet containing observations on the eye. These are continued in part on this page. The first part of the note is difficult to understand unless the reader is familiar with the anatomy of Galen. Leonardo believes that the eye is controlled by four muscles, and that combinations of their actions will account for all the movements of the eyes. This would perhaps require four motor nerves, but tradition had ascribed the motion of the eyes to Galen's second pair of cranial nerves, that is, the oculomotor. Leonardo speculates that this is too great an influence to be expected from a single nerve.

The note continues with an outline of subjects to be taken up in his projected work. Among them mention is made of the vermis or worm. A belief adapted from Galen divided the brain into three ventricles or cells containing the corresponding mental functions of the sensus communis, memoria and cognition. These cells communicated with one another but control was exercised by the vermis, probably choroid plexus, which opened and closed the intervening passage. The vermis of Galen was in fact the vermis of the cerebellum as in modern terminology, but early anatomists were too uninformed on the structure of the brain to perceive that the passage in Galen was at the apex of the tentorium cerebelli which is closely related to the true vermis. For further discussion cf. 101.

Look for the motor nerves of the eyes from all aspects, and consider whether there are 4 principal ones, or more or less, because in all its infinite motions 4 nerves may accomplish all, [and] because as soon as you omit the control of one of these 4 nerves, you add to the influence and assistance of the 2nd nerve. So it [the book] continues:

On the motor nerves [sinews] of the voice and how they work in high, low and medium voices.

On the nerves which open and close the vessels or openings of the spermatic ventricles [seminal vesicles?].

On the nerves or, you might say, muscles which close the gateway of the bladder.

On the nerves and muscles which eject the sperm of the penis with such violence.

On the muscles which close the anus.

On the muscle called the vermis which lies in one of the ventricles of the brain. This lengthens and shortens to open and close the passage of the impressiva or sensus communis to the memoria.

All the sphincters mentioned are opened by the thing which leaves the place shut by them, as the anus by the superfluities of the food, and are then closed by the actions of the muscles. The openings of the spermatic ventricles do likewise. These are opened by the momentum of the compressed sperm and then closed again by their muscles. Furthermore, the urine does the same thing at the gateway of the bladder, that is, the force of the compressed urine opens this gateway and its own muscles are those which shut it again. The same will be found at the mouth of the penis, of the vulva and of the womb, and of all structures which receive necessary things and expel the superfluous.

There are many portions of passages which remain open at death, but which formerly remained closed, that is, the anus, the vulva, the lips and the antechambers of the heart. But that which shuts itself at death is the mouth of the womb.

113

AORTIC PULMONARY VALVES

order of the book, and therefore closely related in time to the present writing. Here (Leicester 15v) we learn that the third book carried the title *libro 3° delle vene,* that is, on the passage of water through pipes, which must be the work to which reference is made.

When the heart contracts, the left ventricle c d e f g [fig. 7], sends out its blood through the opening c d, into the tube a b n m [aorta] which has 3 semiventricles [aortic sinuses] at its base as will be demonstrated in its place. However, the velocity of the blood at the entrance to these semiventricles has its motion varied owing to the fact that the proportional velocity of this blood in equal time will be equal to the proportions of the various dimensions of this tube [cf. fig. 6,N], but they will be inverse, that is, the greater velocity in the greater dimension as is proved in the 3rd [book] of the treatise on water.

Therefore having proved the different velocities of this blood in its antechamber [aortic sinuses], it is necessary to prove the velocity which follows upon the expansion of this blood toward the 3 walls of these semiventricles. Thus, when the highest velocity of this blood has issued from the narrows [aortic vestibule], it beats against and opens the valve. The dilated and lowered valve gives way to the expansion of the blood which follows the momentum of its rising velocity and beats against the blood which lies above it. This percussion throbs all the arteries and pulses distributed throughout man. It then turns to the lateral percussion of the semicircles of the ventricles and, having beaten against them, turns downwards with a circular

motion. The other part [of the blood] revolves above, dividing the upper circular motion from the lower at the upper limit of the semicircle. But the circular motion which revolves below beats against the base of the semicircle and returns to the valve of its first entrance. It strikes the valve with a compound motion and distends its membrane, raising it and shutting it against its opponents, which at the same time with the same order are driven against it. Immediately the circular motions expend their momentum towards the centre of their circumvolution: the momentum slowing by successive steps. The upper revolution in opposite motion does likewise, giving birth to many other revolutions, opposed to one another, in succession one above the other, the velocity continuously slowing until the momentum expends itself.

The statements in the final note are pure Galenism, and since the note was composed in his latest period, they completely destroy the fanciful notions of many that Leonardo possessed a knowledge of the circulation of the blood. Here we meet with the age-old theory of the passage of blood through the interventricular wall to form the vital spirit.

The manner of closure of the left ventricle of the heart having been described, there follows the manner of its reopening. This occurs immediately afterwards in two-thirds of a harmonic tempo and [the left ventricle] not being able to draw any blood from the already closed [mitral] valves, which do [not] shut with their fronts like other valves, but with their sides by extensive contact and force, the blood is then sweated from the right ventricle as is here demonstrated.

During the time which follows the 3 revolutions of the blood in the 3 semicircles [aortic sinuses] and that the 3 valves maintain and strengthen their closure by these 3 revolutions, the heart is dilated and acquires capacity. The blood having already surged above the aforementioned valves and not being able to return into it [left ventricle], it is provided of necessity by the extraction of blood from the right ventricle. This penetrates through lengthy porosities the wall interposed between the right and left ventricles. These porosities proceed from contracting pyramidal cavities until they pass into imperceptible passages through which the viscous blood penetrates becoming subtilized to very great thinness.

114

AORTIC PULMONARY VALVES

fig 6. **The aortic valve open at the beginning of systole.**

The letter S on the right marks the figure as one of a series beginning with the diagram on the extreme right lettered O.

fig 7. **The aortic valve closed during diastole.**

The legend reads: *When it [antechamber or aortic sinuses] is full and the reflected percussion has been received by the membranous valves.*

fig 8. **The aortic valve to show the fitting together of the lunules of the cusps.**

fig 9. **An aortic cusp showing the lunule of its free border.**

fig 10 (below 9). **The aortic cusps in closure.**

This is figure U of the series.

fig 11. **Diagram on circular motion.**

This is figure O and the first of the series. The diagram illustrates the manner of formation of the blood vortex and is similar to figs. 2-3 on 113. The blood stream is marked by the letters b d c, d being the point of reflection from the wall of the aortic sinus. Compare the accompanying statement to Newton's first law of motion.

Everything movable desires to expend its momentum along a straight line. And for this reason the percussion [of the blood] delivered against the semicircular wall [of the aortic sinus], on leaving this wall, directs its first curved course in a straight line.

fig 12 (below 11). **A diagram; significance unknown.**

fig 13. **Diagram of aortic valve and sinuses demonstrating the formation of a vortex of blood.**

The lettering is difficult to read. Aortic orifice, f g; the blood stream at r, parts at e, to describe a circular eddy e a c, about a, center at b, in the aortic sinus n o p.

When the momentum of blood is directed through the left ventricle to the aorta through the orifice f g, it beats against and dilates the membranous valves and ascends with the momentum created by the percussion occurring at the junction r. The momentum separates from the site of the percussion in the narrows r, and revolves backwards along the curve e n, and beats against the wall of channel n o p [aortic sinus]. It then continues this circular motion imparted to it by the wall which yields, and beats against the membrane of the valve with the front of the impetus b. Having received this percussion, the membranous valve immediately expands its folds and is dilated until it abuts against the opposite valve which through the opposed momentum advances to meet it and abuts against it. And so in a similar manner do the 3 said valves which shut together in close contact until the momentum, converted into a cochleariform motion, expends itself. In a healthy individual the time occupied is about half of a harmonic tempor. And then the heart is dilated, and since a vacuum cannot exist, this left ventricle attracts the blood from the right ventricle.

146

CENTRAL NERVOUS SYSTEM & CRANIAL NERVES

tained in the lung. It is necessary that the lung be supported in a stable place and that the air which is enclosed in the lung may be compressed, restrained and condensed. The lung having no muscles itself is unable to do so, hence it is necessary that it should

be done by others. Consequently the longitudinal and transverse muscles of the body compress the intestines. The wind which is confined in these intestines is condensed and forces the diaphragm against the lung. The muscles of the ribs, behind and in front, draw the ribs together on which the lung is supported. And therefore the lung is secured against bursting by the great violence of the air condensed within it.

Finally the lung remains protected by the ribs which compress it, owing to the contraction of the muscles, 5 of which are placed behind on the right below the right scapula and 5 on the left. There are also opposite them 5 placed below the right nipple and 5 on the left. In all there are twenty very strong muscles and cords. The curvature is on the dorsal aspect.

Leonardo's sources are mentioned in the scattered memoranda with the statement:

Have Avicenna translated "On the utilities".

The book on the science of machines precedes the book "On the utilities".

He reminds himself to, *Describe the tongue of the woodpecker and the jaw of the crocodile.* The crocodile would be of great interest since the literature of the times stated that this was the only animal which moved its upper jaw. Finally, Leonardo defends the use of anatomical illustration, condemned by Galen, and discusses the difficulties encountered in the study of anatomy.

And you who say that it is better to witness an anatomy made than to see these drawings would be right if it were possible to see all these things which are shown in such drawings in a single figure. In an anatomy, with all your ability, you will not see and will not obtain knowledge except of a few vessels, to acquire a true and full knowledge of which I have dissected more than ten human bodies, destroying every other member and removing in very minute particles all the flesh which surrounded these vessels without causing them to bleed except for the insensible bleeding of the capillary vessels. A single body was insufficient for so long a time, so that it was necessary to proceed by degrees with as many bodies as would give me complete knowledge. This I repeated twice in order to see the differences.

And if you have a love for such things, you will perhaps be hindered by your stomach, and if this does not prevent you, you may perhaps be deterred by the fear of living during the night in the company of quartered and flayed corpses, horrible to see. If this does not deter you, perhaps you lack the good draughtsmanship which appertains to such demonstrations, and if you have the draughtsmanship, it will not be accompanied by a knowledge of perspective. If it were so accompanied, you lack the methods of geometrical demonstration and the method of calculation of the forces and power of the muscles. Perhaps you lack the patience so that you will not be diligent. Whether all these qualities were found in me or not, the hundred and 20 books composed by me will supply the verdict, yes or no. In these pursuits I have been hindered neither by avarice nor by negligence but only by lack of time.

Farewell.

147

CENTRAL NERVOUS SYSTEM & CRANIAL NERVES

gether, we can then conclude that the sense of touch passes to this ventricle, in view of the fact that in all processes Nature operates in the shortest time and way possible and so would the sense, in the shortest time.

fig 8. **Diagram illustrating localization of the sensus communis.**

The sketch roughly indicates the position of the third ventricle in the center of the base of the brain. To this ventricle converge a series of lines representing the optic nerves anteriorly, and the acoustic and trigeminal laterally, so establishing this ventricle as the site of the *sensus communis*.

156

PERIPHERAL NERVES: UPPER EXTREMITY

NOTES.

You will make with extreme care this demonstration of the neck from in front, from behind and from the side, and the proportion of the cords and of the nerves to one another, and with the positions where they arise and terminate, because by doing otherwise, you would be able neither to treat of nor demonstrate the function or employment for which Nature or necessity had ordained them. In addition to this, describe the distances existing between the nerves with respect to their depth as well as width, and likewise the proportions of their thicknesses and lengths, and the differences in height above and below of their origins. You will do the same for the muscles, veins and arteries, and this will be a very useful thing for those who treat wounds.

169

RESPIRATORY SYSTEM

note: *Write on what sound is and what is noise, uproar, hubbub, etc.*

fig 7. **Upper end of larynx: lateral view.**

fig 8. **Laryngeal aperture from above.**

The figure is somewhat puzzling at first sight. Below it is written the single word *uvula*, which suggests that the larynx is viewed through the naso-pharyngeal isthmus. Above the illustration an incomplete note discusses the soft palate.

If you inspire air through the nose and send it out through the mouth, you will hear the sound made by the partition (tramezzo [=palate]), that is, the membrane in [. . .]

fig 9. The larynx: posterior aspect.

The special purpose of the illustration is to show the laryngeal ventricles, which are greatly exaggerated, non-human, and resemble what is found in the pig. The *tongue* is so labelled. The hyoid bone, pharynx and its piriform sinuses are easily identified.

fig 10. On the right is a companion illustration.

fig 11. Coronal section through the larynx to illustrate its ventricles.

Leonardo describes his figure and the function of the ventricles thus: *The air enters and leaves by the opening d [laryngeal aditus], and when food passes over the bridge d n [epiglottis], some particle might fall into the opening d and pass through c [rima glottidis] which would be fatal. But Nature has prepared the saccules a,b [ventricles] which receive this particle and tend to keep it until, on coughing, the wind which escapes with force from the lungs by way of c, eddies and drives the crumbs held by the walls of the saccules a,b, out through the route d, and so this injurious material is cast out of its position.*

GROUP III, RIGHT CENTER.

fig 12. Surface modeling of the lower extremity: anterior view.

This excellent écorchée of the leg should be compared with its companion on 61, where the muscles are labeled.

GROUP IV, RIGHT MARGIN.

fig 13. Outline of the palate and tongue to show the uvula: posterolateral aspect.

fig 14. The larynx in deglutition.

fig 15. The larynx in deglutition.

These two figures illustrate the action of the epiglottis in deglutition. In the first, the epiglottis has assumed a horizontal position and in the second a bolus of food is shown passing over it to enter the oesophagus. The action of the epiglottis in swallowing has been a subject of great contention until very recent times. It was long held that it did not act as a trap-door for the larynx. However, with the introduction of high-speed cineradiography it has now been established beyond question that the epiglottis closes the laryngeal aperture, but the motion occurs with such rapidity as to be almost impossible to detect with the naked eye on ordinary fluoroscopic examination. Leonardo's statement follows traditional assumptions: *a, represents how a mouthful [of food] completes the closure of the epiglottis (linguella) b, over the opening by which the wind enters the lungs.*

fig 16. The hyoid bone and larynx: lateral view.

fig 17. The hyoid bone.

Below fig. 16 and surrounding fig. 17 is the following note: *Rule to see how the sound of the voice is generated in the front [i.e., upper part] of the trachea. This will be understood by removing the trachea to-gether with the lung of man. If the lung filled with air is then suddenly compressed, one will immediately be able to see in what way the flute (fistola) called the trachea generates the voice. This can be seen and heard well in the neck of a swan or goose which is often made to sing after it is dead.*

A similar statement on the goose, employing a method familiar to all country boys, is made by Fabricius ab Aquapendente in his publications on phonetics, 1601, 1603, but, like Leonardo, he ascribes the sound to the true larynx since he was unacquainted with the organ of the voice in birds, the lower larynx or syrinx. Gerard Blaes, or Blasius (d.1692), seems to have been the first, in 1674 and 1681, to associate the voice of birds with the lower larynx, but the discovery of the syrinx we owe to C. Perrault (1613-1688) in 1680. It was rediscovered by Duverney in 1686, by Girardi in 1784 and by Cuvier in 1795, according to F. J. Cole (1944).

figs 18-19. The larynx to illustrate the ventricles.

Leonardo failed to appreciate the function of the vocal cords.
These are the two ventricles which make the sound of the voice; and when they are full of humor, then the voice is hoarse.

At the top of the page is a group of unrelated notes in one of which Leonardo considers arranging his book in the typical scholastic tradition from head to the foot, rather than by systems. It was Mundinus who broke away from this restrictive order and introduced a more practical arrangement by dividing the body into its major cavities and their contents.
Begin the anatomy at the head and finish at the soles of the feet.
Put in all the swellings which the veins of the flesh and their ramifications between the flesh and skin made, and so you will place all the veins which proceed between the flesh and the skin.
What are the muscles which contract or pull, in the movement of each member and in each [individual] motion?

173

RESPIRATORY SYSTEM

branchings of the bronchus are noted from above downwards in picturesque terms as *The smallest feathers; The middle-sized feathers; The largest feathers;* and the statement that *There are as many feathers as there are ramifications.*

At the lower pole of the lung is an encircled area labelled N, representing some pathological process, possibly a tubercle which is described in these terms:

Nature prevents rupture of the ramifications of the trachea by thickening the substance of the trachea and making a crust, like the shell of a nut. It is cartilaginous, and this with its hardness, like a callus, repairs the rupture and in the interior, powder and an aqueous humor remain.

In the Galenical physiology the function of the lungs was to cool and refresh the blood and to supply to the left heart a portion of the air, the pneuma, from which the vital spirits were elaborated. Contemporaries believed that a free passage existed to allow the air to be brought to the heart. Earlier, Leonardo accepted the traditional view but is now almost ready to challenge this dogma. He is unable to find any communication, only contact between vessels and bronchi. He hesitates to state positively that communication does not exist through the parenchyma until he has completed a dissection in hand to elucidate this point.

WHETHER AIR PENETRATES INTO THE HEART OR NOT.

To me it seems impossible that any air can penetrate into the heart through the trachea [i.e., bronchi], because when it is inflated, no part of the air escapes from any portion of it. This occurs owing to the dense membrane with which the entire ramification of the trachea is clothed. This ramification of the trachea as it divides into the most minute branches proceeds together with the very smallest ramifications of the vessels which accompany them in continuous contact to the end. It is not here that the contained air escapes through the narrow branches of the trachea and penetrates through the pores of the smallest branches of these vessels. But on this question I shall not positively affirm my first statement until I have inspected the anatomy which I have in hand.

Finally Leonardo theorizes that it is the respiratory movements of the lung which by acting through the diaphragm cause the peristaltic movements of the alimentary tract, cf. 170.

If it were not for the expansion and contraction of the lung, the stomach would not pour the food into the intestines nor would the food move through the bowels when a man is lying down. As the child in the womb does not breathe, it cannot evacuate any faeces except by the breathing of its mother.

figs 2-3. **Terminal bronchi on inspiration and expiration.**

The smallest tracheae [bronchi] not inflated and also inflated, which double themselves in capacity on its expansion. This view that the lung increases in capacity by separation of the bronchi, was held till recent times when it was demonstrated by radiography that the lung expands by the lengthening of the bronchi.

fig 4. **Detail of the cartilages of a medium-sized bronchus.**

Legend *On the shape of the rings, and* Trachea [bronchus] *of medium thickness.*

175

RESPIRATORY SYSTEM

tagonistic to its extension. Their synergists are the lumbar muscles [quadratus lumborum, fig. 8] *which lie on the side, internal to the spine, and their antagonists are the larger muscles of the backbone.*

Finally, having in mind the alternate action of the diaphragm and abdominal wall in respiration, Leonardo seeks an explanation. He arrives at what may seem to be a curious conclusion that the diaphragm and belly-wall alternately lend their force to one another. However, it should be remembered that following the Averroist interpretation of Aristotle's physics, force is thought of as something tangible, like a fluid which may be potential or kinetic and so may be lent or transferred from diaphragm to abdominal wall, constituting apart from the intrinsic force of contraction, the force of rebound. Usually Leonardo thinks of this force as being conveyed by the nervous system. These concepts are inherent in the following note.

When the diaphragm suspends its force, this provides the force of the anterior abdominal wall, and when the abdominal wall suspends its force, this returns the force to the diaphragm. Finally, the sum of the forces which are successively interchanged between the diaphragm and the belly cavity and the belly cavity to the diaphragm, remain divided, half in the diaphragm and half in the belly cavity.

The diaphragm and the anterior abdominal wall exchange their powers, lending their powers successively to one another, and finally they divide this power between them in half.

Muscle is not able to recover nor increase its force if it does not first relax.

176

RESPIRATORY SYSTEM

the air enters on dilatation of the lung to fill this [potential] vacuum.

figs 1-2. **Diagrams of the serratus anterior and serratus posterior muscles.**

These diagrams illustrate the note below in which it is contended that the muscles shown assist the diaphragm in forcing the content of the alimentary tract onwards. The muscle a n m o r, is presumably the serratus anterior, but its extent suggests the inclusion of digitations of the latissimus dorsi and possibly serratus posterior inferior. The serratus posterior superior is shown above. The note is written somewhat confusedly, but the general idea can be followed. The superfluities are not necessarily the equivalent of excreta but of residues since the stomach extracts its nourishment from the food, and the residues pass on to the next segment which in turn extracts its requirements to leave residues for the next, so-called, "less noble part" and so on.

WHAT HOLDS THE DIAPHRAGM SO THAT IT DOES NOT DILATE WHEN THE INTESTINES EVACUATE THEIR SUPERFLUITIES.

The diaphragm would be greatly dilated when the intestines are constricted and compressed by the transverse muscles [of the abdomen] to evacuate the superfluities, were it not for the [serratus anterior]

muscles a n m o r, which draw the ribs together with great force in such a way that they resist the dilatation of these ribs and, consequently, the dilatation of the diaphragm. For this reason the diaphragm contracts as much as possible and presses downwards the enlargement of the intestines which runs back there [under the diaphragm] on being compressed below by the transverse muscles. For this reason the superfluities escape downwards.

177

RESPIRATORY SYSTEM

by the straight, oblique and transverse muscular fibers which make up the coat of the organ. Leonardo not only discards this theory of attraction, retention and expulsion, but incorrectly has the transverse fibres function to retain instead of to expel the food.

The stomach does not move by itself at the expulsion of chyle but is moved by other influences, that is, by the flux and reflux that the [natural and vital] spirits have, and the motion of the diaphragm together with the abdominal wall, that is, when the abdominal wall contracts and the diaphragm relaxes, and when the abdominal wall relaxes and the diaphragm contracts. This they do constantly except at the expulsion of the superfluities when driven out of the intestines. To this end the force of the abdominal wall and of the diaphragm contributes at one and the same time during which time the lung loses its use.

If you should say that [the above is due to] the longitudinal and transverse muscles of the stomach, that the longitudinal attract the food, [and] the transverse retain [for expel] it, it will be answered that every intestine and every structure which is adapted to relaxation and contraction has transverse and longitudinal fibres like those seen in the weave of a cloth. This occurs so that no transverse, longitudinal or oblique force can rupture or tear them.

201

GENITO-URINARY SYSTEM

The vagina and uterus may be observed lying below and behind the disproportionately enlarged bladder. Extending to the vagino-uterine junction may be seen the so-called seminal duct, ovary and ovarian vessels in continuity. Above these is a structure on either side, equivalent of the round ligament, which runs upwards to the anterior abdominal wall from where it was supposed to extend to the mammary glands to convey the suppressed menstrual blood during pregnancy for purposes of lactation. The uterine tubes proper are not shown. The remaining structures are readily identifiable.

In relation to the figure, evidently that of a woman in early pregnancy, Leonardo makes a note in which he falls into a mistake by saying that the human placenta is cotyledonous. Nevertheless, his quantitative outlook is evident.

The child turns with its head downwards on separation of the cotyledons.

The child lies in the womb surrounded by water because heavy objects weigh less in water than in the air and the less so the more viscous and greasy the water is. Further, the water distributes its own weight together with the weight of the creature over the entire base and sides of the womb.

202

GENITO-URINARY SYSTEM

the superior epigastric extends from the uterus to the breast. In the Galenical physiology this vessel carries the retained menses to be converted into milk. It is variously shown as a branch of a uterine, hypogastric or umbilical vessel.

A further note beginning with the statement, Man dies and always regenerates in part, has been so destroyed that the few remaining words make little sense. The body of the note seems to be concerned with the function of the meseriaic or portal vein. These few words, which do not merit translation, suggest that Leonardo was thinking in part of the cause of death of the centenarian (cf. 128) which he ascribed to hepatic insufficiency.

A final note reminds him of The females of Messer Iacomo Alfredo and "Lleda ne' Fabri".

212

EMBRYOLOGY

All seeds have an umbilical cord which breaks when the seed is mature. And likewise they have a womb and secundines, as herbs and all seeds which grow in pods, show. But those which grow in nutshells, as hazelnuts, pistachios and the like, have a long umbilical cord which shows itself in their infancy.

The above passage is characteristic of Leonardo's capacity for generalization. For his drawing of seeds in a pod, cf. 214. The word secundine he uses in various ways, either as foetal membranes in general or as the chorion in particular. In the figure, the uterus has been laid open to expose the chorion and then the amnion with its contained foetus. Close inspection of the chorion will reveal its cotyledonary nature, taken from animals and exhibited in greater detail in figs. 3-4 on the left, and figs. 6-7 on the right. The cervix is clearly shown within the outline of the upper end of the vagina. The accuracy of the foetal position indicates familiarity with the gravid uterus or with the products of an abortion.

figs 6-7. **Detail of cotyledonary placenta.**

Note whether the globosity of the cotyledons faces towards the center of the uterus or the opposite.

In this instance cotyledonary villi are shown on both maternal and foetal sides imbricated with one another. At other times, 208, 210, the villi are described as attached to only one of the two contributing structures. Leonardo's hesitation is possibly due to his uncertainty as to the true type of placenta in man as was seen in 211.

fig 8. **Rough sketch of foetus in utero.**

fig 9. **Foetus in utero.**

The foetal coverings illustrated are similar to those of fig. 5 above. However, certain of the adnexa such as the ovary, uterine "horn" and vagina, have been included. The significance of these structures in Leonardine anatomy is discussed with 215. The position of the foetus is carefully noted with the remark, *The chin has its commissure between the border of the back of the hand and the shoulder.*

Leonardo's thoughts then turn to forms other than man with the note, *See how birds are nourished in their eggs.* Finally he returns to his subject and observes, *The allantois passes between the hands and knees of the child as it lies curled up, and it passes between the arms and outer part of the thigh as far as the flanks and binds and encloses, making a covering for the child from its flanks downwards.*

Again Leonardo apparently draws on animal anatomy and describes the more highly developed allantois of the ruminant.

213

EMBRYOLOGY

ovens of the fire-place. He jots down and perpetuates an ancient and persistent error. *Eggs which are round in shape produce males, and those that are long produce females.*

Again Leonardo refers to erection in death by hanging, cf. 182. *Man frequently dies with the genital member in erection, and especially those who are suffocated as hanged and the like.*

At the foot of the page Leonardo compares the representational aspects of the art of poet and painter. He follows the neo-Platonic ideal of poetic rapture, the delight in the true and essential beauty of things as the true test of poetic power. The passage loses somewhat in translation because of the play on the words *figurare* and *figuratione*, representation in the sense of the artist's brush and the descriptive words of the poet.

When the poet ceases to represent in words what in fact exists in Nature, then the poet ceases to be the equal of the painter. For if the poet, leaving such representation, were to describe in the ornate and persuasive words of one whom he wishes to represent as speaking, then he becomes an orator and is no longer a poet or a painter, and if he speaks of the heavens, he becomes an astrologer and a philosopher—and a theologian when speaking of the things of Nature or of God. But if he returns to the representation of any object, he would become the equal of the painter, if,

with words, he could satisfy the eye as the painter does with brush and color [creating] a harmony to the eye as music to the ear—instantaneously.

214

EMBRYOLOGY

posite to that by which it enters when the child breathes outside the uterus.

When women say that the child is sometimes heard to cry within the womb, this is more likely to be the sound of wind which rushes out. . . .

An unrelated note indicates how dependent Leonardo was on local physicians for advice in his anatomical studies and nomenclature.

The names of the vessels, the muscles, the bones and the membranes and ask about the vein which was searched for in the lungs on Sunday.

The dissection of the human foetus raised questions as to how it was nourished and on quantitative aspects of its growth. He concludes that the foetus is nourished by the menstrual blood, an old Galenical notion, and attempts to explain this in some detail, taking the existence of the foetal stomach into consideration since "Nature makes nothing in vain". The term faeces (*fecca* or *stercho*) is here rendered excrement to be regarded as residue which may be utilized by other parts and not as excrements in the modern sense.

The excrements found in the intestines of children lying in the uterus arise from the menstrual blood of the mother. This blood comes from the 2 ramifications [uterine veins] of the great vein [cava] of the gravid mother and passes through the umbilical cord of the child and enters through the umbilical vein which ramifies in the liver of the child and through the [portal] vein which goes to the pylorus (portinario) of the stomach, and proceeds to pass into the stomach. The stomach effects the digestion of the maternal blood converting it into chyle. Then the passage of the excrements follows through the intestines in the same way as it does when it [the foetus] is outside the belly of its mother but not with the same speed, because the miseriaic [mesenteric] veins attract from it a large part of the substance of these excrements to form the bulk of the child which daily grows far more when lying in the body of its mother than it does when it is outside her body. This teaches us why in the first year when it finds itself outside the body of its mother, or in the first 9 months, it does not double the size of the 9 months when it remained within the body of its mother. And likewise, in 18 months it has not doubled the size it was for the first 9 months that it stayed outside the body of its mother. Thus, in every 9 months diminishing the amount of such increase, it at length comes to achieve its greatest height. In this case the bile carries out its function by being joined to the vein which comes from the pylorus.

NOTES